European and American Paintings in the Isabella Stewart Gardner Museum

by Philip Hendy

PUBLISHED BY THE TRUSTEES OF THE ISABELLA STEWART GARDNER MUSEUM, BOSTON

Library of Congress Cataloging in Publication Data

Isabella Stewart Gardner Museum, Boston.
 European and American paintings in
the Isabella Stewart Gardner Museum.

 Bibliography
 1. Paintings — Boston — Catalogs. 2. Isabella
Stewart Gardner Museum, Boston. I. Hendy, Philip,
1900- II. Title.
N521.I7A52 750'.074'014461 74-79188
ISBN 0-914660-00-4

The Trustees gratefully acknowledge a grant from the Ford
Foundation which helped in the publication of this catalogue.

Introduction

THE AUTHOR'S preface which follows this introduction discusses some of the singular aspects of the Gardner Museum and the reasons which led to this, the second catalogue of paintings.

When, in 1926, the Museum was fortunate enough to secure the services of Philip Hendy, he was Assistant Keeper of the Wallace Collection and was engaged in writing the catalogue of the pictures there. Upon completion of the Gardner Museum catalogue, he became Curator of Paintings at the Boston Museum of Fine Arts, then, returning to England, Director of the City Art Gallery, Leeds, and in 1946 Director of the National Gallery, London. Before his retirement in 1968 Sir Philip was persuaded to write this book. Work was postponed for two years while he served as Adviser to the Israel Museum, Jerusalem.

The contents of the first catalogue, with extensive biographies of the artists and notes on the condition of the paintings — exceptional at that time — was presented in a handsome volume by the master printer D. B. Updike. Every effort has been made to meet those standards given the increase in the text and the decision to include not only monochrome reproductions of every picture but thirty-eight color plates as well. The staff of the Museum and the designer have devoted months to the present format and the verification of photographs. On the four extended visits to Boston by Sir Philip he has made these tasks seem lighter and more pleasurable. Needless to say the text and the opinions expressed therein are his.

It only remains to add that this book is an insight into the taste of Mrs. Gardner and her times. The collection is an integral part of the museum building in a way that is immediately apparent. Together they represent Mrs. Gardner's forceful, at times prophetic, ideas on what a museum should be. And while it is a personal museum it was dedicated by her to the enjoyment of the public. This book is one more act toward that goal.

Rollin van N. Hadley
Director

Preface

THE FIRST *Catalogue of the Exhibited Paintings and Drawings* in the Isabella Stewart Gardner Museum was published in 1931, but it was not the first essay in this direction. In 1907, but a few years after the building of Fenway Court had been finished and many years before Mrs. Gardner had completed her collection, appeared the first of fifteen projected volumes entitled *Noteworthy Paintings in American Collections*, edited by John La Farge and August F. Jaccaci (New York, the August F. Jaccaci Co.; London, The Burlington Magazine, Ltd.). The only volume to attain publication, this contained, besides descriptions of four other private collections, 253 pages dedicated to that at Fenway Court: an introduction by John La Farge, a catalogue of twenty-nine of Mrs. Gardner's pictures, and essays upon each of these by three or four critics. The book is described briefly throughout the footnotes of the following catalogue as *Noteworthy Paintings*. In 1968 the Trustees published *Drawings* (Isabella Stewart Gardner Museum) by Rollin van N. Hadley. This includes not only many drawings which were not catalogued in 1931, since, though left in the galleries, they are in closed cases, but seventeen which were included in the 1931 catalogue that are displayed with the pictures. These seventeen, which are drawings in the strict sense, having no colour, are omitted from the present volume except for a brief reference to the *Drawings* catalogue. In both catalogues entries are cross referenced to the 1931 volume. On the other hand there has been added a small number of pictures on panel or canvas which were previously omitted, mainly because of the obscure positions in which they were hung.

Between the two catalogues of paintings more than four decades have intervened, and in these perhaps as much has been written about the history of art as in the four centuries preceding. Research has re-assembled the *oeuvre* of many artists whose very names had in some cases been forgotten and has defined and dated more clearly that of those who have always remained known. Inseparable from this development in study has been the parallel growth of museums, in the sheer quantity of pictures made available to the public and in a matching improvement in quality: in methods of presentation, of conservation, of information, above all in a bid for the deeper understanding of the public, an effort to develop out of its original curiosity a permanent enrichment of its life; and in the public response.

In her conception of the role of the museum Isabella Stewart Gardner holds a place among the pioneers. In her instructions to her Trustees she enlarged the common idea of this by specifically stating that the Museum was founded "for the education and enjoyment of the public forever." In her lifetime there was always music and this has been continued by the Trustees. There have always been flowers. These provisions make quite clear her belief that art was to be enjoyed.

Mrs. Gardner is equally well known for two negative injunctions which she imposed: that no addition should be made to her collection; that no fundamental re-arrangement should be made on the principal floors of her palace. Perhaps only those who have been involved in the often febrile

workings of a growing institution can appreciate the subtleties of expansion made possible by this contraction of permissible effort. Probably only those who have been privileged to observe at close quarters the functional progress at Fenway Court since it was first dedicated to the public can realise how fully these potentialities have been appreciated and used.

The Museum's first Director, the late Morris Carter, certainly performed an act of courage when he invited me, then aged twenty-six, to make a catalogue of the pictures, and when, moreover, he gave his approval to the somewhat unusual form which I advocated. In 1927 perhaps only Harvard's Fogg Art Museum had a catalogue of pictures in which their history and their authorship were discussed in full. The great developments which I have summarised above have only increased the public interest in the pictures which Mrs. Gardner collected, so high a place do many of them permanently occupy among the world's masterpieces of painting. They have increasingly drawn the attention of those who have re-written the history of art partly for this reason of preeminence, partly because the collection includes also some important and fascinating problems for the historian. The catalogue of 1931 has therefore for a long period been accumulating upon its original mistakes a host of deficiencies which have become obvious in the light of new discoveries.

While I myself am so much indebted to Morris Carter, this new catalogue owes one of its indisputable over-all improvements to the second Director, George L. Stout, now Director Emeritus. Mr. Stout brought to the Museum a then almost unique comprehension of the meaning and the problems of conservation. He initiated the work of physical examination, treatment and recording which has been continued under his successor by James W. Howard, Jr. and Leo V. Klos, Jr., who have given me generous assistance. In 1931 I could only record what were largely mere assumptions concerning the condition of each picture, and the measurements had to be taken on the spot, often without removing frames. The work of these Conservators has made it possible to describe — with such precision as is possible in the briefest summary — the physical condition of each picture. Of the measurements, in the metrical system, which are given below, those in four figures are taken from the careful records of the Conservation Laboratory.

Rollin van N. Hadley, with all the Director's advantages of living and working among the pictures and of a contemporary viewpoint in his own scholarship, might well have come to produce a much worthier catalogue. He has been more than generous in allowing me to return to my old task and to attempt improvement on the former product. He has given me continuous sympathy and frequent help. While sanctioning my continuance of the previous form, he has himself created a new format which, among other accomplishments, copes ingeniously with the increased volume of material. His concern and unflagging attention have resulted in another undeniable improvement.

A catalogue is no different from any other book in the consideration that has to be given to the needs of the reader. In 1935 a *General Catalogue* of the Museum compiled by Gilbert W. Longstreet was published under the supervision of Morris Carter. This is an excellent handbook. The present catalogue of paintings is frankly a library book, intended for the general reader. The form that I chose originally, with as much discussion of the painter as of the picture, is possible only with a small and finite collection. I have persisted in using this advantage in the belief that to the majority of readers the character and history of the artist are of at least as much interest as are divergent scholarly opinions of the picture as to its attribution, its chronology and its provenance. The art historian can easily pass over the biography, though I hope that he will pause to read in some cases, where the attribution

is in question. The answer must depend upon the history of the artist and our interpretation of his character and work.

The debt which this new edition owes to the authors of the great developments in museology and scholarship which have been summarised above I cannot overemphasise. Comparisons of one picture with another are more instructive than books, and my gratitude must be expressed first to those who have made so many more pictures accessible or have restored to others already exhibited an approximation to their original appearance. My extensive debt to the authors of very many books and articles can be expressed only in the references which have been made under virtually every item. So much is owing to so many that I cannot particularise here except in the case of a few who have shown a special constructive interest in the collection: Everett Fahy; David Farmer; Sydney Freedberg; Elizabeth F. Gardner; Mason Hammond; David McKibbin; Richard Ormond; Judith Berg Sobré; Federico Zeri. To these the warmest thanks.

In 1931 a large proportion of the pictures catalogued was the work of living artists. Mrs. Gardner not only commissioned and bought pictures by established contemporaries; she befriended and gave generous assistance to many young painters — as she did to musicians. It seemed unsuitable to attempt biographies of the living. All but one of these artists are no longer alive. The consequent need to give some account of their lives and work has added considerably to the bulk of the new edition. Of the American artists a great majority were Bostonian, or were trained or worked for some time in Boston or its neighbourhood. It is fifty years now since Mrs. Gardner died, so that many of these artists and their work have become a part of Boston history. Sometimes they have helped to illustrate it. In this new emphasis I have needed special help, and it has been generously given by the Director and his Assistants: especially Linda V. Hewitt, Paula M. Kozol and Frances L. Preston. To these also I owe the careful editing of both manuscript and proofs. Indeed the Director and his staff have made me feel at all times as if I were again in Boston, where, alas, I have in fact been able to spend only a limited time.

When there I have always been the guest of the Museum Trustees. To them above all I wish to express my thanks for the trust that they have placed in me and for the warmth of their hospitality.

Philip Hendy
Whistlers Barn
Great Haseley
Oxford

Colour Plates

———

Colour plates follow page 210; a black and white illustration
accompanies each entry.

Catalogue of
European and American
Paintings

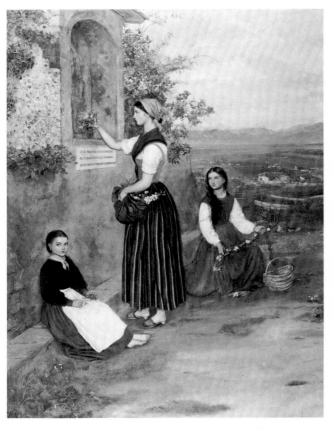

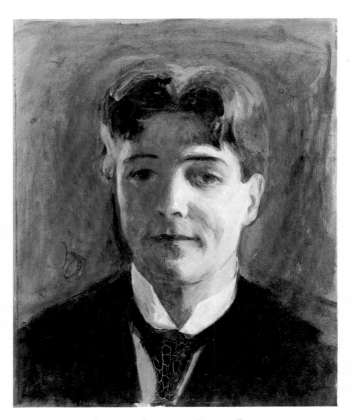

Francesca Alexander — *Decorating a Shrine*

Andreas Andersen — *George Proctor*

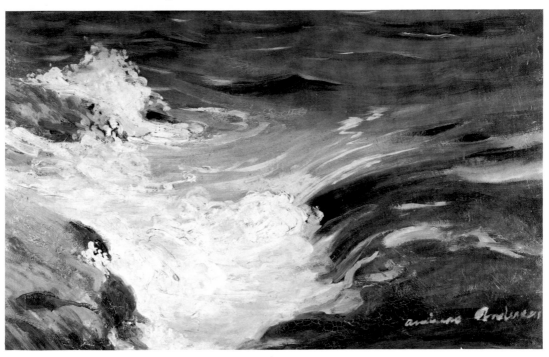

Andreas Andersen — *The Surge of the Sea*

Catalogue

Francesca Alexander

ESTHER FRANCES ALEXANDER: born in Boston, Massachusetts, 27 February 1837; died in Florence, Italy, 21 January 1917. The daughter of Francis Alexander, a portrait painter who worked for some time in Boston, and of his wife Lucia Gray Swett of Boston and Cambridge. They moved, while Francesca was still a girl, to Italy. There she interested herself in the life of the peasants and devoted herself to charity among them. She translated into rhyme a body of country songs in her *Roadside Songs of Tuscany* (Orpington, 1885; Boston, as *Tuscan Songs*, 1897). Ruskin, who called her FRANCESCA, bought her manuscript with its illustrations, as well as her earlier illustrated poem *Story of Ida* (Boston, 1883). He praised the drawings in lectures of 1883 and edited and published both books as well as *Christ's Folk in the Apennines* (New York, 1888). Her drawings, many of which are preserved in the Ruskin Museum at Sheffield, at Oxford and in Girton and Newnham Colleges at Cambridge, were for the most part of flowers. She painted but rarely.

DECORATING A SHRINE *Short Gallery*

Oil on canvas, 1.252 x 0.930. The shrine is inscribed: *IN TE MISERICORDIA IN TE PIETATE IN TE MAGNIFICENZA IN TE S'ADUNA QUANTUNQUE IN CREATURA È DI BONTATE* [IN THEE MERCY, IN THEE PITY, IN THEE GREAT WORKS, IN THEE IS UNITED WHATEVER THERE IS OF GOODNESS IN CREATION].

Religion and its propagation were essentials of Miss Alexander's painting. It was her identification of beauty with piety which brought Ruskin, always in search of it, to her feet. The landscape below the shrine is a view of the Val d'Arno from the hill of Bellosguardo outside Florence, upon which she was living with her mother at the time.

The picture was evidently commissioned of the artist in Florence by Mrs. Gardner's mother-in-law. There is a letter to her in the Museum thanking her for prepayment, signed Fanny Alexander and dated Villa Brichieri November 10th [1864]. P17w29

Andreas Andersen

ANDREAS MARTIN ANDERSEN: born at Bergen in Norway 14 August 1869; died in Boston, Massachusetts, 1 February 1902.

He came as a child with his family, including his brother Hendrik Andersen, the sculptor, to settle at Newport, R.I. He studied at the Cowles School of Art in Boston, won an Ernest Longfellow scholarship and went to study in Paris at Julian's. After spending three years in Paris and travelling with his brother in northern Italy he returned to Boston. He painted there and at Newport. In the year of his death he married Olivia Dulaney Cushing, sister of the painter Howard Gardiner Cushing (*q.v.*).

THE SURGE OF THE SEA *Blue Room*

Oil on canvas, 0.31 x 0.49. Signed at the bottom on the right: *Andreas Andersen*.

Purchased by Mrs. Gardner in 1900. P3s11

GEORGE PROCTOR *Blue Room*

Oil on canvas, 0.43 x 0.34. Signed with a monogram over the right shoulder.

George Proctor (1873-1949), pianist, was born in Boston. At the age of fifteen he was already organist at the Church of the Redeemer in South Boston. He studied and taught for most of his life at the New England Conservatory of Music. Mrs. Gardner had early engaged him as a pianist, and Mr. and Mrs. Gardner maintained him abroad 1892-96. After her husband's death, he became one of Mrs. Gardner's intimate friends. In 1911 his very brief marriage to Margaret L. Burtt, librarian at the Conservatory, was celebrated at Fenway Court. P3n11

For a portrait drawing by Andersen, *George Santayana*, see Hadley, *Drawings* (Isabella Stewart Gardner Museum, 1968), p. 59.

Andrea di Vanni

See Paolo di Giovanni FEI

Fra Angelico

GUIDO DI PIETRO: born about 1400 in the Mugello valley to the northeast of Florence, traditionally at Vicchio; died 18 February 1455 in Rome.

It was not until some years after his death that he became known as ANGELICO. In his lifetime he was FRA GIOVANNI, the name adopted after he had entered the friary of S. Domenico at Fiesole between 1418 and 1423.

Angelico probably began painting as a miniaturist under the influence of Lorenzo Monaco (died 1422-24), who helped to form his earliest, more or less Gothic style. For both S. Domenico and for S. Maria Novella, the chief Dominican house of Florence, he painted much in fresco and in tempera; though not a great deal of this has survived. He was already a famous painter by 1433, when he was commissioned by the Florence Linen Guild to paint the most monumental of his panel pictures, a folding triptych painted on five sides. Its marble frame is from the studio of the sculptor Lorenzo Ghiberti, who was by now probably the strongest formative influence on the painter's figure drawing. The ensemble is now in the Fra Angelico Museum of S. Marco, where most of his extant works have been brought together.

This friary of S. Marco was obtained for the Observant Dominicans by Cosimo de' Medici, the virtual ruler of republican Florence, who now became Angelico's consistent patron. From 1437 church and convent were rapidly rebuilt by Michelozzo in the new style of the Renaissance. It cannot have been long before Angelico with his assistants set up a workshop there, which remained active for several years. There are some fifty frescoes, mostly at least from his design.

In 1446-47 the master was called to Rome by the Pope, taking assistants with him. After two years he returned to S. Domenico, and perhaps remained there while serving a three-year term as Prior. By the end of this he was back in Rome. There he died in 1455, at S. Maria sopra Minerva. The triptych with *The Last Judgment* in Rome is likely to have been painted while he lived there. Of the several undertakings in fresco of this time there survive only the decoration of the chapel of Pope Nicholas V in the Vatican and the vault of a chapel in Orvieto cathedral, largely executed by assistants.

Angelico is the least monumental of the really great Italian painters. It was his pictures on panel, mostly on a comparatively small scale, that influenced future developments. He was the greatest master since Duccio (died 1319) of the technique of painting in egg tempera which had been traditional since the early Middle Ages. He developed to its highest pitch the application of gold, and he used more than any other contemporary the no less costly ultramarine blue which had an ancient religious significance. These methods were archaic, a part of the immemorial custom of dedicating precious materials to God. Yet he was advanced in his use of colour, even while perfecting this tradition. For more than two centuries the best painters had used only clean hues, shaded not in neutral darks but with the same positive tint, deepened and intensified. Angelico never departed from this principle of pure colour, evolving an even greater intensity and variety. The element in space composition which has proved more lasting in value than that of artificial perspective is the unity which can be given to a scene by the consistent representation of natural light. The brilliant synthesis of light and colour which Angelico achieved became the essence of the illusion of space. This made him incidentally a pioneer in landscape painting.

THE DORMITION AND THE ASSUMPTION
OF THE VIRGIN *Early Italian Room*

Gold and tempera on wood, 0.618 x 0.385. The panel seems to have been reduced a little all round, and it has been reshaped at the top. Originally, it probably terminated in an ogive arch. At some time it was cut to the shape at present visible. More recently it was made rectangular by the addition of pieces above the shoulders, and these were painted with clouds. The additions are mostly covered by a modern frame. Except for scratches through the heads of Christ and the babe, the painting is in excellent condition. There is a little retouching on the clouds supporting the lowest Angels, on the Apostles' feet and on the bases of the candlesticks.

In *The Dormition* scene, below, Christ stands holding the Virgin's soul in the form of a child, in the center of a group of fourteen Saints. These are probably eleven Apostles and three others: S. Dionysius the Areopagite, a convert of S. Paul's, S. Timothy, to whom Paul addressed two famous epistles, and Hierotheus, who perhaps never existed. The missing Apostle is S. Thomas, who arrived on the scene late. At the head of the bier S. Peter, as he had been enjoined to do, is singing the 114th Psalm, about the delivery of Israel from Egypt. At its foot S. John carries the palm given him for the purpose by Mary, to whom it had been brought by the Angel foretelling her assumption.

In *The Assumption*, above, the Virgin rises, body and soul re-united, among a host of music-making Angels, to be received by Christ in a mandorla of Cherubim.

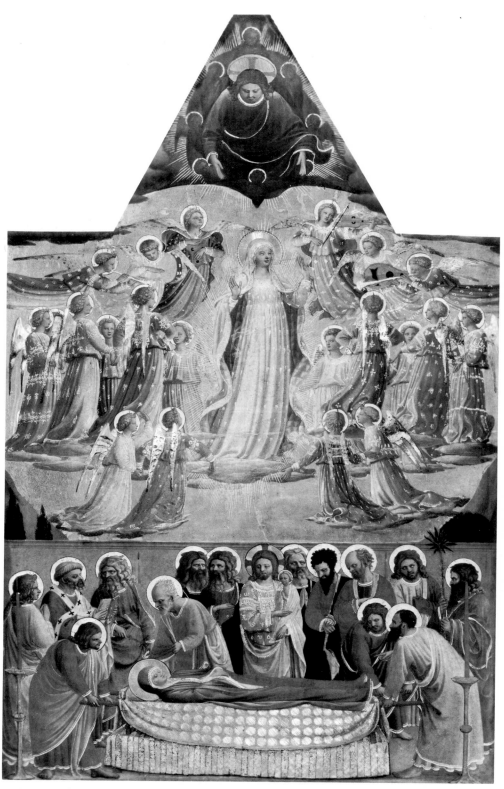

Fra Angelico — *The Dormition and the Assumption of the Virgin* (SEE COLOUR PLATE)

Angelico has followed the apocryphal legends of the Virgin with careful attention to detail, although he has excluded certain women whom some admitted to the Dormition.

Almost certainly the panel is from one of four reliquary tabernacles which were made for S. Maria Novella, the great Dominican church of Florence.[1] Padre Modesto Biliotti in his Latin *ms.* of 1580, *Chronica pulcherrimae aedis . . . Sanctae Mariae Novellae*, records: "We also own many relics of a great many saints, which a certain Fra Giovanni Masi of Florence, . . . had enclosed in four tabernacles, which the painter Fra Giovanni of Fiesole, named Angelico, decorated with exquisite pictures of the very blessed Virgin Mary and Saints and Angels."[2] Fra Giovanni Masi died in 1434. Vasari in his life of Angelico states that the reliquaries were placed on the altar on occasions of high ceremony.[3]

Biliotti's statement suggests that he had access to a record of Masi's commission to Angelico; but he does not state his source. He was writing in the last quarter of the sixteenth century, and Vasari's of 1550 is thus the first recorded attribution (1st edition, p. 370) of the four reliquaries to Fra Angelico. The other three have been in the Fra Angelico Museum since 1868. Two of them, the "*Madonna della Stella*," which has a predella painting with *S. Domenic, S. Thomas Aquinas* and *S. Peter Martyr* and is probably the earliest, and *The Annunciation* over *The Adoration of the Kings*, have kept their reliquary form, though the carved frames were much overlaid and regilt in the last century. The third, *The Coronation of the Virgin*, has presumably been reframed and is (1973) in a condition which makes the painting difficult to judge.

The most careful modern study of the four pictures was made by Mario Salmi.[4] He thought the Gardner picture the most mature, dating it about 1430, some five years later than the approximate date he suggested for the "*Madonna della Stella*." Of supreme quality, the Gardner picture is certainly richer in colour and in the resulting sense of atmosphere. Light as air, bright as light itself, the Seraphim have escaped from their burning rows to surround the brilliant figure of the air-borne Virgin. Below, round the bier, the Saints are not all equally interesting; but they stand firmly in attitudes which show that Angelico has skipped a century and gone back to the source of the Florentine Renaissance in the work of Giotto (*q.v.*).

A tentative suggestion made in 1928 by van Marle,[5] who knew the Gardner picture only in a photograph, that the predella, now in London, from Fra Angelico's altarpiece at S. Domenico, and these four reliquary paintings should be attributed to Zanobi Strozzi, was taken up a quarter of a century later by Pope-Hennessy.[6] He stated categorically "All four panels [from S. Maria Novella] are by Zanobi Strozzi." Stylistic and aesthetic considerations apart, this contention, which has never been supported by serious critical argument, is not consistent with chronology. In 1433 Angelico was already famous, and produced in the altarpiece for the Linen Guild a monument of early Renaissance painting. Many years of previous experience in painting must be presumed. The S. Domenico altarpiece and the four reliquaries of S. Maria Novella fit well with this presumption as preparatory works, certainly painted before 1433. Zanobi Strozzi was born in 1412, and was therefore in 1433 only twenty-one. Even if he painted well by then, he had had no time for the evolution which is evident in these four paintings. In fact, though Strozzi's manuscript illuminations owe much to Fra Angelico, none is documented earlier than 1446. No documented panel picture by Strozzi exists. Vasari, who wrote that the houses of Florence were full of them, coupled Strozzi and Benozzo Gozzoli as disciples of Angelico; but it was Benozzo, not Strozzi, whom he distinguished as always imitating the master.

The tabernacles are all recorded as in the sacristy of S. Maria Novella in 1754.[7] The Gardner picture was the first to go. By 1816 it had been acquired by the Rev. John Sanford (1777-1855), then Rector of Nynehead, Somerset. He formed a considerable collection of pictures, mostly between 1830, when he settled for some years in Florence, and 1839, when he sold the greater part of it by auction in London.[8] In 1855 he bequeathed this, with other pictures, to his only daughter's son, Lord Methuen, second Baron, of Corsham Court near Chippenham, Wiltshire.[9] From Paul Sanford Methuen, third Baron, it was bought by Mrs. Gardner, through Colnaghi and Berenson, in February 1899. *P15w34*

[1]Douglas, *Fra Angelico* (London, 1900), pp. 34-38; idem, larger edition (1902), pp. 29-33; in *Crowe and Cavalcaselle's History of Painting in Italy*, IV (London, 1911), pp. 90, note 6, and 96, note 1; and in *Noteworthy Paintings*, pp. 141 and 145-47.

[2]Marchese, *Memorie dei piu insigni pittori, scultori ed architetti domenicani* (Bologna, 1854), I, p. 270; he transcribed Biliotti in a footnote.

[3]Vasari, *Le Vite*, ed. Milanesi (Florence, 1878), II, p. 513. Milanese, pp. 513-14, note 4, stated that only three remained in 1878, kept in the glazed reliquary cupboard. He described them clearly.

[4]Salmi, *Il Beato Angelico* (1958), p. 101.

[5]Van Marle, *The Italian Schools of Painting*, X (The Hague, 1928), pp. 42 and 46.

[6]Pope-Hennessy, *Fra Angelico* (London, 1952), pp. 199-200. The author will abandon the attribution to Strozzi in a new edition.

[7]Richa, *Notizie Istoriche delle chiese fiorentine* (Florence, 1754), III, ii, p. 49.

[8]Nicolson in *The Burlington Magazine*, XCVII (June 1955), pp. 207-08. He attributes the picture to Strozzi.

[9]Waagen, *Supplement* (1857), p. 397, No. 29; following a catalogue of the Sanford collection made in 1847 (see Nicolson, above), he stated that the picture came from a chapel near Leghorn, perhaps a provenance invented for the Rev. Sanford's sake.

OTHER AUTHORITIES

Berenson in a letter (4 February 1930); also *Florentine School* (1963), I, p. 11.

Ciraolo and Arbib, *Il Beato Angelico* (Bergamo, 1925), pp. 57 and xix, attributed the lower part and the Christ above to a collaborator.

Fahy, in a letter of 16 April 1973, does not accept the attribution to Fra Angelico.

Fredericksen and Zeri, *Census of Pre-Nineteenth-Century Italian Paintings in North American Public Collections* (Harvard University Press, 1972), p. 9.

Meiss in *The Burlington Magazine*, July 1937, p. 25: "... towards 1430 Fra Angelico in his beautiful *Assumption* in the Gardner Museum ..."

Perkins in *Noteworthy Paintings*, p. 157; he dated the picture 1420-25, before the others of the series, with which he did not connect it.

Schneider, *Fra Angelico da Fiesole* (Paris, 1924), pp. 34-35; he attributed the lower part to an assistant.

Supino, *Fra Angelico* (Florence, 1901), pp. 44-45, and in *Noteworthy Paintings*, pp. 147 and 151-52.

Urbani, *Il Beato Angelico* (1957), p. 34, and in *The Encyclopaedia of World Art* (1959), I, p. 443, attributes the whole to Zanobi Strozzi.

Venturi, L., *Pitture Italiane in America* (Milan, 1931), Pl. CXLV.

Exhibited 1816, London, British Institution, No. 81; 1847, London, B.I., No. 137; 1877, London, R.A., Old Masters, No. 154; 1892, London, Corporation Art Gallery, No. 40.

Boris Anisfeld

Born at Beltsy, in the Russian province of Bessarabia, 2 October 1879; died in Stonington, Connecticut, 4 December 1973.

At the age of twenty-one he left the Odessa School of Art for the Imperial Academy in St. Petersburg. With this he was officially associated for eight years. The painter, sculptor and costume designer Wrubel was the strongest influence in his early years; but it was Diaghilev who organised his first successes as a painter: in St. Petersburg 1905; in Paris 1906; in Venice 1907. He painted a variety of subjects and was a forceful portraitist; but from

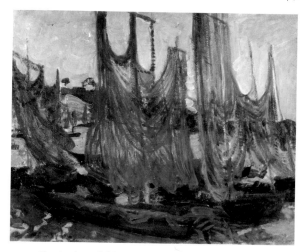

Boris Anisfeld — *Blue Nets-Concarneau I*

1909, when Russian ballet suddenly stormed the West, he was largely preoccupied for some twenty years with the stage. He worked less for Diaghilev than for those who broke away from him: Fokine, Pavlova, Nijinsky. The United States saw his décor first in Pavlova's *Les Préludes,* performed at the Manhattan Opera House in 1913.

He escaped from the Russian Revolution with his wife and daughter; and in 1918 the Brooklyn Museum organised an Anisfeld exhibition, which included the picture below. Circulated to twenty cities in the United States, the exhibition created a *furore.* In the ten years succeeding Anisfeld designed many famous productions. From 1928 to 1958 he was head of the Department of Painting at the School of the Art Institute of Chicago.

BLUE NETS — CONCARNEAU I *Blue Room*

Oil on canvas, 0.58 x 0.71. Inscribed at the foot on the left: *Boris Anisfeld 1910.*

Bought by Mrs. Gardner at the exhibition of Anisfeld's work (see above) held by the Copley Society at the Boston Art Club, December 1918 (No. 18).

P351

Exhibited 1910-11, Soyuz ("Union"), St. Petersburg and Moscow; 1918, Boston Art Club, Anisfeld exhibition, No. 18.

Anonymous

FLORENTINE; 1365-95. *The Annunciation*

FLORENTINE; 1375-1425. *The Martyrdom of S. Bartholomew*

GERMAN; 1450-1500. *The Annunciation*

GERMAN(?); 1850-97. *A Procession*

ITALIAN or FRENCH; 1700-50. *Cupids at Work*

LIGURIAN; 1450-1500. *S. Thomas Receives the Madonna's Girdle*

LOMBARD; 1425-75. *Mater Dolorosa* and *An Angel Catching the Blood of the Redeemer*

MILANESE(?); XV CENTURY. *Three Women*

NEAPOLITAN(?); 1610-50. *The Musicians*

NORTH ITALIAN; 1430-80. *The Madonna and Child with an Apple*

NORTH ITALIAN; 1575-1625. *Two Scenes from Early History* and *A Scene from the Old Testament(?)*

NORTH ITALIAN; 1650-1725. *Three Scenes from the Old Testament*

ROMAN; 1575-95(?). *S. Philip Neri*

RUSSIAN; XV CENTURY. *The Assumption of the Virgin*

SCOTTISH(?); 1770-1800. *Mary Brough Stewart(?)*

SIENESE; *ca.* 1500. *A Hero of Antiquity*(2)

VENETIAN; 1350-1400. *The Madonna and Child; The Crucifixion*

VENETIAN; 1365-1415. *The Madonna of Humility, with Saints*

VENETIAN(?); 1400-50. *The Madonna and Child Enthroned* and *S. Francis*

VENETIAN; 1425-75. *The Madonna and Child*

VENETIAN(?); 1525-75(?). *The Adoration of the Statue of Nebuchadnezzar*

VENETIAN or AUSTRIAN; 1550-1600. *The Birth of Caterina Cornaro(?)*

VENETIAN; 1766(?). *Alessandro Contarini(?)*

Antoniazzo Romano

ANTONIAZZO DI BENEDETTO AQUILIO: first recorded (he had to pay a fine) in 1452 in Rome. He is mentioned as deceased there 12 September 1512.

The date 1461 has been read beneath overpainting on his free rendering of Giotto's *Navicella* in mosaic, destroyed with the old St. Peter's in Rome. This is now in Lyons, France. His earliest known original work is at Rieti, some 50 miles northwest of Rome: a *Madonna Enthroned, with a Donor*, inscribed — ANTONIVS — DE — ROMA — DEPINXIT 1464. The frescoes which he was commissioned by Cardinal Bessarion to paint in the SS. Apostoli in Rome in 1464-65 have not survived. A triptych signed similarly and dated 1467 is in S. Francesco at Subiaco, 45 miles west of Rome. The much damaged and retouched cycle of frescoes in the old chapel of S. Francesca Romana in Rome bears the date 1468, but

was probably begun earlier. There is then a long gap in the list of dated works. An altarpiece in the cathedral at Capua, near Naples, is dated 1489, and several signed pictures are dated in the nineties. The rubbed and ruinous, but still noble *S. Fabian* in the Fogg Art Museum may be part of a triptych which Antoniazzo contracted to paint for S. Maria della Pace, Rome, in 1491. A triptych in S. Maria Assunta at Castelnuovo di Porto, in Lazio, is signed and dated 1501.

The interval of more than twenty years, however, includes probably the period of his greatest activity. In 1478 he was one of three artists appointed by the Papacy to found the Roman Guild of Painters. He was employed by a succession of Popes at all manner of work, for coronations and funerals and on coats of arms and banners. He ran a large workshop. This and himself he put at the disposal of great painters whom the Popes summoned to their court. He is actually recorded as working in the Vatican with the Florentine Domenico Ghirlandaio in 1475, with Melozzo da Forlì in 1480-81, with Perugino in 1484.

Among the pictures on panel which are signed by him or accepted as his by modern scholars there is a wide variety of competence and no very striking evolution. This is no doubt due to the collaboration of inferiors in his workshop. In his frescoes there are significant developments, and the explanation of this is perhaps to be found in similar circumstances in reverse. Thus in *The Invention of the True Cross, with Christ in Glory* in S. Croce in Gerusalemme, Rome, now widely accepted as Antoniazzo's, the lively invention and spacious grandeur are perhaps to be explained by inspiration from Melozzo da Forlì, or by a more positive participation. Antoniazzo's frescoes in S. Giovanni Evangelista at Tivoli, where there is little space for grandeur, have the same robust quality of form.

Attributed to Antoniazzo

THE ANNUNCIATION *Raphael Room*

Transferred (in Boston, perhaps before 1920) to mahogany panel, 1.024 x 1.148. The painting, apparently in tempera with glazes in oil or emulsion, is worn almost throughout, and there is much restoration, of different periods. Among well preserved parts are the landscape, the upper part of Gabriel (mostly), including his left hand, and the Virgin's head and hands, with her headdress and book. The original panel had vertical joins, and there is fundamental damage the whole length of two of these: through Gabriel's wing and through the Virgin's nose and left wrist. A thorough treat-

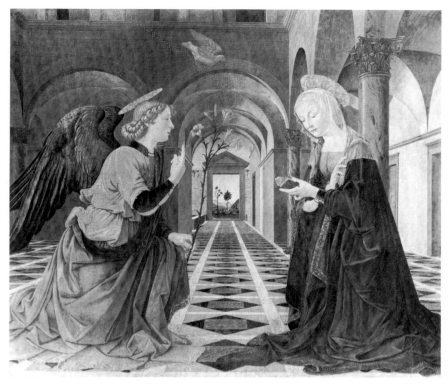

Attributed to Antoniazzo Romano — *The Annunciation* (SEE COLOUR PLATE)

ment in 1936-38 has consolidated the structure and improved the appearance.

For the most part, at least, the frame is a reconstruction; but the face of the predella has been preserved, with its painting in imitation of marbles and its three pictures in roundels: *S. Peter, Christ Rising from the Tomb* and *S. Paul,* apparently by another hand.

From the very beginning Italian painters had provided an architectural setting for this most popular of all scenes; but Masaccio (*q.v.*), in a picture which has disappeared from S. Niccolò in Florence, had been the first to revivify the age-worn theme by a dramatic perspective effect. Nearly two generations later, Piero della Francesca (*q.v.*) painted the now mutilated *Annunciation* above his altarpiece at Perugia. The Gardner *Annunciation,* though in the concentration of its architectonic design it is perhaps superior to Piero's (at least in that picture's present state), almost certainly owes it much, not only in the use of perspective but in the near attainment of a unity which is perhaps Piero's supreme accomplishment: the identification of form and colour, light and space in a single convincing impression. There are minor characteristics of form here which derive from Ghirlandaio, and the freedom with which the

Archangel's wings are painted is reminiscent of Melozzo da Forlì; but there can be little doubt that this picture is the work of an eclectic painter done with a knowledge of Piero's powerful prototype, painted probably in the decade 1475-85. The closeness of these two *Annunciations* in time and space puts a more intimate relationship between their two authors within the range of possibility. On the other hand, there is likely to have been an intermediary in Melozzo.

As long ago as 1919 G. H. Edgell pointed out the close relationship of the Gardner *Annunciation* with Piero's *Annunciation* at Perugia and with Antoniazzo's frescoed *Annunciation* in the Pantheon in Rome, then generally attributed to Melozzo.[1]

The definitive attribution of the Gardner picture to Antoniazzo, first made in the Catalogue of 1931, has not found favour with many historians. Roberto Longhi had already in 1927 invented the ''Master of the Gardner Museum Annunciation,''[2] and Berenson had accepted this identification in a letter of 4 February 1930, quoted in the 1931 edition.[3] Frederico Zeri in a letter of 30 January 1950 agrees with these two writers, and argues against the attribution to Antoniazzo;[4] in an article of 1953 he makes his own list of pictures attributable to the ''Master of the

Gardner Museum Annunciation,"[5] recently identified as Piermatteo da Amelia. Berenson retained this title and identification in his lists of Italian painters and their works published after his death.[6]

The pictures thus grouped by different writers with few variations do indeed form an *oeuvre* sufficiently consistent, if somewhat insignificant; with the all-important exception of the altarpiece by which the formerly anonymous painter has been so distinguished. There are close resemblances, as was noted in the 1931 Catalogue, between the Virgin of this *Annunciation* and the *Madonna of the Pomegranate*, dated 1481, in East Berlin, once the centrepiece of a now scattered polyptych; but they are resemblances in physiognomy only, in types of head and headdress and hands. No picture of this group offers any parallel to *The Annunciation* in composition, or any quality which suggests that its author had so rich a palette or, above all, the essential capacity for spatial design and atmosphere. This Antoniazzo undoubtedly had, witness the two series of frescoes, accepted as his by these writers, in S. Croce in Gerusalemme in Rome and in S. Giovanni Evangelista at Tivoli, both having much in common with *The Annunciation*. The similarity of the headdress in the Berlin *Madonna* does no more than offer a date for the Gardner *Annunciation*. In 1481 Antoniazzo was working with Melozzo in Rome. The fact that this *Annunciation*, if it is not by Antoniazzo, must be by a greater, not a lesser, man has been recognised only by Lionello Venturi. In 1931 he attributed it to Melozzo himself, comparing it with *The Annunciation* in the Pantheon in Rome (then attributed to Melozzo but now generally accepted as Antoniazzo's), while also noting iconographical affinities with the two *Annunciations*, then already recognised as the work of Antoniazzo, in S. Maria sopra Minerva in Rome.[7] All these *Annunciations* are greatly inferior to the Gardner altarpiece, an exceptional picture, for the harmony of its elements deserving a place among the masterpieces of the early Italian Renaissance.

For very many years, possibly for centuries, it hung in S. Maria degli Angeli, below Assisi. It decorated the outside of a wall of the Porziuncula, the little chapel of S. Francis which was enclosed by a huge temple in the sixteenth century. Until then the Porziuncula seems to have been protected only by a roof, and it is unlikely that *The Annunciation*, which has the form of an altarpiece, had been placed there any earlier. In 1900 it was sold by the church to a syndicate in London which included Colnaghi and Berenson. From them it was bought by Mrs. Gardner through Berenson 10 July 1900, as by Fiorenzo di Lorenzo, a Perugian painter. *P16w4*

[1]Edgell in the catalogue *Mediaeval and Renaissance Paintings*, Fogg Art Museum (1919), p. 163.

[2]Longhi, in *Vita Artistica*, II (1927), Nos. 11-12, p. 228, note 1.

[3]Museum archives.

[4]Museum archives.

[5]Zeri in *Bollettino d'Arte*, 1953, pp. 125-39.

[6]Berenson, *Central Italian and North Italian Schools* (1968), I, p. 251.

[7]Venturi, L., *Pitture Italiane in America* (1931), Pl. CCXLV.

OTHER AUTHORITIES

Borenius in *Crowe and Cavalcaselle's History of Painting in Italy*, V (London, 1914), p. 270, note; he attributed the picture to Fiorenzo di Lorenzo.

Edgerton in *Essays in Honour of Millard Meiss* (to be published in 1974).

Fahy in a letter of 16 April 1973, accepts the attribution to Piermatteo da Amelia.

Fredericksen and Zeri, *Census* (1972), p. 129, attribute it to the Master of the Gardner Annunciation.

Gnoli in *Art in America*, IX (1921), pp. 71-72; he compared *The Annunciation* with the frescoes at Tivoli, but attributed all to "Antonio de Calvis" from an inscription on an altarpiece at Lisieux in Normandy. He suggested that "Antonio de Calvis" was an assistant of Antoniazzo.

Graham, *The Problem of Fiorenzo di Lorenzo of Perugia* (Perugia and Rome, 1903), p. 147; he included it in a list of "attributed works not generally accepted as works of Fiorenzo di Lorenzo," describing it as a detached fresco.

Perkins in *Noteworthy Paintings*, p. 141, attributed it to Fiorenzo di Lorenzo.

Richter in *Noteworthy Paintings*, p. 135, attributed it to Fiorenzo di Lorenzo; also in *The Burlington Magazine*, LXI (1932), p. 239: "Lionello Venturi's attribution to Melozzo may be the solution of the problem."

Venturi, A., *Storia dell'Arte Italiana*, VIII, 2 (1913), p. 250-54; he attributed it to Lorenzo da Viterbo.

Bacchiacca

FRANCESCO DI UBERTINO VERDI: born in Florence 1494-95; died there 1557. His father was a goldsmith.

Francesco is said by Vasari to have been the pupil of Perugino, presumably as a boy about 1505-06, when Perugino was continuously in Florence. Some ten years after this he was one of a team of artists, with his exact contemporary Pontormo and two older men, Granacci and del Sarto, decorating a nuptial room for Pier Francesco Borgherini in Florence. It was made famous by their work. Bacchiacca's contribution is represented by two little panels now in London, and four in the Borghese Gallery, Rome.

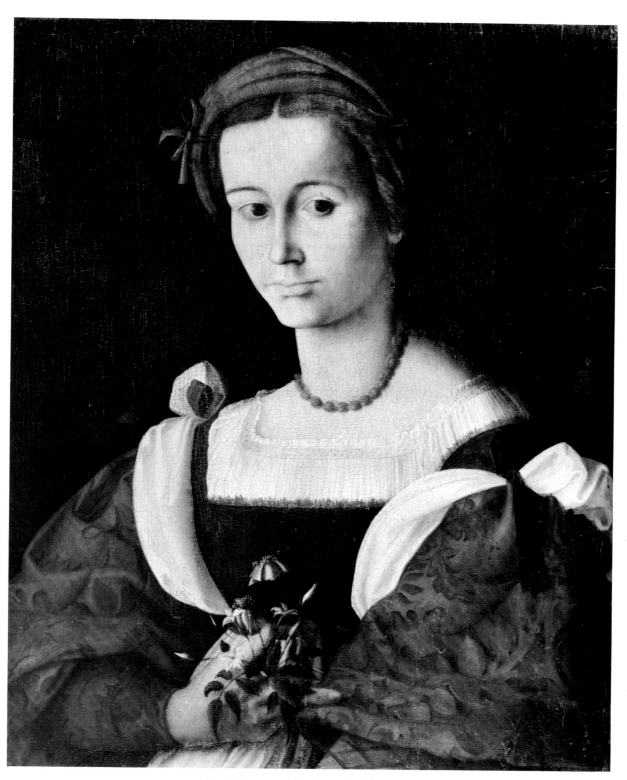

Bacchiacca — *A Lady with a Nosegay*

Most of his painting was on this small scale, but there is an altarpiece attributed to him in a chapel of S. Firenze in Florence, and he painted a number of large groups of the Holy Family. These are in a Michelangelesque style, and he often imitated Perugino or, as in the picture below, Andrea del Sarto. According to Vasari Andrea was his friend. He entered the service of Cosimo de' Medici, who became Duke of Florence in 1537; but three tapestries of 1546 are the only surviving evidence of this patronage.

A LADY WITH A NOSEGAY *Early Italian Room*

Oil on wood, 0.570 x 0.438. Cleaning in 1938 has shown that there is a general abrasion of the paint film, which becomes severe in the hair and in the shaded parts of the head and headdress.

The sitter may well be an imaginary one, for she differs little from the type which features frequently in Bacchiacca's paintings, as in his *Magdalen* in the Pitti Palace. The portrait seems modelled less from nature than upon the study of Andrea del Sarto. The peculiar dislocation of the shoulders, the left in profile, the right in full view, and the fantastic line of the beads are explained by a comparison with del Sarto's portrait, perhaps of his wife, Lucrezia, in Madrid, though there the remainder of the body is at a consistent angle and the head is more in profile. The dress, the colours and the arrangement in Bacchiacca's portrait are all based upon those of del Sarto and point to a position among the painter's later works.

Having belonged to William Rankin in New York, the panel returned to Florence, where it was bought from Carlo Coppoli through Berenson in February 1901. *P15e13*

AUTHORITIES

Berenson, *The Florentine Painters of the Renaissance*, 3rd ed. (New York and London, 1909), p. 108, in a letter (4 February 1930) and *Florentine School* (1963), I, p. 19.

Fredericksen and Zeri, *Census* (1972), p. 13.

McComb, *Francesco Ubertini (Bacchiacca)* (New York University, 1926), pp. 146 and 150; he dated it 1525-35, wrongly describing it as hitherto unpublished.

Nikolenko, *Francesco Ubertini called Il Bacchiacca* (New York, 1966), p. 49; she dates it 1523-25.

Leon Bakst

LÉON NIKOLAIEVITCH BAKST: born in St. Petersburg 1866; died in Paris 1924. He painted in oils, and drew many penetrating portraits; but his years of maturity were largely devoted to the design of stage scenery and costume. His career began in St. Petersburg; but he worked increasingly in Paris from 1909, when he designed his first décor for a ballet produced by Serge Diaghilev, *Cléopâtre*. His designs for *Shéhérazade* in the following year brought him international fame. He worked with Diaghilev after this for more than ten years.

COSTUME FOR IDA RUBINSTEIN *Short Gallery*

Pencil and water colour on white paper, 0.28 x 0.21. Inscribed in pencil on the right, at the top: *St. Sébastien II acte/Mme Ida Rubinstein* and at the foot: *BAKST/1911*.

Ida Rubinstein danced the title role in *The Martyrdom of S. Sebastian*, first produced at the Chatelet Theatre in Paris in 1911. The book was by d'Annunzio, the music by Debussy, the choreography by Fokine.

Originally her property (label in French on the reverse), the watercolour was bought by Mrs. Gardner after an exhibition of Bakst's designs held in several American cities and at the Boston Art Club, 9-27 December 1913. *P17e87*

COSTUME FOR ANNA PAVLOVA *Short Gallery*

Pencil and water colour on white paper, 0.31 x 0.24. Inscribed in pencil on the right, at the top: *BALLET HINDOU/POUR A. PAVLOVA*, and at the foot: *BAKST/1913*.

A drawing with a similar inscription is in the Museum of Fine Arts. Presumably they were for Pavlova's *Oriental Ballet*, with music by Seroff, Moussorgsky and Rimsky-Korsakov and choreography by Zajlich, which was performed at the Royal Opera House, London, in October 1913.

Bought with the above drawing in 1913. *P17e86*

Baccio Bandinelli

BARTOLOMMEO (*Baccio* is Tuscan slang) DI MICHELANGELO DE' BRANDINI: born in Florence 1488; died there in 1559. He adopted the name BANDINELLI in 1529, when the Emperor made him a Knight of S. Iago.

His father was a distinguished goldsmith, patronised by the Medici. Baccio began work in his shop; but he soon displayed the scale of his own ambitions and was apprenticed to the sculptor Giovanni Francesco Rustici. The Medici having returned to Florence in 1512, Bandinelli secured the patronage of Cardinal Giulio de' Medici, who in 1523 became Pope Clement VII. Among the works done for Clement, before and after he became Pope, are a

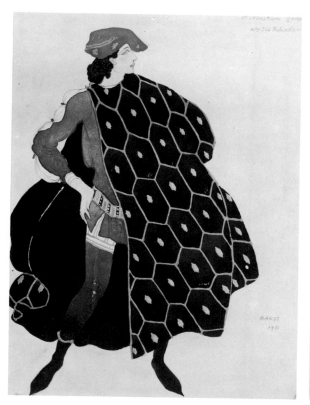

Leon Bakst — *Costume for Ida Rubinstein*

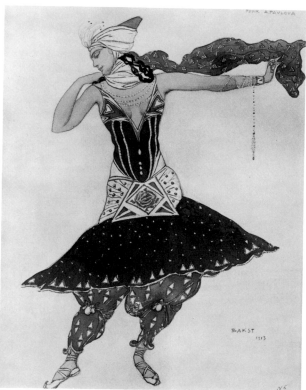

Leon Bakst — *Costume for Anna Pavlova*

S. Peter in Florence cathedral, a group of *Orpheus and Cerberus* in the Medici Palace, the restoration of the recently excavated late Hellenistic *Laocoon* in the Vatican; above all, the huge *Hercules and Cacus* beside the entrance to the Palazzo Vecchio in Florence. This was set up in 1534, the year of Clement's death.

After continuing for a time at work on the tombs of Clement and his cousin and predecessor Pope Leo X in S. Maria sopra Minerva in Rome, Bandinelli left these unfinished to enter the service of Duke Cosimo de' Medici in Florence. For him he did the fine marble bust in the Bargello and undertook a multitude of schemes. The marble parapet enclosing the choir in the cathedral is his work. Nearly all his sculpture is carved, and on a pretentious scale. He employed a multitude of assistants.

He had climbed more warily to a more shining position than Benvenuto Cellini, the romantic and adventurous example of the same vainglorious, pushing type. Cellini gleefully records how, when they met for a moment and jostled one another on the principal rung of the ladder, before Duke Cosimo at

Florence, he easily outmatched his rival in scurrilous abuse before the grinning duke. Bandinelli's cup of success was embittered only by the transcendent genius of Michelangelo, who was architect, sculptor, painter and poet. He found it hard to follow suit. The two hundred sonnets mentioned in his *Memoriale*, which is preserved in the National Library at Florence, have disappeared; his architectural schemes were never clad in stone; his sculpture was too often left unfinished, after a bitter intrigue for the commission.

He never went through an apprenticeship as a painter. There is a record of a fresco painted for the Servites at Florence in 1512 and another of *The Martyrdom of S. Lawrence* in a chapel in S. Lorenzo, engraved by Marcantonio. Vasari mentions several pictures; but it is not clear in what medium they were done or to what extent they were finished. *The Creation of Eve* and *Adam and Eve Driven from Paradise,* painted for the Pitti Palace and still there today, were designed by Bandinelli but painted by Andrea del Minga.

Attributed to Bandinelli

SELF-PORTRAIT *Titian Room*

Oil on wood, 1.422 x 1.128, excluding a strip 0.63 high which has been added to the foot. Cleaning in 1947 showed that a general abrasion of the paint is severe only in the background.

The sitter wears on a gold chain the badge of the Order of S. Iago (a red-enamelled cross on a gold scallop shell), bestowed on Bandinelli by the Emperor Charles V in 1529. With his right hand he points to a highly finished drawing in sanguine; in his left, which supports the board on which the paper is stuck, he holds the red crayon which produced it. This suggests that the drawing was recently made. Bandinelli's marble sculpture of *Hercules and Cacus* was set up in the Piazza at Florence in 1534 and the preliminary drawings were made several years before that, when Bandinelli was scarcely forty. He looks much older here. This drawing, however, is quite different even from the *modello* for the group, and it can hardly therefore be a preparatory study for this sculpture, as was suggested in the 1931 edition of the Catalogue. Only the figure of Hercules is reminiscent of the marble group, but the drawing is in his style at that period, not in the more Mannerist style of his later work.

Hadley[1] has recently suggested for the portrait a date in the 1540's; and this conforms with the date December 1540 inscribed on a three-quarter length Florentine portrait in the Corsini Gallery in Florence which also probably represents Bandinelli. The subject, who displays a document with the seal of Clement VII, seems slightly younger than in the Gardner portrait.

That this represents Bandinelli there is no doubt. The Order of S. Iago and the character of the sanguine drawing support the evidence of the strong resemblance to many self-portraits in stone which he introduced into his work. One of these is signed, a relief in marble in the Opera del Duomo, Florence, where Bandinelli had his studio. Two pictures in the Uffizi Gallery which are described as self-portraits by Bandinelli have little in common with these sculptures, or with this picture.

The question of authorship is less certain; but the evidence is strong in favour of Bandinelli's own hand. He is known to have painted, and to have painted badly, and the qualities of this picture are typical of those by sculptors trying an unaccustomed hand: the limited colour divided into unbroken masses, the uninteresting quality of the paint itself. The large sweeping outlines of the figure are characteristic of Bandinelli's sculpture. The same attitude, with the feet arched as if in dancing, can be found in his relief, *The Drunkenness of Noah*, in the Bargello and in the pictures finished by Andrea del Minga; the gown is designed like the draperies in the reliefs of the cathedral choir-screen; the hands are characteristic. Above all, the drawing, which is really a monochrome painting, is a typical Bandinelli invention, but not a sketch for any known sculpture. The portrait is recorded as that of Bandinelli in Cecchi's engraving for *Serie Degli Uomini I Piu Illustri Nella Pittura, Scultura, e Architectura*, published in Florence in 1772; but it was then attributed to Salviati.

At that time it belonged to Ignazio Hugford, painter, engraver and collector, in Florence. In 1830 (29th June, No. 65) it was in the London sale of Alexis Delahante, a French refugee dealer. By 1854[2] it belonged to Mr. George Vivian at Claverton, near Bath. It was then thought to be a portrait of Michelangelo by Andrea del Sarto. In 1879-80, when it had passed to Lieut.-Col. Ralph Vivian, it was exhibited in London as a portrait of Michelangelo by Sebastiano del Piombo. The exhibition called forth the first recorded suggestion that it was a Self-Portrait by Bandinelli.[3] From the Vivian family it was bought by Colnaghi, of London. In January 1899 it was bought from them by Mrs. Gardner through Berenson as a portrait of Michelangelo by Sebastiano del Piombo. In a letter of 7 December 1898 Berenson described it as "the only portrait of Michelangelo in existence which is certainly authentic." *P26e22*

[1]Hadley in *Fenway Court*, Vol. 1, No. 3 (December 1966), pp. 17-24.

[2]Waagen, *Treasures of Art in Great Britain* (London, 1854), III, p. 176; he attributed it to Sebastiano tentatively.

[3]*The Athenaeum* (31 January 1880); an anonymous critic of the Old Masters exhibition (below).

OTHER AUTHORITIES

Fredericksen and Zeri, *Census* (1972), p. 14; they attribute it to Bandinelli.

Heikamp, *Giorgio Vasari, Vita di Baccio Bandinelli*, with an introduction and notes by Detlev Heikamp (Milan, 1964), p. 19, note 1; he refers to it as Bandinelli's self-portrait. Also he is quoted as orally supporting the attribution to Bandinelli in Freedberg, *Andrea del Sarto* (Harvard University Press, 1963), II, p. 59.

Zeri in *Proporzioni*, II (1948), p. 182, note 2, attributes the picture to Jacopino del Conte, and dates it 1538-39.

Exhibited 1879-80, London, R.A., Old Masters (No. 102): "*Michelangelo by Sebastiano del Piombo.*"

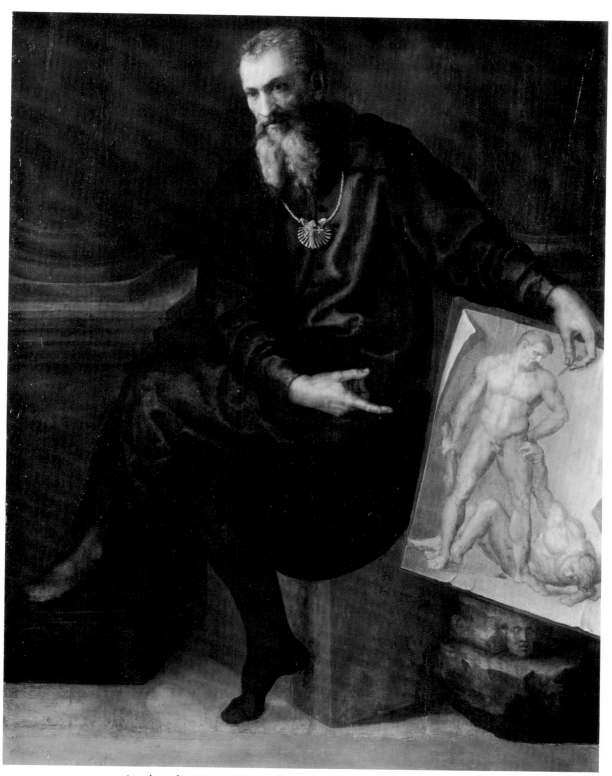

Attributed to Baccio Bandinelli — *Self-Portrait* (SEE COLOUR PLATE)

Bartolommeo Veneto

The only documents are the inscriptions on his pictures, of which the earliest is dated 1502, the latest probably 1546. *The Madonna* formerly in the collection of Count Donà delle Rose near Venice is dated 9 April 1502 and inscribed: *Bartolamio mezo Venizian e mezo Cremonexe*, which would normally refer to his parentage but may mean that he was born at Cremona but had settled at Venice, or the reverse. The picture belongs to the school of Giovanni Bellini, and in his *Madonna* of the Accademia Carrara at Bergamo, signed *Bartholomaeus Venetus* and dated 1505, the landscape is actually taken from Giovanni Bellini's *Resurrection* in Berlin. Again, *The Circumcision*, signed and dated 1506, in the Louvre is one of a score of Venetian versions of the composition by Bellini in the National Gallery, London. Piacenza has recorded from a *Madonna* once in the Ercolani collection at Bologna the date 7 April 1509 and the signature *Bartolamio scholaro de Ze. . . Be . . .* (Bartolommeo pupil of Gentile Bellini). The adoption of the surname VENETUS from 1505 by no means implies a habitation at Venice, where it would not have distinguished him.

He is probably not the Bartolomeo da Venezia who worked at Ferrara about 1505-08, for an older artist of that name had certainly preceded him there. If he were, however, it might well account for the change in the nature of his art.

In the early sixteenth century painting was becoming secularised to a greater extent, and portraiture a more widespread fashion. The earliest certain date on a portrait by Bartolommeo is 1520, but probably long before then he had ceased to be the provider of plagiarised religious pictures in Venetian style. He appears instead as an increasingly successful painter of portraits and fanciful half-length figures of girls, posing as S. Catherine or S. Mary Magdalen or in profane guise, like the half nude *Flora*(?) in Frankfurt-am-Main, or the sing-song girl below. He became so stylish a portraitist of men that he takes a significant place in the great development of portraiture which characterises the sixteenth century. His portraits in Rome, Budapest and Brno, in the Thyssen-Bornemisza collection at Lugano-Castagnola or in Cambridge, England, are something more than the epitome of fashion. These meticulously painted eccentricities of splendid costume are instruments in the intensifying search for individuality.

Many of these pictures come from Milan and are akin in both means and expression to pictures painted after Leonardo's sojourn there. Bartolommeo borrowed motifs from German prints and gave some of his pictures a Germanic character. The last influence is that of Moretto (*ca.* 1498-1554) of Brescia. The view of the Frari church in a late portrait at Nancy suggests a return to Venice; and that is the source of what may well be Bartolommeo's last portrait, *Ludovico Martinengo* in London, where the date is now read as 1546. This is the only portrait of which the sitter is certainly identified — by an inscription.

A GIRL WITH A LUTE *Titian Room*

Oil on nut wood, 0.668 x 0.505. Inscribed on the paper sealed to the stone sill: *1520*.

A good deal of fundamental damage is largely confined to the background, but the headdress and the hair on the left side of the head are ruined. Elsewhere, however, the surface is for the most part well preserved. A prolonged treatment in 1935-36 revealed the fact that the faint halo was traced on a part of the background which is not original. There is a nimbus also in the exact and equally autograph version in the Ambrosiana Library in Milan, but it has not been established whether this is original or not.

The lute and the song for tenor and bass lying open on the sill signify the artist's ambition to transcend the conventions of painting and produce a song-haunted mood. This lyrical idea overran Lombardy and Venice in the early sixteenth century and had been quickly brought to its most moving pitch at Venice in the light and colour of Giorgione. Here sombre shadow prevails, under the influence of the more mystic Leonardo. The picture was painted presumably in Milan, where there are still three versions, two of them by Bartolommeo himself, one of these bearing the same date.

A small label with four signatures in late eighteenth century or nineteenth century writing is fixed to the back of the Gardner panel by two different seals. The arms have been identified in Coronelli, *Blasone Veneto*, as of the Donado family. Since the picture was acquired in Italy and the signatories are all Italian, though only two signatures, *Paolo* and *Dionisio Lazzari*, can be read clearly, this seems more probable than Van der Put's identification of the arms in the left-hand seal as those of a member of the French family d'Aligre, probably Etienne François (1727-98). The picture was bought by Mrs. Gardner, on the advice of Richard Norton, in 1899-1900 from Count Pio Resse in Rome. P26s2

AUTHORITIES

Berenson, *Dipinti Veneziani in America* (Milan, 1919), p. 240; in a letter (4 February 1930) and *Venetian School* (1957), I, p. 11.

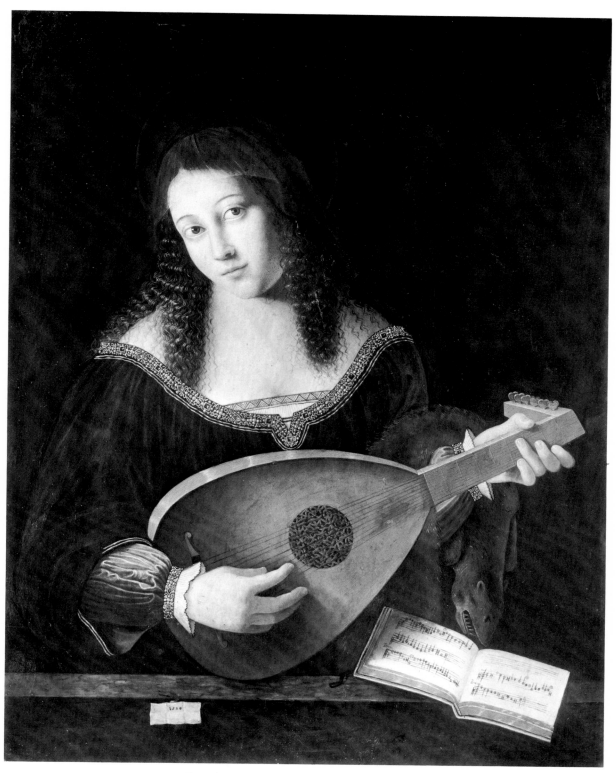

Bartolommeo Veneto — *A Girl with a Lute*

Fredericksen and Zeri, *Census* (1972), p. 17; as *S. Cecilia.*

Mayer in *Pantheon,* II (1928), p. 574.

Offner, *Bartolomeo Veneto* (typescript in the Museum archives, 1912), pp. 30 and 44-45.

Versions: (1) Milan, formerly Contessa Giuseppina del Mayno Vassalli, panel, 0.66 x 0.51, dated 1520, exhibited 1930, London, Royal Academy, Italian Art, No. 307. (2) Milan, Ambrosiana Gallery, panel, 0.62 x 0.50, without the *cartellino* but with further varieties of colour and tone. (3) Milan, Castello Sforzesco, No. 461, panel, 0.59 x 0.48, contemporary copy. (4) Paris and Brussels, Gaston Neumans (1911), from Agnew, Sir George Donaldson and George Salting collections. (5) New York, Blakeslee sale (April 1925), No. 26. (6) New York, Kleinberger Galleries (1926-28), an inferior copy not by Bartolommeo, perhaps identical with the last. (7) London, Samuel sale (Christie's, 25 March 1927), No. 65, bought by Westmore; from Henry Doetsch collection (1895) and Howorth sale (Christie's, 14 December 1923, No. 54). (8) London, Coesvelt collection (1836), No. 79, attributed to Leonardo, etched in line by F. Joubert. (9) Glasgow, Corporation Art Gallery, the head and shoulders serve with the aid of a wheel and a chaplet of flowers to make a *S. Catherine,* dated 1520. (10) Boston, formerly Mrs. Edward Jackson Holmes, the same composition as the last.

Gentile Bellini

Died 23 February 1507. Son of the painter Jacopo Bellini and his wife Anna, perhaps that expected by Anna when she made her her will 6 February 1429 in Venice. Jacopo was no great artist, but he had worked in Florence under Gentile da Fabriano, after whom presumably he christened his son; and he perhaps lived for a time at Padua: he was in touch with the ideas of his time. Gentile's brother Giovanni (*q.v.*) was one of the great painters of the age, and their sister Niccolosia was married to Mantegna (*q.v.*).

A lost altarpiece once in the Santo at Padua was said in 1590 to bear the signature of Jacopo and his sons Gentile and Giovanni with the date MCCCCLX[?]. Gentile would obviously have begun in the workshop of his father, who was highly esteemed in Venice; but by 1464 at the latest he was established independently there. His signed *Lorenzo Giustiniani,* now in the Accademia, is dated 1465, and the signed organ-shutters of S. Mark's must be of this time. For the Scuola Grande di S. Marco he undertook to paint two large historical pictures 15 December 1466. He was knighted by the Emperor in Venice 13 February 1469; was appointed by the government 2 September 1474 to restore the old pictures and to paint new in the Hall of the Great Council in the Ducal Palace; and in September 1479 was sent to Constantinople. Sultan Mohammed II had asked for a painter when he invited the Doge to the wedding of his son. What is perhaps the remains of Gentile's portrait of the Sultan is now in the National Gallery, London. After some fifteen months he resumed work in the Ducal Palace, with his brother Giovanni beside him. All their work there was destroyed by fire. Of the three great canvases with *Stories of the Holy Cross* now in the Accademia one is dated 1496, another 1500. A still larger canvas, his *Sermon of S. Mark,* now at Milan, was finished by Giovanni for the Scuola di S. Marco.

Not only his earliest works, which are clumsy imitations of Mantegna, but the *Apostle* at Frankfurt-am-Main and *The Madonna Enthroned* in the National Gallery, London, though these are more refined in technique and colour, show little inspiration for composition or for the expression of abstract ideas. Even in the historical representations to which he turned the design is less broadly conceived, the space less powerfully organised than in those of the younger painter Carpaccio, whose great series, *The History of S. Ursula,* precedes anything of the kind by Bellini which has survived. Yet the minutely careful portraiture with which he filled his compositions, though stiff and timidly conceived, has force and dignity in its determined search for character. The Venetians had a peculiar love of pageantry and an extraordinary historical consciousness; and these Gentile was able to express with solemn dignity.

Attributed to Gentile Bellini

A TURKISH ARTIST *Early Italian Room*

Pen and gouache upon parchment, 0.18 x 0.14 (divided horizontally by folding, with a small piece broken from the lower right corner and a rectangle cut from the top left), mounted upon parchment of a century later which supplies a coloured border and a vertical inscription in Arabic inserted in the top right corner. The flower in the background over the sitter's shoulder is probably an oriental addition.

The inscription has been translated: *Work of Ibn Muezzin who was a famous painter among the Franks.* Ibn Muezzin may well be an erroneous transcription[1] of the name Bellini, probably once written in Greek on the border or on the back of the painting. *Bellini* is interpreted as *son of Bellin; Bellin* would be written in the Greek of that period μπελλιν, since the Greek β was then as now pronounced *V;* μπελλιν, misunderstood and probably rubbed in the course of a century, could be transcribed μουεζζιν, since the Greek π in its then form could be misread ου, and λ and ζ were then somewhat alike. Thus we have *Ibn* (son of) *Muezzin* (the caller-to-prayer).

The sitter's rich costume suggests a courtier, per-

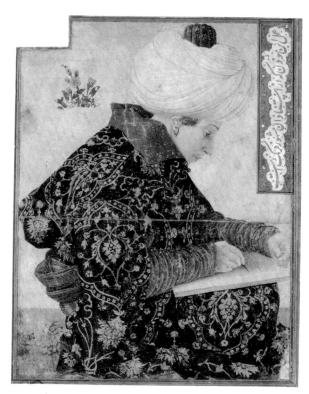

Attributed to Gentile Bellini — (SEE COLOUR PLATE)

The Gardner miniature had been thus inscribed and mounted[2] in an album of the late sixteenth or early seventeenth century containing thirty European engravings and thirty-two oriental miniatures. The album was bought from a Turkish family by F.R. Martin. From him Mrs. Gardner bought the painting in 1907 through Zorn (*q.v.*), anticipating both the British Museum and Dr. Bode of Berlin. *P15e8*

[1]Sarre in *Jahrbuch der K. Preuszichen Kunstammlungen*, XXVIII (1907), pp. 51-52, published this transcription, suggested to him by Heinrich Brockhauss in a letter from Florence. The remarks on the Greek alphabet were sent him by Prof. Gardthausen of Leipsic.

[2]Martin in *The Burlington Magazine*, IX (1906), pp. 148-49, related his discovery, and XI (1907), pp. 115-16, translated the essentials of Dr. Sarre's article; also *The Miniature Painting of Persia, India and Turkey* (London, 1912), I, pp. 91-92.

OTHER AUTHORITIES

Atil, Esin, in *Ars Orientalis*, IX (1973), pp. 112-13, 116-17: "most likely [by] an Italian."

Berenson in a letter (4 February 1930) and in *Venetian School* (1957), I, p. 28: Gentile Bellini.

Borenius in *Crowe and Cavalcaselle's History of Painting in North Italy*, I (London, 1912), p. 126: Gentile Bellini.

Fredericksen and Zeri, *Census* (1972), p. 21: Gentile Bellini.

Fry in *The Burlington Magazine*, XVII (1910), p. 6, editorial note: Gentile Bellini.

Version: Washington, D.C., the Freer Gallery, a miniature (0.188 x 0.127) formerly attributed to Bihzad, the great Persian miniature painter of the earlier sixteenth century, but now merely to the Turkish School in Constantinople in the late fifteenth century. The dress is opened down the front to show a contrasted lining, there is a second scarf, and the sleeves are pale green. Published by Dr. Martin in *The Burlington Magazine*, XVII (1910), p. 5; and Atil, *loc. cit.*

Giovanni Bellini

Died in Venice 29 November 1516. The grandson of Niccolò Bellini, a tinsmith of Venice, he was the son of the painter Jacopo, perhaps not by his wife. He was apparently younger than their son Gentile (*q.v.*), who was born probably not before 1429.

Of Giovanni's career there is little documentation until he was old and famous. But most of his pictures are signed, many are still in position and dated by inscriptions or documents, and the chronology of the earliest can be roughly guessed through their relationship with pictures by Mantegna, who married his sister, or half-sister, Niccolosia, and lived at Padua until 1460. The brothers-in-law, so different in character and in their later paintings, were closely

haps a princely dilettante. Bellini could have painted the miniature in 1479-80, when he was present at the court of Sultan Mohammed II. Certainly it seems rather less oriental in character when it is compared with the contemporary Turkish picture in the Freer Gallery, Washington, D.C., which is widely believed to be copied from the Gardner portrait. In the latter the painter has not completely adopted the oriental convention of the silhouette. Light comes from behind to throw shadow upon the courtier's head and hands and on his tablet. The dark blue of the coat, the wine colour of the sleeves and fez and the deep purple of the collar all suggest volume; and the abrupt outline is more a contour than a silhouette. It is surprising nevertheless that Gentile should have attempted and so far succeeded in orientalising his style, and that he should so quickly have thrown off his stiffness and achieved this subtle reading of oriental character. After more than fifty years of acceptance, these hypotheses remain hypotheses. It is not impossible that the Freer Gallery miniature is the original. In it there is little suggestion of the third dimension. The outline of the silhouette is refined and elaborated, and the decorative content increased by the slighter patterns on the robe and by other varieties of dress and colour.

related in their early work, their drawings hard to distinguish. Giovanni's first monumental work still more or less *in situ* is a set of four triptychs in the Venice Accademia. Documents of 1462 show at best that he had begun to paint this series by then, whereas he had already probably produced such highly individual works as *The Transfiguration* in the Correr Museum, and *The Agony in the Garden* in London. In 1464 the altar was constructed for which his great polyptych with *S. Vincent Ferrer* in SS. Giovanni e Paolo in Venice was destined. To about the end of this decade belongs *The Coronation of the Virgin* at Pesaro, one of the great picture monuments of the early Renaissance. Giovanni's *oeuvre* has no equal for quantity in the fifteenth century.

It was the departure of Gentile for Constantinople in 1479 which brought Giovanni his first recognition by the State. He stepped into his brother's official place, and, when Gentile returned from the East, remained at work beside him. They were occupied intermittently with large historical paintings in the Hall of the Great Council in the Ducal Palace for the remainder of their lives. Their work was soon burned, and Giovanni's *Doge Leonardo Loredano* in London, with a larger, ruined picture of the Doge at work, is perhaps the sole relic of his office. From 1483 the title of Painter to the Republic (*Pittore del Dominio*) gilded his affluence, while the continuous development of his ideas is now witnessed by a succession of signed and dated pictures in the Academy and the churches of Venice, in Milan (*The Madonna and Child* dated 1510) and in Washington, D.C. (the great idyl *The Feast of the Gods*, painted for the Duke of Ferrara, signed by Bellini and dated 1514 but partly overpainted by Titian). His old age was famous. Sung by Ariosto and by Pietro Bembo, who wrote sonnets to his mistress' portrait by Bellini and sat to him for his own, his work was coveted by neighbouring princes.

Venice at Bellini's birth was still part oriental in custom and costume. But in the dominion the city had established on the mainland painting now became the first means of artistic expression, and at Padua Mantegna shaped the ideas of a band of young artists. Bellini in his early pictures adopted all Mantegna's moulds; but he was scarcely touched by Mantegna's neo-classicism. The sympathies of a great designer had never before been given so intimately to nature: witness his *Landscape with S. Francis* in the Frick Collection, the large *Transfiguration* at Naples and the background of a score of *Madonnas* and *Pietàs*. He explored further than any painter before him the emotional value of her moods.

Meanwhile his life study of the play of light and shade over form led him gradually from the exag-

geration of outline to a method of painting in which the values of the colour alone describe the forms. In *The Coronation of the Virgin* at Pesaro the still rugged outlines minister austerely to the creation of a plastic whole, in which light and shade and colour play an equal part. In this achievement he must have been strongly influenced by Piero della Francesca (*q.v.*). Bellini was also perhaps aided by the technical experiments of Antonello da Messina, who was in Venice 1475-76. In *The Madonna and Child with Saints and Angels*, now in the Accademia at Venice, which is known to have been in S. Giobbe probably for some years by 1489, substance is realised by the suggestive quality of the very texture of the paint. Contours are dissolved in the atmosphere created, and colour and form are so thoroughly identified that the illusion of space is complete. In his means of expression and in his vision Bellini invented the essence of what Giorgione and Titian were to teach to all Europe.

THE MADONNA AND CHILD *Raphael Room*

Tempera with oil glazes on wood, reduced in thickness and cradled, 0.62 x 0.423. Seriously damaged with numerous losses throughout. The major loss is a vertical strip down the center of the panel including the right side of the Madonna's face, her neck and veil, the middle of her hand and the complete hand of the Child, as well as the cushion and the parapet. The Child's face, despite minor scratches, and his neck are well preserved. His left hand and arm are intact. There is a large loss above his head and the sky has been abraded. The relief carving of the parapet is damaged. Restoration begun in 1974 was incomplete at the time of printing, and the photograph here reproduced represents a much earlier restoration. The first two letters are restored in the inscription: *IO[A]NNES BELLIN / VS P.*

There are few other *Madonnas* by Bellini in which there is no glimpse of the earth, and the very similar example in the Correr Museum in Venice belongs to almost the same moment. The composition of the Gardner picture seems an improvement on the other, though comparison is difficult owing to its distorted condition and the fact that a thorough and greatly superior restoration of the Correr picture may have taken place when it was transferred from wood to canvas. The two pictures belong to the period of the great altarpiece in SS. Giovanni e Paolo in Venice, probably about 1465.

The Gardner picture was for sale in Italy in 1890. By 1893 it was in the collection of Prince Hohenzollern-Sigmaringen, though not exhibited in his museum at Sigmaringen.[1] From him it was bought

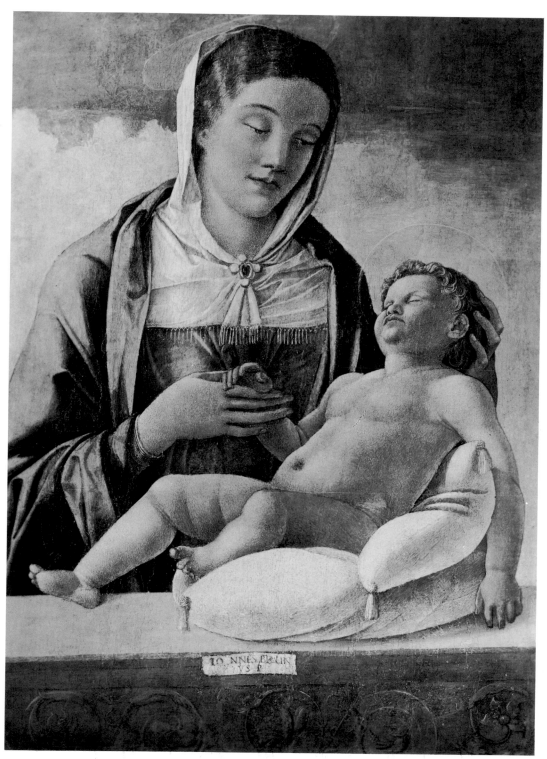

Giovanni Bellini — *The Madonna and Child*

before 1915[2] by Böhler of Munich, who sold it to Henry Reinhardt and Son, New York. From them it was bought, on the strong recommendation of Berenson, 10 May 1921. *P16s2*

[1]Starck in *Archivio Storico dell'Arte*, VI (1893), p. 389.

[2]Venturi, A., *Storia dell' Arte Italiana*, VII, 4 (Milan, 1915), p. 266; he referred to it as then in America.

OTHER AUTHORITIES

Berenson in a certificate letter to Reinhardt, in another to the compiler (4 February 1930) and *Venetian School* (1957), I, p. 30.

Bode in a certificate letter to Böhler dated it about 1470.

Bottari, *Tutta la Pittura di Giovanni Bellini* (1968), I, p. 34, describes it as a replica of the Correr Museum picture, though attributing both to Bellini.

Fredericksen and Zeri, *Census* (1972), p. 22.

Gronau, *Giovanni Bellini* (1930), p. 30.

Palucchini, *Giovanni Bellini* (Milan, 1959), p. 48.

Pignatti, *L'Opera Completa di Giovanni Bellini* (1969), p. 89, No. 35.

Robertson, *Giovanni Bellini* (1968), Pl. XLIII; he describes the signature as "mutilated."

After Giovanni Bellini

CHRIST BEARING THE CROSS *Titian Room*

Oil on nut wood, cradled, 0.529 x 0.423. Cleaned and restored in 1974. The paint surface is in good condition, despite warping and severe buckling of the panel. The resulting vertical cracks through the cross, the sleeve, from below the lip to the bottom and in two small places at the top, have caused relatively little paint loss. Abrasion above the left eye has revealed the underlying flesh tone, an indication of the layers of paint used by the artist. The painting of the face, most probably done with oil-resin added to the tempera, seems to be a conscious effort to use this advance in technique. The rest of the picture is painted summarily in the standard egg tempera medium.

This is a free copy of the picture by Giovanni Bellini now in Toledo, Ohio. The original, also on wood panel, a little smaller (0.488 x 0.375), may well be the picture recorded in the diary of the Venetian Marcantonio Michiel, who saw it in the house of Taddeo Contarini in Venice: "The picture of Christ with the cross on his shoulders, bust length, was from the hand of Giovanni Bellini."[1] This was in 1525, some twenty years or less after Contarini's picture was painted. From that time its history is unknown until about 1938, when it was discovered in France. It was first published by G. M. Richter as the work of Bellini in 1939,[2] and was exhibited at Toledo in 1940. It is possible, however, that Contarini's picture was not that now in Toledo since

a picture which has been for more than a century at Rovigo is considered by some authorities an earlier version by Bellini himself. Very few of Giovanni Bellini's smaller pictures were not reproduced in contemporary copies and variants; but the number in this case is extraordinary in view of the subject, which was not popular outside the Veneto.

The copyist who made the Gardner picture has gone out of his way to modify the significance of the original. For the profound melancholy of Bellini's Christ and the grandeur of form by which it was expressed he has substituted a more self-centred grief, accentuated by tears. The sharper lighting, which makes the tears glisten, puts a glint in the formless hair and draws attention from the head towards the grain in the wood of the cross.

Such modifications as these, even when taking into consideration the remarkable boldness and devotion with which the artist painted the face where he used a richer medium, are hardly likely to have been made by Giorgione, to whom the picture has long been attributed by many writers. The suggestion made in the Catalogue of 1931 that the copyist may rather have been Palma Vecchio (active 1510-28) has found no favour. The objections raised against it would all seem to apply equally to an attribution to Giorgione. They do not take into account the hastily finished condition of the copy, while a certain resemblance remains between the copyist's head and some of those by Palma. If the head of his *Violante* in Vienna (now attributed there to Titian), for instance, is photographed in reverse, this becomes striking. Sydney Freedberg has recently suggested, orally, that the copyist was Andrea Previtali (active 1502-28); the figure of S. John Baptist in Previtali's *Sacra Conversazione* in Vienna shows indeed that he was familiar with Bellini's *Christ Bearing the Cross*. However, the discovery of Bellini's undoubted original, long expected by at least one writer,[3] has made the identity of the copyist a matter of less significance.

Mrs. Gardner made up her mind to buy this picture, as the work of Giorgione, in September 1896. She finally acquired it from Count A. Zileri dal Verme through Berenson in December 1898. It had hung for many years in the Loschi palace at Vicenza, the Count's father having bequeathed it to the town by a will which had to be revoked. *P26n17*

[1]Tietze in the catalogue of the exhibition at Toledo, *Four Centuries of Venetian Painting* (March 1940), No. 6, was the first to identify the picture there with the passage in Michiel's diary. He quoted the Italian: "*El quadro del Christo con la croce in spalle, insino alle spalle, fu de mano de Zuan Bellino.*"

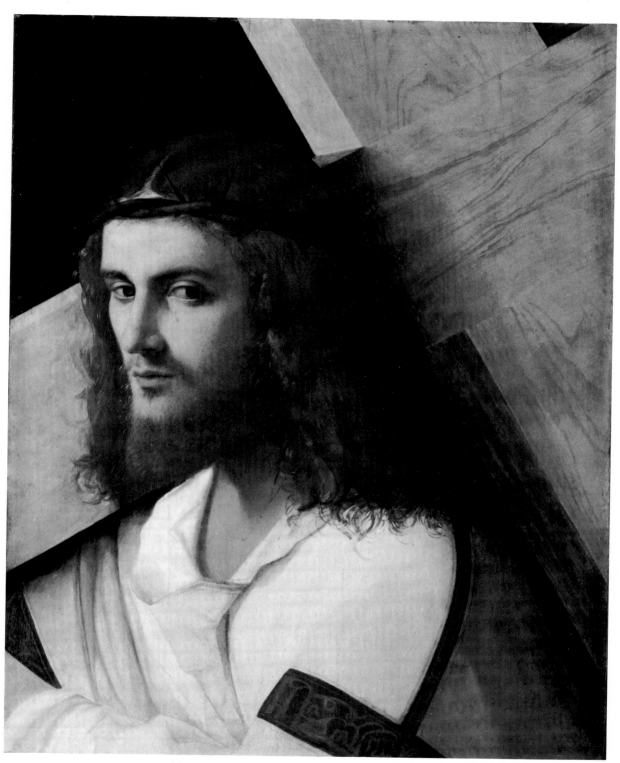

After Giovanni Bellini — *Christ Bearing the Cross*

[2]Richter in *The Burlington Magazine*, LXXV, No. 438 (September 1939), pp. 95-96; he appeared to confirm his previous doubts of Giorgione's authorship of the Gardner picture. He described the Contarini picture as "rediscovered in the collection of a French duke." The Toledo catalogue states merely "Collection: Marquis B. de B." At the time it belonged to Jacob M. Heimann, New York.

[3]Bode in *Art in America*, I (1913), p. 229; he attributed the Gardner picture to an anonymous copyist of Giovanni Bellini.

OTHER AUTHORITIES

Berenson in a letter (4 February 1930) attributed the Gardner picture to Giorgione, and *Venetian School* (1957), I, p. 83, to Giorgione (copying Bellini).

Bottari, *Tutta la Pittura di Giovanni Bellini* (1963), p. 30; he describes it as *"una disincantata repetizione"* of the Toledo picture.

Coletti, *Tutta la Pittura di Giorgione* (1955), p. 61, to Giorgione.

Cook, *Giorgione* (London, 1900), pp. 15, 18 and 62, to Giorgione.

Crowe and Cavalcaselle, *A History of Painting in North Italy* (ed. Borenius, London, 1912), III, p. 36, note 2; after hesitation, they declared "it deserves the name of Giorgione."

Fiocco, *Giorgione* (1948), p. 19, to Domenico Mancini.

Fredericksen and Zeri, *Census* (1972), p. 22, to Giovanni Bellini.

Frizzoni in *Noteworthy Paintings*, p. 183, to Giorgione.

Heinemann, *Giovanni Bellini e Belliniani* (1962), II, Pl. 26; he attributes it to Titian working in Giovanni Bellini's workshop. He gives a list of 55 "copies" after Bellini's picture at Toledo; but many of these are far-ranging derivatives.

Justi, *Giorgione* (Berlin, 1926), II, p. 146; he did not attribute it to Giorgione.

Morassi, *Giorgione* (1942), p. 173: "School of Giovanni Bellini."

Morelli, *Italian Masters in German Galleries* (London, 1883), p. 159, to Giorgione.

Palucchini, *Giovanni Bellini* (Milan, 1959), p. 88; he considers that Bellini's original at Toledo "had the luck to be repeated shortly afterwards by Giorgione himself" (trans.).

Pignatti, *Giorgione* (1969), p. 94, to Giorgione, 1500-04.

Richter, J. P. in *Noteworthy Paintings*, pp. 186-87, to Giorgione.

Robertson, *Giovanni Bellini* (1968), p. 124; he considers the picture at Toledo to be the only version by Bellini himself, but suggests that others, including the Gardner picture, may be earlier and based on "another earlier autograph version, perhaps dating from the 1490's."

Venturi, A., *Storia dell' Arte Italiana*, IX, 3 (Milan, 1928), p. 55, note 1; he attributed it to an anonymous follower of Giovanni Bellini.

Venturi, L., orally at Fenway Court (31 January 1929), to Giorgione; *Pitture Italiane in America* (Milan, 1931),

Pl. CCCLXVII. He contradicted the attribution to Palma and attributed it on balance to Giorgione.

Zampetti, *L'Opera Completa di Giorgione* (1968), No. 47; he states that it is now generally, and appropriately, attributed to Giovanni Bellini himself.

Copy: Vicenza, Palazzo Loschi, a copy by Robert David Gauley (died 1943) painted for Mrs. Gardner to replace the original.

Bartolomé Bermejo

Died after 1495. BERMEJO (vermilion), his principal name in the documents, translated on signed pictures into the Latin *Rubeus*, probably derives from the colour of his own hair. Such nicknames passed from father to son; but in one contract he is named Bartolomé de Cárdenas. DE CÁRDENAS almost certainly was his surname.

Only two extant pictures are signed in full *Bartolomeus Rubeus*: the *S. Michael* in the Wernher Collection at Luton Hoo in England, probably from Tous, near Valencia, and *The Madonna and Child, with a Donor*, centre of a Spanish triptych of unknown provenance, now in the cathedral at Acqui (between Turin and Genoa) in Italy. A *Madonna* in Madrid signed only *Bartolomeus* may be by Bermejo. Only two pictures are documented: *S. Domingo de Silos* from Daroca, now in Madrid, of 1474-77, and *The Pietà* in Barcelona cathedral, of 1490.

Recorded in 1468 at Valencia, Bermejo first makes his appearance as a painter in Aragon, at Daroca, a then prosperous town in the province of Saragossa. The great retable in many panels from S. Martín, now in the museum there, is probably his earliest recognised work. He was living at Daroca in September 1474 when he contracted to paint for S. Domingo there the great panel *S. Domingo de Silos, with the Seven Virtues* now in Madrid. The time allowed was sixteen months. Presumably the painting took more, for contracts of September and November 1477 concerning further panels (not identifiable today) for this altarpiece suggest some distrust of Bermejo's expedition. By then he lived at Saragossa. Probably at least his last ten years were spent in Catalonia. A document suggests that he was in Barcelona in 1486; he was evidently there for many months before 23 April 1490, the date inscribed on the frame of his *Pietà* in the cathedral, together with the names of the painter and the depicted donor, Archdeacon Luis Desplà. A document shows that he was there in 1491, and in 1495 another records a token payment to be made to him for designing a window for the cathedral baptistery and nine others for the cupola. A *Noli me tangere* in stained glass there is probably from his design.

The main currents of Spanish painting were exotic, some potent foreign influence always prompting its best moments. Bermejo, who seems to have inherited something from the monumental Catalan Romanesque painters of two centuries before, is of the first generation inspired by the art of the Netherlands. Post in his *History of Spanish Painting* (to the Renaissance) in fourteen volumes (Harvard University, 1930-66) was not alone in postulating a visit by Bermejo to the Netherlands. He placed this early, and all the more Netherlandish of his pictures before the *S. Domingo* or the *S. Engracia* below. In these he found a recovery of Bermejo's equilibrium and a return to an innate Spanish monumentality. The recently discovered history of the *S. Engracia* seems to support the present author's opinion that the story of Bermejo's development is rather that of a gradual saturation, by his own experiment, in the translucent oil colours and the glowing shadows of Rogier van der Weyden, or more probably, of a follower of Rogier's who was nearly Bermejo's contemporary, Dieric Bouts.

Bermejo's earliest retable at Daroca is as indigenous as himself. The whole effect is limited in expression by the profuse decoration of gilded ornament embossed above the paint surface, a method which crops up in the fifteenth century in the corners of Europe, and especially in Aragon (see the great retable by de Soria in the Boston Museum of Fine Arts, which also illustrates the original construction of Bermejo's *S. Engracia* retable). Yet the designs share the rugged strength of the characters themselves, with their large bones and grave features sharply sculptured amid the decoration. In the later pictures from Daroca this strong flavour, local and personal, is refined and enriched by Netherlandish influences. In the *S. Domingo* there is no embossed ornament; but the great gilded throne and cope, against a gilded background, give the appearance of a Gothic chryselephantine high-relief, enamelled here and there with strong colour. The Saint has the stare of a cult figure; but his tough features are sensitively modelled and his character makes itself powerfully felt through his magnificence. Bermejo has brought the Spanish saints to vigorous life. It would seem a logical development from this to the *S. Michael,* in which gold is confined to the background and the Saint moves freely in golden armour of which the metal provides opportunity not for craftsmanship but for a brilliant display of virtuosity in the painting of reflected light. On the small scale of narrative Bermejo's technique gains its full polish in the little *Death of the Virgin* in Berlin, where the thousand reflections of a Flemish indoor scene are combined with his own intense colour. His palette,

however, has remained limited. It is better suited to such a large sculptural form in simple relief as the *Head of Christ* at Vich. Strengthening as they matured, his colours are now softly blended, and the carved timber of his forms is here smoothed into a new shapeliness without losing the grandeur of its expression. There is some documentary evidence that this is the latest of his works.

It is perhaps in *The Pietà* of 1490, however, that he found fullest expression, with the mood of its great landscape used to reinforce the agony of the theme.

S. ENGRACIA *Tapestry Room*

Gold and oil on pine wood, 1.640 x 0.730, including a monochrome vertical strip about 0.015 wide added later to each side. Cleaning in 1950 revealed a good deal of fundamental damage, now partly retouched, throughout the blue of the outer garment, and in a small area of its green lining, below the right hand. The remainder of the dress and the head and hands are well preserved. The throne and its plinth are a good deal rubbed. Removal of modern gilding from the whole background revealed the original gold, for the most part in good state. The inscriptions on the shoe *IRFM* and *NOV* are believed to be merely decorative. The frame is of the last century.

S. Engracia carries in her right hand the palm of the Virgin Martyr and in her left the nail of her own agonies. Born a Portuguese, she was martyred with some seventeen companions in 304 under Diocletian at Saragossa, where her feast is kept 16 April. Her remains were discovered there in the fourteenth century, and the crypt of the church dedicated to her contains two Christian sarcophagi of the third and fourth centuries. In 1468 the King of Aragon proclaimed (somewhat ungratefully towards a Moorish surgeon) that his cataracts had disappeared on contact with S. Engracia's nail. He gave a large sum of money for the building of a convent and church in her name.

The picture was first published as the work of Bermejo by Claude Phillips.[1] It has gradually of recent years been identified[2] as the centre panel of a large retable, of which the other parts have gone unrecognised hitherto. The Museum at Daroca has *The Crucifixion* which plainly surmounted the *S. Engracia* panel in the centre and the whole of the predella, consisting of five panels: *The Resurrection* in the centre and four Saints: *S. Onofrius; S. Valerius; S. Braulius; S. Catherine of Siena.* It also has the upper half of *The Imprisonment of S. Engracia,* one of the four scenes from her martyrdom which evidently flanked the main panel. Of these, another,

The Flagellation of S. Engracia, is at Bilbao,[3] a third, *The Arrest,* at San Diego, California.[4] The presumed fourth is missing. The fact that so much of the altarpiece, including even the inferior painting on the *guardapolvos,* or dust-shields, which protect *The Crucifixion* in the apex, is now at Daroca makes it probable that it has always been there and that the complex of pictures was commissioned for one of the nine Daroca churches then existing. It seems less likely that these parts of it should have been brought to Daroca than that, as the town declined, the centrepiece should have been moved to the provincial capital, forty miles away. The fact that the *S. Engracia* panel was in the nineteenth century at Saragossa, the scene of the Saint's martyrdom, has led to the supposition that it was painted there, and therefore after the *S. Domingo,* for the documents connected with that panel show that Bermejo was living at Daroca in 1474 but in Saragossa in 1477. Now, however, the *S. Engracia* retable falls into its place stylistically in the centre of the three great retables of Daroca. Post had already remarked on the resemblance between the head of S. Martin in the earliest retable and that of S. Engracia.[5] Her gilded halo and all the smaller haloes which abound in the narrative scenes are embossed with concentric rings, as the haloes in the *S. Martín* retable had been. On the other hand the style of the whole *S. Engracia* retable is considerably more mature: the drawing simpler and more powerful, the colour more translucent, the handling of the paint more masterly. S. Engracia herself shares a strong family likeness with the richly dressed Virtues who occupy the niches in S. Domingo's magnificent throne. For the *S. Domingo* panel gilt embossment on a large scale was specified in the contract with Bermejo;[6] yet he omitted such ornament altogether, plainly because it was incompatible with the more painterly style which he was developing under the influence of Netherlandish models. Since the *S. Domingo* was commissioned in 1474, it may now be assumed that the painting of *S. Engracia* was at least begun some time before that.

The church and convent of S. Engracia at Saragossa, endowed by King Juan II, was built early in the next century; and the *S. Engracia* panel could have been moved to it at any time thereafter. The buildings were largely destroyed in the siege of Saragossa by the French in 1806. The religious orders were suppressed in Spain some twenty-five years later. The *S. Engracia* is stated to have been saved from a church at that time,[7] and sold to the Recorders of Saragossa, who placed it among the archives of the Hall of Justice. It was then attributed to Juan Flamenco. Before 1899 it was bought at Saragossa by de Somzée. From him R. W. Curtis attempted to buy it for Mrs. Gardner in the spring of 1901. She succeeded in buying it, against the bidding of the Brussels and Budapest museums, at the de Somzée sale, Brussels, 27 May 1904 (No. 546, "S. Engracia, Maître Inconnu"). *P19e25*

[1]Phillips, Sir Claude, in *The Daily Telegraph,* 13 December 1904.

[2]Berg in *Fenway Court,* Vol. 2, No. 3 (October 1968), pp. 17-28. The origin of the predella had been a subject of much speculation, the possibility often discussed of its being the addition ordered for the *S. Domingo* panel, though the subjects did not correspond. Post, *op. cit.,* V (1934), pp. 126-31, assumed "a second (and smaller?) retable for the church of S. Domingo, of which the predella is the sole relic." Miss Berg illustrates the four other and larger panels from Daroca and her "hypothetical reconstruction" of the retable; she is the first to suggest that this was destined for Daroca.

[3]Angulo Iñíguez in *Art in America,* Vol. 27 (October 1939), No. 4, pp. 155-59, was the first to publish the picture as Bermejo's work. He identified its subject and deduced from this that the *S. Engracia* had been the centre of a retable to which the smaller panel (0.92 x 0.52) had also belonged. It was then in a private collection in Madrid. This identification was the first stage in the reconstruction of the retable.

[4]Sperling in *Art in America* (1941), pp. 230 ff.: "Another Panel from the Altar of Santa Engracia."

[5]Post, *op. cit.,* p. 196.

[6]*Ibid.,* p. 116, but see his footnote 2.

[7]Baes in the catalogue of the de Somzée collection (Brussels, 1904), II, p. 103.

OTHER AUTHORITIES

Cook in *The Burlington Magazine,* VIII (1905), p. 129, accepted the attribution made more tentatively by Phillips in a daily newspaper.

Friedländer in *Repertorium für Kunstwissenschaft,* XXIII (1900), p. 258; he attributed it to the Spanish School of 1480. In spite of its Spanish origin, it was then attributed to the Netherlandish School (see the exhibitions below).

Gaya Nuño, *La Pintura Española fuera de España,* pp. 111-12.

Von Loga, *Die Malerei in Spanien* (Berlin, 1923), p. 29.

Post, *op. cit.,* pp. 131- 36.

Tormo in *Archivo Español de Arte y Arqueologia,* IV and V (1926), pp. 9, 13 and 48 (the first comprehensive study of Bermejo).

Exhibited 1899-1900, London, New Gallery, "Pictures by Masters of the Flemish and British Schools," No. 16, "St. Helena(?), Early Flemish School." 1900, Paris, Exposition Universelle, Belgian Pavilion.

Bartolomé Bermejo — *S. Engracia* (SEE COLOUR PLATE)

Paul Albert Besnard

Born in Paris 2 June 1849; died 5 December 1934.

He studied at the Ecole des Beaux-Arts, first under Brémont, then under Cabanel. Winning the Grand Prix de Rome in 1874, he spent four years in Italy. In 1879-81 he lived in London, for the most part painting portraits. Returned to Paris, he soon had an extraordinary success as a decorator of public buildings: Entrance Hall of the Ecole de Pharmacie, 1883-87; Salon des Sciences in the Hôtel de Ville, 1890; Chemistry Amphitheatre in the Sorbonne, 1896; ceiling in the Comédie-Française, 1905-13; cupola in the Petit-Palais, 1907-10. In 1890 he was a Founder Member of the Salon de la Société Nationale des Beaux-Arts. Yet historically he is an isolated figure among his contemporaries, neither an academic nor a member of any of the well known groups. A recent official exhibition of the French Symbolists included him as on the movement's fringe.

A LADY WITH A ROSE *Blue Room*

Pastel on grey paper, 0.54 x 0.44, signed on the left at the level of the mouth: *A Besnard* (capital letters in monogram).

Bought from the painter in Paris in the spring of 1892. *P3s29*

Paul Albert Besnard — *A Lady with a Rose*

Bicci di Lorenzo

Born in Florence 1373; died there 1452.

The middle member of three generations of painters, he was presumably the pupil of his father Lorenzo di Bicci (died 1427). Bicci and his son Neri di Bicci (1419-91) were exceptionally prolific during their long lives, and the excellence of their conservative technique enabled their work to survive in quantity. Florence is still full of pictures in fresco and tempera by Bicci di Lorenzo, and he had a number of commissions in Tuscany and Umbria. His earliest dated work, the large triptych of 1414 in S. Maria Assunta at Stia, in the Casentino, belongs entirely to the century before. After the inherited tradition, the strongest influence on his painting was probably Gentile da Fabriano, who was in Florence 1422-25. In the Florentine Renaissance Bicci took no more than an imitative part, though in 1439-45 he collaborated with one of its leaders, Domenico Veneziano. This was in the choir of S. Egidio, for the façade of which he had earlier painted one of his finest frescoes, now in S. Maria Nuova. In 1447 he undertook to decorate the principal chapel of S. Francesco at Arezzo. His painting of the vaults there, which he left almost completed, must be his best known work, because he bequeathed the walls to Piero della Francesca. Probably his last altarpiece, of about 1450, is the triptych in the cathedral at Fiesole.

THE MADONNA AND CHILD, SS. MATTHEW
AND FRANCIS *Early Italian Room*

Gold and tempera on wood, Gothic-arched, the painted surface 0.841 x 0.518. *The Redeemer*, in half length, has been almost obliterated from the small cusped panel above. On the predella only one of three half-length figures in roundels has survived: on the left, a female Saint wearing the black hood and habit of a nun. The Virgin's nimbus is embossed in Gothic characters: AVE · MARIA · GRATIA · PLE ·; that of S. Matthew SAS (for Sanctus) · MATTEVS · APO; that of S. Francis SAS · FRANCISCVS (the S. damaged). The engaged frame is original, though the pillarettes are missing, two from either side. The paint is much abraded, especially from the heads.

The picture reflects the influence of Gentile da Fabriano (*q.v.*), who was in Florence 1422-25. The version in the Metropolitan Museum, New York (see below) has been dated 1425-50 by the design of the damask cloth which covers the floor. This seems very much the same in both pictures. Comparison between the two is difficult owing to the severe wearing of the paint in the Gardner picture; but the

Version: New York, Metropolitan Museum (No. 41.100.16). See Zeri and Gardner, *Metropolitan Museum of Art, Italian Paintings, Florentine School* (1971), p. 72, where it is reproduced. The measurements are stated as 0.832 x 0.476. They quote B. Klesse, *Seidenstoffe in der italienischen Malerei der vierzehnten Jahrhunderts* (1967), p. 241, No. 131b, for the dating 1425-50.

Joseph Blackburn

Active in British colonies along the Atlantic seaboard 1753-63, exclusively as a portrait painter.

His earliest known portraits, *Colonel Henry Tucker* and *Mrs. Henry Tucker*, are believed to have been painted in 1753 in Bermuda. His *Margaret Sylvester Cheesborough*, now in New York, is signed and dated 1754. The sitter then lived in Newport, R.I. Blackburn's portraits of *James Otis*, the revolutionary, with *Mrs. James Otis*, and his four portraits of Mr. and Mrs. Gillam Phillips, their son and daughter, are signed and dated 1755. These were all residents of Boston, Massachusetts. So Blackburn probably lived in Boston at least until 1763, though he visited Portsmouth and other towns in the course of his practice, and may have gone to reside in Portsmouth. His *Jeffrey Amherst* is dated 1758, the year in which the sitter became Commander-in-Chief of the British Army in North America. He was evidently the leading colonial portraitist at this time. He is last recorded in London 1 January 1764.

His origin is obscure; but his style seems to owe much to Thomas Hudson, then the best known portraitist in England. In turn, he had a strong influence in Boston upon Copley.

A LADY OF THE RUSSELL FAMILY (?)

Short Gallery

Oil on canvas, 1.268 x 0.945. The edges have been trimmed all round. Cleaning (after relining) in 1953 revealed paint in generally good condition. Fundamental losses are confined to small holes in the background. Some retouching was necessary on a small patch in the forehead above the nose, in a corresponding place between the nose and the upper lip, and on the back of the left hand.

The picture was catalogued in 1931 according to tradition in the family of John Lowell Gardner, Jr., as a portrait of *Rebecca Chambers Russell* by John Smibert (1684-1751). The attribution to Blackburn,[1] which is almost certainly correct and is well supported,[2] makes this identification of the sitter impossible. Rebecca Chambers Russell died in 1729. She had a daughter named Rebecca, born in 1721, who married David Wyer, a loyalist. At least the sitter probably belonged to the Russell family, which

Bicci di Lorenzo
The Madonna and Child, SS. Matthew and Francis

attitude of S. Francis here, holding a cross and turning his head, undoubtedly softens the effect of the group. In the New York version he looks straight before him and holds up his left hand to show the stigma.

The Gardner panel was bought from a Florentine dealer before 1899 by Joseph Lindon Smith (*q.v.*). From him it was purchased after October 1912.

P15w36

AUTHORITIES

Berenson in a letter (10 March 1930) and *Florentine School* (1963), I, p. 27.

Fredericksen and Zeri, *Census* (1972), p. 28.

Exhibited 26 April 1899—22 October 1900, Boston, Museum of Fine Arts, with the suggested attribution to Memmi; 11 June 1909—18 October 1912, attributed to Bicci di Lorenzo.

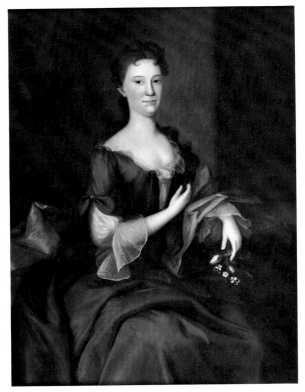

Joseph Blackburn — *A Lady of the Russell Family* (?)

Rosa Bonheur — *A She-Goat*

is shown by letters to have known Blackburn and his painting.

The portrait came to Mrs. Gardner by inheritance from her husband in 1898. *P17w31*

[1]Park, Lawrence, *Joseph Blackburn* (American Antiquarian Society, 1923), p. 54, No. 76, as "Unknown Woman"; he dated it about 1755.

[2]Morgan, John Hill, in a letter of 2 July 1935 in the Museum archives.

Bles

See HERRI met de Bles

Rosa Bonheur

Born at Bordeaux 16 March 1822; died at By, near Fontainebleau, 25 May 1899.

She was taught painting first by her father Raymond Bonheur, head of the Free School of Design for Girls in Paris, a post which she occupied after his death, and later by Léon Cogniet. From 1841, when she first exhibited at the Salon, she rapidly became famous for her studies of animals. In the Salon of 1845 she won a medal, and in 1848 the Gold Medal and a commission from the government. Her huge *Horse Fair* now in the Metropolitan Museum in New York was exhibited in 1853. In 1859 she bought the Château By near Fontainebleau. Here she lived and worked for forty years, a woman so much in love with the strong and the virile that she cut her hair, wore the rough costume of a peasant man and kept a pet lion. Her large pictures are all of the stress and strain of powerful animals in action, reproduced with great facility of draughtsmanship. She was visited at Château By in 1864 and 1865 by the Empress Eugénie, who brought her the Cross of the Legion of Honour, and in 1894 she was presented by the Republic with the Officers' Cross, never before given to a woman.

A SHE-GOAT *Blue Room*

Oil on canvas, 0.25 x 0.32. Signed at the foot on the left: *Rosa Bonheur.*

The picture was in the painter's studio at her death, and was sold with the other contents in Paris 30 May—2 June 1900 (Georges Petit, No. 593; the cachet of the sale and the number are on the back). *P3s16*

Exhibited April-May 1900, London, Hanover Gallery, No. 593.

Bonifazio Veronese

BONIFAZIO DI PITATI: born at Verona 1487; died in Venice 19 October 1553.

His presence at Venice is first recorded by his signature as witness to a will in October 1528; but that was just after the death of Palma Vecchio, in whose studio he had evidently worked for some years. *The Madonna and Child with SS. John Baptist, Francis, Catherine and Nicholas*, which was left unfinished in Palma's studio and is now in the Querini-Stampalia Museum at Venice, was evidently completed, in fact largely painted by him. He was soon preoccupied for the rest of his life with the decoration of a great public building, the Palazzo dei Camerlenghi, or Treasury, by the Rialto Bridge. The first payment was in 1529, towards four canvases in a room appropriated to the Council of Ten; two other payments were made in 1537 and 1545. Three of the pictures can be identified: *The Adoration of the Kings* and *The Massacre of the Innocents* now in the Accademia at Venice, *Christ among the Doctors* in the Pitti Palace at Florence. In 1530 he received the order for the first of those votive pictures which commemorated periodically the terms of the groups of officers as they were completed. He had the monopoly of this work, and it seems to have been continued after his death by the assistants in his studio, as well as by Tintoretto. *The Christ Enthroned amid Saints*, dated 1531, is now in the Accademia at Venice with others of the series. Of these the *Madonna with SS. John Baptist, Barbara and Homobonus* is signed and dated 1533. In 1547 Bonifazio's will speaks of a long illness.

His art was never robust or brilliant. Few of his compositions have such solidity and such coherence as *The Rich Man's Feast* in the Accademia at Venice; but his colours are too well grounded in the principles of Palma and Titian to fail in producing some richness of effect.

SACRA CONVERSAZIONE *Titian Room*

Oil on nut wood, 0.705 x 1.005, including a strip added along the head and foot. Damaged by a number of horizontal cracks. The painting has suffered from scaling and repaint, which have damaged the forehead and chin of S. Joseph, the right cheek of the Virgin and the left temple of the Saint, behind the eye. The picture was cleaned in 1945.

A woman Saint presents to Jesus the infant S. John, who hands him a bunch of flowers. These *Sacre Conversazioni*, groups of saints seated in the open round the Madonna and Child, were a favourite subject with the Venetian painters of the earlier

Bonifazio Veronese — *Sacra Conversazione*

sixteenth century and especially with Palma Vecchio. In them Bonifazio is at his best, and he shows himself Palma's pupil in a large number of early compositions, which repeat not only Palma's idea, but his design and his arrangement of draperies, the types of his figures and landscapes, his colours and his pigments. This is a good example of his earliest phase, no doubt painted within a few months of Palma's death in 1528.

The picture belonged by 1893 to Dr. J. P. Richter, from whose collection came also the pictures by Bordone, Catena and Giotto. From him it was bought through Berenson 27 April 1895. P26w8

AUTHORITIES

Berenson in a letter (4 February 1930) and *Venetian School* (1957), I, p. 41.

Fredericksen and Zeri, *Census* (1972), p. 31.

Freedberg, *Painting in Italy, 1500-1600* (1971), p. 231; he dates the picture 1528-30.

Morelli, *The Italian Painters* (London, 1893), II, pp. 245-46; he believed that there were three painters called Bonifazio and attributed this to the eldest and best.

Westphal, *Bonifazio Veronese* (1931), pp. 27, 29, 31, 35.

Exhibited 1893, London, R.A., Old Masters, No. 156 (label on frame).

From the Studio of Bonifazio

THE CONTINENCE OF SCIPIO *Titian Room*

Oil on canvas, 1.806 x 1.738. The canvas has been torn and rejoined from top to bottom, through the feet of Scipio. The paint is much abraded in the lowest third of the picture. It was cleaned in 1948.

The subject was previously identified as *The Wife of Darius before Alexander*; but the scene depicted does not conform with the texts. It is more plausible as an illustration to an episode in the story of Scipio Africanus the Elder related by Livy in his *History of Rome* Book XXVI.L,[1] and retold by Petrarch in his epic *Africa*. After his conquest of New Carthage in Spain in 209 B.C., the young Proconsul restored to her family a captured Spanish maiden brought to him by his soldiers. He returned with her a considerable treasure which her relatives had brought as ransom.

A comparison with Bonifazio's *Sacra Conversazione* is enough to relate this canvas closely to him.

From the Studio of Bonifazio
The Continence of Scipio

From the Studio of Bonifazio
The Magnanimity of Antigonus

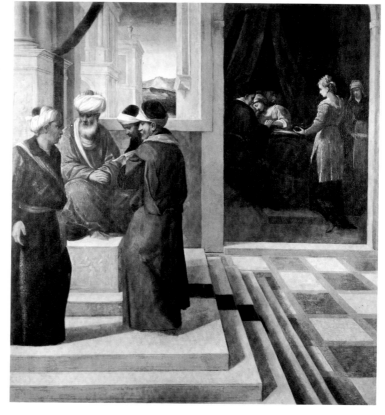

The colours however are duller than his own and shaded with black, the pigments are thinner and the attenuated figures are not characteristic. This and its pendant *The Magnanimity of Antigonus* are doubtless among the many large canvases painted by assistants in his studio. The slender figures, influenced perhaps by Tintoretto, suggest a date towards the end of his career.

This and *The Magnanimity of Antigonus* (below) were bought together by Mrs. Gardner in October 1892 from Consiglio Ricchetti at Venice. *P26n5*

[1]Mason Hammond kindly suggested this identification in a letter of 1 December 1971.

OTHER AUTHORITIES

Berenson in a letter to the compiler (4 February 1930) considered this and the pendant late works of Bonifazio; also *Venetian School* (1957), I, p. 41.

Fredericksen and Zeri, *Census* (1972), p. 31, attribute both pictures to Bonifazio without qualification.

Westphal, *Bonifazio Veronese* (1931), p. 83, included them in her list of pictures wrongly attributed to Bonifazio; she related them to Jacopo Bassano's *Beheading of S. John Baptist* in Copenhagen.

THE MAGNANIMITY OF ANTIGONUS
Titian Room

Canvas, 1.810 x 1.600, probably reduced a little at the side. The height is that of the preceding picture; the two canvases come from the same source and have even been torn in much the same place. They must have been pendants, since they are also painted by the same hand or hands. Cleaning in 1950 revealed a surface better preserved than that of the other picture.

Antigonus Gonatas, King of Macedonia (277-39 B.C.), divorced his wife Stratonice in order that Seleucus, his son by an earlier marriage, might marry her. He had married this very young girl at an advanced age, and Seleucus had become ill with a love which had to be concealed. The cause of his sickness was discovered, however, by the doctor, who was feeling his pulse when the young Queen approached the bed — as she does on the right of the picture. To the left, King Antigonus gives audience to three ministers (?), perhaps informing them of his decision to give Stratonice to his son, the future Antioches I.

The subject was previously unidentified, and the picture called *The Consultation*. Professor Hammond's recent identification[1] is borne out by the relevance of the subject as another historic scene of renunciation and by the popularity of the story in ancient, medieval and Renaissance times.[2] Boni-

fazio treated the same subject in a panel now in the Poldi Pezzoli Museum, Milan *P26s3*

[1]Mason Hammond in a letter of 5 February 1972.
[2]Stechow in *The Art Bulletin*, XXVII, 4 (December 1945), pp. 221-37.

Bono da Ferrara
See MANTEGNA, influenced by

Gerard ter Borch

Born at Zwolle 1617; died at Deventer December 1681. Both towns are in Overyssel.

With his sister Gesina he was first taught by his father Geert ter Borch, a tax-collector and painter. A drawing by Gerard is inscribed *in Amsterdam 1632*, another, signed and dated 1634, shows part of the Grote Kerk in Haarlem. Here he was the pupil of Pieter Molyn, with whom he collaborated occasionally for several years. He entered the Haarlem Guild in 1635. He seems to have been at Zwolle again in 1636. He is said to have visited England and travelled through Germany and Italy to Rome, and there is evidence at least that he was in Rome in 1640 or 1641. The stories of his travels go well with the fact that he was at Münster in Westphalia while the Dutch and Spanish delegates were negotiating the Treaty of Münster in 1646-48. This was the great moment in the history of the United Provinces. After some eighty years of almost continuous war with Spain, they were finally recognized by her as an independent nation. Yet ter Borch's little picture, *The Swearing of the Oath of Ratification of the Treaty of Münster, 15 May 1648*, now in London, seems to have been painted on his own account. He refused an offer, and it remained in his own possession. It contains more than seventy figures, and possibly he did have commissions for a considerable number of portraits on a miniature scale of individuals who attended the conference. Half a dozen of these are still known. The questions whether he was the Dutch painter in the service of the Spanish plenipotentiary the Conde de Peñaranda, and whether he afterwards went to Spain are still debatable. There is a similarity between the earlier full-length, life-size portraits by Velázquez, such as the *King Philip IV*, below, and the tiny full-lengths by ter Borch; and there is no doubt that Velázquez set the scene first.

Ter Borch was in Amsterdam in November 1648, and two years later is recorded at Kampen, near Zwolle. In 1655 he became a citizen of Deventer, where he spent the rest of his life. He had married

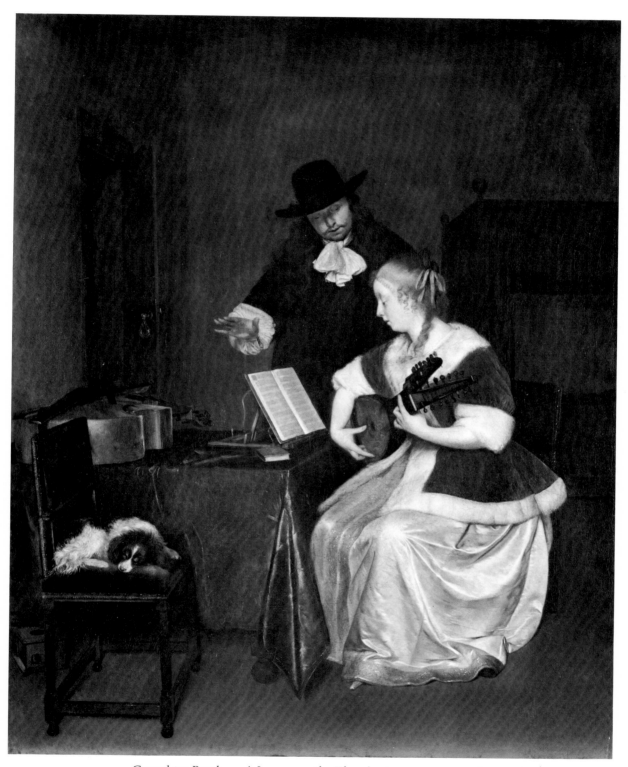

Gerard ter Borch — *A Lesson on the Theorbo* (SEE COLOUR PLATE)

there early the year before. He was elected a member of the Common Council in 1666, and next year painted the group portrait of its Regents which is still in the Council House.

The earliest of his many pictures are influenced by the Amsterdam painter Willem Cornelisz Duyster (d. 1635) and describe, as did he or Pieter Codde (1599-1678), the doings of the military off parade. A picture of this kind by ter Borch is *Unwelcome News* in The Hague, dated 1653; another is *Despatches* in Philadelphia. From the models of Duyster descend also ter Borch's tiny portrait groups like *The Treaty of Münster* or *The Deventer Council*. From him he caught the fascination of painting delicate stuffs; and, as his handling came to surpass Duyster's in fineness, he concentrated it upon the representation of scenes from fashionable life. He came to surpass even Metsu as the most exquisite interpreter of Dutch high life in its richly appointed drawing-rooms, the ladies dressed in the silkiest of stuffs. Such pictures as *The Letter* in the British Royal Collection or another of the same title in Toledo, Ohio, are a triumph of fresh colour and meticulous manipulation. His composition has a suitably precious quality, his figures always grouping themselves and arranging their furniture with tender care; yet motifs and whole compositions are not seldom repeated and the dainty outlines tend to form a favourite pyramid.

A LESSON ON THE THEORBO *Dutch Room*

Oil on canvas, 0.662 x 0.524. The monogram *GTB* on the footwarmer in the corner to the left is an addition of later date. Cleaning in 1948 revealed that it was applied over an early layer of varnish. It disclosed some paint losses in the lower left corner.

Cleaning also removed some overpaint; but ter Borch's own painting still seems less fine than in the version belonging to Mrs. W. J. Roach in England. Gudlaugsson categorises Mrs. Gardner's picture as a "workshop replica,"[1] though this postulates the existence of a studio about which there is no evidence.

Both pictures belong to a comparatively late moment in the painter's career. The colours are restrained, though the general effect is a little harder in Mrs. Gardner's picture.

Ter Borch's love of the subtle moment led him often to scenes of amateur music making, and these same characters repeat themselves, even in the same room. In a contemporary picture in the London National Gallery, *A Young Woman Playing the Theorbo to Two Men*, the husband overlooks the scene and the dog stands distrustfully by the door.

The picture is first recorded in Rotterdam in 1753, when it was sold, with another picture attributed to ter Borch, by the dealer Pieter Ietswaart to Jan and Pieter Bisschop. On Jan's death their collection was sold in 1771, probably to Adriaen and Jan Hope in Amsterdam.[2] Their collection was brought to England about 1789 by Thomas (d. 1831) and Henry Philip Hope (d. 1839). It included also Rembrandt's *Storm on the Sea of Galilee* and *A Lady and Gentleman in Black*, now in the same room. The further history of all three pictures is related under the last mentioned. They were bought by Mrs. Gardner in 1898. *P21e24*

[1]S. J. Gudlaugsson, *Gerard Ter Borch* (The Hague, 1960), pp. 203-04, No. 221, a; he describes it as *Werkstattwiederholung*, and dates Mrs. Roach's picture about 1668.

[2]C. Hofstede de Groot, *Catalogue of Dutch Painters*, V (trans., London, 1913), Ter Borch, No. 126.

Other Authorities

Conway in *Noteworthy Paintings*, pp. 213-14: "The signature may be modern over the old one."

Martin in *Noteworthy Paintings*, pp. 210-13; he dated it after 1650.

Smith, *A Catalogue Raisonné of the Works of the most eminent Dutch, Flemish and French Painters* (London, 1829-42), IV, p. 124; he described it as a duplicate of the variant below.

Waagen, *Treasures of Art in Great Britain* (London, 1854), II, p. 116.

Exhibited 1855, London, R.A., Old Masters, No. 6; 1881, No. 116. 1891-98, London, South Kensington, Collection of Lord Francis Pelham Clinton-Hope, No. 74.

Engraved by C. G. Lewis.

Versions: (1) England, Mrs. W. J. Roach, canvas, 0.66 x 0.51. A superior picture, almost identical. Gudlaugsson, No. 221, I. Exhibited 1952-53, London, R.A., Dutch Pictures, No. 407; 1944, Liverpool, No. 20; 1871, London, R.A., Old Masters, No. 142. Ex collections John Fattorini, Lionel de Rothschild, Mrs. Bradshaw (1871), John Fairlie, Prince Galitzin, de Calonne. Gudlaugsson lists 9 copies, or probable copies: Nos. 221b-221j in his catalogue. (2) Chicago, Art Institute, canvas, 0.635 x 0.490, signed in monogram: *GTB*. A variant in which the master beats time with the bow. Gudlaugsson, No. 221, II. Exhibited 1947, St. Louis, No. 37; 1939, New York, Metropolitan Museum, No. 368; 1929, Detroit, No. 74; 1893, Chicago, No. 6. Ex collections Charles T. Yerkes, Prince Demidoff. Engraved by D. Mordant. Gudlaugsson lists 3 copies: Nos. 221k-221m.

Paris Bordone

Paris Paschalinus Bordon: baptised at Treviso 1500; died in Venice 1571.

His father Giovanni, a saddler, was dead by 1507, and his mother returned with him by 1508 to Venice.

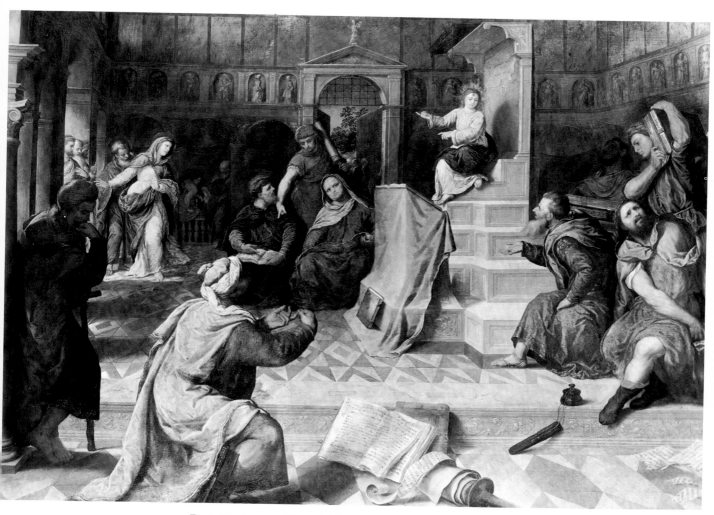

Paris Bordone — *The Child Jesus Disputing in the Temple*

Here, according to Vasari, he was later apprenticed to Titian; but in 1518 he apparently was living in a house of his own. Later he redeemed and enlarged his father's farm at Lovadina near his birthplace, and at Venice he moved to the open neighbourhood of the Madonna del Orto. Here in the summer of 1566 took place the interview with Vasari, who published in the new edition of his biographies the principal record of Bordone's life. He explained to Vasari that he lived in peaceful retirement, painting only to please a few princes and other friends and avoiding the society of his colleagues from dislike of their jealousy and ambition. He had received neither employment nor recognition from the state. Perceiving that Venice was no place for so honest a man he had gone in 1538 to the court of François I in France, where he painted many pictures of women for the King and other pictures for the Cardinals of Guise and Lorraine. In 1540 he went to Augsburg, where he painted decorations in the palace of the Fuggers. His portrait of Jerome Crofft (?) in the Louvre is indeed dated Augsburg, 1540. In 1534 Bordone had painted for the Scuola Grande di S. Marco in Venice the *S. Mark's Ring Brought to the Doge* in the Accademia there. His *Last Supper* in S. Giovanni in Bragora evidently belongs to his last years. In between he seems to have painted little in Venice. He was employed mainly on the mainland. He had patrons in Milan, for one of whom he painted the altarpiece still in S. Maria presso S. Celso; and there were altarpieces by him at Crema. He had commissions at regular intervals from his birthplace, where a number of pictures remain in the cathedral and in the museum. The *S. George and the Dragon* in the Vatican Gallery, of about 1525, comes from Noale near Treviso, and the altarpiece in Berlin from Belluno. He painted a number of portraits.

He was an ambitious artist, planning in large measurements from the first and setting his figures in grandiose architecture or in big rolling landscapes. For these he lacked the necessary science. His most successful pictures are the comparatively small Holy Families or *Sacre Conversazioni* which he painted under the influence of Titian.

Of his many mythological scenes the germ is contained in Titian's *Flora*, now in the Uffizi at Florence, painted about the time of an apprenticeship to Titian which he did not enjoy. A momentary adventure of the great painter became a lifelong prescription for the pupil. The faint discord of auburn hair and lilac gown, the lusciousness of skin and flowered silk too often turn under his hands into a strident clashing and a rankness of rouge and satin, tendencies perhaps encouraged by contact with the Brescian painter

Savoldo, who established himself in Venice about 1520. In the ambitious stylism of his compositions Paris was influenced by Titian's would-be rival Pordenone.

THE CHILD JESUS DISPUTING IN THE TEMPLE
Titian Room

Oil on canvas, 1.63 x 2.29. The deeper colours are somewhat rubbed. Signed at the base of the column on the left: *BORDONVS*.

The canvas belongs to much the same moment in Bordone's career as his picture in the Accademia at Venice, *S. Mark's Ring Brought to the Doge*: 1534-35. The column and entablature on the left are almost the same as those in that picture, and there are many analogies of colour and design.

It came probably from either the Tiepolo palace, Venice, or a church of which the Tiepolo family were patrons. It was sold[1] by Count Tiepolo at Venice to Auguste Louis de Sivry, a French adventurer who settled there at the period of Napoleon's domination, after 1797, and is known to have dealt in pictures. It belonged to him in 1831. It passed into the collection of John Benjamin Heath, F.R.S., F.S.A., who was Italian Consul-General in England and was afterwards made Baron of the Kingdom of Italy. At his sale in London in 1879 (8 March, Christie's, No. 135, "from the Tiepolo Palace at Venice"), it was bought by Rutley. At the sale of the Rt. Hon. G. A. F. Cavendish Bentinck in London in 1891 (11 July, Christie's, No. 610; the date of the first day's sale 8 July is written twice on the back and the No. 610 on the frame) it was bought by J. P. Richter, former owner also of the pictures by Bonifazio, Catena and Giotto. From him it was bought by Mrs. Gardner in September 1901 through Berenson.
P26w11

[1]Bianchetti, a historian of Treviso, in a lecture to the Accademia delle Belle Arti at Venice (1831). He is quoted by Bailo and Biscaro.

OTHER AUTHORITIES

Bailo and Biscaro, *Della Vita e delle Opere di Paris Bordon* (Treviso, 1900), No. 40 (pp. 130-31) and p. 36; they stated that it was restored by Cavenaghi.

Berenson in a letter to the compiler (4 February 1930), and *Venetian School* (1957), I, p. 45.

Canova, *Paris Bordon* (1964), p. 75; she dates the picture 1540-45.

Fredericksen and Zeri, *Census* (1972), p. 32.

Freedberg, S. J., *Painting in Italy, 1500-1600* (1971), p. 367; he dates it 1545-50.

Schaeffer in *Allgemeines Lexikon der Bildenden Künstler*, IV (ed. Thieme-Becker, Leipsic, 1910), p. 349; he had not seen the picture and wrongly described it as in Dr. Richter's collection.

Venturi, A., *Storia dell' Arte Italiana*, IX, 3 (Milan, 1928), p. 1023.

Exhibited 1878, London, R.A., Old Masters, No. 148 (label on back); 1894, London, R.A., Old Masters, No. 114 (label on back); 1895, London, New Gallery.

Botticelli

ALESSANDRO FILIPEPI, born in Florence 1444-45; buried there 17 May 1510. He was the youngest son of Mariano di Filipepi, a tanner. BOTTICELLO (Tubby), the nickname of the painter's eldest brother Giovanni, took the place of Filipepi as the surname of his generation. At thirteen Alessandro was described by his father as sickly and, it is understood, as apprenticed to a jeweller. A bachelor, he lived all his life with a houseful of relations in Florence, though in 1494 he and his two surviving brothers bought a villa and farm outside the wall.

He must have been sent to Prato to have been the pupil of Filippo Lippi, as is asserted by early biographers and witnessed by some of his pictures. But he belonged rather to the school of the sculptor-painters, Verrocchio and Antonio del Pollaiuolo, when he painted in 1470 for the Guild of the Merchants at Florence his first documented work, the *Fortitude,* which completed the series of *Virtues* by the Pollaiuolo brothers now in the Uffizi.

The year before, Piero de' Medici had bequeathed the velvet Medicean gloves which guided Florence to his young sons Lorenzo and Giuliano. The painter was no such intimate of their court as the poets and scholars; but he became the chosen illustrator of its poems and its studies. He painted the portrait of *Giuliano de' Medici,* of which there are several versions, and, when Giuliano was assassinated in 1478, it was he who counterfeited the executed murderers upon the wall of the Palazzo Vecchio. His *Spring* in the Uffizi is an illustration to the ode written round Giuliano's tournament by Poliziano, the ablest poet of the court, and he designed the engravings for the first printed edition (1481) of *The Divine Comedy* by Dante, the object of its hero-worship. He was one of the decorators, probably about 1483, of Lorenzo's villa near Volterra and painted, about 1486, the two frescoes now in the Louvre from the villa of Lorenzo's godson Lorenzo Tornabuoni. He was designing for Lorenzo mosaics for the chapel of S. Zenobius in the cathedral when his patron died, in 1492. It was perhaps for Lorenzo's cousin Lorenzo di Pierfrancesco de' Medici that he painted *The Birth of Venus* and *Pallas with the Centaur* now in the Uffizi Gallery. Pope Sixtus IV was another patron. Botticelli's name heads the list of painters in the contract of October 1481 for the decoration of the walls of the Sistine chapel in Rome. His frescoes there are his largest undertaking to survive.

The golden age was short; and in his last eighteen years Botticelli's world was filled with terror. After Lorenzo's death his son Piero de' Medici was expelled the city and Lorenzo Tornabuoni was beheaded. Few of the scholarly court survived the sack of the Medici palace and of Lorenzo's library. Botticelli's brother Simone was an ardent follower of Savonarola, who set up a new theocratic government only to be executed in his turn. The preacher had put an end to paganism, and the movement in Botticelli's few subsequent pictures like the ruined *Crucifixion* in the Fogg Art Museum or *The Nativity,* dated 1500, in the National Gallery, London (his one signed work), is extravagantly tragic. In 1502 he was offering his services in vain to Mantua.

Botticelli turned his back on much of the science and the naturalism of the earlier Florentine Renaissance. A few early pictures show him searching after fulness of form; but the strongest influence he felt was that of Andrea del Castagno, and his method often narrowed to a kind of relief. Thus, since the painters of his day were expected to organise an impression of considerable depth, his large altarpieces were not always fully successful, though that which he painted in 1483 for S. Barnabà, now in the Uffizi, is with its purple and gold one of the most sensuously gorgeous decorations of the Renaissance. When his theme was an emotional moment he became a moving interpreter, so that his *Annunciation* in the Uffizi Gallery is the best designed of his large altarpieces. Their predella scenes are full of vivid poetry. His invention was happiest of all when he was illustrating for the comparative privacy of palaces new themes that touched the fine strings of his emotions. In *The Birth of Venus* he proved the ideal illustrator, inventing a new convention of design which in its simplicity of plan and breadth of touch made for perfect decoration. It was when he clearly established this shallower relief that his line attained all its haunting, luxurious tenderness. It has a music, an emphasis of rhythm, which could scarcely be combined with a stronger illusion of volume, though the form is always there.

For one more generation at Florence painting was to keep this simplicity of execution, and Michelangelo in his Sistine ceiling wove into a similar movement forms which were sculptured with more power and controlled with greater science. Botticelli, however, had already realised the utmost lightness of touch of which an European pencil has been capable. Their dreams were born of the same rich imaginative world, that of Dante, of the Bible and

of Classical literature in the freshness of its re-discovery.

THE MADONNA OF THE EUCHARIST
Long Gallery

Tempera (possibly with some oil in the shadows) on nut(?) wood, 0.85 x 0.645. Cleaning in 1970-71 revealed a surface worn in places; which has also suffered from the loss of minute flakes all over. The fundamental damage is to the Child's left hand and the drapery over the arm. The balance of the brilliant colours remain intact, only changed by the darkening of the green collar and lining of the Virgin's mantle, and of the vine leaves beneath the grapes.

The ears of the corn and the grape bunches proffered by the Angel symbolise the Eucharist. They are to become the bread and the wine, as the Child is to grow into the Redeemer. This solemn concentration on the symbolic separates the young Botticelli at once from Filippo Lippi, who is thought to have been his master. The design is for Botticelli unusually sculptural. The forms are substantial, their disposition leads the eye into a space firmly defined by the plain stone parapet, and the rounded hills of the landscape seen through its embrasure complete the plasticity of the design. Botticelli has turned for once full into the main Florentine current of sculptural composition, and he was rarely to return to it. The picture must have been painted between the *Fortitude* in the Uffizi, painted in 1470, where the drapery falls into the same rounded striations, and the *S. Sebastian* in Berlin, which is thought to have been once dated 1474.

Upon the back of the panel is a variety of seals with the arms of Prince Chigi, Duke of Ariccia. These appear to date from the eighteenth century. In 1892 the picture hung on the ground floor of the Palazzo Chigi (now the Italian Foreign Office) in Rome.[1] In 1899 Prince Chigi sold it to Edmond Despretz. At the suit of the government the Prince was fined the amount he had received for infringing the Pacca law forbidding the export of pictures; but the court of appeal found him to be punishable by a fine not exceeding 2,000 lire and the Supreme Court of Appeal at Perugia is said (*Athenaeum*, 2 March 1901, p. 282) to have reduced it to 10 lire. Meanwhile the picture had been bought by Mrs. Gardner in July 1899 through Berenson from Colnaghi of London and, after exhibition in London in November 1901, it was finally dispatched to Boston that month.

P27w73

[1]Morelli, *The Italian Painters* (London, 1892), I, p. 83.

OTHER AUTHORITIES

Berenson in a letter (4 February 1930) and *Florentine School* (1963), I, p. 33.

Bo and Mandel, *L'Opera completa del Botticelli* (1967), p. 88.

Bode, *Sandro Botticelli* (London, 1925), pp. 18, 23-26, 99, 105, and 158; and *Botticelli* (Klassiker der Kunst, Stuttgart, Berlin and Leipsic, 1926), Pl. 12.

Boskovits, *Botticelli* (1964); he dates it about 1472.

Douglas in *Crowe and Cavalcaselle's History of Painting in Italy*, IV (London, 1911), p. 252, note.

Fredericksen and Zeri, *Census* (1972), p. 33.

Horne in *Noteworthy Paintings*, pp. 192-93; also, *Sandro Botticelli* (London, 1908), pp. 35-36; here he stressed the influence of Verrocchio.

Müntz in *Gazette des Beaux-Arts*, XX (1898), pp. 177-87.

Post in *Art in America*, II (1914), pp. 257-63; he related the picture to the Neo-Platonism of the period.

Ricci, C., in *Noteworthy Paintings*, pp. 188-89.

Salvini, *Tutta la Pittura del Botticelli* (1958), I, pp. 18 and 43; he dates it about 1472.

Steinmann, *Botticelli* (New York, 1901), p. 14.

Supino, *Sandro Botticelli* (Florence, 1900), pp. 19-20, and in *Noteworthy Paintings*, p. 188.

Ulmann, *Sandro Botticelli* (Munich, 1893), p. 35, note, and No. 155; he quoted Morelli.

Venturi, A., *Botticelli* (Rome, 1925), pp. 28-29 and 108.

Venturi, L., *Pitture Italiane in America* (Milan, 1931), Pl. CXCI; and *Botticelli* (1961), p. 9.

Yashiro, *Sandro Botticelli* (London and Boston, 1925), I, p. 227.

Exhibited 1-15 November 1901, London, Colnaghi's, largely in order to disperse the various rumours as to the picture's identity and destination caused by the trial of Prince Chigi.

Versions: (1) Chantilly, Musée Condé, No. 23, contemporary composition based on Botticelli's. (2) Scandicci (near Florence), the Comtesse de Turenne, a fragment (Horne); this is perhaps the *Head of a Madonna* noted as copied from Mrs. Gardner's picture (Yashiro, I, p. 234).

THE TRAGEDY OF LUCRETIA
Raphael Room

Tempera(?) and oil on hard wood panel, 0.835 x 1.800. Cleaning in 1954-55 revealed scattered fundamental damage due to flaking of the paint. The distant landscape, the arch and the gilded reliefs are little affected and the serious losses are confined mainly to the three armed men nearest to the dead Lucretia's head, the three men on the extreme right of this centre group and the two men in the middle of the group supporting the dying Lucretia on the right. Even here, the heads are not very seriously damaged.

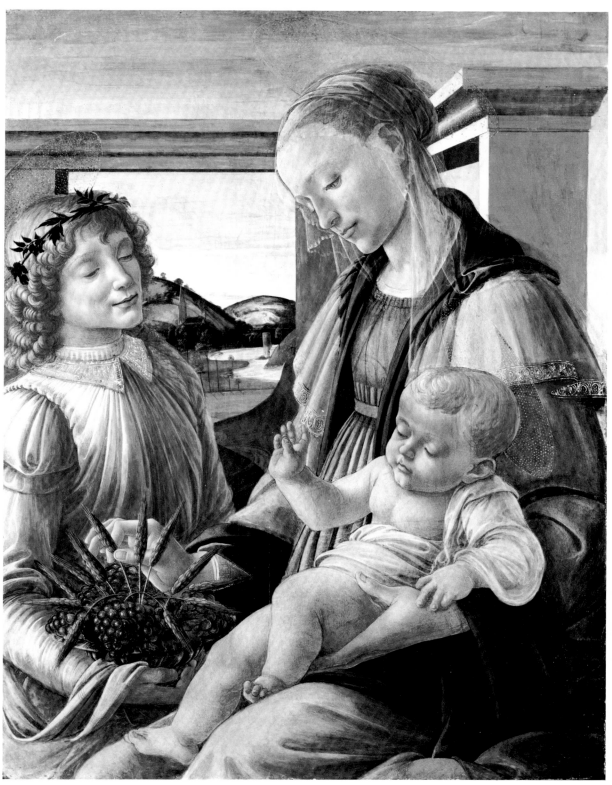

Botticelli — *The Madonna of the Eucharist* (SEE COLOUR PLATE)

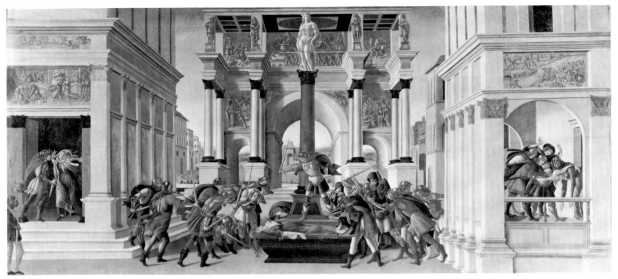

Botticelli — *The Tragedy of Lucretia* (SEE COLOUR PLATE)

On the left Sextus, son of King Tarquin, prepares to violate Lucretia, threatening her with his dagger. On the right she falls self-slain into the arms of her husband Collatinus, her father and their friends. In the centre over her corpse extended on a bier Junius Brutus incites his fellow Romans to revolt and to the expulsion of the brood of Tarquin from Rome. The crime was the consequence of a bet made by a party of Roman officers in camp upon the comparative virtue of their wives. Lucretia alone, when surprised, was chastely spinning. She was awarded the prize. Tarquinius Sextus, inflamed by her beauty and modesty combined, left the camp some nights later intent on his crime. As a result of this the king and the prince were killed, and the ancient form of government by elected Consuls was restored to Rome for a time. The story related in prose by Livy and in verse by Ovid was recapitulated by Dante in his *Inferno*.

It was ancient practice to detail several episodes of a story in one picture. To unite them thus formally as a theatre scene, in a stage setting designed on the architectural principles of Vitruvius, was a fashion of the contemporary Renaissance. For the centre of his stage Botticelli has elaborated on the arch of Constantine in Rome, a motif which he had already used in fresco in the Sistine Chapel there. Not content with the main story, he has decorated his marble buildings with reliefs in gold, each celebrating a hero or a heroine from the Old Testament or from ancient history. Over the portico on the left is the story told in the apocryphal Book of Judith, who saved Israel by decapitating Holofernes, the generalissimo of the Assyrian conqueror Nebuchadnezzar. In the frieze above, a cavalry battle offers no means of identification. Over the right portico Horatius Cocles alone at a bridge saves Rome from Tarquin's ally King Porsena; on either side of the arch Mucius Scaevola (left) tries to stab Porsena and (right) holds his hand in the fire ordered by Porsena to consume him, as proof of his courage — three episodes in Roman history related by Livy and Plutarch. Above these, on the left, Marcus Curtius rides his horse into a chasm which had opened in the Forum but closed itself on this demonstration of heroic citizenship, a story told by Livy and Valerius Maximus. Less certainly to be identified is the panel to the right: (?) Achilles dragging Hector's body through the Greek camp outside the walls of Troy, as he does in Homer's *Iliad*. The large scene between these two remains a riddle.

Only in Florence perhaps would Judith occupy a place among the heroes of Antiquity. Donatello had designed a statue of her for the old Medici (now Riccardi) palace, and, when the Medici were expelled in 1492, this was moved to the Piazza della Signoria and set up as a memorial of deliverance from tyranny. With it came Donatello's *David*, which was placed in the Palazzo Vecchio. Botticelli, on the other hand, has given first place to David, elevating a gilded statue of him on the great porphyry column in the very centre, with Junius Brutus mounting its plinth below for his harangue. It has been argued with reason that he would not have done this before 1504, when Michelangelo's *David* was set up in the Piazza and Donatello's *Judith* took second place.[1] At least it is highly probable that there is a reference here to the expulsion of the Medici, for it seems

that we are called upon to admire, even more than the chaste Lucretia, her husband the republican tyrannicide. It was argued in the 1931 Catalogue that this was unlikely since the Medici were Botticelli's patrons; but artists have not always been loyal to their patrons or stable in their politics, and there is evidence in this picture of the painter's tense state of mind.

The tragic dancing of the little figures and the rapid, continuous rhythm of the line point to the painter's last years. They are found also in *The Nativity* of the London National Gallery, signed and dated 1500. The *Lucretia* panel is a pendant to *The Story of Virginia* (0.82 x 1.65) in the Accademia Carrara (Morelli Collection) at Bergamo, where six episodes are enacted in a single richly decorated building.

Vasari in his *Lives* (Vol. I, p. 492 of the first ed., 1550) related of Botticelli that he "carried out in the Via de' Servi [at Florence] in the house of Giovanni Vespucci, now the property of Piero Salviati, many paintings enclosed in walnut ornaments which formed frames and wainscots, with many life-like and beautiful figures." It has been suggested[2] that these two[3] panels once formed part of that decoration. Too summarily painted to have been more than pieces of furniture, yet large for cassone panels, they are the most suitable for such a situation that survive; but there is no proof of their identity. Botticelli painted the decorations mentioned by Vasari more probably[4] for Giovanni Vespucci's father, Guidantonio, who bought the house 5 March 1498-99. The decoration would naturally date from the next few years, which are roughly the period within which the painting must have been done. Guidantonio Vespucci was twice Gonfaloniere, the highest public officer in Florence, and was Orator of the Florentine Republic at various Italian courts and in France. The Vespucci family owned the best part of the parish of the Ognissanti, in which Botticelli lived.

Mrs. Gardner's panel was bought through Berenson from the Earl of Ashburnham 19 December 1894. *P16e20*

[1]Walton, Guy, *The Lucretia Panel*, etc., from *Essays in Honour of Walter Friedländer* (1965), pp. 177-86. He is alone in not attributing the picture to Botticelli.

[2]Morelli, *op. cit.*, I, p. 87, note 6; he suggested that this was the history of his own panel, *The Story of Virginia*.

[3]Ulmann, *op. cit.*, pp. 139-40 and No. 39; he was the first to connect the two panels and to extend Morelli's historical suggestion to the *Lucretia*.

[4]Horne in *Noteworthy Paintings*, pp. 104-05 and 109; and, *Sandro Botticelli* (London, 1908), pp. 285-86; he adopted Ulmann's suggestion and thought Botticelli was assisted.

OTHER AUTHORITIES

Berenson in *Gazette des Beaux-Arts*, I (1896), p. 206, in a letter (4 February 1930) and *Florentine School* (1963), I, p. 33.

Bo and Mandel, *L'Opera completa del Botticelli* (1967), p. 108; they suggest that Botticelli employed assistants. This is probable, as in most of Botticelli's pictures, with regard to the architectural features, but unlikely for the figures owing to the great freedom of their execution.

Bode, *Sandro Botticelli* (London, 1925), pp. 128-29; he stated as a fact that these are the panels mentioned by Vasari; and *Botticelli (Klassiker der Kunst*, Stuttgart, Berlin and Leipsic, 1926), Pl. 94.

Boskovits, *Botticelli* (1964), p. 95.

Douglas, *loc. cit.*, IV (London, 1911), p. 270.

Fredericksen and Zeri, *Census* (1972), p. 33.

Richter in *Noteworthy Paintings*, pp. 98 and 103-04; he considered the picture an allegory of the expulsion of the Medici from Florence.

Salvini, *Tutta la Pittura del Botticelli* (1958), II, pp. 31-32 and 64.

Schubring, *Cassoni* (Leipsic, 1915), p. 27 and Pl. LXXII.

Supino, *op. cit.*, pp. 84 and 94, and in *Noteworthy Paintings*, pp. 109-10; he considered the picture an allegory of the triumph of virtue under Savonarola.

Venturi, A., *op. cit.*, p. 86.

Venturi, L., *Pitture Italiane in America* (Milan, 1931), Pl. CC; and *Botticelli* (1961), p. 79.

Yashiro, *op. cit.*, I, p. 230.

Exhibited 1893-94, London, New Gallery, Early Italian Art, No. 160.

Studio of Botticelli (?)

THE NATIVITY *Long Gallery*

Tempera (?) on light hardwood, circular, 0.792 x 0.788. A partial cleaning in 1950 and a thorough examination in the Research Laboratory of the Boston Museum of Fine Arts in 1972 have made it possible to estimate the present state of the picture's preservation. In the right half there is a good deal of retouching, over paint losses which are widely scattered, and over some worn areas. The blue of the Virgin's mantle has become opaque and discoloured with overpaintings of different periods, and the left sleeve of S. Joseph is also retouched in the shadow. This may be to cover the *pentimento* there (see below); but there are small retouchings over paint losses round the lower part of his head on this side. Perhaps the shepherds were always sketchily painted; perhaps their heads and hands have been rubbed. There is much retouching in this area and the black lamb is largely a restoration. The remainder of the picture is well preserved, except at the base. Here the condition is confused, and there are various small retouchings on the Child.

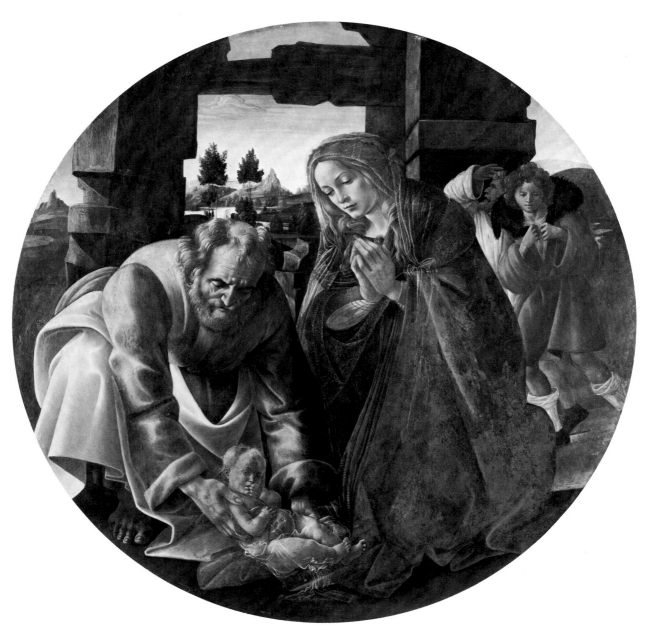

Studio of Botticelli(?) — *The Nativity* (SEE COLOUR PLATE)

On the other hand, these examinations have by no means fully explained the disparities in the composition and in the painting, which must be due largely to the participation of at least two hands. Botticelli had able assistants, and the figure of the Virgin is typical of many pictures of charm and tenderness which came from his studio about 1485-1500; the stonework behind and the landscape seen through it are also typical Botticelli motifs. An example is a slightly smaller tondo (0.596) in Washington, attributed to Botticelli by L. Venturi and Salvini. The shepherds are perhaps less characteristic, and the black lamb carried by the younger is a solecism. What seems even less characteristic of Botticelli and incompatible with the rest of this picture is the figure of S. Joseph. His powerful form, somewhat different in scale, would tower over the Madonna if he were to stand up. Kneeling, he contradicts the rest of the scene by the deeper strength of his attitude. Radiography strengthens the impression given by the painting that he was not part of the original design and was painted over more voluminous draperies which had already been represented as spread before the Virgin. The Virgin adoring the Child, lying upon her mantle on the ground in this way, was a popular subject, favoured by Botticelli; but S. Joseph, formerly a somewhat neglected figure, became increasingly revered throughout the fifteenth century. This idea of the composition's evolution thus goes with the trend of the times; but it implies that the shepherds also were part of the enlargement of the theme, though they are as much the weakest part of the whole as S. Joseph is the strongest. The picture appears to be a case probably not of the finishing in one studio of a picture begun in another but of an uneasy collaboration in one shop.

The figure of S. Joseph, so much less tentative than the others, is more in the style of Domenico Ghirlandaio (1449-94); but since the discrepancies in the painting were pointed out in the Catalogue of 1931 other suggestions have been made. The influence of Luca Signorelli, who had a studio for a time in Florence, has been noted by two writers,[1] and the S. Joseph has even been attributed to Michelangelo, who was probably a youth in Ghirlandaio's studio at about this time.[2]

The picture was bought by Mrs. Gardner in 1900, probably through Richard Norton, from the Duke of Brindisi. It hung in the Antinori (now Aldobrandini) Palace in Florence. P27e1

[1]Salvini, Tutta la Pittura del Botticelli (1958), II, p. 75: "Opera di notevole qualità, che tuttavia i forti elementi signorelliani (notati del resto dal Gamba) impediscono d'attribuire al maestro."

[2]Von Holst, Christian, in Pantheon, September-October 1967, pp. 329-35. The article is translated and abridged in Fenway Court, II, No. 5 (February 1969), pp. 37-48.

OTHER AUTHORITIES

Berenson, Florentine School (1963), I, p. 33; he attributed it to Botticelli "in great part."

Douglas, loc. cit., IV (London, 1911), p. 270, quoted Horne.

Fredericksen and Zeri, Census (1972), p. 37, as Botticelli.

Horne, Sandro Botticelli (London, 1908), pp. 265-66; he discussed its authorship carefully, concluding that it was an independent work by an assistant of Botticelli, imitating all the "lighter and more attractive qualities" of his art. He implied that it was painted about 1494.

Ulmann, op. cit., p. 126; he attributed it to Botticelli.

Yashiro, op. cit., I, p. 238; he noted it among a list of contemporary copies and versions as a variation upon Botticelli's drawing of The Nativity in the Uffizi Gallery.

Francesco Botticini

FRANCESCO DI GIOVANNI: born in Florence 1446; died there 1497. Both his father Giovanni di Domenico and his son Raffaello seem to have been painters.

It was probably Francesco who was apprenticed to Neri di Bicci in the autumn of 1459 but decamped the following summer. The earliest dated altarpiece attributed to him is one in the Jacquemart-André Museum, Paris, of 1471. Very little is recorded of him, partly perhaps because he inevitably became confused with Botticelli, whose style he imitated. Thus already in the mid-sixteenth century, the wide Assumption of the Virgin in London was attributed wrongly to Botticelli by Vasari. He records rightly, however, that it was commissioned for a chapel in S. Pier Maggiore in Florence by the writer Matteo Palmieri, who died in 1475. The Crucifixion in Berlin, dated that year and more certainly attributable to Botticini, is influenced rather by Verrocchio. Verrocchio dominates his strongest pictures, like the Capponi altarpiece in S. Spirito, Florence, S. Monica Handing the Rule to Her Nuns, or The Three Archangels with Tobias in the Uffizi Gallery, probably from the same church. The only commission which Botticini is recorded to have received was from Empoli, twenty miles from Florence. Now in the museum there, together with other paintings of his, the tabernacle was commissioned in 1484. It was brought from Florence only in 1491, and some years after Botticini's death his son seems to have done more work on it. The many pictures now attributed to him are of unequal quality.

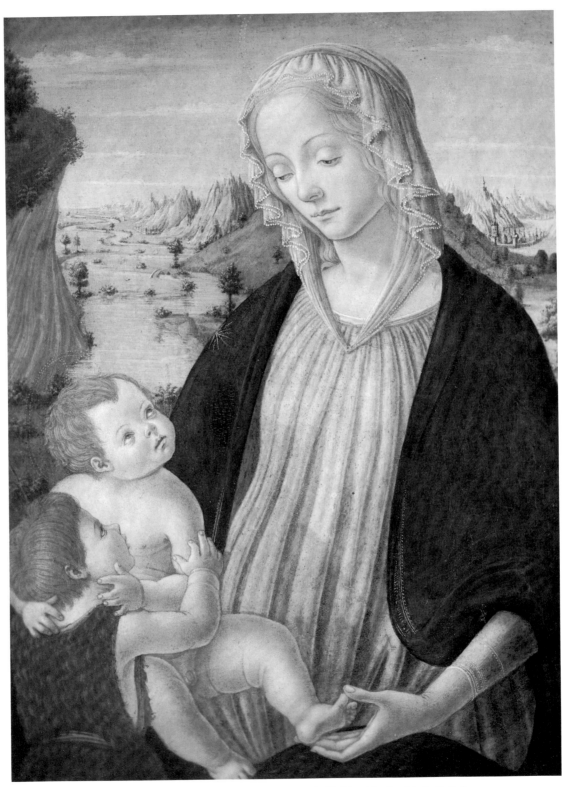

Francesco Botticini — *The Madonna and Child with the Little S. John*

THE MADONNA AND CHILD WITH
THE LITTLE S. JOHN *Raphael Room*

Tempera on wood, 0.720 x 0.540. The blue of the mantle is darkened and much retouched, the crimson of the robe faded. The picture has not been cleaned for a long time, but the general condition seems good.

The style is that of an altarpiece attributed to Botticini in S. Andrea at Brozzi, between Florence and Empoli. This may well have been painted in 1480, like the dated lunette in fresco there.

The picture was bought from Lawrie and Co., London, through Berenson in July-August 1901.

P16w21

AUTHORITIES

Berenson, *Three Essays in Method* (Oxford, 1927), p. 107; "surely a transcript of Botticelli of about 1480"; and *Florentine School* (1963), I, p. 39.

Fredericksen and Zeri, *Census* (1972), p. 34.

Kühnel, *Francesco Botticini* (Strasbourg, 1906), p. 12, No. 16a; he knew the picture only by photograph and included it in his list of Botticini's works with a mark of interrogation.

Version: Cleveland Museum of Art, *Madonna and Child*, measurements virtually identical. The Virgin is evidently painted from the same cartoon, though probably not by Botticini. The rest of the composition is entirely different (Berenson, 1963, *loc. cit.*, attributed it to Botticini. So do Fredericksen and Zeri, *loc. cit*).

François Boucher

Born in Paris 29 September 1703; died there 30 May 1770.

He was the pupil in Paris for a few months of François Le Moyne. His real training was in Italy, where he travelled 1727-31 with the painter Carle van Loo and his nephew Louis-Michel van Loo. He was received at the Académie Royale 30 January 1734 with his *Rénaud et Armide* now in the Louvre. In the same year he became a designer under the painter Jean Baptiste Oudry at the tapestry works at Beauvais. In France the patronage of the crown was organised on a grand scale for the decoration of the royal palaces, and it extended to the control of the Academy and the direction of the manufactories of the various decorative arts. Boucher was fortunate in attracting the attention of the Marquise de Pompadour, the mistress of King Louis XV. He painted several portraits of her. His great *Rising of the Sun* and *Setting of the Sun*, dated 1753, in the Wallace Collection were bought for her by Louis XV and the series of four canvases there was painted for her in 1754. Boucher was her confidant, and his

voluptuous decorations were among the means by which she kept her control of the King. Her brother was Director of Royal Buildings, and they made Boucher Director of the Gobelins tapestry works. The year after the Pompadour's death he was made First Painter to the King; later, Director of the Academy and Inspector of the Beauvais works.

Le Moyne, who influenced his composition, introduced him to the academic tradition, of which he became the leading representative. This continued to draw its themes from Classical mythology and based its design, theoretically at least, upon the figure painting of the Italian High Renaissance. The one Italian artist who influenced Boucher seriously was his contemporary Tiepolo, greatest exponent of the Rococo manner, which was the expression of the age. With his various administrative posts, Boucher must have worked as hard as Tiepolo; but he had little of his witty invention. He studied the figure only in so far as it was necessary for expert decoration. To some extent he took his models from Rubens, whose blond flesh-tints he powdered and whose vigorous outlines he massaged down to suit the atmosphere of drawing-rooms. Oudry and the earlier painters of still life were the first to use the fresh blue-greens and mauve-pinks, set off with white and pale grey, which lightened the whole scheme of decoration. Boucher went furthest. He was the first in France to restore to figure painting a lightness of tone which gave it its most spontaneous expression since the foundation of the Academy.

THE CAR OF VENUS *Little Salon*

Oil on canvas, 0.88 x 0.70.

Boucher is at his least pompous, and so almost at his best, with only the pink and blue that are his happiest colours and only the billowing plumpness of the cupids to try his draughtsmanship. They are scattered among the clouds with the careless movement of the Rococo and painted with all the boudoir delicacy which Boucher had at his command.

The canvas was bought July-August 1902 from Wildenstein in Paris through Mrs. Gardner's agent Robert and R. W. Curtis. The picture by Tiepolo had come from the same sources. *P18w5*

Drawings: Boucher did many drawings of Cupids, and three are known which were used for this picture, whether they were made for it or not. (1) Two cupids on the left, red chalk on paper, 0.28 x 0.255; exhibited 1904, Brussels, *L'Art Français au XVIIIe Siècle*, No. 99; with Wildenstein in 1966; engraved in reverse and published by E. Wattier (Paris, 19th c.), No. 47; Anatoff, *L'Oeuvre dessiné de Boucher*, I (Paris, 1966), No. 847. (2) Of three cupids in a red chalk drawing of the same

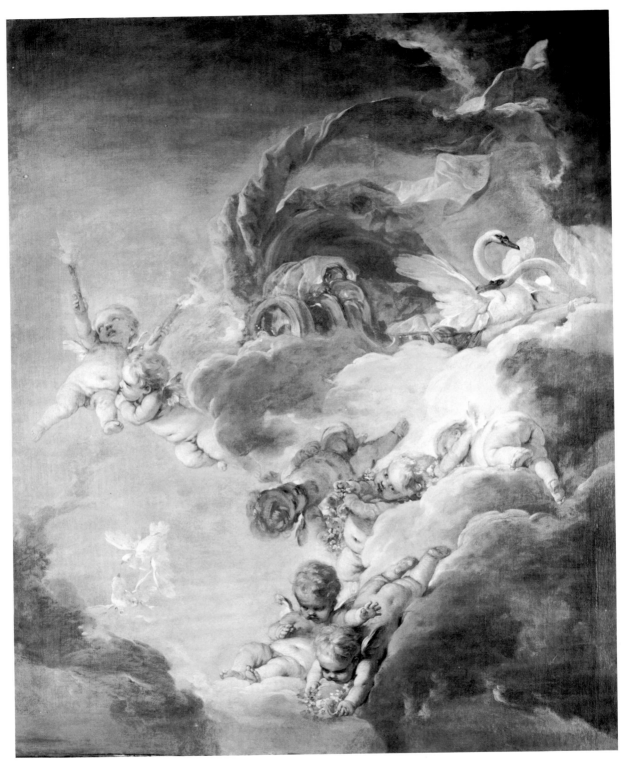

François Boucher — *The Car of Venus*

dimensions and the same provenance as the last (Mal-
fait, Brussels, and Wildenstein, New York) the upper-
most corresponds with the cupid on the right of the
painting; Anatoff, *op. cit.*, No. 848. Exhibited 1904,
Brussels with (1) and 1953, Ringling Museum, Sarasota,
No. 26. (3) Sotheby, London, 10 June 1959, No. 4, *Deux
Amours Jouant*, black chalk heightened with white on
buff paper, 0.222 x 0.310, inscribed; or No. 5, *Amours,*
same media and paper, 0.267 x 0.320, inscribed.

Hercules Brabazon Brabazon

Born in Paris 27 November 1821, younger son of
Hercules Sharpe. He took the surname Brabazon
under the will of his uncle Sir William Brabazon,
Bt., after the baronet's death in 1840. He died at
Oaklands, Battle, Sussex, 14 May 1906.

He studied art in Rome 1844-47, and remained a
keen student of earlier painters all his life. He
travelled constantly in Europe — in France once
with Ruskin — and visited Egypt and India, always
sketching. He remained an amateur, neither exhibit-
ing nor selling his work, until he was seventy, when
he joined the New English Art Club in London.
In 1892 he held his first exhibition at a dealer's
gallery there, at the instance of J. S. Sargent (*q.v.*).
Sargent wrote a foreword to the catalogue. Brabazon
was also an accomplished pianist.

BEAULIEU *Macknight Room*

Water colour and pastel on paper, 0.23 x 0.34.
Signed in pencil (?): *H. B. Brabazon*. Painted pre-
sumably at Beaulieu, Alpes-Maritimes, France, a sea-
side resort much favoured by the Victorians.

Bought by Mrs. Gardner through John Singer
Sargent from the musician William Shakespeare in
London 7 September 1920. *P11s31*

Hercules Brabazon Brabazon — *Beaulieu*

Bronzino

ANGELO DI COSIMO DI MARIANO: born at Monticelli,
near Florence, in 1503; died in Florence 23 Novem-
ber 1572.

His first master was Raffaelino del Garbo; but it
was first as pupil and later as assistant of Pontormo
that Bronzino formed his highly Mannerist style. He
painted a number of large religious and allegorical
panels remarkable for the smooth brilliance of their
execution. As a portraitist he was outstanding. The
Uffizi Gallery in Florence has a series of portraits
of the Medici family, to whom he became virtually
Court Painter.

Style of Bronzino

A LADY IN BLACK AND WHITE *Dutch Room*

Oil on wood, 0.984 x 0.705. The mouth and the tip
of the nose are retouched.

Except for the orange braid embroidered in green
and gold upon the white sleeves and for the strip
of colour revealed where the long black surcoat
parts at the bottom, the dress is entirely of white and
black. This severity comes from Spain. In Sánchez
Coello's portrait in the Titian Room, of *Juana of
Austria, with (?) her Niece Margaret*, the little girl
wears the same sleeves and coiffure, with the long
dress fastened up to the neck by a stiffer ruff.
Bronzino's patroness Eleonora of Toledo, wife of
Duke Cosimo de' Medici of Florence, was a Span-
iard, and it is possible that the portrait represents
her, modelled as it is on portraits of her by Bronzino.
The modelling is too weak, the painting too coarse
to allow an attribution to Bronzino himself, the most
finished and stylish of the great portrait-painters of
the sixteenth century. Of his many imitators, Ales-
sandro Allori (1535-1607), often called "Il Bron-
zino," is the most likely candidate for the author-
ship.

Bought through Berenson as the work of Bronzino
in London August 1898. *P21n19*

AUTHORITIES

Berenson in a letter (4 February 1930) attributed it to
Agnolo Bronzino; also *Florentine School* (1963), I, p. 41.
He considered it a late work.

Emiliani, Andrea, *Il Bronzino* (1960), p. 70; he quotes
Roberto Longhi as having spoken against the attribu-
tion to Bronzino. He indexes the picture (p. 331) as
"Bronzino(?): *Ritratto di una giovinetta di Casa Medici.*"

Fredericksen and Zeri, *Census* (1972), p. 36; they attrib-
ute it to Agnolo Bronzino.

McComb, *Agnolo Bronzino* (Harvard University, 1928),
p. 47; he attributed it to Bronzino.

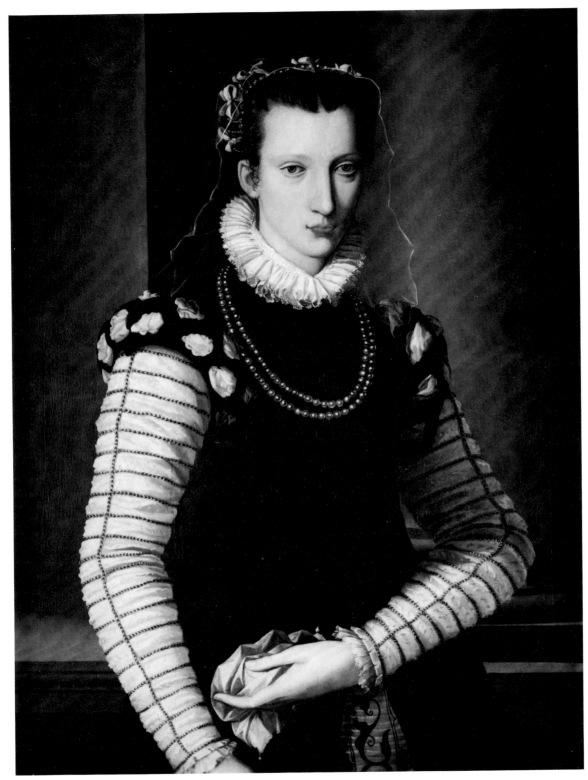

Style of Bronzino — *A Lady in Black and White*

John Appleton Brown

Born at Newburyport, Massachusetts, 1844; died in New York City 1902. He studied in Boston and Paris and, after 1886, worked mainly in New England.

POPPIES IN A GARDEN *Yellow Room*

Crayon on buff paper, 0.553 x 0.457. Signed at the foot on the right: *J Appleton Brown.*

The garden, on the Isles of Shoals, belonged to Celia Thaxter, poetess and amateur painter. There are in the collection two volumes of poems by Celia Thaxter, with her watercolour drawings of flowers.

Mrs. Gardner bought the pastel from Doll and Richards, Boston, 16 December 1891. *P15¹*

Felice Brusasorci
See NEAPOLITAN (?); 1610-50

Bartolommeo Bulgarini

Recorded in Siena at frequent intervals perhaps from 1337, certainly from 1345; died there 4 September 1378.

He painted book covers for the Biccherna, the combined Treasury and Public Works of Siena, and executed a number of more important commissions for the city and its churches. In 1347-50 he was named in Pistoia as one of the best Sienese painters, for a commission eventually executed by the Florentine Taddeo Gaddi. In 1363 he was entered in the *Libro delle Capitudini delle Arti* as *Bartholomeus domini Bolgarini.* Ten years later he painted a picture for S. Maria della Scala, church of the principal hospital in Siena. He had already in 1370 given to this hospital most of his substantial fortune, subject to the life interest of his wife Batalomea and his daughter Meldinuccia. From the deeds we know that they were then living in their own house in the parish of S. Pietro Ovile. He was painting an altarpiece for the hospital church when he died. Bulgarini features in Vasari's *Lives* as Bartolommeo Bologhini, the disciple of Pietro Lorenzetti. Vasari attributed to him an altarpiece then in the chapel of S. Silvestro in S. Croce, Florence, and stated that he painted pictures in various parts of Italy.

No work bears, however, his signature or is certainly authenticated by contemporary documents, and nothing creditable was assigned to him until 1936. Then Millard Meiss identified him as the author of a considerable *oeuvre* which Meiss himself had already done much to clarify and to enlarge.[1] The nucleus, including the Gardner picture, had been brought together by Berenson under the fictitious name of "Ugolino Lorenzetti," which helps to establish the position of the painter in the evolution of the Sienese School.[2] Bulgarini may well indeed have begun as the pupil or assistant of Ugolino di Nerio (active 1317-27) of Siena, for Ugolino painted the high-altarpiece for S. Croce in Florence (the remains are now in London), and Ugolino's influence is evident in a Sienese polyptych with *The Madonna and Saints* which is still in S. Croce. It was rare for a Sienese painter to obtain a commission in Florence. It is probable therefore that this is the altarpiece attributed to Bulgarini by Vasari, and that it is our painter's earliest known work of importance. This is one of the strongest arguments brought by Meiss as evidence for his identification. Another is his attribution to this artist of a Biccherna book-cover painting of 1352-53, a year when Bulgarini was paid for such work. Circumstantial evidence lies in Bulgarini's connection with S. Maria della Scala, which owned three works by this artist now in the Siena Pinacoteca, and with S. Pietro Ovile, which has a *Madonna Enthroned, with Four Angels,* perhaps the most majestic of the whole group of works. A nucleus of it was at one time ascribed to the "Ovile Master."[3]

Bulgarini therefore may be accepted with very little hesitation as the painter of a large group of

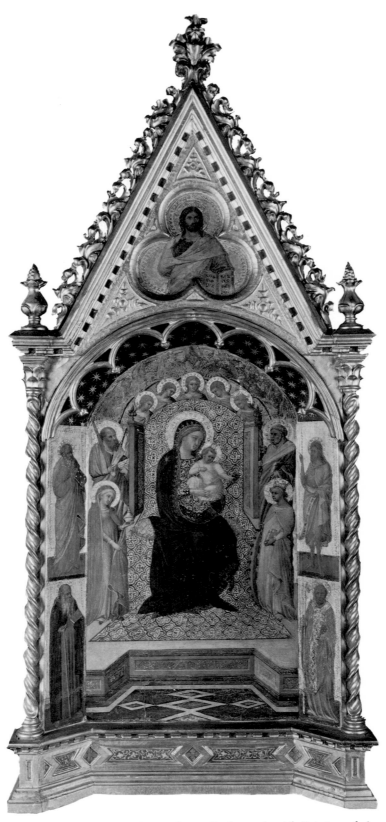

Bartolommeo Bulgarini — *The Madonna Enthroned, with Saints and Angels*

pictures mostly now dispersed through several countries. A triptych with the *Madonna and Saints*, of which the centrepiece is still in the parish church of Fogliano, the wings now in Siena, shows the mixture of influences. Another, now divided between Lucca and Washington, D.C., becomes still more imposing through the reflected power of Pietro Lorenzetti. Three large panels in S. Bartolommeo at Sestano, where Bulgarini owned land, near Siena, with *S. Peter Enthroned*, between *S. Paul* and *S. John Evangelist*, form a triptych as majestic as the *Ovile Madonna*. There is no evidence that Bulgarini painted in fresco. While he accepted the modifications of type and style introduced by Pietro Lorenzetti, he did not inherit Pietro's passionate quest for new forms and freedoms of expression. He was usually content to carry on the grandiose hieratic tradition of Duccio, with its sophisticated grace. After Simone Martini (*q.v.*) and the Lorenzetti had ceased to paint, he must be reckoned its chief representative for a generation. His large *Nativity* in the Fogg Art Museum is therefore a somewhat unusual picture; but it well illustrates Meiss' description of Bulgarini's world: one of "graceful and unimpassioned romanticism. His shy Virgins and Saints . . . are preoccupied with a reverie in which the life lived in reminiscence is too long past to be poignant. . . . Their composure does not proceed from confidence in their command of experience, but is the result of complete withdrawal from it."

THE MADONNA ENTHRONED, WITH SAINTS AND ANGELS *Early Italian Room*

Tabernacle: *The Virgin with the Child Holding a Bird, with SS. Lucy (?), Paul, Peter and Catherine, and with Five Angels.* On the reveals of the arch are *SS. Anthony Abbot, John Evangelist, John Baptist and Nicholas (?)*. Above, in a fragment of the original frame, *The Redeemer* appears in a trefoil.

Gold and tempera on wood, round-arched. The flat measures 0.60 x 0.40; the whole, excluding the tympanum, 0.65 x 0.46. The starred roof is repainted; the winged heads of Cherubim between this and the Angels are almost obliterated; but the main features of the painting are not seriously damaged. The Redeemer's book is inscribed: *EGO SVM LVX MVNDI Q VIC RED (?) . . .*; the scroll of S. John Baptist: *ECCE · AGNVS · DEI · EC.* Beneath the two SS. John are their names in abbreviated Latin.

The tabernacle is painted with the rather turbid pigments characteristic of the painter's mature works. The peculiar milky blue of the throne and steps, repeated in the robes of S. Lucy (?) and the Angels, and the contrasting orange of the hair and complexions, intensified in the tunic and yellow shirt of the Child, make a scheme of colour to be found equally in the large *Nativity* of the Fogg Art Museum, a picture important in itself and as the painter's only known scene on a significant scale. These two pictures also share the same pensive, moody expression.

The tabernacle was bought in Italy about 1873 by Samuel Gray Ward. His widow gave it to Mrs. C. B. Perkins, daughter-in-law of Charles Callahan Perkins, the author of books on Italian sculpture. From her it was bought by Mrs. Gardner 27 July 1911. *P15n8*

[1]Meiss in *Art Bulletin*, XIII (1931), pp. 376-97; and in *Rivista d'Arte*, XVIII (1936), pp. 113-36.

[2]Berenson in *Art in America* (1917), pp. 259-75 and (1918), pp. 25-52; he included the Gardner tabernacle among the artist's works from the first.

[3]Dewald in *Art Studies*, I (1923), pp. 45 ff.

OTHER AUTHORITY

Fredericksen and Zeri, *Census* (1972), p. 133; they attribute it to the "Master of the Ovile Madonna."

Exhibited 1910, Cambridge, Mass., Fogg Art Museum.

Denis Miller Bunker

Born DENNIS MILLER BUNKER in New York City 1861; died in Boston 1890.

He studied first in New York at the National Academy of Design, then in Paris at Julian's, under Hébert and Gérôme. He came to Boston in 1885, to manage the painting and drawing classes at the new Cowles Art School. In 1887-88 he painted portraits of the Gardners and other leading Boston families. In the year of his death he had married and moved back to New York.

MARBLE TORSO OF A WOMAN *Blue Room*

Oil on canvas, 0.43 x 0.27.

Probably a very early study mentioned by Gammell,[1] which may have been painted at the National Academy of Design, New York. *P3n5*

[1]Gammell, *Dennis Miller Bunker* (New York, 1953), p. 4: "an oil study preserved in the Isabella Stewart Gardner Museum might well have been painted when he was not more than seventeen."

CHRYSANTHEMUMS *Blue Room*

Oil on canvas, 0.90 x 1.21. Inscribed near the foot on the right: *DENIS BUNKER / 1888*.

Marble Torso of a Woman

Chrysanthemums

Moonrise

The Brook at Medfield

Mrs. Gardner wrote a cheque for this picture 28 May 1889; but it was perhaps this cheque which was returned in an undated letter from the painter, begging her to accept as a gift "a very poor sketch of your favorite flower." *P3w5*

THE BROOK AT MEDFIELD *Blue Room*

Oil on canvas, 0.62 x 0.76. Inscribed at the foot on the left: *D.M. BUNKER / 1889.* *P3s19*

AUTHORITY

Gammell, *op. cit.*, p. 68.

MOONRISE *Macknight Room*

Pastel on rough paper, 0.36 x 0.55.
 Bought by Mrs. Gardner at the St. Botolph Club exhibition 7 February 1891. *P11n14*

Exhibited 1891, Boston, St. Botolph Club, No. 50.

Bartolommeo Caporali

See GIOVANNI da Rovezzano, studio of

Vittore Carpaccio

See Hadley, *Drawings* (Isabella Stewart Gardner Museum, 1968), pp. 3-5.

Catalan (?); 1400-1500

See LIGURIAN; 1450-1500

Vincenzo Catena

He was probably active from about 1500; but the earliest document concerning him is the abbreviated inscription on the back of the panel of Giorgione's *Laura* in Vienna, which may be expansively translated: "1 June 1506 this was painted by the hand of master Giorgione of Castelfranco, colleague of master Vincenzo Catena, at the instance of master Giacomo." Catena died in Venice in September 1531.

Most of our information is due to frequent wills and codicils — five between 1515 and 1531 — his preoccupation with these suggesting precarious health and substantial wealth. We learn that his father was Biagio; that he had two brothers, and also step-brothers and step-sisters; that he lived in his own house in S. Bartolommeo di Rialto in Venice with Domenica Furlana, the daughter of a furrier at Udine. The residuary legatee was the Guild of Painters, who were able in 1532 to erect a guild hall out of his bequest.

There is no date on any of his pictures, but 1520 is inscribed on the frame of *The Glorification of S. Christina,* in S. Maria Mater Domini in Venice. This is a mature painting; but his previous development may be followed in a succession of signed pictures. The earliest is probably a *Madonna and Child with Saints* now in the Walters Art Gallery at Baltimore. Another, now in the Correr Museum, Venice, containing the portrait of Doge Leonardo Loredano, seems to have been painted after 1505, to judge by its apparent derivation from a picture by Giovanni Bellini bearing that date.

This dependence upon Bellini (*q.v.*) characterises Catena's work until almost the end. Though he seems to have moved in humanist circles and evidently had some professional relationship to Giorgione, he did not venture far in the fields of vision or expression. He adopted the current method of composition and the types and attitudes of other painters with a hesitancy which almost makes him conspicuous when Giorgione and Titian and Palma Vecchio, scarcely younger men perhaps, were advancing so boldly on life.

Vasari distinguished him for his portraits, of which there is undoubtedly a series, beginning perhaps with the *Young Man in Black* in London. Two of these represent identifiable sitters: *Giangiorgio Trissino* in Paris and *Doge Andrea Gritti* in London. Only the *Portrait of a Canon* (?) in Vienna bears Catena's signature.

THE DELIVERY OF THE KEYS TO S. PETER
Titian Room

Oil on canvas, 0.829 x 1.353, reduced on all sides. There are tears in the upper right and lower left corners. Cleaning in 1947-48 showed that the left hand of the left-hand figure had been destroyed, that the head of S. Peter was much damaged and retouched and that the paint elsewhere was considerably worn. It also revealed a probable superiority to the version in Madrid, which has no sky but a background of cold grey.

Faith, Hope and Charity witness the delivery to S. Peter of the keys of Heaven. For the most part Catena avoided the pagan subjects of the modern Venetian painters like Giorgione, Titian and Palma Vecchio, but these three blond ladies bring into a subject perhaps intended as a compliment to the See of Rome, or as a reminder of its claims, something of the ripe and tranquil opulence of contemporary Venice. He was probably influenced in painting them by Palma Vecchio's famous *Three Sisters* now at Dresden, which was mentioned already in 1525 and could have been painted ten years earlier. Especially

Vincenzo Catena — *The Delivery of the Keys to S. Peter*

the woman on the right resembles Palma's type and wears her hair in the same way. Catena was never happier than in the creation of this group. The braiding of the hair and the embroidery across the bosom of the woman on the right are indicated with delicate Titianesque touches which belong to the last phase of his painting. The width of the canvas is characteristic of his decorative intention.

The Delivery of the Keys to S. Peter was in the collection of the Marquis of Exeter at Burleigh House by 1871. At his sale in London, 9 June 1888 (Christie's, No. 307; the chalk marks are on the back) it was bought by Dr. J. P. Richter. From him it was bought through Berenson 27 April 1895. The *Sacra Conversazione* by Bonifazio and the pictures by Bordone and Giotto also came from his collection.

P26e17

AUTHORITIES

Berenson, *Dipinti Veneziani in America* (Milan, 1919), pp. 234-36; he dated it about 1521, the Madrid version about 1517, suggesting that perhaps Palma took the figures of his *Three Sisters* from Catena, that perhaps a lost picture by Giorgione served as model or inspiration to both; also *Venetian School* (1957), I, p. 61 (wrongly described).

Borenius in *Crowe and Cavalcaselle's History of Painting in North Italy*, I (London, 1912), p. 262, note, No. 4.

Crowe and Cavalcaselle, *A History of Painting in North Italy* (ed. Borenius, London, 1912), I, p. 188, note, mentioned it in a list of "nameless Bellinesques."

Fredericksen and Zeri, *Census* (1972), p. 49.

Robertson, *Vincenzo Catena* (Edinburgh, 1954), pp. 29, 35 and 65-66: "another case of an authentic replica by Catena himself"; he also considers the Prado picture an earlier original.

Exhibited 1894, London, Old Masters, No. 151 (label on back).

Versions: (1) Madrid, Prado Museum, No. 20, panel, 0.86 x 1.35, considered by Crowe and Cavalcaselle, *loc. cit.*, a copy of the Fenway Court picture; by Berenson, *loc. cit.*, the earlier version by Catena; and by Borenius, *loc. cit.*, an original by Catena. The colours are different and there are slight variations in the draperies. The background is cold grey. The surface is much rubbed. (2) England, Anthony, a dealer, a "smaller repetition" mentioned by Crowe and Cavalcaselle, *loc. cit.*

Antonio Cicognara

Recorded 1480-1500.

The date is 1480 on his elementary signed *Madonna and Child in a Niche* now at Ferrara. Its provenance is unknown, but Cicognara is believed to have assisted in the execution of some of the frescoes

painted for Duke Borso d'Este in the Palazzo Schifanoia in Ferrara. These were begun by Francesco Cossa in 1470, but largely executed by other artists over a period of time. All certain records of Cicognara are from Cremona. In 1482 he was illuminating choir books for the cathedral there, and in the Pinacoteca is an antiphonary from the cathedral signed and dated 1483. He was associated with Bonifacio Bembo of Cremona in the production for the Milanese court of a famous set of playing cards of which the remains are now divided between the Accademia Carrara at Bergamo and the Pierpont Morgan Library, New York. From S. Elena at Cremona comes an altarpiece with figures in almost life-size, *The Madonna and Child, with SS. Justine and Catherine*, signed and dated 1490. His one outstanding picture, this was formerly in the Speroni (1930) and (later) Cologna collections in Milan. Cicognara was last recorded 22 August 1500, valuing frescoes by Bergognone at Lodi, between Cremona and Milan.

Though Cremona is at no distance from Milan, the influences which formed his art — or as much of it as can be recognised today — come from the Ferrarese painters Cossa and Tura (*q.v.*).

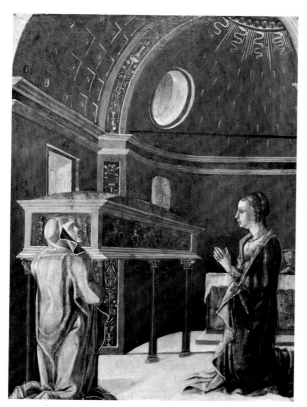

Antonio Cicognara — *A Prayer before a Tomb*

A PRAYER BEFORE A TOMB *Early Italian Room*

Tempera on wood, 0.434 x 0.321. A little piece in the centre of the tomb is restored, and the mantle of the woman on the right has lost its colour.

The subject has recently been identified as S. Lucy with her mother before the tomb of S. Agatha.[1] S. Lucy there had a vision of S. Agatha. When she awoke from her trance, she found her ailing mother, Eutychia, healed.

The fresh contrast of colours is characteristic of Cicognara's signed altarpiece of 1490. So are the free brushwork, the hang of the draperies and the angular line which marks their hem. In the altarpiece the hem-line is actually raised in relief.

Bought as *Laura and Petrarca*, attributed to the school of Padua, 28 September 1897 from Guggenheim at Venice. *P1554*

[1]Fredericksen and Zeri, *Census* (1972), p. 52.

OTHER AUTHORITIES

Berenson in a letter (4 February 1930) attributed it to Leonardo Scaletti.

Clark, K. (September 1928), from a photograph, was the first to attribute it to Cicognara.

Salmi (May 1929), from a photograph.

Cima

GIOVANNI BATTISTA CIMA (for CIMATORE, cloth-dresser, the profession of his father) DA CONEGLIANO, near Treviso: born not later than 1460; buried at Conegliano 1517-18.

Among the taxpayers of Conegliano between 1 March 1473 and 1 March 1474, he was still on the list in 1489. In 1493 he painted the altarpiece with *The Madonna and Child with Saints* in the duomo, his only picture now at Conegliano. His early work is influenced by Bartolommeo Montagna of Vicenza, and his first signed picture, a handsome altarpiece dated 1489, now in the Pinacoteca at Vicenza, came from S. Bartolommeo there. Already in Venice by December 1492, in 1494 he painted *The Baptism of Christ* in S. Giovanni in Bragora there. He now modelled himself closely upon Giovanni Bellini. Many of his pictures are in Venice, but he also painted many for the mainland: *The Madonna and Child*, signed and dated 1496, in S. Maria delle Grazie at Gemona, Udine; *The Incredulity of S. Thomas* now in London, finished in 1504 for S. Francesco at Portogruaro; the polyptych ordered in 1513 in S. Anna at Cape d'Istria on the Dalmatian coast.

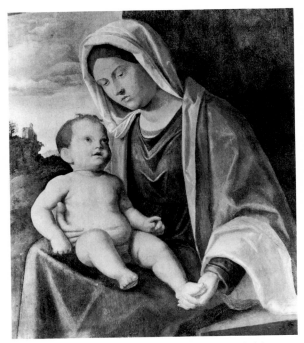

After Cima — *The Madonna and Child*

After Cima

THE MADONNA AND CHILD *Raphael Room*

Oil on panel, 0.537 x 0.455, considerably deteriorated and thinly retouched throughout.

This is a contemporary copy of Cima's signed picture at Lockinge House, Wantage, England. It is simplified in composition by the green curtain which shuts off the greater part of a delicate landscape and in the play of the draperies, though in the original the Madonna's blue cloak does not show a yellow lining where it is turned back down the front and over the wrist. The copy is coarsely done: the expression of the heads is ruder, the forms heavier and less surely drawn; the pure colours of a limpid technique are changed to a dull opacity.

Acquired by the Milanese merchant Giuseppe Baslini, it was sold with his collection at Milan in 1888 (26 November, No. 14) as the work of Cima. It was then bought about 1895 of Grandi at Milan by Artaria of Vienna, and sold by him through Berenson to Herbert Cook of Richmond, Surrey. Bought by Mrs. Gardner April-May 1897 through Berenson from Colnaghi of London as the work of Cima. *P16w1*

AUTHORITIES

Berenson, *Dipinti Veneziani in America* (Milan, 1919), p. 191, described it as a replica, two or three years later than the Lockinge House picture, by Cima's own hand. He mentioned a version by "a timid pupil" from the Pfungst collection, London, probably that with Dowdeswell, below; also *Venetian School* (1957), I, p. 64. Here it is listed as by Cima without comment.

Fredericksen and Zeri, *Census* (1972), p. 53; they consider it autograph.

Venturi, L., *Pitture Italiane in America* (Milan, 1931), Pl. CCCXII, considered it autograph, but later than the Lockinge House picture, about 1510.

Versions: (1) Lockinge House, nr. Wantage, Christopher Loyd, Esq., the original, panel, 0.585 x 0.407, signed *Joannis baptista* (or *e*) *Coneglanensis;* a marble sill along the bottom, no curtain, a different landscape extending across the back with a horseman to the right, the Madonna's costume more elaborate and her cloak monochrome blue; collections: Minghetti (Bologna), Prince Gérôme Bonaparte (Palais-Royal), Albert Levy, Lady Wantage (1902 catalogue, No. 42). (2) London, Messrs. Dowdeswell (formerly); midway between Lockinge House and Gardner pictures in quality; a marble sill, a different landscape extending across the back; the Madonna's cloak lined with another colour as in the Gardner picture; probably by an assistant in the studio; perhaps from the Pfungst collection.

Alonso Sánchez Coello

See SANCHEZ Coello

Francesc Comes

Active in Valencia before 1380; in Palma, Majorca 1388-95.

He was already a master in 1380, in the city of Valencia. A document of 13 August that year records the contract of apprenticeship to him of a young Catalan, Guillelmi Rubiols. A complex retable in the Church of the Blood at Liria in Valencia province contains a panel recently attributed to him with *The Virgin and Child, with Angels, in a Rose Garden.* From 1388 a number of documents refer to his activity as a painter in Majorca, and a *Salvator Mundi* in S. Eulalia in Palma has recently been found to bear his signature. This is his only signed work. A *S. George and the Dragon* formerly in S. Francisco at Inca in Majorca is now in the custody of the Sociedad Arqueologica Luliana in Palma. In 1395 he was recorded as painting an altarpiece with *S. Anthony,* now lost, for the church at Valldemosa in Majorca. In the same year he was paid for two imaginary portraits of the English King Richard II and the "Duke of England" — perhaps the Duke of Lancaster, John of Gaunt, who had been in Spain a few years before. These were to be presented to King Juan I of Aragon, to which kingdom Majorca belonged. We hear no more of Comes after this year.

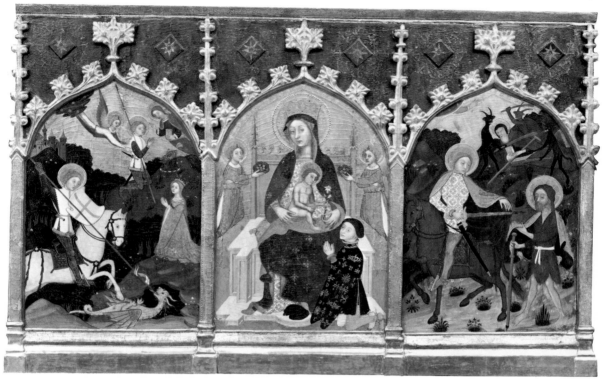

Francesc Comes — *The Virgin and Child, S. George and S. Martin*

His painting, in the Spanish version of the International Gothic style, was influenced by that of the Catalan brothers Jaime and Pedro Serra.

THE VIRGIN AND CHILD, S. GEORGE AND S. MARTIN
Raphael Room

Triptych, 0.751 x 1.145-65, egg tempera on larch wood. In the centre *The Madonna with the Child Blessing a Knight of S. George*; on the left *S. George and the Dragon*; on the right *S. Martin Dividing his Cloak, and The Flagellation of S. Anthony*. In the original frame, carved and heavily regilt.

S. George's colours of red and white carry the day. His princess is dressed in scarlet, and he on his white horse wears a white tunic and holds a white shield, each emblazoned with his red cross. In the background he is presented to Christ by an Angel — a very unusual piece of iconography. S. Martin in deference wears a white tunic and a scarlet cloak, and the ground beneath their horses' feet has sent up white and scarlet flowers. Behind, S. Anthony is tormented by demons. In the centre panel the donor kneeling to the enthroned Virgin has one white stocking and one red. His black doublet is sown with golden Gothic letters, possibly to be read:

n (?)-e-t-d-a-d-e-r-e, and with a device which may be a section of the crown of thorns pierced by the letter *I* (or *F* or *L*; it is repeated on the frame to encircle each of the six diamond-shaped lozenges containing a star). Another crown, of which a section is embroidered in gold twice or thrice, and once upon a larger scale, is probably[1] the double crown of Aragon, first adopted 1392-93 by King Juan I (d. 1397), and borne by his brother and nephew King Martin (d. 1410) and Martin the younger of Sicily (d. 1410). Upon the breast is a plain red cross, the badge probably of the Augustinian Order of S. George of Alfama, founded by King Peter II of Aragon, who bestowed upon it the castle of Alfama near Tortosa in Catalonia. The Catalan character of the painting and the colours of S. George suggest that the cross is that of the Knights of S. George rather than that of the Knights of Our Lady of Montesa (in Valencia), who bore the same badge. The two orders were united after 1400.

The little altarpiece, with its lively movement, its blue-eyed, orange-haired beauties, its dark woods and its flower-strewn hill topped by a turreted castle, expresses the chivalry professed by the nobility of the middle ages. It is painted in the Gothic style which in the fourteenth and early fifteenth centuries

took a local form in every country of Europe. In Spain this was influenced both by a German painter who settled in Valencia and by Italian Gothic painting, which had its centre in Siena.

The triptych was attributed in the 1931 Catalogue to the studio of the Catalan brothers Jaime and Pedro Serra. In 1951 Chandler Post attributed it to the painter whose work he was the first to bring together under the pseudonym of the "Inca Master."[2] This painter, whom Post described as dependent on Jaime Serra, has recently been identified as Francesc Comes.[3]

By his reading of the lettering on the donor's sleeves as net de re [i] d [']a [rago], "grandson of the king of Aragon," and because of the aptness to the history of Fadrich d'Arago of the themes represented in the wings, Van de Put identified the donor as this prince, bastard son of Martin II, King of Sicily, grandson and favourite of Martin I. In 1959 Dr. Martin de Riquer, of Barcelona University, tentatively suggested that he was rather King Juan I of Aragon. He cited a description of the king by his secretary, Bernat Metge: "a man of middle stature, with a reverend face, dressed in red velvet strewn with golden double crowns, with a red velvet cap on his head." Perhaps King Juan preferred a black dress when kneeling before the Virgin.[4]

Formerly in the collection of Emile Gavet in Paris, this triptych was bought 27 February 1901 from Durand-Ruel of New York as a painting of the North Italian School. P16e16

[1]Van de Put, in a letter (21 January 1930) described this as the only instance known to him of the figuration of the double crown in Spanish painting; also in *Art in America*, XX, 2 (1932), pp. 51-59.

[2]Post in a letter to the Director, 15 March 1951.

[3]Sobré, Judith Berg, in *Fenway Court*, III, 2 (December 1969), pp. 9-16.

[4]Riquer in a letter to the Director of 11 April 1959; and in *Bernat Metge, obras completas* (Barcelona 1955), pp. 166-67.

OTHER AUTHORITIES

Canton, S. (at Fenway Court, 10 December 1930) attributed it to a Valencian painter.

Post, *History of Spanish Painting* (Harvard University, 1930), II, pp. 312-14; he was then doubtful of the triptych's Spanish origin.

Corneille de Lyon

Born in The Hague, but living at Lyons, France, at least by 1536. The name implies that he had lived there long enough to be identified with the town, but also perhaps that he had left it. Indeed by 1541 he was at court, described as Painter to the Dauphin, the future King Henri II. Henri succeeded in 1547, and Corneille became Painter to the King. The same year he was naturalised a Frenchman. Brantôme in his *Vie des Dames illustres* gives a contemporary description of his portraits of the Queen Mother Catherine de Médicis and her family; but none of these is identified today. No attribution goes back further than the latter part of the seventeenth century, when Roger de Gaignières accepted as his a number of portraits bought at Lyons. All the pictures attributed to him are portraits on the small scale of the picture below. He is represented at his best in the Boston Museum of Fine Arts.

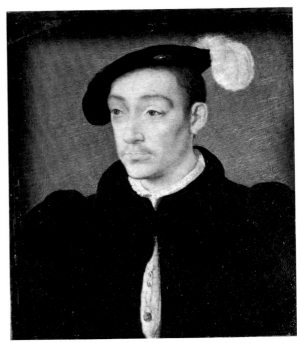

After Corneille de Lyon — *The Dauphin François*

After Corneille

THE DAUPHIN FRANÇOIS *Dutch Room*

Oil on panel, 0.15 x 0.13.

The Dauphin's black dress, touched with pale blue, is relieved against an emerald ground characteristic of Corneille's portraits.

François (1517-36), eldest son of King François I and his first wife Claude de France, was heir to the throne of France, and was crowned Duke of Brittany in 1532. He is said to have resembled his maternal grandfather King Louis XII. His premature death at Valence was doubtless due to sickly health,

Corot — *Noonday*

though it was later attributed to the hated Catherine de Médicis, wife of his younger brother Henri, who took his place on the throne.

The panel must have been painted about 1536, for the Dauphin does not look less than nineteen years old. An original of this panel by Corneille himself is probably still to be found, for neither this nor any of the three versions listed below is well enough painted to be his own work. However, Louis Dimier identified the version now at Chantilly with a portrait owned by Gaignières and attributed by him to Corneille in the later seventeenth century.[1]

Bought by Mrs. Gardner 22 May 1895 through Berenson from the Bonomi-Cereda collection in Milan as the work of Clouet. The Museum's copy after Mabuse came from the same collection, formed by Luigi Bonomi of Milan in the early nineteenth century. *P21s23*

[1]Dimier, *La Peinture de Portrait en France au XVIème siècle*, II (Paris and Brussels, 1925). See below.

Versions: (1) Chantilly, Musée Condé, No. 244, wood, 0.17 x 0.15. Dimier, *op. cit.*, No. 251; he described it as of Corneille's workshop and entirely repainted. (2) Philadelphia, J. G. Johnson Collection, No. 771, wood, 0.18 x 0.152, from the Magniac collection. (3) Paris, Louvre, No. 1000 (Sauvageot collection), wood, circular, 0.17, engraved in Reverdi, *Promptuaire des Médailles*, fol. 242. Dimier, *loc. cit.*, No. 252.

Corot

JEAN-BAPTISTE-CAMILLE COROT: born in Paris 1796; died there 1875.

His parents kept a successful millinery shop in Paris, and he began his career with several years as assistant to a draper. Given financial independence in 1822, he became the pupil of Michallon and, on Michallon's sudden death, of Victor Bertin, 1823-25. He acknowledged, however, as his teacher only Caruelle d'Aligny, whom he met in Rome. He had gone there in the fall of 1825, and remained in Italy, roaming the south, until 1828. He returned to

Italy in 1834-35 and in 1843-44. He paid many visits to Switzerland, and often disappeared on long excursions in his own country. Between these he normally spent the winter in Paris, the summer in the suburb of Ville d'Avray, where his parents had a villa. A bachelor, he shared this with his sister after their death. At intervals from 1835 he stayed near Fontainebleau, becoming associated with the Barbizon School. Though they met elsewhere, he became the intimate friend of Daubigny.

He went to Rome so that the scenes of his first landscapes might be hallowed by two centuries of academicians. Many of them he designed upon the classic model of Claude, ignoring local colour and the wide spectrum of full day, always intent on adjusting the masses of dark and light and on refining harmonies of tone. While Delacroix was proclaiming that the enemy of painting was grey, Corot was mixing all his few quiet colors with white. He had neither the theoretical science of colours nor the actual excitement of the senses which were shared by the rising young Impressionists. He was passionate only in opposing their revolution. Yet his quiet transformation of landscape art was no less significant. The Englishman Constable was twenty years before him in his observation of the sky and of the effects which its mutations had upon the earth. He was a passionately objective observer. The Frenchman Corot was more observant in the discovery of tonal harmonies, more sensuously plastic in his architectonic constructions. He gave to classical landscape a re-birth, injecting a new variety into its composition, discovering within its traditional scale of colours harmonies which are sometimes no less deeply moving than those of the succeeding school.

NOONDAY *Blue Room*

Oil on canvas, 0.409 x 0.540. Signed at the foot on the right: *COROT*. When the picture was relined and cleaned in 1945 a large complex tear in the sky to the right of the square tower was discovered and retouched. It had been made before the original lining.

The heavy clouds of a northern sky hang over low country, reflected in the water. Their thick white predominates, overwhelming all local colour but the red blouse of one of the standing girls.

Though the picture is not distinguished and is not listed in Alfred Robaut's *L'Oeuvre de Corot* (1905) or in either volume of the *Supplement* by A. Schoeller and J. Diéterle (1948 and 1956), it seems to be an authentic work of Corot's later period.

Canvas and stretcher both have the stamp of the Paris dealer Goupil, as well as another stamp: *Diot*.

The picture was bought by Mrs. Gardner from Doll and Richards, Boston, 15 April 1880. *P3e3*

Exhibited 26 April 1880 — 3 June 1881, Boston, Museum of Fine Arts.

Correggio
See RAPHAEL, derived from

Gustave Courbet

JEAN-DÉSIRÉ-GUSTAVE COURBET: born at Ornans, Franche-Comté, 10 June 1819; died at La Tour-de-Peilz, near Vevey, Switzerland, 31 December 1877.

He went to Paris in 1840 to study law according to his father's wish; but he had already studied painting at Besançon, and was soon entirely devoted to it. He worked with Bonvin in the studio of Desprez. He copied Géricault and Delacroix, whose romanticism he was soon to decry. Above all he frequented the Louvre, making free versions of pictures by the Old Masters, mainly of the Dutch school. In 1843 he took a studio of his own, and in 1844 the Salon accepted his *Courbet au Chien Noir*, painted at Ornans in 1842. It is now in the Petit-Palais, Paris. *After Dinner at Ornans* was bought at the Salon of 1849 by the state. It is now at Lille. His pictures had found their first admirers in the north, and the Mesdag Museum in The Hague contains some of the first that he sold. He visited Holland in 1847 and in 1854 Belgium, where he had been invited to exhibit in 1851. There was a natural response there to his Burgundian enjoyment of the glut of life, and this was welcomed as readily in Germany. In 1860 he spent six months at Frankfurt, hunting as well as painting such pictures as the *Fighting Stags* in the Louvre. When he exhibited at Munich, in 1869, he had already been decorated and given the title of Baron by the Bavarian king. Not that he was inconspicuous in France. Here a storm had gathered round his work, raised partly by its robust realism and partly by the stentorian voice with which he denounced Classicism and Romanticism in art and the revival of Napoleonic ideas in politics. At the Paris World Exposition of 1855, when his great picture *The Artist's Studio*, now in the Louvre, and two others had been rejected by the jury, he set up a pavilion of his own. In 1861 he found himself placed at the head of a large body of rebels from the Ecole des Beaux-Arts. He loved rebellion, and reconciled it with his new post of teacher by teaching independence. In 1870 he refused the Riband of the Legion of Honour with a reasoned but truculent denunciation of monarchy and an oath to die free, above all, of any régime but

Gustave Courbet — *A View across the River*

that of liberty. Later in the year, he was elected in a free assembly President of the new Federation of Artists. The suppression of the Commune of 1871 led to his arrest by the army from Versailles and six months in a Paris prison. He fled the country in 1873, and passed his last years at La Tour-de-Peilz in Switzerland.

He had lived enormously, at the table, in bed and in the hunting field, and his painting was upon the same intrepid scale. His pavilion in 1855 was called *Le Pavillon du Réalisme*, and in the manifesto which accompanied it he called for pure perception, without thought or emotion. From the first, he had painted everyday scenes from the ample Franche-Comté life. In *The Artist's Studio* in the Louvre, of 1855, or the *Burial at Ornans* there, of the same year, his canvases reach vast dimensions. He put heart into the younger painters by the boldness of his warm and genial sentiments and of the rich pigments which he laid on, often with his knife. There was a fundamental value in his freedom from style, in the sincerity of his sensualism. These, incidentally, opened the way for Manet and Degas, for Renoir and the Impressionists.

A VIEW ACROSS THE RIVER Blue Room

Oil on canvas, 0.46 x 0.56. Signed in red at the foot on the left: *G. Courbet.*

From the rising foreground two ladies look across the water to a village which fills the gap between white cliffs. The village belongs, no doubt, to Courbet's native valley of the Loue: his birthplace itself is dominated by such a cliff. The scene has the weight of atmosphere and the width of view which belong to his conceptions, the sky clear and coldly luminous, but the foreground laid with the knife in heavy masses of dull green and the dark water almost without reflection. The painting is probably unfinished. *P3w16*

Exhibited 26 April 1880 — 3 June 1881, Boston, Museum of Fine Arts, lent by Mrs. Gardner.

Lucas Cranach

Born at Kronach in upper Franconia 1472; died at Weimar 16 October 1553. Pupil of his father. He worked in Vienna 1500-03. In 1505 he became Court Painter to Frederick III of Saxony, the protector of Luther. He spent most of his life at Wittemberg, where he was Burgomaster from about 1537 to about 1544. In 1550 he went to the imperial court at Augsburg, where his master was the prisoner of Charles V; and in 1552 he moved with him to Wei-

mar. He painted many portraits, altarpieces and mythological subjects. The large workshop which he maintained for the multiplication of his pictures included two sons.

Influenced by Cranach

ADAM AND EVE Gothic Room

Oil on oak, 1.484 x 0.979.

It is the moment of temptation. Adam holds one apple to his thigh and with his right hand takes another from Eve. In the distance to the left they reappear in miniature, Adam holding up a garment in shame before the Almighty. Behind them the terrestrial Paradise unfolds itself, the creatures browsing on the banks of its winding river.

It is the character of this landscape that distinguishes the panel most easily from Cranach's work. The conception is not at all his, but moulded on that of the early Netherlandish painter Joachim Patinir (died about 1524), who set his Biblical stories in the foreground of a wide panorama such as this, with blue-green distances and a sky patterned with flat, sharp-edged clouds. The figures however show a careful study of Cranach's and a technique learnt perhaps in his studio. He painted a number of groups with Adam and Eve; but these two figures most resemble those on separate panels in the Uffizi at Florence. A comparison shows that this imitator was some way from realising Cranach's subtlety. The black lines which mark the contours and touch the hair and eyelashes are less deft and life-giving; the skin, with its archaic contrast of male tan and female ivory, is tougher and less voluptuous; the whole realisation of form is less complete and expressive. Cleaning in 1952 yielded no evidence that figures and landscape were by different hands. Between the two the paint overlaps in different ways, in different places.

The panel is said to have belonged to an old man of illustrious family at Venice, and was recommended to Mrs. Gardner by Prince Friedrich Hohenlohe through Mrs. Katherine de Kay Bronson. She bought it from Antonio Carrer, Venice, 15 November 1892 as the work of Cranach. *P30n4*

AUTHORITIES

Friedländer (from a photograph, 14 August 1928) considered that the figures might be by Cranach, and suggested that the landscape might be by Cornelis Massa.

Goldschmidt (at Fenway Court, April 1928) attributed the landscape to Jan de Cock.

Pauli, Gustav (at Fenway Court, 7-9 March 1935) thought the figures by Cranach, 1530-40, the landscape painted 50-60 years later.

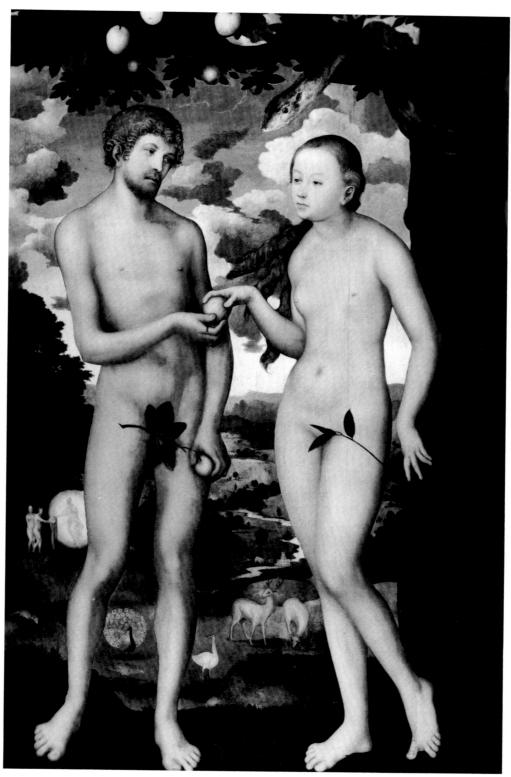

Influenced by Cranach — *Adam and Eve*

Lorenzo di Credi

Born in Florence about 1448; died there 12 January 1537. He was the son of Andrea di Credi, a goldsmith, and his wife Lisa. His grandfather Oderigo di Credi was a farmer and the author of a practical diary preserved in Florence.

Lorenzo is described in his mother's tax return of 1480-81 as twenty-one years old and employed in painting at twelve florins a year. His employer was Verrocchio, for *The Madonna and Child with SS. John Baptist and Zeno* in Pistoia cathedral, ordered from Verrocchio by the executors of Bishop Donato de' Medici probably in 1479 and not finished until about 1486, was evidently painted, upon Verrocchio's design, by Credi. When Verrocchio was dying in 1488 he recommended to the Doge of Venice that Lorenzo should have the finishing of his great bronze statue of Colleoni. Credi soon confined himself to painting; yet the Pistoia altarpiece shows by its suggestive atmosphere and deep colour, its open space and wide landscape that Verrocchio, sculptor and goldsmith, had a broader view of painting than his pupil. Credi developed into one of the elegant stylists of his generation. Adopting the grouping of his master and of his fellow pupil Leonardo da Vinci, he composed at first with the same idea of plastic relief, though always with frank artificiality, in hard bright colours and with enamelled surfaces. Gradually he became preoccupied with the sophisticated arabesques traced by the outlines of his figures, and his colours became paler, more precious, and distributed in larger masses, more obviously decorative. He was the first academic painter of the Renaissance in Florence, exercising an influence upon the deliberate stylists of the next generation.

He is mentioned frequently in the Florentine records, often as in consultation with his colleagues over the city's decoration. But there are few records of his pictures. *The Madonna and Child with SS. Julian and Nicholas*, now in the Louvre, was set up 20 February 1493 on an altar in S. Maria Maddalena de' Pazzi at Florence, and he was paid 10 December 1510 for the large altarpiece in S. Maria delle Grazie at Pistoia. He lived through difficult times, through the expulsion of the Medici and the ignoble circumstances of their restoration. In 1531 he retired to the hospital of S. Maria Nuova.

A BOY IN A SCARLET CAP *Early Italian Room*

Oil on poplar wood, 0.465 x 0.345. The painting has suffered through a fine crackle typical of Lorenzo's later work. Cleaning in 1954 confirmed that the original surface glazes are lost and the damage to hair and left temple is deeper. Cap and landscape are less damaged.

The deteriorated condition and the faint character of the portraiture indicate Credi's decadence, but the composition is broad and easy and there are nice oppositions between the different pinks of face and dress, the light auburn of the hair and the scarlet cap. The misty rockbound lake is his invariable convention for landscape, prettily applied.

On the back is a seal of the nineteenth century with the arms probably of the Counts Negroni of Rome (inscribed on the roll of the Roman nobility in 1752). The panel was bought in Italy by Sulley and Co. of London, and was acquired from them through Berenson in January 1914. *P15e11*

AUTHORITIES

Berenson in a letter (4 February 1930) and, *Florentine School* (1963), I, p. 114.

Degenhard in *Pantheon*, VIII (September 1931), pp. 361-62; he stated that the picture was formerly in the de Turenne and Grassi collections, Florence.

Fredericksen and Zeri, *Census* (1972), p. 110.

Dalli Regoli, *Lorenzo di Credi* (Cremona, 1966), p. 157 and No. 121.

Venturi, L., *Pitture Italiane in America* (Milan, 1931), Pl. CCXVI.

Carlo Crivelli

Recorded 1457-95.

He had a younger brother Vittore, who imitated him closely, and no doubt often worked with him. They were perhaps the sons of Jacopo Crivelli, who is twice recorded as a painter in Venice, in 1444 and 1450. Each of the brothers added *Venetus* to his signature; but the only record from Venice is of Carlo's conviction and sentence to six months' imprisonment and a fine for abducting the wife of an absent sailor from the house of her brother-in-law. He was already described as a painter. This was in 1457. In 1465 he turns up as a citizen of Zara, a Venetian port on the Dalmatian coast. Within three years, however, he was established on the opposite shore, in the Marches. There his prolific and prosperous career is to be traced through a succession of signed and dated pictures.

There is an elaborate polyptych of 1468 at Massa Fermana, north of Ascoli Piceno, and a *Madonna* of 1470 at Macerata, further north. He was established at Ascoli by 1473, the date on the great signed altarpiece in the cathedral there. From its churches come many of his greatest pictures — the composite altar-

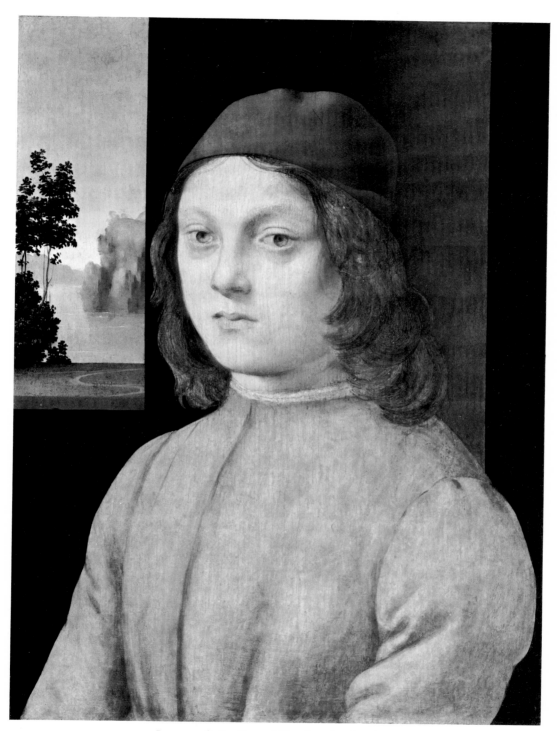

Lorenzo di Credi — *A Boy in a Scarlet Cap*

piece in London, dated 1476, the signed *Fra Jacopo della Marca* in Paris, dated the following year, and the *Annunciation* in London, signed and dated 1486. In 1489 he received a knighthood from Prince Ferdinand of Capua, the crown of an evidently successful career. The last inscribed picture, *The Coronation of the Virgin*, signed and dated 1493, now in Milan, came from Fabriano.

Crivelli had turned his back upon Venice on the very eve of her becoming one of the great centres of painting, through the profound expression and the new techniques of Giovanni Bellini (*q.v.*). He took with him into exile only the memory of a rather febrile moment, when the last floridities of the Gothic were competing with the lessons of exuberant Florentine Renaissance draughtsmen. From the Venetian generation of Giambono (*q.v.*) he inherited an enamel-like translucence of paint, harmonised with embossed and gilded ornament in a composite which was decorative in its primary intent. But, like the mediocre Bartolommeo Vivarini of Murano, with whom he may well have had an early relationship, he owed much to painters who worked at Padua. Mantegna invented many of the little conceits which enliven his pictures. The architecture of his *Annunciation* from Ascoli perhaps owes something to the album of drawings by Jacopo Bellini in the British Museum, and his *Blood of the Redeemer* in the Poldi Pezzoli Museum at Milan seems to be indebted to an early picture by Giovanni Bellini in London. His Virgin often shows in her youth a close likeness to the model of Filippo Lippi, who also painted at Padua.

Thus equipped, he retired among the steep hills and richly coloured valleys of the March, where, isolated from the expanding thought of his day, he was free to give full play to his love of the exotic. His own gifts were great. His architectural motifs — always of the Renaissance — are beautifully constructed; his perspective is accurate and fascinating; his drawing sure and pliant. He was thoroughly conversant with the nude, and he drew beasts and birds, fruits and flowers with loving realism. He could never get enough of these things into his compositions. He was at once the most conservative of painters, developing the character of his first pictures with unwavering perseverance, and the most eccentric, his strange characters growing ever more extravagant in their mannered blend of detached elegance and intense expression.

S. GEORGE AND THE DRAGON *Raphael Room*

Gold and tempera, possibly with oil glazes, on poplar (?) wood, 0.940 x 0.478-85.

An extensive treatment and cleaning in 1935, necessitated by violent reaction to the atmosphere, revealed the exact condition of the original paint. Throughout all the lighter parts it is excellent, whereas there is extensive loss through flaking in the ribs and belly of the horse and the shadows of the rocks to the left. The gilded sky is patchy, but the embossed ornament is in good state. S. George's right eye had disappeared.

Mantegna in his little panel, now in Venice, painted S. George on foot; but it was probably he who gave this popular subject its fashionable scheme of colours: the saint's own scarlet and white standing out from a landscape tinted mauve and green. Certainly Mantegna's ideas dominate this scene of Crivelli's, with its stratiform rock, the perspective landscape and the precise drawing. A certain stiffness and angularity in this show that the picture is an early one; but Crivelli is already fully himself in the balance which he has struck between representation and decorative convention. He always weighted the side of decoration with intricate ornament and rich material. Here the trappings of horse and rider are embossed and gilded and the sky is a sheet of gold. The sculptured rock of the foreground gives way behind the combat to a topiary garden. The formality in the action is deliberate; and there is a fiery energy which is not always to be found in Crivelli's mellower work.

This panel originally formed part of a great altarpiece painted in 1470 for the high altar of the parish church at Porto S. Giorgio, a little town on the Adriatic coast which served as port to Fermo, in the Marches. The altarpiece was commissioned by Giorgio, an Albanian immigrant who founded the family of Salvadori at Fermo. Its centre panel was *The Madonna and Child Enthroned*, now in Washington. On the left was *SS. Peter and Paul*, now in London. *S. George and the Dragon* was on the right. The central *Madonna* panel has an arched top. The two pendants are not only smaller but rectangular, and so were topped by two lunettes: on the left, *SS. Catherine and Jerome*, now in the Philbrook Art Centre at Tulsa, Oklahoma (Kress Collection), on the right, over *S. George and the Dragon*, the *SS. Anthony Abbot and Lucy*, now at Cracow. Over all was the wide lunette with *The Entombment*, now at Detroit.

A scene of action in a landscape, *S. George and the Dragon* may have looked anomalous among static figures drawn against a gold ground; but S. George was the patron saint of the donor, of the church and of the port itself.

The altarpiece was still in place on the high altar in 1771; but in 1803 the church was demolished,

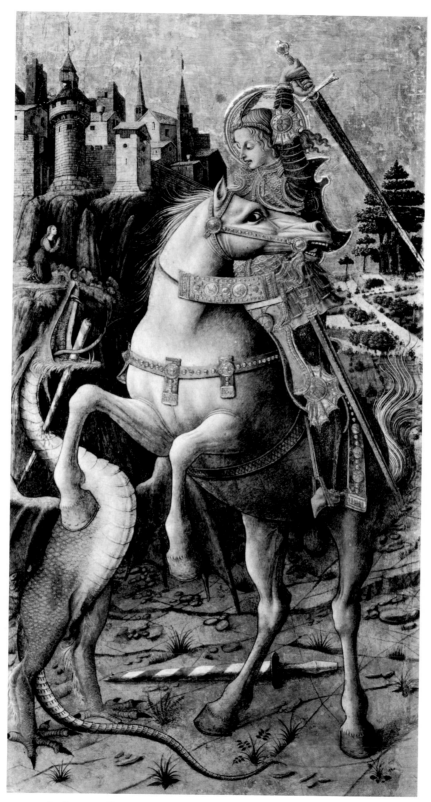

Carlo Crivelli — *S. George and the Dragon* (SEE COLOUR PLATE)

and in 1832 the altarpiece was described by A. Maggiori, author of a local guidebook (II, p. 219), as in the house of the Salvadori, descendants of the donor.[1] The smaller lunettes seem to have remained there; but the four main panels were once more in a church in 1834.[2] In 1851, however, all six panels were in London (see under *Exhibited*), in the collection of Lord Ward, where they were described in 1854 by Waagen.[3] From Lord Ward they passed to the Earl of Dudley.[4] At his (anonymous) sale in London, 17 April 1876, Lot 135, the main panels were bought by Martin Colnaghi. Shortly after, *S. George and the Dragon* and its pendant *SS. Peter and Paul* were in the collection of Frederick R. Leyland, of Liverpool and London, who was the owner of two other pictures in this museum: Pesellino's *Madonna* and Rossetti's *Love's Greeting*. At Leyland's sale, 28 May 1892 (Christie's, No. 99) *S. George and the Dragon* was bought by Davis for Stuart M. Samuel, who was still the owner in 1895. It was bought by Mrs. Gardner through Berenson from Colnaghi, London, in December 1897. *P16e13*

[1]Zampetti, *Carlo Crivelli* (1961), pp. 15 and 72-74. He cites a contract of 1470 said to exist in the Fermo archives but not to be found in 1961, also an extant archiepiscopal inventory of 1771, according to which the picture was then inscribed at the foot (presumably on the lost frame): *Carolus Crivellus Venetus pinxit anno 1470*. Zampetti's Plate 16 reproduces a drawing of the altarpiece reconstructed.

[2]Ricci, Amico, *Memorie storiche delle arti e degli artisti della Marca di Ancona* (Macerata, 1834), I, pp. 209 and 227.

[3]Waagen, *Treasures of Art in Great Britain*, II (1854), p. 235.

[4]Crowe and Cavalcaselle, *A History of Painting in North Italy*, I (1871), p. 91.

OTHER AUTHORITIES

Berenson, *The Study and Criticism of Italian Art*, I (London, 1920), p. 102; and *Dipinti Veneziani in America* (Milan, 1919), pp. 32-33; *Venetian School* (1957), I, p. 69.

Drey, *Crivelli* (Munich, 1927), p. 128.

Fredericksen and Zeri, *Census* (1972), p. 60.

Fry in *Noteworthy Paintings*, p. 117.

Gronau in *Gazette des Beaux-Arts*, XIII (1895), p. 165, and in *Noteworthy Paintings*, p. 115.

Longhi, *Viatico per Cinque Secoli di Pittura Veneziana* (1946), p. 57.

Perkins in *Noteworthy Paintings*, p. 115.

Ricci in *Noteworthy Paintings*, p. 110.

Rushforth, *Carlo Crivelli* (London, 1900), pp. 46-47 and 116.

Venturi, L., *Pitture Italiane in America* (1931), Pl. CCLXXIV.

Exhibited 1851, London, the Egyptian Hall, with other pictures from the collection of Lord Ward (Davies, *National Gallery Catalogues, The Earlier Italian Schools* [2nd ed. 1961], p. 168); 1882, London, R. A., Old Masters, No. 194; 1894-95, London, New Gallery, Venetian Art, No. 40.

Ralph Wormeley Curtis

Born in Boston, Massachusetts, 1854; died at Beaulieu, Alpes-Maritimes, France, 1922.

He was the son of Daniel Sargent and Ariana Randolf (Wormeley) Curtis, who bought and occupied the Palazzo Barbaro at Venice. There he became the friend and companion of a distant relative, John Singer Sargent, with whom he travelled and painted in Spain. He married in Rome 5 June 1897 Lizette de Wolf Rotch, *née* Colt, of Providence, Rhode Island. With his parents they are seen in the *salone* of the Palazzo Barbaro in Sargent's picture, *An Interior in Venice,* in the Diploma Gallery of the Royal Academy, London.

His painting was influenced by Manet (*q.v.*) and Sargent (*q.v.*).

THE GONDOLA *Blue Room*

Oil on canvas, 0.74 x 1.42. Inscribed at the foot on the right: *R. CURTIS. 84.*

Bought by Mrs. Gardner from the painter. A letter from him to her dated December 23 about the purchase mentions another picture, *The Garden,* which Mrs. Gardner also bought but left at her house Green Hill at Brookline. *P3n1*

A JAPANESE TEAHOUSE *Macknight Room*

Water colour on paper, 0.32 x 0.50. Inscribed at the foot on the left: *Mrs. Gardner/from her friend/ Ralph Curtis.* *P11n16*

Sylvia Curtis

Born in Paris 5 May 1899; living painter.

Daughter of the painter Ralph Wormeley Curtis (*q.v.*) and his wife Lizette. She was a goddaughter of Mrs. Gardner from 1918. She married in 1926 Alexander Steinert, and later, Schuyler Owen.

VILLA SYLVIA, ST. JEAN-SUR-MER

Macknight Room

Water colour, 0.46 x 0.30. Inscribed at the foot on the right in pencil: *With / Sylvia's love / 1923.*

The villa at St. Jean-sur-Mer, Alpes-Maritimes, belonged to the painter's parents, and was named after her. *P11s25*

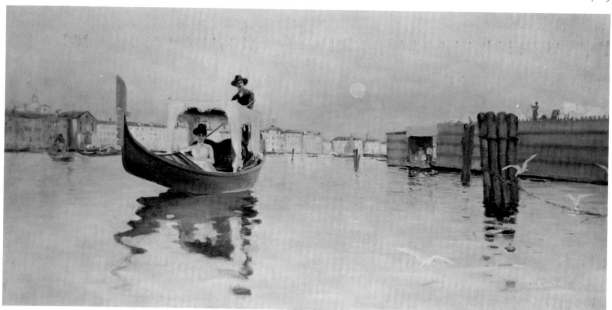

Ralph Wormeley Curtis — *The Gondola*

Ralph Wormeley Curtis — *A Japanese Teahouse*

Sylvia Curtis — *Villa Sylvia, St. Jean-sur-Mer*

Howard Gardiner Cushing — *The Shower of Gold*

Howard Gardiner Cushing — *Among the Rocks*

Howard Gardiner Cushing

Born in Boston, Massachusetts, 1869; died in New York City, 1916.

He studied in Paris at Julian's, and his work shows the influence of modern French painting.

THE SHOWER OF GOLD *Blue Room*

Oil on canvas, 0.765 x 0.640. Inscribed at the foot on the right: *Howard G. Cushing 1908*.

The model with the cascade of golden hair is the artist's wife, whom he had married in Boston in 1904. *P3n17*

Exhibited 1908, Philadelphia, Academy of Fine Arts, No. 724 (stencil on frame).

AMONG THE ROCKS *Blue Room*

Oil on card, 0.20 x 0.25. *P3w18*

Bernardo Daddi

BERNARDO DI DADDO DI SIMONE: he signed pictures *Bernardus de Florentia.* He died in Florence 1348; probably at no great age, for guardians had to be appointed for two of his three sons.

In Florence before 1320 he had matriculated in the Guild of Physicians and Pharmacists, to which the painters were then affiliated. Later, he was a founding member of their Guild of S. Luke, and was elected to its Council. In 1335 he had bought a house in Florence. There is a succession of dated works over two decades, from the triptych of 1328 from the Ognissanti church, now in the Uffizi Gallery, Florence, to the polyptych from S. Giorgio a Ruballa, near Florence, now at Highnam Court, near Gloucester, England (Courtauld Institute), dated the year of his death. His *Virgin and Child with Angels* in Orcagna's tabernacle in Or San Michele had been paid for in 1346 and 1347. The complex and splendid altarpiece from S. Pancrazio, Florence, now in the Uffizi, was evidently painted in his full maturity.

He was among the immediate followers of Giotto (*q.v.*). Most of his significant contemporaries were in the first place painters in fresco, like Giotto himself. The only existing frescoes by Bernardo are those, strongly influenced by Giotto, in the Pucci-Berardi chapel of S. Croce. It seems likely that he was occupied mostly with panel pictures in a workshop. Indeed he seems to have given special attention to portable triptychs, like the miniature altarpiece (completely restored) in the Bigallo Museum, Florence, with the date 1333. He must have helped to make this the most popular form of private devotional picture in the second half of the century. It originated perhaps in Siena, and Bernardo mixed the Sienese with the Florentine style without losing his own individuality. His presumed abandonment of fresco suggests that he knew his limitations; yet on the small scale his narrative pictures could be very expressive in their simplicity. He understood Giotto's conception of space, even if he did not have all his science; and within it his characters move slowly and ceremoniously, their grave expres-

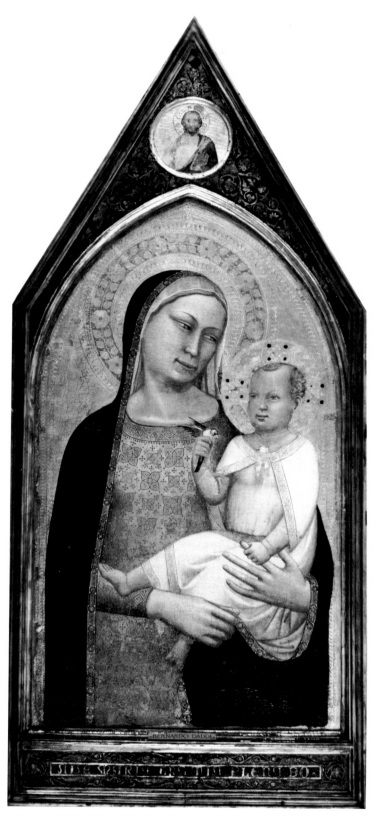

Bernardo Daddi — *The Madonna and Child, with a Goldfinch*

sion rarely broken by more than a half smile or playful gesture. His larger figures have an archaic stiffness, through which they maintain their strength.

THE MADONNA AND CHILD, WITH A GOLDFINCH

Early Italian Room

Gold and tempera, Gothic-arched, transferred to mahogany panel, 0.982 x 0.556. The transfer was made between 1915 and 1927. In 1938 removal of a series of layers of old varnish and retouchings revealed a number of damages: a fundamental loss from the left side of the Virgin's face, from the tip of the nose to the chin. Below her right hand, the Child's left foot and much of her faded crimson robe had been destroyed. The shading of the flesh is badly rubbed throughout. Above, a fragment of the original frame, with its foliated ornament painted in blue and green over silver leaf, contains in a roundel a small half-length figure: *The Redeemer*. This is well preserved. Below, the panel bearing an inscription is modern, like the mouldings of the frame.

The goldfinch, with its clearly contrasted colours, each of them potentially symbolical, had popular superstitions attached to it. When represented in art it is often said to be a bundle of symbols, some of them contradictory. Still the most popular cage-bird, it used to be given to children, for their amusement, on a string. The advance of naturalism may therefore be enough to explain its frequent appearance in religious pictures, most commonly in simple pictures of the Virgin and Child. Nevertheless Bernardo's use of the motif here, in the least playful of pictures, seems to justify the claim to a symbolic meaning.[1] Among other virtues, the goldfinch was believed to be efficacious against the plague, which was an increasing menace in Bernardo's lifetime, culminating in the year of his death.

Of his many figures of the Madonna in half length this is one of the most severely monumental. It resembles the Madonna of the S. Pancrazio altarpiece, and the patterns of the haloes in the two pictures are almost identical. In spite of the number of other pictures which are dated, it is not easy to be precise about the date of either of these; but the breadth of the forms, the simplicity of the drapery and the absence of deep shadow suggest a comparatively late date.

The picture is likely to have been the centre of a triptych, or polyptych; in which case a *S. Dominic* formerly in the collection of Charles Loeser in Florence, must have originally stood on the left of it.[2]

It was bought from Sulley and Co., London, through Berenson in April 1914. *P15w26*

[1] Friedmann, *The Symbolic Goldfinch* (Bollingen, VII, 1946), p. 142; he lists ten pictures with a goldfinch by Daddi himself and sixteen by followers; he discusses (pp. 113-14) the significance of the bird held in the hand.

[2] Offner, *A Critical and Historical Corpus of Florentine Painting*, Section III, Vol. V (1947), pp. 72-76. The *S. Dominic* is reproduced in his Plate XIV.

OTHER AUTHORITIES

Berenson in a letter of 4 February 1930; also *Florentine School* (1963), I, pp. 52-53, where Offner's suggested association with the ex-Loeser *S. Dominic* is accepted.

Fredericksen and Zeri, *Census* (1972), p. 61.

Sirèn, *Giotto and Some of his Followers* (Harvard University, 1917), pp. 176 and 270; he included it in his list of Bernardo Daddi's works only with a query.

Venturi, L., *Pitture Italiane in America*, Pl. XXXI. He attributed it to Daddi's first period. He also considered it the centre of a polyptych.

Degas

HILAIRE-GERMAIN-EDGAR DEGAS: born in Paris 19 July 1834; died there 27 September 1917.

His grandfather De Gas had fled the French Revolution; but his father had brought back a branch of the family bank from Naples to Paris, where he had married Célestine Musson, a Creole from New Orleans. Degas, as he called himself, was an aristocrat with wide connections and strong family feelings, immortalised by a series of portraits. One of the best of these is in the Boston Museum of Fine Arts.

In 1853, after obtaining his *baccalauréat*, he entered the studio of Barrias. More important, he began the intensive study and copying of Old Masters, mostly of the Renaissance, which he pursued until the end of the decade. His revolutionary and exceptionally personal art was founded securely on tradition. He was also a balanced critic, making in the course of his life a comprehensive collection of pictures by his great contemporaries and precursors, particularly Ingres and Delacroix. In the early formation of his art Ingres was the strongest influence. He met him at the Ecole des Beaux-Arts, where he had enrolled in 1855 at the instance of Lamothe, one of Ingres' disciples. He preferred, however, to study on his own. In 1854 he had already visited his grandfather in Naples, and the greater part of the years 1856-58 were spent in Italy, painting and studying the Italian Renaissance. Only in 1859 did he establish himself in Paris.

For the first five years there he produced carefully prepared and ambitious "histories." In the largest, *Jephthah's Daughter*, now at Smith College, Northampton, he showed too much of his learning; there was a clutter of references to earlier painters. He had worked at it some four years. In *Les Malheurs de la Ville d'Orléans*, now in the Louvre, history and imagination have united, with a result which is deeply moving. Yet this essay of 1865 was the last of its kind. In 1866 he exhibited at the Salon a *Racing Scene with a Fallen Jockey*. Studies like the watercolour below and many portraits already painted show that the change was mostly one of themes. In 1862 Degas had made friends with Manet, and at least from 1866 they belonged to the group frequenting the Café Guerbois, where academic painting was denounced, Japanese prints extolled, nature and daily life declared the true essence.

The Franco-Prussian War of 1870, in which Degas served in the artillery, caused profound disturbances, political and social; and Degas was harshly conservative. When he went to New Orleans in 1872-73 he may well have been prepared to stay there. He painted many pictures, including *The Musson Office at New Orleans*, now at Pau, in subject perhaps the most unconventional of all his pictures, and a more sketchy treatment of a similar theme in the Fogg Art Museum. But cotton was dull and the light too brilliant for eyes which were already troubling Degas. Back in Paris, he found his friends preparing the first of the Impressionist exhibitions. From 1874 to 1881 he contributed to these not only a large number of works in different media but the enthusiasm of a propagandist. In the sixth exhibition, in 1881, his ideas were pushed to their logical conclusion, in one direction at least, with his life-size wax figure of a teen-age ballerina dressed partly in actual stuff. The subject of heated controversy, it was probably the only "sculpture" he ever exhibited; but some 150 dusty wax models found in his studio had been the chief means — he also used photographs — by which he got his unique knowledge of movement in three dimensions. Such a practice, common in the Renaissance, distinguishes him equally from the relics of the Academic tradition and from the Impressionists (a name which he disliked). They and Cézanne were much preoccupied with the colour of light outdoors. Degas' most significant pictures were composed in the studio, where the light was monochrome, undiffused and often artificial. Yet his hard-won knowledge of attitudes and appearances, of volume and contour, depended equally upon the study of light. As his sight grew dimmer and he took almost exclusively to pastel, his welding of chiaroscuro with broad masses of colour became ever more effective.

No pictures have ever seemed more objective or less studied in expression. When he claimed that no art was less spontaneous than his, he was referring to his method: of drawing not what one sees but what one remembers seeing. "Then memory and imagination are freed from the tyranny which nature exercises. . . . To make a portrait, pose the sitter on the ground floor, do the painting on the floor above, so that you get the habit of memorising form and expression and never drawing or painting directly." Of his many nude studies he claimed that until then the nude had always been posed in consciousness of a viewing public. "My women are unsophisticated, natural, occupied with nothing more than the care of their own bodies . . . seen through the keyhole." This visual truthfulness he extended throughout his compositions. He anticipated the cinema, turning the camera of his eye upon its swivel instead of bringing the subjects to pose, and so continually discovering fresh angles of vision. Yet these things would have little value without his sense of form, his ability to isolate from the rest of appearances what has permanent strength and meaning.

MADAME GAUJELIN *Yellow Room*

Oil on canvas, 0.612 x 0.457. Inscribed at the top on the left: *Degas. 1867.*

Joséphine Gaujelin was a ballet dancer, and became an actress. A drawing of her by Degas, full-length in ballet costume, now in Rotterdam is inscribed somewhat enigmatically: *1873/ Josephine Gaujelin/ autrefois danseuse à l'Opéra/ puis actrice au Gymnase.* Perhaps Degas added the inscription later; but that makes the date difficult to understand. It seems unlikely that Gaujelin should have posed for Degas in ballet costume at that time, when she had apparently ceased to dance and must, some years before, have had something like a quarrel with the painter.

She herself had commissioned this portrait; but she refused to take it.[1] Not unjustly, for the study of her head at Hamburg (below) shows a softly beautiful girl. She complained that the full length did not do her justice. According to Mrs. Gardner she was even displeased at its passage to America.

Formerly in the Manzi collection in Paris, it was bought by Mrs. Gardner through Berenson April-July 1904 from Eugene Glaenzer and Co., New York. *P1e4*

[1]Alexandre, Arsène, in *Noteworthy Paintings*, pp. 252-54.

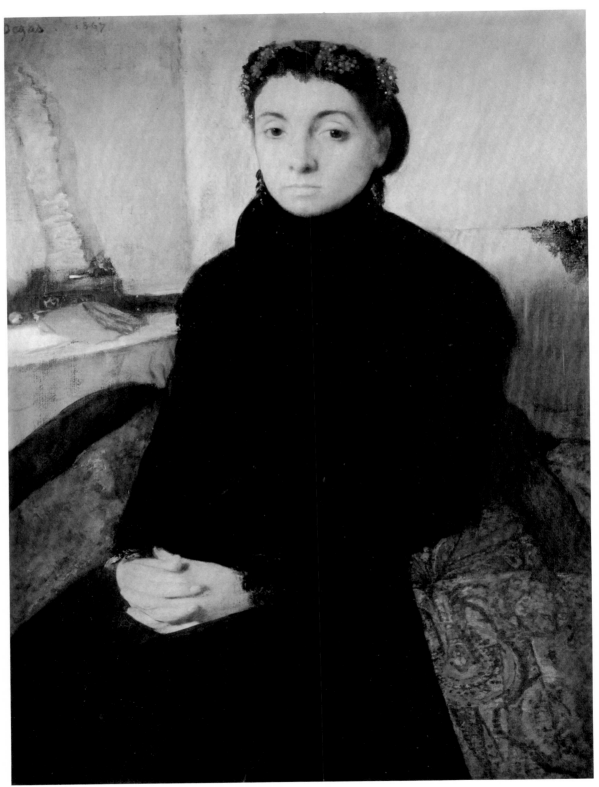

Degas — *Madame Gaujelin* (SEE COLOUR PLATE)

Degas — *La Sortie du Pesage*

Degas — *Cortège aux Environs de Florence*

OTHER AUTHORITIES

Boggs, *Portraits by Degas* (University of California Press, 1962), p. 30.

Rouart, *The Correspondence of Berthe Morisot* (1957), p. 32. Berthe Morisot in a letter of 5 May 1869 described the portrait as very ugly.

Russoli and Minervino, *L'Opera completa di Degas* (1970), p. 96, No. 224.

Studies: (1) Hamburg, No. 2417, panel, 0.35 x 0.27, study in oils for the head; the expression is far more genial, the brushwork very free and the light and shade more contrasted; there are no details of dress. (2) Le Havre, M. Olivier Senn (1931), pencil drawing, 0.36 x 0.23, a study for the head; inscribed at the foot on the right: *Mme Gaujelin;* exhibited in Paris, Georges Petit, 12 April-2 May 1924, *Exposition Degas, au profit de la Ligue Franco-Anglo-Américaine contre le cancer,* No. 95; with the study below it had formed No. 405 of the third sale from the studio of Degas, Paris, Georges Petit, 7-9 April 1919. Mrs. Gardner tried in vain to obtain them from M. Senn June-July 1919. (3) Le Havre, M. Olivier Senn (1931), pencil drawing, 0.36 x 0.23, a study for the hands.

CORTEGE AUX ENVIRONS DE FLORENCE
Short Gallery

Pencil and wash on paper, 0.16 x 0.21. Stamped in red at the foot on the right: *Degas,* the cachet of the sales from his studio. Degas was in Florence frequently between 1857 and 1860; but it is difficult to find any connection with Florence or to discover how the picture came by this title. The procession seems to be a reconstruction of Antiquity, and the lighting suggests the stage. Minervino, who dates it 1861, suggests that it is a study for *Semiramis Building a City,* a large canvas painted that year and now in the Louvre.[1]

Bought with three other studies by Mrs. Gardner's agent Robert at the fourth sale from the painter's studio (2-4 July 1919, Paris, Georges Petit, No. 66b, *Cortège sur une Route aux Environs de Florence*). Robert chose these from eleven items which Mrs. Gardner instructed him to buy. P17e93

[1] Russoli and Minervino, *op. cit.,* p. 90, No. 97.

LA SORTIE DU PESAGE *Short Gallery*

Pencil and water colour on paper, 0.10 x 0.16. A piece torn from the top left corner. Stamped in red at the foot on the right with the cachet: *Degas.*

No. 66a, with this title at the fourth sale from Degas' studio. P17e92

Russoli and Minervino, *op. cit.,* p. 93, No. 166.

For other drawings by Degas see Hadley, *Drawings* (Isabella Stewart Gardner Museum, 1968), pp. 42-46.

Delacroix

FERDINAND-VICTOR-EUGÈNE DELACROIX, born at Charenton, now a suburb of Paris, in April 1798; died in Paris 13 August 1863.

He was the youngest child of distinguished parents. He entered the studio of Pierre Guérin and the Ecole des Beaux-Arts in Paris in 1816. Already at the Salon of 1822 his work found potent admirers. His *Dante et Virgile* was purchased officially; and again in 1824 his *Episode des Massacres de Scio.* Both pictures are now in the Louvre. But his exhibits in 1827, which included the *Mort de Sardanapale* now in the Louvre and the *Doge Marino Faliero Décapité* in the Wallace Collection, London, raised such a storm that he had to wait for further recognition until the revolution of 1830 put his admirer Thiers into power. *Le 28 Juillet 1830,* his one theme from contemporary history, earned him after the Salon of 1831 the Cross of the Legion of Honour. The following year he accompanied the Comte de Mornay on the expedition to Morocco, of which the recollection intensified his sense of colour and occasionally provided him with themes for the rest of his life. Before returning to Paris he crossed to the south of Spain.

In 1833 Thiers commissioned of him the decoration of the Salon du Roi in the Palais Bourbon, seat of the Chamber of Deputies, and in 1838 he began upon the Library there. This was perhaps his greatest undertaking, not finished until 1847. Meanwhile, in 1840 he had begun on the cupola and hemicycle of the Library in the Palais du Luxembourg, seat of the Senate. The revolution of 1848 made no difference. For the new government he completed the work of Lebrun (1619-90) in the Galerie d'Apollon in the Louvre. His decoration in the Hôtel de Ville, begun in 1854, was destroyed in 1871. His last and perhaps greatest murals are those in a chapel of S. Sulpice, Paris, painted 1855-61.

Delacroix was the only painter of the nineteenth century capable of such great undertakings. They required the employment of many assistants, especially as he was meanwhile painting large canvases, and exhibiting regularly at the Salon. From the first his exhibits aroused controversy. Géricault, whom he greatly admired, was cut off in 1824, and he found himself leading the attack on the academic principles of two centuries, now personified in Ingres (1780-1867). The greatest representative of the nineteenth century Romantic Movement, Delacroix by no means eschewed the subjects of Antiquity, ranging the whole of history and of epic poetry. But he approached all his subjects emotionally and laid the emphasis in expression and in

Delacroix — *The Crusader*

design upon colour. He thus led thought in new directions, stimulating the growth of new ideas. His significance in history is perhaps greater than the absolute value of the greater part of his art. From the hints of Titian, Veronese and Rubens and of his English contemporaries Constable and Turner he began the modern research into the values of colour, the action upon colour of light. He advocated that juxtaposition of pure colours which became the essence of Impressionism. The Romanticism which he drew from Shakespeare or Goethe or Byron was no less artificial than the old Classsicism; but it brought a new freedom to the art of painting, which was exploited fully in the next generations.

THE CRUSADER *Blue Room*

Oil and bitumen on card, 0.39 x 0.29, signed at the foot on the left: *Delacroix* —. The pigments in many of Delacroix's earlier paintings have not stood the test of time, but this is an extreme example of the deterioration of the bituminous paint.

Besides the seated figure of a man in armour it is possible to distinguish at the bottom on the right a turbaned Turk or Saracen and to the left a man holding a horse's head, suggestions of such a medieval subject as Delacroix loved.

His huge picture, *The Entry of the Crusaders into Constantinople* in the Louvre, was painted in 1840. It was one of Delacroix's great symphonies in colour, and this now dark little sketch would seem to have been painted some time earlier. Yet it shows the painter considering the Crusaders as a subject, and the soldier has some resemblance to the king in the great canvas.

Bought 20 February 1882 from S. M. Vose, Boston. *P3e21*

Thomas Wilmer Dewing

Born in Boston, Massachusetts, 4 May 1851; died in New York City, 5 November 1938.

Youngest child of Paul Dewing, a millwright, whose ancestor had emigrated from England to

Thomas Wilmer Dewing — *A Lady in Yellow*

Exhibited 1888, Boston Art Club; 1889, Paris, Exposition Universelle Internationale (silver medal); March-April 1895, Boston, Copley Hall, "Portraits of Women" (label on frame), No. 109.

Diaz

NARCISSE-VIRGILE DIAZ DE LA PEÑA: born at Bordeaux 1807; died at Mentone 1876.

His parents were refugees from Spain and Joseph Bonaparte, and he himself was left at the age of ten a penniless orphan in the care of a priest at Bellevue near Paris. He lost one of his legs through blood-poisoning, and was apprenticed at the age of fifteen as decorator in a pottery in Paris. His faint, sensuous colours are splashed on his panels or his canvases in rich, buttery pigments with a broad and easy sense of design. He had no professional training, save for a few months under Souchon on quitting the factory. From about 1840 he painted in oils, at first mostly Romantic subjects, under the influence of Delacroix and of the writings of Victor Hugo, or naked nymphs in woodland glades, which tell of contact with Corot. It was when he joined the school of Fontainebleau and painted landscapes under the influence of Millet and Rousseau and Daubigny that he put most vigour and consideration into his abundant art.

Dedham, Massachusetts, in the 1640's. Thomas worked for a time in Boston as a lithographer, and then in Albany as a portrait-draughtsman. In 1876-79 he studied under Boulanger and Lefebvre in Paris. He returned to live in New York, where in 1881 he married Maria Richards Oakey, a flower-painter. Their daughter Elizabeth Bartol was a novelist. From 1895 Dewing exhibited with the Ten American Painters, a group of Boston and New York painters who were regarded as American Impressionists. He was distinct from them in his subject matter. A friend of the architect Stanford White, he designed a ceiling for the Imperial Hotel in New York, which is now in the National Collection of Fine Arts, Washington, D.C. He painted many portraits; but he is best known for his small pictures of women in reverie. These are well represented in Washington: in the National Collection and in the Freer Gallery.

A LADY IN YELLOW *Yellow Room*

Oil on wood, 0.50 x 0.40. Inscribed at the foot on the right: ..'88/T.W.Dewing.

The picture was bought by Mrs. Gardner through Denis M. Bunker in Boston 6 March 1888. *P1w3*

ON A TERRACE *Yellow Room*

Oil on canvas, 0.25 x 0.32. Signed at the foot to the right: *N. Diaz.*

Painted perhaps in the decade 1845-55.

Bought by Mrs. Gardner in March 1876 from Leonard and Co., Boston. *P1w5*

Exhibited 26 April 1880—3 June 1881, Boston, Museum of Fine Arts.

Diaz — *On a Terrace*

Albrecht Dürer

ALBRECHT DÜRER (or TURER or THURER): born at Nuremberg, a free city of the Empire, 21 May 1471; died there 6 April 1528.

He was third of the eighteen children of Albrecht Dürer and his wife Barbara Holper. His father, a Hungarian who settled in Nuremberg in 1455, and his maternal grandfather were goldsmiths, and he began at their craft. However, he entered the studio of the painter and engraver Michael Wolgemut 30 November 1486, remaining there until 1490. His precocious portrait in oils, *Albrecht Dürer the Elder*, in Florence, is dated 1490. After Easter that year he left Nuremberg on his travels. In 1492 he was at Colmar in Alsace and probably at Basel, and late in 1493 and in 1494 he was at Strasbourg. Two portraits painted there in 1494 are mentioned in an old inventory. His earliest *Self-Portrait*, in the Louvre, is dated 1493. Returned to Nuremberg, he married Agnes Frey 7 July 1494. In 1495 he went to Italy, visiting Venice and perhaps other northern towns.

Already a famous engraver, he now became busy with large paintings. For Elector Frederick the Wise of Saxony, Luther's protector, he painted in tempera the portrait now in Berlin, about 1496, and the triptych now at Dresden, in 1496-97 and 1503-04; and in oils the altarpiece now in the Archbishop's palace at S. Veit near Vienna, about 1502. The "Paumgartner" altarpiece now at Munich was painted probably in 1502-04, and *The Adoration of the Kings* from Trento, now in Florence, is dated 1504.

The next year he paid a second visit to Venice, where he remained until 1507. The German merchants there ordered for S. Bartolommeo the great *Rosenkranzfest*, finished by September 1506 and now, much damaged, in Prague. The Doge and the Patriarch came to see it in his studio, and Giovanni Bellini visited him. He painted other panels in Venice; and for a few years after his return he devoted himself principally to pictures. *The Martyrdom of the Ten Thousand Christians*, now in Vienna, was painted for Elector Frederick in 1508, the altarpiece with *The Adoration of the Trinity*, now in Vienna, for a Nuremberg almshouse in 1511. But he grumbled that painting meant a loss. His engravings had a wide circulation, and from 1512 the Emperor Maximilian employed him upon woodcut decorations, giving him a pension from 1515.

Maximilian's death drew all Germany to Aix-la-Chapelle in October 1520 for the coronation of Charles V. The Nuremberg Councillors went to take the regalia, Dürer to get his pension renewed. He was away for a year, mostly at Antwerp, where he was feasted by the painters, by his own Town Council, by public bodies and finally by the King of Denmark, whom he drew and painted. He visited Bruges and Ghent. Flanders gave a second great stimulus to his painting. For a long time after his return to Nuremberg he worked on a great picture which was probably to be a triptych. Only the wings were completed, and these, SS. *John and Peter*, SS. *Paul and Mark*, he gave to the city of Nuremberg in 1526 (now in Munich). They are his most monumental works. Their long inscriptions show the vehemence with which he had embraced the ideas of Luther. After his return from his second visit to Italy, he had begun to plan a theoretical treatise on painting. It was never completed. His last few years were spent largely in writing. His *ms.* treatise on proportion was finished in 1523; his geometrical treatise published in 1525; his four books on human proportions several months after he had died.

With all the curiosity and the self-assertion of the Renaissance he stepped into a circle of medieval religious painters at Nuremberg. Some of them painted subtler and more splendid altarpieces than his, and are now anonymous; but Dürer's monogram is on almost every picture, and his own figure often prominent. His self-portrait of 1493 in Paris is inscribed: *Myn sach dy gat als es oben schtat* (My affairs will go as ordained on high); that in Munich, dated 1500, represents him in a way hitherto reserved for effigies of Christ. His altarpieces at first continue the fabric of the local school; but the spirit is another, more strenuous, impatient both with subject and technique, most effective in the wings of the "Paumgartner" triptych, fancy-dress portraits of Paumgartner men. His peculiar genius, strongly imbued with Nuremberg's love of technical complexities, was best suited to engraving. His prints had an almost immediate impact upon Europe, and he has remained the most famous engraver of all time.

In pictures painted under Venetian influence his frowning characters find themselves in a new world of light and colour; but these elements he never wholly integrated in his compositions. In his pictures the instinct and habit of the engraver remained dominant. Even in portraiture the conscientiousness of his labour sometimes diminishes the effect. Such more formal presentations as the *Jacob Muffel*, dated 1526, in Berlin, with its grand summary of the outward facts, are less expressive than the bust portrait, *A Girl in Lombard Dress*, dated 1505, in Vienna, or *Bernard van Resten*, dated 1521, in Dresden.

A MAN IN A FUR COAT: 1521 *Dutch Room*

Oil (?) on oak, 0.506 x 0.329. Inscribed at the top in the centre: *1521 / AD* (in the characteristic monogram).

Cleaning in 1935 revealed that very little of the surface layer of paint has survived. Best preserved are the hand and the sleeve, the parts of the fur collar nearest to the opening, the eyes and the background, with its inscription. This is worn, but authentic. The earlier restoration, removed in 1935, had been done in 1902 by Hauser, official restorer to the Kaiser-Friedrich Museum, Berlin. Enough of the original had remained to justify Hauser's reconstruction, though a degree of refinement was lacking from the result. This was therefore followed in the new retouching, which was, however, carried less far.

The inscribed date and the nature of the support provide limits of time and space within which the identification of the sitter must be sought. For the first six months of 1521 Dürer was in the Netherlands; and only while he was in the Netherlands did he paint on oak,[1] the characteristic support in the Low Countries for small pictures. In Nuremberg he normally used lime, in Italy the prevailing poplar wood.

With this guidance different Dürer authorities have supported three candidates for the distinction of having sat for this portrait. The first to be put forward was Lorenz Sterck, the City Treasurer of Antwerp. Dürer records his painting of Sterck's portrait in the journal which he kept during his travels in the Netherlands.[2] The original of this notebook is lost, but there are two transcripts of later date. According to these it was not a systematic diary, but a series of notes, made at irregular intervals, leaving room for many omissions and mistakes. For this identification of the sitter as Sterck there is no supporting evidence; but the name has stuck. Most writers have used it as a title for the picture since it was first given in 1918.

Ten years later a new candidate was put forward: Lazarus Ravensburger,[3] the Lisbon agent of an Augsburg firm. The grounds were the sitter's resemblance to the subject of a silverpoint drawing by Dürer now in the Berlin Print Room. This is on a leaf from a sketchbook which he used during his visit to the Netherlands, and is inscribed: "... *rus rafensburger ... gemacht zu antorff.*" On the same sheet is the drawing by Dürer of a tower which has been identified as that of the court of Lière at Antwerp.[4] The drawing is by no means a study for the painted portrait; but in the first days of 1521 Dürer recorded in his diary: "I gave Lazarus of

Ravensburg a portrait head on panel which cost 6 stivers, and besides that I have given him eight sheets of the large copper engravings, eight of the half sheets, an engraved *Passion*, and other engravings and woodcuts, all together worth more than four florins."[5] This identification of the sitter for the portrait was accepted in the first edition of the Catalogue (1931). It has not found support with most Dürer authorities. It is indeed far from certain that the sitters are one and the same person. Moreover, if it were a question only between these two pictures, Dürer's own description of his portrait of Sterck, "a neat and careful portrait in oils," must have suited the Gardner picture in its original state better than that of his gift to Ravensburger: "a portrait head on panel." The inventory recording this gift shows that he was not understating its nature.

The third identification is recent.[6] It is based on a certain resemblance to a much more splendid and careful drawing by Dürer in the Berlin Print Room,[7] long identified as a portrait of Ruy Fernandes d'Almada from the note in the journal made between 16 March and 6 April 1521: "Ruderigo has given my wife a little ring, worth more than 5 gulder ... I have made R's portrait with black and white pencil [*pinzel*=very fine brush] on a large sheet of paper."[8] This is the only drawing in such a technique to be mentioned in Dürer's Netherlandish diary, and perhaps the first he ever made with it; moreover, the identification suits the character of d'Almada, so far as this can be deduced from his patrician background and distinguished career. It must be noted, however, that it was the same authors, Veth and Muller, who identified the sitter for this drawing as d'Almada and the sitter for the Gardner painting as Sterck.

It may be argued that when a similar cast of features and similar costume are to be found in three portraits by Dürer, made at much the same time and place, and when the two drawings have been clearly identified as representing two different men, it seems more likely that the painting is of one of these than that the Antwerp Treasurer had the same by no means common type of countenance. That the artist recorded painting the portrait of Lorenz Sterck and did not record any oil painting of d'Almada is not a very strong argument, given the character of the journal and the degree of resemblance between the sitters in the Gardner portrait and the great Berlin drawing. A stronger argument against this identification would be the superiority in every respect of the drawing, which is one of Dürer's masterpieces, over the painting. In the drawing the bust seems to fill the allotted space

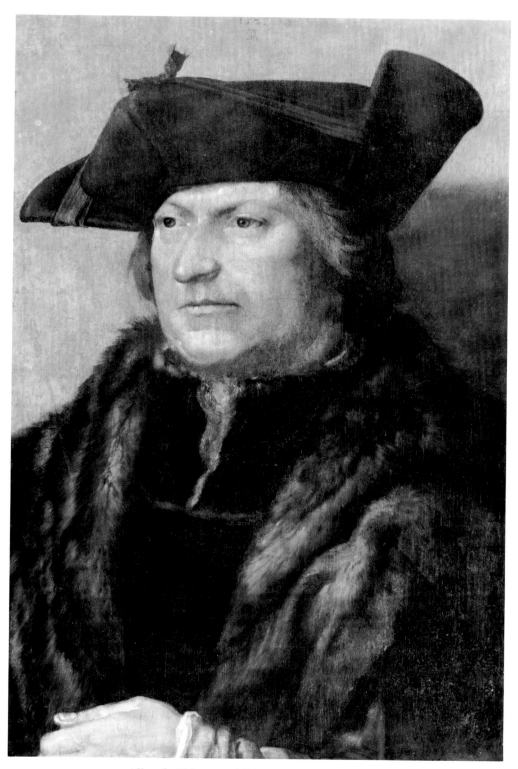

Albrecht Dürer — *A Man in a Fur Coat: 1521*

more splendidly and by its mere mass to suggest a nobler impression of the man. The meaner proportions of the panel may be explained by the fact that this was standard size for Dürer while he was in the Netherlands; but little or nothing has been gained by the tentative introduction here of the rather nerveless sleeve and hand, apparently in observance of Netherlandish tradition. Much of the difference, however, may be explained by the present condition of the painting. The author of the painted version (see below) at Hampton Court plainly had the Gardner picture at his disposal; and it is therefore justifiable to accept this free replica of the portrait by a Netherlandish painter of a generation later as a better likeness of the sitter than the reconstruction of the original in the twentieth century. The resemblance to the Berlin drawing is stronger in the Hampton Court picture. There remains to be explained, however, the far greater refinement in the appearance of the drawing's subject. In the picture the sitter seems to be more fleshy and less sensitive, altogether less alive. But here, again, it has to be remembered that Dürer's graphic work is normally more sensitive than his painting. The drawing of d'Almada, apparently a special effort, was made towards the end of the artist's long stay in the Netherlands. It may be that he was dissatisfied with an earlier painted portrait.

Ruy Fernandes d'Almada is at least much the most interesting candidate. In 1521 he had been for several years secretary to the Portuguese Factor in Antwerp. Save for a short interval as Ambassador for Portugal to France, he lived there, in considerable state, until 1548. In September 1519, in the course of a mercantile mission through several German states, he had spent some days in Nuremberg. A distinguished humanist, a participant in the extraordinarily comprehensive correspondence of Erasmus of Rotterdam, he would naturally have been introduced there to Dürer, Nuremberg's most distinguished citizen. It may, therefore, have been he who introduced the artist to the Portuguese colony in Antwerp. The Portuguese held an exceptional position in the great commercial capital of the North owing to their monopoly of an important section of the spice trade. Dürer was loaded with spices, wines and all manner of sweet things, especially by d'Almada. In return he gave him not only many engravings but a *S. Jerome* "diligently painted in oils,"[9] presumably the picture, dated 1521, now in Lisbon.

The Gardner portrait seems to be unrecorded before 1902, when it was exhibited in London, lent by J. T. Dobie, Esq. From him it was bought by Colnaghi, who sent it to Berlin to be restored. From Colnaghi it was bought through Berenson 2 December 1902. *P21n10*

[1] Walter L. Strauss in a letter to the Director (26 May 1969). These facts are generally recognised.

[2] Veth, J., and Muller, S., *Albrecht Dürer's Niederländische Reise* (Berlin and Utrecht, 1918), I, p. 42 and II, p. 269.

[3] Tietze-Conrat, E., orally to the compiler (Vienna, 1928); also Tietze, H. and Tietze-Conrat, E., *Kritisches Verzeichnis der Werke Albrecht Dürers* (Basel-Leipzig, 1937-38), II, 1, No. 792.

[4] Silverpoint on paper, 0.112 x 0.169. No. 48 in an exhibition circulated in 1965 by the Smithsonian Institution, Washington, D.C., to New York (Morgan Library), Chicago and Boston. The author of the catalogue, Dr. Fedja Anzelewski, accepts the connection with this portrait, suggesting that the drawing was done first.

[5] *Records of Journeys to Venice and the Low Countries*, trans. Tombo, ed. Fry (Boston, 1913), p. 68. In a note Roger Fry deduced (presumably) from the price of the panel: "This can scarcely have been a picture; probably a drawing on a thin leaf of prepared wood, such as was used for sketch-books." Others have followed him. The 6 stivers, however, were the price of the panel itself. Dürer records only a few lines below: "I gave 6 stivers for a panel."

[6] Grote, L., in *Zeitschrift der Deutschen Vereins für Kunstwissenschaft*, XXV, 1-4 (Berlin, 1971), pp. 115-22. The details given above concerning d'Almada are taken from Dr. Grote's article. He quotes Maria do Rosario de Sampaio Themudo, *Rui Fernandes da Almada, Diplomata Portugues do secolo XVI*, 2 vols. (Lisbon, 1967). He finds further justification for the new identification of the sitter in the changes in the picture made by the removal of Hauser's restoration. He thinks that the panel must have been reduced a little on the left side (there is no evidence of this) and is sceptical about the authenticity of the sleeve and hand, and of the shadow on the background.

[7] No. W813, black and white on dark purple paper, reproduced by Grote, *loc. cit.*

[8] Veth and Muller, *loc. cit.*

[9] *Ibid.*

OTHER AUTHORITIES

Bode (in conversation with the compiler, Berlin, 1928) had seen the picture in Hauser's studio. He was not confident of the attribution to Dürer.

Della Chiesa, *The Complete Paintings of Dürer* (New York, 1968), No. 170.

Flechsig, *Albrecht Dürer* (Berlin, 1927), p. 427; while rejecting the inscription, he supported Veth and Muller's identification of the sitter as Sterck.

Friedländer, *Albrecht Dürer* (Leipzig, 1921), pp. 178-80.

Kuhn, *A Catalogue of German Paintings of the Middle Ages and Renaissance in American Collections* (Harvard, 1936), No. 205; he reproduced the picture in different states.

Panofsky, *Albrecht Dürer* (1948), II, No. 67; he agreed with the identification of the sitter as Lorenz Sterck.

Winkler, *Albrecht Dürer* (Berlin, 1957), p. 302; he maintains the identification of the sitter as Lorenz Sterck.

Exhibited 1902, London, R.A., Old Masters, No. 211: "Dürer. *Martin Luther* [. . . *Luther*, written in old German hand, is on the back of the panel]. Lent by J. T. Dobie, Esq." The inscription is not mentioned.

Version: Hampton Court Palace, No. 249, oil on oak, 0.535 x 0.607. The right arm is also shown, and the right hand, holding a paper, covers the left. Under the discoloured varnishes the colours are probably much the same; but the artist, apparently a Netherlandish painter of the later sixteenth century, must have been commissioned not so much to copy Dürer's portrait but to use it, in the absence of the sitter, in producing a portrait in the contemporary style. This picture may well have been part of the huge collection of King Charles I of England; but it appears first in the time of Charles II, in an inventory of the Whitehall Gallery: No. 278, "said to be Alberdure."

Dutch (?); XVII Century (?)

See Hadley, *Drawings* (Isabella Stewart Gardner Museum, 1968), p. 65.

Van Dyck

ANTOON (in England ANTHONY) VAN DYCK: born at Antwerp 22 March 1599; died in London 9 December 1641.

The son of Frans van Dyck, a well-to-do merchant, and his second wife Maria Cuyperis, he was apprenticed already in 1609 to Hendrik van Balen. By 1615 he was independent, and in 1618 he became a Master in the Guild of S. Luke, and a citizen of Antwerp. He entered for a time the great picture factory of Rubens, to be recognised at once as his most able assistant.

Van Dyck's brilliant imitation of Rubens was the cause of his precocious progress; and at the same time the presence of Rubens in Flanders forced him to seek eminence abroad. In November 1620 he was in England, receiving next year £100 from King James I, for "special service"; but at the end of February 1621 he obtained through Lord Arundel eight months' leave of absence to go to Italy. He returned home, and reached Italy only in November 1621, to stay there several years. Visiting all the great towns, plainly including Venice, he had several commissions in 1622 in Rome, and in 1624 he went to paint the Viceroy of Sicily at Palermo. There are still altarpieces by him there in S. Caterina and in the Oratorio del Rosario. Meantime he had settled at Genoa. There he enjoyed his first

supremacy. Such portraits as *The Marchesa Cattaneo* in Washington witness that it was deserved. He never surpassed these in vivacity or splendour.

He was back in the Netherlands by 1627, and perhaps then visited England again. In 1628 he was once more at Antwerp. Rubens was setting off on his mission to Spain and England, and for two or three years Van Dyck occupied his place. He was Court Painter in Brussels to the Regent Isabella, of whom there is an earlier portrait by Pourbus in the Dutch Room. Of Van Dyck's portrait of Isabella in monastic dress there are versions at Turin and Parma, in Paris and Vienna. He painted those of her successive commanders-in-chief: *Count Henri de Berghues*, now in Madrid, *The Marquis d'Aytona on Horseback*, now in Paris, *Thomas de Savoie-Carignan on Horseback*, now at Turin. Religious compositions painted at this period are still to be seen in many cathedrals of Flanders, in Antwerp and in Vienna.

But Rubens had returned in 1630; and, when he devoted himself again wholly to painting, Van Dyck accepted the offers of King Charles I of England. In London by April 1632, he was soon made Court Painter, pensioned and knighted. The *King Charles I on a White Horse, with M. de St. Antoine*, now at Windsor, is probably one of the earliest of his great court portraits. The other equestrian portrait of the King is in the National Gallery, London. King Charles took a fancy to Van Dyck and constantly visited his studio; but he cut down the prices he put upon his portraits, and Van Dyck was evidently bored at the English court. In 1634 he returned to Antwerp, bought an estate within that domain of Steen soon after purchased by Rubens, and proceeded to Brussels. There he painted the portrait of the new Governor General, *Cardinal Infante Ferdinand*, now in Madrid. In the spring of 1635, however, he was back in London. Besides a long series of the King, of the Queen and of the whole royal family, he painted an extraordinary number of portraits not only of courtiers but of members of the growing opposition. He also painted for the King a number of subject pictures, of which there survives only the *Cupid and Psyche* in the Royal Collection.

The death of Rubens coincided with the outbreak of the civil war in England; and in October 1640 Van Dyck was back at Antwerp. He was in Paris in January 1641, competing for the commission for a series of decorations for King Louis XIII; in London again by May. In October he was again at Antwerp, in November in Paris and then for the last time in England, where he died, soon after. He left a widow, Maria Ruthven, whom he had married in London in 1635, and a daughter.

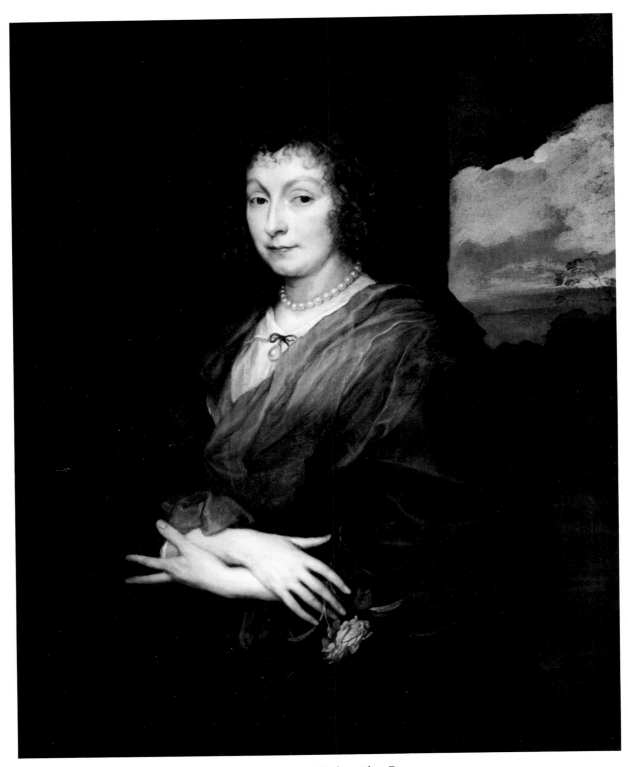

Van Dyck — *A Lady with a Rose*

Van Dyck — *The Rape of Europa*

It is his portraits principally which have given Van Dyck his place in history. The capacity for likenesses was the heritage of the Flemish painter; but it was his cunning in ennobling their features which so endeared him to his sitters. He knew how to impart a consummate courtliness, endowing his sitters with all things that all men envy: health and stature, wealth and high breeding.

In the evolution of his art his story is likewise one of a gradual emancipation from Rubens. He too studied Titian, and went further in collecting a number of his works. He revolutionised English painting; but it was not only in England that the luminosity of his fair colour and the finesse of his elegant brushwork were a formative influence in the eighteenth century.

A LADY WITH A ROSE *Dutch Room*

Oil on canvas, 1.015 x 0.795. Cleaning in 1948 revealed the silvery brilliance of tone characteristic of Van Dyck's last five years.

It follows that the picture probably represents an Englishwoman, who sat for it in England; and this is borne out to some extent by the apparently English provenance of the replica (below).

On the other hand the Gardner portrait belonged in the last century to the Duke of Osuña. The Duke had an estate at Beauraing, near Dinant in Belgium. A sale of his collection of objects of art from there took place in 1890; but it did not include this picture. With others belonging to him, it was exhibited in Madrid in 1896. In January 1897 it was bought through Berenson from Colnaghi, London. *P21n12*

Giovanni Maria Falconetti — *A Story from Antiquity*

AUTHORITY

Glück, *Van Dyck* (Klassiker der Kunst, 1931), p. 450.

Exhibited 1896, Madrid, The Osuña Collection of Pictures, No. 33.

Version: Santa Barbara Museum of Art, canvas, 0.625 x 0.520, head and shoulders only, no landscape; apparently a replica. Glück in a certificate of 1929 described it as "achieved by van Dyck's own hand" and as "probably earlier" than the Gardner picture. He stated it would be included in the then forthcoming *Klassiker der Kunst* volume; but it appeared there only in a note as a replica *(Wiederholung)*.

THE RAPE OF EUROPA *Titian Room*

Red and black pencil, wash and body colour on paper, 0.34 x 0.40. This has been halved horizontally and rejoined.

This sketch cannot have been made from the original by Titian (q.v.), which remained during Van Dyck's lifetime in Spain, a country he never visited. Presumably it is from the copy painted by Rubens in Madrid in 1628, which is now in the Prado there. Rubens' copy was in his studio at his death and probably had been brought by him to Antwerp in 1628-30. Van Dyck may have made his sketch between then and his own departure for England in 1632. It is evidence both of his continued intimacy with Rubens and of the debt which they both owed to Titian. This is the most careful of the many studies that Van Dyck made from that artist. At his death he seems to have been the owner of nineteen pictures by Titian, including the pendant to *The Rape of Europa*, the *Perseus and Andromeda* now in the Wallace Collection in London.

There is no record of its provenance or of when Mrs. Gardner acquired it. *P26e13*

Emilian(?); 1350-1400

See VENETIAN(?); 1365-1415

Giovanni Maria Falconetti

Born in Verona 1468 (?); died in Padua 1534.

According to Vasari he spent many years in Rome studying the principles of Roman architecture; and to his contemporaries he seems to have been best known as an architect. He was, however, undoubtedly very active as a painter, not only in Verona, at least in the earlier part of his career. According to Marcantonio Michiel, who may well have known him in Padua, he was the pupil of Melozzo da Forlì; but his style belongs more distinctly to the neo-classicism introduced by Mantegna (q.v.). His elaborate *trompe-l'oeil* monochrome decoration of the S. Biagio chapel in SS. Nazaro e Celso at Verona was carried out in 1497-99. His frescoes in the Calcasoli chapel in the cathedral of Verona are signed and dated 1 September 1503. He had already in 1507 and 1508 been to Trento, where he painted the organ-shutters in the cathedral; and in 1514 he is recorded as restorer of an altarpiece there. According to Vasari he left Verona for political reasons. Certainly during his last twenty years he was active mainly as an architect in Padua.

A STORY FROM ANTIQUITY *Raphael Room*

Oil on pine-wood, 0.455 x 1.845. At the top of the panel a length of the moulding which originally enclosed it has survived; while the ends are dovetailed. These features, with the keyhole in the centre, show that this was the front of a cassone, or marriage chest.

Cleaning in 1970 removed a number of crude restorations, together with dark overpainting of the original background of smalt blue.

Otherwise, the scene is painted in grisaille. In 1871 Crowe and Cavalcaselle in their *History of Painting in North Italy* (see ed. Borenius, 1912,

II, p. 179, note 1) recorded frescoes by Falconetto on a housefront in the Piazza S. Marco, Verona, with "Roman contests, victories, sacrifices, and allegories, imitating the classic; hasty and incorrect in drawing, all on blue grounds. . . ." The remains are still there.

Here in the centre a green laurel wreath with yellow pears and (?) lemons at intervals surrounds a coat of arms in black and white and scarlet. This seems to divide the composition into two episodes, no doubt from the same story. On the left an enthroned king greets a small company of knights, whose leader, with one foot on the step of the throne, receives a scroll from the hand of a priest, or monk. On the right, in front of their camp, the knights are engaged in battle. The scene could represent a conversion to Christianity.

This is probably a comparatively early work by Falconetti, to whom it was already attributed when bought by Mrs. Gardner, probably in Venice in 1901. It has not previously been included in the Catalogue. *P16w2*

AUTHORITIES

Berenson in a note on Palazzo Barbaro (Venice) notepaper, undated: "Cassone pictures [*sic*] with young Warriors by Falconetto of Verona (architect & decorator, beginning of 16th century)."

Buddenseig, Tillman, in a letter to the Director of 16 April 1968, relates the picture to frescoes by Falconetti in the Palazzo d'Arco, Mantua.

Buddenseig and Schweikhart in *Zeitschrift für Kunstgesichte* (1970), pp. 35-36; they describe it as an early work.

Paolo di Giovanni Fei

First recorded in Siena 1369; died there 1411.

In 1368 the government of Siena was wrested from the nobles by the middle class, and for some seventeen years the merchants and professional men managed the affairs of the republic. Fei was elected to the Council in 1372. He was not the first painter to have been elected, and there is no record of him as a politician.

Of the many pictures attributed to him only the *Madonna* in S. Domenico at Siena bears a date: 1387. His only signed work is an elaborate polyptych with a much damaged central *Madonna* from a church near Rapolano, midway between Siena and Cortona, now in the Pinacoteca Nazionale at Siena. It is round this work, with its inscription *PAVLVS JOVANNE . . .*, that a large *oeuvre* of varied quality has been reconstructed. This and a still larger work in the Pinacoteca, a triptych with *The Birth of the Virgin* in the wide centre compartment, clearly show the inspiration of Pietro Lorenzetti, one of the monumental painters of the first half of the century. Paolo's typical products were on a much smaller scale. He seems to have been mostly occupied with portable altars: triptychs like the one below, diptychs and panels for domestic use. These he sought to modernise with a manneristic style, though they are based on earlier tradition.

Attributed to Fei

THE CRUCIFIXION, WITH SAINTS

Early Italian Room

Triptych, gold and tempera on wood. The centre panel 0.630 x 0.345, the wings (left) 0.617 x 0.173, (right) 0.619 x 0.180. Cleaning in 1940 revealed paint in good condition for the period. The engaged frame is largely original.

In the centre panel, *The Crucifixion*, the Virgin and S. John Evangelist, under the frenzied Cherubim, stand on either side of the cross; the Magdalen kneels to clasp it. Over *The Crucifixion* the *Redeemer* appears in a roundel. In the left wing are *SS. Stephen and Anthony Abbot*, and, above them, the *Angel of the Annunciation*. In the right wing are *SS. Catherine and John Baptist*, with the *Virgin Annunciate* above them. S. John's scroll is inscribed: *ECCE · AGVS* [sic] *· DEI*.

Such miniature folding altarpieces were fashionable in the fourteenth century, and were produced in greatest number at Siena. The panels were gilded and pounced and their Gothic tracery in low relief modelled in gesso (pastiglia work), generally in the artist's own workshop, before the painting was begun. Inevitably, they are apt to derive in varying degree from pictures by greater masters. Thus the figure of Christ on the cross in this picture is reminiscent of Simone Martini (*q.v.*), as can be seen from the small picture by Simone in the Fogg Art Museum. The little Cherub who bares his breast in anguish beneath Christ's left arm is taken from the large *Crucifixion* in fresco by Pietro Lorenzetti in S. Francesco, Siena. On the other hand, Fei's S. Stephen is very close to the same Saint in the great altarpiece in S. Stefano at Siena by Andrea di Vanni, who is said to have been his master.

Indeed the Gardner triptych was formerly catalogued as the work of Andrea, and this attribution has been widely accepted. As early as 1924, however, Van Marle declared that Fei was the painter,[1] and the compiler has gradually come to the conclusion that he was probably right, while admitting

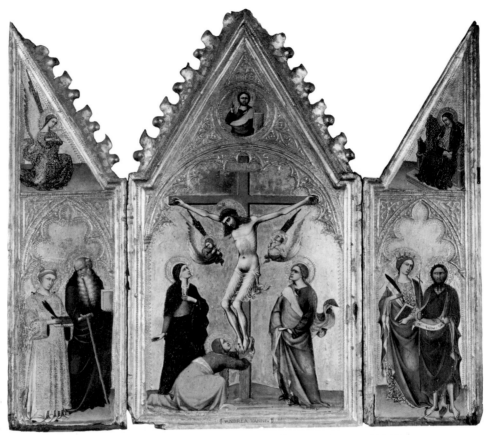

Attributed to Paolo di Giovanni Fei — *The Crucifixion, with Saints*

that either attribution must be tentative. Andrea di Vanni was rarely so spontaneous as this, or capable of this pleasant balance between the passionate and the decorative; nor was his colour so varied.

The triptych was bought for Mrs. Gardner by Joseph Lindon Smith (*q.v.*) from Simonetti in Rome, 27 October 1902. There was then no attribution. *P15n2*

[1]Van Marle, *The Italian Schools of Painting*, II (The Hague, 1924), pp. 534-35 and 537.

OTHER AUTHORITIES

Berenson in a letter to the compiler 4 February 1930; also *Central Italian and North Italian Schools* (1968), I, p. 440. He attributed the triptych consistently to Andrea di Vanni.

Fahy, in a letter to the Director of 16 April 1973, expresses doubts about the attribution to Fei.

Fredericksen and Zeri, *Census* (1972), p. 208; they attribute it to Andrea di Vanni.

Studio of Fei

SS. JEROME, MARY MAGDALEN AND FRANCIS *Long Gallery*

Tempera on wood, 0.23 x 0.33. The gold has been picked from the haloes and there are many fundamental losses; but cleaning since 1931 has revealed a painting of better quality than was previously apparent.

In the centre the Magdalen rises into heaven supported by two Angels. To the left of her S. Jerome chastises himself before his crucifix, his cardinal's hat on the ground, his lion in attendance. To the right S. Francis receives the stigmata before the eyes of his companion.

The inclusion of three such scenes in one picture is unusual. At the same time it is self-contained. There is a true paint edge on all four sides, where the painting originally finished against the engaged frame. These facts, combined with the comparatively large dimensions, make it unlikely

Studio of Fei
SS. Jerome, Mary Magdalen and Francis

had already catalogued it in 1909 as the work of Fei,[1] and the attribution was maintained both in 1932 and in his posthumous lists. The revised dating thus implied is certainly justified, and there is a resemblance to Fei's types. P27w23

[1]Berenson, *The Central Italian Painters of the Renaissance* (1909), p. 165; *op. cit.* (1932), p. 183; *op. cit.* (1968), I, p. 128.

OTHER AUTHORITY

Fredericksen and Zeri, *Census* (1972), p. 192; they attribute it to Stefano di Antonio (1407?-83).

that it ever adorned a predella as part of a series. This was possibly an economical substitute for a triptych.

It was catalogued in 1931 with unjustifiable vagueness as "Tuscan (?); 1350-1450." Berenson

Florentine; 1365-95

THE ANNUNCIATION *Early Italian Room*

Gold and tempera transferred (not long after purchase) to linen stuck to a mahogany board, 1.414 x 1.085. The original shape, with round-arched top, has almost certainly been retained. In the 1931 Catalogue the picture was described as "no doubt

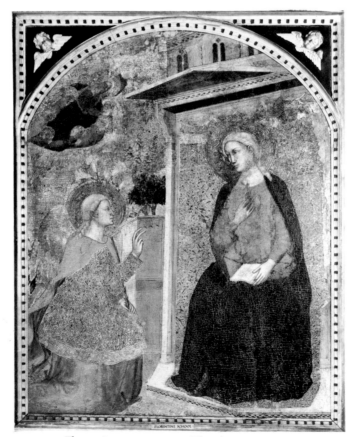

Florentine; 1365-95 — *The Annunciation*

reconstructed from the wreck of a Florentine panel of the late fourteenth or early fifteenth century." In 1937 the comparatively recent overpainting of the whole surface was removed, together with the gesso and gold in which the original pastiglia had been reconstructed or overworked. Though the restorer had invented some detail, he had not altered the basic design. Gabriel's head and hands and the upper part of the Virgin's head, with her left hand, are not in bad condition, and the original textures have regained a worn charm. Enough of the Child travelling on a cloud from the Eternal Father to the Virgin has survived to explain the restorer's reconstruction, which has been removed. This motif was an unusual feature at the time.

The original effect must have been exceptionally gorgeous, the austere simplicity of composition and outline allowing for a surface almost completely overlaid with gold and silver, for the most part finely patterned and glowing in many places through translucent colour. The gold sky is pounced in rays and the ground under the Archangel covered with cloth of gold. This character and the worn condition make an attribution unusually difficult; but the picture must belong to the time when Orcagna was the leading painter in Florence. The style is perhaps nearest to that of his brother Jacopo di Cione (active 1365-98),[1] in his earlier years.

Berenson was eager for Mrs. Gardner to acquire this picture which he described as a "very important" work by Agnolo Gaddi and "a very great bargain." On 16 October 1901 he acknowledged a cheque for the sum which he had quoted and wrote that he had forwarded it to "Miss Toplady," a firm recently established by Mrs. Berenson's brother and sister.[2]

P15s2

[1]Berenson in a letter (4 February 1930) attributed it to an anonymous Florentine of about 1400 "in the neighbourhood of Jacopo di Cione"; and *Florentine School* (1963), I, p. 103, to Jacopo di Cione(?).

[2]Morris Carter in a note in the Museum archives.

OTHER AUTHORITIES

Boskovits, Miklòs, in a letter to the Director of 21 June 1972 and in an earlier conversation with the compiler, attributes it to Lorenzo di Bicci. This attribution had been suggested by the late Hans Gronau in a note on the photograph in the Witt Library, Courtauld Institute, London.

Fredericksen and Zeri, *Census* (1972), p. 218, as Florence, fourteenth century.

Van Marle, *The Italian Schools of Painting*, III (1924), p. 557, note; he contradicted the former attribution to Agnolo Gaddi, but offered no alternative.

Sirèn in *The Burlington Magazine*, XV (1909), p. 197, attributed it to the North Italian School of the early fifteenth century.

Florentine; 1375-1425

THE MARTYRDOM OF S. BARTHOLOMEW
Long Gallery

Tempera on wood, 0.18 x 0.32, including a strip added to each side. A black border confines the composition to an octagon, and the corners of the rectangle are gilded and pounced.

Evidently from the predella of an altarpiece. Attributions have been suggested to Bicci di Lorenzo (*q.v.*)[1] and Stefano di Antonio (1407?-83).[2]

P27w24

[1]Boskovits, Miklòs, in a letter to the Director (Florence, 21 June 1972); he suggests a date about 1420.

[2]Fredericksen and Zeri, *Census* (1972), p. 192.

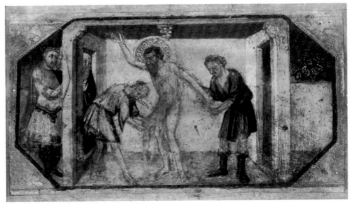

Florentine; 1375-1425 — *The Martyrdom of S. Bartholomew*

Pietro Fragiacomo — *A Venetian Lagoon*

Pietro Fragiacomo

Born at Trieste 14 August 1856; died in Venice 1922. He studied in the Accademia at Venice under Favretto 1878-80, and exhibited first at Turin in 1880. He lived in Venice, and won a great success with his paintings of the lagoon country, exhibiting in Berlin in 1886 and in Paris in 1889. His art is represented in the Gallerie Moderne of Venice and of Rome.

A VENETIAN LAGOON *Macknight Room*

Oil on panel, 0.27 x 0.41. Signed at the foot on the left: *P Fragiacomo.*

Bought by Mrs. Gardner from the painter in Venice, June 1884. *P11n2*

Il Francia

FRANCESCO RAIBOLINI: born at Bologna 1450 (?); died there 1517-18. His father Marco di Giacomo Raibolini was a woodcarver. Francesco is traditionally believed to have taken the name FRANCIA from that of the goldsmith to whom he was apprenticed; and a goldsmith he remained throughout his career, entering the Guild at Bologna 10 December 1482 and acting as its Steward for the last time in 1512. He made costly ornaments for the rulers of Bologna and Ferrara. He was Mint Master to Giovanni Bentivoglio, and was continued in the office by Pope Julius II, who expelled the Bentivogli from Bologna in 1506.

Francesco Cossa, who had come to Bologna in 1470 from Ferrara, helped to form Francia's earliest pictures: the signed *S. Stephen* in the Borghese Gallery in Rome or *The Holy Family*, also signed, in Berlin. Francia painted this for the dilettante Bartolommeo Bianchini, whose portrait, now in London, he also painted. Cossa's ideas show themselves not only in Francia's motifs but in the sharp clear technique to which he gave an enamel in keeping with his goldsmith's craft. But this early delicacy of finish and richness of colour quickly gave way to a more summary use of opaque oils as he applied himself more to painting. Mantua and Ferrara had their great painters, and the time was ripe at Bologna. In 1490 Francia opened there a school of all the arts and crafts in partnership with the painter Lorenzo Costa. The first of his great altarpieces, the signed *Madonna and Child with Six Saints and the Donor, Bartolomeo Felicini* in Bologna, is dated 1494. Giovanni Bentivoglio commissioned his great signed altarpiece in S. Giacomo Maggiore there in 1499, and between 1504 and 1506 the cycle of frescoes in the oratory of S. Cecilia, of which Francia did the two pictures on either side of the altar. He painted another cycle in the Bentivoglio Palace, destroyed soon afterwards, and he had painted in 1499 for Giovanni's second son, Archdeacon Anton Galeazzo, *The Adoration of the Child, with S. Augustine and the Donor,* now in the Pinacoteca. He did several altarpieces for churches at Modena, including *The Baptism* from S. Biagio, now in Dresden, dated 1509. There is a large *Coronation of the Virgin with Saints* in the cathedral at Ferrara. The portrait of *The Young Federigo Gonzaga* in New York was painted at Bologna in 1510 for Federigo's mother Isabella d'Este, Marchioness of Mantua. The next year Francia probably went to Lucca to paint there *The Immaculate Conception* in S. Frediano, whence also comes the great signed altarpiece, *The Madonna and S. Anne with Saints* now in London. *The Pietà with S. Anthony of Padua,* now in Turin, and *The Madonna and Child with Saints* at Parma are both signed and dated 1515.

The earlier of these great altarpieces belong in effect to the school of Giovanni Bellini. The ideal is an illusion of rich, absorbing atmosphere within a deep architectural space such as Bellini and his pupils were creating at Venice. Francia's open scenes are less successful. Sentimental expression came freely to him, and he soon developed a flowing ease of formal design more akin — though much less tense — to that of Perugino, whose influence from his earliest years is also visible in landscape motifs, in the expression of his characters and in his impure colouring. Francia's altarpiece from Lucca in London shows his style mature. The scale of the design is broadened and the relief made shallower in order that more ample but less plastic contours may sweep the surface.

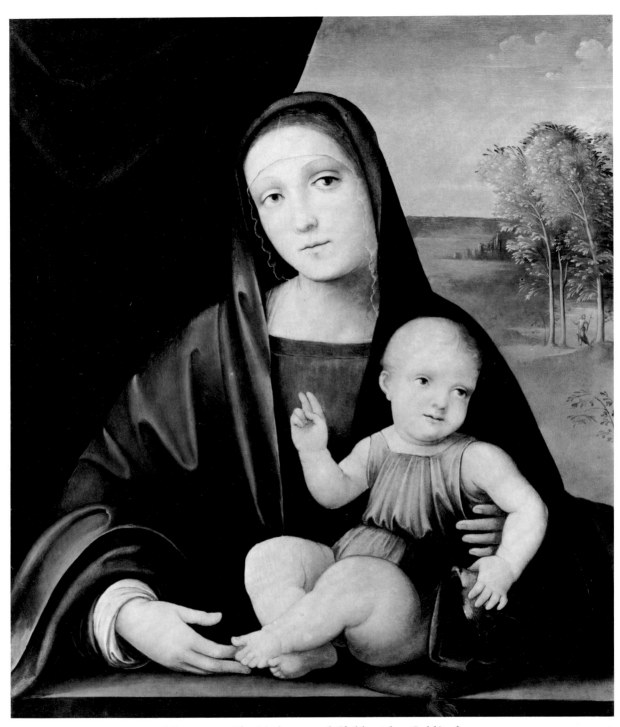

Il Francia — *The Madonna and Child, with a Goldfinch*

Francia was very prolific, and had a great reputation. He was celebrated at Bologna in prose and in poetry for the sweetness both of his art and of his disposition. He took some part in public affairs, being elected one of the sixteen Gonfalonieri of the popular party in 1511 and proposed as a representative for one of the districts governed with the city in 1514. That year he was Steward of the Guild of Four Arts, which he had entered in 1503. Two sons, Giacomo and Giulio, born in 1485 and 1487, continued his style of painting.

THE MADONNA AND CHILD, WITH A GOLDFINCH
Raphael Room

Oil on chestnut (?) wood, 0.582-88 x 0.483-86. Cleaning in 1954 revealed very little damage except from scattered worm holes. There is a paint loss in the outer corner of the Virgin's left eye, and some abrasion on the Child's left thigh.

Behind, in the distant landscape S. John Baptist wanders among the trees. For the significance of the goldfinch, see under Daddi.

The design has those sweeping, somewhat superficial contours which are characteristic of Francia's late style. This emanates perhaps from Perugino, and in a sense anticipates the ideas of Raphael. Raphael was an admirer of Francia, praising the expression of his Madonnas. The likeness of Francia's trees here to those in Raphael's little *Pietà* (*q.v.*) gives another hint of their relationship.

The panel was bought in 1899 through Berenson of Costantini in Florence. *P16e7*

AUTHORITIES

Berenson in a letter to the compiler (4 February 1930); also in *Central Italian and North Italian Schools* (1968), I, p. 146.

Fahy, in a letter to the Director of 16 April 1973, attributes it to Francia's workshop. The possibility is not to be disputed.

Fredericksen and Zeri, *Census* (1972), p. 74.

Pedro García de Benabarre

PERE GARCÍA DE BENABARRE on his one signed work. Benabarre, in the Aragonese province of Huesca, is not far north of Lérida, which was then in Catalonia.

One of the leading exponents of the International Gothic style in Catalonia was Bernardo Martorell. He died in 1452. By a contract of December 1455 his widow and their young son Bernat took into partnership Pedro García de Benabarre, who pledged himself to carry on the Martorell workshop for five years from 1 January 1456. Soon after Martorell's death the widow had made a similar contract with Miguel Nadal; but the partnership had proved unsatisfactory. García thus presumably succeeded both Martorell and Nadal as head of a prolific workshop. García's signature on a *Virgin and Child Enthroned, with Angels* in Barcelona is the only other contemporary document concerning him. It comes from Bellcaire, Lérida. Among many works of varying quality the most notable are the two main panels of a retable in the parish church of Graus, north of Lérida. The picture below is entirely typical, continuing the Catalan tradition at a time when this was dominated by Jaime Huguet. García's painting differs from Huguet's mainly in its slighter capacity to find expression beneath the gilded load of embossed ornament and broadly figured brocades.

S. MICHAEL
Tapestry Room

Gold and tempera (?) on wood, 1.84 x 1.44. The panel is in vertical strips and there are slight losses down the join in the centre, as well as some abrasion of the whole surface. A patch of clumsy restoration covers fundamental damage to Satan's left leg, below the knee, and right ankle.

The brigandine of crimson velvet over the black chain armour is studded and buckled with gold, embossed like the pommel and the hilt of the sword. Similarly embossed and gilded are the haloes and the great pattern of thistle ornament on the gilt background. The black-lined cloak is crimson, the shoes and sleeves scarlet; the figured damask behind is gilt on a blue ground. The Archangel executes both his offices: as general against Satan, who lies beneath his feet, still able to clutch at the scales with which S. Michael performs his other office, of weighing the souls who wish to enter Paradise. The scale is tipped against the Angel who rescues a soul from the other side.

This panel once formed part of a colossal retable, with five others now in Barcelona: *S. Jerome with his Lion* and four *Scenes from the Life of S. John Baptist*. All six are of much the same size, and it is believed that there was a centre panel, larger still, now lost or unrecognised. In the last century they are said to have been in the parish church of Benavente, in Huesca, Aragon;[1] but they were brought there from a church which has been destroyed, S. Juan del Mercado at Lérida.[2] The presumed lost centrepiece would therefore have been a figure of S. John Baptist.

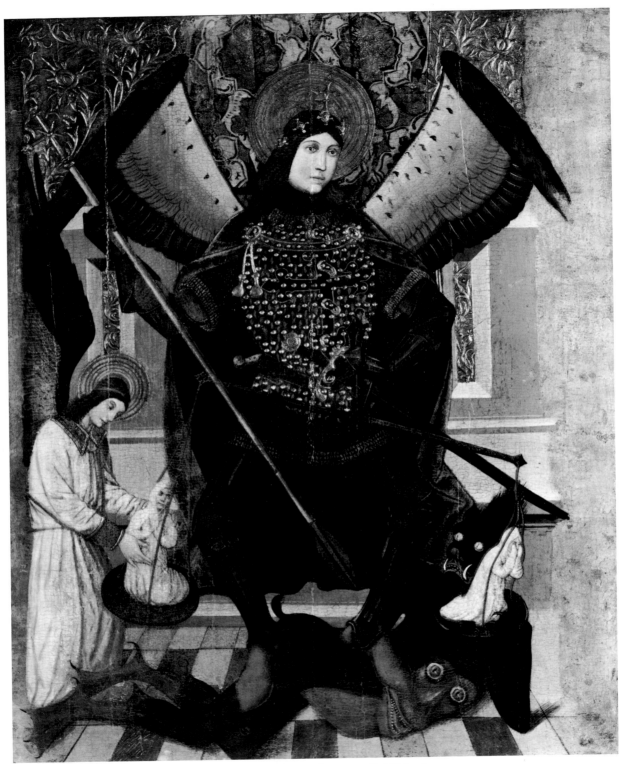

Pedro García de Benabarre — *S. Michael*

Ignaz Marcel Gaugengigl — *Self-Portrait*

The panels are very similar in style and in crafts-manship to García's one signed picture, now in Barcelona.

The *S. Michael* was bought ("tableau primitif") from Demotte of Paris in April 1916 by Paul J. Sachs. At her request he sold it to Mrs. Gardner the same year. *P19s7*

[1]Pijoan in a letter of December 1929 quoted Dupont, a dealer who claimed to have brought the retable (or most of it) to Barcelona in 1907.

[2]Sobré, Judith B., in *Fenway Court*, III, No. 4 (April 1970), pp. 25-31.

OTHER AUTHORITIES

Dieulafoy, *Art in Spain and Portugal* (New York, 1913); he did not mention the picture, but it was reproduced as a coloured frontispiece with the legend: "Saint Michael, Fragment of the Reredos of Benavent."

Gaya Nuño, J. A., *La Pintura Española fuera de España* (1958), p. 152.

Post, *A History of Spanish Painting*, VII (1938), pp. 268-75; he accepted the attribution to García, made for the first time in the Catalogue of 1931.

Ignaz Marcel Gaugengigl

Born at Passau in Bavaria 1855; died in Boston 3 August 1932.

He was educated in Munich, finishing at the Academy of Fine Arts there. He came to the United States in 1880, and settled in Boston. Here he re-mained for the rest of his life.

SELF-PORTRAIT *Blue Room*

Oil on canvas, 0.75 x 0.62. Signed at the top on the right: *I. M. GAUGENGIGL.*

Painted, presumably about 1910, for the Tavern Club, Boston, where it hung until the painter re-signed from the club during World War I. It was then returned to him. It was bought from him by Mrs. Gardner 12 February 1920. *P3e20*

Gentile da Fabriano

Born at Fabriano, in the Marches, presumably about 1370; died in Rome 1427.

His great polyptych, now in Milan, comes from near Fabriano, and was painted probably not much after 1400. He returned to his native town at intervals. He is first recorded in 1408 in Venice; and there for a number of years he painted with Pisanello frescoes in the Great Hall of the Doge's Palace, which were later destroyed. In 1421 he was a Master of the Guild of S. Luke in Florence, where he painted the altarpiece with *The Adoration of the Kings*, now in the Uffizi Gallery. This is signed and dated 1423. In 1424-25 he was working at Siena. His *Madonna* in fresco in Orvieto cathedral is dated 1425. He had already worked for Pope Martin V in Rome, and in 1426 was summoned to return. He died while painting for Pope Martin in S. Giovanni in Laterano.

The style which he had rapidly developed from Nuzi (died 1373) in Fabriano, sumptuously decorative, represents the subtlest flowering of the International Gothic in Italy. Its poetic naturalism, greatly stimulated by the contact with Pisanello, had a strong influence upon several otherwise divergent local schools: especially the Florentine and, more profoundly, the Venetian.

Style of Gentile

THE MADONNA OF HUMILITY, WITH A DONOR
Early Italian Room

Gold and tempera on poplar wood, with cusped top: 1.000 x 0.580. Cleaning in 1942-43 revealed, besides a generally worn condition, some fundamental damage to the Child's face, including the eye, and small horizontal losses along the craquelure across his left shoulder and his body, below the chest. The Virgin's dark blue mantle has suffered in the same way, more severely; and there is a small paint loss in the corner of her left eye. The foreground is considerably damaged. The arms previously visible on the shield in the centre proved to be modern, and were removed. The engaged frame is perhaps largely original.

The Virgin's halo is inscribed: *AVE MARIA PLENA DOMIN..* and the words *AVE MARIA* are inscribed and gilded wherever the hem of her mantle shows.

The "Madonna of Humility," seated on the ground, is normally suckling the Child; but here he has to bless the donor, evidently a dignitary of some importance, with his scarlet robe and hood, ermine-lined.

The picture is coarsely painted and clumsily designed after the model of Gentile. Its rounded calligraphic outlines, enriched and emphasized by the curling scroll of the hem, belong to the late Gothic tradition in which he designed until the last few years of his career. The Madonna, with the characteristic droop of the head, is of the type he painted for many years, and the little animals of the foreground are a concession to the interest he developed in depicting every kind of living thing. The design, however, is most in sympathy with one of his earliest panels, *The Coronation of the Virgin* in Milan, which comes from near Fabriano. *The Madonna of Humility* perhaps also comes from the Marches; but the handling of the paint is too different from Gentile's to be that of an assistant.

It was bought after 1909 from Joseph Lindon Smith, formerly the owner also of the panel by Bicci di Lorenzo and the author of several paintings in this collection. *P15w5*

AUTHORITIES

Fredericksen and Zeri, *Census* (1972), p. 79; they attribute it to a follower of Gentile.

Gnoli (at Fenway Court, 16-17 December 1926) attributed it to the workshop of Gentile.

Van Marle, *The Italian Schools of Painting*, VIII (The Hague, 1927), pp. 22-25: "I know this picture only from a poor photograph. . . . Judging from the face of the Virgin I should say all the same that the picture is probably from the hand of Gentile." At Fenway Court (February 1930) he maintained this attribution.

Zeri, F., in a letter to the Museum (1950): "derivation from a youthful work by Gentile himself . . . by a painter from the Veneto or Emilia."

Exhibited 1909, Boston, Museum of Fine Arts, as of the Venetian School.

Influenced by Gentile

THE MADONNA AND CHILD BEFORE A ROSE HEDGE
Early Italian Room

Gold and tempera on birch (?) wood panel, with arched top, 0.825 x 0.480. The panel has been reduced at the sides; but not by enough to prove that the carved and gilt Gothic frame, with its arcaded canopy, is not the original. It is, however, not engaged and is much restored, base, left side and pinnacles being modern. After cleaning in 1940 no attempt was made to make good the severe losses in the painting. Even the gesso ground has gone from the Child's halo and from the greater part of the Virgin's, in some places from her mantle, where only traces of the azurite pigment have survived. Much paint has been lost from the Child's body and left arm.

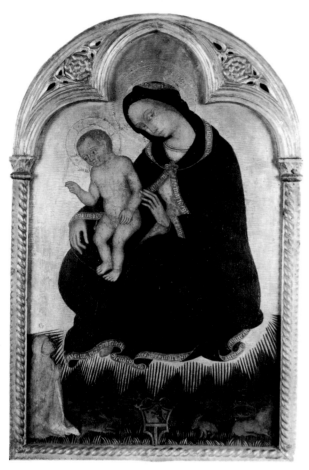

Style of Gentile
The Madonna of Humility, with a Donor

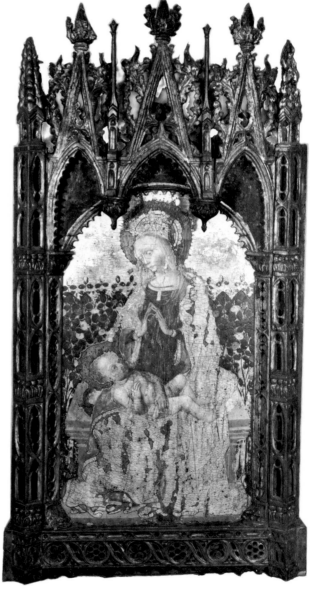

Influenced by Gentile
The Madonna and Child before a Rose Hedge

The motifs of the rose hedge or rose garden and of the crown which supplements the Madonna's halo are of German origin, a part of those Gothic ideas which in the late fourteenth and early fifteenth centuries came down through Venice and Verona into the Italian Marches. The conversion of the hedge into a formal grille is peculiar. The personality of Gentile da Fabriano has gone to mould the types and to curl into a scroll the hem of the Madonna's robe. But the painting contrasts strongly with that of the other picture influenced by him (above) in its refined character, in the daintiness of scale and detail and in the bright colouring — the hair of Madonna and Child is orange and the seat is of the same hue, gaily opposed to the light crimson lining of her mantle and the green of her robe.

By now this particular follower of Gentile has been recognised as the author of a group of pictures. A similar composition in a similar frame in the collection of the Marchese Visconti Venosta in Rome was attributed by Carlo Gamba to a follower of Gentile from Umbria or the Marches.[1] More recently the same hand has been observed by Federico Zeri in an altarpiece at Lonigo, near Vicenza, *The Madonna with SS. Anthony Abbot and Jerome, and Two Angels*, and in another, No. 5 in the Musée Bonnat at Bayonne, *The Madonna of Humility*. The painter has been dubbed by Serena Padovani "The Master of Lonigo," and she has gathered under this name not only the Gardner picture and all those already mentioned but others of *The Madonna of Humility* in three Milanese private collections and in a fourth private collection in Berlin.[3]　　　　*P15n12*

[1]Gamba in *Dedalo*, I (1920), p. 517.

[2]Zeri in a letter from Rome, 30 January 1950.

[3]Padovani in a letter from Florence, 11 July 1973.

Niccolò di Pietro Gerini

Active in Florence 1368; died before February 1416.

He may well have learned to paint in the studio of Taddeo Gaddi, who influenced his earlier works. Taddeo died before 1366, and in 1368 Niccolò matriculated in the Guild of Physicians and Pharmacists in Florence. He joined the circle of Orcagna. He is probably the Niccolaio who collaborated in the painting of several pictures in the style of Orcagna after his death in 1370: such as the large altarpiece with *The Coronation of the Virgin* from S. Pietro Maggiore, Florence, now in London (Nos. 569-78, under Orcagna), and another *Coronation*, undertaken three years later with a painter called

Simone and with Jacopo di Cione for the Florentine Mint and now in the Uffizi Gallery. In 1383 at Volterra he collaborated with Jacopo di Cione in the large fresco triptych *The Annunciation, with Saints* which survives in a ruinous condition in the Palazzo dei Priori there. In 1399 he contracted, together with his son Lorenzo and with Spinello Aretino, to supply an altarpiece for the high altar of S. Felicità, now in the Florence Accademia.

His earliest and best preserved frescoes are those covering one wall of the sacristy of S. Croce at Florence. These still show the influence of Taddeo Gaddi. In 1391 he was working with Taddeo's son Agnolo at Prato, and the date 1392 was once to be read on the now half-ruined frescoes which Niccolò painted in the chapter house of S. Francesco at Pisa. He painted the *S. Nicholas* on a pillar of Or San Michele at Florence 1408-09. In 1408 and in 1411 he was again at Prato. There are some frescoes there by him and his assistants in the chapter house of S. Francesco.

The easy collaboration with other painters is characteristic of the vast quantity of painting produced in Florence in the later fourteenth century, in which the painters are to be distinguished rather by their manner than by their ideas. Niccolò was one of the most prolific. His execution, though coarse, is firm and careful; and he thus occupies a foremost place among the painters who succeeded Orcagna. In his hands already dry conceptions took on a ponderous formality which he maintained for nearly fifty years. His heavy figures, with their simple, sculpturesque outlines, and his rigid formality of composition stand as a kind of bulwark against the Gothic airs and graces affected by his son Lorenzo and the younger generation. The picture below is among the finest of his panels.

S. ANTHONY ABBOT, WITH FOUR ANGELS
Early Italian Room

Gold and tempera on wood, Gothic-arched, 3.075 x 1.272. The original Gothic frame, considerably restored, has, in a trefoil above, a figure of *The Redeemer* in half length. The condition of the painting is good.

From the rigid symmetry of his setting S. Anthony stares square and solemn. The background is of gold, the hanging of black and gold and scarlet, and the black and the icy grey of his habit and the scarlet of his book are in tune with Niccolò's hard and abrupt outlines. Typical also is the yellow, shot with dull purple, which colours part of the robes of each Angel. The stolid composition is a good example of that phase of Florentine painting

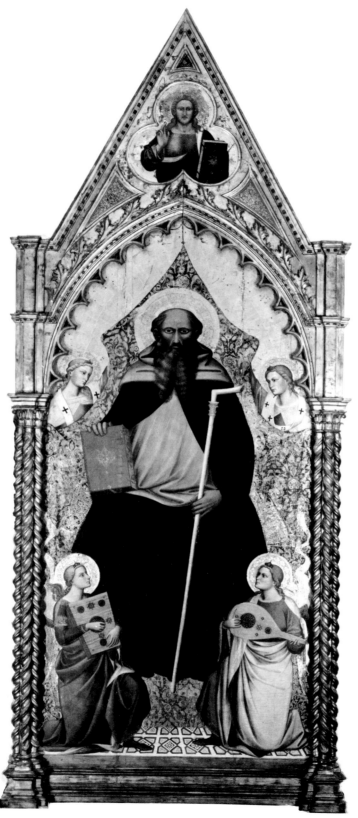

Niccolò di Pietro Gerini — *S. Anthony Abbot, with Four Angels*

between the death of Giotto and the coming of Masaccio, which attempted, against the floridity of the prevailing Gothic, to uphold Giotto's tradition of plastic simplicity. It maintained the purity of his technique and the largeness of his composition; but in its unbending conservatism it lost variety of expression and vitality.

Bought 20 October 1906 from the Galleria Sangiorgi in Rome, who were already the owners in 1904. It was called *S. Jerome* and attributed to Orcagna. *P15n9*

AUTHORITIES

Berenson in a letter (4 February 1930); also in *Florentine School* (1963), I, p. 158.

Fredericksen and Zeri, *Census* (1972), p. 81.

Van Marle, *The Italian Schools of Painting*, III (The Hague, 1924), p. 627; he attributed it hesitantly to a follower of Niccolò, together with a number of pictures including Nos. 58 and 60 in the Vatican Gallery and *The Trinity with Two Donors* in the sacristy of the church at Impruneta near Florence. The former, attributable probably to different artists of the succeeding generation, are of poor quality; the latter is perhaps by Niccolò's son Lorenzo, to whom the *S. Anthony* was at one time attributed.

Offner, *Studies in Florentine Painting* (New York, 1927), p. 91; he dated it between 1392 and 1401. Also *A Critical and Historical Corpus of Florentine Painting*, Section IV, Vol. 3 (1965), p. 115, note 5.

Sirèn, *Giottino* (Leipsic, 1908), p. 89, and in *The Burlington Magazine*, XIV (1909), p. 193, note 4, attributed it to Jacopo di Cione.

Exhibited April-August 1904, Siena, Early Sienese Art, No. 2720 (Sala XL, No. 11), attributed to the Tuscan School (Corrado Ricci, *Catalogo Generale*, p. 363).

German; 1450-1500

THE ANNUNCIATION *Chapel*

Oil on wood, 0.65 x 0.38. There is a diagonal abrasion above the Madonna's knee. The scroll entwined round Gabriel's wand is inscribed with the first words of the *Ave Maria*.

The canopy is of light green with a damask lining of crimson and silver. A gold curtain is behind. The Madonna is dressed in blue with a white mantle, and Gabriel in yellow shot with red, with a cloak of scarlet lined with green.

Painted by a rough provincial hand, the panel comes probably from the south of Germany, and the composition may be traced perhaps to that on a wing of the altarpiece by Michael Wolgemut in the church of the Holy Cross at Nuremberg.

Bought perhaps from Theodor Einstein of Munich 16 August 1897. *P28e22*

German (?); 1850-97

A PROCESSION *Chapel*

Oil on wood, 0.94 x 0.48.

The costumes and the architectural motifs are of the sixteenth century; but the painting is probably of the later nineteenth century.

It was bought from Julius Böhler in Munich as "goth. Bild 'Prozession'" 17 August 1897. *P28e13*

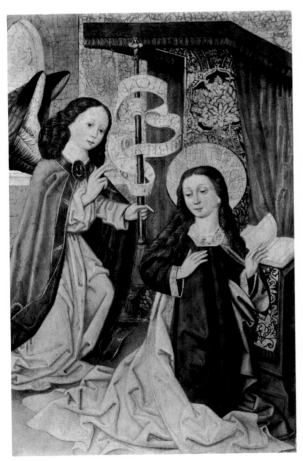

German; 1450-1500 — *The Annunciation*

German(?); 1850-97 — *A Procession*

Michele Giambono

MICHELE DI TADDEO DI GIOVANNI BONO: already married and a painter in 1420; last recorded alive in 1462.

He signed himself *Venetus* on two works, and appeared intermittently in Venetian records throughout his life, usually as a resident in the quarter of S. Gregorio. In 1422 he entered the important Guild of S. Giovanni Evangelista. Only two, not very significant, commissions are recorded: 28 December 1440 he received with the sculptor Paolo Amadei the contract for the carved and gilded altarpiece for the high altar of S. Michele at S. Daniele del Friuli, now in S. Antonio there (Giambono presumably did the design and the painting and gilding of the surface); 31 May 1447 he accepted an order to

copy for the church of S. Agnese in Venice the altarpiece with *The Coronation of the Virgin* by Giovanni d'Alemagna and Antonio Vivarini in S. Pantaleone there. His copy is probably the damaged picture now in the Accademia. In 1453 he was one of two artists employed by Gattamelata's son and heir to value Donatello's famous bronze equestrian statue of the general at Padua.

As well as painter and gilder he was a mosaicist. *The Birth of the Virgin* and *Her Presentation* in mosaic in the chapel of the Mascoli in S. Mark's bear his signature and all the qualities of his art, while in *The Visitation* and *The Death of the Virgin* he collaborated with the Vivarini. These works were begun in 1444. There are also two panel pictures with his signature: the altarpiece with *S. James the Great, S. John Evangelist, Filippo Benizzi, S. Michael and S. Louis of Toulouse,* from S. Giacomo alla Giudecca, now in the Venice Accademia, and *The Madonna* in Rome. A late work of his at Venice is the *S. Crisogono on Horseback* in the church of S. Trovaso.

In Venice, until Giambono was at the end of his career, Gothic ideas still dominated art, and the forms of architecture helped to make glass and mosaic as important as painting. The frame was as significant as the picture, and in the picture the ornament was often as much considered as the paint. Painting had come to have little expression and fixed ideas of composition. Inheriting the ideas of Jacobello del Fiore (d. 1439), Giambono surpassed him in subtlety of design, in beauty of colour, in the quality of his ornament. This was due partly no doubt to the inspiriting influence of Gentile da Fabriano (*q.v.*), who had been painting in Venice from 1408 for several years.

Giambono died at the opening of the new era begun by Giovanni Bellini (*q.v.*), keeping the full flavour of the last Gothic style. The ogive of a hundred sumptuous church and palace façades then gracing the canals of Venice is reflected and refined in the graceful, richly flowing curves of his figures. These are single figures only. Giambono was innocent of the Renaissance interest in space or light.

A BISHOP SAINT *Early Italian Room*

Tempera, with oil glazes, on pine wood, 0.388 x 0.289. Cleaning in 1938 revealed fairly well preserved paint, except for the background of azurite. This had been overpainted in black, and only close to the contour of the figure did it not have to be extensively retouched.

The panel has long been recognized as a part of a polyptych by Giambono.[1] More than twenty-five

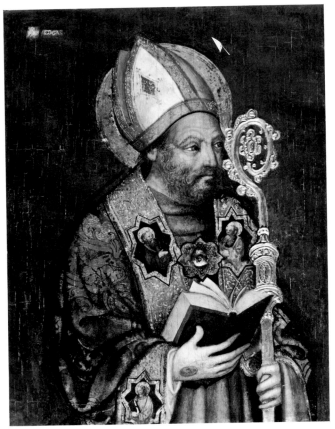

Michele Giambono — *A Bishop Saint*

years ago, most of the altarpiece was reconstructed from panels now scattered through different museums.[2] The centrepiece was the *S. Michael Enthroned* (1.03 x 0.57) in the Berenson Collection at Settignano, Giambono's outstanding masterpiece. The four full-length Saints which probably completed the main tier are *S. Peter* (0.86 x 0.35), now in Washington, D. C.; *S. John Baptist* (0.85 x 0.35), now in the Bardini Museum, Florence; *A Pope* (0.84 x 0.35) and *A Bishop* (0.84 x 0.35), both in Padua. Over these were four Saints in half length: the Gardner *Bishop*; *A Saint with a Book* (0.38 x 0.28) in London (these two on the left); *A Bishop Martyr* (0.37 x 0.30) in Padua; *S. Stephen* (0.31 x 0.23) in the Gibert collection at S. Giovanni di Biagio, Como.[3] One or two minor anomalies have to be explained. The *S. Stephen* panel is smaller, and has to have been reduced. The London *Saint* alone has a black background; but this is almost certainly due to an overpainting of the nineteenth century or earlier. Like the Gardner picture, it came from Guggenheim, a dealer, in Venice, and Mrs.

Gardner's picture then also had a black ground, removed in 1938. This piece of history makes it possible to discount the fact that the London panel is of poplar, the Gardner panel of pine. Some idea of the original effect of the whole may be gained from the great polyptych with *The Madonna Enthroned* at Fano, even though the upper tier there is not by Giambono.

Though this now dismembered altarpiece was probably Giambono's most important work, its original destination is unknown. It seems likely, however, to have been a church or other public building in Padua, since six out of the nine panels are probably traceable to private collections there in the latter part of the nineteenth century.[4]

Mrs. Gardner bought her picture 28 September 1897 from Gugghenheim in Venice, as the work of "Vivarini." *P15e1*

[1]J. P. Richter, *The Mond Collection* (1910), I, p. 62.

[2]R. Longhi, *Viatico per Cinque Secoli di Pittura Veneziana* (1946), p. 50; he omitted the Gardner picture.

[3]E. Sandberg-Vavalà in the *Warburg and Courtauld Journal* (1947), pp. 20-26; she concluded the reconstruction initiated by Longhi, including the Gardner picture.

[4]M. Davies, *National Gallery Catalogues, The Earlier Italian Schools* (1961), pp. 224-26.

OTHER AUTHORITIES

Berenson, *Dipinti Veneziani in America* (Milan, 1919), p. 19; in a letter to the compiler (4 February 1930); *Venetian School* (1957), I, p. 82.

Fredericksen and Zeri, *Census* (1972), p. 84.

Pallucchini, *Michele Giambono* (1947), p. 21.

Giorgione

See Giovanni BELLINI, after

Giotto

GIOTTO DI BONDONE: born at Colle di Vespignano in the Mugello valley, north of Florence, probably in 1267; died in Florence 1336-37.

Traditionally the pupil of the Florentine Cimabue, whose greatest work is a cycle of frescoes in the apse and transepts and part of the nave in the Upper Church of S. Francesco at Assisi. The decoration of this church was a joint achievement by many great painters working in the last two decades of the thirteenth century. It provides a fruitful field for controversy. A considerable body of modern historians seems justified in recognising as Giotto's earliest extant work the scenes from the lives of Isaac and Joseph and Christ, in the upper part of the nave at the west end. These, however, are found in the company of other paintings by artists from Rome; and those now attributed to Giotto show the influence of Pietro Cavallini. While Cimabue's hieratic but passionate art is an intensified extension of the Byzantine tradition, Cavallini's serener humanism belongs to a Roman revival. Giotto, according to Cennino, writing towards the end of the fourteenth century, "translated the art of painting from Greek into Latin, and made it modern." The modernism is striking in the *Scenes from the Life of S. Francis*, painted in the grand tier of the nave in the Upper Church, some ten years later, from 1296. The best of these are attributed to Giotto; otherwise we have to postulate the existence of a now forgotten painter who could respond with forms powerful enough for the drastic magnification in the scale of the scenes, and to the new conception of space achieved by the church's architect and the need of narrative freshness in the story of the modern Saint. The painter drew some inspiration from the great sculptor and architect of the previous generation, Arnolfo di Cambio.

Nor can Giotto have arrived without arduous preparation at the great achievement which is his with universal acknowledgement: the cycle of frescoes including *Scenes from the Life of the Virgin and of Christ* covering the interior of the Arena Chapel at Padua. Here the sense of architectural space is sacrificed to the much greater compactness of composition which smaller scenes make possible. Giotto began to paint the cycle in 1303-04 and must have finished at latest by 1310.

Giotto returned to Padua to do other work which has disappeared, and he also worked in Rimini. He had been in Rome in 1300, probably painting a cycle of frescoes in the Lateran Palace, of which there are now only traces. He was apparently there again in 1313, and it may have been then that he designed his famous mosaic, the *Navicella*, in old S. Peter's, of which copies survive. Probably in 1314 he returned to Assisi about the fresco decoration of the Cappella di S. Maddalena, carried out for Tebaldo Pontano at least from Giotto's designs. Other frescoes to be attributed to him are in two chapels of S. Croce in Florence, those of the Bardi and of the Peruzzi families, painted probably in the twenties.

Some modern writers have seen the hand of Giotto in mosaics in the Baptistery in Florence. None of the documents connecting him with the city refers certainly to any of his extant works. They inform us that he married a Florentine woman, Ciuta di Lapo, and had eight children; that he owned a house in Florence from before 1305; that in 1327, with Bernardo Daddi (*q.v.*) and other painters, he was admitted to the Guild of Physicians and Pharmacists. With his unique prestige, he must have helped to open their doors to his profession. In 1334 he was appointed Master of Works for the Cathedral and for the city fortifications. He had then not long returned from Naples. He had been called there in 1328 by King Robert, to whose court he still seems to have belonged in 1332.

Giotto relaid the foundation of European painting. No picture survives earlier than the frescoes at Padua showing so intense a sympathy with humanity or such belief in its basic dignity. The broad Tuscan types from Giotto's mountain valley have expelled the too elegant figures, remote or phrenetic, of the Byzantine tradition. Their majestic features and their massive frames are concentrated on the dramatic moment, and their gestures hold the very essence of its emotion. To give them full play there is a drastic simplification of

design. Centuries had elapsed since any painter had so concentrated on the essentials of form and structure. Giotto had already realised, at least on one plane, a sculptural force which has scarcely been surpassed in painting. And colour has received a similar adaptation to nature. In the clear light and the blue shadows of the Tuscan hills Giotto discovered a particular unity of colour and form which was made more atmospheric and was developed in a more complex recession of planes by Fra Angelico (*q.v.*) and Piero della Francesca (*q.v.*). Applied at Padua in clear masses, the colour there is scarcely influenced by contrast of light and shade. The great altar panel in the Uffizi is a blaze of red and green, little modulated. Later, in *The Death of the Virgin* in Berlin and in the frescoes of the Peruzzi chapel, the colours are deeper, and their saturation with light and shade helps to give further plasticity and a serener pathos to the forms.

The serenity, the order and the clarity of the Classical world having been re-established, Giotto had already stated the interests and the representational problems which occupied the majority of great artists throughout the Renaissance. He was in advance of his time; but after more than a century the scientific examination of form and colour was resumed by Masaccio (*q.v.*), and the painting which followed seems often to have been a conscious development of Giotto's ideas.

THE PRESENTATION OF THE INFANT JESUS IN THE TEMPLE *Gothic Room*

Gold and tempera on wood, 0.452-54 × 0.436-38. At the top the paint has a true edge, as if it had been applied against an engaged frame; at the foot the edge is ragged, as if broken. At the sides the panel has been neatly sawn. When the painting was cleaned in 1938-39 a spurious nimbus was removed from the head of Anna, on the right; also a few retouchings. The paint is in good condition and now virtually untouched. The exceptionally brilliant green, freely used also (but now sadly dimmed) in *The Entombment* from the same series of pictures, was found by analysis to be without copper, the normal base of green pigments until comparatively modern times. In most Italian pictures of later date green was obtained with verdigris ground in resin and the mixture has become brownish.

The scene is from Luke 2:27-38. Clad in this bright green and identified by her scroll, the ancient Anna prophesies. Next to her, old Simeon in a robe of crimson-pink, having "done for" the Child "after the custom of the law," hands him

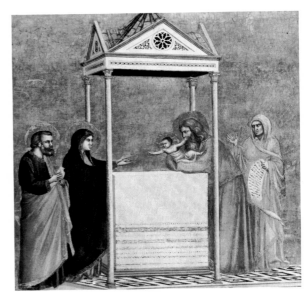

Giotto
The Presentation of the Infant Jesus in the Temple
(SEE COLOUR PLATE)

back to his Mother before singing the *Nunc dimittis*. Joseph holds two young pigeons, the traditional offering in exchange for the first-born male. In the Arena Chapel at Padua, Giotto treated the subject in fresco more elaborately, with a handmaid holding a taper and an Angel in the sky. In this, the simplest composition of the seven to which it belongs, he adhered closely to the form established in Rome in the last decade of the thirteenth century. It survives in a mosaic by Jacopo Torriti in S. Maria Maggiore there and in another by Pietro Cavallini in S. Maria in Trastevere. Giotto has both compressed their compositions and humanised them.

This is one of a series of scenes, all on panels of one size, of which only seven of an uncertain original number are known to have survived. They are now scattered among five public collections, including the Gardner Museum. The other panels are *The Epiphany* in New York; *The Last Supper, The Crucifixion, The Descent into Hell* in Munich; *The Entombment* in the Berenson collection at Settignano; *Pentecost* in London. These (and no others) were all known and attributed to Giotto at the beginning of the nineteenth century. Of their history before that there is no evidence. However, it has been suggested[1] that they are the same series of pictures or of fragments from a large picture about which Vasari tells a story in his "Life of Giotto."[2] After the death in 1327 of the Bishop of Arezzo, Piero Saccone was involved with the late Bishop's brother in commissioning Giotto to de-

sign a tomb. Saccone was so much impressed by Giotto that when, not long afterwards, he captured Borgo Sansepolcro, he carried away from that town a picture by Giotto's hand with small figures. Exactly what happened to this picture in the long interval which followed is not made quite clear by Vasari. *"Se n'è ita in pezzi"* presumably means that it came to pieces; but the pieces must have each been complete in themselves, or none would have survived into the sixteenth century. Vasari goes on to tell how an acquaintance of his in Florence, Baccio Gondi, when he was Commissario in Arezzo, diligently sought for pieces of the picture there, found some of them and brought them back to Florence. Of the seven panels surviving today at least four were together in Florence in the early nineteenth century, in the collection of Prince Stanislas Poniatowski. His collection of pictures was brought to London and auctioned in 1839. Of the other three, now together in Munich, one already belonged in 1805 to the Crown Prince Ludwig of Bavaria, two were bought in 1813 by his father King Maximilian I from a Conte Lucchesi. Two of these seven pictures provide some evidence of their history. In *The Crucifixion* S. Francis kneels at the foot of the cross on one side and on the other kneel a couple, the donors. This suggests that the seven came from a church dedicated to S. Francis, and most likely from a private altar. Adhering to the original paint surface of *The Presentation*, under the layers of varnish, were found in 1938 spatterings of wax. This supports the supposition that the panel formed part of an altarpiece — as such panels sometimes did — rather than of the doors of a cupboard, as is suggested still by those who are unwilling to see Giotto's own hand in the painting.[3] The Franciscan monastery at Borgo Sansepolcro was founded in 1258. Its church, S. Francesco, until it was remodelled in the eighteenth century, had frescoes in the principal chapel which were attributed to Giotto's school.

The question of attribution has never been wider than between the hand of Giotto himself and that of one or more of his assistants; but the outstanding position of Giotto in history gives it a particular importance. It is perhaps worth noting that the two pictures which are catalogued with the strongest conviction of the compilers that they are by Giotto himself, this *Presentation* and *The Epiphany* in New York,[4] are the only pictures of the series which are not distorted by semi-opaque and discoloured varnishes and old retouchings. *The Presentation* was already less distorted than the rest when Mrs. Gardner acquired it; and its superior condition may explain why in 1839 it was picked

out of the four sold by Prince Poniatowski by a Mr. Simes, who paid no less than £4.6s.0d for it — more than half the price of the other three pictures together(!); or why in 1908 Sirèn, who rejoined it with the three in Munich, saw the hand of Giotto himself only in *The Presentation*.[5]

The question of date is also much disputed. The majority of writers has come to place these panels near the end of Giotto's career, and an attempt has been made to relate them to the frescoes in the Peruzzi chapel of S. Croce, Florence, painted probably in the 1320's. The close analogy with the compositions in Rome may suggest an earlier date. There is, however, no other painting by Giotto on this scale for comparison.

The estate of Mr. Simes, of Mond Park, Horsham, Sussex, lost money on *The Presentation*; it was bought from the Simes collection for £1 by Henry Willett, of Brighton, Sussex, to whom it belonged in 1892-94. It was then bought by Dr. J. P. Richter. From him Mrs. Gardner bought it through Berenson in 1900. *P30w9*

[1]Bologna, *Novità su Giotto* (1969), pp. 97-99. The possible connection had already been noted by Davies (see below) and others.

[2]Vasari, *Vite* (ed. Milanesi, 1846), I, pp. 330-31.

[3]F. J. Mather, Jr., in the *American Journal of Archaeology*, XVI (1912), p. 102, was probably the first to make this suggestion. He thought Giotto responsible for the design of this and the panel in New York, but attributed the execution largely to Taddeo Gaddi.

[4]Zeri and Gardner, *The Metropolitan Museum of Art, Italian Paintings, Florentine School* (1971), pp. 13-16.

[5]Sirèn in *The Burlington Magazine*, XIV (1908), pp. 125-26; also *Giotto and some of his Followers* (Harvard University, 1917), pp. 80 and 265.

OTHER AUTHORITIES

Bacchischi, *The Complete Paintings of Giotto* (1966), p. 116, No. 132; he attributes the series to Giotto and assistants.

Berenson in a letter (4 February 1930) attributed *The Presentation* to the workshop of Giotto; in *Florentine School* (1963), I, p. 82, the series is listed under "Giotto's Assistants."

Cecchi, *Giotto* (1937), p. 125-26, dismissed the series as by a hand working alongside that of the Master.

Coletti in *Bollettino d'Arte*, XXXI (1937), p. 57, thought the series possibly executed under Giotto's direction.

Davies, M., *National Gallery Catalogues, Earlier Italian Schools* (1961), pp. 230-32; "ascribed to Giotto." He considers the series a production of Giotto's studio, from a date rather later than that of the frescoes in Padua, possibly from the doors of a sacristy cupboard.

Fredericksen and Zeri, *Census* (1972), p. 87; they attribute it to Giotto.

Fry in *Noteworthy Paintings*, pp. 241-42; he dated the picture before the Paduan frescoes.

Gamba, C., in *Rivista d'Arte*, XIX (1937), p. 274; he considered that Giotto had the assistance of pupils.

Gnudi, *Giotto* (1958), pp. 220-48; he attributes the whole series to Giotto, and considers it contemporary with his decorations of the Peruzzi chapel in S. Croce, Florence.

Longhi in *Paragone*, III, 25 (1952), p. 8; he attributed the series to Giotto, suggesting that they were part of one of four altarpieces in S. Croce mentioned by Lorenzo Ghiberti (died 1455) in Book II of his *Commentarii*.

Van Marle, *The Italian School of Painting*, III (1924), pp. 185-91; he attributed the series, together with other pictures, including the *Madonna* now in Washington, to an artist of Giotto's "immediate surroundings — perhaps even of his workshop."

Meiss, *Painting in Florence and Siena after the Black Death* (1951), p. 19, note 24, refers in passing to *The Presentation* as "workshop of Giotto."

Oertel, *Early Italian Painting to 1400* (1966); he attributes them to "a gifted assistant."

Perkins in *Noteworthy Paintings*, pp. 240-41, attributed *The Presentation* to Giotto.

Previtali, G., *Giotto* (1967), pp. 112, 143, 317; he attributes the series to Giotto, about 1310-15. He stresses the centrality of the composition of the Munich *Crucifixion* as evidence that the number of panels was uneven; but also suggests that they were arranged round a sculptured group or a reliquary.

Richter, J. P., in *Noteworthy Paintings*, pp. 244-47, attributed *The Presentation* to Giotto, ten years after the Paduan frescoes.

Salmi in *Emporium*, LXXXVI (1937), pp. 358 ff., attributed the series to Giotto's workshop, executing his designs.

Salvini, *Tutta la Pittura di Giotto* (1952), p. 50; he attributes the series to Giotto's workshop at a late date.

Sinibaldi and Brunetti, *Pittura italiana del duecento e trecento* (1943), pp. 339-45; they attributed the series to Giotto's workshop.

Venturi, L., *Pitture Italiane in America* (1933), Pl. XXV; he attributed *The Presentation* (and *The Epiphany*) to Giotto.

Exhibited 1892, R. A., Old Masters, No. 177, "School of Giotto." 1893-94, London, New Gallery, Early Italian Art from 1300 to 1550, No. 24, "Giotto."

Giovanni di Paolo

Also known as GIOVANNI DAL POGGIO (from the Hill, the part of Siena in which he lived); died at Siena 1482-83.

The date of his birth is uncertain. He had painted for some years before he signed and dated an extant picture: the large *Madonna of the Rosary, with Angels* now at Castelnuovo Berardenga. Dated 1426, this is the centrepiece of a polyptych painted for S. Domenico at Siena, of which the two wings are now in the Pinacoteca there, the predella at Baltimore and at Altenburg. His last work known to have been signed and dated (on a pediment now lost) is the polyptych with the *Madonna della Cintola*, now in Siena, from S. Silvestro at Staggia. This is not all from his own hand, and before that he had probably ceased to do much painting himself. Between these dates he had produced a prodigious number of panel pictures.

Siena was in her decadence; but her capital was by no means spent. She was the scene in Giovanni's lifetime of some gorgeous spectacles of Church and Empire. One of her noble citizens became Pope Pius II. She had become a delicious backwater, and that is the relation of Giovanni's art to the deep current of Italian painting. His delight was in the surface of nature, in the pattern of fields and gardens; and for his compositions or for other ideas he sipped frequently at the works of other painters. His was a largely derivative art. His first great polyptych might be, for all essentials, by a contemporary of Simone Martini (q.v.). He was strongly influenced by his fellow citizen Sassetta, and he borrowed motifs from Gentile da Fabriano, Fra Angelico and the Lorenzetti. Yet he was by no means without invention, and even his borrowings he clothed in a style of striking individuality. His is the beauty of the convolvulus, leaning upon sturdier plants that it may become more tortuously delicate. He rarely attempted fresco, but turned frequently to the illumination of manuscripts; and on this small scale he naturally inclined, full of vitality as he was, to eccentricity and preciousness. He elaborated the architecture of his scenes in a manner which would appear Teutonic if it had not all the gaiety and elegance of Siena. His fanciful design is usually at its best in such small pictures as *The Madonna of Humility* in the Boston Museum of Fine Arts, with its version in Siena, or the six *Scenes from the Life of S. John Baptist* in Chicago, which probably once formed an altarpiece with the three panels in New York (Lehman Collection), the two in Münster and another at Villandry, near Tours. Though he made use of the motifs of the Renaissance, he was perhaps the last great Gothic draughtsman, not attempting to render the full volume of form or space but drawing with great refinement of line. He maintained unmodified the traditional tempera technique, long abandoned in Florence, preserving its fresh dry quality and its purity of colour.

THE CHILD JESUS DISPUTING IN THE TEMPLE
Early Italian Room

Tempera transferred to linen attached to mahogany, 0.275 x 0.239. The paint is abraded above the arch on the right, and in the lower half of the panel a number of worm holes have been stopped. Cleaning in 1943 revealed a surface otherwise well preserved.

Giovanni di Paolo
The Child Jesus Disputing in the Temple
(SEE COLOUR PLATE)

The scene is from Luke 2:42-49, with Mary and Joseph rediscovering their twelve-year-old Son in the temple, listening to the doctors and asking questions. Giovanni has made the Son more magisterial than ever by enthroning him in a completely symmetrical architectural setting, one very much like that in which Domenico Veneziano had enthroned the Madonna in an altarpiece set up some fifteen years before in S. Lucia de' Magnoli in Florence. A more decided borrowing is typical of Giovanni's search for the bizarre. The strange little doctor seated on the right is taken from a figure in a similar position in the treatment of the same subject over the sacristy door in S. Croce, Florence, by Giotto's disciple Taddeo Gaddi (died 1366).

One would expect such a picture as this to have formed a part of a series; and, to judge by the dimensions, it may indeed have been painted to go with *The Nativity*, now in the Fogg Art Museum,[1] and with *The Adoration of the Kings*, now in the collection of Mr. Jack Linsky, New York.[2] S. Joseph is very much the same person in all three pictures; but it has to be admitted that the other two, which are plainly both of the same moment, are more finely painted, and might well belong to a rather earlier moment in Giovanni's career. This picture is typical of his last years, when the colour is brighter than ever but the drawing has become hurried and coarse, and the figures often strangely disproportionate.

Pope-Hennessy, who first related *The Nativity* to the other two panels, adds a fourth to the series: *The Baptism* in the Ashmolean Museum, Oxford.[3] He suggests that they together belonged to a predella with *The Baptism* in the centre.[4] It would have to have been so placed, for its dimensions are quite different from those of the other three; and three more panels would then have been needed to complete the predella of a very large altarpiece. If indeed the three panels which have similar dimensions were part of a predella, it seems more plausible to postulate only two missing subjects, with the Gardner picture, exceptionally centralised as it is in its composition, in the centre.

It first appeared in the collection of Sir George Donaldson. From him it was bought by Thomas Agnew and Sons, who sold it to Mrs. Gardner through Berenson 18 August 1908. *P15w21*

[1]Cambridge, Mass., Fogg Art Museum, No. 1943.112; panel, 0.279 x 0.241.

[2]New York, Mr. Jack Linsky, formerly in the von Auspitz collection, Vienna; panel, 0.260 x 0.229.

[3]Oxford, England, Ashmolean Museum, No. 179; panel, 0.257 x 0.357.

[4]Pope-Hennessy, *Giovanni di Paolo* (1938), pp. 90-91, 93 and 111.

OTHER AUTHORITIES

Berenson, *Central Italian and North Italian Schools* (1968), I, p. 175; he accepted Pope-Hennessy's proposition (above).

Fredericksen and Zeri, *Census* (1972), p. 89.

Hadley, R., in *Fenway Court*, I, No. 7 (October 1967), pp. 49-56.

Van Marle, *The Italian Schools of Painting*, IX (1927), pp. 448 and 462.

Giovanni da Rovezzano

GIOVANNI DI FRANCESCO: born presumably at Rovezzano, a suburb to the southeast of Florence, about 1412; died, according to Vasari, 1459.

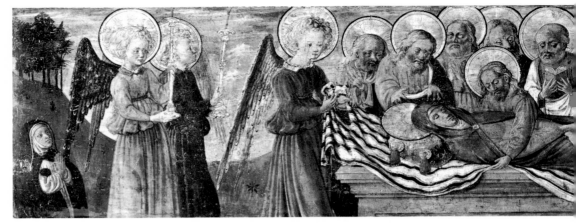

Studio of Giovanni da Rovezzano — *The Dormition of the Virgin, with a Nun*

In 1435 Giovanni moved to Florence itself, where he lived henceforth near S. Ambrogio. According to Vasari he was the pupil of Andrea del Castagno. He matriculated in the Guild of S. Luke in 1442. There are only two documented paintings: 1 November 1439 he contracted to paint for the Convento del Paradiso, near Bagno a Ripoli, a few miles beyond Rovezzano from Florence, the triptych: *The Madonna with Two Angels between S. Bridget and S. Michael*, now in the J. Paul Getty Museum, Malibu, California; twenty years later, 1458-59, he was paid for the now ruinous lunette in fresco over the chapel door in the Loggia degli Innocenti, Florence: *The Eternal Father, with Two Angels and Many Innocents*. Closely associated with the earlier of these two pictures is the altarpiece from S. Giovanni Evangelista at Pratovecchio in the Casentino, east of Florence, of which the picture below seems originally to have formed a part. Round this Roberto Longhi grouped a number of pictures which he attributed to the "Master of the Pratovecchio altarpiece." Close rather to the lunette of 1458-59 is a triptych now in the Bargello Museum, Florence, *The Madonna Enthroned, between SS. Francis and John Baptist and SS. Nicholas and Peter*. Round this picture Berenson for many years grouped others under the name of the "Master of the Carrand triptych." The two groups overlapped to a considerable extent; and, after the publication of the documents concerning the lunette, Berenson united them in one, attributed (posthumously) to Giovanni di Francesco. The correctness of his assumption in the main has recently been noted by Fredericksen,[1] quoting Sara Eckwall. Berenson's list is a long one, and not every picture is easily acceptable; but the four pictures mentioned above are enough to show that more than one hand was responsible for the large output of Giovanni's workshop. It was not merely prolific. No pains were spared. Frames were elaborate, and, perhaps because Giovanni was most successful on a small scale, the larger pictures had a multiplicity of compartments and of figures. The design of these was unequal and eclectic, reflecting now Castagno, now Filippo Lippi, most of all, perhaps, Uccello. Yet a strong individuality prevails, fertile in lively motifs and intense characterisations, which are not without an eccentric elegance.

Studio of Giovanni da Rovezzano

THE DORMITION OF THE VIRGIN, WITH A NUN
Early Italian Room

Tempera on wood, 0.33 x 1.91. The painting is somewhat rubbed over most of the surface.

The subject is the same as that of the lower part of the small panel by Fra Angelico in the same room. Christ, in the centre of a group of eleven Apostles — S. Thomas arrived on the scene late — standing round the bier, takes up the Virgin's soul in the form of a little child. Fra Angelico in his picture had illustrated also the second episode in a legend which dates from early Byzantine times: the Virgin's bodily Assumption amid an angelic throng. In this picture the Angels are present by the bier, three to each side: one pulling the shroud and two bearing golden candlesticks. In the left corner kneels a nun, evidently the donor of the altarpiece of which this was a part.

The proportions of this panel show that it comes from the predella of an altarpiece. Roberto Longhi[2] was almost certainly right when he sup-

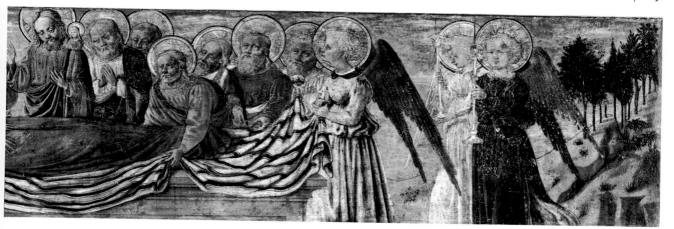

posed that this was an elaborate triptych once in the Church of S. Giovanni Evangelista belonging to the Carmelite nunnery at Pratovecchio. The greater part of this altarpiece is now in the National Gallery, London;[3] the centre with *The Virgin of the Assumption*, certainly from S. Giovanni at Pratovecchio, is (1973) at Anghiari, near Arezzo, in a building to be opened as a museum. It must have stood between two wing panels now in London: left, *SS. Michael and John Baptist*; right, *A Bishop Saint and a Female Martyr*. Over these, in a smaller tier, are *The Virgin* and *S. John Evangelist*, whose mourning attitudes suggest that the centrepiece, now missing, of this tier was *Christ on the Cross*, or perhaps a carved *Crucifix*. Between the two tiers are two small half-length figures in roundels: *The Announcing Angel* and *The Virgin Annunciate*. The gilt *pastiglia* work surrounding these tondi is all that remains of the original frame; but twelve paintings, each with a standing saint on the same scale as the figures of the upper tier, have survived from its pilasters. Among these are *S. Benedict*, inventor of the rule followed by the Camaldolese Order, and, probably, *S. Romuald*, the Order's founder. The subject of the centre panel, *The Virgin of the Assumption*, is what is needed to complete the theme of the Virgin's dormition, and the dimensions of the Gardner *Dormition* are suitable enough for the altarpiece. The two panels of the main tier in the National Gallery measure 0.940 x 0.495, approximately. The centre panel at Anghiari now measures 0.880 only x 0.580. However, the curtailment of the design at the foot, where the panel has been sawn, shows that it has been reduced in height by at least 0.21. Allowing for the stiles of

the frame at the side of all three panels and for the two pilasters which must have separated them, there must have been space enough on the predella for *The Dormition* without its ends underlying the pilasters in the awkward way suggested by Longhi in his photographic reconstruction. The pilasters must have projected in proportion to their large size. There can be no doubt that *The Virgin of the Assumption* is by the same hand as *S. Bridget* in the triptych from Bagno a Ripoli, one of the two documented works of Giovanni da Rovezzano. The two figures are singularly unlike the main body of the work attributed to him, including the remainder of this altarpiece. They may therefore be by another artist, whom he employed. This analogy dates the Pratovecchio altarpiece, with the Gardner *Dormition*, about 1440.

The painting of *The Dormition*, apparently not by the same hand as *The Virgin of the Assumption*, is at the same time more summary in design and execution than the rest of the altarpiece. This may be due, however, to impatience with the awkward dimensions of the panel, dictated by the design of the frame. It seems to be by the same artist as the somewhat damaged miniature altarpiece in the Morgan Library, New York, *The Madonna del Baldachino*, which Longhi included among the works of the Master of the Pratovecchio altarpiece.[4]

The Dormition of the Virgin was bought from J. Eastman Chase at Boston 18 May 1900. P15s6

[1]Fredericksen, Burton B., in *Catalogue of Paintings in the J. Paul Getty Museum* (1972); he quotes Sara Eckwall's publication of the contract for the Bagno a Ripoli triptych in *Kunsthistorisk Tidsckrift* (1970), pp. 169-70.

[2]Longhi in *Paragone* (March 1951), p. 58, and in *Paragone* (November 1952), Pl. 11 and pp. 24-28.

[3]Davies, *National Gallery Catalogues, The Earlier Italian Schools* (1961), pp. 521-24, under Tuscan School. He objects that the nun in *The Dormition*, who must have been the donor of the altarpiece and a member of the community to which she gave it, is not dressed in the Camaldolese habit, which is entirely white.

[4]Zeri drew attention to the resemblance in a letter to the Director, 30 January 1950.

OTHER AUTHORITIES

Berenson in a letter of 4 February 1930 maintained an attribution, which he had first made about 1900, to the Perugian Bartolommeo Caporali. In *Florentine School* (1963), I, pp. 87-88, he attributed *The Dormition* tentatively to Giovanni di Francesco.

Fredericksen and Zeri, *Census* (1972), p. 135.

Giuliano da Rimini

His signed picture, below, is dated 1307. It comes from Urbania, in the Marches, and, to judge by its weight, it was painted in that town. The signature shows that its painter came from Rimini; and indeed Giuliano is recorded as the deceased owner of some property there 19 March 1346.

In the first half of the fourteenth century, and for little more, Rimini was the centre of one of the largest schools of painting in Italy. The painters have left great cycles of fresco decoration in churches, not only in and around Rimini and Ravenna on the Adriatic coast, but as far north as Padua, as far south as Tolentino in the Marches, as far west as Bologna. The school has been described as choral; for the frescoes, many of which have the uplifting quality of a chant, are often apparently the fruit of many cooperating hands. The owners of these are for the most part still anonymous. Francesco da Rimini signed work in the refectory of S. Francesco at Bologna which has now been largely removed to the Pinacoteca. Pietro is credited with ruinous scenes in Padua from the Eremitani church there. There are pictures in tempera on panel signed by Pietro, by Giovanni and by Giovanni Baronzio da Rimini, the latter dated 1345; but there is no certainty who painted the best of the fresco cycles: in S. Francesco, Rimini; in S. Maria in Porto Fuori (destroyed in 1944), Ravenna; or in S. Chiara there; in S. Pietro in Silvis, Bagnacavallo; in the great abbey of Pomposa; in S. Nicola, Tolentino.

Giuliano's dossal, below, represents the earliest document of this school, and, because of this and of its great size, attempts were made in the past to discover in him the author of one or more of these cycles. All have been unsuccessful, though Giuliano must have painted many pictures, and this was probably among his first. It is difficult to credit him with another great dossal at Cesi in Umbria, unsigned but dated the next year in a similar inscription, also mentioning Pope Clement V; the difference in style is too great. Led by Mario Salmi, modern criticism has put much emphasis upon Giuliano's preoccupation with small patterns in the Gardner picture and upon its relative lack of plasticity. These criticisms can be exaggerated, and they should not be allowed to mask the grandeur of the whole effect. The recent discovery of its connection with the painting of S. Francesco at Assisi may well show the artist opening his eyes for the first time to a new idea of painting, far different from the moribund Byzantine tradition which was perhaps all he knew before. With Giotto himself working at Rimini in 1313, Giuliano must have developed in the direction of plasticity. It may not be fanciful therefore to see his hand at a later date in other pictures still in the Marches which Salmi grouped round a fragmentary polyptych with *The Coronation of the Virgin*, now in Urbino. Since this was written some frescoes attributable to Giuliano have been uncovered in S. Francesco at Fermo; but these have not been seen by the compiler.

THE MADONNA AND CHILD, WITH SS. FRANCIS AND CLARE AND OTHER SAINTS
Long Gallery

Gold and tempera, formerly on light hardwood, 1.790 x 3.20, transferred in 1941-42 to a modern panel of composite construction. Cleaning in 1942-44 revealed that the gilt and painted surface, except for some hard knocks, is in excellent condition in the upper half. In the lower there is much obvious damage from abrasion, especially towards the centre; but the heads and hands are in fair condition throughout. The gilt and painted frame, originally engaged, was detached and re-attached in 1941-44.

In the centre, two flying angels swing their perfumed censers, while they hold up the heavily fringed and embroidered cloth behind the enthroned Madonna. The Child strides across her lap, much as he does in the *Madonna* by Cimabue in S. Maria dei Servi, Bologna. At her knee kneel members of a sisterhood, with three ladies in lay dress, one wearing a golden diadem, another a chaplet of beads. In the painted arcade of two storeys on each side are: above, *S. Francis Receiving the Stigmata; S. John Baptist, S. John*

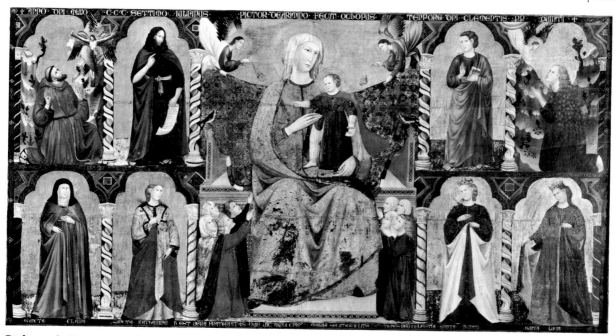

Giuliano da Rimini — *The Madonna and Child, with SS. Francis and Clare and Other Saints* (SEE COLOUR PLATE)

Evangelist; S. Mary Magdalen Visited by the Angel;
below, *S. Clare; S. Catherine; S. Agnes; S. Lucy.*
The painting is inscribed along the top:
✠ *ANNO · DNI · MLLO · · C · C · C · SETTIMO*
· · IULIANUS · · PICTOR · DEARIMINO · ·
FECIT · OCHOPUS [sic] *· TENPORE* [sic] *· DNI*
· · CLEMENTIS · · ̶P̶P̶ · · QUINTI · ✠ along the
middle with the names of the upper row of saints,
along the bottom with those of the lower row and
in the centre: ♄ *EST VERA FRATERNITAS · QVE*
V̄IC MŪDI CRIM [. .] *· MARIA · SECUTA · Ē ·*
ĪCLITA TENĒS · RĒG · CELESTIA · The scroll of
S. John Baptist is inscribed: *Ecce Agnus Dei &c.*

The general design of the retable, with a cen-
tral composition occupying the full height of the
panel between smaller scenes or figures in com-
partments, is as traditionally characteristic of the
times as the lavish use of gold and the profusely
patterned ornamentation of all the simulated
stuffs. What is most unusual, if not unique, is the
use of painted arcading, instead of carved columns
or painted bands of ornament, to form the com-
partments. This, with its suggestion of space, de-
rives from contemporary painted architecture, real
or simulated; and it has been pointed out that the
particular source of inspiration for this picture may
be found in S. Francesco at Assisi.[1] Here not only
are the prototypes for the twisted columns sup-
porting cusped arches, with their inlaid spandrels,

to be found in Cimabue's decoration of the choir
and transepts of the Upper Church, but also there
are models for perhaps both of the two composi-
tions on the extreme left of the picture. *The
Stigmatisation of S. Francis* has been taken, almost
without doubt, from the frescoed scene by Giotto
in the Upper Church. The *S. Clare* has a resem-
blance to the figure of that Saint in the S. Nicholas
chapel of the Lower Church, painted by one of
Giotto's followers or assistants.[2] This almost cer-
tain derivation of the *S. Francis* panel of the dossal,
coupled with one only a little less certain for the
S. Clare panel and the fact that prototypes for
Giuliano's arcade are to be found in the Upper
Church of S. Francesco suggest that the painter
himself visited Assisi; but there were other sources
for his arcade and the reasons for modelling these
two pictures on Assisi prototypes were primarily
iconographical, not artistic. The dossal was painted
for the Poor Clares, named after S. Clare, who was
the first nun to follow S. Francis. The representa-
tion of these two Saints was therefore the prime
distinction between this and other Madonna altar-
pieces, and it is not impossible that the rich lady
who intended to present it had obtained copies of
the latest models from Assisi before ever she gave
Giuliano the order to paint.

The altarpiece was painted evidently for a sister-
hood, doubtless of the Order of S. Clare, and was

probably the gift of one or all of the three patron-
esses who kneel among the sisters. It was brought
from the cathedral at Urbania,[3] the ancient Castel
Durante, which lies in a bowl of clay hills south-
west of Urbino. It was bought by Mrs. Gardner
from an Italian restorer in Great Portland Street,
London, through Joseph Lindon Smith (q.v.) in
May 1903. P27e46

[1]White, John, in *The Burlington Magazine*, XCVIII
(October 1956), pp. 344-52.

[2]Meiss, Millard, *Giotto and Assisi* (1960), pp. 3-4.

[3]Venturi, L., in *L'Arte*, XVIII (1915), p. 7.

OTHER AUTHORITIES

Berenson, *Central Italian and North Italian Schools*
(1968), I, p. 364.

Bonicatti, Maurizio, *Trecentisti Riminesi* (Rome, 1963),
pp. 34 and 67-68.

Fredericksen and Zeri, *Census* (1972), p. 93.

Previtali, *Giotto e la sua bottega* (1967), pp. 45-46, he
reproduces Giuliano's *Stigmatisation of S. Francis*, with
details from Giotto's compositions in Assisi and Paris
and with the panel in the Fogg Museum; and pp. 84-86,
he reproduces Giuliano's *S. Clare* with the figure from
the S. Nicholas chapel in Assisi and his central *Madonna*
with a detail from a picture by a Romanesque Umbrian
painter in S. Pietro in Valle at Ferentillo.

Salmi, M., in *Rivista dell' Istoria Nazionale di Archeol-
ogia e Storia dell' Arte*, III (1931), pp. 230-31. Also,
L'Abbazia di Pomposa (1966), pp. 171-72; he discusses
and dimisses the possibility of Giuliano having taken
any part in fresco painting and likens him to the
miniaturist Neri di Rimini.

Volpe, *La Pittura Riminese del 300* (Milan, 1965), Pls.
1-9.

Francesco Guardi

Born in Venice 1712; died there 1793.

His father Domenico, a decorative painter, was
brought up in Vienna, where he married Maria
Claudia Pichler. He came to Venice in the first years
of the eighteenth century. Francesco married Maria
Pagani, with whom he lived near S. Maria Formosa,
presumably in the house of his father. She bore
him three sons and died in childbirth in 1769. He
was registered in the Guild of Painters in Venice
1761-63; and was received into the Academy there
in 1784, at the tardy age of seventy-two. When he
died, he was living near S. Canciano with his
eldest son, who was a priest. His son Giacomo, a
painter, attempted to follow in his footsteps.

His elder brother Gian Antonio, born in 1698,
was old enough to have carried on the workshop
of their father when he died in 1716. Casanova
mentions in his memoirs the studio which Gian

Antonio kept, and there Francesco, perhaps with
another brother, Niccolò, probably began his career.
The brothers composed altarpieces and large deco-
rations on canvas, in a style a good deal influenced
by Giambatista Tiepolo (q.v.), whom their sister
Cecilia had married in 1719.

Gian Antonio died in 1760. In 1764 Francesco
is mentioned as the owner of the studio near the
SS. Apostoli, as the pupil of Canaletto and as the
painter for an Englishman of two views in Venice
which were exhibited in the Piazza S. Marco. The
character of the Guardi studio was changed. Al-
ready probably Francesco had painted the pair of
large genre scenes, *Il Parlatorio delle Monache* and
Il Ridotto, now in the Correr Museum at Venice,
which borrow from Pietro Longhi, yet are incom-
parably more suggestive of light and atmosphere.
Now, when his views of the city and its canals
were found to be in great demand, especially after
the death of Canaletto in 1768, his art came into
the open air. Milestones towards the other end of
his career are the four *Scenes from the Visit of
Pope Pius VI to Venice* which were painted for the
Republic in 1782.

Guardi's landscapes are witness of what a
phoenix is art. Much of their beauty is the beauty
of decay, of a dying city with the sails drooping
on her idle ships. At Venice the looms were largely
idle and the glass furnaces were almost out. Society
there could have given the artist little encourage-
ment towards new studies of reality. But the for-
eign tourist wanted views of the Venice he had
seen; and, when Guardi applied his sensibilities
to real scenes, there came a breath of new life.
While he made a few unexpected studies, such as
that in the Castello Sforzesco at Milan, of the open
stormy sea, his observations were mostly limited to
the veiled lights of the lagoons. The faint colours
of his skies and their reflections are the first steps
in a new advance in the study of the atmosphere.
The lovely light of Venice was soon drawing to her
the new landscape painters from the North, and
first Bonington and Turner, then Whistler and
Sickert and Monet came to find that her last painter,
while remaining quintessentially Venetian and a part
of the Rococo movement of his century, had antici-
pated a part of their ideas.

VENICE: THE CLOCK TOWER IN THE
PIAZZA S. MARCO *Veronese Room*

Oil on canvas, 0.823 x 0.995. Cleaning in 1949 re-
vealed a worn condition of the paint, especially
in the façade of the Clock Tower building and in
the sky to the right. There are fundamental losses

Francesco Guardi — *Venice: The Clock Tower in the Piazza S. Marco*

of original paint below this, in the façade of S. Mark's. It also, however, revealed the brushwork of Francesco Guardi himself, previously covered to a considerable extent by overpainting of a later date and by discoloured varnishes.

The view shows the east end of the north side of the great Piazza, with part of the façade of S. Mark's at right angles. To the left is shown part of the old Procuratie, which forms the greater part of this side of the square. Completely regular, it is a somewhat composite building, preserving in early Renaissance form the close arcading of the old Byzantinesque style, yet built in the course of some thirty years at the beginning of the sixteenth century. The central building of the picture was originally a tall narrow clock tower, designed by Mauro Coducci and built 1496-99. Over the archway connecting the square with the Mercerie, the shopping streets, is the clock itself, with its great face of gilt and blue enamel, and at the top of the tower are two bronze figures, cast in 1494, which strike the hours on the great bell. The tower was flanked almost immediately by the four-storey wings which join it to the Procuratie; and to these additional floors, recessed, were added about 1755. The side view of the façade of S. Mark's stops short of the great central arches in two tiers. The basilica was begun in 1063; but the continuous adaptation and enrichment of the façade reached its culmination only in the middle of the fifteenth century. The three flagpoles which are seen diagonally across the scene are fixed in elaborate bronze bases designed by Alessandro Leopardi in 1505.

The picture was not attributed to Guardi himself in the Catalogue of 1931; but its appearance has been greatly changed by the removal of overpainting and semi-opaque varnishes. Even with allowances made for the damaged condition, it is painted with an unusual looseness. The chronology of Guardi's *vedute* is still a matter of controversy; but perhaps this is one of the earlier, painted not long after he had ceased to work with his brother on decorations which were in general loosely composed. The number of versions shows that it was very popular.

This picture belonged in Venice to Charles Stein; and on the advice of R. W. Curtis (*q.v.*), it was bought by Mrs. Gardner (through her agent Robert) at his sale in Paris 8 June 1899 (Galerie Georges Petit, No. 323). *P25w46*

AUTHORITIES

Fredericksen and Zeri, *Census* (1972), p. 96; they catalogue it as in the style of Guardi.

Simonson, *Francesco Guardi* (London, 1904), p. 86, No. 27, as Guardi. He stated that it came from the collection of Lady Ashburton; but he was perhaps confusing it with the picture following, his No. 28.

Variants: A dozen are known, based on the same design, but varying in shape and dimensions, in the lateral extent of the buildings and the distance to them from the foreground, as well as in the figures. Many of the figures are constant but differently distributed. The Gardner picture is among the largest and best. The most extensive, and the only other version in a public collection is that in the Akademie in Vienna.

VENICE ACROSS THE BASIN OF S. MARCO
Veronese Room

Oil on canvas, 0.543 x 0.863. Cleaning in 1949 revealed an almost perfect state of preservation.

The view is taken from a point between the islands of S. Giorgio Maggiore and Giudecca, or from the tip of either. Thus the grandest public buildings of Venice are reviewed across the lagoon. Behind the boat on the left is the Mint, with the Library to the right, beside it. Immediately behind that is the Campanile. The two tall granite columns supporting figures of S. Theodore (left) and the Lion of S. Mark stand in the Piazzetta, across which are seen, to the left, the Clock Tower, and, to the right, the flank of S. Mark's, with a part of its largest cupola. To the right is the Doge's Palace, with the Doge's galley lying canopied before it, and further right, the Prison. The Riva degli Schiavoni extends along here. The large square building seen to the right of the mast was originally the Dandolo Palace and is now Danieli's Hotel. Far to the right, the largest building, with the pitched roof, is the Church of the Pietà. This is one of the views which brought Guardi to anticipate much of nineteenth century landscape. The delicate gradations of tone in a pale and liquid atmosphere were never more patiently observed and rendered; and here Guardi's hand has surpassed itself also in the sparkling elegance of its touch.

According to Berenson the picture came from the collection of Lady Ashburton. It was bought through him from Colnaghi of London in January 1896. *P25w47*

AUTHORITIES

Fredericksen and Zeri, *Census* (1972), p. 96.

Simonson, *Francesco Guardi* (London, 1904), p. 86, No. 28.

Venturi, L., *Pitture Italiane in America* (1931), Pl. CCCCXXXVIII.

Variants: Ten are known approximately on this scale, always with considerable variations in the extent of

Francesco Guardi — *Venice across the Basin of S. Marco*

The Nativity

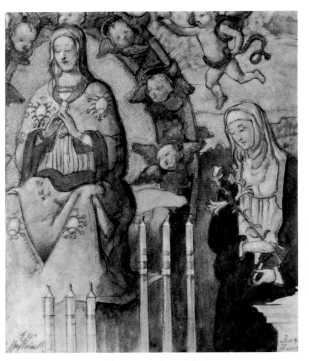

An Altarpiece by Balducci

The Marriage at Cana

the view and the distribution of the shipping, and all in private collections. An exception in every way is the large canvas, 2.850 x 3.950, in the Waddesdon Manor Collection, Buckinghamshire.

George Hallowell

GEORGE HAWLEY HALLOWELL: born in Boston 1871; died there 1926.

He studied painting at the School of the Boston Museum of Fine Arts, and under Frank W. Benson, Edmund C. Tarbell and Harold B. Warren. In 1906 he went to Europe. His early works are studies of the Italian Masters; but on his return to the United States he gradually became a painter of the New England woods and mountains. He spent much time in the White Mountains, as well as at Mt. Katahdin in Maine. He used a camera to record details of nature and life in the logging camps of Maine; a number of his paintings and photographic plates are now in the Maine State Library at Augusta.

THE NATIVITY *Blue Room*

Ink and water colour on paper, 0.23 x 0.15. Signed at the foot on the left: *G.H. Hallowell.* *P3e9*

AN ALTARPIECE BY BALDUCCI *Blue Room*

Pencil and water colour on paper, 0.157 x 0.131. Inscribed at the foot on the left: *G.H./Hallowell,* and on the right: *Bar/ducci* [sic].

The centre and right part of Matteo Balducci's altarpiece, *The Assumption of the Virgin, with SS. Francis and Catherine of Siena*, in S. Spirito at Siena is shown behind the tops of the altar candles.
 P3w39

THE MARRIAGE AT CANA *Blue Room*

Ink and water colour on paper, 0.235-39 x 0.396-99.

The original canvas painted by Jacopo Tintoretto in 1561 is in S. Maria della Salute in Venice. *P3w37*

Childe Hassam

FREDERICK CHILDE HASSAM: born at Dorchester, Massachusetts, 17 October 1859; died at East Hampton, Long Island, 27 August 1935.

Eldest son of Frederick Fitch Hassam, a merchant and collector of American antiques, whose Puritan ancestors spelled their name Horsham. After leaving Dorchester High School, he began his career as a wood-engraver and illustrator. In 1883 he took painting materials abroad, and remained in Europe

until 1889, returning to Boston only in February 1884 to marry Kathleen Maude Doane. In 1889 he settled in New York, where he lived and worked for more than thirty years, visiting Europe again only in 1897.

Though he studied in Paris for three years, he maintained that the true roots of Impressionism were to be found in Constable and the English water-colour painters. In the United States he developed a subdued type of Impressionism of his own for rendering his favourite New England scenes: town-scapes and, mostly, landscapes. In 1898 he joined with Twachtman (*q.v.*) and others to form the group of Ten American Painters. After he bought his house at East Hampton in 1919, he spent most of his summers there.

A NEW YORK BLIZZARD *Blue Room*

Pastel on grey paper, 0.35 x 0.24. Inscribed at the foot on the left: *Childe Hassam. N.Y.*

Done probably in the 1890's. *P3w19*

Childe Hassam — *A New York Blizzard*

Paul-César Helleu — *The Interior of the Abbey Church of S. Denis*

Paul-César Helleu

Born at Vannes, Brittany, 1859; died in Paris 1927. He began as a disciple of Monet, painting scenes in broken colours and choosing the vibrations from the stained glass in the gloom of Gothic cathedrals or from the fountains in the brilliant light of Versailles. It was when he turned from these to scenes and portraits from Parisian drawing-rooms that he achieved fashionable fame. This reached to London, where he painted the Duchess of Marlborough, the Countess of Warwick and other prominent ladies of Edwardian society. In 1904 he won the Cross of the Legion of Honour.

THE INTERIOR OF THE ABBEY CHURCH
OF S. DENIS *Chapel*

Oil on canvas, 1.94 x 1.55. Signed at the foot on the right: *Helleu.*

The royal abbey of S. Denis dates from the time of Pepin and Charlemagne. The church was largely rebuilt in the reign of King Louis IX (1226-70). It came to be the burial place of the French kings, and many of their tombs are preserved there. It is famous also for the stained glass in the two great rose windows of its transepts.

The picture was recommended to Mrs. Gardner by their mutual friend Sargent in a letter.[1] It was purchased in 1892 in Paris. *P28e15*

[1] Museum archives.

Exhibited 1893, Chicago, World's Columbian Exhibition.

Herri met de Bles

"Henry with the White Lock," probably the Herri de Patinir who entered the Guild of S. Luke at Antwerp in 1535.

Carel van Mander, the Netherlandish Vasari, writing early in the seventeenth century, already confused him with Joachim Patinir, of a generation earlier, who may indeed have been his uncle. They

Herri met de Bles — *The Story of David and Bathsheba*

came from the same district in southern Flanders. Joachim was one of the pioneers of landscape painting as a self-contained art, and was Herri's inspiration as far as landscape is concerned. Van Mander mentions Herri de Patinir and Herri de Bles as two individuals, while giving little account of either. Herri's fondness for putting an owl in his pictures — indeed an owl is enriched in an engraved portrait of him about 1570-75 — earned him the Italian title of *Civetta,* and this suggests that at least many of his pictures reached Italy. Marcantonio Guarini in a book published in 1621 at Ferrara claimed that Civetta was buried in that town.

THE STORY OF DAVID AND BATHSHEBA
Veronese Room

Oil on oak panel, 0.462 x 0.692. There are a few restored losses along horizontal cracks in the panel, parallel with its single join, and inevitably there is a little wearing where the paint is thinnest; but the general condition is good, the colour brilliant, since a cleaning in 1935.

It was long established custom to illustrate in one picture more than one episode from a story. Here are some three scenes from the Old Testament, II Samuel 11:2-27. From a balcony of his palace in Jerusalem, on the extreme right, King David, sceptre in hand, gazes across to the pool; here the naked Bathsheba is already receiving his *billet doux* from the hand of the messenger; on the terrace below, the King appears again, handing to her husband Uriah the *lettre de cachet* for his commander-in-chief which will send Uriah to the post of danger and his death. The elders are perhaps already expressing their disapproval.

Except of course for Bathsheba, the *dramatis personae* and the chorus are clad in Roman or in Oriental dress. In the grounds below, men and women in contemporary clothes are enjoying every outdoor recreation of a sixteenth century palace. In the foreground is tennis, with a jester peering at the players through a grille; a lady has a hawk on her wrist, and behind her and her chaperone, in an enclosure to the left, are the bats and balls and hoop of another game; behind these is the swimming pool, and,

to the right, the archery butts; on the other side of these is a maze and, in the open country, stag-hunting. In the landscape beyond, the fantastic city is pressed between towering mountains and the sea, where ships are loading or unloading at its docks.

The popularity of this picture is shown by the repetition and a large number of variants (see below). These are all of inferior quality except the variant in the Wadsworth Athenaeum, Hartford, Connecticut. The Gardner picture seems superior to this in the mannerist painting of the gaily coloured figures on the foreground terrace, and these may be by another hand than that of the landscape. The figures in the Hartford picture are quite different and are inferior in quality, though perhaps more consistent with those in the gardens. The landscape, on the other hand, seems superior, with a little more fine detail added to some buildings and a further elaboration of the tall Gothic fountain on the left, with its *mannekins pis*.

These two pictures therefore may contest the claim to be the original of a great many variants, though it is only of the Gardner picture that there is an exact replica and none of the variants borrows the most idiosyncratic feature of the Hartford version, the dog and the chained monkey in the foreground.

The date 1559 on a variant belonging to Lord Aberdare which has departed very far from the original gives a *terminus post quem*; but the original is likely to have been painted 1525-40.

Friedländer apparently lists none of these pictures in his *Die Altniederländische Malerei*, though he includes groups under most of the names which have been attached at one time or another to the various versions. It has been suggested that he was responsible for the attribution of the repetition to the "Brunswick Monogrammist" when it was sold at Christie's in 1929 (see below). Charles Sterling, however, in a letter to Frank Partridge of 28 January 1950 (copy in the Museum archives) attributed this to Lucas Gassel. The variant at Hartford also is now attributed to Gassel. Sterling, however, goes on to say that he believes the original composition was the invention of the Brunswick Monogrammist. This painter, named after the mono-grammed *Feeding of the Five Thousand* in Brunswick, has been variously identified, usually by an attempt to decipher the monogram and fit the initials to an artist. Since the monogram does not recur on other pictures it is not necessarily a signature.

The unusual theme of the landscape in the middle distance makes the author of the *Story of David and Bathsheba* unusually difficult to identify; but the distant landscape has much in common with many pictures widely accepted as the work of Herri met de Bles, such as those in Brussels, Vienna and Cleveland, with his favourite subject of *S. John Baptist Preaching*.

This picture was bought by Mrs. Gardner as the work of Herri met de Bles at auction in Rome, Galleria Sangiorgi, 8-10 April 1895, lot 9. *P25w40*

Versions: (1) Wokingham, Surrey, Mr. John Rickards, a replica on panel, *ca.* 0.51 x 0.67. It formerly belonged to Jervis Wegg, and came from a sale at Christie's, 20 December 1929, lot 41: "Master of the Brunswick Monogram." (2) Hartford, Connecticut, Wadsworth Athenaeum, panel, 0.455 x 0.68, attributed to Lucas Gassel. It has very slight variations, described above, in the landscape and architecture but entirely different figures on the terrace in the right foreground. This is the variant recorded in the 1931 Catalogue as in a sale at Amsterdam, 1-2 December 1925. (3) London, Marylebone Cricket Club, variant, 0.52 x 0.73, the subject identified in a Latin inscription carved on the foreground parapet and a date: 15[?]4. Here the buildings and landscape have only minor variations; but on the balcony a courtier seems to be remonstrating with the King and below the elders and even David's page are expressing disapproval. Bathsheba is clothed and dipping only her toes in the water. The fountain has abstract scrollwork.

There are many variants resembling the original only in the theme and the general lay-out of the gardens.

Hans Holbein

Born in Augsburg 1497-98; died in London October or November 1543.

His father Hans Holbein was a painter and portrait draughtsman, and Hans the younger must have begun in his studio in Augsburg. In 1515 he and his elder brother Ambrosius were already settled at Basel. Hans made his reputation in Switzerland, where he found employment for the next eleven years. At Basel he seems at first to have worked with his brother in the studio of Hans Herbster. Early in 1517 he moved to Lucerne. Here he decorated the Mayor's house and painted a portrait of his son, *Benedikt von Hertenstein*, now in New York. From a change in his style at this period he is believed to have visited Italy at this period. Returned to Basel, he entered the Painters' Guild in September 1519, and became a citizen the following July. He married Elsbeth, a tanner's widow, who was his elder and had children of her own. She bore him four more, remaining at Basel to survive him. He decorated the house of a Basel goldsmith and two walls of the City Council Hall, one in 1521, the other in 1522; and in these years he painted two altarpieces for Basel merchants. The wings of one are now in the cathedral at Freiburg in Breisgau, and *The Dead*

Christ, dated 1521, at Basel is probably the predella; the other, dated 1522, is now at Solothurn. A little later, he painted for the Burgomaster Jakob Meyer the altarpiece now at Darmstadt. It was perhaps in the train of Meyer that he set out in 1524 for France. There, as we know from drawings, he visited Bourges and probably the Loire. A letter of Erasmus to Pirckheimer records that he had already painted Erasmus more than once.

Amerbach was the first of the scholars with whom Holbein was connected. Holbein's portrait of him, dated 14 October 1519, is still at Basel. The *Erasmus* now in the Earl of Radnor's collection at Longford Castle is dated 1523, and the portrait now in the Louvre must have been done about the same time. They were both sent to England, one to Archbishop Warham; and in 1526 Holbein followed them there. His portrait of the Archbishop is still in Lambeth Palace, a version in the Louvre, both dated 1527. Holbein was probably lodged in the very centre of English culture, the house of Sir Thomas More at Chelsea; he painted for him a great family portrait group. This is lost, but seven drawings for heads are preserved at Windsor Castle. From one of these was also painted the portrait of *Sir Thomas More,* dated 1527, now in the Frick Collection, New York.

The drawing for the whole group, now at Basel, Holbein took back with him to Erasmus there. At Basel he bought a house 29 August 1528, and later a small property which improved it. In the summer of 1530 he frescoed a third wall of the Council Hall. He painted at this time the pathetic portrait, of which the ruin is still at Basel, of his wife and his children Philipp and Katharina.

He returned to London in 1532. Warham was dead and More dismissed from court, and he found employment at first among the German merchants. He painted three frescoes in the hall of their steelyard, and portraits of individual merchants. The great full-length double portrait in London, commissioned by the French Ambassador there, is dated 1533.

In 1536 he was in the service of King Henry VIII, and from then until his death was constantly employed on frescoes in Whitehall Palace, in court portraiture and on diplomatic missions. The small *King Henry VIII* in the Thyssen-Bornemisza collection at Lugano-Castagnola and the *Queen Jane Seymour* in The Hague are evidently from the same studies as a great mural representing the Tudor dynasty painted in 1537, later destroyed by fire. In 1538 he painted for King Henry the other full-length portrait, also in London: *Christina of Denmark.*

Only Holbein's portraits concern us here, and it is only his portraiture which has earned him universal stature. He had learned from his father, a mannerist painter of strong character, to delineate what was interesting in a face; but he developed his inherited command of line with a strength which enabled him to eliminate the mannerisms. His integrity omitted everything irrelevant to the subject and all that was not organic in form. In painting, as he worked his pigments gradually into the finest enamel, he reduced his decorative schemes to the utmost simplicity. As often as not his backgrounds are in plain colour. Even where, as in the sensuous *Georg Gisze,* dated 1532, in Berlin or in the *Ambassadors,* in London, an exercise in virtuosity, a hundred little objects narrate the sitters' tastes and interests, his pure, unbroken, shining colours enhance his character descriptions. Few painters so consistently convince us that they are revealing the true character in the calm gaze of their sitters; yet few have invested them with such dignity. The small *Henry VIII* at Lugano is the most concise expression in painting of absolute authority.

SIR WILLIAM BUTTS, M.D. *Dutch Room*

Oil on oak, 0.468-72 x 0.370-73. The inscription on the blue-grey background ANNO · ÆTATS · SVE · LIX · has been restored. X-radiography appears to show that the sitter originally wore a round skull cap. Since the copy belonging to Major Trevor Cox (below) has the same phenomenon, it seems likely that either the copy was made contemporaneously and was modified as Holbein modified the original or the hat of both portraits was added after Holbein's time. The condition of the picture makes it difficult to judge. There are several sizable losses of paint and even of the ground beneath, including one in the tuft of hair over the ear, another in the temple over the right eye, a third, more serious, which runs from beside the nostril, through the very corner of the mouth, to almost the end of the chin. The surface of the paint is a good deal disturbed by past cracking.

Yet these accidents have little impaired the dignity and breadth of Holbein's rendering. He has given the full volume of one of those grave and roundly developed characters which must have satisfied his own serious and analytical taste.

William Butts (1485?-1545), son of William Butts of Shauldham Thorpe and his wife Margaret Kerrill, evidently combined learning and wisdom with practical skill and knowledge of the world. He was a prominent figure at Cambridge University, where he was a student and a fellow of Gonville Hall, B.A.

Hans Holbein — *Sir William Butts, M.D.* (SEE COLOUR PLATE)

Hans Holbein — *Lady Butts*

in 1506, M.A. in 1509 and M.D. in 1518. In 1524 he became Principal of S. Mary's Hostel. He became a Fellow in its second year, 9 November 1529, of the Royal College of Physicians, whose books describe him in an obituary as *vir gravis, eximiâ literarum cognitione, singulari judicio, summâ experientiâ et prudenti consilio doctor* (a man of weight, of the widest reading, of exceptional judgment, a professor of tried experience and wise counsel). He furthered the advancement both of Cheke, Cambridge's first Greek Professor, and of Hugh Latimer the reformer. He was also the friend of the great minister Cardinal Wolsey and of Archbishop Cranmer, both of whom he strove to reconcile with Henry VIII. He was physician to the King, and to the Princess Mary, afterwards Queen, whom he is thought to have saved from death by poisoning with his stern warnings to her governess Lady Shelton. The King knighted him Sir William Butts of Norfolk about 1545 and granted him abbey lands and manors there; but he lived, after he came to court, mostly at Fulham. He was buried in the old parish church there. He was still remembered in Shakespeare's day, making a brief appearance in *Henry VIII* (Act V, Scene 2), where he intercedes for Cranmer. The Museum of Fine Arts, Boston, has a portrait in half length by Holbein of the doctor's eldest son Sir William Butts, Lord Lieutenant of Norfolk. The Tate Gallery, London, has a portrait believed to be of his third son, Edmund Butts, attributed to Holbein's pupil, or imitator, John Bettes.

In 1541 Holbein began the large group, *King Henry VIII Grants the Charter to the Barber-Surgeons*, of which the ruin is still in Barbers' Hall in the city. Sir William appears in the group on the King's right behind the Principal of the Guild, Dr. John Chambers, of whom also there is a portrait by Holbein, in Vienna. These single portraits of the physicians were done from parts of the cartoon, now with the Royal College of Surgeons, London, which were cut out, pricked for transfer and then stuck back into the cartoon.[1] If Sir William was born in 1485 and the inscription on his portrait was restored correctly, this must have been painted in 1543, the last year of Holbein's life.

It is pendant to that of Lady Butts (below). The pair belonged in 1880 to William H. Pole-Carew at Antony in Cornwall. They seem to have been deposited with the Trustees of the National Gallery, London, while an order in court to break the entail upon them was being obtained from Mr. Justice North in 1899. They were then bought from Colonel Pole-Carew by Colnaghi of London, from whom Mrs. Gardner bought them through Berenson in June 1899. On the back is a seal with a demy uni-

corn issuant out of a coronet. It does not appear to be English, and might be that of the Dutch noble family Van Brienen van Ramerus (a demy unicorn gules).

<div align="right">P21e1</div>

[1] Strong in *The Burlington Magazine*, CV (1963), pp. 4-14.

OTHER AUTHORITIES

Ganz, *The Paintings of Hans Holbein* (London, 1950), p. 255.

Salvini and Grohn, *L'Opera pittorica completa di Hans Holbein il giovane* (Milan, 1971), No. 142.

Exhibited 1880, London, R. A., Old Masters, No. 175.

Copies: (1) London, National Portrait Gallery, No. 210, oil on panel (0.470 x 0.375), virtually contemporary (palest blue background; no inscription); (2) Roche Old Court, Winterslow, Salisbury, Major H. B. Trevor Cox, oil on oak (0.47 x 0.33), contemporary; (3) Arbury, Mr. F. H. M. FitzRoy Newdegate, copy "of considerably later date" recorded by Strong, *National Portrait Gallery: Tudor and Jacobean Portraits* (London, 1969), I, p. 34.

LADY BUTTS <div align="right">*Dutch Room*</div>

Oil on panel, 0.472 x 0.369. The inscription on the dull blue-green background *ANNO ÆTATIS SVE · LVII ·* is restored.

Holbein has perhaps found less sympathy here with his subject and has given compensation with his most meticulous precision in the details of costume and complexion. Some of these are perhaps of his own invention, for the pink flower, probably the handicraft of a German enameller, does not appear in the drawing for the portrait, now in the Royal collection at Windsor Castle, whereas it is to be seen also in the portrait of *Margaret Wyatt, Lady Lee* in New York.

Margaret Bacon (b. 1486?) was daughter and heiress of John Bacon of Cambridgeshire. She was Lady-in-waiting to the Queen, Catherine Howard.

This is the only instance of pendant portraits by Holbein of man and wife except for the earliest *Jakob Meyer* and *Dorothea Kannengiesser* at Basel and the miniatures of *A Court Officer of Henry VIII* and *His Wife* in Vienna. *Henry VIII* (Thyssen collection) and *Jane Seymour* (The Hague) are not identical in size, but may well have been pendants.

<div align="right">P21e5</div>

AUTHORITIES

Ganz, *op. cit.*, p. 255.

Salvini and Grohn, *op. cit.*, No. 143.

Exhibited 1880, London, R. A., Old Masters, No. 178.

Engraved by Wenceslas Hollar, 1649, in reverse without the flower and with modifications of the costume, probably after the drawing.

Drawing: Windsor Castle, a sketch by Holbein for the painting; there is no flower; engraved by F. Bartolozzi, 1796.

Copy: Raveningham Hall, England, Sir Edmund Bacon, Bt., the pendant to the copy in the National Portrait Gallery, above.

William Morris Hunt

See Hadley, *Drawings* (Isabella Stewart Gardner Museum, 1968), p. 17.

Italian; 1400-1500

See NORTH ITALIAN; 1430-80

Italian; 1450-1500

See VENETIAN; 1425-75

Italian or French; 1700-50

CUPIDS AT WORK *Little Salon*

Oil on canvas, 1.29 x 1.05. *P18w5*

Italian; 1700-1800

See Giuseppe ZAIS

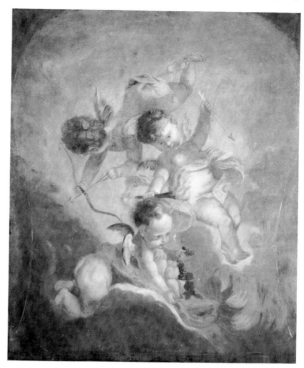

Italian or French; 1700-50 — *Cupids at Work*

Charles-Emile Jacque

Born in Paris 1813; died there 1894.

He was apprenticed as a boy to an engraver of maps; but after a short time he enlisted for seven years, during which he took part in the expulsion of the Dutch from Antwerp. He then spent two years in England, engraving illustrations to books. Returning to France, he worked first in Burgundy and then in Paris. He exhibited his first picture at the Salon in 1848. In 1867 he obtained the Cross of the Legion of Honour. Influenced by Millet and Rousseau, and painting often in the forest of Fontainebleau, he is a minor member of the Barbizon School.

SHEEP IN THE SHELTER OF THE OAKS

Blue Room

Oil on canvas, 0.652 x 0.540. Signed at the foot on the left: *Ch. Jacque.*

Bought by Mrs. Gardner of Doll and Richards in Boston 27 January 1873. *P3w2*

Exhibited 26 April 1880 — 3 June 1881, Boston Museum of Fine Arts.

Charles-Emile Jacque
Sheep in the Shelter of the Oaks

Francis Edward James

Born at Willingdon, Sussex, 1849; died 1920.

Self-taught and painting exclusively in water-colour, he was influenced at first by his English predecessor Peter de Wint; later, to some extent, by the Impressionists and by Brabazon (*q.v.*). His subjects were mostly landscapes and flowers. He exhibited in London at the Society of British Artists and the New English Art Club. He travelled in Germany and Italy, and for some years had a villa on the Gulf of Spezia.

S. MARIA DELLA SALUTE FROM THE
GIUDECCA, VENICE　　　　　　*Blue Room*

Water colour on paper, 0.178 x 0.260. On the back is inscribed: *Painted by Francis E. James of England.*　　　　　　　　　　　　　P3w7

A BRIDGE OF BOATS, VENICE　　*Blue Room*

Water colour on paper, 0.255 x 0.356. Signed on the nearest boat: *Francis. E. James* and inscribed at the foot on the left: *To Mrs. Gardner—/Tanti Salute!* [sic] *Venice Novr. 21. 1892.*

The bridge went to the Campo Santo on All Souls' Day.　　　　　　　　　　　P3w6

William James

Born at Cambridge, Massachusetts, 17 June 1882; died in Chocorua, New Hampshire, September 26, 1961.

He was the son of William James, the philosopher and psychologist, and nephew of Henry James, the novelist, the subject of the portrait below. "Billy" was very much the favourite of his famous uncle, with whom he often stayed in England. Henry James encouraged him to study in Paris, always regarded his progress with interest and often watched him paint. He lived in Boston, where he was befriended by Mrs. Gardner. He taught at the School of the Museum of Fine Arts, Boston, where he had studied earlier, and was Acting Director of the museum itself from 1936 to 1938.

HENRY JAMES　　　　　　　　*Blue Room*

Oil on canvas, 0.665 x 0.565.

Henry James (1843-1916) was born in New York, the second son of Henry James, theologian and philosopher, disciple of Swedenborg and friend of Thomas Carlyle. The eldest son William James became an eminent psychologist at Harvard College. From his father the younger Henry gained the two guiding impulses of his life, his love of Europe and his intense interest in human character. At the age of twelve he accompanied him to Europe for five years, living mainly at Geneva. They returned to Newport, Rhode Island; and in 1862 Henry entered the Harvard Law School. There he formed friendships with Charles Eliot Norton and with William Dean Howells, and began his career as a writer with contributions to *The Atlantic Monthly.*

In 1868 he left the United States for Europe, to return for a few months only at long intervals of years. In London he made friends with Robert Louis Stevenson and Edmund Gosse and in Paris with Flaubert, Zola, de Maupassant and Daudet. He came to speak and write French perfectly, and it was these French contemporaries who most influenced his later work. He travelled in France and Italy, publishing in 1875 *Transatlantic Sketches*, in 1883 *Portraits of Places* and in 1884 *A Little Tour in France*. His collections of stories had already begun in 1875 with *A Passionate Pilgrim and Other Tales* and his novels in 1876 with *Roderick Hudson*, modelled upon Hawthorne. He was much interested in the contact of Americans with Europe, and only two of his earlier novels, *Washington Square* and *The Bostonians*, describe Americans alone. In 1890 *The Tragic Muse* was devoted entirely to England

William James — *Henry James*

and the English. In 1896 James bought Lamb House at Rye in Sussex and settled permanently in England, and in June 1915, largely to express his sympathy with the cause of England in World War I, he was naturalised a British subject.

As polished in his conversation as in his writing, more popular as guest and host in a small circle than as a novelist with the reading public, he extended his sympathy mainly to the leisured class, in which social relationships are the pith of existence, sometimes at the expense of the individual. He described society in the late Victorian and in the Edwardian era with a brilliance which only a perfectly initiated foreigner could achieve, depicting the thoughts and motives of its members with unique subtlety and detail. In his later novels, *The Wings of the Dove, The Ambassadors* or *The Golden Bowl* (1902-04), many of the characters and even much of the scenery are seen only through the minds of others. His last — and perhaps most moving — publications, *A Small Boy and Others* (1913), *Notes of a Son and Brother* (1914) and *The Middle Years* (published posthumously) are autobiographical.

Henry James was the friend of Mrs. Gardner. She stayed with him at Lamb House, Rye in November 1899 and he stayed with Mrs. Gardner at Green Hill, Brookline for a week in October 1904. They met frequently in Europe, and, above all, constantly exchanged letters. The Museum archives include 100 letters from Henry James to Mrs. Gardner, written between July 1879 and 20 April 1914. In the last he signed: "your faithfullest, & from further back now surely than *any one*, old Henry James."

The portrait was painted in Cambridge, Massachusetts. It must have been with the sitter's approval that the painter presented it to Mrs. Gardner 29 March 1911.[1] His letter accompanying the gift is preserved in the Museum archives. P3n18

[1]Clara Kozol in *Fenway Court* (1972), pp. 4 and 6.

Louis Kronberg

Born in Boston, Massachusetts, 1872; died at Palm Beach, Florida, 1965.

He studied at the School of the Museum of Fine Arts, Boston, at the Art Students' League and at Julian's in Paris.

He was keenly interested in the stage and painted many prominent theatre people. Late in her life Kronberg became Mrs. Gardner's friend and assisted her in several of her last purchases, notably the small picture by Manet.

THE PIROUETTE *Macknight Room*

Oil on paper stamped to imitate canvas, 0.23 x 0.34. Inscribed at the foot on the right: *1904/LOUIS KRONBERG*. P11s2

AT THE WINDOW *Blue Room*

Oil on canvas, 0.49 x 0.34. Signed at the foot on the right: *LOUIS KRONBERG*. P3s27

Exhibited 1918, Newport, Rhode Island, Art Association; 1918, Philadelphia, Pennsylvania Academy of the Fine Arts, No. 1230; New York, National Arts Centenary.

LA GITANA *Tapestry Room*

Oil on canvas, 0.80 x 0.63. Inscribed at the top, to the left: *LOUIS KRONBERG:—/SEVILLE.* and to the right: *1920.*

Bought from the artist 7 November 1921. P19w13

Exhibited Fall 1921, Rhode Island School of Design (label on frame).

BACK TO BACK *Macknight Room*

Water colour on paper, 0.18 x 0.25. Inscribed at the top on the right: *Grez 1913*, at the foot, on the left: *Louis Kronberg. Jan 1st 1914.* and on the right: *To Mrs. J. L. Gardner.* On the frame is: *painted at Grez Seine et Marne.* P11e4

THE GRAND CANAL, VENICE *Macknight Room*

Water colour on paper, 0.20 x 0.29. Inscribed at the foot on the left: *L Kronberg* and on the right: *1914/ Venice June 29.* P11e5

SOUVENIR OF FAUST *Macknight Room*

Body colour on grey card, 0.29 x 0.22. Inscribed at the foot on the right: *Louis Kronberg*, and again at the top on the right: *L.K./1915.* P11s13

IN THE DRESSING ROOM *Yellow Room*

Pastel on canvas, 0.60 x 0.49. Inscribed at the foot on the left: *PARIS 1910—/LOUIS KRONBERG—.* P1e10

FAN DESIGN: COPPELIA *Macknight Room*

Crayon on grey paper, fan-shaped, 0.20 x 0.36. Inscribed at the foot on the left and right: *L.K. 1911.* P11e9

Exhibited Boston Art Club (label on back).

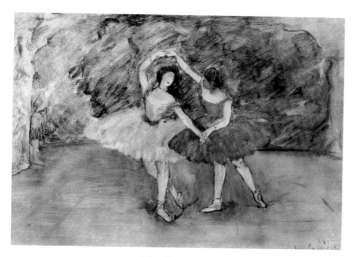

The Pirouette

At the Window

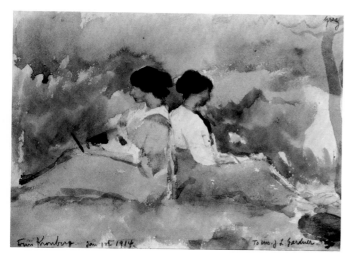

Back to Back

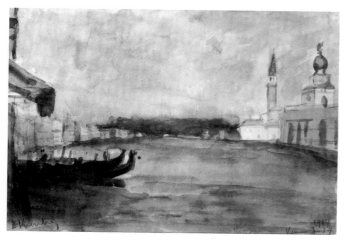

The Grand Canal, Venice

La Gitana

Souvenir of Faust

In the Dressing Room

Fan Design: Coppelia

Fan Design: La Maladetta

FAN DESIGN: LA MALADETTA *Macknight Room*

Pastel on grey paper, fan-shaped, 0.25 x 0.52. Inscribed at the foot to the right in pencil: *L. Kronberg. 1922.* On the back is written: *Ballet Paris 1923 Opera House Mme. Zambelli.* P11n37

John La Farge

Born in New York City 31 March 1835; died in Providence, Rhode Island, 14 November 1910.

The son of a French officer who had immigrated in 1806, he grew up in the small French colony near Washington Square in New York. His maternal grandfather, Louis Binsse de Saint Victor, was a miniature painter and is said to have given him his first lessons, at the age of six. Graduating in 1853 from Mount Saint Mary's College, Maryland, he went on to study law. But during 1856-57 he travelled in Europe, studying art. In Paris he worked for two weeks in the painting studio of Manet's influential teacher Thomas Couture. In England he studied the great exhibition at Manchester in 1857 of Old Masters, and met Rossetti (*q.v.*) and Burne-Jones. In 1859 he left New York and the law for Newport, Rhode Island, and began painting with William Morris Hunt, another pupil of Couture's. For ten years at Newport he painted pictures which deserved more encouragement from critics and collectors than they received. However, the original and eclectic mind that they project brought him many admirers. He was to be described later in *The Education of Henry Adams:* "Of all men who had deeply affected their friends since 1850 John La Farge was certainly the foremost . . . La Farge alone owned a mind complex enough to contrast against the commonplaces of American uniformity."

One of his admirers was the architect Henry Hobson Richardson, who was building the new Trinity Church in Boston 1872-77. Richardson entrusted the interior decoration to La Farge, who coloured it completely, painting groups of figures on the walls under the central tower, above the arches, over the windows and in the nave. Later, he made the three-lancet window over the west gallery in a glowing opalescent glass of his own invention. Like the architecture, La Farge's painting and stained glass were a compound of old traditions with new, courageous thinking. Virtually the first of its kind in this country, the Boston work brought him many commissions in both media from all over the United States. For these enterprises he had to develop a large workshop, with many assistants, in New York. After 1886, the date of his huge mural *The Ascension* in the Church of the Ascension there, he restricted his own activities largely to design.

In 1886 he visited Japan with Henry Adams, and in 1890-91 they went on a long voyage in the South Seas, La Farge painting watercolours in Hawaii; Samoa, Tahiti, Fiji and Tonga. Many of these are reproduced in his book *Reminiscences of the South Seas,* published in 1912, after his death.

An enthusiastic critic, he had embarked in 1907 with August F. Jaccaci on the publication of a series of fifteen volumes, *Noteworthy Paintings in American Collections.* Only the first volume achieved publication. It contained a catalogue of the collection of his friend Mrs. Gardner, with an introduction by himself.

THE OLD BARN UNDER SNOW, NEWPORT
 Blue Room

Oil on wood, 0.31 x 0.23.

La Farge wrote later to his biographer Royal Cortissoz that this was painted "a few months after coming to Hunt. The first distinctive paintings were a couple of landscapes painted in December 1859, or perhaps as late as January 1860. . . . You can see one of them at Mrs. Gardner's. . . . They are studies out of the window to give the effect and

John La Farge — *The Old Barn under Snow, Newport*

appearance of *looking out* of the window and not being in the same light as the landscape. And also to indicate very exactly the time of day and the exact condition of the light in the sky. This is to be done without using the methods of mere light and dark, and thus throwing away the studio practice for any previous habit."[1]

Mrs. Gardner bought the picture at an auction sale conducted by Leonard and Co., Boston, 19 November 1868. P3s26

[1]Cortissoz, R., *John La Farge* (1911), pp. 115-16.

THE SPIRIT OF THE WATER LILY *Blue Room*

Opaque and transparent water colour on paper board, 0.129 x 0.086.

La Farge did many flower paintings in his earliest days. Several with water lilies are dated 1861 or 1862. He wrote to Cortissoz: "My painting of flowers was in great part . . . a means of teaching myself many of the difficulties of painting . . . for example, the necessity of extreme rapidity of workmanship and very high finish . . . there were . . . certain ones in which I tried to give something more than a study or a handsome arrangement. Some few were paintings of the water lily, which has . . . always appealed to the sense of something of a meaning — a mysterious appeal such as comes to us from certain arrangements of notes of music."[1]

Mrs. Gardner bought the picture at an auction sale of watercolours by La Farge at the Art Galleries, Broadway, New York, 17 April 1884. P3n3

[1]Cortissoz, R., *op. cit.*, pp. 135-36.

Engraved in reverse in *Songs from the Old Dramatists*, ed. by Abby Sage Richardson (New York, 1873), p. 154.

THE RECORDING ANGEL *Blue Room*

Water colour on paper, 0.207 x 0.260. Inscribed at the foot on the left: *LA FARGE. 1890.*

Under the mount is written on the back: *Study for Glass* and on the front, below the painting: *first sketch Williams of Chicago/July 1890.*

Bought by Mrs. Gardner from Doll and Richards, Boston, 11 March 1893. P3n2

John La Farge — *The Spirit of the Water Lily*

John La Farge — *The Recording Angel*

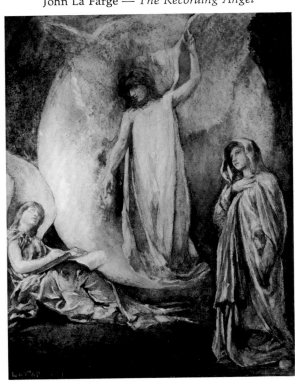

John La Farge — *A Samoan Dance*

A SAMOAN DANCE — Blue Room

Water colour on white rag board, 0.304 x 0.458.

On a wide strip along the top, coloured only by a few experimental dabs of paint, is inscribed in ink: *My dear B, You will see at once that this sketch is either carried too far, or not far enough I stopped because I am so doubtful of the light in/ which I work. It comes from below in our hut only raised a few inches above the grass, and the light comes between the posts & is reflected / from the ground outside / This is an attempt to represent one of the motions of the Siva, when the dancers stretch out their hands to right & left and draw them lightly / along the mats. The cocoa-nut fire supposed to light them is extremely brilliant, & at a distance at night, I see Rembrandt pictures, where / the central [?] light reflected from some figures, some child or woman of deep brown color, becomes like silver, then passes into shade through every variety of / tone. But the figures lit by it, mainly [?], in the house, when oiled as are the dancers, look like ivory, like old ivories. Were I a Rembrandt / and had time, which I have not, I might hope some day to give this. As it is, I have to stop short in every way. —— In this scene the hut / is decorated with palm branches, which are also wrapped around the great center pillar on the right, whose tone is tolerably correct; on the right edge the reflected light / was like silver. The light flickered & caught now this now that and a faint haze of smoke quite [?] light [?] blurred things near the light. And again, who shall give it? Dec. 19. 90.*

Along the foot, now covered by the mount, are the names of five dancers: *SamuElu, Aolele* (flying cloud), *Tulagono* (the law), *Aotōa* (cloud that stays), *Apslu.*

B. is Bancel La Farge, the artist's son, to whom he wrote from the Islands. Mrs. Gardner bought the watercolour from the artist 30 January 1892. A letter to her from him dated New York, 19 October 1894, expresses disappointment that she had refused to lend it back to him, "as was agreed between us," for use as a sketch for a picture on a larger scale and begs her at least to lend it to an exhibition in Paris the following spring. However, this or the version (below) was reproduced in colour in *Reminiscences of the South Seas.* P3n12

Version: Pittsburgh, Carnegie Institute, reproduced in *Scribner's Magazine,* XXIX (1901), p. 680.

Lanciani

RODOLFO AMADEO LANCIANI: born in Rome 1847; died there 1929.

His profession was archaeology. He was appointed Professor at Rome University in 1878. Rome had become the seat of the Italian government in 1871, and there followed a programme of excavation in the ancient city far surpassing previous efforts. Lanciani became the third Director of Excavations in a rapid succession. His books and his command of English made him well known in the English-speaking world. Harvard University made him an Honorary Doctor in 1886. In 1888 his *Ancient Rome in the Light of Recent Discoveries* was published in Boston, where he paid what must have been at least a second visit, advising the Museum of Fine Arts that year on the purchase of Roman antiquities. He married Mary Ellen Rhodes of Providence, R.I.

A SNOW-CAPPED MOUNTAIN — Blue Room

Water colour on paper, 0.25 x 0.37.

Lanciani — *A Snow-Capped Mountain*

Lanciani does not seem to have exhibited his paintings. He may well have given this to Mrs. Gardner, who probably met him on his visits to Boston and attended his lectures in Rome in 1895. Two undated letters from him in the Museum archives show him arranging to guide Mr. and Mrs. Gardner on an antiquarian tour. *P3w29*

Filippo Lauri

Born in Rome 1623; died there 1694.

The younger son of Baldassare Lauri, a landscape painter from Antwerp, he was the pupil first of his father and later of his brother Francesco and brother-in-law Angelo Caroselli. In 1654 he joined the Guild of S. Luke in Rome, and from 1656-57 he assisted in the decoration of the Quirinal Palace there. He later collaborated with Claude Lorraine, painting the figures in several of Claude's landscapes. His own large history paintings are less happy and he is at his best on a small scale. He worked on both canvas and copper, and his pictures were much in demand. The subjects were perhaps more frequently mythological than sacred, but there is a *S. Francis in Ecstasy* (canvas, 0.48 x 0.38) in the Louvre.

THE VISION OF S. ANTHONY OF PADUA
Veronese Room

Oil on copper, 0.279 x 0.213. Aside from slight damage to the sky seen through the window, the painting is in good condition.

The boy S. Anthony, already in the brown habit of the Franciscan Order, is embraced by the Infant Jesus in a pink dress. The Virgin appears above in a scarlet robe with a blue mantle. Over the table is a green cloth. The book with a bright red cover on the floor under the Child no doubt refers to S. Anthony's great ability as a preacher. The church seen through the window probably represents either S. Antonio at Padua or S. Francesco at Assisi.

The patron Saint of Padua, S. Anthony (died 1231) was born and brought up in Lisbon. Later he traveled to Assisi, where he became the disciple and close friend of S. Francis. He undertook much of the educational work of the Franciscan Order, preaching in cities throughout Italy, until he died in Padua at the early age of thirty-six. He was canonized by Pope Gregory IX the year after his death. The building of the church of S. Antonio in Padua, the famous "Santo," was begun in 1237.

The picture was not catalogued in 1931. The attribution to Lauri was suggested by Anthony Clark[1]

and is here published for the first time. Nothing is known of its acquisition by Mrs. Gardner. *P25n12*

[1]Clark in a letter of 17 November 1967 in the Museum archives.

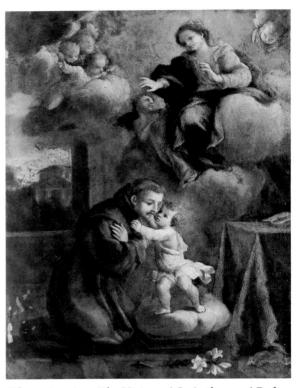

Filippo Lauri — *The Vision of S. Anthony of Padua*

Liberale da Verona

LIBERALE DI JACOPO DALLA BIAVA: born at Verona about 1445; died there about 1526.

The record of his career begins in Tuscany, where he worked for more than ten years: first for the Benedictine monastery of Monte Oliveto, near Siena, on illuminations now in the cathedral at Chiusi; then for the cathedral in Siena on a still larger series now in the Piccolomini library there.

He may well have already begun to paint in oils, and Berenson tentatively attributed to him the large altarpiece *Christ Blessing, with Four Saints* in the cathedral at Viterbo, near Rome. The picture is dated 1472, and is more usually attributed to Liberale's contemporary and compatriot Girolamo da Cremona, who may have collaborated with him in miniature-painting. The great altarpiece, *The*

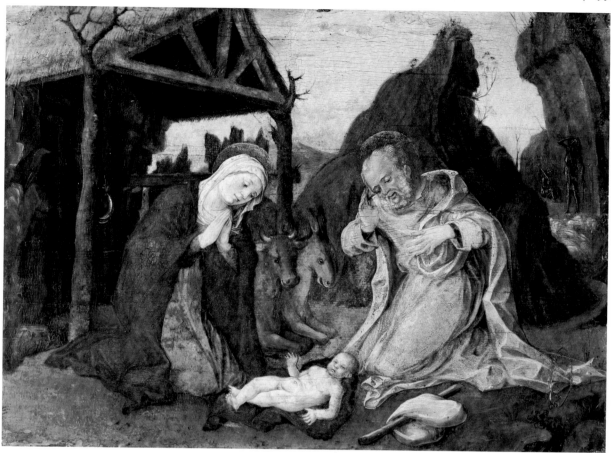

Liberale da Verona — *The Nativity*

Madonna Enthroned, with Four Saints, now in East Berlin, is signed by Liberale and dated 1489. It may have come from Monte Oliveto; but Liberale is believed to have been in Venice in 1487, the date of a painting attributed to him in S. Lio there. He had settled in Verona certainly by 1490, when he painted frescoes in S. Anastasia there; but, again, his *Adoration of the Kings* in Verona cathedral seems in its bright hardness to have emerged only recently from his practice as a miniature-painter. It seems to be the last manifestation of the old Teutonic influences which had helped to form the earlier painting of Verona, and of the spirit of Pisanello, who had painted the walls of Veronese churches. His many later pictures still in Verona, in the museum, the churches and the Archbishop's palace, show that Liberale was impatient to adopt the large scale of the High Renaissance. He may be said to have initiated it in Verona. His main inspiration was Mantegna (*q.v.*).

THE NATIVITY *Titian Room*

Oil emulsion on pine, 0.410 x 0.545. Cleaning in 1936 revealed a general abrasion and considerable loss of paint from flaking, especially in the lower sky, the peak, the hill on the right, the draperies and the upper part of the Child. The condition of the paint has exaggerated the rough appearance of the painting.

In the background on the right is the Annunciation to the Shepherds. The picture evidently belongs to the earliest years of Liberale's career as a painter, after his return to Verona. The predella by him in the chapel of the Archbishop's palace there, though more carefully painted, offers the closest analogies of type and draperies and of the restless gesticulation.

The panel was bought by Mrs. Gardner from Antonio Carrer at Venice 28 September 1897, without attribution to an artist. *P26s8*

AUTHORITIES

Berenson in a letter (4 February 1930) and *Central Italian and North Italian Schools* (1968), I, p. 210.

Brenzoni in Thieme-Becker, *Künstler-Lexikon*, XXIII (1929), p. 184.

Del Bravo, *Liberale Da Verona* (Florence, 1967), p. CXXXVI, Pl. CXXXVII.

Fredericksen and Zeri, *Census* (1972), p. 104.

Ligurian; 1450-1500

S. THOMAS RECEIVES THE MADONNA'S GIRDLE *Gothic Room*

Altarpiece, 2.600 x 2.125 (including the frame), in sixteen compartments, gold and tempera on wood. On each side of the large panel are two saints: *S. Lawrence* and *S. John Evangelist, S. Stephen* and *S. Paul*. Above in half length is *Christ Rising from the Tomb, with the Instruments of the Passion*, and on each side are two figures in half length: *Gabriel Announcing* and *S. Catherine, S. Mary Magdalen* and *The Madonna Annunciate*. Upon each side are three smaller figures one above the other; on the left: *A Pope, A Bishop* and *S. Apollonia*; on the right: *A Cardinal, A Bishop* and *S. Lucy*. The gold grounds and the paintings are much restored. When extensive conservation treatment was carried out in 1939-40 and 1945-46 it was considered advisable to leave most of the old retouching. The centre panel, however, the most important and one of the least damaged, was fully cleaned in 1940; the left side of the Virgin's head, including the eye, was found to be much damaged. The frame, a reconstruction, is an elaborate example of North Italian Gothic wood carving.

Among the colours scarlet and black predominate, relieved by the gold. The drawing is stiff and awkward, and the painting crude and provincial. One of the places which claim to preserve the

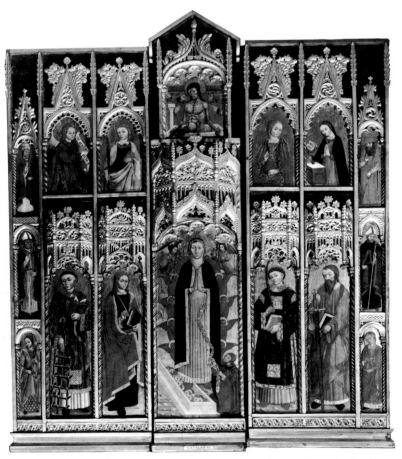

Ligurian; 1450-1500 — *S. Thomas Receives the Madonna's Girdle*

Madonna's girdle is Tortosa in Catalonia, and this altarpiece has been considered Catalan.[1] It was tentatively catalogued as such in 1931. To judge more by the frame, the shape and arrangement of the panels than by the paintings, it comes from the neighbourhood of the Italian Riviera. Its crudeness makes the attribution to an individual painter difficult; but there are affinities with the work of Giacomo Durandi, a painter of Nizza (Nice) who died probably before 1469 and is the author of altarpieces at Fréjus and Lucerame, and with that of Ludovico Brea (1443-1523?), who has left pictures along the coast from Nice to Genoa.[2] Brea's old-fashioned style is a mixture of local Franco-Flemish traditions with occasional borrowings from the painters of Milan, or even of Tuscany and Umbria. The Sienese Taddeo di Bartolo was in Liguria towards the end of the fourteenth century, and his influence has been discerned in the two figures forming *The Annunciation* here. This may well have come indirectly through Niccolò da Voltri of Genoa.

The altarpiece was bought probably in 1899 from Giuseppe Piccoli of Venice. *P30n1*

[1]Pijoan at Fenway Court, 27 July 1926.

[2]Venturi, L., at Fenway Court, 31 January 1929; he attributed it to Ludovico Brea.

OTHER AUTHORITIES

Fredericksen and Zeri, *Census* (1972), pp. 230-31, under Liguria, fifteenth century.

Zeri in a letter from Rome, 30 January 1950, attributes it to Ludovico Brea.

Filippino Lippi

See Hadley, *Drawings* (Isabella Stewart Gardner Museum, 1968), p. 3.

Wilton Lockwood

Born at Wilton, Connecticut, 1861; died at Brookline, Massachusetts, 1914.

He studied in the United States under John La Farge (*q.v.*), and later for some ten years in Paris. He practised in Boston as a portrait-painter. His portrait of La Farge is in the Museum of Fine Arts.

PEONIES *Macknight Room*

Oil on canvas, 0.60 x 0.71. Signed at the foot on the left: *WILTON LOCKWOOD.*

Bought by Mrs. Gardner from Brooks Reed in Boston 8 January 1914. *P11n15*

Wilton Lockwood — *Peonies*

Lombard; 1425-75

MATER DOLOROSA *West Cloister*

Fresco and (?) tempera on lime plaster transferred to linen, 0.595 x 0.418. An area on the left is

missing the whole length of the rectangle and 0.145 at its widest point, above the elbow. The paint film is abraded in large areas throughout. *P12w16*

AN ANGEL CATCHING THE BLOOD OF THE REDEEMER *West Cloister*

Fresco and (?) tempera on lime plaster transferred to linen, 0.577 x 0.588. A large piece of the original is lost from the top right corner, and the film is abraded in scattered areas.

The two fragments are evidently from a *Crucifixion*, in which the Angel was plainly to the left of the cross. The Virgin must have been standing at the foot of the cross, beneath the Angel. They are said to have come from a church in the Veneto.

The fragments were bought by Mrs. Gardner from Antonio Carrer in Venice 25 September 1897. *P12w17*

AUTHORITIES

Fredericksen and Zeri, *Census* (1972), p. 231.

Ragghianti in *La Critica d'Arte*, XXVII (1949), p. 297, note 27; he describes them as very close to the art of Bonifacio Bembo, and suggests Cremona as their provenance.

Lombard; 1425-75
An Angel Catching the Blood of the Redeemer

Alessandro Longhi
See VENETIAN; 1766(?)

Ambrogio Lorenzetti

Presumably born in or near Siena. He is believed to have been younger than his brother Pietro, though Pietro's first dated work, the polyptych in the Pieve at Arezzo, is of 1320, while Ambrogio's first, *The Madonna* from Vico l'Abate, now in the Seminario Maggiore, Florence, is of 1319. However, the grandiose Madonna there is still stiffly Romanesque, and free movement belongs only to the Child. In 1324 Ambrogio sold land at Siena. There are no dated works of that decade; but the two great frescoes surviving in S. Francesco at Siena probably belong to it, and also, a little later perhaps, the great *Maestà* at Massa Marittima, south of Siena. In these Ambrogio fully expressed his powerful character. In 1332 he was probably working in Florence. That date was read in the seventeenth century on the centre panel of the triptych from S. Procolo there, now in the Uffizi Gallery; and in S. Procolo he painted frescoes, now lost. He matriculated in Florence in 1334. Next year he painted frescoes no longer at Cortona, and 1335 was inscribed, with the signature of the two brothers, on frescoes no longer decorating the façade of the hospital at Siena. It was probably in 1338-40 that Ambrogio painted in fresco in the Palazzo Pubblico in Siena the two great allegories of *Good Government* and of *Bad Government* which have survived in a battered and much retouched condition. *The Presentation* from Siena, now in Florence, is dated 1342; *The Annunciation* from the Palazzo Pubblico, now in the Siena Gallery, 1344. His frescoed lunette in the Piccolomini chapel of S. Agostino, Siena, may have been painted in 1348, before the Black Death cut off both the brothers; but the last definite record of Ambrogio is of 1347.

Suitably enough, he was then speaking in the Council. Ambrogio is the political philosopher among the painters of his century, as his noble *Allegories* clearly show. They are too well designed and too full of meaning to have been merely the product of dictated ideas. While Ambrogio's weighty figures, influenced more by the sculpture of the Pisani perhaps than by Giotto's painting, seem impassive almost to the point of abstraction, his city scenes and landscapes are landmarks on the way to the naturalism of the Renaissance. The four predella scenes from the S. Procolo triptych in Florence, composed in pure colours, must have been an inspiration to Fra Angelico (*q.v.*). In his formal design he liked, according to the theme,

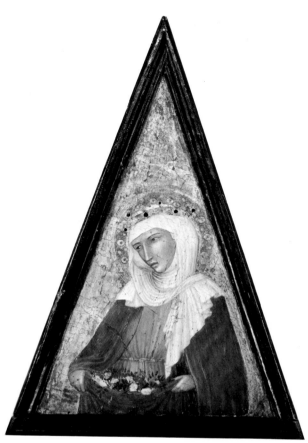

Ambrogio Lorenzetti — *S. Elizabeth of Hungary*

This must[1] be companion to the *S. Agnes* of the Fogg Art Museum, Cambridge, which, of almost identical dimensions, shows the figure turned the other way. They must come from the top of opposite wings of the same polyptych. S. Elizabeth, with the mild, rather vague air of Ambrogio's women, droops her head and raises her small nervous hands just as they usually do. The veil falls into the fine regular folds he alone affected, and is caught up just as it is over the shoulder of Prudence in his *Allegory* of the Sala della Pace at Siena. The head is sharply pointed and evenly shaded, and is drawn with more of the side exposed than is compatible with such a view of the face — all characteristics of his earlier works.

The *S. Elizabeth* was given to Mrs. Gardner 24 June 1917 by Mr. and Mrs. John Jay Chapman in memory of their son Victor (d. 23 June 1916). It was attributed to Andrea di Vanni. *P15n10*

[1]Hendy in *The Burlington Magazine*, CCCXVIII (1929), p. 109.

OTHER AUTHORITIES

Berenson in a conversation with the compiler (15 April 1928) attributed it to Andrea di Vanni; *Central Italian and North Italian Schools* (1968), I, p. 441, to Andrea Vanni (?). He attributed *S. Agnes* to Ambrogio, *op. cit.*, p. 216.

Fredericksen and Zeri, *Census* (1972), p. 109; they attribute both pictures to Ambrogio.

Van Marle, *The Italian Schools of Painting*, II (The Hague, 1924), p. 448, to Andrea di Vanni.

Ugolino Lorenzetti
See Bartolommeo BULGARINI

Bernardino Luini

Born perhaps at Luino, Lago Maggiore, perhaps in Milan, about 1475-85; died 1532.

He passed his prolific life in Milan, painting also for churches and villas in the neighbourhood and in the lake district. His earliest works, like the *Pietà* in S. Maria della Passione in Milan or the fresco fragments from the Convento delle Vetere now in the Brera Gallery, are witness of his training among the local painters of Milan: Bergognone, Bramantino, Solari. His earliest signed and dated fresco, of 1507, is in the church at Gerenzano, Lago Maggiore. At least from then until his death he must nearly always have had a scheme of fresco-painting in hand. In his narrative scenes he shows invention and charm, and in that medium his work remained fresh and straightforward. He is less

to ring the changes between luxury and severity. *The Presentation* describes a gorgeous ceremony in the most ornate of churches. One of the most sumptuous designs of the period, it became the model for all subsequent compositions at Siena. In *The Annunciation* of 1344 and the polyptych from S. Petronilla, also in the Siena Gallery, he quickly returned to the severe simplicity of his youthful *Madonnas*. In the next century Lorenzo Ghiberti, the Florentine sculptor and critic, described Ambrogio as "very expert in the theory of painting."

S. ELIZABETH OF HUNGARY

Early Italian Room

Gold and tempera on willow wood, triangular, 0.365 x 0.250. After the removal of old varnishes in 1934 almost no retouching was necessary. The moulding seemingly engaged on the two long sides is not of willow but of pine wood, and it may therefore not be original, though it appears to be the same on the companion painting.

After Bernardino Luini — *The Madonna and Child*

happy with static subjects, and in his oil paintings he is dominated by Leonardo da Vinci, who worked in Milan for several long periods in the thirty years before 1513. Few painters have imitated Leonardo successfully.

After Luini

THE MADONNA AND CHILD *Long Gallery*

Oil on poplar wood, 0.543 x 0.432.

The painting does not appear to be of any great age and in the lower right corner there are traces of earlier remains beneath. The composition follows that of a picture attributed to Luini in the Ambrosiana Gallery (No. 4) in Milan. There the Madonna is clad in bright pink with a blue mantle lined with yellow over her knees. In this reproduction the landscape is in an entirely different manner.

It was bought for Mrs. Gardner as the work of Luini in April 1903 from Veneziani in Florence by Joseph Lindon Smith, to whom it was recommended by Charles Loeser. *P27e22*

Mabuse

JAN GOSSAERT VAN MAUBEUGE (Mabuse); born at Maubeuge in Hainault, now part of France, between 1478 and 1488; died at Middelburg, Zeeland, before 13 October 1532.

As JENNYN VAN HENEGOUWEN he matriculated in 1503 in Antwerp. The tendency of modern scholarship is to assign virtually nothing to his five years of mastership before he was discovered by a princely patron. This was Philip of Burgundy, youngest of the bastard sons of Duke Philip the Good, who took the artist with him to Rome in 1508. There Mabuse spent a year studying the antiquities and painting them. He remained in the service of Philip until his patron's death in 1524.

His earliest important work is the large signed *Adoration of the Kings* in London, from S. Adrian, Grammont. Here already in his hands the technique of van Eyck, further elaborated by Gerard David, performs miracles of virtuosity. In this altarpiece there is nothing of the Renaissance. His first

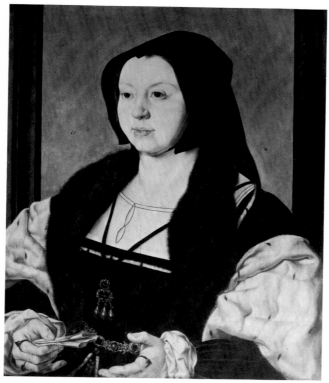

After Mabuse — *Anna van Bergen, Marquise de Veere*

dated picture, *Neptune and Amphitrite,* now in Berlin, painted for Philip in 1516, is in a highly polished neo-classical style, more than fit for the Napoleonic era.

Philip was succeeded as Mabuse's patron by his great-nephew Adolphe of Burgundy, Marquis of Veere. Of the many pictures painted for Adolphe at Middelburg there are known today only the portrait of the Marquise (see below) and the group portrait of the *Three Children of King Christian II of Denmark,* of which there are versions in three English private collections; possibly also a portrait of her daughter in London. The first of the great Mannerists in the North, Mabuse was a perfect craftsman and a brilliant stylist. Luxury is the main characteristic of his cold art, in which deeper and warmer feelings disappear before the glint of precious stones and stuffs. In rendering all the parts of a picture he shows consummate mastery; but all are so highly worked and so rationally organised that one has to wonder mainly at the superlatives in skill and style.

After Mabuse

ANNA VAN BERGEN, MARQUISE DE VEERE
Dutch Room

Oil on oak, 0.527 x 0.427, including a narrow strip added all round. The fingers of the left hand are slightly damaged.

Anna van Bergen (or de Berghes, 1492-1541) was the daughter and heiress of Jan III van Glijmes, Lord of Walhairm and of Bergen. She married 18 June 1509 Adolphe of Burgundy, Marquis of Veere. He was son of Philip of Burgundy, grandson of Antoine, "Le Grand Bâtard," and great-grandson of Duke Philip the Good. His great-uncle, the illegitimate Philip of Burgundy, Prince Bishop of Utrecht, was Mabuse's first patron. Mabuse entered the service of the Marquis after Philip's death in 1524; and passed most of his remaining years at Middelburg, where Adolphe resided as Admiral of Zeeland. The sitter is identified by an inscribed drawing, after the picture, in a codex in the library of S. Vaast at Arras (*Recueil d'Arras,* No. 106). She

is said to have died of a protracted nervous malady. Their son Maximilian died childless, and his lands came into the possession of William the Silent of Orange.[1]

The question of the picture's authorship was left open in the 1931 edition of the Catalogue. There is, however, little doubt that this is a free copy, too simple in its execution — the paint too opaque — to be by Mabuse himself. It seems more or less contemporary.

It was bought as the work of Jan Scorel, 1 March 1895, through Berenson from the Bonomi-Cereda collection, Milan, formed by Luigi Bonomi in the early nineteenth century. The portrait catalogued under Corneille de Lyon is from the same collection. The remainder of this was sold in Milan in 1896. *P21s13*

[1]Mrs. Alma F. Oakes in a letter to the compiler (from Veere, 7 June 1928).

AUTHORITIES

Conway, *The Van Eycks and their Followers* (London, 1921), p. 374, as Mabuse.

Friedländer, M. J., *Early Netherlandish Painting* (posthumous, VIII, 1972, ed. Pauwels and Herzog), p. 100, No. 76a: "A replica of approximately equal merit."

Panofsky at Fenway Court, 1935, considered it "more delicate than the New York version."

Segard, *Jean Gossart dit Mabuse* (Brussels and Paris, 1924), p. 66 and No. 23, as Mabuse.

Weisz, *Jan Gossart gen. Mabuse* (Parchim, 1913), pp. 85-86 and 118, as Mabuse.

Versions: (1) Formerly private collection New York, the original, oil on oak, 0.54 x 0.41 in., originally arched at the top, from the collections of Sir Abraham Hume (1834), Lord Alford and the Earl of Brownlow (1923); exhibited 1899-1900, London, New Gallery, No. 97, and 1927, R.A., Flemish Art, No. 188. The background is a deep green and has no stone entablature; the colours are deeper, the modelling and the quality of the pigments richer. The complexion is sallow with pronounced violet shading. (2) San Antonio, Texas, Marion Koogler McNay Art Institute, oil on wood, 0.435 x 0.335, from the collection of Princess Mary of Thurn and Taxis, Vienna, and Dr. F. G. Oppenheimer, San Antonio; exhibited 1930, Vienna, Three Centuries of Flemish Art, No. 161, as by Mabuse (known to the compiler only in a photograph, but apparently inferior to the Gardner replica).

Francis McComas

FRANCIS JOHN McCOMAS: born at Fingal, Tasmania, 1875; died 1938.

Educated at Sydney Technical College, New South Wales, he came to the United States in 1898. He studied in San Francisco with Arthur Mathews, and

in 1899 he visited London and Paris. In 1902 he held his first exhibition in San Francisco. Later, he lived and worked at Pebble Beach, California.

OAKS OF MONTEREY, CALIFORNIA
 Blue Room

Water colour on rag paper, 0.241 x 0.308. Inscribed at the foot on the right: *Francis McComas 1904.*

Given to Mrs. Gardner by the painter in Boston, March 1904. *P3n13*

Dodge Macknight

Born in Providence, Rhode Island, 1 October 1860; died at East Sandwich, Massachusetts, 23 May 1950.

Although he had passed the Brown University entrance examination before he was sixteen, he began his career as apprentice to a scene and sign painter, 1876-78; and then spent some five years as employee of the Taber Art Company at New Bedford, Massachusetts. He had begun to paint, and, when offered a loan enabling him to go abroad for four years, he left at the end of 1883 for Paris. There he studied with Fernand Cormon 1884-86. He did not return to the United States until 1897.

Meanwhile, he had confirmed his bent for painting landscape in watercolour, preferably in brilliant light. After working in various parts of France, he spent the winter of 1886-87 in Algeria. In 1888 his first exhibition, with Doll and Richards in Boston, included scenes from France and Algeria, and one from Belgium. The majority of these were small, but his success led to a rapid development. In 1890 he visited London, and held an exhibition in the studio of Sargent (*q.v.*). Next year he paid the first of several long visits to Spain. At

Orihuela he married in 1892 a French girl, Louise Queyrel, of Valserres, Hautes-Alpes, where he stayed for a good part of the next five years.

In the United States he spent most of 1898 and 1899 at Mystic, Connecticut. In 1900 he moved to East Sandwich, Cape Cod. There he soon acquired the house in which he lived for the remaining fifty years, enjoying a phenomenal success. His travels were now mostly on the American continent, where he ranged far and wide; but he returned to Spain in 1904, visited Jamaica in 1906, Morocco in 1921 and Bermuda in 1923. In that year he had exhibited sixty-three watercolours in Paris at the Exposition d'Art Americain.

First mention of a Macknight Room at Fenway Court came in a humorous letter of 27 March 1904: "Won't you do me the honor to run in to Doll & Richards's . . . when I am hanging my pictures? . . . I am not trying to drag you in there to buy my pictures by the bushel to start a Macknight room. . . ." On 13 December 1915 just after a ground floor guest room had been made into a gallery in his honor he wrote, "If I come up, I should like to see the new Macknight room. . . ." The Museum archives include seventy-six letters from Macknight to Mrs. Gardner, mostly urging her to see his pictures when they were being shown in Boston. One of these shows that his custom from about 1908 of framing his pictures in white was due to her suggestion, through Denman Ross (q.v.).

A LITTLE GIRL OF DOUARNENEZ
Macknight Room

Pastel on paper, 0.46 x 0.34. Signed below the skirt on the right: *W.D. Macknight*.
 Done in Brittany in 1889.
 Bought by Mrs. Gardner from Doll and Richards, Boston, 11 April 1890, and later given by her to Theodore F. Dwight. After his death, 3 February 1917, it returned to her by his bequest. P11s29

THE BAY, BELLE-ILE *Macknight Room*

Water colour on paper, 0.38 square. Signed in ink at the foot on the right: *Dodge Macknight*.
 Painted in Brittany in 1890.
 Bought by Mrs. Gardner, probably in 1891, from Doll and Richards, Boston. P11s33

Exhibited 1891, Boston, Doll and Richards.

ALMOND TREES, VALSERRES *Macknight Room*

Water colour on paper, 0.37 x 0.55. Signed at the foot on the left: *Dodge Macknight*.

Painted in 1894-95 at Valserres, Hautes-Alpes, France, the birthplace of his wife. Bought by Mrs. Gardner from the painter, perhaps 22 July 1907.
 P11s6

THE STREAM, VALSERRES *Macknight Room*

Water colour on paper, 0.37 x 0.55. Signed at the top on the right: *Dodge Macknight*.
 Painted in 1894-95.
 Bought by Mrs. Gardner from the painter perhaps 22 July 1907. P11s1

A ROAD IN WINTER, CAPE COD
Macknight Room

Water colour on paper, 0.38 x 0.55. Signed at the foot on the left: *Dodge Macknight*.
 Painted at East Sandwich 1901-04. The road is one near the painter's house, the boy his son John, born at Valserres in 1893.
 Given to Mrs. Gardner by Denman W. Ross.
 P11e18

A LANE THROUGH AN ORANGE GROVE, ORIHUELA *Macknight Room*

Water colour on paper, 0.37 x 0.54. Inscribed at the foot on the right: *Dodge Macknight*, and on the left: *To my/dear friend/Isabella Stuart* [sic] *Gardner*.
 Painted in 1904 at Orihuela, Alicante, Spain.
 P11s8

THE ROAD TO CORDOBA, MEXICO
Macknight Room

Water colour on paper, 0.37 x 0.55. Signed at the foot on the left: *Dodge Macknight*.
 Painted in 1907 during the artist's first visit to Mexico.
 Bought from him by Mrs. Gardner, probably in 1908. P11s30

A WOMAN IN A LANE *Macknight Room*

Water colour on paper, 0.37 x 0.53. Signed at the foot on the left: *Dodge Macknight*.
 Painted in 1907 at Cordoba, Mexico.
 Given to Mrs. Gardner by the artist. P11e3

THE BASIN, SHELBURNE *Macknight Room*

Water colour on paper, 0.38 x 0.55. Signed at the foot on the right: *Dodge Macknight*.
 Painted at Shelburne, New Hampshire, in 1910.
 Probably given to Mrs. Gardner by the artist.
 P11e8

Exhibited 1910, Boston, Doll and Richards.

A Little Girl of Dourarnenez

The Bay, Belle-Ile

Almond Trees, Valserres

A Lane through an Orange Grove, Orihuela

The Stream, Valserres

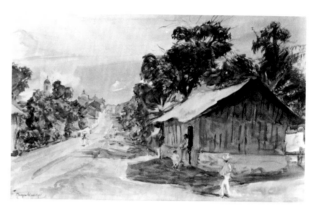

The Road to Cordoba, Mexico

A Road in Winter, Cape Cod

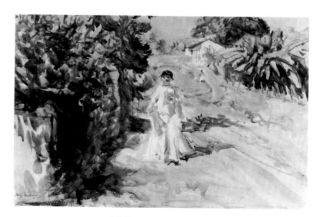

A Woman in a Lane

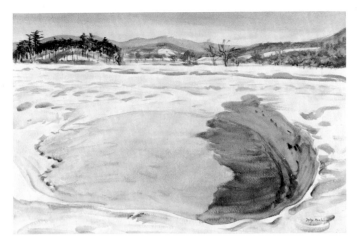

The Basin, Shelburne

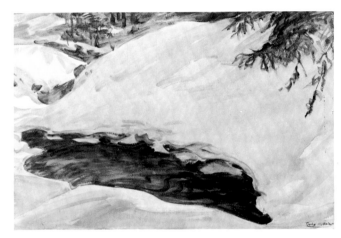

The Pool, Shelburne

Towering Castles, Grand Canyon

THE POOL, SHELBURNE
Macknight Room

Water colour on paper, 0.37 x 0.55. Signed at the foot on the right: *Dodge Macknight.*

Painted at Shelburne, New Hampshire, early in 1914.

Bought by Mrs. Gardner from Doll and Richards, Boston, 9 April 1914. *P11s24*

TOWERING CASTLES, GRAND CANYON
Macknight Room

Water colour on paper, 0.45 x 0.53.

Painted presumably in the autumn of 1914, when the painter is first recorded as visiting the Grand Canyon.

Bought by Mrs. Gardner from Doll and Richards, Boston, 13 April 1915. *P11e7*

Il Maestro Esiguo

Il Maestro Esiguo (The Tiny Master) is a name given by Roberto Longhi to a painter whose identity is unknown. He has left no dated work. In the museums of Italy there are reasonably attributed to him *Tobias and the Archangel* at Pisa (No. 38); *The Madonna and Child with Four Saints and Angels* in the Bargello at Florence (Carrand collection); *The Deposition*, from a predella, in the Vatican Gallery (No. 73) in Rome. In the United States there are small pictures by him at the University of Missouri, Columbia; Denver; Rutgers University, New Brunswick; Princeton; and Tulsa.

The Tiny Master evidently occupied a tiny place among the Umbrian painters of the later fifteenth century, following at a distance the ideas of Benozzo Gozzoli (1420-97), of Fiorenzo or of Perugino. Berenson called him "Alunno di [disciple of] Benozzo." His drawing and expression are but faint; yet his colours are quite peculiar, gay and audacious as the pottery and needlework of central Italy.

THE CRUCIFIXION
Early Italian Room

Tempera on wood originally with a completely rounded top, 0.460 x 0.335, including a strip added to each side. The border with a geometrical pattern characteristic of the painter marks the original dimensions. The figures are all a little worn. Small, fundamental damages are scattered more thickly towards the top.

The Magdalen kneels to embrace the foot of the cross; on the left the Virgin stands in prayer and

Il Maestro Esiguo — *The Crucifixion*

on the right S. John Evangelist clasps his hands before heaven. The composition, with the low-brimmed bowl of hills, is influenced by Perugino. The relative freedom of the painting points perhaps to the end of the exiguous painter's career, but the little mannerisms are unchanged. In all the pictures mentioned above, the draperies fall in similar folds, the hair in the same corkscrew curls and the trees and clouds have edges similarly pinked. Characteristic too are the quite peculiar colours, the contrasting reds and the curious mustard yellow of S. John's cloak. The draperies of Christ and the Angels are salmon pink shot with yellow and the flesh is like rosy wax. Of all the painter's works, this is perhaps the most dramatic in expression.

It was bought from Antonio Grandi of Milan 14 September 1906 as a work of the Florentine School. *P15n13*

AUTHORITIES

Berenson in a letter (4 February 1930) and *Florentine School* (1963), I, p. 2, under "Alunno di Benozzo."

Fredericksen and Zeri, *Census* (1972), p. 128, under Master Esiguo.

Raffaele Mainella

Born at Benevento, Naples, 1850; died in Venice
1942.

He had moved to Venice early, with his parents,
and studied at the Accademia there. Though he
painted in oils, he soon concentrated largely upon
topographical landscapes in watercolour. Drawings
by him of Egypt and of Palestine were repro-
duced in books by Baron von Gauzembach (or
Gonzembach), whom he had accompanied on geo-
graphical expeditions in 1890 and 1895. Water-
colours of Venice, Egypt and Palestine were ex-
hibited at the Venice Biennale in 1897, and brought
Mainella much admiration. He exhibited in Paris
first in 1901, and was a frequent visitor thereafter.
For Mme Stern he painted decorations in her hôtel
in the Faubourg Saint Honoré and illustrations to
her book *Leggenda di Venezia*.

Meanwhile he had become interested in the
decoration and restoration of buildings, and finally
became an architect. He decorated palaces and
villas in Venice and Trieste; he designed a neo-
Gothic palace at S. Barnabá on the Grand Canal,
and a number of villas, including one for the ex-
Empress Eugénie. He died in a villa designed for
himself on the Lido.

THE DEAD LION *Macknight Room*

Water colour on paper, 0.16 x 0.32. Signed at the
foot on the left: *R. Mainella*. P11n3

Antonio Mancini

Born in Rome 1852; died there 1930.

The son of a poor tailor, he appeared a boy
genius and entered the Accademia in Naples at
the age of twelve. He attracted the attention of
the painter and designer Fortuny, and at his sug-
gestion went to Venice in 1872. In a first stay in
Paris, 1875-76, he worked for Goupil and Co.; in
a second, 1877-78, he was assistant to the Dutch

painter Mesdag. He lived in Naples 1878-83, and
finally in Rome. A great exhibition of his work
was held there in 1911. In Paris he had met the
Roman Marquis Giorgio Capranica del Grillo, son
of the actress Adelaide Ristori. The Marquis
bought a picture of him and was consistently
helpful, especially in managing his finances, until
he died in 1922. Mancini's reputation first reached
great proportions in London, John S. Sargent ex-
pressing admiration for his work, Hugh Lane ac-
tively promoting it. Six pictures bequeathed by Sir
Hugh Lane and now in the Tate Gallery include
Mancini's portrait of the Marquis and a *Self-
Portrait*. The three pictures following are typical.

THE STANDARD BEARER OF THE HARVEST
FESTIVAL *Blue Room*

Oil on canvas, 1.65 x 0.85. Inscribed at the foot on
the right: *A Mancini / Roma*.

It was bought before 1885 through R. W. Curtis
in Venice. P3s23

AUTHORITIES

Cecchi, D., *Antonio Mancini* (1966), p. 155, note 1.

Curtis, R. W., in *Noteworthy Paintings*, pp. 87 and 91.

Hind, C. L., in *Noteworthy Paintings*, pp. 91-92.

Marx in *Noteworthy Paintings*, pp. 92-93; he stated
wrongly that it was painted expressly for Mrs. Gardner
about 1897.

Exhibited 1885, Boston Art Club (undated label on the
frame with Mrs. Gardner's address on Beacon Street).

THE LITTLE GROOM *Blue Room*

Pastel on paper, oval 0.48 x 0.31. Signed at the
foot: *C A Mancini*.

Bought by Mrs. Gardner 8 April 1895 from
Nicola Pierangeli, doorkeeper to the Marquis
Capranica del Grillo, in Rome.[1] P3w13

[1]Cecchi, *op. cit.*, p. 155, note 2.

JOHN LOWELL GARDNER *Short Gallery*

Oil on canvas, 1.04 x 0.74. Inscribed at the top
on the right: *A Mancini—Venezia*.

John Lowell Gardner (1837-98) was the son of
John Lowell Gardner of Boston and Catherine
Elizabeth Peabody of Salem. He married in New
York 10 April 1860 Isabella Stewart, who created
the Museum. Her portrait by Sargent is in the
Gothic Room. Their only child John Lowell, born
in 1863, died in 1865; but after the death of Mr.
Gardner's brother Joseph P. Gardner they reared

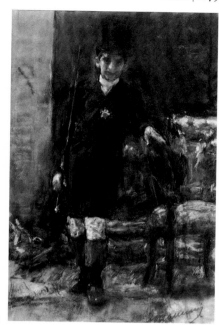

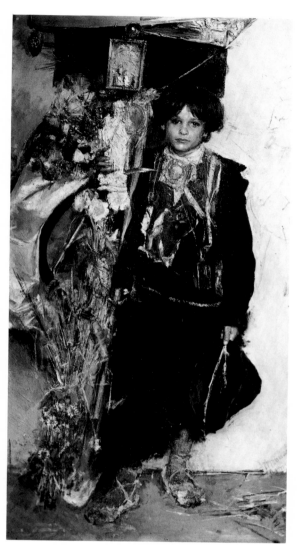

The Little Groom

The Standard Bearer of the Harvest Festival

John Lowell Gardner

and educated his three orphan sons. Mr. and Mrs. Gardner were ardent travellers, leaving the United States every other year from 1884 for Europe or the East. Mr. Gardner was elected in 1886 a Trustee and the Treasurer of the Boston Museum of Fine Arts, to which he bequeathed a sum of money at his death. He was throughout his life a leader in business and in public undertakings.

Mr. and Mrs. Gardner met Mancini in Rome in April 1895. They bought the pastel entered above and arranged for the painter to follow them to Venice to paint this portrait. It was the year of the first Biennial International Exhibition in Venice. Mancini was sending two pictures to it, and the proposal enabled him to be present at the opening.[1] The portrait was painted at the Palazzo Barbaro, where Mr. and Mrs. Gardner were staying with Mr. and Mrs. Curtis. *P17e1*

[1]Cecchi, *op. cit.*, pp. 155-56.

Edouard Manet

Born in Paris 1832; died there 1883.

The eldest son of Auguste Manet, a divisional chief at the Ministry of Justice, he was destined by his father for a like civil office. But his school career was unpromising, and he then failed twice for the navy. Early in 1850 he entered the studio of the fashionable painter Thomas Couture. This he attended with decreasing regularity until 1856. In 1863 he married in her native Holland Suzanne Leenhoff, who had taught him and his brothers the piano and who had already in 1852 borne him a son Léon Leenhoff. In 1870 he took part in the defence of Paris against the Prussians. In the National Guard his colonel was the painter Meissonier. He was already suffering from lameness when he was struck in 1879 with locomotor ataxy. He died three weeks after the amputation of a foot.

In 1853 he had visited Florence and Rome, and then Germany and Vienna; in 1865 Madrid; and in 1868 he crossed for a few days to London. In 1872 he went with his wife to Holland, where he saw the work of Hals at Haarlem, and in 1875 he went alone to Venice. But he spent only a fortnight where he had intended to remain two months. He was a passionate Parisian. With Victorine Meurend, the model in many of his earlier works, or with Berthe Morisot, later his sister-in-law, and Eva Gonzales, both of whom in his studio turned into accomplished artists, or with his men friends the painters Latour and Degas (*q.v.*), the writers Baudelaire, Mallarmé and Zola, his most uncompromising publicist, he lived a free life between his studio and the café. At the same time the small circle of his family was close and intimate, and annually he accompanied his mother (see below), his wife and his son to the sea. Well-groomed, urbane and sociable, he longed for the recognition of his art by society. For a long time he achieved only notoriety. His pictures were treated as a scandal from the rejection of the first, *Le Buveur d'Absinthe*, from the Salon of 1859; and success in 1861 was only momentary. *Le Déjeuner sur l'Herbe*, now in the Louvre (Jeu de Paume), was rejected in 1863, and found its way into the Salon des Refusés only to shock its patroness the Empress Eugénie. Yet Manet never distrusted his vision. At the Exposition Universelle in 1867 he spent all he had on the erection of a pavilion for the exhibition of the whole of his work, and in the catalogue appealed against the Academy jury, of which half were government officials. He sold no picture. At the Salon of 1873 *Le Bon Bock*, being free of his usual brilliant colours, was suddenly acclaimed a masterpiece. Gradually the public ear was reached by his literary friends, and the public eye was opened by the growing number of artists who were developing his ideas. In 1881 the official representatives were removed from the jury of the Salon; and that year Manet obtained a medal and the Cross of the Legion of Honour. Two years before his death, he was successful at last.

It was no coincidence that his career extended through the hollow, makeshift constitution of the Second Empire to reach its fullness during the first years of the Republic. Nor is it any paradox that a great revolution in painting was accomplished by this man-about-town. Living on no fictitious Olympus, as Ingres, in no imagined Orient, as Delacroix had done, he ignored with history and legend the conventions of centuries of French painting. At first he posed his models in fancy dress, often in Spanish costume which avows his sympathy with Velázquez and Goya; and the sentiment rings a little hollow, the unbroken colours and black shadows are harsh and sombre. But there are early paintings like *La Musique aux Tuileries*, dated 1862, in London or the great *Olympia* and, above all, *Le Déjeuner sur l'Herbe*, both dated 1863 and both in Paris, which are as convincing in their picture of life as in the freshness of their colour arrangement. He soon gave himself wholly to impressions of the daily life he loved, and, just as the world was growing ugly with cast iron, he devoted himself to painting the café and the quayside. He was spurred on by the observations of

Edouard Manet — *Madame Auguste Manet* (SEE COLOUR PLATE)

younger men like Monet, his friend from 1866, Pissarro and Renoir to the brilliant, clear colours of his later outdoor scenes: *En Bateau* in New York, *Dans la Serre* in Berlin or *Chez le Père Lathuille* at Douai. Painting almost entirely in the studio, he never studied light and colour with so scientific a spirit as Delacroix or Monet or Seurat; but his resource and originality in finding new and living motifs for his designs and the thought which he gave from the first to the relation of their colours underlie the hundred facets of modern painting.

MADAME AUGUSTE MANET *Blue Room*

Oil on canvas, 0.98 x 0.80, signed near the foot on the right: *Manet.* There are long fine cracks where the pigment is pale and thick, and the thin dark glazes have opened here and there to reveal the white ground.

The painter's mother, Eugénie-Désirée (born 1811) was daughter of Joseph Antoine Ennemond Fournier, at one time French Consul at Gottenburg. Her brother Colonel Edmond Fournier was Aide-de-camp to the Duc de Montpensier, son of King Louis Philippe. She thus came of the same high official class as her husband Auguste Manet, to whom she was married at twenty in 1831. Auguste Manet had no sympathy with painting; but Colonel Edmond paid, unbeknown to him, for Edouard's first lessons in drawing, and took him on visits to the Louvre; and Mme Manet from the first encouraged her eldest son in his choice of a career. She was always his confidant. A widow from September 1862, she went to live with him after his marriage in October 1863, remaining with his wife and his son after his death. She passed her later years at Sarcelles, north of Paris.

In this portrait she is clearly a widow, a black veil hanging from her still black hair, her silk dress entirely black, separated from the sombre grey of the background by the pink streak of the upholstery of the chair. The gold bracelets at her wrists and the rings on her hands of warm ivory only emphasise the severity. There is no local colour either in hands or face. There are few halftones, and the pigments are kneaded into a thick paste. All this in sharp contrast with the tender expression, the blue eyes and open brow that the painter inherited.

Flament states that the portrait was painted in 1866, in Manet's studio in the Rue Guyot.[1] Unfortunately he does not give the source of his information; but the unbroken masses of colour are opposed with a harshness which belongs to pictures painted under Spanish influence immediately after Manet's visit to Madrid in 1865. Duret dated the portrait 1869-70, also without stating his reasons.[2] Tabarant in his revised book merely asks the question. He there gives a slightly bitter account of the sale of the picture by the sitter's grandson Léon Leenhoff in 1909.[3] The Prince de Wagram had offered fr. 60,000, the Berlin Museum fr. 70,000. It was sold by Leenhoff for fr. 90,000 to Thomson of London.

Mrs. Gardner bought it through Berenson 2 May 1910 from Wallis and Son ("The French Gallery"), London. *P3s4*

[1]Flament, *La Vie de Manet* (1928), p. 243.

[2]Duret, *Histoire d'Edouard Manet et de son oeuvre* (1902), No. 124.

[3]Tabarant, A., *Manet et ses oeuvres* (1947), p. 79; and — better — *Manet, Histoire catalographique* (1931), p. 109, No. 68.

Exhibited 1909, London, International Exhibition, lent by Leenhoff (label on frame).

CHEZ TORTONI *Blue Room*

Oil on canvas, 0.26 x 0.34. Signed at the foot on the left: *Manet.* It is possible to read also: *75*; but this is doubtful. The painting was cleaned and relined in 1938 and a loss in the lower left area made good.

The present title, which assumes that the little portrait was painted in the famous café in the Rue Laffitte, Paris, where Manet habitually lunched, cannot be traced beyond this century. The picture was called *Journaliste* in the *ms.* catalogue of Manet's works by Etienne Moreau-Nélaton,[1] perhaps the best equipped of the early authorities on the subject. Duret does not mention the picture. Tabarant, who retains the title *Journaliste*, states that the café was not Tortoni's but La Nouvelle Athènes. He does not offer any evidence. Jamot and Wildenstein[2] state that the subject is the painter Chenard-Huché; but the painter (1864-1937) was only sixteen years old in 1880, the date to which they wrongly ascribe the picture. The sitter seems literary for a painter, and somewhat smartly dressed for a journalist. Tabarant dates the picture 1878.[3]

According to Jamot and Wildenstein it belonged to Chenard-Huché. It certainly belonged to Alphonse Kann, whose collection was auctioned in Paris 6-8 December 1920. Bought by Kélékian, it was sold by him at auction in New York, 30-31 January 1922, American Art Association, No. 104; bought by Mrs. Gardner through the painter Louis Kronberg (*q.v.*). *P3s5*

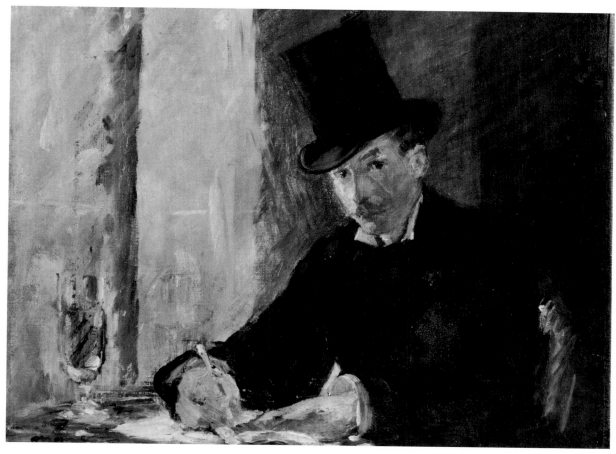

Edouard Manet — *Chez Tortoni*

[1]Tabarant, *Manet, Histoire catalographique* (1931), p. 340, No. 292; the statements are repeated in *Manet et ses oeuvres* (1947), p. 331.

[2]Jamot and Wildenstein, *Manet* (1932), I, p. 165, No. 367: *Portrait de Chenard-Huché, Peintre, Chez Tortoni.*

[3]Tabarant, *Manet et ses oeuvres* (1947), p. 331.

Exhibited March 1921, Brooklyn, N.Y., the Brooklyn Institute.

Andrea Mantegna

Born in 1430-31, probably at Isola di Carturo between Padua and Vicenza; died at Mantua 1506. His father Biagio was a carpenter.

Between 1441 and 1445 Andrea was enrolled in the Guild at Padua, as the adopted son of Francesco Squarcione, a contracting decorator and crude painter, from whose bondage he was legally freed in January 1448. That year upon a lost altarpiece for S. Sofia he proudly inscribed his seventeen precocious years, and on May 6 he and Niccolò Pizzolo, a painter-sculptor who was probably ten years his senior, were commissioned to decorate one wall and to supply an altarpiece in terra cotta for the oratory of S. Cristoforo in the church of the Eremitani in Padua. Others were to do the remainder of the decoration; but a series of fortunate misfortunes left to the youngest the greater part. In 1453 Andrea married Niccolosia, daughter of the painter Jacopo Bellini, to become the brother-in-law of Gentile and Giovanni and the father of a brigade of children.

In 1459-60, when he had finished the triptych on the high altar of S. Zeno at Verona, he was established by Marquis Lodovico Gonzaga at Mantua as Court Painter, a position he continued to occupy under Lodovico's son and grandson until his own death. In return for lands and money and

unusual distinction and consideration he laboured almost continuously. Yet of all his frescoes in the various Gonzaga residences the mists and misfortunes of Mantua have left almost nothing but those in the Camera degli Sposi in the Castello at Mantua, portraying Lodovico with his family, his horse and hounds and household. These are dated 1474. The panels and canvases are scattered in the museums of Europe and America. In 1466 Mantegna visited Florence, perhaps not for the first time. In 1488 Marquis Francesco II lent him to Pope Innocent VIII, for whom he painted during more than a year in Rome the decoration of the Belvedere chapel in the Vatican, destroyed by a later pope. Returned to Mantua, he found the patronage of the court quickened by Isabella d'Este, the new Marchioness. In 1492 he was still working upon the splendid canvases, *The Triumphs of Caesar*, now at Hampton Court, already begun in 1486. In 1495-96 he painted for the Marquis *The Madonna della Vittoria*, now in Paris. The even larger *Madonna and Saints* painted for S. Maria in Organo in Verona, now in the Castello in Milan, is dated 15 August 1497. The *Parnassus* and *Wisdom Victorious over the Vices* now in the Louvre were painted for Isabella's study in 1497 and 1501-02. When he died, he had just completed for Francesco Cornaro in Venice the wide grisaille picture now in London.

Occupying an unique position unusually long, Mantegna has had his character better recorded than most painters of his generation. He lacked a little the quality of sympathy, his pride involving him in litigation and making him awesome at court. He demanded a full acknowledgment of his genius and a thorough reward. Yet Cardinal Francesco chose him as companion to allay the tedium of a cure, and Feliciano has described a picnic on Lake Garda with the young Mantegna and other archaeologists, who explored the Roman antiquities and crowned one another with wreaths. The artist's schemes of property seem to have been too grandiose, and he was in some embarrassment when he died.

While he was so rapidly growing to maturity, the eyes of Lombardy and the Veneto were dazzled by Florentine draughtsmanship. Uccello, Castagno and Filippo Lippi each passed several years in Venetian territory. At Padua Donatello had left the finest series of his bronzes. Some giants painted by Uccello on the façade of a house there are said by Vasari to have been an education to Mantegna. The science of these artists and the force of their ideas stimulated a desire for expression and appreciation in a district now grown to its highest point,

and a new freedom of ideas was opening men's eyes also to the relics of antiquity. Mantegna arrived in Mantua to find there, in the retinue of Pius II, Leon Battista Alberti, the herald of the Renaissance, learned archaeologist and architect. Alberti paid further visits to Mantua over the building of the great church of S. Andrea after his design. Mantegna knew the amphitheatre at Verona, and at Mantua made his own cabinet of antique busts.

His art is the first significant fruit in painting of this new sowing of the Lombard soil, a little forced, but springing up quick and straight as the Lombard poplar. In the frescoes at Padua he falters little in the precision of his draughtsmanship; his mind is perfectly urbane. Already he robes his figures in Roman garments, fashions his foregrounds and decorates his distant landscapes with Roman buildings; and it remained always his passion to reproduce his vision of antiquity. The cold heat of his expression hardly varies again. He marches straight forward upon a narrow path hewn from the marble hills of his imagination, the distant prospect crowned by the city of Rome. He is the first and the greatest of the neo-classicists. This detachment from humanity, while he looks inward upon a world of his own creation, made possible the immaculacy of his design. It is perfect with a rather narrow symmetry, tending towards the idea of a sculptured bas-relief, which is frankly adopted in some of his canvases. His drawing is refined, and even his frescoes painted as if they were miniatures. It is in *The Triumphs of Caesar* at Hampton Court that his genius swells to full expansion, his own fastidious pride finding its most genial rhythm in the pomp of a victorious procession. This series of nine great tableaux is perhaps the most moving expression of that dream of Roman grandeur which continued to obsess the artists of Europe for more than three centuries.

SACRA CONVERSAZIONE *Early Italian Room*

Tempera on light hardwood, 0.535 x 0.428. Signed on the face of the rock a little to the right in the near foreground: *ANDREVS MANTINA* (the *MA* in monogram).

The appearance of the picture was greatly modified by cleaning in 1951. Enlargements were removed from all four sides. The entire sky had been overpainted to conceal a condition of general abrasion and two lacunae: in the centre of the sky at the top and (larger) to the left of centre, lower down; also a curved break in the surface which runs from above the centre of the sky

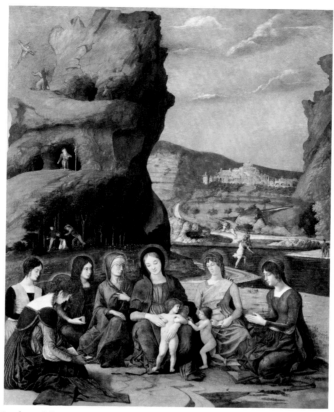

Andrea Mantegna — *Sacra Conversazione* (SEE COLOUR PLATE)

through the head of the Saint behind the infant S. John and through his left forearm into the Virgin's left leg. The removal of much repaint and discoloured varnishes has revealed a worn condition, severe in many places: along the edges, in all four corners, in the costumes of the Virgin, S. Elizabeth and S. Mary Magdalen, in the hair of the Magdalen and of the nearest Saint. It has also, however, disclosed not only brilliant colours and painting as fine as miniature painting but several motifs previously invisible. The Death of S. Peter Martyr in the wood at the base of the nearer crag had been painted out. The signature remained unaffected by the cleaning. There is no evidence that it was added later, as several writers have believed.

Behind the holy group S. Christopher bears the infant Christ across the stream; on the far bank S. George is seen sitting his horse in the shadow of a cave, and then charging the dragon. On the rock to the left S. Jerome, watched by his lion, chastises himself before the crucifix. Below this, in the shade of the trees, S. Peter Martyr meets his death by assassination, and, above, S. Francis

receives the stigmata before the eyes of his companion. Among the group of seven holy women, all with aureoles of gold, who are seated round the infants Jesus and John, S. Elizabeth is on the Virgin's right and beyond her the Magdalen. This is perhaps the first instance in which an Italian artist followed the Netherlandish custom of seating a group of the Holy Family in an open landscape, the first of those *Sacre Conversazioni* which became a favourite subject of the more intimate Venetian pictures of the sixteenth century.

Mantegna was an admirer of the Northern painters who were beginning to visit and find employment in the North Italian cities; but he was more influenced by the sheer refinement of their drawing and technique than by their fundamental aims. This picture, like the centre of the triptych in the Uffizi painted probably upon Mantegna's first arrival at Mantua, reflects the strong pull away from his own strict path of design which he received from the Netherlandish influences. The landscape, with the fanciful secrets of its rocks, is more loosely constructed than usual, the drapery more restless and angular in its arrangement and

the types a little modified. But the foreign influence and the condition of the picture should be enough to explain these slight aberrations from the normal and the difficulty of some critics in placing the picture among Mantegna's works. Comparison with the *Allegories* in Paris show that it is a late work.

Mrs. Newton deduces from the waist lines and other details of the dress, including the hair fashions, that the picture must have been painted about 1497-1500.[1] She writes that the dress is fashionable except for that of the Saint immediately behind the little S. John; that her costume could be intended to be gipsy, and so perhaps to identify her as S. Mary of Egypt.

With a panel of different date, *The Death of the Virgin*, now in Madrid, this picture passed from Mantua to King Charles I of England,[2] who purchased from Duke Vincenzo Gonzaga the greater part of his collection. The last consignment of this left Italy 25 July 1632. After the King's execution in 1649 his collections were by act of Parliament dispersed through private treaty, and these two panels were bought by Jasper.[3] He was perhaps agent for the Spanish Ambassador Alonso de Cardenas, who doubtless sent these in a large portion of the royal collection to King Philip IV of Spain. They remained together in the collection of the Spanish kings until Queen Christina of Spain, who was Regent from 1885 during the minority of her son the last king, gave[4] this panel to her daughter, who married Prince del Drago. From the Prince it was bought by Mrs. Gardner in October 1899 through Richard Norton in Rome. *P15s5*

[1]Stella Mary Newton in letters from the Courtauld Institute of 22 January and 4 February 1969.

[2]Vertue, *A Catalogue and Description of King Charles the First's Capital Collection of Pictures, Limnings, Statues, Bronzes, Medals, and other Curiosities; Now first published from an Original Manuscript in the Ashmolean Musæum at Oxford* (London, 1757), p. 9: "No. 33. A Mantua piece, done by Andrea Mantanio. Item. Another as aforesaid fellow piece of Andrea Mantanio, also in the like ebony frame, joined in another wooden frame, where our Lady, Christ, and St. John, and six other Saints sitting by; and in the landskip, a St. Christopher carrying Christ over the water; and also another, St. George on horseback, running with a spear to kill the dragon; and also on high upon the rock, a St. Francis, and St. Jerom and St. Dominica, painted upon the right light. Length 1 f. 9, Breadth 1 f. 5."

[3]Fry in *Noteworthy Paintings*, pp. 163-67; he quoted the seventeenth century manuscript in the library of the Victoria and Albert Museum: "*An Inventorie of the Personall Estate of y^e late King which was sold by Act of Parlt^t.*, under 'Pictures at St. James's Palace': *Death*

of Marie, water colours, Mantegnia £15 Jasper, *Marie and divers Sts* by Manteyner £15 Jasper." Fry was the first to identify the picture with that in Vertue's catalogue and to publish the attribution to Mantegna. He suggested that the pair hung in the Castello at Mantua on the ground that the landscape of *The Death of the Virgin* is a view from one of its windows; but actually it shows the Ponte de' Molini at the other side of the town, and there was nothing at Mantua to connect the two pictures. He suggested also that Francesco Gonzaga refers to the pair in a decree of February 1492 granting Mantegna land in return for his work in "the Chapel and Camera of our Castello." Fry dated the picture shortly after 1459.

[4]Richard Norton in a letter of 1 March 1900. In another of 8 November 1899 he stated that (Fairfax) Murray had hoped to buy the picture from the Prince.

OTHER AUTHORITIES

Berenson, *Dipinti Veneziani in America* (Milan, 1919), pp. 61-65; he dated it about 1485; *Central Italian and North Italian Schools* (1968), I, p. 239; he attributed it to Mantega only "in great part" and stated "signature added later."

Borenius in *Crowe and Cavalcaselle's History of Painting in North Italy*, II (London, 1912), p. 97, note 2; he identified the picture by hearsay with that which Crowe and Cavalcaselle reported as missing from King Charles' collection.

Cipriani, *Tutta la pittura di Mantegna* (1956), p. 79; she is uncertain about the attribution.

Fahy, in a letter to the Director of 16 April 1973, supports the attribution to Mantegna.

Fiocco, *Mantegna* (1937), p. 208; he considered the signature an addition.

Fredericksen and Zeri, *Census* (1972), p. 118; they consider it not autograph.

Frizzoni in *Noteworthy Paintings*, pp. 159 and 162; he did not accept it as Mantegna's. He stated that there are "no clear indications of either his spirit or his hand" but that "the signature may well be justified by the work having come from the master's workshop, and the master himself having had some part in it."

Martindale and Garavaglia, *The Complete Paintings of Mantegna* (1967), p. 98, No. 34F; they consider that the picture has been reduced in size, that the signature is not genuine, that Tietze-Conrat's views are in general correct.

Tietze-Conrat, *Mantegna* (1955), p. 180: "without parallel in Mantegna's oeuvre, especially in the treatment of the figures. . . . More likely by a minor Ferrarese painter around 1480."

Influenced by Mantegna
THE MADONNA AND CHILD *Raphael Room*

Tempera (?) on canvas, 0.93 x 0.67. Cleaned and relined in 1944, which revealed details in the Virgin's hair, and in the heads of the Cherubim and in the clouds surrounding them.

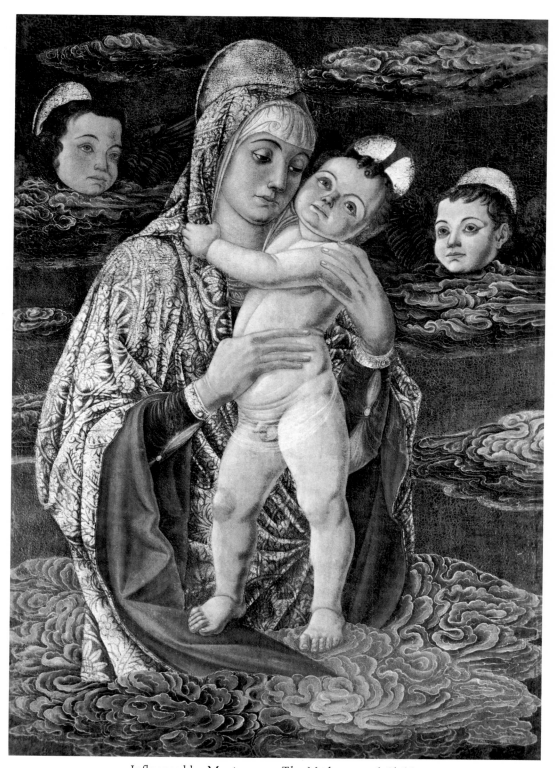

Influenced by Mantegna — *The Madonna and Child*

The presentation of the theme is unusual, for it is normally at the moment of her Assumption that the Virgin appears thus in heaven, supported on clouds among the winged heads of Cherubim. The form — or rather pattern — of the clouds is quite peculiar. Almost equally unusual is the simple and arbitrary colour scheme, confined to crimson, pink and green, where there is not gold.

Almost certainly, the picture was bought in 1892 in Venice as the work of Antonio della Corna (active 1478-1502), an attribution which was supported in 1932 by G. M. Richter[1] and has been recently revived by Everett Fahy.[2] There are indeed points of resemblance in two pictures signed by Corna: the polyptych in the Bagatti Valsecchi collection, Milan, and *S. Julian Killing his Parents* in the collection of Prince Schwarzenberg in Rome. This is dated 1478 in an inscription which declares the painter to be a disciple of Mantegna. These resemblances are hardly enough, however, to be entirely convincing, and there seems no parallel at all in the most important work attributed, since the early sixteenth century, to Corna, the frescoed ceiling from the Casa Maffi at Cremona, now in the Victoria and Albert Museum, London. Here *Apollo and the Muses* are represented in grisaille *trompe-l'oeil* architectural effects in an elegant style closely imitative of Mantegna. The influence of Mantegna is the one style-characteristic of this *Madonna* upon which everyone is agreed, and the contrast between the *Madonna* and the ceiling painting is only emphasised by what they have in common. An attribution to Bono da Ferrara, or at least to the Bono who in the early 1450's signed the large fresco in the oratory of S. Cristoforo in the Eremitani church in Padua, mostly decorated by Mantegna, was suggested in the 1931 Catalogue; but it has received no support. Berenson at that time believed that the canvas must be a contemporary copy of a lost picture by Mantegna. In his posthumous lists he maintained this attribution, while attributing the copy to another of Mantegna's followers, Bernardo Parentino (1437-1531).[3]

This is presumably the picture, "la Vergine con il Bambino ed un coro di angioli," attributed to Corna, which was bought from Favenza in Venice by Mr. Gardner in November 1892 and given to Mrs. Gardner at Christmas. *P16w15*

[1]Richter, G. M., in *The Burlington Magazine*, LXI (1932), p. 239.

[2]Fahy in a letter to the Director, 1972.

[3]Berenson in a letter of 10 March 1930 and *Central Italian and North Italian Schools* (1967), I, p. 318.

OTHER AUTHORITY
Fredericksen and Zeri, *Census* (1972), p. 235, under Padua, fifteenth century.

After Mantegna

See Hadley, *Drawings* (Isabella Stewart Gardner Museum, 1968), p. 66.

E. Newell Marshall

Born in Boston, Massachusetts.

THE PARROT *Macknight Room*

Water colour on paper, 0.32 x 0.23. Signed with a monogram.

Bought by Mrs. Gardner, on the recommendation of John S. Sargent, from Doll and Richards, Boston, in 1916. *P11s11*

Exhibited 1915, San Francisco, Panama-Pacific International Exposition.

E. Newell Marshall — *The Parrot*

Masaccio

TOMMASO DI SER GIOVANNI DI MONE CASSAI:
born 21 December (S. Thomas' day) 1401 at San
Giovanni Valdarno, a small town thirty miles up
river from Florence; died in Rome 1428-29.

Tommaso matriculated in the Guild of Physicians
and Pharmacists in Florence in January 1422, and
two years later joined that of S. Luke. The only doc-
umented work is the complex altarpiece painted for
the church of the Carmine at Pisa in 1426 and long
dispersed; but two pictures certainly painted by
him before this are the ruined *Madonna of Humil-
ity* now in Washington and *The Madonna with
S. Anne and Five Angels* painted for S. Ambrogio
in Florence and now in the Uffizi Gallery there.
The Pisan altarpiece was painted in the course of
1426. Much of it is lost; but the central *Madonna
and Child with Four Angels*, somewhat truncated,
is now in London. Over it was *The Crucifixion*
now at Capodimonte, Naples, and from the same
tier are the *S. Paul* in Pisa and *S. Andrew* in the
Lanckoronski collection. In Berlin-Dahlem are four
panels with Saints from the pilasters of the frame and
the predella with five scenes on three panels (two
on one panel by an assistant). In the remaining
two years of his brief life he painted in fresco
the great altarpiece *The Trinity with the Virgin
and S. John Evangelist and Two Donors*, together
with its *Imago Mortis* below, in S. Maria Novella,
Florence, and the famous series of scenes, mostly
from *The Life of S. Peter*, in a chapel of the
Carmine church there. He began these in association
with the elder painter Masolino, continued on his
own and left them unfinished, probably towards the
end of 1428, to go to Rome. Here he died before he
had completed his twenty-seventh year.

There can rarely have been so much painting
in one town, especially on the grand scale of wall
decoration, as in fourteenth century Florence; but
before the middle of the century its form had
come to lack the substance, its expression the
deep humanity of the great precursors. It was a
period of unsurpassed craftsmanship, pure colour
and graceful design, often splendidly decorative
and always dedicated, like the monasteries which
were responsible for so much of it, to a somewhat
formalised religion. Masaccio broke with violence
into these conventions.

The new stir of ideas was perceptible first in
architecture and in sculpture. Brunelleschi put
aside the florid conventions of Gothic architecture
which had affected the style of contemporary
painting. While he was researching into the prin-
ciples of Roman architecture, his younger con-
temporary Donatello expressed a quickening of the
senses perceptible in contemporary life. Associated
with great mathematicians, they both became
masters of artificial perspective. Masaccio under-
stood their intentions and how these could revo-
lutionise painting. There is some evidence that
Brunelleschi designed the perspective effect in the
Trinity altarpiece, but Masaccio alone can have
realised to the full the emotional impact of this
realism of space and form. This is the very first
of all the great Renaissance altarpieces, involving
the worshipper in its scene as he had never been
involved in a Byzantine or a Gothic painting. Al-
ready in the Pisan altarpiece humanism had taken
possession. No longer do the saints attend in
courtly ranks, like ladies- and gentlemen-in-wait-
ing, upon the Madonna and Child enthroned as
for an audience. Masaccio's saints are reverend
with solemn experience; the Child in the London
centrepiece sucks his grapes with a foreboding
intensity; the Madonna bends her powerful frame
without elegance, but with a new solicitude. In the
Florentine fresco, *The Tribute Money*, the rolling
hills of the Val d'Arno, their trees stripped naked
by the winter winds, take the place of the con-
ventional rocks and flowering shrubs. Naturalism
has acquired a new value, to create perhaps the
first modern landscape as a setting for man as
part of nature, which he is mastering anew.

This conquest was possible because Masaccio
took up from where Giotto (*q.v.*) had left it the
serious study of form and developed it by his
more powerful command of light and shade. Since
Giotto's day edges had become hard and colour
flat; Masaccio saturated them once more with
light and shadow as Giotto had begun to do. In
The Tribute Money the light flows from one source,
seeming of itself to create the form; in *The Rais-
ing of the King's Son*, the last of the Florentine
frescoes, left unfinished, it has gained complete
mastery over the elements, and unfolds with
startling clarity the innermost personalities of an
astonished throng. His characters have a degree
of individuality which can scarcely have appeared
before in painting, and in this, just as in a method
which dispensed with the symbolism of line more
nearly than that of any other artist of the Floren-
tine Renaissance, he stands out from his genera-
tion and anticipates the ideas of later centuries.
All the great painters who have got expression and
achieved form by the true study of light and
shade have Masaccio as their ancestor.

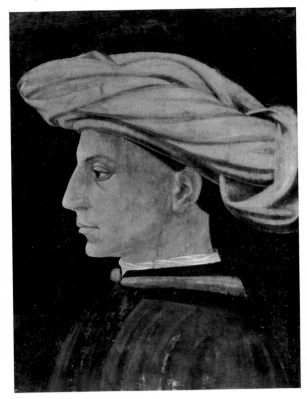

Masaccio
A Young Man in a Scarlet Turban (SEE COLOUR PLATE)

A YOUNG MAN IN A SCARLET TURBAN
Early Italian Room

Tempera on panel, 0.41 x 0.30. The surface of the paint has been rubbed away.

Painted probably between 1425 and 1427, this is one of the first of modern portraits, one of the earliest of serious pictures not devoted to religion. It exemplifies both the individualism to which Masaccio gave expression and the growing courage with which secular life was laying hold on the arts. The profile of the head is naturally the first aspect seized upon for representation, and, though portraiture was rapidly elaborated, these simple medallion portraits with the profile in low relief against a dark ground remain a characteristic form of representation throughout the fifteenth century.

The closest parallel to this portrait is one at Chambéry inscribed *ELFIN · FATVTTO*; but this unfortunately is so much overpainted that even its period is disputable. This has not prevented its attribution by several authorities to Uccello, and both portraits have much in common with a pro-

file drawing in bistre wash in the Uffizi which has been widely attributed to him. All three are much more acceptable as work of Uccello's middle period than are the two rather lifeless Olivieri portraits attributed to him in Washington. None of the four panels, however, seems to have Uccello's character as the compiler interprets it, and many writers agree in attributing the Gardner portrait to Masaccio.

In spite of the rubbing which has destroyed the sense of atmosphere and the finer modulations of the surface (the bridge of the nose and lower lip have plainly been thrown out of perspective), the ear has retained a subtle atmospheric definition and the whole head a curiously living suggestion of the play of light and shade. This, together with the warm strong colours (the complexion almost brick red, the cloak of plum colour), the strength and breadth of the features and the boldness of the design, is characteristic of Masaccio. The restless liveliness of Uccello is absent. The very clumsiness with which the white scarf is handled is a natural feature in an art so rapidly developed as Masaccio's. It is easily overshadowed by the vigorous arrangement of the turban, the skill with which the mass of the shoulder is suggested without undue projection and by the splendid virility of the characterisation.

Bought December 1898 through Berenson from Costantini at Florence. *P15e26*

AUTHORITIES

Berenson in a letter (4 February 1930) attributed it confidently to Masaccio; in *Florentine School* (1963), I, p. 134, it is included in his list of Masaccio's works with a question mark.

Berti, Luciano, *Masaccio* (Pennsylvania University, 1967), pp. 151, note 222, and 166; he is in favor of an attribution to Uccello; and *L'opera completa di Masaccio* (1968), pp. 88-89; he gives a list of opinions.

Del Bravo, *Tutte le Opere di Masaccio* (1969), No. 47, to Masaccio.

Fahy in a letter to the Director of 16 April 1973 is against the attribution to Masaccio.

Fredericksen and Zeri, *Census* (1972), p. 123, to Masaccio.

Longhi, *Opere Complete*, II, 1 (1967), p. 140, to Masaccio.

Van Marle, *The Italian School of Painting*, X (The Hague, 1928), p. 268, to Masaccio.

Pope-Hennessy, *The Portrait in the Renaissance* (1966), pp. 35-36: "mistakenly given to Masaccio"; and p. 307, note 53.

Procacci, *Tutta la Pittura di Masaccio* (1951), pp. 37 and 39 and Pl. 85; he has not seen the picture and accepts the attribution tentatively.

Ragghianti in *Sele Arte*, 2 (1952), p. 65, suggests an attribution to the young Piero della Francesca under Masaccio's influence.

Salmi, *Masaccio* (Milan, 1947), pp. 176-77; to Masaccio, about 1425.

Sindona, Enio, *Paolo Uccello* (Milan, 1957-59), to Uccello.

Somaré, *Masaccio* (Milan, 1924), p. 228, to Masaccio.

Henri Matisse

Born at Cateau, Nord, 1869; died at Cimiez, Alpes-Maritimes, 1954.

He began his career with several years of law study. This may well have had a part in shaping his clear and methodical approach to the problem of picture making. Certainly his beginnings as a painter, about 1890, were equally studious. While attending the Ecole des Arts Décoratifs and Julian's in Paris, and then the Ecole des Beaux-Arts there under Gustave Moreau, he was frequently copying pictures of the seventeenth and eighteenth centuries in the Louvre. Even after leaving the Ecole and spending months in Brittany, under the influence of Gauguin, not to mention a brief visit to Corsica and Toulouse early in 1899, he attended the Académie Carrière for some time. In 1901, however, he was one of those who revived the Salon des Indépendents. He had a great triumph there in 1906 with his *Joie-de-vivre*, now in the Barnes Foundation, and continued to exhibit there until 1910. Meanwhile, since no qualifications were demanded for admission, another type of exhibition became essential, and the Salon d'Automne was inaugurated in 1903. The first exhibition was centred on a memorial to Gauguin, which was repeated on a larger scale in 1906. In the intervening year Matisse was the dominant figure. In 1905, for the first time, "Les Fauves" (The Wild Beasts) exhibited together, and Matisse was recognised as their leader by the others of the group, with whom he had worked and exchanged ideas: Marquet, Derain, Vlaminck, Van Dongen, etc. This was the first great, distinct movement in the art of the twentieth century. It reached its full strength in the following year, when it was joined by Braque. It was in 1906 also that Matisse met the young Picasso, who was to become his rival for leadership among the artists of Paris until the second World War.

Although Fauvism as a group movement had come to an end before 1910, Matisse never abandoned the basic principles he had announced as its leader: "What I strive for above all is expression . . . I discover the expressive value of colour in a way which is purely instinctive. My choice of colours is not based on any scientific theory; it is based on observation, on feeling, on my own perceptive experience. . . . My aim is to achieve that concentrated essence of feeling which is the making of a picture."

Perhaps it takes a rational mind to admit the irrational. Matisse's philosophy is summed up in his retort to a criticism that the woman in a painting had too long an arm: "Madam, this is not a woman, it is a picture." Though Matisse was thus the father of Expressionism, he differed greatly from most of its exponents in the classical, Mediterranean clarity of his design. Though, like Gauguin, he insisted always on the paramount value of the element of decoration, it is always decoration powerful with clear intention. He was one of the keenest of draughtsmen, practising sculpture for a long period, perhaps mostly for the sake of clarifying his sense of form. He was the great simplifier; and in this sense was the initiator of all modern movements.

Leo and Gertrude Stein were among his earliest supporters. Then until 1918 the pick of his large canvases was shared between two Russian collectors; so that Matisse is best represented in Moscow and Leningrad. The Misses Cone were also consistent collectors of his work, up to a much later date. They bequeathed their collection to Baltimore.

THE TERRACE, ST. TROPEZ *Yellow Room*

Oil on canvas, 0.72 x 0.58, signed at the foot on the right: *Henri · Matisse*. Cleaned in 1971.

The seated lady is the painter's wife,[1] the building behind her the boathouse of La Hune, Signac's villa at St. Tropez. She is wearing a kimono.[2]

Matisse's stay with Paul Signac, the Neo-Impressionist, in the summer of 1904 was an important moment in the evolution of his art. He was soon to denounce as sterile the methodical application of colour in dots, known as pointillism, which Signac practised; but meanwhile his adaptation of it brought his first vibrant success as a Fauve. Henri Edmond Cross, a brilliant colourist, lived near Signac, and, above all, there was the dazzling light of the Riviera, which was henceforth to provide the essence of Matisse's colour. One has only to compare his *Carmelina*, painted the year before, in the Boston Museum of Fine Arts, in which also Mme Matisse was the model. There is a great deal of brilliant light in the colour of *The Terrace*, and very little pointillism. It usually took many weeks of nervous tension to produce the vividly spontaneous and simple effect

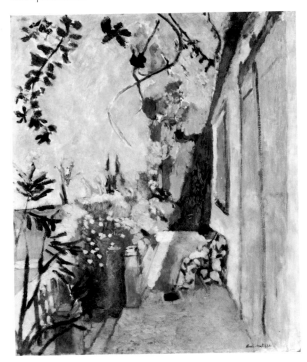

Henri Matisse
The Terrace, St. Tropez (SEE COLOUR PLATE)

of Matisse's pictures; but this picture must have been at least begun at St. Tropez in the summer of 1904.

It was bought from the artist by Thomas Whittemore (1871-1950), of whom there is a portrait drawing by Sargent in the Macknight Room and a brief description in Hadley, *Drawings*, pp. 52-54. Whittemore gave the picture to Mrs. Gardner probably in 1912. He gave her also four sheets of drawings by Matisse, of which one is dated 1912 (*Ibid.*, pp. 59-62). These were the first works of Matisse to enter a museum in the United States.

P155

¹Thomas Whittemore in a conversation with the compiler, 24 December 1929; he described the terrace as that of Signac's house.

²Alfred Barr, *Matisse* (Museum of Modern Art, New York, 1966), p. 53; he dates the picture 1904.

Lippo Memmi

LIPPO DI MEMMO DI FILIPUCCIO: born in Siena; died there 1357.

At San Gimignano in 1317 he finished in the Council Hall of the Palazzo del Popolo the fresco commissioned of his father and perhaps begun by him, but signed by Lippo alone. It is a *Maestà* in evident imitation of that at Siena by Simone Martini (*q.v.*). The signed *Madonna dei Raccomandati* in Orvieto cathedral was painted in 1320. Lippo is said to have signed and dated 1325 a polyptych on the high altar of S. Paolo at Pisa. This has long disappeared; but a *Madonna* now in Berlin is thought to have been the centrepiece, and panels with half-length saints believed to have belonged to it are now in Siena, Washington, New Haven and New York. In 1324 Simone had married Lippo's sister Giovanna. In spite of these independent works, sited at a distance from Siena, Lippo had already perhaps been his brother-in-law's assistant for some years. He may have continued to work in his studio until Simone's departure to Avignon in 1339. He cannot have gone with him then, for in 1341 he was commissioned to design the crown of the tower of the Palazzo Pubblico at Siena. He may have followed later, as in 1347 there is mention at Avignon of "Lippus et Federicus de Senis Memmi," who were at work in the church of S. François there.

His artistic personality was long subordinate to that of his brother-in-law, and his position in the joint workshop was evidently the minor one. The fact that the one picture in which the hands of the two can be distinguished, the altarpiece from the chapel of S. Ansano in Siena cathedral, now in the Uffizi Gallery in Florence, is signed by them both suggests that Lippo's part in other compositions was usually small. His own individual pictures show great accomplishment in the art of decorating gilded panels with pounced designs, while their colour and technique are usually so distinct from those of Simone that he cannot have had an important share in the actual painting of Simone's panels. The S. Ansano altarpiece, for which Lippo evidently painted the two side panels, *S. Ansano* and *S. Margaret*, is dated 1333; and these, with the *Maestà* at San Gimignano, are the only dated pictures. Another *Madonna and Child* in Berlin still bears his signature, and there are signed Madonnas also at Altenburg and in the church of the Servi at Siena.

His painting became more effective as it freed itself from the influence of Simone Martini, whose subtle method of drawing in low relief he never fully mastered. In his later works, such as *The Madonna and Child* in the Servi, he developed a method of modelling in the round which gives his figures greater force and makes his designs more effective; while his colour, which never had the complex rhythms of Simone, is marshalled in simpler masses for a more immediate effect. Few of Lippo's

Lippo Memmi — *The Madonna and Child*

designs, however, come so near perfection as does the little picture below.

THE MADONNA AND CHILD *Gothic Room*

Tempera on panel, 0.335 x 0.253. Below, an arcade in relief within the moulding contains in half length the figures of *S. Helen, S. Paul, S. Domenic*, who in the centre is drawn at closer range than the others and is evidently the patron saint, *S. Stephen*, and, in full length, the figure of *A Praying Nun* of some order attached to the Dominicans. She was evidently the donor. The raised moulding of the engaged frame is repeated on the back, which is overlaid with a paler gold and pounced with a border of similar pattern.

A complete ornament, the picture relates its own history; and its exquisite craftsmanship is quite intact, except that the pure blue of the Madonna's mantle has become opaque through chemical action, while the green of the lining, translucent over gold, has become brown. Her robe is of deep purple. Over the Child's lace vest are wrapped shawls, of bright blue above, of pink below.

The picture makes an interesting comparison with Simone Martini's large *Madonna and Child, with Four Saints* in the Early Italian Room, for it is in the small panel that the forms are heavier and more squarely set, the colours stronger and more squarely contrasted. In spite of its dimensions, this is perhaps the most forcible of Memmi's pictures, and, though the Madonna's head is almost identical with that in Simone's earlier panel, this is one of Memmi's most individual creations. The rounded relief of the forms and the colour so different from Simone's suggest that it is one of his latest.

It was bought by Mrs. Gardner herself from Stefano Bardini at Florence 6 October 1897.

P3ow8

AUTHORITIES

Berenson in a letter (4 February 1930); also *Central Italian and North Italian Schools* (1968), I, p. 269.

Fredericksen and Zeri, *Census* (1972), p. 141.

Van Marle, *Simone Martini et les peintres de son école* (Strasbourg, 1920), pp. 107-08; he described the Saint in the centre as S. Anthony and wrote of the picture's bad state of preservation [!]. In a footnote he gave a wrong date for Perkins' article; also *The Italian Schools of Painting*, II (The Hague, 1924), p. 260.

Perkins in *Rassegna d'Arte Senese*, I (1905), p. 75.

Weigelt, *Sienese Painting of the Trecento* (Florence and New York [1930?]), p. 83.

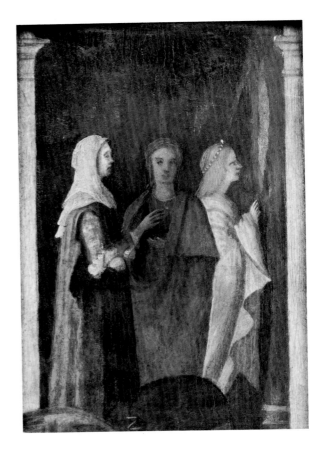

Milanese (?); XV Century

THREE WOMEN *Early Italian Room*

Tempera on wood, 0.21 x 0.13.

Bought through Berenson from Antonio Carrer at Venice 28 September 1897, as the work probably of Bramantino. It was never included in any Berenson list.

P15w20

Mor

ANTHONIS MOR VAN DASHORST: born at Utrecht about 1519; died at Antwerp 1576-77.

He evidently grew up at Utrecht, where he was the pupil of Jan Scorel. Mor's earliest signed work, dated 1544, in Berlin, represents *Two Pilgrim Canons of Utrecht*. He owned property at Utrecht, and was there at intervals to enjoy what he had of domestic life.

Within a few months of the painter's death the citizens of Utrecht pulled down the fortress built by the Emperor Charles V, and there two years later was declared the union of the seven rebellious

provinces which made up the Dutch Republic. In his lifetime the Netherlands were still bound together under Hapsburg rule. In 1547 Mor entered the Guild of S. Luke at Antwerp, and two years later he was a familiar of the Hapsburg court in Brussels. He gained admission through the service of Granvella, Bishop of Arras, the Emperor's right hand. He had his studio in Granvella's house in Brussels. 1549 is the date on his signed portraits of *Granvella* in Vienna and of *The Duke of Alba* at the Hispanic Society in New York. He was paid the same year for work apparently done for the Emperor Charles V. He had become the great Court Portrait-Painter. At Holyrood Palace, Edinburgh, is a portrait of *Maria of Hungary,* the Emperor's sister and Regent of the Netherlands, and in Earl Spencer's collection at Althorp, Northamptonshire, one of his son, the future King Philip II of Spain. In 1550 Mor was in Rome. Before June the Regent sent him to Lisbon, where he painted the portrait of her sister *Queen Catherine* now in Madrid and also *King Juan III.* He no doubt went and returned via Madrid, where are still the portraits, dated 1550 and 1551, of *King Maximilian of Bohemia,* later Emperor but then Regent in Spain, and of his wife *Mary of Bohemia.* Probably in the autumn of 1553 he was sent to England by the future King Philip II of Spain to paint the Queen, who was betrothed to him. The two portraits of *Queen Mary* in Madrid and at Castle Ashby, Northamptonshire, are dated 1554. He must have been in Brussels during the great assembly in the autumn of 1555, when Charles V abdicated in favour of Philip. He was in attendance there to paint the successive Governors who attempted to subdue the Netherlands after King Philip had retired to Spain.

Mor painted also a number of religious and mythological pictures, and he Italianized his name; but his reputation depends upon portraiture which is peculiarly Northern in its cool and rigorous attention to detail. Titian (*q.v.*) was the head of those who painted for the Hapsburgs and Mor copied his *Danaë* for Granvella in Rome. His own handling never got such variety, nor his colour such feeling, but they became fluent and refined. His likenesses are more instantaneous than Titian's, marking the accidents of feature with extraordinary keenness. The *Queen Mary* in Madrid is one of Mor's first pictures to show his full powers. His best portraits give him a more than momentary position in the history of painting. They were to be admired by Rubens and Velázquez, and were the inspiration of many minor artists like Sánchez Coello (*q.v.*). In Spain his manner lingered in court portraits until the advent of Velázquez.

Studio of Mor

QUEEN MARY OF ENGLAND *Dutch Room*

Oil on oak, 1.118 x 0.831. Inscribed at the top to the left in a later hand: *MARYE the QUEENE* (there are traces of a second line). Cleaning in 1972-73 revealed that the dark paint is much abraded on both sides above the chair, and there are scattered losses over the russet gown. There are fundamental losses along vertical joins and cracks. Otherwise the condition is good.

The Queen holds in her left hand the essential pair of gloves. The ring on the third finger is presumably her engagement ring. The flower in her right is said to be the rose of the Tudors. From her girdle hangs a pomander, perhaps that given her at her christening by Mary Tudor, her aunt and namesake. In 1554 King Philip sent his betrothed by the Marqués de los Navas "a great diamond with a large pearl pendant, one of the most beautiful pieces in the world," and it is likely that she wore this pendant to sit for the portrait commissioned by him.

Not signed and dated, like the other two versions, this picture is not entirely by Mor himself. This has been made clear by the recent removal of toned varnishes and some repaint.

Queen Mary called forth one of Mor's finest pieces of characterisation, and Justi was not the last to find a memory of the Prado portrait in that of Velázquez' *Pope Innocent X* in Rome, a more audacious study in reds and red-browns.

Mary (1516-58), the only child to reach maturity of King Henry VIII and his first wife Catherine of Aragon, succeeded her half-brother Edward VI on the throne of England and Ireland in 1553. She was the first Queen Regnant. Politics were then religion, and Mary's part was cast at birth. Her Catholic Spanish mother, whom she adored, was aunt of the Emperor Charles V. Mary was betrothed to Charles in babyhood; but he married elsewhere, and Henry's divorce from Catherine caused the rupture also between England and Rome. Her royal father had her bastardised by act of Parliament; and thus she lived in order to mend the quarrels with the Pope and with Spain and to forget the past. During the short reign of the boy Edward VI the Protestant Book of Common Prayer was enforced; but the Council were more concerned for the Catholic estates and titles, which they might lose by Mary's accession. On Edward's death therefore they proclaimed the Protestant Lady Jane Grey, and Mary had to fight her way to the throne. She was crowned 1 October 1553. Parliament now repealed the acts relating to her

mother's divorce and to the establishment of the Protestant church. The anti-papal church of Henry VIII was restored, with Mary in his place as Supreme but embarrassed Head. The articles of her marriage with the Emperor's son Philip, heir to the Kingdom of Spain, caused a second rebellion, in which she was actually besieged by Wyatt in London. The wedding, however, took place at Winchester 20 July 1554. England and Spain were to remain separate; but Mary looked for direction to Philip, who remained in England until August 1555, and returned for some months in 1557. When the Pope had confirmed in possession the new owners of the monastic estates, they quickly voted for reconciliation with Rome, and Mary made a thank offering of her supremacy. It was only from this time, when husband, Parliament and a severe illness left her little command of affairs, that the persecutions took place which earned her the Protestant title of "Bloody Mary."

She was in fact singularly gentle, certainly conspicuous among the Tudors for her loyalty. She remained Roman Catholic, while Henry and Elizabeth twisted about for their advantage. But she was no bigot; indeed she was authoress in her youth of a translation of Erasmus' *Paraphrase of S. John*, afterwards burned by her own minister, Gardiner. The first act of her Parliament repealed some of the tyrannies of Henry VII and Henry VIII. Her reign was only the stormy climax to a miserable life. Very short-sighted, she was racked continually from youth by a disease which regularly prostrated her, and was no doubt the cause of her sour looks. She lacked neither courage nor a cool head when her throne and her life were in danger. She was the most refined of the Tudors, entertaining Elizabeth with a concert in return for a bear-baiting, playing the lute and the virginals and patronising the great musicians of her day.

Mor's portrait was one of the customary preliminaries to Mary's marriage with the future King Philip II of Spain. She told the Pope's envoy that she was set upon the marriage in August 1553, and Mor probably came to England before the actual treaty was made 12 January 1554. Van Mander[1] says: " . . . at the Emperor's order" the painter "made the voyage to England to paint queen Mary, second wife of King Philip, a portrait for which they paid him a hundred pounds sterling, and a gold chain, apart from his annual pension of a hundred pounds. He had to copy many times the head of the queen, who was a very beautiful woman, with a view to offering these reproductions to personages of the court, to members of the Order [of the Golden Fleece] and

to Granvella. The Emperor paid two hundred florins for the copy he received." The Queen had received in exchange a portrait of Philip by Titian.

When rebellion had greeted her accession, Mary was joined in Essex by Sir Henry Jerningham and other gentlemen of Norfolk, and with them retreated to Framlingham in Suffolk. A fleet was sent after her by the Council, but at Yarmouth Sir Henry put out to meet it in a boat. When the crew demanded what he wanted he answered, according to Speed, a contemporary historian: "Your captains, who are rebels to their lawful queen, Mary." "If they are," replied the sailors, "we will throw them into the sea, for we are her true subjects." Sir Henry's capture of the fleet and other fidelities were rewarded with the posts of Captain of the Queen's Guard, Vice Chamberlain and Master of the Household, with the manor of Costessy in Norfolk; and with this version of Mor's portrait.

It hung for generations at Costessy Hall in Norfolk, where it is mentioned by Lady Jerningham[2] in a letter of 1819. From Sir Henry Jerningham's descendant Lord Stafford-Jerningham it was bought in 1901 by Dowdeswell of London, from whom it was bought by Mrs. Gardner in September through Berenson.

<div style="text-align: right">P21e22</div>

[1]Van Mander, *Le Livre des Peintres* (trans. and ed. Hymans, Paris, 1884), I, p. 277.

[2]*The Jerningham Letters* (ed. Egerton Castle, London, 1896), II, p. 144, Lady Jerningham in a letter to Lady Bedingfield dated Holkam, 28 August 1819: "Yesterday we came off at half past eleven, knowing the Duke [of Sussex] intended to come to Cossey [*sic*], but it was intended we should be gone, otherwise we could not have arrived here as we took our own horses to give up the posters to himself and suite. He told me he admired Cossey of all things, and the Howard picture and Queen Mary in the library did not escape him."

OTHER AUTHORITIES

Hymans, *Antonio Moro* (Brussels, 1910), p. 77: "the work of the Gardner collection at New-York [*sic*], seeming to have all the characteristics of authenticity." In a note he added: "We only know this last work by a photograph of it which Dr. Friedländer of the Berlin Museum has kindly communicated to us"; and p. 164: "old repetition of the Madrid portrait."

Strong, R., *National Portrait Gallery, Tudor and Jacobean Portraits* (1969), I, pp. 211-12; he considers it autograph.

Waterhouse, E., *Painting in Britain 1530-1790* (1953), p. 14; he accepts the traditional attribution to Mor himself.

Versions: (1) Madrid, Prado Museum, No. 2108, panel, 1.09 x 0.84, inscribed: *Antonis Mor faciebat 1554.* The velvet robe is dark purple and the rose a deeper pink. There is a column in the background, Mary wears her wedding ring and the pattern on the chair is different below the fringe. Perhaps the loveliest version, said to

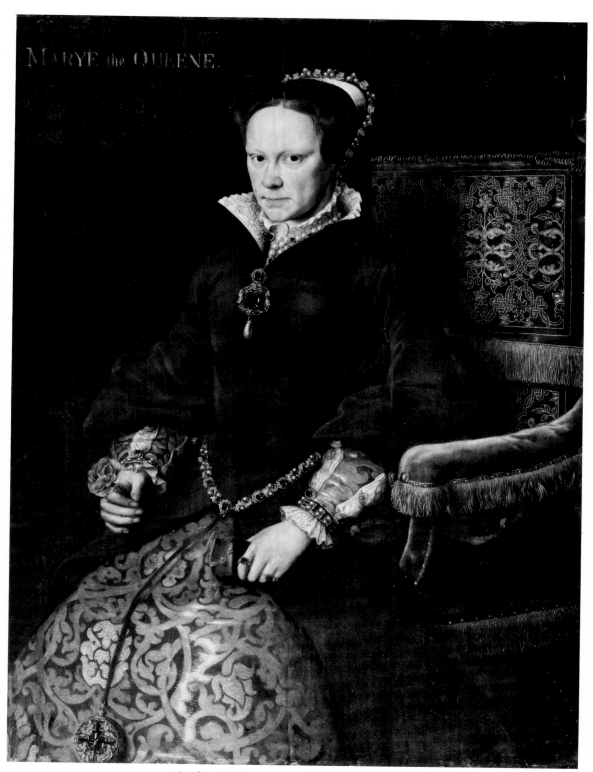

Studio of Mor — *Queen Mary of England*

have been taken by Charles V into his retirement at the monastery of Yuste. (2) Northamptonshire, Castle Ashby, the Marquis of Northampton (from the Escorial), panel, 1.095 x 0.840, inscribed: *Antonio mor pinxit 1554*. The dress is black. Said to have been given to the first Lord Ashburton by the Queen or by King Philip. (3) Antwerp, 1682, Diego Duarte, a dealer; in his inventory is a portrait of Mary of England by Mor, from the gallery of the Emperor Rudolph in Prague. (4) Budapest, No. 658, panel, 0.36 x 0.25, head only, a rapid sketch probably by Mor after the large picture (Van Mander mentions copies of the head). Companion to a head of King Philip II, No. 657, both from the collection of the Archduke Leopold William in Brussels. (5) Cambridge (England), Trinity College, canvas, original size, a later copy. The dress is blue. (6) Durham cathedral, circular card, 0.495, inscribed: *Queene Marie*, an old copy by Flicke of the bust only. (7) Paris, Bibliothèque Nationale, paper, a pencil copy of the head. (8) England, 1778, "an original drawing" of the head and shoulders, belonging to Mare Tunstal, Esq., engraved by C. Hall and published by J. Thane.

Giovanni Battista Moroni

Born at Albino, near Bergamo, about 1520; died at Bergamo, which then belonged to Venice, 1578.

He lived at Brescia, probably for but a short time, as the pupil and assistant of Moretto (Alessandro Bonvicino); and he remained Moretto's follower all his life, at least in his altarpieces. Some of these, like *The Madonna in Glory, with S. John Baptist and the Doctors of the Church* in S. Maria Maggiore at Trento, have figures copied from Moretto's compositions; but this is an early work, possibly commissioned as a copy. Two other pictures by him in Trento are dated 1548. At least after Moretto's death in 1554, he was constantly employed upon large paintings of this kind for churches at Bergamo and in the neighbourhood, and many are still in place. A *Madonna and Child Appearing to SS. Catherine and Jerome* in the cathedral is dated 1576. The picture below bears the same date. *The Last Judgment* at Gorlago nearby was ordered 29 April 1577 and was to take fifteen months, so that it was left unfinished at his death. His compositions were not only religious: in 1549 he had decorated two rooms in the Spini palace at Albino.

Commissions for portraits often accompanied his decorative undertakings. The portraits in full length at Bergamo of *Bernardo Spini* and his wife *Pace Rivola Spini* are among his finest paintings; and it is by his portraiture that he made his reputation outside his own city and his own day. Many of his best portraits are of noted Bergamasks; that of *Canon Ludovico di Terzi* is now in London,

that of *Antonio Navagero*, the Podestà, dated 1565, in Milan; but Titian is said to have sent to him from Venice his own superfluous sitters.

Moroni has all the skill of the professional portrait painter of modern times. He could render a photographic likeness, and was expert at the professional pose: witness his *Tailor* in London or his many portraits of lawyers and scholars interrupted at their studies. Sometimes, as in the portraits of the Spini couple, he arrived at something more, at dignity and depth both of characterisation and of design. His master had been the pupil of Titian in Venice, and one sees in Moroni's paintings Titian's great realistic instrument put to a more prosaic use.

A BEARDED MAN IN BLACK　　　*Titian Room*

Oil on canvas, 1.71 x 1.01, including a strip of restoration about four inches wide along the foot. Dress and background are damaged, but head and hands are intact. Inscribed on the pedestal of the pilaster on the right: *IO BAT MORONVS / MDLXXVI.*

Moroni's composition is at its simplest and his characterisation at its most dignified. Sydney Freedberg[1] writes of "an imposing density of presence." The rich, absorbent black of the dress and the half black of sleeves and hose are unusually soft against the grey architecture. Yet in Moroni's characteristic way the legs and cap cut a silhouette which looks curiously ungainly opposite the thoughtful pattern of Velázquez' *King Philip IV*. The carnations are warmly tanned and matched by the even terra cotta of the floor.

Bought by Mrs. Gardner from the Galleria Sangiorgi, Rome, 30 September 1895.　　*P26w1*

[1]Freedberg, *Painting in Italy, 1500-1600* (1971), p. 409.

OTHER AUTHORITY
Fredericksen and Zeri, *Census* (1972), p. 145.

Martin Mower

Born at Lynn, Massachusetts, 1870; died in Vancouver, British Columbia, 1960.

From 1893 for many years he was on the teaching staff at Harvard University. An exhibition of his work was held at the Fogg Museum in 1927, when he was Lecturer in Fine Arts. The pictures below witness a long friendship with Mrs. Gardner, whom he advised with regard to several pieces of Spanish furniture which she bought in New York in 1921.

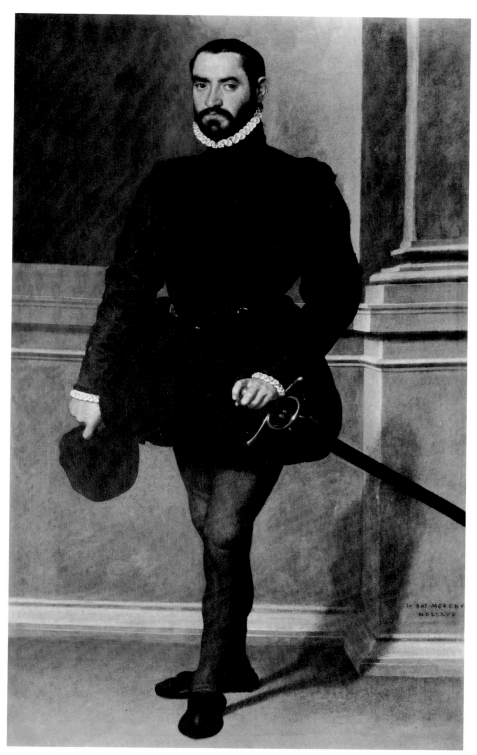

Giovanni Battista Moroni — *A Bearded Man in Black*

The Croquet Party

Isabella Stewart Gardner

The Bird House, Villa Borghese, Rome

Charleston

The Meet

The Long Gallery, Fenway Court

The Fountain

THE CROQUET PARTY — *Yellow Room*

Oil on canvas, 0.31 x 0.40. Signed at the foot on the right: *M.M.*

 Given to Mrs. Gardner by the painter in 1913.
P1s6

ISABELLA STEWART GARDNER — *Short Gallery*

Oil on canvas, 0.83 x 0.66.

 Painted in 1917, with the use of the photograph taken ten years before in London. The picture was given to Mrs. Gardner by the painter. *P17w44*

THE BIRD HOUSE, VILLA BORGHESE, ROME — *Blue Room*

Oil on canvas, 0.34 x 0.42. Signed at the foot on the right: *M/M.*

 Painted in 1922, and given to Mrs. Gardner by the painter 14 April — her birthday. *P3e4*

CHARLESTON — *Yellow Room*

Oil on canvas, 0.25 x 0.35.

 Bought by Mrs. Gardner of the painter for the gate money of a day when Fenway Court was open to the public. *P1s7*

THE MEET — *Macknight Room*

Pastel on canvas, 0.62 x 0.80. Signed at the foot on the right: *M/M.*

 Given to Mrs. Gardner by the artist, probably in 1914.[1] *P11n6*

[1]Carter, a note in the Museum archives.

THE FOUNTAIN — *Macknight Room*

Water colour on paper, 0.25 x 0.36.

 This represents Mrs. Gardner in Miss Caroline Sinkler's garden at Gloucester, Massachusetts, where it was painted in 1918. *P11s4*

THE LONG GALLERY, FENWAY COURT — *Macknight Room*

Water colour on paper, 0.20 x 0.15. Signed at the foot on the left: *M/M.*

 Painted 1922-23, and given to Mrs. Gardner by the artist. *P11s27*

Neapolitan (?); 1610-50

THE MUSICIANS — *Second Floor Hall*

Fresco in plaster, 0.99 x 1.60. The architectural surround is incomplete; almost inevitably, since this is probably a detail from the decoration of a courtyard. The surface of the dark background of the embrasure has flaked away and has been partly repainted; but the figures are not ill-preserved considering the probable exposure of the painting out-of-doors. There are large paint losses on the left sleeve of the boy in the centre and on the hand of the grey-beard next to him.

 The group probably represents a band of itinerant musicians: four men playing some kind of horn, the fifth a trombone.

 The picture was catalogued in 1931 as the work of Felice Brusasorci of Verona (1542-1605), following an early attribution by Berenson, which he maintained in 1930.[1] The picture is absent from his posthumous lists.

 The present tentative attribution is based largely on the fact that Mrs. Gardner bought the weighty fragment in Naples. The influence of Caravaggio (1573-1610) can be assumed, and this may have come through one of his Neapolitan followers.

 Mrs. Newton writes,[2] "the dress [of the boy in the centre] is teutonic in type but this probably simply means that he is being a musician and therefore wearing a fanciful livery . . . I should think from various small signs in the dress that it [the date] is in the 1630s."

 The fresco fragment was bought by Mrs. Gardner 26 October 1897 from Vincenzo Barone in Naples. *P22e1*

[1]Berenson in a letter (10 March 1930).

[2]Stella Mary Newton in a letter from the Courtauld Institute (12 June 1973).

OTHER AUTHORITY

Fredericksen and Zeri, *Census* (1972), p. 37; they catalogue it under Felice Brusasorci as an uncertain attribution.

Karl Frederik Nordström

Born at Hoga 1855; died at Drottningholm, near Stockholm, 1923.

 In Sweden he was the pupil of Edvard Perséus, 1880-82. He went to Paris, where, according to Thieme-Becker, he studied under Grèz. He returned to Sweden in 1886, and from 1895 lived in Stockholm. He had considerable success there as a

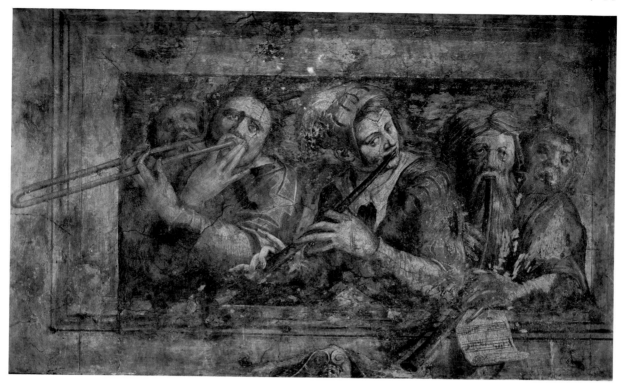

Neapolitan (?); 1610-50 — *The Musicians*

landscape-painter, and is well represented in a number of Scandinavian museums.

THE HEADLAND — Blue Room

Pastel on paper, 0.35 x 0.45.

The scene is on the outskirts of Varberg in southwest Sweden, with the old castle in the background.[1] Nordström lived at Varberg 1893-95.

Mrs. Gardner's attention was called to the work of Nordström by his fellow-countryman Anders Zorn (*q.v.*); but in 1922 she expressed uncertainty where she had bought the pastel: possibly at the World's Columbian Exposition, Chicago, 1893-94.

P3w36

[1]Boström in *Konsthistorisk Tidskrift* (Stockholm, 1948), pp. 17-18; he dated the pastel 1894-95, and stated that it is signed with Nordström's monogram. Boström restored to the painter his correct name, which had become Nordheim in the Museum archives, and in the 1931 Catalogue.

North Italian; 1430-80

THE MADONNA AND CHILD WITH AN APPLE — Gothic Room

Tempera on wood, the painted surface 0.475 x 0.360. Part of the original engaged frame has survived in the arched top and spandrels, broadly carved in low relief and painted red and green.

The colour of the picture is scarcely more complicated: the Virgin's robe and the Child's tunic

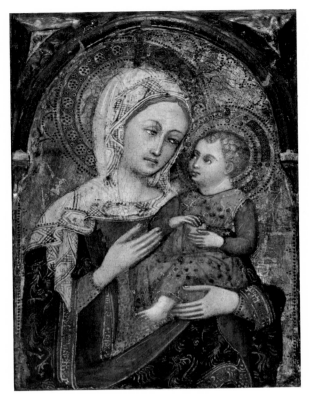

North Italian; 1430-80
The Madonna and Child with an Apple

having the same scarlet red, the lining of her mantle and the Child's sleeves virtually the same green. Her dark blue mantle is embroidered with cocks freely drawn in gold.

These are perhaps the best clue to the origin of the picture, which comes from a workshop of no great distinction. This free sprinkling of stuffs with motifs, as opposed to the application of regular patterns, seems to derive from Gentile da Fabriano or Pisanello. It became popular in the Emilia-Romagna region. Michele di Matteo, for instance, a Bolognese painter in the tradition of Gentile, used cocks of a more refined breed in several pictures. This and its general characteristics suggest a date about the middle of the fifteenth century.

Bought as "Madonna byzantine XV century" from Consiglio Ricchetti in Venice probably 2 September 1897. *P3oe8*

AUTHORITY

Fredericksen and Zeri, *Census* (1972), p. 224 (the reference to the 1931 Catalogue is given as p. 192, not 191).

North Italian; 1575-1625

TWO SCENES FROM EARLY HISTORY
Early Italian Room

Oil on canvas (lined), 0.498 x 3.016 (left) and 0.497 x 3.011 (right).

The vertical joins in both original canvases towards the sides seem to be due only to insufficient width in the original material. Each picture seems to have been painted in one.

With the picture below, these form a set of three, which must originally have been hung high on the walls of a room or inset in a frieze.

The subjects are difficult to identify, though in the first picture (left of the fireplace) at least the significance of the scene is clear enough: a young man brings words of comfort to two prisoners, while their Roman guard sleeps.

In the second (right) a young woman converses with a patriarch in the centre foreground, before a procession of flocks and herds. In this the women ride, the men walk. Almost at the head of the caravan a naked child stands tied behind his mother on the back of a mule. The Exodus is a possible subject.

The three pictures are considerably darkened by old varnish; but the style appears to be that of a painter or painters of the late sixteenth or early seventeenth century in Venice or the Veneto. *P15w38, P15w6*

A SCENE FROM THE OLD TESTAMENT (?)
Raphael Room

Oil on canvas (lined), 0.500 x 3.574. As in the two pictures above, the original canvas is in three pieces.

With the two above, this forms a set of three pictures.

This picture might possibly represent the infant Samuel prophesying to his elders.

The three pictures have been framed with the one below to make a set of four. The four have not previously been catalogued. A note by Morris Carter of 9 December 1922 in the Museum archives states that in Mrs. Gardner's time they were all attributed to Zuccarelli (1702-88). She acquired them together from Antonio Carrer in Venice 27 September 1886. *P16s2o*

North Italian; 1575-1625 — *Two Scenes from Early History*

North Italian; 1575-1625 — *A Scene from the Old Testament (?)*

North Italian; 1650-1725 — *Three Scenes from the Old Testament*

North Italian; 1650-1725

THREE SCENES FROM THE OLD TESTAMENT
Raphael Room

Oil on canvas (lined), 0.495 x 3.582. The three scenes are on three pieces of canvas, inserted later into a larger canvas, no doubt in order to make a set with the three earlier pictures above. The insertions measure, from left to right: 0.385 x 1.052; 0.432 x 1.050; 0.385 x 1.045. There is a filling 0.002 wide round each.

On the left Hagar, the concubine of Abraham in his old age, weeps over the fate of their son Ishmael cast into the wildnerness with her by the jealousy of Abraham's wife Sara, after the birth of their son Isaac. Hagar is comforted by God through an Angel, who promises that Ishmael will be made "a great nation" (Genesis 21:9-18).

In the centre Lot worships the two Angels who came to him in Sodom in the evening, and later advised him to take his family out of the town before they destroyed it (Genesis 19:1-13).

On the right, while Sodom burns and after Lot's wife had been turned into a pillar of salt, his daughters intoxicate and seduce him, in order to procreate Moab and Ammon (Genesis 19:29-38).

The style is neater and later than that of the three earlier pictures with which it has been matched. It is less certainly Venetian. For the history see under the last picture. *P16n1*

Perugino

See Hadley, *Drawings* (Isabella Stewart Gardner Museum, 1968), pp. 6-9.

Pesellino

FRANCESCO DI STEFANO: born, probably in Florence, 1422; died there 1457.

Stefano, a painter, died while his son Francesco was a child, and Francesco was brought up in the house of Giuliano Pesello, his mother's father. Giuliano was also a painter; and the nickname PESELLINO was due to the need of distinguishing Francesco from Giuliano.

In 1453 Pesellino entered into a profit-sharing partnership with Pier di Lorenzo and Zanobi Migliore. Zanobi dropped out; but the other two continued to cooperate, sometimes working on the same pictures or sets of pictures, and sharing the profits on those they painted independently. These financial details are known from the record of a lawsuit by which Pier di Lorenzo recovered from Pesellino's widow Tarsia his share of the profits from the large altarpiece, *The Trinity with Saints and Angels*, now in London. This Pesellino was commissioned to paint for the Company of S. Trinità at Pistoia in September 1455. Ten months later, he was still working on it when he died at the age of thirty-five, leaving his widow with young children. It was expressly stated in court that in Pesellino's studio he alone had worked upon this picture. It was sent to Filippo Lippi at Prato to be finished, and Filippo obviously painted the predella.

This is Pesellino's one documented picture; but there has been attributed to him since before Vasari's time the painting of a predella to an altarpiece by Filippo Lippi from S. Croce at Florence, now in the Uffizi Gallery. These predella scenes, of which three are also in the Uffizi, the other two in the Louvre, are evidently among Pesellino's earliest works. The constitution of these two altarpieces, from the end and the beginning of Pesellino's brief career, show his close association with Filippo Lippi throughout. Gradually he drew from Filippo much of his sentiment and his delicately nebulous atmosphere. He was a derivative artist, indebted also to Uccello and above all to Fra Angelico (*q.v.*), who inspired the two cassone pictures below. These are evidently early works, and there is evidence to suggest that they were painted about 1448 for Piero de' Medici, "the Gouty," who patronised Fra Angelico, Filippo Lippi and Uccello, and seems to have commissioned a picture of

Pesellino at a later date. The maturity of his art in cassone decoration is illustrated by the two panels in Mr. Christopher Loyd's collection at Lockinge House, Wantage, England: *The Heroism* and *The Triumph of David*. A religious picture of the same rich character is *The Madonna and Child with the Young S. John Baptist and Two Angels* now in Toledo, Ohio. In this the figures are almost of life size. The scale is unusually small in all the earlier work leading up to it: the predella with *Scenes from the Lives of S. Silvester*, of which the centre panel is in Worcester, Massachusetts; two others in the collection of Prince Doria in Rome; *The Crucifixion* in Berlin; *The Annunciation* in the Gambier Parry Collection, Highnam Court, near Gloucester, England; *The Madonna and Child with Saints* in Philadelphia. At least until his very last years, Pesellino evidently specialised, and he succeeded best, in small panels. His forms, at first delicately angular and sharply lighted, grew round and ample. Conventional and rather dull colours changed to the exquisite rose pink and gold of the Lockinge House cassoni, their paintings a mirror of chivalry. These and the Toledo *Madonna*, one of the most sumptuous devotional panels of the Renaissance, with its fair rounded forms, its roses and gold curtains, show Pesellino master of himself. Without the need for larger fields of expression which was urging his bolder contemporaries to open up new perspectives of architecture and landscape, he had the instinct of the decorator to reduce the pretended depth of his designs. Inspired no doubt by the reliefs of contemporary sculptors, he arrived before the end of his short life at a method which was brilliantly decorative. A small host of copyists and imitators strove to satisfy the demand for domestic pictures that he had created.

THE TRIUMPHS OF LOVE, CHASTITY
AND DEATH *Early Italian Room*

Tempera on chestnut wood, 0.454 x 1.574. From this and from its companion panel, below, a piece has been cut from the back at the top edge in the centre, to take the lock, proof that these formed the fronts of a pair of cassoni, or wedding coffers. The painting was much scratched and indented by knocks from heavy keys, etc. Cleaning in 1934 removed a considerable amount of overpainting, and of gilt decoration which was not original. In this panel the paint was found to be most worn on the right, where, for instance, the row of five heads to the right of Chastity is much defaced.

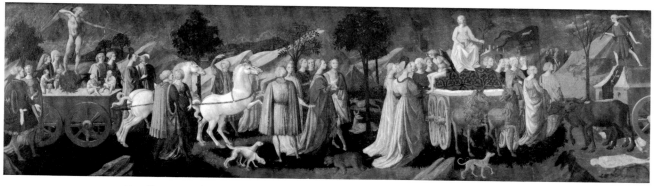

Pesellino — *The Triumphs of Love, Chastity and Death* (SEE COLOUR PLATE)

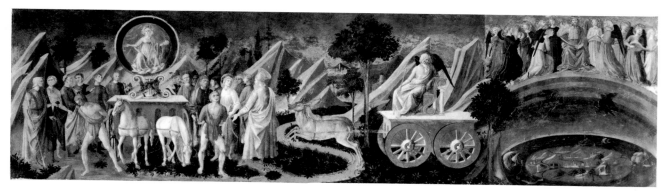

Pesellino — *The Triumphs of Fame, Time and Eternity* (SEE COLOUR PLATE)

Upon a car drawn by four white horses Love, with his feet on a ball of fire tended by cherubs with bowls of flame, menaces with taut bow amid a throng of willing victims. Chastity then has him bound and weaponless at her feet, while she sits erect, laurel in hand, her car drawn by two unicorns, symbolical of purity. Among her train of virgins one bears the ensign described by Petrarch, a white ermine upon a green ground. Against them Death advances, with shouldered scythe and the black banner with a white cross of the Misericordia, upon a hearse drawn by a yoke of starved black buffaloes, symbols of the slow but inevitable. Corpses, not flowers, are beneath her wheels, and her passing brings winter to the trees. No doubt the fair young couple on the extreme left are to remind us both of Petrarch and his Laura and of the pair whose wedding is commemorated. *P15e5-s*

THE TRIUMPHS OF FAME, TIME
AND ETERNITY *Early Italian Room*

Tempera on chestnut wood, 0.425 x 1.581. Here the painting has been more badly damaged on the left side. The section on the right is well preserved.

Fame is seated in a circle of glory, mounted upon a car with two white horses. Captives go before; and round her are the famous, on her right the great rulers and on her left the heroes of science and literature. Among these Dante is conspicuous, Vergil with his laurel crown and Sappho. But Time comes fastest, seated on a car drawn by stags, the swiftest of animals. Finally, Eternity is a scene apart, where in the new heaven God is seated among the angels sending down blessings on a new earth. Between them are two of the beasts of the Revelation, the lion of S. Mark and the eagle of S. John.

These two pictures illustrate the poem in *terza rima*, the *Triumphs* written by Petrarch in the vernacular Italian between 1352 and 1374. The six books form a continuous narrative in which the poet actually describes only the car of Love. His chariot is of fire, and a friend of Petrarch's unfolds the names and stories of the famous victims who surround it. Among them is one whose beauty troubles him by the coldness with which his instant love is

returned. Her name Laura is indicated by mention of the laurel. Become a victim himself, he follows in Love's train to the isle of Cyprus, the kingdom of Venus, and is there imprisoned. But Love, attacking Laura with his weapons, is vanquished, and led bound in the cortège of virgins to Rome and the temple of Chastity. The procession moves onward triumphant, only to be met by Death, to whom Laura willingly surrenders herself, appearing to the poet later in glory to tell of her affection. Fame then appears in the sky with her train of heroes and heroines, statesmen and men of art and science, from the ancient world, from the Bible and from Petrarch's Italy. The sun pursuing its swift course reminds the poet that even Fame is the subject of Time. He realises that he can put his trust only in God, and he seems to see the new heaven and the new earth, where present, past and future become one, and Laura appears again even more beautiful.

The poet wove the thread of his own platonic love story into a moral allegory which was already in Pesellino's day breeding a race of commentators. The *Triumphs* soon became a favourite subject for illustration; but this is perhaps the earliest instance of their representation in paint. The depiction of all six is rare. Representations of four or less are common. *The Triumph of Love* is a favorite subject for marriage salvers.

Enjoyment seeking to be expressed in paint has taken pedantry as her chaperon, and these panels, with their mixed flavour of classicism and of the contemporary pageant, are an early instance of the mythological subjects which painters, especially in Italy, were to exploit for four centuries, as the artists of Antiquity had done. The modern idea of a picture was still scarcely in existence, but mythological scenes with a secular purpose are soon to appear boldly upon the walls of private houses. First, they decorate its furniture, and especially the cassoni in which the trousseau of a bride accompanied her to her husband's house. These wedding coffers, of which there is a complete example of a few years later in the Raphael Room, remain an aristocratic custom into Napoleonic times.

These two panels come probably from the pair of chests (*forzieri*, gilt, 3½ *braccia* each) with *The Triumphs of Petrarch* which are entered in an inventory of the contents of the Palazzo Medici (now Riccardi) in Florence made after the death of Lorenzo de' Medici, "the Magnificent," in 1492.[1] They stood "in the bedchamber adjoining the great parlour, called the chamber of Lorenzo." The painter is not mentioned; but they might well have celebrated the marriage of Lorenzo's father, Piero de' Medici, "the Gouty," son of the first Cosimo,

with Lucrezia Tornabuoni. This took place about 1448, and that would fit well with the historians' ideas of Pesellino's development.

In the first half of the nineteenth century the Gardner cassone fronts belonged to Samuel Woodburn; but they were not in his sale at Christie's in May 1854. He had probably sold them to the Rev. Walter Davenport Bromley, in whose sale they appeared at Christie's, 12-13 June 1863 (Nos. 72 and 73, attributed to Piero di Cosimo), to be bought by Colnaghi. They were then in the collection of J. F. Austen, Capel Manor, Horsmonden, Kent. From the "collection of Mrs. Austen and of the Trustees of the late Mr. Austen" they were bought through Berenson in December 1897. P15e18-s

[1]Horne in *Noteworthy Paintings*, pp. 129 and 133-35; he also suggested that they were the *corpi di cassoni* mentioned by Vasari as "painted by Pesello," whom Vasari confounded with Pesellino, "in the house of Medici." But these had "little stories of jousts on horseback," and are more probably the panels at Lockinge House, which portray many mounted and armoured knights.

OTHER AUTHORITIES

Berenson in a letter (4 February 1930); also *Florentine School* (1963), I, p. 167.

Douglas in *Crowe and Cavalcaselle's History of Painting in Italy*, IV (London, 1911), p. 203.

Fredericksen and Zeri, *Census* (1972), p. 162.

Logan, Mary (Mrs. Berenson), in *Gazette des Beaux-Arts*, XXVI (1901), p. 18.

Richter in *Repertorium für Kunstwissenschaft*, XVII (1894), p. 239.

Scharf, A., in *Pantheon* (July 1934), p. 220.

Schubring, *Cassoni* (Leipsic, 1915), Nos. 266-67, p. 279 and Pl. LX. He dated them about 1445.

Venturi, A., *Storia dell'Arte Italiana*, VII, 1 (Milan, 1911), pp. 389-91; he stated that they came from the Torreggiani Palace; those were the Lockinge House panels.

Venturi, L., *Pitture Italiane in America* (1931), Pls. CLXXXVII and CLXXXVIII: "*opere giovanile.*"

Weisbach, *Francesco Pesellino und die Romantik der Renaissance* (Berlin, 1901), pp. 75-83, and in *Noteworthy Paintings*, pp. 127-29.

Exhibited 1893-94, London, New Gallery, Early Italian Art, Nos. 139 and 129, attributed to Piero di Cosimo.

THE MADONNA AND CHILD, WITH A SWALLOW *Raphael Room*

Tempera on wood, 0.597 x 0.395.

The barn swallow was held to be a symbol of the Resurrection. This picture evidently belongs to the centre of Pesellino's career. The execution is richer

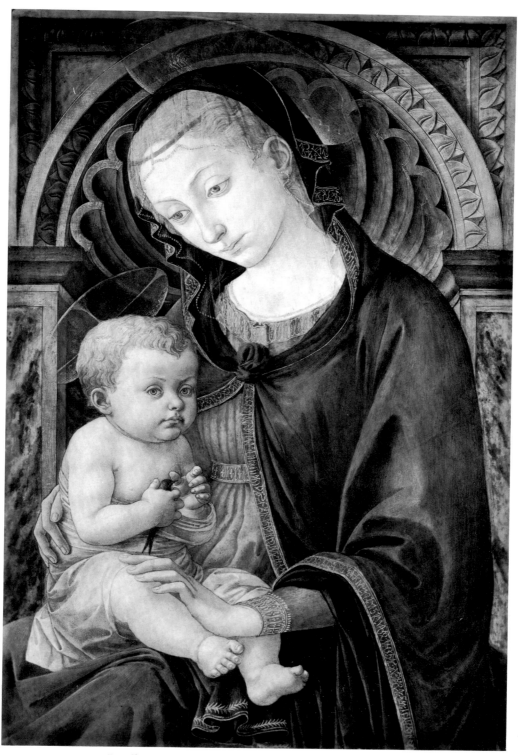

Pesellino — *The Madonna and Child, with a Swallow*

and more finely finished than that of the cassone panels above, and the types, with the formal coiffures and the curious embossed eyebrows, the rounded modelling of the flesh, with its enamelled texture, and the square folding of the draperies, begin to resemble those of *The Trinity* in London, his last and his single authenticated work. This *Madonna and Child* seems to have been one of the most popular of Florentine paintings. The heads are the same in a larger and more sumptuous, and probably rather later, picture in Toledo, Ohio, *The Madonna and Child with the Young S. John Baptist and Two Angels*. While many contemporary copies exist of each, there are versions which combine features from both. The drawings for the pictures must have been passed round from Pesellino's studio, or the pictures must both have hung at Florence in some accessible place.

This panel belonged in 1876 to Frederick R. Leyland, of Liverpool and London, the patron of Whistler and the former owner also of the panels in the Museum by Crivelli and Rossetti. Mrs. Gardner was at Leyland's sale in London (28 May 1892, Christie's, No. 105), where it was bought for her by B. F. Stevens as the work of Filippo Lippi.

P16w11

AUTHORITIES

Berenson in a letter to the compiler (4 February 1930); also *op. cit.* (1963), I, p. 167.

Fredericksen and Zeri, *Census* (1972), p. 162.

Mackowsky in *The Burlington Magazine*, LVII (1930), p. 218; he attributed it to Piero di Lorenzo.

Exhibited 1876, London, R.A., Old Masters, No. 196, as by Filippo Lippi (label on back).

Versions: There are innumerable variations of this picture, some of which combine with it features from the picture in Toledo, Ohio (examples in Budapest and in the Jacquemart-André Museum). The following are those known to the compiler (1931) which have only the same figures of Madonna and Child. None are by Pesellino himself and none have the same background. They are all different from one another in minor details: (1) Munich, F. Haniel collection: behind is a rectangular embrasure pierced at the sides; the Madonna's right hand is raised a little and there are variations in her costume. Possibly from Pesellino's studio. (2) London, Lord Battersea (exhibited New Gallery, 1893-94, No. 95), panel, 23¼ x 15¼ in.: background of rose branches. Perhaps from Pesellino's studio. (3) Brussels, Fievez, 25-26 June 1924, Brousse, No. 36, panel, 0.64 x 0.45: a background of sky and the Madonna's right hand different. It was at the Sackville Gallery 1920. (4) Brussels, exhibited Musée Royal, spring 1922, panel, 24½ x 18 in.: a background of rose branches; in front a ledge with a pomegranate and a bird. It had been formerly in the possession of Messrs. Dowdeswell in London. Perhaps by the same hand as No. 3. (5) Cheltenham, A. Whitcombe (a restorer, 1910), the same composition as the last, perhaps the same picture, but measuring 27 x 20½ in. (6) Reproduced in *Rassegna d'Arte*, May-June 1922, probably identical with one or both of the above pictures. (7) London, Christie's, 20 March 1914, T. G. Arthur (Glasgow), No. 140, panel, 23¼ x 16½ in.: a background of rose branches. From the collection of the Duke of Marlborough. Perhaps by the same hand as Nos. 3-6. (8) New York, Mr. Felix Warburg, panel with arched top. Probably by the same hand as Nos. 3-7. (9) New York, Yerkes collection, No. 105, panel, 23¾ x 17¾ in. (Cologne, November 1898, Ittenbach, No. 4, as Baldovinetti): background of rose branches. Probably by the same hand as Nos. 3-9. (10) London, Asscher and Welker (1930), panel, 23¼ x 16¼ in.: a background of mountains. (11) Paris, Louvre, not exhibited: a rose tree in the background. Almost ruined.

Piero della Francesca

PIERO DI BENEDETTO DEI FRANCESCHI: born at Borgo Sansepolcro, in the upper valley of the Tiber; died there 1492.

The earliest reference to him, merely marginal, states that in 1439 he was in Florence with Domenico Veneziano, who was at work on wall paintings in S. Egidio there. Probability and Piero's development suggest that he was in Florence again, perhaps several times; but his presence is recorded only this once.

In 1442 he was made a Councillor at Sansepolcro, then newly acquired by Florence from the Pope. In January 1445 he was commissioned by the Misericordia there — a consistent patron — to paint the polyptych now in the Municipio, his earliest significant work. In expression it shows a quite original character, in the forms and their lighting the strong influence of Masaccio (q.v.). His first signed and dated picture, painted in fresco in 1451, is at Rimini on the other side of the Apennines. In *Sigismondo Malatesta Kneeling to S. Sigismund* in S. Francesco there, a measured classicism evidently resulted from contact with the critic and architect Leon Batista Alberti, who was remodelling the church. In the interval, probably, Piero had painted *The Baptism*, now in London, for S. Giovanni Battista at Sansepolcro, and perhaps *The Madonna and Child with Four Angels* now in the Sterling and Francine Clark Institute at Williamstown, Massachusetts. Moreover, he had come to Rimini probably from Ferrara, where he is known to have painted frescoes in S. Agostino and in the old palace of the Este. In 1454 he was commissioned to paint for S. Agostino at Sansepolcro a polyptych from which four of five panels survive, in London, Lisbon, Milan (Poldi

Pezzoli Museum) and New York (Frick Collection). To complete this altarpiece he apparently took many years.

This was perhaps largely because he had already begun to paint in the principal chapel of S. Francesco at Arezzo the one great cycle of frescoes by him which has survived. There is no documentation: only the facts that Bicci di Lorenzo (*q.v.*), who had the original contract, died in 1452, and that the frescoes were mentioned in 1466. Almost certainly he had done a good proportion of this work when he was summoned to Rome by Pope Pius II. In April 1459 he is recorded as working in the Vatican palace, presumably on two frescoes known to have been overpainted by Raphael.

By 1466 he had already portrayed Federico di Montefeltro, Count (later Duke) of Urbino; but the pair of portraits of *Federico* and of his wife *Battista Sforza*, with their *Triumphs* on the reverse of each panel, were painted probably to commemorate a happy union which had ended with the death of the Countess in 1472 (see the copy of her portrait, below). These pictures are now in Florence. Urbino still has the most sophisticated of Piero's pictures, the little *Allegory with the Flagellation of Christ*; and it was for Urbino that he painted his last great altarpiece, now in Milan, probably in memory of Duke Federico, who had died in 1482 and is shown kneeling before the Madonna. A detail in this picture had to be finished by another hand. It was perhaps therefore at this moment that Piero had gone blind, as he is recorded to have done.

In the present century he has been allotted a place in history which in Renaissance times was his in the eyes of only a very few. That writers in the last two or three generations have found him so significant is due probably to the example of Paul Cézanne, who applied to the modern subjects of landscape and still life and portraiture a vision somewhat like that which Piero had evolved. To both men the perfect definition of form in three dimensions and the identification of light with colour were aims of equal significance, which they gradually merged into a total harmony. Piero's figures, remote as ancestral heroes in their gravity, have little of the movement essential to the Florentine draughtsmen-painters; but in line with Renaissance thinking he turned mathematician to the extent of writing theses on perspective and proportion. His *Allegory with the Flagellation*, moreover, is composed with the most complex application of mathematics to design. It owes its unity as much, however, to a study of the colour of light which is equally near to perfection, and subtler in its acknowledgment of the infinity of nature. In his

last great *plein-air* picture, *The Nativity* in London, probably from his own estate, there is an equal degree of harmony, emotionally warmer and outside the boundaries of geometry. To this picture the Venetian painters, most natural and sensuous of all the Italian schools, might have looked for their parent spirit.

HERCULES *Early Italian Room*

Fresco in plaster, 1.51 x 1.26. Of the painted framework enclosing the figure only the left side remains — possibly — complete; the right has been pared down and the top cut away. The lower part of the picture from the middle of the shins was destroyed to make room for a doorway[1] beneath its original position. The painting is damaged, and there are restorations, notably in the head above the forehead and the left leg below the knee.

The hero stands high in an embrasure framed with cool grey stone, his body a warm pink shaded with grey and his lion skin a subdued purple, grey-lined. Behind him in shadow is seen the corner of a chamber with grey walls and purple timber roof, of which the corbels are carved and the deep red beams painted with Classical ornament in grey. The dull richness of the colours has outlasted the subtleties of light and shade; but the contours, in which the pricking from the cartoon is clearly to be seen, retain much of their magnificent strength. Hercules has all the primitive simplicity of his legend and the quiet massiveness of Piero's mature art. His features are seen also several times in the frescoes at Arezzo, where in *The Death of Adam* the young man stands in profile similarly draped. This fragment may have been painted at much the same time — or perhaps a little later, 1465-70.

It has been assumed by many writers, including Longhi, that this is only one figure of several in a scheme of decoration modelled on the one by Castagno of which the remains are now in Florence. There is no evidence, however. The *Hercules* was painted on a wall of the never very large Casa Graziani, once probably the painter's dwelling, at Sansepolcro. Isolante, a descendant of his brother Marco, married Luigi Graziani in the sixteenth century. The house became the property of the Collacchioni and the painting was uncovered 1860-70, by Senator Collacchioni and taken to his villa outside the town. It is said to have descended with the villa to the Senator's nephew Marco Collacchioni[1] and to have been brought back in 1896[2] to the Casa Graziani and placed over the chimney in a reception room. Cavaliere Giovanni Battista Collacchioni was the owner[3] in 1901; and it was presumably he who

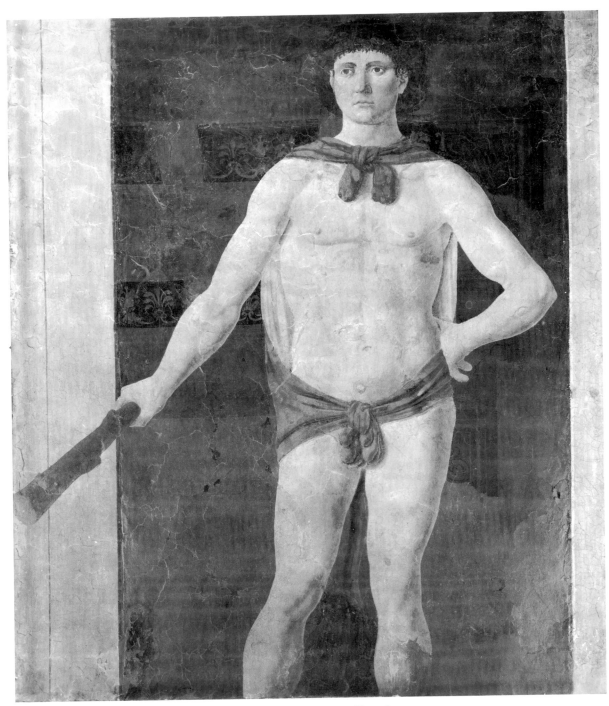

Piero della Francesca — *Hercules*

sold it to Elia Volpi at Florence in 1903. From Volpi it was bought by Mrs. Gardner through Joseph Lindon Smith 11 December 1906. *P15e17*

[1] Graziani, *L'Arte a Città di Castello* (Città di Castello, 1897), p. 170; he was the first to publish the picture.

[2] Graber, *Piero della Francesca* (Basel, 1922), pp. 24-25; he repeated the legend of a transfer to canvas.

[3] Waters, *Piero della Francesca* (London, 1901), pp. 56 and 127; he stated wrongly that the picture was transferred to canvas.

OTHER AUTHORITIES

Berenson in a letter to the compiler (4 February 1930); also *Central Italian and North Italian Schools* (1968), I, p. 341.

Bode in a letter to Mrs. Gardner dated Florence, 6 October [1906?]; he had heard of Mrs. Gardner's interest in the picture and informed her that Volpi had it in Florence.

Borenius, *Crowe and Cavalcaselle's History of Painting in Italy*, V (London, 1914), p. 27, note 4; he repeated the legend of a transfer to canvas.

Clark, K., *Piero della Francesca* (2nd. ed., 1969), pp. 79 and 226.

Franceschi-Marini, E., in *Cronache della Civiltà ellenolatina* (Rome, 1902); and *Piero della Francesca* (Città di Castello, 1912), pp. 129-32, described the picture as a youthful work and explained the choice of subject by the fact that Monterchi, the birthplace of the painter's mother near Sansepolcro, is said to have been once named Mons Herculi, to commemorate its deliverance by Hercules from a dragon.

Fredericksen and Zeri, *Census* (1972), p. 164.

Hendy, *Piero della Francesca and The Early Renaissance* (1968), pp. 78 and 143.

Longhi, *Piero della Francesca* (Rome, 1927), pp. 84-85, 121 and 178; he dated the picture 1460-70; also *Opere Complete*, III, pp. 57, 91, 102, 144 and 215.

Venturi, A., *Piero della Francesca* (Florence, 1922), p. 75, No. 16; he repeated the legend of a transfer to canvas.

After Piero della Francesca
BATTISTA, COUNTESS OF URBINO

Long Gallery

Oil on panel, 0.46 x 0.34, slightly damaged by cracks and rubbing.

Probably pendant to the *Federico di Montefeltro, Count of Urbino* in the Horne Foundation at Florence (No. 87, panel, 0.47 x 0.33). Both are copies of the portraits by Piero della Francesca now in the Uffizi Gallery, Florence. The copy of the portrait of of the Count is more evidently in the Florentine technique of the sixteenth century, while this panel seems to follow a little more closely the method of its original. The identity of size and the similarity

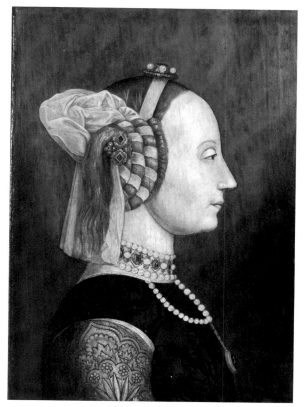

After Piero della Francesca
Battista, Countess of Urbino

of the green backgrounds, however, make it probable that they are by the same hand.

Battista Sforza (1446-72) was the youngest daughter of Alessandro Sforza, lord of Pesaro. When she was four her uncle Francesco became Duke of Milan, whither she was sent to be brought up at his court. Her mother, grandmother and great-grandmother had been paragons of pedantic accomplishment, and the poor child was by the age of four sufficient mistress of rhetoric to orate publicly in honour of her uncle's guests. He offered her hand to the widower Federico di Montefeltro, Count of Urbino. Their betrothal took place at Pesaro in November 1459, their marriage at Urbino 10 February 1460. Federico was the foremost professional soldier of his day, leading the armies in turn of Naples, Milan, Florence and the Papacy. Among the princes of his day he was remarkable for the sincerity and refinement of his character and, above all, for his library. The dwelling of his ancestors at Urbino was transformed by the architect Laurana into a palace which was famous already during his rule for the cultured happiness and hospitality of its court.

Battista's funeral panegyric describes the wisdom and clemency with which she ruled the county during her husband's continuous campaigns; but the twelve years of her married life, beginning at the age of thirteen, were perhaps sufficiently occupied with the birth of eight daughters and a son. She died at Gubbio in 1472, soon after the birth of Federico's only legitimate son, Guidobaldo. Piero's portrait of her suggests that it was done from a death mask, and the panegyrics on the reverse of the panels seem to refer to Federico as alive and to Battista as dead.[1] But this is not the general view.

The panel was bought by Mrs. Gardner 9 April 1895 from the Galleria Sangiorgi in Rome. *P27e21*

[1]Hendy, *op. cit.*, pp. 135-40.

OTHER AUTHORITY

Fredericksen and Zeri, *Census* (1972), p. 164; as a copy.

The original: Florence, Uffizi Gallery, No. 1615 with the pendant, panel, 0.47 x 0.33; the pendants have backgrounds of distant landscape and on the reverses *Triumphs* with inscriptions painted in imitation of chiselled stone. They reached Florence in 1631 and the Uffizi in 1773.

Pintoricchio

BERNARDINO DI BETTO (Benedetto) DI BIAGIO: born in Perugia about 1454; died in Siena 1513. The nickname PINTORICCHIO (dabbler in paint) was acquired.

He entered the Guild of S. Luke in Perugia in 1481, bought a house there the same year, and a larger in 1484. Yet already within these years he was painting in Rome. He must have early accompanied Perugino there as assistant; for of the frescoes in the Sistine Chapel undertaken by Perugino for Pope Sixtus IV in 1481-83 two are widely thought to be largely from Pintoricchio's hand. In his own cycle of frescoes with the *Story of S. Bernardino* in a chapel of S. Maria in Aracoeli his style is clearly developed. In Rome again from Perugia by 1487, he painted for Innocent VIII frescoes in the Belvedere palace of which only fragments survive. In 1492 Alexander VI was elected; and Pintoricchio began upon his best known work, the fresco decoration of the Borgia apartments in the Vatican palace. Largely the work of assistants, this was finished by 1495. He decorated many other buildings in Rome, including the choir of S. Maria del Popolo for Julius II. In the autumn of 1508 he had begun with Perugino and Signorelli to decorate for Julius the Stanze in the Vatican; but they were soon to be dismissed.

Once Raphael had reached Rome, there was no call for Pintoricchio's festive but old-fashioned art.

From 1502 he lived mostly in Siena. Here his great work is the decoration of the cathedral library for Cardinal Francesco Piccolomini, who, before it was finished, became Pope Pius III. Pintoricchio bought a property in Siena, and the Council granted him land and freedom from taxation. With Signorelli and others he decorated the palace of Pandolfo Petrucci, from which his *Return of Ulysses* was brought to London and the elaborate decoration from a ceiling to New York. His *Madonna and Child in Glory* from Monte Oliveto, now at San Gimignano, is dated 1512; his little *Road to Calvary* in the Palazzo Borromeo on Lake Maggiore bears the year of his death.

One can understand the applause of the invading French King Charles VIII when feasted by an obsequious Pope in the newly painted Borgia apartments. Pintoricchio had omitted nothing which pleases the senses. Feathery trees and fairy castles make an earthly paradise. The costly ultramarine dominates the colours and gold rains from the skies to gild the haloes and diadems and even whole buildings modelled in relief. Pintoricchio's festive decoration sprang from a school in which design had already become stereotyped. Perugino never hesitated to repeat a composition or to fashion a new one from the motifs of an old, and he evolved a regular system of composition. Pintoricchio impatiently broke up these formalities with a style which is essentially narrative, even in his groups of Madonna and Child. This reaches its full glamour in the *Scenes from the Life of Aeneas Sylvius* in the Siena library. Never has history been more successfully converted into a pageant of fine liveries and horsemanship. Yet Pintoricchio was really less adventurous than Perugino. He adopted his types and gestures and draperies, and for the frescoes in the Borgia apartments seems to have used drawings by Gentile Bellini. In the Piccolomini library, for all the anecdote, he never seems to succeed in involving the *dramatis personae* in the themes.

THE MADONNA AND CHILD

Early Italian Room

Tempera on wood, 0.302 x 0.260. The blue is modified by chemical action. The picture was cleaned in 1938.

The flat gold of the curtain is painted casually over the blue of the sky, and its unmodulated sheen is matched by the rawness of the ultramarine and crimson of the Madonna's robes and of the yellow garment of the Child. The contours are turned with

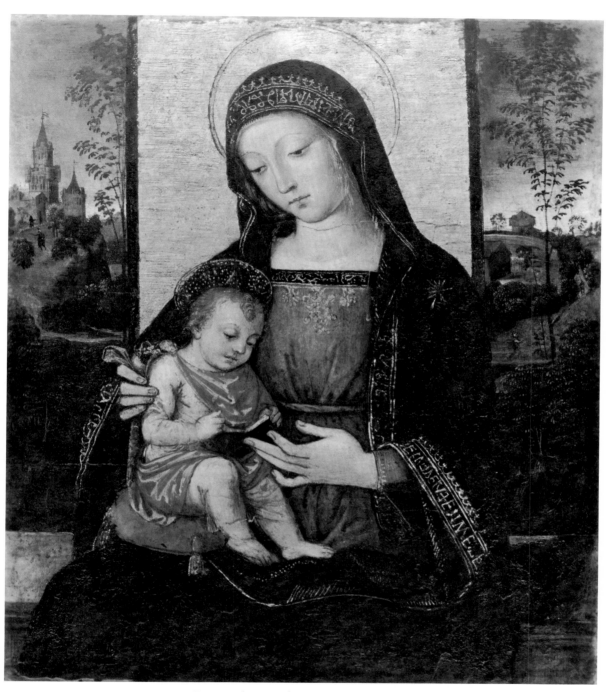

Pintoricchio — *The Madonna and Child*

equal brusqueness, and the form is amplified only by a few hasty gathers in the robes. This little picture is done in the random manner of the Borgia apartments (1492-95). The type of the Madonna is influenced by older Sienese artists, and the background, with its romance of wooded hills and Gothic castles, is typical of Pintoricchio's summary adaptation of Netherlandish landscapes.

The panel was bought from Costantini at Florence by Berenson, and from him it was bought by Mrs. Gardner 19 February 1902. P15w35

AUTHORITIES

Berenson in a letter (4 February 1930); also *Central Italian and North Italian Schools* (1968), I, p. 344.

Carli, Enzo, *Il Pintoricchio* (Milan, 1960), pp. 56-57.

Gnoli (at Fenway Court, 16 December 1926) considered it a school work.

Ricci, C., in *Noteworthy Paintings*, p. 122.

Rushforth in *Noteworthy Paintings*, p. 127; he suggested an early date.

Steinmann in *Noteworthy Paintings*, p. 122.

Venturi, A., *Storia dell'Arte Italiana*, VII, 2 (Milan, 1913), p. 661; he suspected the picture's authenticity.

Piero del Pollaiuolo

PIERO DI JACOPO D'ANTONIO BENCI, or DEL POLLAIUOLO (son of the poulterer): born in Florence 1443 (?); died in Rome before November 1496.

He was the youngest of four brothers, of whom two, Antonio, the eldest, and Giovanni, who carried on the poultry business, were living with him in Florence in 1480. Piero was maintaining his mother. We know less of him as an artist than of his brother Antonio (*ca.* 1432-98), who, beginning as a goldsmith, had taken to painting probably before Piero was an independent artist. Antonio mentioned in a letter that he had been assisted by one of his brothers in the three great *Labours of Hercules* which he painted for the Medici about 1460. Piero was then about seventeen years old. These pictures are lost; but perhaps the tiny *Hercules and the Hydra* and *Hercules and Antaeus* in Florence record two of the compositions. These two and the equally small picture *Apollo and Daphne* in London are so like Antonio's sculpture in their vivid outlines and lively movement that they are likely to have been painted by him. *The Rape of Dejanira* at Yale has the same characteristics, and so, above all, does the fresco in the Torre del Gallo, outside Florence, with *Three Nude Dancers*. These five pictures are widely accepted as Antonio's work. There is no such appearance of easy skill or blithe, unselfconscious spirit

in the large *Tobias and the Angel*, from Or San Michele, Florence, now in Turin, with the ill proportions and the dragging gait of the figures. The panoramic landscape is less poetical than in *The Rape of Dejanira,* and the heavy draperies show a highly individual preoccupation with the painting of textures. It is easy to postulate for Piero a temperament at the opposite pole to his brother's: tentative, inclined to melancholy, earnest, always vainly aspiring to attain his brother's verve. Perhaps they collaborated in the frescoed *Angels* in the chapel of the Cardinal of Portugal in S. Miniato, Florence, and in the altarpiece from there, now in the Uffizi Gallery, with SS. *James, Eustace and Vincent,* all painted by 1467. Likewise in the great *Martyrdom of S. Sebastian,* now in London, painted for an oratory in the SS. Annunziata, Florence, according to Vasari in 1475.

Happily there is some documentation. In August 1467 Piero was commissioned by the Florentine Merchants' Guild to paint on seven panels *The Seven Virtues.* Antonio seems to have helped him with the first, by drawing the figure for *Charity* on the back of the panel. Five months after it was given, the commission was reviewed; but it was again given to Piero, though the *Valour* was eventually painted by Botticelli. All seven are now in the Uffizi. Meanwhile Piero had painted the *Portrait of Galeazzo Maria Sforza,* presumably in 1471, when he visited Florence, for this picture is ascribed to him in a Medici inventory of 1492. Finally, the great *Coronation of the Virgin,* from the church of S. Agostino at San Gimignano, now in the Collegiata there, is signed by Piero and dated 1483. In the following year he probably followed his brother to Rome, perhaps to assist him with his bronze tombs. Antonio in his will of 4 November 1496 alludes to Piero's death, after confiding to him the care of his natural daughter Lisa.

Piero was evidently the frailer of the two, and certainly less lively. But his pictures are original and sincere. The *Virtues* have a new individualism; their various characters are developed with a subtle reticence, with a sad humour that is Piero's own. The dark richness of their warm colours, laid on in peculiar textures which he developed from the example of Baldovinetti and which in turn assisted the further experiments of Verrocchio and Leonardo, is in strong contrast with the bright smooth tints of the earlier fifteenth century. Piero's gentle melancholy is more fully and more fluently expressed in *The Coronation of the Virgin* at San Gimignano, where the pale evening light of the bare Tuscan hills distinguishes with discrimination the frugal, strenuous features of the throng of saints and

angels. He had finally arrived at a composition more deeply expressive than any that has survived from the hand of Antonio.

A WOMAN IN GREEN AND CRIMSON
Raphael Room

Oil on wood, 0.480 x 0.305.

Cleaning in 1947-48 removed a thick black over-painting from the background of pale greenish blue. This had probably been applied when a missing piece of wood was replaced at the top left corner. Otherwise the paint is in good condition, though worn in a few places: notably in the corner of the eye, where the brown underpainting is revealed. The gold in the hair was found to be modern, possibly replacing original gold.

It is the velvet bodice which is of deep emerald green, the sleeve, of some much thinner stuff, which is a translucent crimson. The silhouette is otherwise of white and ivory, shaded with a purplish brown underpainting left almost bare in the gentle shadows of the face or of the lawn cap. In the hair streaks of gold on the brown have perhaps always helped to separate and enrich the strands.

The technique and colours are singularly close to those in the *Portrait of Galeazzo Maria Sforza* in the Uffizi, though it has been suggested that there the more mobile and plastic drawing of the three-quarter view may be a foundation laid by Antonio for Piero to overpaint. Nothing could be further, on the other hand, than the portraits of two girls in profile, one in Berlin, the other in the Poldi Pezzoli Museum, in which every touch is curly, light and gay in complete accordance with the drawing of the jaunty profiles. The Sforza portrait was attributed to Piero during his lifetime, in a Medici inventory of 1492, which gives some support to the distinction attempted above between the styles of the two brothers.

The sober costume of this woman, with the plain white turban, so far from the brocades and the bejewelled hair-dressing of the girls in Berlin and Milan, or of the girl in the portrait attributed to Uccello in this Museum, are those of an unpretentious home. Nor does this woman look a stranger to the plainer problems of life. No doubt from Piero's immediate circle, she could be the model for the S. Fina of his *Coronation* at San Gimignano. Perhaps she was the mother of his daughter Lisa. The portrait may well belong to this late moment in Piero's development. His line never probed more subtly or rendered character more sincerely, with a result that is less homely than monumental.

The panel has on the back a seal with arms (on

Piero del Pollaiuolo
A Woman in Green and Crimson (SEE COLOUR PLATE)

a mount in base a tall, or Latin, cross with the top and ends of the crossbeam patty and two goats (?) rampant against the upright; at either end of the crossbeam also is a star or roundel) belonging probably to some Italian religious fraternity or pious foundation. The portrait was seen by Bode about 1874 at Florence, where it was bought of Bardini by E. Odiot. At his sale in Paris (26-27 April 1889, Drouot, No. 2, attributed to Piero della Francesca) it was bought by Oscar Hainauer[1] of Berlin. From Frau J. Hainauer it was bought in 1907 by Duveen Bros. From them it was bought by Mrs. Gardner, through Berenson, in September 1907. *P16w7*

[1]Thieme in *The Collection of Oscar Hainauer* (Eng. trans., London, 1906), p. 15 and No. 50.

OTHER AUTHORITIES

Berenson in a letter (4 February 1930): to Piero del Pollaiuolo; but later, *Florentine School* (1963), I, p. 17, to Antonio.

Arthur Pope — *Nasturtiums at Fenway Court*

Cruttwell, *Antonio Pollaiuolo* (London, 1907), pp. 181-82.

Douglas in *Crowe and Cavalcaselle's History of Painting in Italy*, IV (London, 1911), p. 232, note 2, to Piero.

Fredericksen and Zeri, *Census* (1972), p. 168; under "Pollaiuolo, Antonio (and Piero)."

Horne, *Sandro Botticelli* (London, 1908), p. 21, to Antonio.

Venturi, A., *Storia dell'Arte Italiana*, VII, 1 (Milan, 1911), p. 574, to Piero.

Venturi, L., *Pitture Italiane in America* (1931), Pl. CLXXV, to Piero.

Etched by A. Krüger for *The Collection of Oscar Hainauer* (1906), Pl. 6.

Arthur Pope

Born in Cleveland, Ohio, 1880; died in Westport, Massachusetts, 1974.

After graduation from Harvard in 1901 he lectured there for almost fifty years, and was Director of the Fogg Museum from 1946-48.

Author of many publications, including *The Language of Drawing and Painting* (1949 and 1968); *Titian's Rape of Europa* (1960).

An original Trustee of the Isabella Stewart Gardner Museum, appointed in her will of 9 May 1921, he retired and was elected Trustee Emeritus in 1967.

NASTURTIUMS AT FENWAY COURT
Macknight Room

Oil on canvas, 0.45 x 0.20.

The picture was painted about 1919, before Mrs. Gardner gave up her house, Green Hill, in Brookline that year. The flowers had been brought from there annually in their season to trail from balconies in Fenway Court, and the picture commemorates what was believed to be their last appearance there. New hothouses allowed the tradition to be resumed by the Trustees.

The picture was given to Mrs. Gardner by the artist in 1919. P11s26

John Briggs Potter

Born 1864; died 1945.

In 1902 he was appointed Keeper of Paintings at the Museum of Fine Arts, Boston. In 1928 his title was changed to Adviser, in 1931 to Fellow and in 1935, on his complete retirement, to Honorary Fellow. In the correspondence between Bernard Berenson and Mrs. Gardner Potter's work in restoration on her pictures is mentioned.

His portrait by Denman Ross (*q.v.*) is in the Blue Room.

MATTHEW STEWART PRICHARD
Macknight Room

Pencil and water colour on paper, 0.46 x 0.32. Inscribed at the top on the right: *MATTHEW STEWART PRICHARD/BORN JAN. 4 1865 ENGLAND/J. B. POTTER DRAUGHTSMAN/BOSTON 1905.*

M. S. Prichard (1865-1936) was in 1905 Assistant Director of the Boston Museum of Fine Arts. He had come in 1902 from Lewes, Sussex, where he had worked for many years with Edward P. Warren. He had begun his connection with the museum through

John Briggs Potter — *Matthew Stewart Prichard*

correspondence on Warren's behalf over the shipment of ancient Greek works of art. He was already a close friend of Mrs. Gardner, and began his Boston career from rooms at Fenway Court. He was appointed Assistant Director to the Museum of Fine Arts in 1903, and played a large part in the disputes which took place concerning the design and functions of the new building on the Fenway. His ideas, now generally accepted, were in advance of those of the architect and the Trustees. He left the museum in July 1906, and in the following summer returned to England. He remained Mrs. Gardner's friend and confidant.

P11n26

Frans Pourbus II

Born in Antwerp 1569; died in Paris 1622.

His grandfather Pieter and his father Frans, who had come to Antwerp from Bruges, were painters before him. He became a Master of the Antwerp Guild in 1591. An example of his early, austere por-

traiture, based on that of Mor (*q.v.*), is the *Nicolas Hellincx*, dated 1592, in Antwerp. By 1594, it seems, he was working in Brussels at the court of the Spanish Regents. In June 1600 he received a large sum for work done for the Archduke Albert and his wife Isabella. That autumn he left Brussels for Mantua, having pledged himself to the Duke the year before. Vincenzo I Gonzaga was the descendant of the patron of Mantegna (*q.v.*), and owned an enormous collection of pictures, eventually bought by King Charles I of England. From this same year, 1600, the Duke was the patron also of Rubens (*q.v.*). Pourbus, rather than Rubens, was the Gonzaga portrait-painter. His full-length portrait of Vincenzo Gonzaga is now at Tatton Park (National Trust), Cheshire. Portraits of his daughters are in the public galleries in Florence. A bust-portrait of the son and heir, Francesco, is in the California Palace of the Legion of Honor, San Francisco. Duke Vincenzo was connected with the royalty of Europe, and portraits like these were part of the machinery by which the old connections were maintained and new established. Duchess Eleonora was sister to Queen Marie de Médicis, wife of Henri IV of France. Pourbus joined the Duchess in France in 1606, and made a portrait of the Queen, of which only the head was painted in 1607. By August of that year he was in Rome, and was sent to buy pictures and paint portraits of pretty women in Naples. In 1608 he accompanied Vincenzo and Francesco to Turin for Francesco's marriage with Margherita of Savoy, whom Pourbus had been sent to paint in 1605. He went on to Innsbruck with the Duke, to paint his niece Anna for his sister the Archduchess of Tyrol.

In autumn 1609 he was again in Paris. Within a short time he had painted the signed portraits now in the Louvre of *Queen Marie de Médicis* in full length and of *King Henri IV* in bust size only, as well as another of the King in armour. His full-length portrait of their daughter *Elizabeth of France* is in Florence. He remained in France as Court Painter to the Queen, who became Regent in 1610, after Henri's assassination. In 1618 he was entitled Painter to the King, Louis XIII. In that year he painted for S.-Leu et S.-Gilles in Paris the best known of his few subject pictures, the large *Last Supper*, signed and dated, now in the Louvre. It was admired by Poussin.

His place in history, however, is due to his court portraits. Their formal, decorative style was developed under Spanish influence, which dominated alike the fashions of the Netherlands and of the Italian states. The portrait convention of the younger Pourbus is little changed from that developed by Sánchez Coello (*q.v.*).

Frans Pourbus II — *Isabella Clara Eugenia, Archduchess of Austria*

ISABELLA CLARA EUGENIA, ARCHDUCHESS OF AUSTRIA
Dutch Room

Oil (with resin?) on canvas, 1.349 x 0.982. The original dimensions were somewhat different, a strip having been cut from one side of the painted canvas and added along the top. There it was overpainted to lengthen the composition.

In 1942 much overpainting was removed: from the grey background, where it covered extensive abrasion; from the head, where it concealed only slight damages but remodelled the features in order to soften the expression, particularly of the eyes and mouth; from the ear, where a bow of ribbon had been tied to the pearl; from both hands, where a jewelled ring had been fastened upon each of two fingers; from the dress, on which countless pearls had been sewn. These were all comparatively modern embellishments.

The Archduchess wears a dress of white silk so heavily embroidered with gold that the metal almost covers it, little ridges of paint making a facsimile of its thread. It may well be her wedding dress.

Isabella Clara Eugenia (1566-1633) was daughter of King Philip II of Spain and of his third wife Elizabeth of Valois. She was thus niece of Juana of Austria, whose portrait by Sánchez Coello is in the Titian Room. In 1598 the Infanta was married to her cousin the Cardinal Archduke Albert Charles of Austria, and received as her dower from King Philip the sovereignty of the Catholic Netherlands. These were a bloody dowry, for their Spanish rulers kept them at continuous war with the northern Protestant United Provinces, which had revolted in 1568. Isabella held court for the rest of her life in Brussels as joint sovereign with her husband. They did their duty with vigour and at least with more intelligence than the kings of Spain. They arranged the Twelve Years' Truce of 1609 between the United Provinces and Spain, and would have prolonged it but for the death of the Archduke in 1621. Isabella then became merely Governess for Philip III, and Spinola was sent to reopen the war. She had employed Rubens (*q.v.*) as Court Painter during the truce. In her widowhood she came to recognise his vast ability in practical affairs. Their efforts for peace are summarised in Rubens' biography.

Here the Infanta is evidently younger than in Rubens' portrait of 1609. Pourbus must have painted her before his departure for Mantua, at the outset of his career, probably soon after her marriage in 1598. This may well be a part of the work for which he received 27 June 1600 the large sum of 620 livres for work done for the Archdukes.

The portrait was bought by Mrs. Gardner 22 March 1897 from Durand-Ruel in New York.

P21n1

Versions: Many portraits of the Duchess are based on the same head; but no actual version of this picture seems to be known. The fine three-quarter length portrait in the John and Mable Ringling Museum, Sarasota, Florida, has the same head and a much more freely painted costume in the style of Rubens (Suida's Catalogue, 1949, No. 217, "Spanish Painter of the late XVIth Century"). A bust-portrait in New York could be a study for the head and shoulders. A variant, attributed to Pourbus, in the Williams College Museum of Art, Williamstown, Mass., includes in the lower left corner, in place of the table, the head and shoulders of a little girl.

William Ranken

WILLIAM BRUCE ELLIS RANKEN: born in Edinburgh 1881; died 1941.

He studied at the Slade School, London, and exhibited first with the New English Art Club there. He was for many years Vice-President of the Royal Institute of Painters in Oil Colours, London, exhibit-

William Ranken — *In a Turkish Garden*

ing at the Royal Academy and in Paris at the Salon des Beaux-Arts.

IN A TURKISH GARDEN *Macknight Room*

Water colour on paper, 0.55 x 0.38. Inscribed at the foot on the right with initials and: *1910*.

Bought from Doll and Richards, Boston, 3 February 1917. *P11s10*

Raphael

RAFFAELLO SANTI: born at Urbino 1483; died in Rome 1520.

Son of Giovanni Santi (died 1494), minor painter and poet at the court of Urbino. Raphael's parents died early, and there was little scope at Urbino just then. We know nothing of him until, about the turn of the century, he appears beyond the Apennines at Perugia. He began as a close imitator of Perugino, who was then dividing his time between Perugia and Florence. His hand has been discerned in varying degrees in Perugino's frescoes of about 1499-1500 in the Cambio (the old Exchange) at Perugia and in the great *Assumption of the Virgin, with Four Saints* in Florence, signed by Perugino and dated 1500. The same year saw Raphael's first known commission, but only two fragments survive, at Brescia and Naples, from this altarpiece for S. Agostino at Città di Castello. After that, commissions for altarpieces came to him thick and fast. In a succession painted for Città di Castello or Perugia he progressively improved on Perugino's ideas and methods, on the variety and depth of his characterisations.

He revisited Urbino, and painted small pictures for Duke Guidobaldo. These included the little *S. George and the Dragon*, now in Washington, and *The Youth with an Apple*, now in the Uffizi. This is possibly a portrait of the young Duke, whose sister introduced him in 1504 to Florence. Perugia, however, continued to be a destination at least for altarpieces, such as *The Entombment* of 1507 now in the Borghese Gallery, Rome. Only in 1508 did he begin upon an altarpiece for Florence. Now in the Pitti Palace, this was left for others to finish when Raphael was called to Rome.

There Pope Julius II set him to decorate the Stanze, a suite of apartments in the Vatican, on which he was occupied with diminishing directness for the rest of his life. His work soon became a centre of interest equal to that of Michelangelo in the Sistine Chapel, while his quick mind and soft manners made him an intimate of the Vatican circle. He painted portraits of Cardinal Bibbiena (version in the Pitti Palace) and Count Baldassare Castiglione,

high priest of polite mysteries. This portrait of 1514-15 is in Paris. His *Portrait of Julius II* is now in London. Julius died in 1513, before the decoration of the second Vatican Stanza was complete. Leo X ordered the decoration of the suite to be continued; but he piled other employments upon the painter. On Bramante's death in 1514 he entrusted him with the continued rebuilding of S. Peter's; and a year later Raphael was made superintendent of excavations. In June he had received the first payment for the huge cartoons, now in the Victoria and Albert Museum, for the Vatican tapestries of *The Acts of the Apostles*. His group portrait, *Leo X with Cardinals Giuliano de' Medici and Luigi de' Rossi*, now in the Pitti Palace, was painted about 1518. He was designing stuccoes and frescoes for the Vatican Loggie 1517-19. In the last year he designed the scenery for Ariosto's *Suppositi* and began a survey of ancient Rome.

Leo's relations too were importunate. Giuliano de' Medici, his brother, ordered a portrait of which the remains are now in New York. For his cousin, the future Clement VII, Raphael designed the Villa Madama outside Rome and the great altarpiece with *The Transfiguration* in the Vatican Gallery, both left to be finished by pupils. For the nephew Lorenzo, made Duke of Urbino, were painted in the studio, probably by Giulio Romano, the large *S. Michael* and *The Holy Family* in the Louvre, both signed by Raphael and dated 1518. The banker Agostino Chigi employed him on a considerable scale, in the decoration of his palace, the Farnesina, and in the building and decoration of his chapel in S. Maria della Pace. Of the frescoes only *The Triumph of Galatea*, finished by 1514, in the Farnesina and the *Sibyls* of the chapel are certainly from Raphael's own hand.

He had taken more and more the part of designer of his assistants' work. In the third Stanza the *Incendio del Borgo* alone can have been more than sketched by him. For the great *Sala di Costantino*, which was to have been the climax of the suite and which is still perhaps the grandest example of the complete decoration of a hall, it is certain only that he made the overall plan and sketches for some of the scenes and figures. One of the drawings is now in the Short Gallery. He died in mid-career.

He had found himself the model of a great school, the pivot of an epoch. The art of Perugia had an easy sentiment, a plausibility and a shallow accomplishment which he thoroughly absorbed in a very few years. His art was showing a deeper content before he came to Florence, witness *The Marriage of the Virgin* now in Milan. The design and the colour have a volume, the paint a quality that were inspired perhaps by Piero (*q.v.*) and the Flemish paintings at

Urbino. In Florence the Doni portraits, now in the Uffizi, are already masterpieces. He painted in oils from the beginning. Influenced perhaps by Venetians, the old Giovanni Bellini (*q.v.*) and the young Giorgione, he developed the subtlest skill in their application. Yet everything was prepared meticulously in drawings and cartoons. The emphasis was on perfection of design.

While he was in Florence, Leonardo and Michelangelo in their rival cartoons for the intended frescoes in the Palazzo Vecchio had forged a new era with their concentration of purpose and their enlargement of scale. The depth and finish of Leonardo's grouping were the goal to which Raphael was already moving; and in Florence he painted a succession of exquisite Madonnas and Holy Families in which the figures are grouped like sculptured bouquets, a spiral movement completing the roundness and the rhythm of the forms. The little *Madonna* from Urbino, now in Washington, is an early and simple example; the "Canigiani" *Holy Family* now in Munich shows how complex became his arabesques in three dimensions.

In Rome he still had to adapt himself in fresco. The first decoration in the Vatican resorts to gold embossments, the cosmetics of Perugia; the design is still bound by Perugian formulae. But in Michelangelo's Sistine ceiling were unveiled a new majesty, a further degree of freedom in the movement of figures through the air. Raphael was quick as ever to assimilate. In the great scenes of the first Stanza, finished by 1511, the climax of Italian formal design is already realised in simple relief; in the *Heliodorus Driven from the Temple* in the next room, completed by 1514, it has arrived in full dimensions. No painter had sustained so bold or so fluent a rhythm across so wide a surface or through so harmonious an illusion of space.

In the *Heliodorus* there is already that vaporisation of the atmosphere which Raphael's pupils quickly coarsened and carried to excess. In their hands the technique of oil painting descended to the mechanical level of the great altarpiece from S. Sisto at Piacenza now in Dresden. In the work of his own hand a certain limitation of feeling is betrayed by the sweetness of Raphael's expression, perhaps by the very ease of his style. Like Pope Leo X, he was the unquestioning child of a classical age. While Leo conscientiously sought the refinement of his senses, scarcely aware of the distant rumble of religious conscience, Raphael turned his back upon nature and regarded his themes with little emotion while he perfected and polished his style. The great beauty of his designs lies in their absolute aesthetic value, in the sculptural completeness with which the

forms are turned and in their rhythmic relationship. Michelangelo had already invented the Olympian grandeur of scale and of expression which marks the classic moment in Renaissance ideas. As a painter Raphael showed himself far more diverse. Perhaps his very freedom from the passions tormenting the poet-sculptor gave him that sense of plastic shape and that fluency of rhythm with which he brought to its most polished ease and refinement the formal design of the Renaissance.

PIETA *Raphael Room*

Oil on poplar (?) wood, 0.235 x 0.288. The constitution of the paint has undergone some slight change, which has rendered it opaque in places. When the old varnish was removed in 1953 it was found to be somewhat rubbed and retouched. Some old retouchings were left, especially in the trees.

S. John Evangelist on one knee helps the Virgin to support the body; behind him stands Nicodemus, and before Joseph of Arimathea S. Mary Magdalen kneels to kiss the feet. Raphael is still strongly influenced by Perugino; Perugino's are the types — those of Christ and Nicodemus are entirely his — the feathery trees and vague distances. But Raphael has gone beyond him in freedom of treatment. The impression of the figures is far from complete; yet there is no distortion, and the general direction of the masses, the balance of the weights, are skillfully rendered. The medium, which has no such fluency or such richness of tone as the perhaps purer oils in which the portrait of Inghirami is painted, is taxed severely by application in extraordinary liquidness and with summary sweeps of the brush.

The panel is part of the predella of the large altarpiece painted by Raphael for the convent of S. Antonio at Perugia. There is no record of its commission, but the style suggests a date between 1503 and 1506. The altarpiece itself, *The Madonna and Child with the Infant S. John between SS. Catherine, Peter, Cecilia and Paul*, and *The Eternal Father between Two Angels* above, is now, with one of the scenes from the predella, in New York. It was sold by the convent 8 May 1677 to Antonio Bigazzini of Perugia, who took it to Rome. It was in the collections of the Colonna family there and then of the kings of Naples. Thence it went with King Ferdinand I to Madrid in 1798. In 1901 it was bought by J. Pierpont Morgan, who presented it to the Metropolitan Museum.

The predella had also *The Procession to Calvary* (in the centre, 0.241 x 0.851), now in London, *The Agony in the Garden*, matching the *Pietà*, in New York and two little figures of saints: *S. Anthony* and

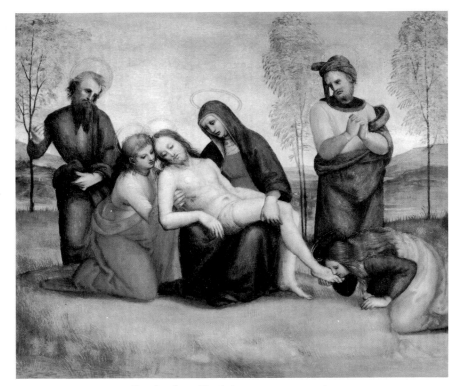

Raphael — *Pietà* (SEE COLOUR PLATE)

A Franciscan Saint now in the Dulwich Gallery, near London. It had been sold separately, before the altarpiece, 7 June 1663 through Cardinal Azzolini[1] to Queen Christina of Sweden,[2] who had abdicated her throne, turned Catholic and formed a large collection of paintings in Rome. This was bought after her death in 1689 by Don Livio Odescalchi, at whose death it was bought in 1721 by the Duc d'Orléans, Regent of France. The Regent was the owner also of Titian's *Rape of Europa*. By his great-grandson the Duc d'Orléans ("Philippe Egalité") the Orléans collection and the predella were broken up.

The *Pietà* was in the sale of the remainder of the Orléans collection (14 February 1800, London, Peter Coxe, Burrell and Foster, No. 43), and came into the possession of the Chevalier Féréol de Bonnemaison (d. 1827), Director of Restorations at the Louvre, a painter and a great admirer of Raphael. It was then in the collection of Count Carl Rechberg at Munich, whose seal is on the back. At the sale of Sir Thomas Lawrence, P.R.A., the English portrait painter (10 May 1830, London, Christie's, No. 125), it was bought by the dealer and restorer John Seguier. Later it belonged to M. A. Whyte of Barron Hill[3] in Staffordshire, from whom it was inherited by M. H. Dawson. From him it was bought by Colnaghi of London, and sold through Berenson to Mrs. Gardner 17 November 1900. It arrived in Boston, via Paris, the following summer. *P16e3*

[1] *Recueil d'Etampes d'après les plus beaux tableaux et d'après les plus beaux desseins qui sont en France*, I (Paris, 1729), pp. 11-12, No. 27. It stated: "M. Crozat has the drawing of the first idea of Raphael for *The dead Christ*" (trans.).

[2] *Giornale di erudizione artistica*, III (Perugia, 1874), pp. 304-10.

[3] Waagen, *Treasures of Art in Great Britain* (London, 1854), II, p. 494.

OTHER AUTHORITIES

Berenson, *Central Italian and North Italian Schools* (1968), I, p. 351.

Crowe and Cavalcaselle, *Raphael* (London, 1882-85), I, pp. 236 and 238.

Dubois de Saint Gelais, *Description des Tableaux du Palais Royal, etc.* (Paris, 1727), p. 436.

Dussler, *Raphael* (London, 1966), p. 15; also *Raphael, A Critical Catalogue* (London, 1971), p. 15.

Fischel, *Raphael* (trans. Rackham, London, 1948), p. 46; the Gardner picture is not specifically mentioned, as it is in the later *Raphael* (Berlin, 1962), p. 33.

Fredericksen and Zeri, *Census* (1972), p. 172.

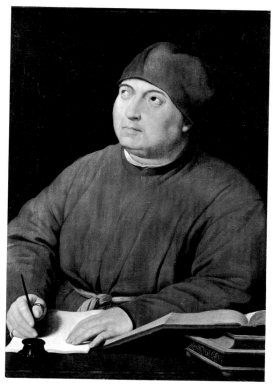

Raphael — *Count Tommaso Inghirami*
(SEE COLOUR PLATE)

Gronau, G., *Raffael* (*Klassiker der Kunst*, 1909), p. 233; he followed Richter (below) in his curious attribution to Eusebio.

Müntz, *Raphael* (trans., London, 1882), pp. 172 and 211.

Oppé, *Raphael* (London, 1970), p. IX, No. 29.

Ricci, C., *Raffaello* (Milan, 1926), p. 129.

Richter, J. P., in *The Art Journal* (March 1902), p. 83, attributed this and other parts of the same predella to Eusebio da San Giorgio.

Rosenberg, *Raffael* (*Klassiker der Kunst*, 1923), p. 224.

Venturi, A., *Studi del Vero* (Milan, 1927), p. 199; he believed that a little *S. Francis* in Dresden is by Raphael and comes from the same predella.

Venturi, L., *Pitture Italiane in America* (1931), Pl. CCCXXXIV.

Engraved by Claude du Flos for *Recueil d'Etampes* (Paris, 1729), Pl. 28.

Version: Perugia, Pinacoteca, copy by Claudio Inglesio Gallo, 1663, made for the convent of S. Antonio.

COUNT TOMMASO INGHIRAMI

Raphael Room

Oil on nutwood, 0.897 x 0.622. There are vertical cracks in the surface and a restoration through the left eye and eyebrow. The amount of retouching was reduced and the old varnish layers removed in 1953.

The sitter wears the scarlet cloth probably of the Secretary to the Lateran Council, whose minutes he perhaps prepares to take. His upward look of attention discreetly minimises the cast of his right eye; and the implied movement is even used by the artist, as Sydney Freedberg in a memorable description[1] points out, as finale to the solid figure's "lifting rotatory pattern," characteristic of Raphael's always finished forms. The rotund body is skilfully introduced and set in space by the flat of the table and the square architecture of the book and pen tray. Inghirami's rich and vehement character and faithfully rendered head are fully exploited by Raphael in the apparent simplicity of what is perhaps his finest portrait design. The simplicity of the colour too is only apparent. Contrasted with the green-black of the background, the luminous magnificence of the red increases the plasticity of the solid form, and melts subtly into the rosy colour of the flesh.

Tommaso Inghirami (1470-1516) came from Tuscan Volterra. His father was killed in the sack of that city by the Florentines in 1472. Lorenzo de' Medici took the child into his protection at Florence, had him well educated and sent him at the age

of thirteen to Rome. Here he rose rapidly in the Church under the tutelage of his fellow countryman Bishop Jacopo Gherardi of Aquino. Pope Alexander VI sent him to Milan as Nuncio to the Emperor Maximilian. The Emperor was captivated, and later sent him in Rome the honours of Poet Laureate and Count Palatine. He was made a Canon of S. Peter's. Pope Julius II appointed him in 1510 Chief Librarian of the Vatican, in 1512 Secretary to the Lateran Council and Secretary to the College of Cardinals. He occupied this post in 1513 at the election of Giovanni de' Medici as Pope Leo X. Leo's court in Rome proved a magnificent rebirth of that of his father Lorenzo at Florence which had first befriended Inghirami; and Inghirami now fully displayed that round and fluent accomplishment which makes him a perfect example of the Vatican society of his day. Rome was the proper home of classical scholarship without textbooks, alive and festive in its youth, and society was engaged in polishing a life of statecraft and entertainment. When Leo celebrated his election by an entertainment for his nephews it was Inghirami who sketched the decoration of the theatre and staged the performance in Latin of the *Poenulus* of Plautus. When, on another occasion, a hitch occurred in the performance of Seneca's *Hippolytus*, he amused the audience with a flow of extempore Latin verse which earned him from the part he was acting the nickname of Fedra. The same easy flow of eloquence and Classical allusion made him the fashionable preacher in Rome. Erasmus boasted his friendship in his letters, and Ariosto extolled him in his *Orlando Furioso*. His remarks on the comedies of Plautus, his commentary on Horace, his defence of Cicero and his outline of Roman history never reached print; but he is thought to be the author of additions to the *Aulularia* of Plautus published in Paris in 1513. The street accident which caused internal injuries and led to his death is illustrated in a pathetic votive picture, prematurely inscribed *T. PHAEDRVS TANTO PERICVLO EREPTVS*, which was found in S. Giovanni Laterano in Rome.[2]

Raphael's three-quarter length *Portrait of Julius II*, now in London, was painted 1511-12. The *Inghirami*, for all its perfection of style, may have been painted even before this, to judge by the less Venetian quality in the handling of the paint. Writers have recently tended, however, to date it about 1513.

On the back of the panel are the remains of a seal, apparently of a department of state of the Grand Duchy of Tuscany under the Hapsburg dynasty, probably under Ferdinand III (1790-1801 and 1814-24) or Leopold II (1824-59). The picture was said to have hung for centuries in the Palazzo Inghirami in the narrow Via Marchesi at Volterra. It

was certainly there in the latter part of the last century, and when it was bought by Mrs. Gardner from the family through Costantini and Berenson in March 1898. P16e4

[1]Freedberg, *Painting of the High Renaissance in Rome and Florence* (Harvard University, 1961), pp. 177-78.

[2]Hadley in *Fenway Court*, Vol. I, No. 6 (May 1967), pp. 41-47.

OTHER AUTHORITIES

Becherucci in Salmi, *The Complete Work of Raphael* (New York, 1969), pp. 138 and 147.

Berenson, *loc. cit.*

Bode in *Noteworthy Paintings*, p. 98.

Crowe and Cavalcaselle, *op. cit.*, II, p. 235; they considered it a replica by another hand of the picture in the Pitti Palace, Florence (below).

Dussler, *Raphael* (London, 1966), p. 34; also *Raphael, a Critical Catalogue* (trans., 1971), p. 34.

Fischel, O., *Raphael* (Berlin, 1962), p. 84; he considered it (with the Pitti version) a copy of a lost original.

Fredericksen and Zeri, *Census* (1972), p. 172.

Freedberg, *Painting in Italy, 1500-1600* (London, 1970), p. 470.

Gronau, G., in *Noteworthy Paintings*, pp. 93 and 97; also *Raffael* (1923), p. 238.

Horne in *Noteworthy Paintings*, pp. 97-98.

Künzle in *Mélanges Eugène Tisserant*, VI (Vatican, 1964), pp. 499 ff.; he suggests that the portrait represented thanks to Inghirami for his help in devising the programme for the first of Raphael's Vatican Stanze, the *Stanza della Segnatura*.

Morelli, *The Italian Painters* (London, 1892), I, p. 58.

Pope-Hennessy, *The Portrait in the Renaissance* (New York, 1963), pp. 117, 119, 316-17.

Ricci, C., *op. cit.*, p. 130.

Rosenberg, *op. cit.*, p. 238.

Versions: (1) Florence, Pitti Palace, No. 171, panel, 0.91 x 0.61. A replica, in the compiler's opinion, from Raphael's studio, outlined and the head probably finished by Raphael himself. The flesh colour browner and monotonous, but this may be due to discoloured varnish. The painting seems more mechanical, but perhaps for the same reason. This makes it difficult to consider it painted by Raphael himself later than the Gardner picture, as some recent writers have suggested. Before 1900 most writers evidently did not know the Gardner picture, and considered the Pitti version the original. Becherucci considers the Pitti picture autograph but later; Berenson a copy; Fischel a copy (also the Gardner picture); Freedberg a later original; Horne, perhaps the only authority who saw the two pictures the same day, considered the Gardner portrait superior. Pope-Hennessy also finds the Pitti version autograph, but later. (2) Volterra, Palazzo Inghirami, a copy made at the time of the sale.

Derived from Raphael
A GIRL TAKING A THORN FROM HER FOOT
Titian Room

Oil on canvas, 0.970 x 0.710. Cleaning in 1940 revealed that the canvas had been torn in several places and that the paint had suffered many fundamental losses as well as a general abrasion.

In the first edition of the Catalogue the picture was entered as "influenced by Correggio," largely in deference to Mrs. Gardner's purchase of it as the work of Correggio from Berenson. As was already stated then, the composition is in fact taken from an engraving by Marco da Ravenna (died about 1527). In this the pose of the girl is identical and the landscape is much the same in broad outline. According to Delaborde, Marco borrowed the composition from the more famous engraver Marcantonio Raimondi (*ca.* 1480-*ca.* 1534), who in turn had taken it from one of the frescoes designed for Cardinal Bibbiena's bathroom in the Vatican palace by Raphael.[1] These no longer exist. The main outline of the landscape may well derive from an engraving by Dürer.

Mrs. Gardner bought the picture as the work of Correggio in December 1897 from Berenson. In a letter of 2 February 1898 he stated that it came from Al. Massori, Rome, and that it seemed to have once formed part of the collection of Cardinal Fesch. In a letter of 24 February 1900 he wrote that he had bought the picture from Gagliardi, Florence. It did not appear in any of Berenson's published lists.[2]

P26w3

[1]Delaborde, *Marc-Antoine Raimondi* (Paris, 1888), p. 167.

[2]Berenson, however, in a letter of 8 December 1907 to Mrs. Gardner: "Mary and I, as we read your last, could not believe it that we had omitted yours from my list of Correggios. . . . Of course I have not gone back on it, and it will go into the next edition. It is almost as bad as our failing once to include the Sixtine Madonna among Raphael's works. Such things, alas!, will happen." Mrs. Gardner had written, 26 November 1907: "By the way in your new book [*North Italian Pictures of the Renaissance* (1907)] why did you not mention my Correggio? Have you gone back on her, and by whom is she?"

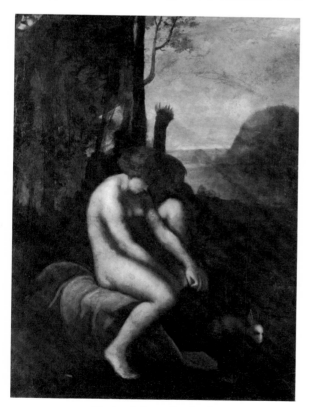

Derived from Raphael
A Girl Taking a Thorn from her Foot

Rembrandt

REMBRANDT HARMENZOON VAN RIJN: born in Leyden 1606; died in Amsterdam 1669.

The younger son of modest parents, Harmen Gerritszoon and Neeltgen van Rijn, he was enrolled at fourteen in Leyden University. After a few months he left it, for the studio of van Swanenburgh, an architectural painter who had been to Italy. In 1624 he went to Amsterdam, as pupil of Lastman, and also of Pynas, both Italianists. With them he stayed barely half a year; but for several years the influence of Lastman's religious and mythological paintings is obvious in many of his own. Back in Leyden before he was twenty, he may have shared a studio with another Lastman pupil, Lievens, who was nineteen. In 1628 he took as his pupil the fourteen-year-old Dou.

About 1631-32 Rembrandt moved permanently to Amsterdam, where he received a commission to paint *The Anatomy Lesson of Professor Tulp,* now in The Hague. Finished in 1632, this life-size group, with the power of its instantaneous likenesses and dramatic presentation, brought him at once into vogue. Probably, before then, the Stadtholder, Prince Frederick Henry, had acquired Rembrandt's *Simeon in the Temple,* now in Hamburg. In 1633 he commissioned of him three pictures with episodes of Christ's Passion. These became five, all now in Munich, together with *The Adoration of the Shepherds,* one of two more painted for the Stadtholder in 1646. Rembrandt owed this patronage initially to the prince's humanist secretary Constantyn Huygens, to

whom he insisted on giving a ten-foot picture, probably the violent *Blinding of Samson* now at Frankfurt, dated 1636.

In 1634 Rembrandt had married Saskia van Ulenborch, who was well connected and handsomely dowered. His renown brought not only fashionable sitters but a host of pupils, for whom he had to convert a warehouse. His etchings sold quickly. In 1639 he acquired a splendid house in the then Sint Anthoniesbreestraat. Here there was soon a great collection of studio props, furniture and *objets d'art*, of pictures by Italian and Dutch artists and, above all, of drawings and prints, again Italian as well as Dutch.

Rembrandt expressed the euphoria of his enviable position with perfect vulgarity in the group portrait now in Dresden, where he drinks to us at the dining-table with Saskia on his knee. There are many portraits of his wife looking less embarrassed and happier, and sometimes idyllic, posed as *Flora* in pictures now in London and Leningrad. But in 1642 Saskia died, after much illness, and leaving of their four children only the newborn son Titus. Her place was taken after an interval by Hendrickje Stoffels, who, defying convention and her church, acted with devotion as wife and mother and model. She is the subject of Rembrandt's warmest portraits of women; and she too appears as *Flora* in New York, as *Venus* in Paris, probably there also as *Bathsheba*, one of Rembrandt's two nudes in life size. A clause in the marriage contract with Saskia explains why Rembrandt never married Hendrickje. His art always had its supporters, and he asked high prices; but the world of fashion now rarely came to sit to him, the pupils dropped away, and after a boom had come a depression. In 1656 he was declared bankrupt, and within a few years everything was sold. The Guild of S. Luke, to which Rembrandt was now anathema, cruelly decreed that bankrupt artists could no longer sell; they could starve. Hendrickje and Titus therefore formed a partnership to employ Rembrandt; and Titus continued to do so when Hendrickje died in 1663. She had borne Rembrandt a daughter, Cornelia. In 1668, when Titus married, Cornelia at fourteen was left alone with Rembrandt. Titus died almost immediately. Cornelia survived, to marry and emigrate, and to have two children called Rembrandt and Hendrickje.

Meanwhile in 1642 Rembrandt had painted the huge "Night Watch," actually *The Militia Company of Captain Frans Banning Cocq*, now in the Rijksmuseum. In it he had proclaimed the growing breadth and freedom of his style, his insistence on the dramatic and his lack of interest in the hard-edged ephemeral portraiture fashionable in the North.

By natural law, as the number of his sitters diminished, the interest of their characters increased. To have sat for him they must have appreciated the ever deepening interpretation of psychology and sense of form, and the transcendent means by which these were realised in paint. It becomes increasingly difficult to know whether the pictures of men and women are portraits commissioned of Rembrandt or his comments on the lot of man. The known portraits are not all of doctors or preachers. There is the *Jan Six* of 1654 in the Six van Hillegom collection, Amsterdam, in which Rembrandt is close to Velázquez in the impression of richly coloured costume brushed on with apparently casual economy, in the carefully rendered dignity of a man fully conscious of his position and deserts. In 1656 the Surgeons commissioned *The Anatomy Lesson of Dr. Deyman*, of which a part still exists in the Rijksmuseum; and there is also *The Syndics of the Clothmakers' Guild* of 1662, another group portrait on the heroic scale. The great *Equestrian Portrait* in London, of an unknown sitter, is probably of 1663.

Of the destination of his later subject pictures, we know almost nothing, unless it is that he had a good friend in the art dealer Abraham Francken. An exception are three pictures, *Aristotle Contemplating a Bust of Homer*, dated 1653, now in New York, *Homer*, now (much reduced) in The Hague and probably *Alexander* (also reduced) in the Gulbenkian Foundation, Lisbon. These were painted for a Sicilian nobleman, Antonio Ruffo.

The largest picture which he painted, *The Conspiracy of Claudius Civilis*, of which the centre alone is now in Stockholm, has an unhappy history. For the new Town Hall in Amsterdam eight pictures were commissioned from Govaert Flinck, Rembrandt's former pupil. When he died in 1660 with nothing accomplished, only three were re-commissioned, and only one from Rembrandt. His picture was in place in 1662; but within a few months it was taken down again.

Of the early history of his later biblical scenes we know nothing: of *Bathsheba*, now in Paris, dated 1654; of *Jacob Blessing Ephraim and Manasse*, in Kassel, perhaps of 1656; of *Peter Denying Christ*, in Amsterdam, dated 1660; even of *The Return of the Prodigal Son*, in Leningrad, one of his last and greatest pictures. We know only that, when he died, probably he was painting *Simeon in the Temple*, now in Stockholm, for the dealer Dirk van Cattenburg.

The most painterly of all painters, Rembrandt is best paralleled in history by the dramatist Shakespeare. No other two artists have disclosed so much of what happens inside their fellow men. In this he

brought to perfection a talent of which the beginnings are seen in Giotto: that of recording the attitude, the gesture, the expression which makes clear the circumstance, the motive, the emotion of his characters. Brought up in the constant reading of the Bible, turning again and again for subjects from its variegated drama to the most concentrated of all histories, the human face, he became the Bible's illustrator beyond compare. No man stands alone, and Rembrandt, we know from the inventory of his collections and from occasional parallels in his own work to that of other artists, to Raphael and Titian, to Caravaggio, ter Bruggen and Elsheimer, was heir to the tradition of European art. He did not have to leave Amsterdam to become part of the *zeitgeist* expressed in the Baroque movement and the obsession with chiaroscuro. Yet no other artist but Titian has to such an extent evolved a style and a method of his own, by the intensity of his personal observation, by tireless experiment in execution, until in his hands the paintbrush becomes light and shade and colour and the subjects of his pictures seem in their pathos to have passed the normal human experience and to have come into existence of their own.

SELF-PORTRAIT *Dutch Room*

Oil on oak, 0.897 x 0.735. Signed in monogram at the right edge, below the centre: *RHL*. This is faint. A date *1629* had been added, and was removed when the picture was cleaned in 1954.

The monogram, standing presumably for Rembrandt Harmensis Leidensis, was used by Rembrandt only until 1631-32, while he was living in Leyden. It therefore gives a *terminus ad quem* for the painting of the picture. Most of the earliest dates on his painted self-portraits are doubtful; but this picture seems nearer to his large etched self-portrait dated 1629 than to the etched self-portrait head, to which he added in charcoal on a copy in the British Museum: *T·24/Anno·1631·*.

Rembrandt is thus some twenty-two years of age; and he had already painted, etched and drawn many self-portraits. This is probably the largest he had yet painted; and the most formal, although he is perhaps in fancy dress, as he often is. Especially numerous in his youth and in his somewhat precocious old age, the self-portraits must represent many things besides an autobiography unique in the work of any great artist. Chronicling his reactions to his fortunes and misfortunes, they show him in every mood. Especially in his later life, the mood is among others a defiant one. He is looking at us; not we at him.

This early portrait is unusual in that we scarcely see his eyes. He seems to be experimenting in how to present a well bred appearance, in a composition of grandeur. It was this, no doubt, which led Bode[1] to the suggestion, unsupported by any evidence, that Rembrandt painted it for his earliest important patron Constantyn Huygens. He is seen again, in a very different mood, in *The Storm on the Sea of Galilee,* hanging opposite.

Its history has not been traced beyond the sale of the Duke of Buckingham at Stowe House, Buckinghamshire, 15 September 1848 (No. 421). There it was bought by Lord Ward. It then entered the Sawyer collection at Hinton St. George in Somerset, acquired perhaps by George Anthony Sawyer (b. 1791). A seal on the back has the Sawyer arms (impaling a coat with a gold cross upon a field azure: perhaps an erroneous transcription of that of George Anthony's mother, daughter of Baron van Capellen, which is a plain couped cross or upon azure with a chapel in the dexter canton). It certainly belonged to one of G. A. Sawyer's twin sons, Lieut.-Col. Charles Richard John Sawyer (1816-91); and was sold by his eldest son, Charles Edward Sawyer (a cleaner's label on the frame has *Edward Sawyer Esq., No. 1, Portrait of Rembrandt, 24/2/90*) in London 13 July 1895 (Christie's, Anonymous, No. 81). It was bought by Tooth, and sold by them to Colnaghi. From Colnaghi it was bought by Mrs. Gardner through Berenson in February 1896.

P21n6

[1] Bode, *Rembrandt* (Paris, 1897), I, pp. 10 and 70, and in *Noteworthy Paintings*, pp. 204-05.

OTHER AUTHORITIES

Bauch, *Rembrandt. Gemälde* (Berlin, 1966), Pl. 292.

Bredius, *Rembrandt* (ed. Gerson, 1969), p. 547, No. 8. Gerson's comment that the picture "is in rather a bad state" is hardly justified.

Dutuit, *Tableaux de Rembrandt* (Paris, 1885), I, p. 17.

Friedländer at Fenway Court (3 December 1924).

Gerson, *Rembrandt* (1968), pp. 198 and 490.

De Groot, *Catalogue of Dutch Painting* (trans., London, 1916), VI, No. 529.

Michel in *Noteworthy Paintings*, p. 204.

Smith, *A Catalogue Raisonné of the Works of the most eminent Dutch, Flemish and French Painters* (London, 1829-42), VII, p. 143, No. 422 (?), described from an anonymous engraving, and p. 149, No. 445, described from Cooper's engraving of the picture then at Stowe.

Waagen, *Treasures of Art in Great Britain* (London, 1854), II, p. 237.

Engraved (?) by R. Cooper (Smith, No. 445); and (?) anonymously (Smith, No. 422).

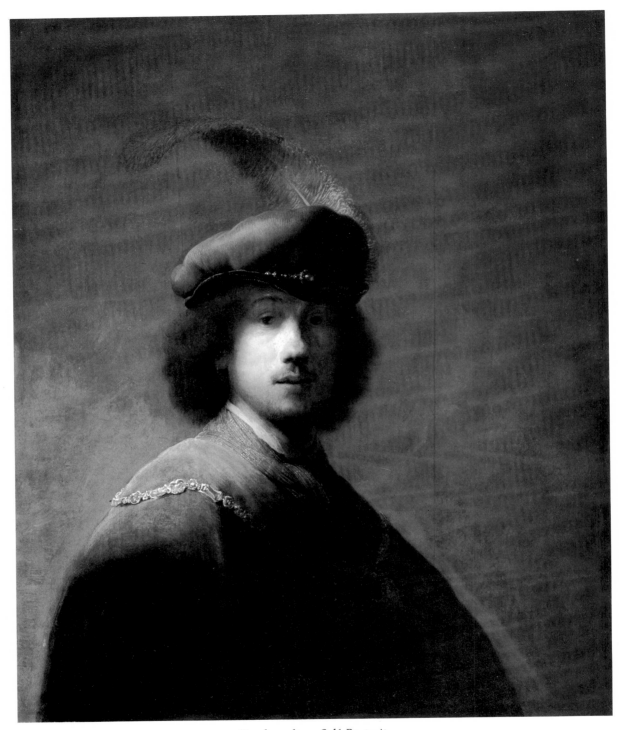

Rembrandt — *Self-Portrait*

A LADY AND GENTLEMAN IN BLACK
Dutch Room

Oil on canvas, 1.316 x 1.090. Inscribed at the foot of the map to the left: *Rembrandt.ft: 1633*. The painting was cleaned and relined in 1949.

The black and white dresses stand out sharply against the neutral background; and in contrast with both are the cushions of brilliant crimson on the chairs, the pink binding of the lady's gloves, the flowers embroidered on her stomacher, and the fresh carnations of the wholesome couple themselves. It is a composition thought out most carefully in colour and in spatial arrangement. The year is Rembrandt's second in Amsterdam, when he must still have been flushed with the success of his original composition *The Anatomy Lesson of Professor Tulp*, painted in 1632. One cannot help asking whether this could be Nicolaas Tulp himself, one of the most successful professional men in Amsterdam, a general practitioner who was also a Magistrate and twice Burgomaster.

However, it seems unlikely that such an identity could have been lost by the time the picture was acquired by Henry Hope, a Scotsman who settled in Amsterdam during Rembrandt's life. His collection of pictures by Dutch artists more or less his contemporaries was increased in the eighteenth century by Henry Thomas Hope, who bought Rembrandt's *The Storm on the Sea of Galilee* now in the same room. His sons Thomas (died 1831) and Henry Philip (died 1839) brought the collection, which now included ter Borch's *A Lesson on the Theorbo* in the same room, to London, where it hung in Duchess Street, Portland Place. Henry Thomas Hope, the next owner, bequeathed it to his widow in 1862. Through their daughter Henrietta Adela, who married the sixth Duke of Newcastle, a life interest was inherited in 1884 by Lord Francis Pelham Clinton-Hope. He exhibited the collection at South Kensington 1891-98. In 1898 he obtained permission from Chancery to sell the eighty-three paintings, which were bought by Wertheimer and Colnaghi. From Colnaghi the three canvases were bought through Berenson in September 1898. *P21s9*

AUTHORITIES

Bauch, *op. cit.*, Pl. 531.

Bode, *Studien zur Geschichte der Holländischen Malerei* (Brunswick, 1883), p. 403; *Rembrandt* (Paris, 1897), II, pp. 8 and 78, No. 99; and in *Noteworthy Paintings*, pp. 196-97.

Bredius, *op. cit.*, p. 583, No. 405. There seems to be no justification for Gerson's statement that the "signature is somewhat redrawn."

Bürger, *Trésors d'Art en Angleterre* (Paris, 1865), p. 248.

Dutuit, *op. cit.*, p. 45.

Friedländer, M. J., at Fenway Court (3 December 1924).

Gerson, *op. cit.*, pp. 26 and 494.

De Groot, *op. cit.*, No. 930.

Michel, *Rembrandt* (trans., London and New York, 1894), I, p. 142 and II, p. 236.

Moes, *Iconographia Batava* (1897, 1905), No. 1247, names the couple *Wm. Burchgraeff and his wife*. Their separate portraits, at Dresden and Frankfurt, are dated the same year.

Rosenberg, *Rembrandt* (3rd ed., 1968), p. 121.

Rosenberg, Slive and ter Kuile, *Dutch Art and Architecture: 1600-1800* (1966), p. 54.

Smith, *op. cit.*, p. 117, No. 322.

Vosmaer, *Rembrandt* (2nd ed., The Hague, 1877), p. 499.

Waagen, *op. cit.*, p. 115.

Exhibited (?) 1853, London, British Institution, No. 13. (?) 1857, Manchester, Art Treasures, No. 656. 1881, London, R.A., Old Masters, No. 75 (label on frame). 1891-98, London, South Kensington, collection of Lord Francis Pelham Clinton-Hope, No. 64 (number on frame in chalk).

THE STORM ON THE SEA OF GALILEE
Dutch Room

Oil on canvas, 1.617 x 1.298. Inscribed on the rudder: *Rembrant* [sic]. *f::/1633*.

The miraculous incident is described by Matthew and Mark, but perhaps most graphically by Luke (8: 22-25):

. . . he went into a ship with his disciples: and he said unto them, Let us go over unto the other side of the lake. And they launched forth. But as they sailed he fell asleep: and there came down a storm of wind on the lake; and they were filled *with water*, and were in jeopardy. And they . . . awoke him, saying, Master, master, we perish. Then he arose, and rebuked the wind and the raging of the water: and they ceased, and there was a calm. And he said unto them, Where is your faith? And they being afraid wondered, saying one to another, What manner of man is this! for he commandeth even the winds and water, and they obey him.

Later in his career, when he had acquired subtler means and greater harmony of expression, Rembrandt would have been able to handle the moment of the miracle. In his earlier years, such scenes of violence appealed to him especially. F. Lugt suggested[1] that Rembrandt based his composition on an

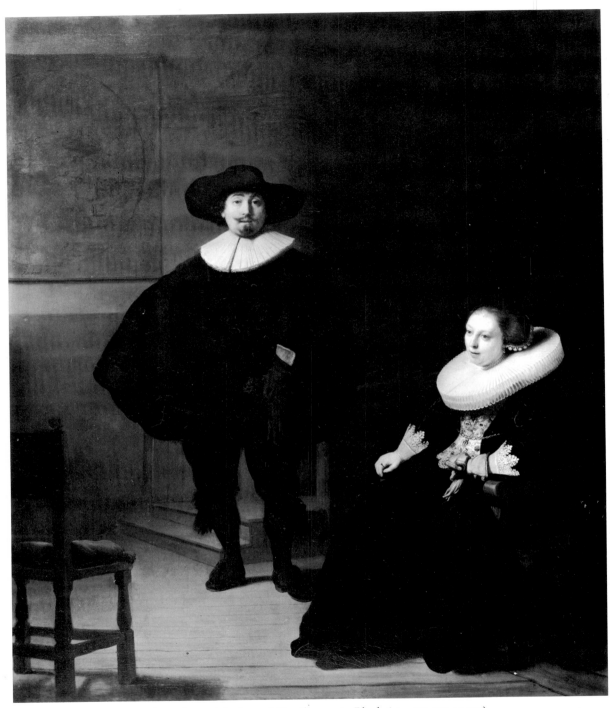

Rembrandt — *A Lady and Gentleman in Black* (SEE COLOUR PLATE)

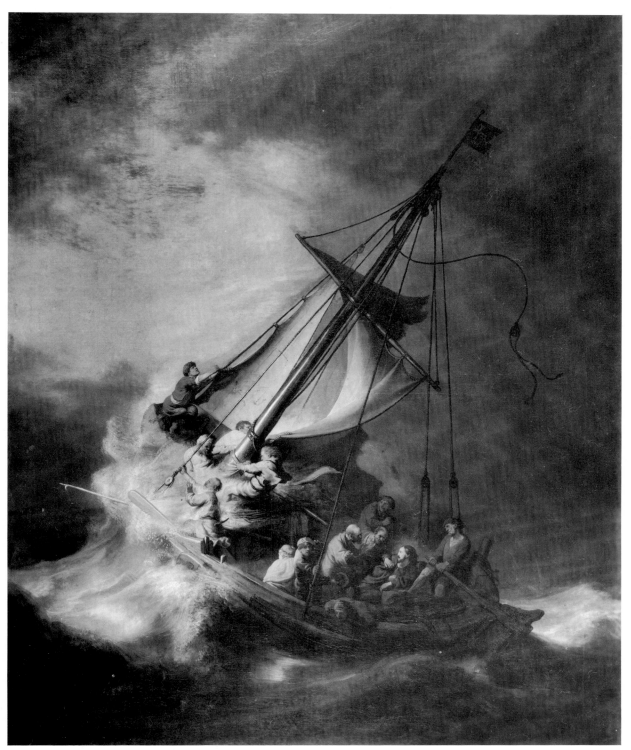

Rembrandt — *The Storm on the Sea of Galilee* (SEE COLOUR PLATE)

engraving of about 1580 by Maerten de Vos, which does indeed anticipate it in broad outline. Yet it is hard to believe that Rembrandt did not, like Turner, lash himself to the mast in a storm, before painting his only seascape. The figures stand out with terrible sharpness, each one projected violently within the hollow of the bark by the blinding concentration of the light towards the point of danger. The great diagonal which fixes the whole scene and the fierce rhythm of outline which weaves its parts together are a legacy from Rubens and the Baroque draughtsmen of the High Renaissance. The texture of the whole composition is somewhat flat and hard; but much of this may be due to the subsequent lining of the canvas, and there are already the elements of Rembrandt's mature colour composition. The warm purples and dull reds of Christ and the men in shadow near him give way to flaming yellows, greens and blues in the centre of agitation. The man near to us, holding his cap on with one hand and clinging to a stay with the other, is clearly the artist.

The picture was called "St. Peter's boat" in the seventeenth century when it belonged to Burgomaster Jan Jacobsz Hinloopen at Amsterdam.[2] It was later in the collection of King Augustus III of Poland at Hubertusburg until 1765.[3] In 1771 at the sale of Gerrit Braamcamp in Amsterdam it was bought by Henry Thomas Hope, descendant of the purchaser of *A Lady and Gentleman in Black*. The subsequent history of the two pictures is the same. P21s24

[1]Bauch, *op. cit.*, Pl. 58 and note; repeated by K. E. Maison in *Themes and Variations* (London, 1960), p. 99.

[2]Houbraken, *De Groote Schouburgh der Nederlandtsche Konstschilders en Schilderessen* (Amsterdam, 1718), I, C, p. 260.

[3]Vosmaer, *op. cit.*, pp. 497-98.

OTHER AUTHORITIES

Blanc, *Trésor de la Curiosité* (Paris, 1857), I, p. 473.

Bode, *Studien zur Geschichte der Holländischen Malerei* (Brunswick, 1883), p. 436; *Rembrandt* (Paris, 1897), II, pp. 12 and 120; and in *Noteworthy Paintings*, pp. 199-200.

Bredius, *op. cit.*, p. 605, No. 547.

Dutuit, *op. cit.*, p. 45.

Friedländer, M. J., at Fenway Court (3 December 1924).

Gerson, *op. cit.*, pp. 48 and 491.

De Groot, *op. cit.*, Rembrandt, No. 103.

Haak, *Rembrandt* (trans., New York, undated), pp. 94-95.

Howard, J. W., in *Fenway Court* (1970), pp. 33-38.

Michel, *op. cit.*, I, p. 152 and II, p. 236.

Münz and Haak, *Rembrandt* (New York, undated), p. 74.

Neuman in *Noteworthy Paintings*, pp. 197-98.

Rosenberg, Slive and ter Kuile, *op. cit.*, p. 162.

Smith, *op. cit.*, p. 34, No. 82.

Waagen, *op. cit.*, p. 115.

Wurzbach in *Houbraken's Grosse Schouburgh der Niederländischen Maler und Malerinnen* (Vienna, 1880), I, p. 114.

Exhibited 1818, London, British Institution, No. 146. 1835, London, British Institution, No. 73. 1881, London, R.A., Old Masters, No. 168, dated by error 1535 (label on frame). 1891-98, London, South Kensington, the collection of Lord Francis Pelham Clinton-Hope, No. 3 (number on frame in chalk).

Etched by Exshaw, Amsterdam, 1760, in reverse.

Engraved by J. Fittler, A.R.A., London, 1807; and by Réveil in outline (for *Musée Religieux*, p. 124), Paris, 1836.

THE OBELISK *Dutch Room*

Oil on oak, 0.545 x 0.710. Inscribed faintly at the foot on the right: *R. 16.8*. The missing cipher must have been 3, as was the modern one which took its place until the painting was cleaned in 1947-48. The faintness of the inscription is due to a wearing which is fairly general in the dark colours. The paint has grown more transparent with time, and the brown colour of the stained oak beneath it is likely to have taken a stronger hold over the whole effect than it had at first, darkening it. Yet in places, as on the right, the paint has gone curiously opaque, owing perhaps to the application of some unsuitable solvent in a past cleaning, perhaps only to the acid exuded by the oak.

Yet we can still both discover the wealth of incident and feel the impact of the overwhelming mood. In the centre foreground a countryman converses with a horseman who is accompanied by his dog. Behind them a carter beats his nag over the bridge towards the water-mill. Beyond the obelisk, a pair of horses draw a great coach away from the town. An obelisk then stood about two miles outside Amsterdam,[1] and Rembrandt some twelve years later included a close view of it in an etching (Münz, No. 157). There are mountains too in several of Rembrandt's later etchings; though most of his etched landscapes describe the familiar scene within a few miles of his home, in marked contrast with this romantic panorama and the swirling Baroque rhythm of its design. The sun is breaking through after the storm; but human life is still pathetic, measured against the battered trees, the space carved by the windings of the wilful river, the power of the foreboding atmosphere.

This panel was in the three sales of Baron E. de

Rembrandt — *The Obelisk* (SEE COLOUR PLATE)

Beurnonville (9 May 1881, Paris, Rue Chaptal, No. 434, bought in; 21 May 1883, No. 84, bought in; June 1884, No. 292). At the last it was bought by A. Posonyi of Vienna. It was then in the collection of Georg von Rath in Budapest. In 1905 von Rath bequeathed his house with its pictures and objects of art to the town; but he had sold *The Obelisk* before the end of the last century to Colnaghi of London. From them it was bought through Berenson in March 1900. Dr. von Bode[2] had hoped to obtain it for Berlin.

Mrs. Gardner had previously attempted to buy from Lord Lansdowne *The Mill* now in Washington.

P21w24

[1]Michel in *Noteworthy Paintings*, pp. 202-03.

[2]Bode in a conversation with the compiler (Berlin, August 1928).

OTHER AUTHORITIES

Bauch, *op. cit.*, Pl. 546 and note; he wrongly suggests the inscription is false.

Bode, *Rembrandt* (Paris, 1897), IV, pp. 4 and 50, No. 250, and in *Noteworthy Paintings*, p. 200; he doubted the signature, but dated the picture 1637-40.

Bredius, *op. cit.*, p. 589, No. 443; Gerson's added comment on the condition is wide of the mark.

Friedländer, M. J., at Fenway Court (3 December 1924).

Gerson, *op. cit.*, pp. 308 and 496 (comments as in Bredius).

De Groot, *op. cit.*, No. 941.

Haak, *Rembrandt* (trans., New York, undated), pp. 148-49.

Michel, *op. cit.*, p. 314.

Münz, *Rembrandt* (1954), p. 86.

Münz and Haak, *Rembrandt* (New York, undated), p. 84.

Neuman, *op. cit.*, pp. 200-01.

Rosenberg, Slive and ter Kuile, *op. cit.*, p. 58.

Stechow, *Dutch Landscape Painting of the Seventeenth Century* (1966), p. 136.

Exhibited 1898, Amsterdam, Rembrandt Exhibition, No. 41 (label on back).

For what is believed to be a copy after a drawing by Rembrandt, see Hadley, *Drawings* (Isabella Stewart Gardner Museum, 1968), pp. 29-32.

Elizabeth Wentworth Roberts

Born in Philadelphia 1871; died at Concord, Massachusetts, 1927.

She was the pupil in Philadelphia of Elizabeth Bonsall and of H. R. Poore, and later in Paris of Bouguereau, Robert-Fleury, Lefebvre and Merson.

THE RIVER AT CONCORD　　　　*Macknight Room*

Oil on canvas, 0.70 x 0.91.

Painted in March 1915 (inscription on the back), and bought by Mrs. Gardner 16 April from Doll and Richards, Boston.　　　　P11n5

Roman; 1575-95 (?)

S. PHILIP NERI　　　　*Chapel*

Oil on canvas, 0.516 x 0.408. Old varnish and overpainting obscure the nature of the original paint.

The costume and the composition are alike typical of the last quarter of the sixteenth century; but the crude technique and the condition make the painting difficult to date. This is possibly a replica, painted not later than about 1800.

Filippo de Neri (1515-95) was born in Florence, the son of a notary and destined for a business career. Educated in Fra Angelico's old convent, S. Marco, he became deeply religious. In 1533 he went to Rome, where he at first led an austere life of study. After some five years, however, he sold his books and devoted himself to the sick and the ignorant. His nights of prayer culminated in an ecstasy in S. Sebastiano in 1544. In 1551 he was ordained, and went to live with a community of priests at S. Girolamo. Here he devoted himself particularly to the spiritual care of young men, with services eventually held in an oratory built over the church. His congregation of the Oratory was approved by Gregory XIII in 1575. It was a free society, devoted to preaching and catechising, and attracting also by the use of the arts, particularly of music. The composer Palestrina was among his penitents, and the name *oratorio* for an extended form of musical com-

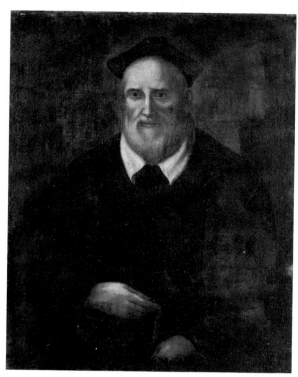

Roman: 1575-95(?) — *S. Philip Neri*

position derives from the hall at S. Girolamo. Filippo de Neri became a popular and influential figure in Rome. After his death he was canonized, in 1622.

The portrait is said to have come from the Palazzo Massimo alle Colonne in Rome.[1] It was here that Filippo de Neri achieved the momentary resuscitation of the boy Paolo, heir to the Prince Massimo of the day, 16 March 1584. A chapel was built within the palace in commemoration, and for centuries was opened to the public every March 16 for eight days.

The picture was bought from A. Fausti in March 1895. *P28wl*

[1]Morris Carter, p. 171 of a notebook in the Museum archives. He quotes a statement by Mrs. Gardner.

Girolamo Romanino

See Hadley, *Drawings* (Isabella Stewart Gardner Museum, 1968), pp. 20-22.

Denman Waldo Ross

Born in Cincinnati, Ohio, 10 January 1853; died in London 12 September 1935.

When he entered Harvard University in 1871 his parents moved to Cambridge, Massachusetts; and there he lived in the same house for the remainder of his life. He became, however, a great traveller. After his mother's death in 1904, he spent long months in India, Cambodia, China, Japan, Mexico and Peru. He began his career as a historian, but turned to the study of art after the death of his father in 1884. In 1899 he became Lecturer on the Theory of Design in the Harvard Architectural Department, and ten years later joined the staff of the Fogg Art Museum. His *Theory of Pure Design* (1907) and *On Drawing and Painting* (1912), together with the influence of his undergraduate teaching, were more significant than his painting, which remained always amateur, in spite of a period of study at Julian's in Paris. Perhaps his most valuable contribution was made as a collector. To the Boston Museum of Fine Arts, of which he was a Trustee for more than forty years, he gave some 12,000 objects, to the Fogg Art Museum 1,500. All the five pictures below were given by him to Mrs. Gardner, whom he advised on one or two purchases.

JOHN BRIGGS POTTER *Blue Room*

Oil on canvas, 0.79 x 0.63.

J. B. Potter (1864-1945) occupied for many years the post of Adviser in the Department of Paintings of the Museum of Fine Arts, Boston. His portrait of Matthew S. Prichard is in the Macknight Room.

The picture was given to Mrs. Gardner by the painter in 1905. *P3w11*

THE BEACH *Blue Room*

Oil on canvas, 0.24 x 0.34.

Given to Mrs. Gardner by the artist 7 June 1910 (label on the back). *P3s17*

A BANDAGED HEAD *Blue Room*

Oil on canvas, 0.57 x 0.39. Inscribed at the foot on the left: *Denman W Ross / Summer of 1919.* *P3s28*

PEONIES *Macknight Room*

Oil on canvas, 0.36 x 0.26. Signed at the foot on the left: *Denman W Ross.* *P11w14*

A VIEW OF POPOCATEPETL FROM CUANTLA
 Macknight Room

Oil on canvas, 0.25 x 0.35. Inscribed at the foot on the left: *Denman W Ross/ Cuantla Morelos/ Mexico 1923.*

Given by the artist 14 June 1923. *P11w15*

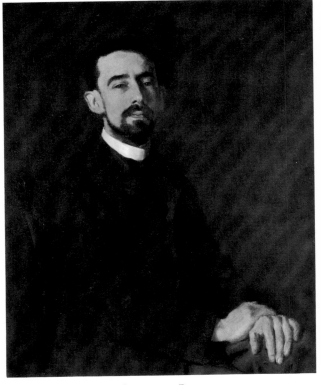

John Briggs Potter

A Bandaged Head

The Beach

A View of Popocatepetl from Cuantla

Peonies

Dante Gabriel Rossetti

GABRIEL CHARLES DANTE ROSSETTI: born in London 1828; died at Birchington-on-Sea, Kent, 1882.

After two years of drawing in the Royal Academy School, he attached himself to Madox Brown, and then to Holman Hunt. Hunt had persuaded Millais into a scheme for the purification of English painting. Rossetti, fresh from the plots of an exiled Italian father, persuaded them to form with four others the Pre-Raphaelite Brotherhood. He had already written his best known poem, *The Blessed Damozel*, at nineteen in 1847. His first important picture, *The Childhood of Mary Virgin*, was exhibited in 1849. It was signed *P.R.B.*, and was applauded. But the first exhibition of the Brotherhood, at the Royal Academy of 1850, was met by a storm of abuse. Rossetti took it hard, and scarcely exhibited in public again. For ten years he produced mainly poetry and watercolours. The Brotherhood virtually disintegrated; but their ideals had been largely inspired by Ruskin's *Modern Painters*, and Ruskin's championship now made Pre-Raphaelitism an influence in English life. He encouraged Rossetti to resume painting in oils, advised him and bought his pictures, until he had found him wealthy and less discriminating patrons. Rossetti worked for several years on the triptych in Llandaff cathedral in Wales, 1855-64. In 1857 he undertook with Burne-Jones, William Morris and others to decorate gratuitously the library of the Oxford University Union Society. Little remains of these murals, but Rossetti accomplished one of the three he had designed.

In 1860 he married Elizabeth Siddal, his fiancée for nearly ten years. She wrote poems, painted watercolours and was the inspiration of countless of Rossetti's own; but she was a dying woman, and in 1862 she took her own life. Her influence coincided with that of Ruskin, who largely supported her, and with Rossetti's more chaste ambitions. It ended with his *Beata Beatrix* of 1863, now in the Tate Gallery. He moved from Bloomsbury to a great dilapidated house in Chelsea, sharing it with the poet Swinburne for the next five years, those of his greatest fertility, of *The Beloved* and *Monna Vanna* in the Tate Gallery, both of 1866. The latter was painted from Fanny Cornforth, the voluptuous and mercenary influence of these years. Rossetti was always unkempt, his habits wildly irregular, his house disordered by pets and bric-à-brac. His largest picture, *Dante's Dream*, was finished in 1871. Nevertheless, insomnia and failing eyesight, chloral and whisky caused a dreadful persecution mania and an attempted suicide in 1872. The two years that he spent afterwards at Kelmscott Manor in Berkshire with

William Morris saw the painting *Proserpine*, sold to Leyland in 1874; but it put an end to friendship with Morris. Of these years Mrs. Morris had been the model and the influence. It was Sir Hall Caine who finally shared the house in Chelsea and tended Rossetti during his last four years.

The Pre-Raphaelite painters had no coherent principles. United mainly in their contempt for their predecessors, they ignored not only Academicism, but the achievements of Gainsborough and Turner and Constable. Like their French contemporaries, they felt the need to return to pure colours, and they talked much of nature; but from classicism they turned to a medievalism which was literary and romantic, and their principles were not developed by observation of life. Thus they achieved an insular and amateurish freak, and it was French influences which eventually resuscitated English painting. Almost without technical training, Rossetti knew little of colour and light or of draughtsmanship. The dreams which arose from his wide reading of Romantic literature and were echoed in his own fluent and sonorous poems took no very concrete visual shape. Whistler asked him why he did not frame his sonnets. His pictures nevertheless had a strong influence on fashion, and even on popular taste.

LOVE'S GREETING *Yellow Room*

Oil on panel, 0.57 x 0.61, which has some vertical cracks. Inscribed on the scroll along the top: *Madonna, Dio vi fece, Dio vi guardi,/Madonna, Dio v'onori* [My Lady, God made thee, God keep thee, My Lady, God honour thee], and along the foot: *Dio v'innalzi,/Madonna, Dio vi dia le voglie vostre* [God exalt thee, My Lady, God grant thee thy wishes]; and over the three figures: *Amor Amata Amator*.

Many of Rossetti's paintings have sonorous titles which are a part of the effect, and Italian inscriptions often heighten their flavour of romance. The characters wear a vaguely medieval dress, with which the painters of the English Romantic movement signalised their regret for an age of imagined chivalry and chastity. The chastity belongs rather to Rossetti's earlier years; the languid, loose-lipped voluptuousness runs through all his art.

The impracticable instrument held by Amor is evidently of Rossetti's own design, based on the medieval psaltery.[1] He made a collection of instruments of all kinds, for the sake of their design.

This is an extension of the composition intended as a frontispiece to Rossetti's first book of translations: *The Early Italian Poets from Ciullo d'Alcamo to Dante Alighieri translated by D. G. Rossetti* (Lon-

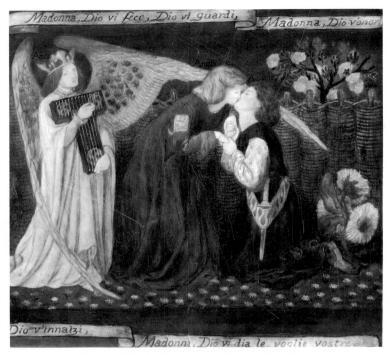

Dante Gabriel Rossetti — *Love's Greeting*

don: Smith, Elder and Co., 1861). He had recently painted two furniture panels for the Red House at Upton, newly built for William Morris, and this panel may have been planned for some similar purpose.

It soon came into the collection of William Graham, M.P., a patron who, on Rossetti's collapse in 1872, lent him in turn his two country houses in Perthshire. At his sale in London (3 April 1886, Christie's, No. 101) it was bought for F. R. Leyland, another patron of Rossetti, as well as of Whistler, and the former owner also of the *S. George* by Crivelli and *The Madonna* by Pesellino in this Museum. Mrs. Gardner attended Leyland's sale in London (28 May 1892, Christie's, No. 60), where it was bought for her, with Pesellino's panel, by B. F. Stevens. *P1w8*

[1]Horne in *Noteworthy Paintings*, pp. 81 and 85; he connected the panel with the decorations done by Madox Brown, Burne-Jones, William Morris and Rossetti for S. Martin's church at Scarborough. There are two stained glass windows there designed by Rossetti.

OTHER AUTHORITIES

Hewitt, Linda V., in *Fenway Court*, Vol. II, No. 8 (August 1969), pp. 65-72; she describes the evolution of the picture and reproduces the more important variants listed below.

Marillier in *Noteworthy Paintings*, pp. 80-81, wrote that "indubitably, though there is no actual record of this fact" it was painted for Morris to decorate some piece of furniture at the Red House. He had formerly stated, *Dante Gabriel Rossetti* (London, 1900), p. 80 and No. 134, that it belonged to Dunlop, of Bingley, Yorks. But this was probably *Roman de la Rose* (see below), a watercolour which also belonged to Graham.

Surtees, *Dante Gabriel Rossetti . . . A Catalogue Raisonné* (1971), I, pp. 79-80, No. 126.

Waugh, *Rossetti, His Life and Works* (London, 1928), p. 100.

Variants: (1) Boston, Museum of Fine Arts, *The Early Italian Poets*, pen and black ink on paper, 0.165 x 0.134, drawing for the title page of the book published in 1861, and for the copper-plate etching which was destroyed unpublished. The lovers alone fill the space, with a background of hearts and crosses behind a rose hedge. Text as given above. (2) Boston, M.F.A., *The Early Italian Poets*, pen and brown ink on paper, 0.175 x 0.108, an earlier (?) drawing for the same design. The text used in the Gardner picture is inserted on the right side. (3) London, Tate Gallery, *Roman de la Rose*, water colour on paper, 0.343 x 0.343, signed with Rossetti's monogram and dated 1864. The two lovers hold the same pose, but Amor is on the right side. Gold background. (4) Boston, M.F.A., *Amata and Amator*, pencil on paper, 0.178 x 0.134, bust-length study on a larger scale, for the heads and hands of the lovers in either (1) above or the Gardner picture. (5) London, 1897-98, three preliminary pen drawings for the title page were exhibited at the New Gallery, No. 13.

1 Giuliano da Rimini — *The Madonna and Child, with SS. Francis and Clare and Other Saints* (detail)

II Giotto — *The Presentation of the Infant Jesus in the Temple*

III Simone Martini — *The Madonna and Child, with Four Saints* (detail)

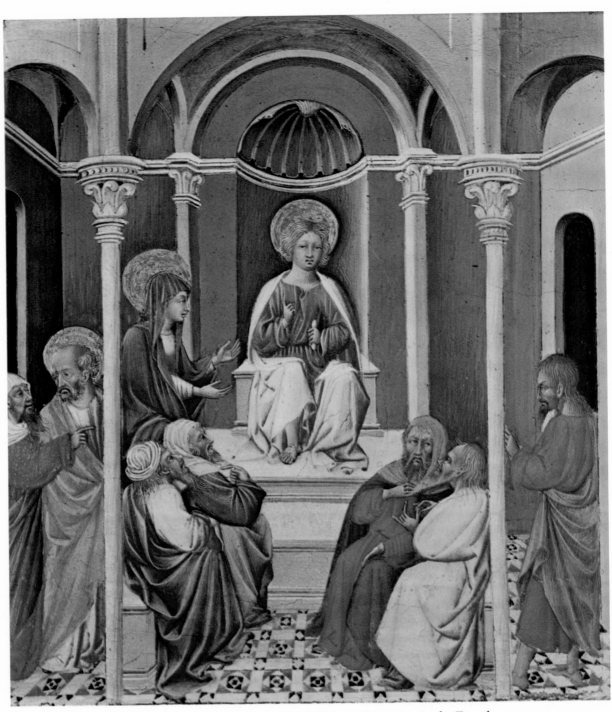

IV Giovanni di Paolo — *The Child Jesus Disputing in the Temple*

v Pesellino — *The Triumphs of Love, Chastity and Death* (detail: *Love*)

vi Pesellino — *The Triumphs of Fame, Time and Eternity* (detail: *Time and Eternity*)

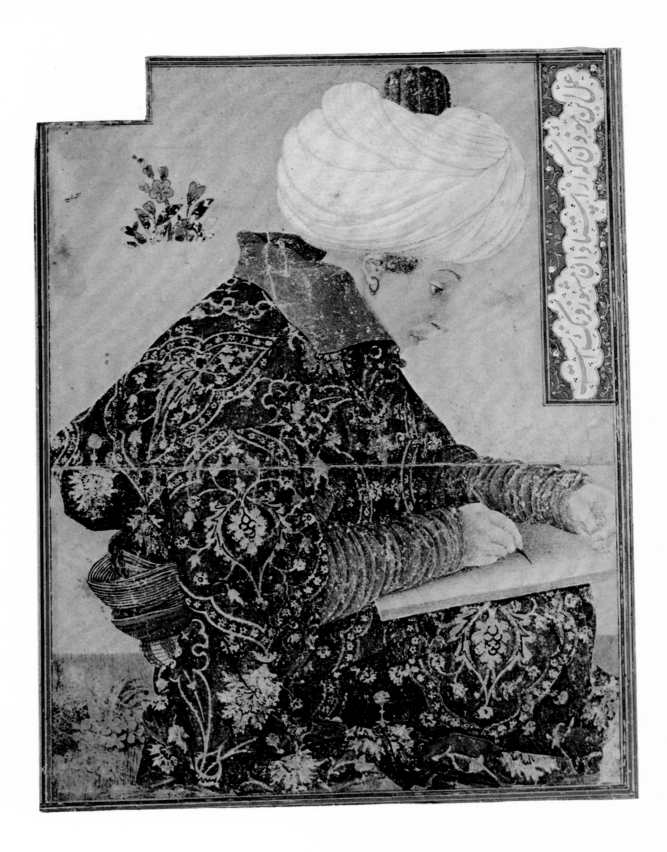

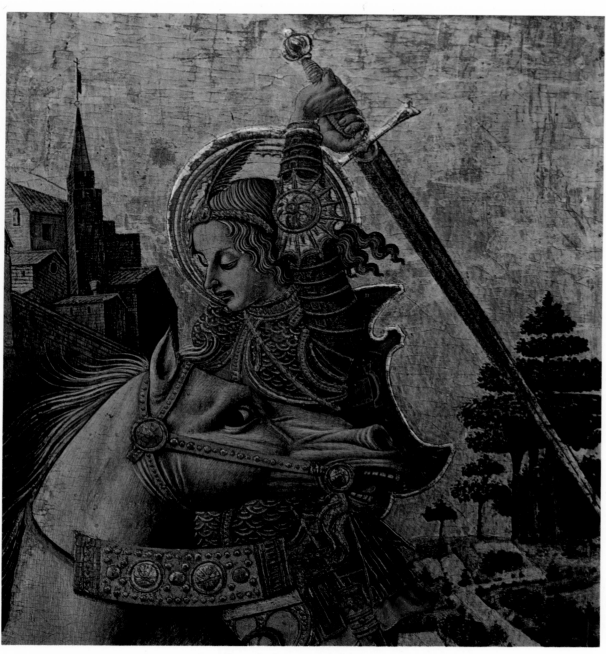

VIII Crivelli — *S. George and the Dragon* (detail)

VII Attributed to Gentile Bellini — *A Turkish Artist*

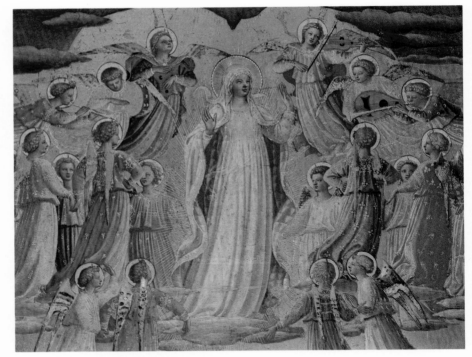

IX Fra Angelico
The Dormition and the
Assumption of the Virgin
(detail)

X Studio of Botticelli
The Nativity (detail)

XI Botticelli
The Madonna of the Eucharist
(detail)

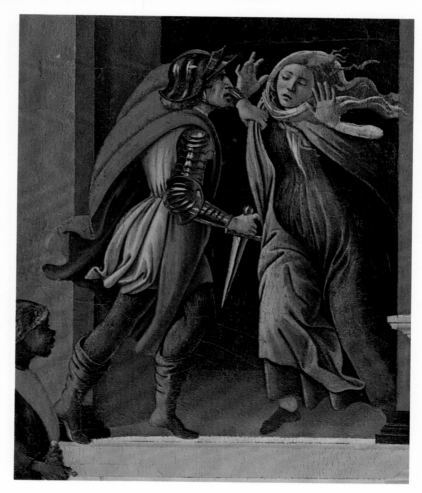

XII Botticelli
The Tragedy of Lucretia
(detail)

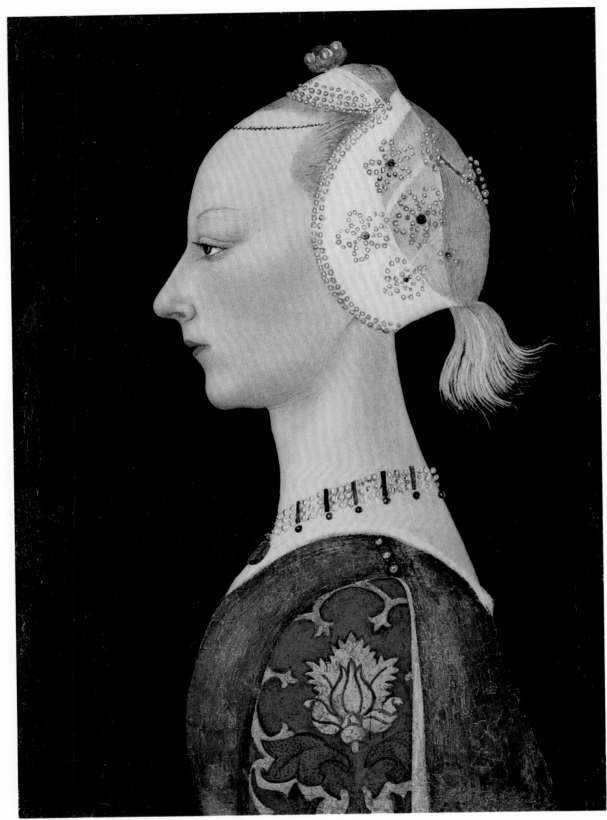

XIII Uccello — *A Young Lady of Fashion*

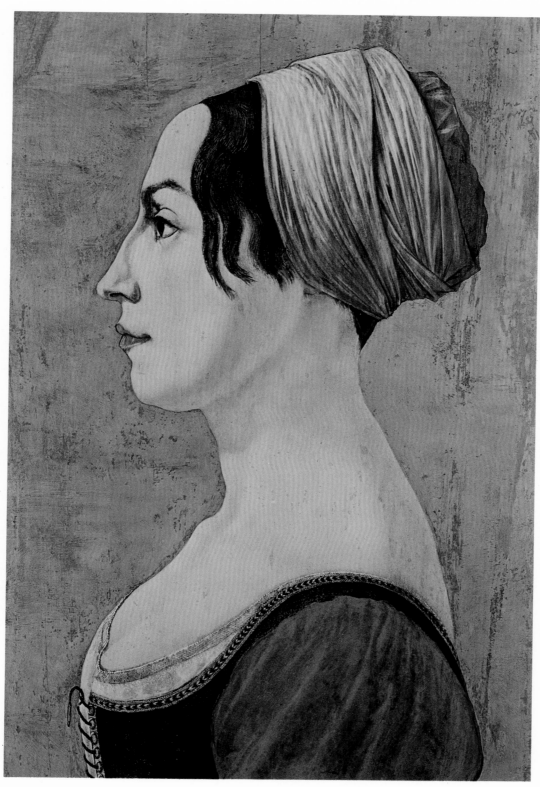

XIV Piero del Pollaiuolo — *A Woman in Green and Crimson*

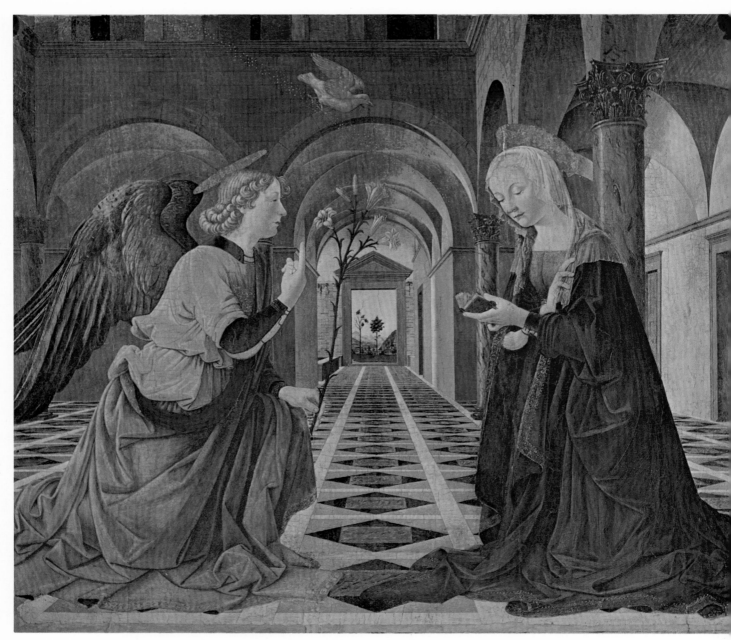

xv Antoniazzo Romano — *The Annunciation*

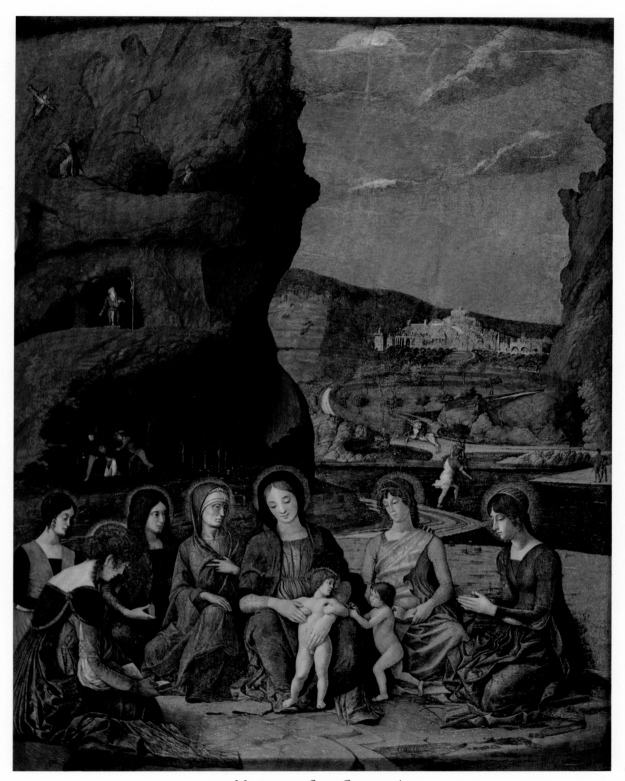

xvi Mantegna — *Sacra Conversazione*

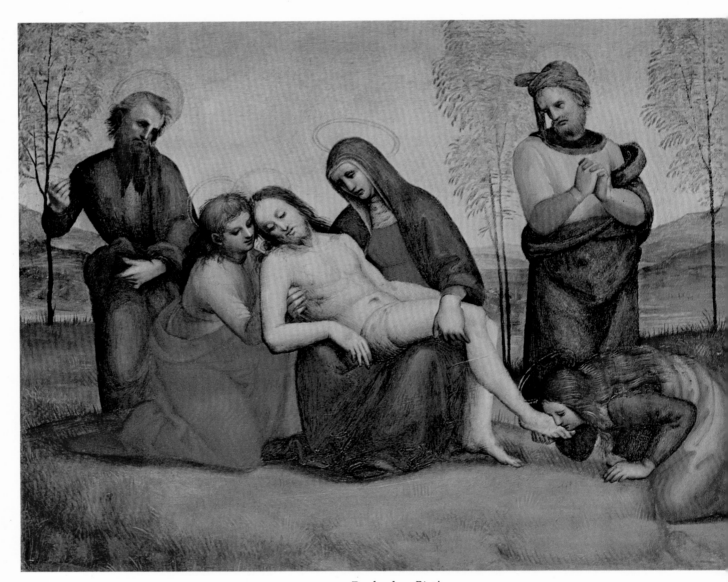

XVII Raphael — *Pietà*

XVIII Raphael — *Count Tommaso Inghirami*

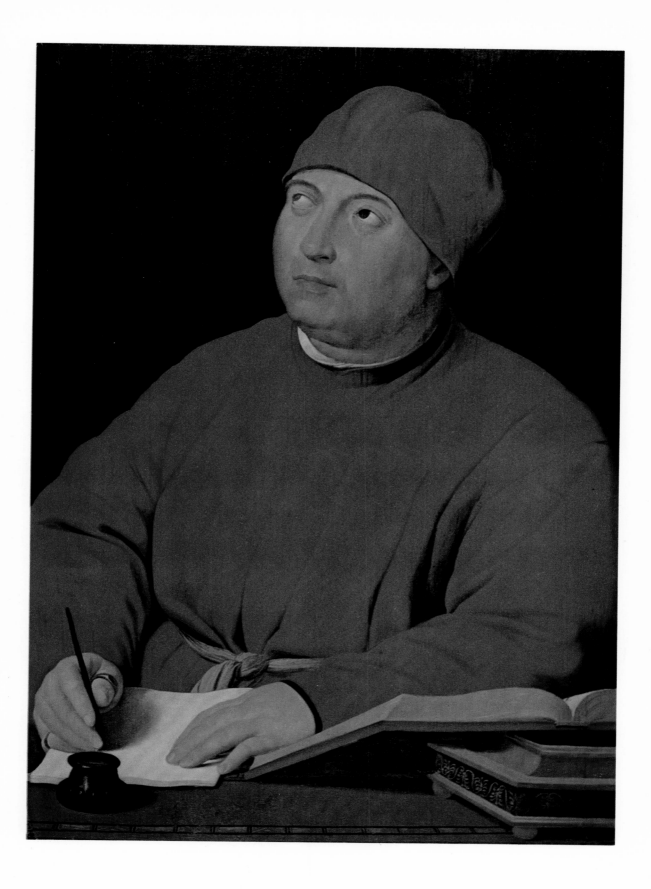

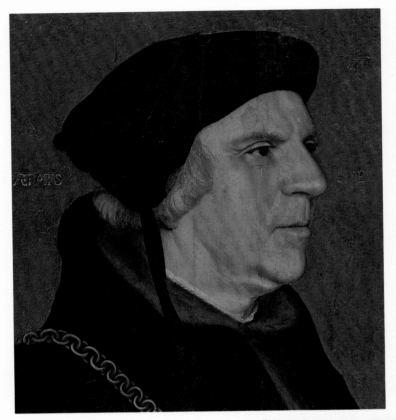

XIX Holbein
Sir William Butts, M.D.
(detail)

XX Masaccio
A Young Man in a Scarlet Turban
(detail)

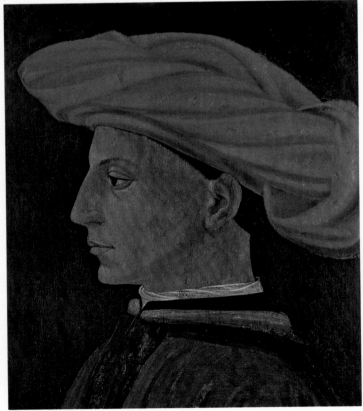

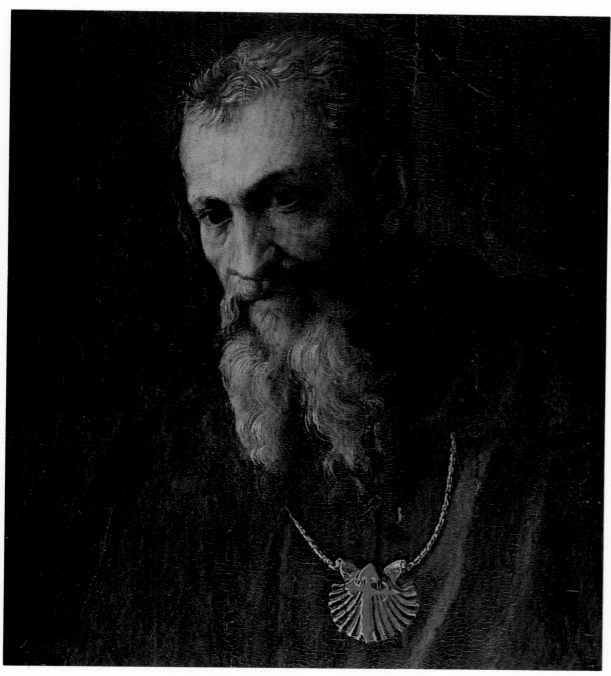

XXI　Baccio Bandinelli — *Self-Portrait* (detail)

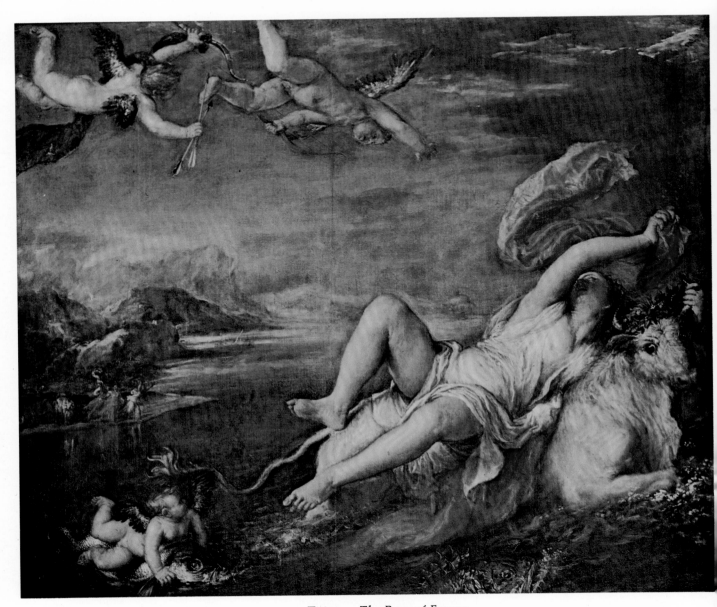

xxii Titian — *The Rape of Europa*

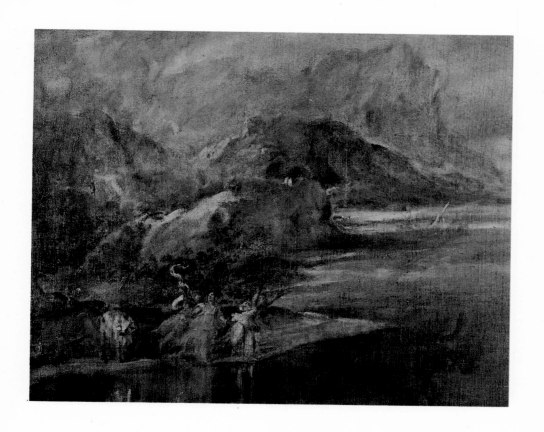

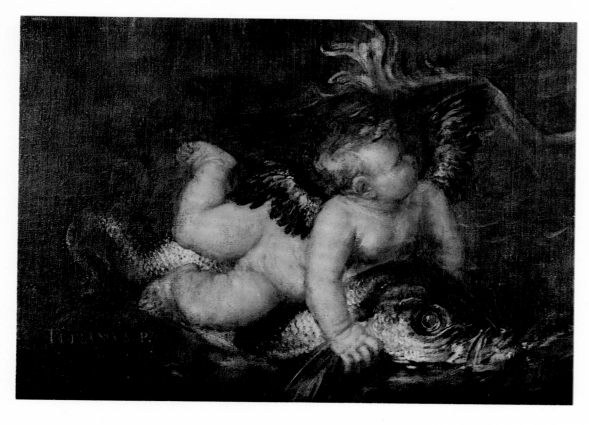

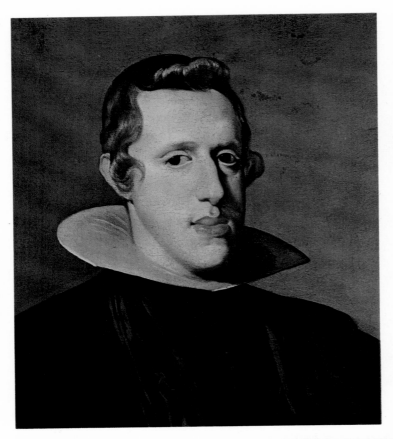

xxv Velázquez
King Philip IV of Spain
(detail)

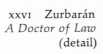

xxvi Zurbarán
A Doctor of Law
(detail)

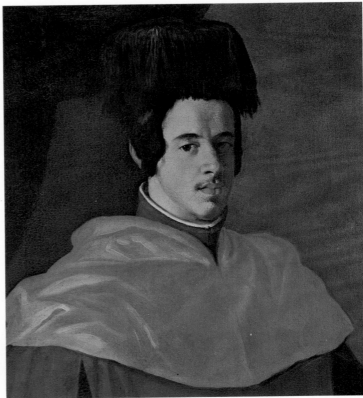

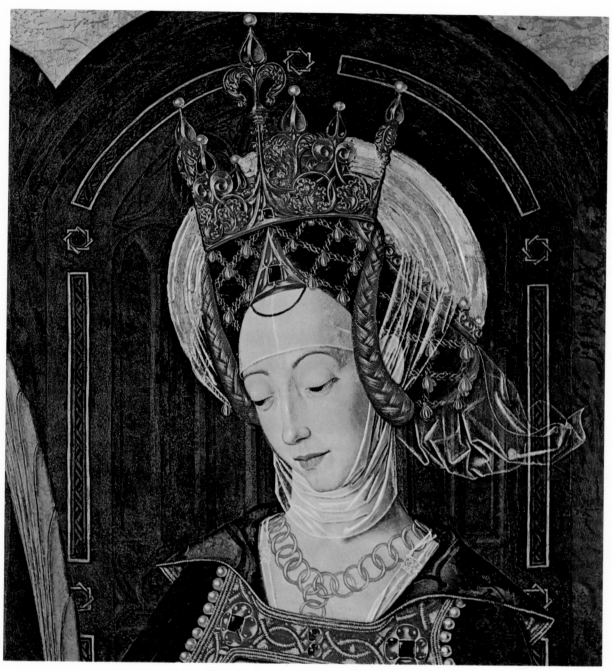

XXVII Bartolomé Bermejo — *S. Engracia* (detail)

XXVIII Rubens — *Thomas Howard, Earl of Arundel* (detail)

XXIX Rembrandt — *A Lady and Gentleman in Black* (detail)

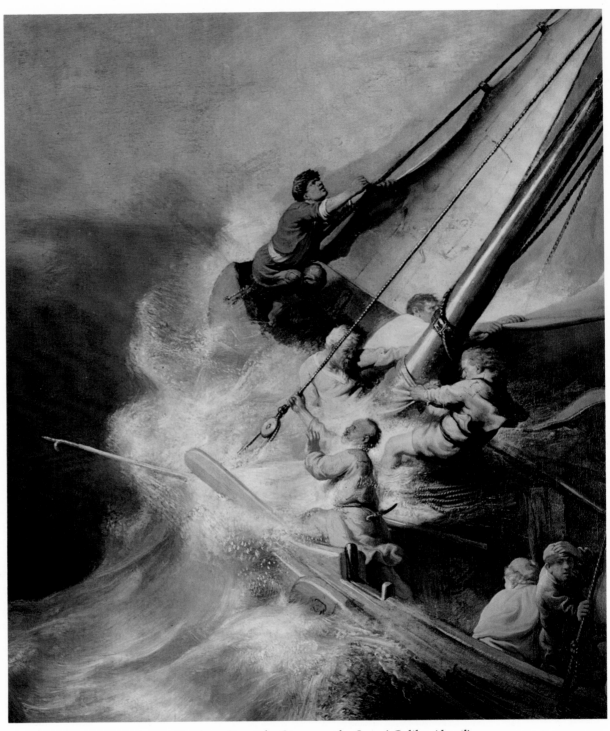

xxx Rembrandt — *The Storm on the Sea of Galilee* (detail)

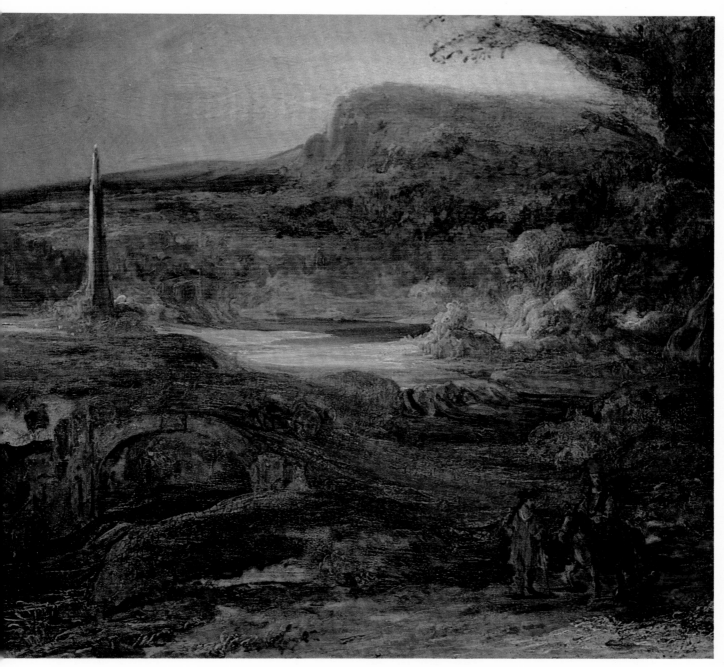

xxxi Rembrandt — *The Obelisk* (detail)

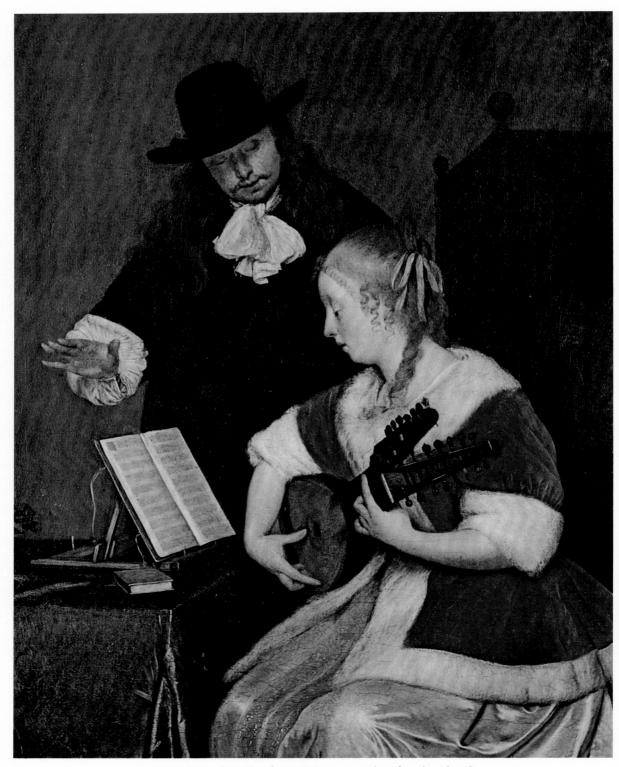

XXXII Gerard ter Borch — *A Lesson on the Theorbo* (detail)

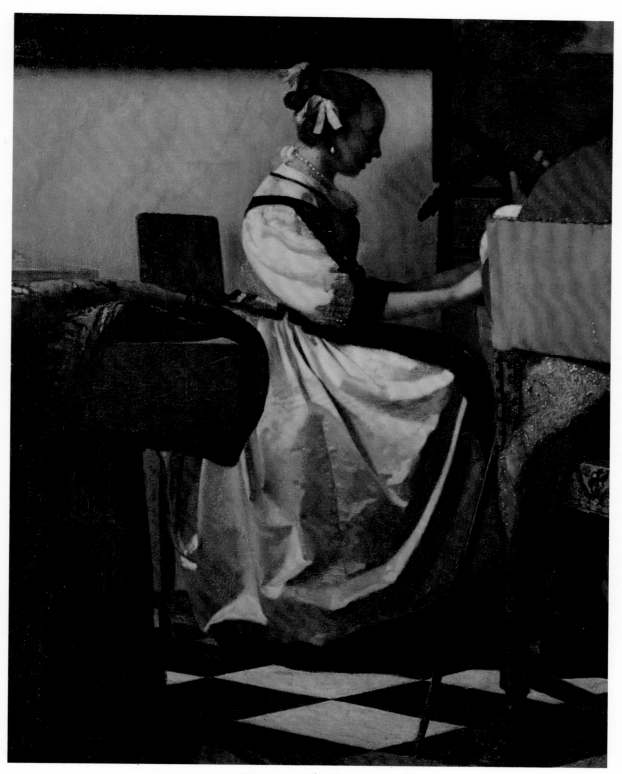

XXXIII Vermeer — *The Concert* (detail)

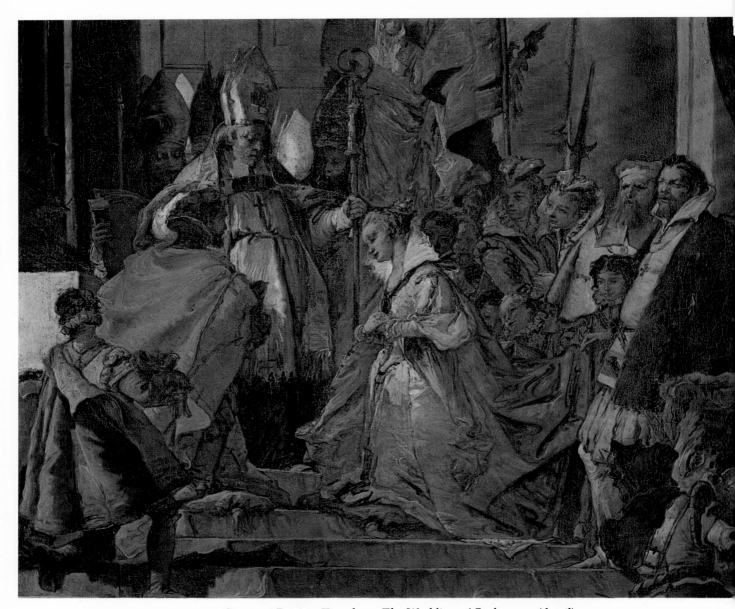

xxxiv Giovanni Battista Tiepolo — *The Wedding of Barbarossa* (detail)

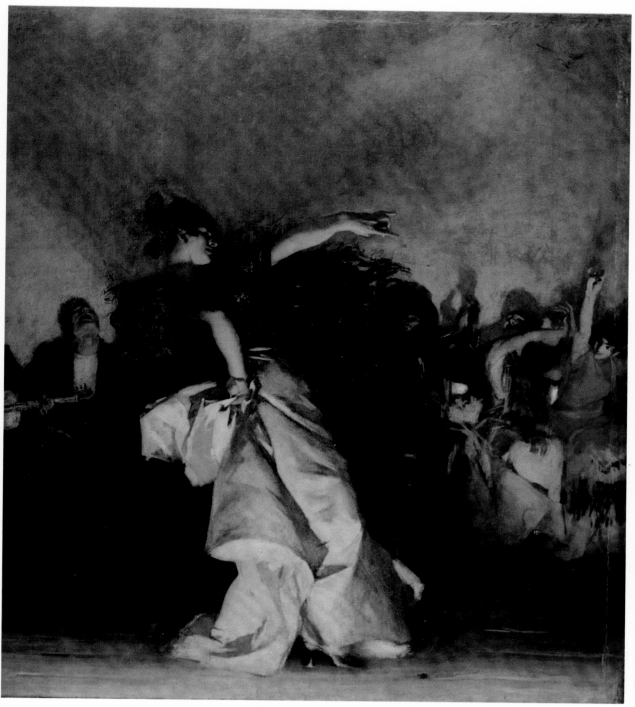

xxxv Sargent — *El Jaleo* (detail)

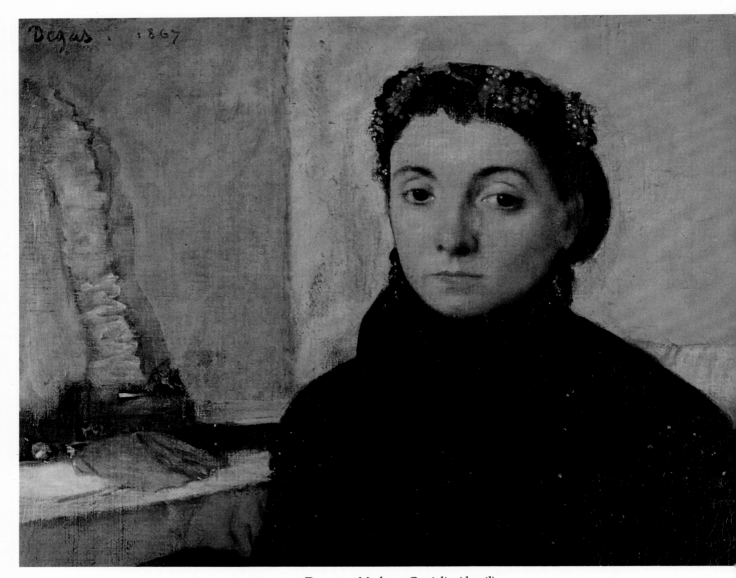

XXXVI Degas — *Madame Gaujelin* (detail)

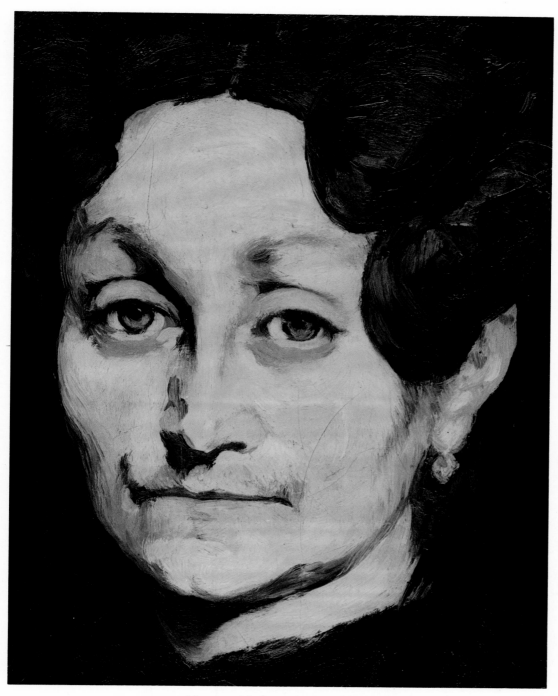

XXXVII Manet — *Madame Auguste Manet* (detail)

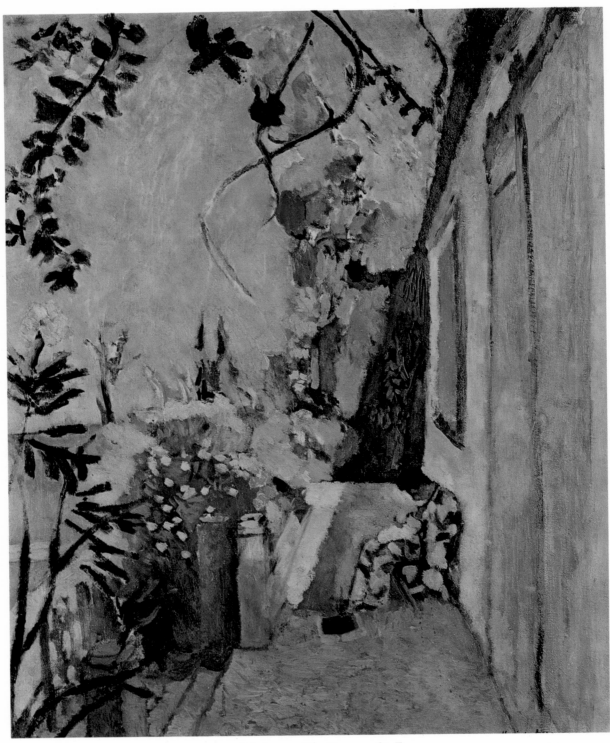

XXXVIII Matisse — *The Terrace, St. Tropez*

Peter Paul Rubens

PEETER PAUWEL RUBENS: born at Siegen, a market town near Cologne, 1577; died at Antwerp 1640.

In 1588, on his father's death, his mother brought him and his elder brother Philip back to Antwerp, whence the family had originally fled from persecution. There, after a time, Peter Paul is said to have been first the pupil of Tobias Verhaecht, a relation by marriage. About 1592 he entered the studio of Adam van Noordt, and four years later that of the fashionable Romanist Otto van Veen. He had become a Master in the Guild in 1598, but continued two more years under van Veen. From him he learned the universal passion for Italy, where he was to educate himself.

By July 1600, already with a pupil, he was in the service of Vincenzo I Gonzaga, Duke of Mantua. While in Rome, 1601-02, copying pictures for Gonzaga, he painted for the Archduke Albert, Regent of the Netherlands, a triptych now at Grasse in southern France. In March 1603 he was sent by Mantua to Spain with a caravan of gifts for King Philip III. His revolutionary *Equestrian Portrait of the Duke of Alba*, then Prime Minister, is now in the Prado. Recalled early in 1604, he painted the three great pictures of which two are now at Antwerp and Nancy, the principal fragments of the third in the palace at Mantua and in Vienna. He also painted in this Italian period a number of pictures for Genoa. In Rome again in November 1605, he lived there with his brother Philip until October 1608. In spite of the presence of famous Italian artists in Rome, he was commissioned to paint the great altarpiece for S. Maria in Vallicella, of which the best version is now in Grenoble.

Returned to Antwerp, he was appointed Court Painter to the Archduke in 1609; but he preferred to Brussels the wider society of Antwerp. Here he married the same year Isabella Brant, who was to bear him a daughter and two sons, and to die in 1626. Here he organised a manufactory of painting, according to custom but upon an unprecedented scale, and built himself a palace. Virtually the whole Flemish school was now organised by him, until every great church in Flanders was filled with decoration of his design. The majority of his commissions were executed by pupils from his small sketches and finished, in different degrees, by his hand. After 1621 his art became a feature of the courts of Europe. Above all, for the French Queen Mother, Marie de Médicis, sister-in-law of Gonzaga, he undertook the decoration of two halls in her Luxembourg palace in Paris. He was in Paris in 1622 to arrange the details, and in 1623 and 1625 to set up

and finish himself the first twenty-one canvases, now in the Louvre. The majority of the sketches are at Munich. Of the second series, never completed, several designs exist and two canvases, painted 1630-31, are now in Florence.

After the death of Albert in 1621, Rubens soon became the trusted advisor of the Archduchess Isabella, who remained as Governor for Spain. Her portrait by Pourbus is in the Dutch Room. For her Rubens did many sketches and the full-scale oil cartoons now in the Ringling Museum, Sarasota, for eight huge tapestries. But Flanders was bleeding to death, and Rubens became Isabella's principal agent for peace. He was employed first in vain attempts to renew the truce with the United Provinces, and then in the reconciliation between Spain and England, whose entry into the Thirty Years' War he stopped in the teeth of Richelieu. It was in this cause that he started for Spain via Paris in July 1628. In Madrid the young Velázquez (*q.v.*) was detailed to entertain him. The King constantly visited his studio, and he was frequently closeted with the minister Olivares. His equestrian portrait of King Philip IV was later burnt; but he brought back heads of the King and of Queen Elisabeth, daughter of Marie de Médicis, from which assistants made the pairs of three-quarter length portraits now in Munich and in Leningrad. Philip sent him as Secretary of his Privy Council for the Netherlands to King Charles I in London, whom he persuaded to the exchange of ambassadors and the opening of negotiations for peace. He was royally entertained in London, and returned to Flanders in March 1630 with an English knighthood, a Cambridge degree and a commission for the great ceiling in Whitehall. Peace between England and Spain was proclaimed before the end of the year. For Isabella he painted in 1632 the great S. Ildefonso triptych now in Vienna. He continued to work vainly for peace with Holland until Isabella's death in December 1633.

He had married 6 December 1630 the young Helena Fourment, considered the beauty of Antwerp, by whom he was to have six more children. In 1635 he bought the estate of Steen, where his landscape was perfected. Yet the volume from his studio did not decrease. Antwerp employed him and a host of assistants on the decorations which greeted the new Regent in April 1635. The Cardinal Infante himself commissioned new portraits, and Philip IV ordered an endless series of mythologies. No less than 112 pictures left Antwerp for the palaces outside Madrid in March 1638. In that summer the painter was already crippled with gout. The Regent kept him at his easel, with more canvases for Spain, to within a few days of his death.

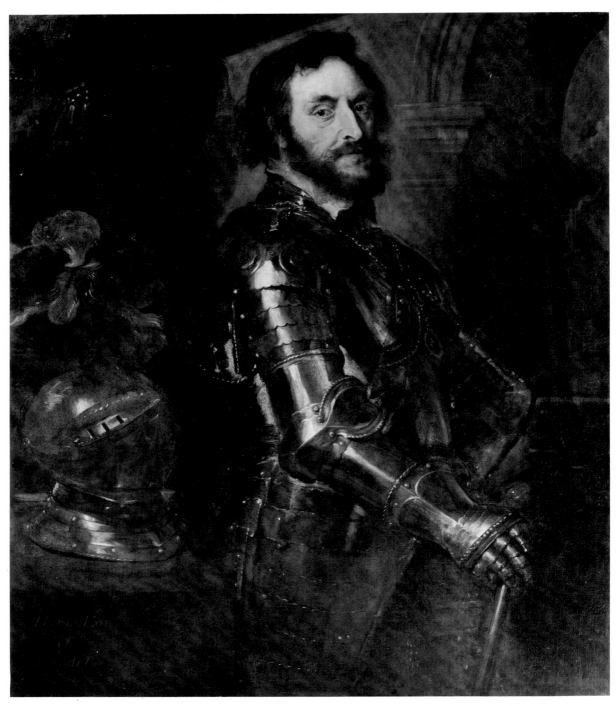

Peter Paul Rubens — *Thomas Howard, Earl of Arundel* (SEE COLOUR PLATE)

Rubens is one of the most richly endowed characters of history. He could endure equally in the saddle or in the studio; he grasped the secrets of politics as readily as those of paint; he charmed with his address even King Philip IV, who hesitated before receiving dispatches from a painter. His voluminous correspondence, in three languages but preferably in Italian, shows acquaintance with the science of his day and with Latin literature. The letters that have survived are only a fraction of what he must have written. Contemporary pedantries, for the sake of which he incorporated fashionable antiques in his pictures or listened to Tacitus while visitors watched him paint, were as much grist to his mill as the splendours of courts and country from which he drew the real colours of his art.

This was as richly endowed as his personality. His dexterity in rendering appearances enabled him to incorporate in it both the largest piece of nature and the greatest variety of ideas that any painter but Titian (*q.v.*) has achieved. A keen man of business, spending the wealth he acquired splendidly, he was yet humble enough to spend days in the copying of older pictures he admired. He drew from Michelangelo in Rome and from Annibale Carracci. His paintings are full of references to the Roman-Italian tradition. They are always strongly sculpturesque, the plasticity of his figures and the depth of his space always forcibly asserted, even among the softer shapes of his last years. His line grew more fluent and rhythmic almost to the end. He copied from Titian's canvases, first at Mantua, later on his second visit to Spain, with a passion for Venetian colour; and he is often described as a colourist. Colour is not separate from form. At first the plastic element is dominant in Rubens' pictures, often combined with forced oppositions of light and shade reminiscent of Caravaggio; the prominent outlines are reinforced by startling reflections within the contours. The great triptych, *The Raising of the Cross*, now in Antwerp cathedral, painted 1609-10, is the climax of this muscle worship. From then the sharper definitions of form gradually vanish in a growing luxury of atmosphere. His palette, from being the simplest, becomes the most complex of all. While his broken colour and rich impasto, his grasp of form and breadth of design show his debt to the Italian tradition, the range and translucence of his tones and the technique of his panels prove him the heir of a long line of Flemish painters.

Flemish too is the animal pitch to which he brought the paganism of the Italian Renaissance. The mere physical exuberance shown in his *Self-Portrait* at Munich explains why his Virgin is as much a goddess of plenty as his Venus, why his dead Christ represents before anything the spending capacity of man. It is when he applies this spirit to landscape that he strikes the most modern note. Rubens' sympathy with tillage and pasture, his knowledge of their light and colour anticipate the nineteenth century. His historical position is unique. Born the year after Titian died, his first patron the house which had employed Mantegna, Bellini, Titian and Tintoretto, he links the Italian Renaissance to the art of seventeenth and eighteenth century Europe.

THOMAS HOWARD, EARL OF ARUNDEL
Dutch Room

Oil on canvas, 1.222 x 1.021 (nineteenth century additions to the top and sides were removed in 1947). The inscription *Thomas, Earl/of/Arundel* is not original. It may be an addition of the same date. Other surface additions, of uncertain date, were removed in 1947, when the canvas was relined and the painting cleaned: especially a crimson overpainting which had concealed the blue and white of the ostrich plumes on the helmet. The original paint is generally in good condition, though very thin in all the shadows. The blue sash is much worn.

The sitter rests his right hand on the gold baton of the Earl Marshal of England, a hereditary office bestowed on him eight or nine years before, in 1621. This explains the armour that he wears and the helmet with the blue and white ostrich plumes which rests on the table covered with a crimson cloth. His younger contemporary Clarendon wrote of Arundel that "he had nothing martial about him but his presence and looks." Rubens' sitters, however, are usually endowed with his own vital energy and sense of splendour. This composition continues in all its elements the portraiture of Titian, whose work Rubens had just been studying for many months in Madrid. A considerable modification in his style resulted, and this may be one of the first pictures painted with the full richness of his last decade. Via Brussels and Antwerp, Rubens had been sent by King Philip IV of Spain to King Charles I of England to begin negotiations for peace between the two countries. He arrived in London 5 June 1629, and departed 23 March 1630. It is generally assumed that this portrait was painted in London.

His sitter, Thomas Howard (1585-1646), second Howard Earl of Arundel and Earl of Surrey, would have been Duke of Norfolk but for the attainder and execution of his grandfather, the fourth Duke. The Dukes of Norfolk were the premier Dukes of England, and their enormous power had made them seem dangerous to the Tudors. Thomas Howard's

own grandson was to be the fifth Duke. Meanwhile James I restored to him the titles and precedence of the Earls of Arundel, inherited from his grandmother, and the office of Earl Marshal hereditary to the Dukes of Norfolk. In 1606 he married Lady Alethea Talbot, heiress to the earldom of Shrewsbury, the oldest not merged in a greater title. In 1611 he was created a Knight of the Garter, whose badge in its small form, "the lesser George," he wears in this portrait on a gold chain, together with the blue sash. The Earl and Countess enjoyed a great position at court, and Arundel became the favourite adviser of the heir to the throne, Prince Henry. On this prince's death his fortunes declined; he had nothing in common with the Duke of Buckingham, the upstart favourite of Prince Charles. One of King Charles' first acts was to send him to the Tower, and this arbitrary detention of a conservative Royalist caused one of the first quarrels between King and Parliament. Later, after Buckingham's assassination in 1628, Charles made use of Arundel's services, sending him on a mission to the Emperor in 1636 and against the Scots as General in Command in 1638. Neither mission was successful. In 1641, as Lord High Steward, he presided over the fatal trial of the Earl of Strafford, Charles' one great minister. After that he retired from public life, escorting Marie de Médicis to France and returning to England only for a brief visit in 1642. He took no part in the Civil War, though contributing a very large sum to the Royalist cause. He died in Padua. Interested in the development of the New World, he had been one of the council appointed in 1620 for the plantation and colonisation of New England.

Today he is best remembered as one of the most famous of English connoisseurs. His wife seems to have been the more interested in painting; but the Earl was the first to form a great collection of antiquities after the manner of the European continent, where he travelled frequently and where he sent his sons to be educated. The famous "Arundel Marbles," Greek and Roman sculptures and inscriptions, published during his lifetime by John Selden, are now mostly in the Ashmolean Museum at Oxford, the bust of Homer in the British Museum. He made a great library, from which the manuscripts, given to the Royal Society, are also in the British Museum.[1] Rubens himself was a classical scholar and an avid collector of marbles and cameos. He was a great admirer of Arundel.

Concerning this portrait there is no documentation. We know only that Rubens implied in a letter of 8 August 1629 to his friend and regular correspondent Pierre Dupuy, Keeper of the Royal Library in Paris, that he had seen the Arundel collection in London.[2] If this portrait was commissioned about then, Rubens would still have had nearly six months before him in England. He had, however, besides the work of his mission, which was not an easy one, to paint as a gift to Charles I the large canvas in London, *Minerva Protects Pax from Mars*. Painted probably in London from a *modello*, certainly in at least two stages and with the aid of many preliminary drawings, this must have taken a long time.[3] It must have been in London that Rubens painted in oils the bust portrait of Arundel in the National Portrait Gallery, London, which is evidently a sketch for the Gardner picture.[4] The almost-profile portrait bust of Arundel in the London National Gallery seems likely also to have been done in London at this time.[5] Finally, there is the quite elaborate brush drawing on paper, that is now at Williamstown, for the whole composition of Mrs. Gardner's portrait. All this, together with the wholly mature quality of the painting, gives support to the view of Hymans that the Gardner portrait was painted as late as 1638.[6] The compiler believes that it was painted at least some years after Rubens' return to Antwerp.

"The picture of the Earle of Arundell, upon cloth" is No. 97 in a list of pictures in Rubens' studio after his death.[7] This, however, is most likely to have been one of the London bust portraits. It seems unlikely that the Gardner portrait was not commissioned by Arundel, or Lady Arundel, and delivered. It first appears in history when it was engraved in 1763. It then belonged to the first Greville Earl of Warwick. From the fifth Earl it was bought by Colnaghi, who sold it to Mrs. Gardner through Berenson in March 1898. P21s15

[1]Hervey, *The Life of Thomas Howard Earl of Arundel* (Cambridge University, 1921); she described the picture, p. 282.

[2]Magurn, *The Letters of Peter Paul Rubens* (Harvard University, 1955), pp. 320-21.

[3]Martin, *National Gallery Catalogues, The Flemish School* (1970), pp. 116-25.

[4]Piper, *Catalogue of the Seventeenth-Century Portraits in the National Portrait Gallery* (London, 1963), p. 15; he considers it a sketch for the Gardner portrait, and dates it 1629.

[5]Martin, *op. cit.*, pp. 203-05; he suggests that this was left unfinished by Rubens, that it may be part of an intended double portrait and that it shares with the National Portrait Gallery bust portrait the probability of having been No. 97 in Rubens' posthumous inventory.

[6]Hymans in *Noteworthy Paintings*, pp. 222-23.

[7]*Catalogue of the Works of Art in the possession of Sir Peter Paul Rubens at the time of his decease* (1839). This was privately printed for Dawson Turner from an English *ms.* sent from Antwerp to London about 1640. The inventory numbers are the same as those

in a catalogue printed in French with a view to an auction sale which was never held.

OTHER AUTHORITIES

Burchard and d'Hulst, *Rubens Drawings* (1963), pp. 263-64. They dated the Williamstown sketch and the London National Portrait Gallery bust portrait London 1629-30; they thought that both were done in preparation for the Gardner picture.

Goris and Held, *Rubens in America* (1947), p. 26, No. 6.

Oldenbourg, *P. P. Rubens* (*Klassiker der Kunst*, 1905), pp. 466-67; he wrongly identified the sitter as Count Heinrich van den Bergh.

Rooses, *L'Oeuvre de P. P. Rubens* (Antwerp, 1890), IV, p. 128, No. 890, and in *Noteworthy Paintings*, pp. 220-22.

Smith, *A Catalogue Raisonné of the Works of the most eminent Dutch, Flemish and French Painters*, II (London, 1830), p. 307, No. 1128.

Waagen, *Treasures of Art in Great Britain* (London, 1854), III, p. 213.

Exhibited 1818, London, British Institution, No. 47. 1857, Manchester Art Treasures, No. 107. 1866, South Kensington, First Special Exhibition of National Portraits, No. 723. 1871, London, R.A., Old Masters, No. 158. 1889, London, R.A., Old Masters, No. 169.

Engraved by James Basire as frontispiece to *Marmora Oxoniensia*, 1763, bust only, 11⅝ x 9¼, line; by E. Scriven as plate to Lodge, *Portraits of Illustrious Personages of Great Britain* (folio ed.), 1817, whole picture, 7¼ x 5¾, "drawn by W. Hilton," stipple; and by H. Robinson for the same book (8vo ed.), whole picture, 5⅛ x 4⅛, stipple.

Versions: (1) Williamstown, Mass., Sterling and Francine Clark Art Institute, a study by Rubens for the whole composition, brush and brown ink with some carmine, heightened with white pigment, on paper, 0.460 x 0.355. Glück and Haberditzl, *Die Handzeichnungen von Peter Paul Rubens* (1928), No. 178. (2) London, National Portrait Gallery, No. 2391. See notes 4 and 5 above. The picture is now widely accepted as a study for the Gardner portrait. It seems to be faintly different in the pose of the head and quite different in execution. Given the considerable variations in Rubens' handling of paint, the attribution to him of the bust portrait would seem to imply that it was done first, the sketch composition after and perhaps later, the full picture considerably later. (3) Greystoke Castle, Cumberland, Mr. Stafford Howard, a copy of the whole picture, attributed to Henry Stone.

John Ruskin

See Hadley, *Drawings* (Isabella Stewart Gardner Museum, 1968), pp. 34-35.

Russian; XV Century

THE ASSUMPTION OF THE VIRGIN
Tapestry Room

Tempera on wood, 0.52 x 0.36, damaged by a long vertical crack. A raised border makes a simple frame.

Above, Christ is enthroned in a mandorla supported by two Angels. Below, the Virgin rises at the bidding of two Angels from the midst of the twelve Apostles. The background is white; the white robes of the two Angels with the Virgin are merely drawn upon this with black strokes and the few, deep colours are gained by staining over the white. The complexions are very dark.

The icon comes probably from Novgorod, where there was already in the fourteenth century a distinct school of painting, with that of Moscow one

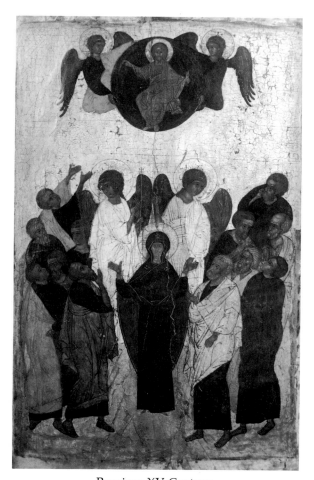

Russian; XV Century
The Assumption of the Virgin

of the two most important in Russia. Greek icons from Constantinople were imported in great numbers, and the early Russian painters modelled themselves closely on the best Byzantine tradition.

The panel was given to Mrs. Gardner 22 August 1922 by Thomas Whittemore (1871-1950), who was Research Fellow and Keeper of Byzantine Coins at the Fogg Art Museum. A portrait drawing of him by Sargent is in the Macknight Room. P19w23

Alonso Sánchez Coello

Born at Benifayró, near Valencia, in 1531-32; died in Madrid 8 August 1588.

He was taken as a child to Portugal, and it was the Portuguese King Juan III who sent him about 1549 to study in Brussels under Mor (q.v.). When Mor was sent to the court at Lisbon, Sánchez returned with him, about 1550. For the King and Queen he painted an altarpiece for the church of the Madre de Dios there and in 1554 the portrait, now in Brussels, of their daughter-in-law *Juana of Austria*, subject of the later portrait attributed to him below. Juana's husband died that year, and she returned to Madrid. Sánchez followed. Mor was also at the Spanish court; but, after he had left in 1558, Sánchez became the favourite painter of King Philip II, who settled in Spain in 1559. The King came to frequent his studio, to call him his "dear Portuguese son" and to commission of him an endless series of pictures, of which many have been destroyed by fire. In 1570, with Diego of Urbino, Sánchez arranged the décor for the triumphal entry into Madrid of Philip's fourth wife Anna of Austria. A full length portrait of this queen in Vienna is probably by Sánchez, though attributed there to Mor. Sánchez' half-length portrait of *King Philip II* in Madrid is believed to have been painted at this time. In 1574-77 he finished the altarpiece begun by Diego for the church of S. Cruz, and after this painted many others alone: in 1578 *The Mystic Marriage of S. Catherine*, in 1582 the *S. Sebastian*, both signed and dated and now in the Prado Museum. Throughout his career in Madrid the huge mausoleum-monastery-palace of the Escorial, outside Madrid, was being built; and for this Sánchez painted eight pairs of *Saints* in 1580-82. In 1580 the Emperor of China had received four pictures by Sánchez: an *Immaculate Conception*, an equestrian portrait of *Emperor Charles V* and two portraits of *King Philip II*, one on horseback, one standing.

In the portraiture which has given Sánchez an international standing he owes much to Mor. He understood the Fleming's severe characterisation, his sharp clear method of painting, and followed him successfully in his earlier portraits. A harder touch, which makes a more frankly decorative use of the richly figured materials and reproduces the features with fewer local modulations, still creates a splendid effect so long as the figures are substantial and boldly placed. But on the arid plateau of Madrid, in the gloom and repression of Philip's court, Sánchez' sitters grew pinched and stiff, his handling mechanical and his very canvases narrow. The bleakness was relieved now and then by the arrival of Titian's pictures, and Sánchez attempted to follow by correspondence a new master whose luxuriant imagination he could not fathom. He adapted the accessories of Venetian portraits and signed his religious pieces in Latin. But the very composition of these was a cold formality in a foreign tongue.

JUANA OF AUSTRIA, WITH (?) HER NIECE MARGARET *Titian Room*

Oil on canvas, 1.938 x 1.080, damaged by the flaking of the paint, mostly from the dresses, though Juana's left eye has suffered a little. The crimson priming, a peculiarity of Spanish oil painting still to be seen in the *King Philip IV* by Velázquez, shows naked in an inch-wide strip along the top.

Juana (b. 24 June 1535) was the youngest of the three children of the Emperor Charles V and his wife Isabella of Portugal. Thus she was sister to King Philip II of Spain. In 1552 she was married to the son of King Juan III of Portugal, Juan, Infante of Portugal and Prince of Brazil. He died in 1554. She was made Regent of Spain while the Emperor and his son Philip were in the Netherlands. Barely eighteen at the time of her appointment, she can have had little control of Spanish affairs, which are principally interesting for the quarrel between her Council of State and the Pope, whose bulls it suspended and whose summons to the Spanish bishops it countermanded. She remained the nominal head of the state until the arrival of King Philip II in September 1559. Brantôme in his *Vie des Dames illustres françoises et étrangères* devotes one of his gossiping chapters to an interview with her in the presence of the Queen, Elizabeth of Valois. He descants upon her extreme beauty, while upbraiding her for the haughtiness with which she had set her heart upon a match only with the King of France. She died at the Escorial in September 1573. Her son Don Sebastian, heir to the Kingdom of Portugal, met his death in 1578 in the battle of Alcazar-Kebir in Morocco.

Juana wears the black robe and white crêpe cap and scarf of widowhood. From the scarf hangs a

Alonso Sánchez Coello — *Juana of Austria, with (?) her Niece Margaret*

cameo with the head of her imperial father. Sánchez had painted a portrait, now in Brussels, of Juana at the age of seventeen with her hand on the pate of a black page; and Mor painted her as a widow of maturer age in a portrait, now in the Prado Museum, which very strikingly resembles the subject of this picture. The round forehead, aquiline nose and normal jaw in all three make Juana peculiar among Hapsburgs.

Margaret (1567-1633) was the youngest child of the Emperor Maximilian II and his wife Maria, elder sister of Juana. She entered a convent, after declining to become the fifth wife of her uncle King Philip.

If the child in the picture is Margaret, it cannot have been painted long after 1576, when she was brought to Spain, a date which accords well with the development of Sánchez' style. He had then quite abandoned the method of Mor and was studying to acquire that of Titian. An embrasure is cut in Venetian fashion in the background, but to reveal only a narrow strip of sky tinged with a chill mauve which is reflected in the pale flesh-colour. The cold colours and dry imitation of Venetian handling, the narrow forms and small heads, with the manner of their modelling, are characteristic of Sánchez' later portraits; but it is not impossible that this is a studio replica of a picture lost or destroyed.

Mrs. Gardner bought the portrait through Berenson in 1898 from the Marquis Fabrizio Paulucci de' Calboli at Forlì as the work of Titian. In his first letter from Fiesole of 16 February 1896 Berenson stated that it was not, as was supposed, by Titian, but in later letters, when he had twice seen the picture, he recommended it highly as his.[1] A letter from G. Cosenza on behalf of the Countess de Brazza Savorgnan to Miss Codman, dated New York, 12 November 1894, mentions the desire of the Louvre to buy the picture the summer before on the recommendation of Pierre de Nolhac and of efforts then being made to buy it for the Museum of Fine Arts, in each case as the work of Titian. *P26w15*

[1]Berenson never included it in his lists of Venetian pictures. In a letter to the compiler of 4 February 1930 he attributed it to Sánchez Coello or Pantoja de la Cruz.

AUTHORITY

San Román, F. de B. de, *Alonso Sánchez Coello* (Lisbon, 1938).

John S. Sargent

JOHN SINGER SARGENT: born in Florence, Italy, 12 January 1856; died in London 15 April 1925.

His father, FitzWilliam Sargent, had given up his medical practice at Philadelphia in 1854; his mother, Mary Newbold Singer, who sketched in water colour, was an insatiable traveller. Sargent's youth was spent in constant movement throughout Europe. In Rome he painted watercolours under Carl Welsch 1868-69; the next two winters he studied at the Accademia in Florence; and in 1874 the family moved to Paris that he might enter the Ecole des Beaux-Arts. He studied portrait painting in the studio of Carolus-Duran, whose portrait he sent to the Salon in 1879. He went also to the studio of Léon Bonnat. He exhibited at the Salon from 1877 to 1900; from 1881 also at the Royal Academy in London. In 1886 he settled in London, in the house in Chelsea in which Whistler (*q.v.*) had previously had a studio; and in a few years he was the fashionable portrait painter of England. He was elected A.R.A. in 1894, R.A. in 1897.

He visited the United States first in 1876, incidentally establishing his United States citizenship. In 1887-88 he wintered in Boston, where the St. Botolph Club held the first exhibition of his painting in America. From this moment he was unquestionably the fashionable portrait painter of the United States until the arrival of Zorn (*q.v.*). Neither man had the seriousness or the deep insight of the then scarcely recognised Philadelphian Thomas Eakins (1844-1916). The majority of Sargent's American sitters were from Boston, where he liked to paint them in their own homes. In 1890 he and Edwin Abbey undertook decorations in the Boston Public Library. Work in the Sargent Hall was not completed until 1919; but, when the ceiling was finished in 1916, Sargent began upon others in the Museum of Fine Arts, which occupied him until his death in 1925. The important part of this decorative work, for which Sargent was very little suited, was carried out in England. He spent the summer with Abbey at Broadway or Fairford, and, until her death in 1906, frequently joined the European travels of his mother. After this, as he grew less interested in portrait painting, he carried his easel far afield in the search for striking scenery, painting usually in water colour.

In June 1918 he was sent to France by the British Ministry of Information to illustrate on canvas the cooperation of British and American troops. From General Headquarters at Boulogne he went to those of the Guards Division, south of Arras, moving with the division into line. He made studies for the large

canvas, *Gassed,* now in the Imperial War Museum, London, and, after visiting various parts of the front, returned to England in October. The first series of his ceiling decorations in the Boston Museum was installed in 1921. In 1922 he painted the group, *Some General Officers of the Great War,* now in the London National Portrait Gallery. He died suddenly on the eve of a visit to Boston, intended for the installation of his second series of decorations.

In 1907 he had refused the offer of a knighthood, and in 1918 he resisted the persuasion of his colleagues to stand for the Presidency of the Royal Academy. He was genial and burly; but he was as shy of publicity as he was invariably popular, and from the social world of his earlier years he had retired gradually into a closer circle of friends and relations. He gave no thought to world affairs and scarcely more to his own. In connection with his art he was not given to contemplation. He came from Paris little affected by the artistic revolution accomplishing there. Some of his earliest and best successes, like *Hylda Wertheimer,* one of nine great portraits of Mr. and Mrs. Asher Wertheimer and their family now in the Tate Gallery (*Betty Wertheimer* is in the National Collection of Fine Arts, Washington), owe their idea to Manet; but Sargent did not consider as seriously as Manet the relation of one colour to another in his designs, nor did he care about the purity of his tints. He differed from the majority of his fellow Academicians primarily in the intensity of his vision and in the greater power of his forms. His pictures stood out from theirs by the professional ease and vigour with which his bold brushstrokes gave a presence to his sitters. His very limitations helped him to bequeath a brilliant record of the social world of his age.

He was a friend of Claude Monet, and a few compositions, like the *Claude Monet Painting at the Edge of a Wood* in the Tate Gallery, or *Paul Helleu Sketching, with Madame Helleu* in the Brooklyn Museum, share Monet's purity of colour; but he liked to explain Monet's art by his astigmatism, and he took no fundamental part in the fresh and profound scrutiny of the atmosphere which occupied his generation, or in their more scrupulous construction of form. His friend Sir Edmund Gosse described his object as "to acquire the habit of reproducing precisely whatever met his vision without the slightest previous 'arrangement' of detail, the painter's business being, not to pick and choose, but to render the effect before him, whatever it may be."

EL JALEO

Spanish Cloister

Oil on canvas, 2.370 x 3.520. Inscribed at the top on the right: *John S. Sargent 1882.* Damage to the black paint of the dancer's back and in the shadow round the feet of the man behind her was probably caused by a hot iron used in the lining of the canvas.

There is perhaps a flavour of Whistler in the subtlety and restraint of the colours, and yet Sargent is already at his boldest. This early picture has all that dexterity in creating illusions by a few great strokes of light or dark which later was turned to a more prosaic account. It is given effective purpose by the exacting study of logic in the theatrical lighting, as well as by the exciting contrasts of vertical and horizontal. Worked upon over several years, this is the painter's best composed and most imaginative picture.

It was born of two enthusiasms. In Paris the hero of his teacher Carolus-Duran was Velázquez (*q.v.*), and Sargent was prepared to share the taste for Spain and all things Spanish which had been introduced by Manet (*q.v.*). He was also keenly musical, and was to succumb to the insistent charm of the half-Arab songs and dances of Andalusia.

In the autumn of 1879 he went with the French painters Daux and Bac to Madrid, where he made free copies from Velázquez in the Prado. They rode thence through the Ronda mountains to Andalusia, stopping in Granada and Seville and eventually crossing from Gibraltar to Tangier. Sargent was back in Paris by February 1880. In the Salon of that year he exhibited a picture begun in Morocco, *Incensing the Veil* (see below), and a few portraits intervened; but drawings made in Spain suggest that before he left there he was already planning for the Salon a large picture based on the Spanish dance.[1]

El Jaleo is the name of a particular Spanish song and dance which had become increasingly popular since it was introduced at Jerez about 1870. Sargent, though he gave the picture this precise title, has constructed with careful calculation a synthetic, stylised scene, based on a compromise perhaps between an Andalusian dance-hall with its bare walls and a Paris music-hall stage presentation with its footlights. From scores of drawings, of which only a few perhaps were made in Spain, through many oil sketches, for details and for the whole composition, Sargent's most ambitious picture was worked out in time for the Paris Salon of 1882. The only (presumed) documentation consists of a date *Nov 9th* [1880?] inscribed in the wet paint of the crudest of the oil sketches and a letter from the artist to Vernon Lee of 20 November 1881: ". . . the Span-

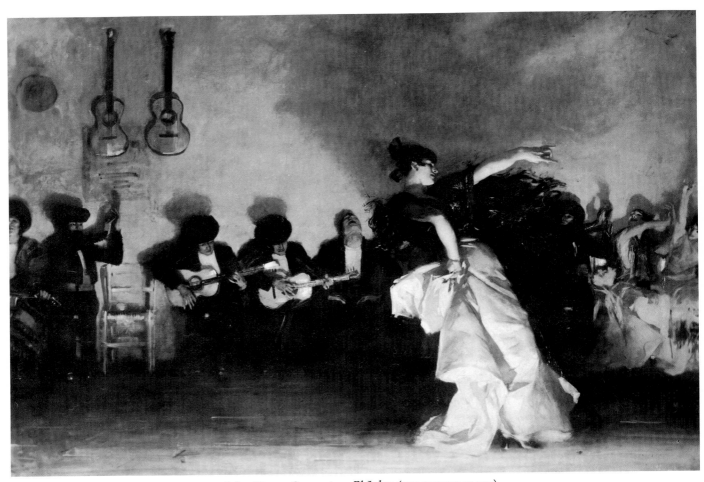

John Singer Sargent — *El Jaleo* (SEE COLOUR PLATE)

ish Dancers are getting along very well." According to the American painter Walter Gay, who lived mostly in Paris, the model for the dancer was Marie Renard, a professional who posed for him and for many well known artists, and another American painter, Kenyon Cox, lent his hands for those of the guitarist.[2]

At the Salon the picture was an instant success, alike with critics[3] and public. In the *Art Journal* Sargent was described as "the most talked-about painter in Paris." *El Jaleo* was bought by the Schaus Gallery, New York, and, after exhibition there, sold to T. Jefferson Coolidge, of Boston, later United States Minister to France. Mr. Coolidge had soon been made to promise to bequeath it to Mrs. Gardner; but he gave it to her in 1914, when she destroyed the Music Room at Fenway Court and built the Spanish Cloister. This was designed partly with a view to the picture's exhibition.

In 1919 Sargent gave Mrs. Gardner a little book into which he had pasted twenty-one pencil sketches, of which sixteen relate to the painting of this picture.[4] *P751*

[1]Ormond, Richard, in *Fenway Court* (1970), pp. 2-18; he gives the most extensive account of the picture's genesis, including the various drawings and sketches related to it.

[2]McKibbin, David, *Sargent's Boston* (1956), p. 103.

[3]Proust, Antonin, in *Gazette des Beaux-Arts*, XXV (1882), p. 551: "reveals the most remarkable qualities of observation and invention. Mr. Sargent also adds to these merits the great merit of not subordinating the impression received to the use of borrowed methods" (trans. Downes).

[4]Hadley, *Drawings*, pp. 46-47.

OTHER AUTHORITIES

Charteris, *John Sargent* (London, 1927), pp. 51 and 57.

Downes, *John Sargent, his life and work* (London, 1926), pp. 128-29.

Ormond, *Sargent* (1970), pp. 28 and 238.

Exhibited 1882, Paris, Salon; New York, Schaus Gallery; 1888-89, Boston, St. Botolph Club; 1898-99, 1900 and 1912, Boston, Museum of Fine Arts.

Studies: Two studies for the whole composition, in oil on canvas, one measuring 31¾ x 23¼, the other 32 x 25¾, were listed in the 1931 Catalogue as having been with Knoedler and Co., New York, in 1927; a third, in oil on cardboard, 0.555 x 0.67, inscribed in the wet paint *Nov 9th*, belongs (1973) to Mr. Michael Hall, New York. Two studies in oil on canvas for musicians are in the Fogg Art Museum. A study in water colour for the dancer was with the Hirsch and Adler Galleries, New York, in 1970. There is a very large number of drawings, mostly in pencil, in the Gardner Museum (see above), in the Fogg Art Museum, in the Metropolitan Museum, New York, and

in private collections. For a discussion of these see Ormond's article in *Fenway Court* (1970).

Etched by Bocourt for *L'Art*, 1882.

MADAME GAUTREAU DRINKING A TOAST
Blue Room

Oil on wood, 0.32 x 0.41. Inscribed at the top on the right: [A] *Me Avegno témoignage d'amitié/ John S. Sargent.*

The dedication is to the sitter's mother. The daughter, Virginie Avegno, was born in Louisiana. After the Civil War, in which her father was killed, her mother brought her to Paris, where she married the banker Pierre Gautreau. She became a notorious beauty, conspicuous also for her artificial complexion and the decolleté of her splendid dresses. She was reputedly the mistress of the fashionable gynaecologist Dr. Samuel-Jean Pozzi, who was to become the owner of this panel and of the little watercolour study *Incensing the Veil.* Sargent painted Pozzi's portrait, now owned by Mr. Armand Hammer, New York, in 1881, and it has been suggested that it was through him that the artist first met the sitter.[1] In 1882-83 he wrote to his lifelong friend, Ben del Castillo: "I have a great desire to paint her portrait and have reason to think she would allow it and is waiting for someone to propose this homage to her beauty. If you are 'bien avec elle' and will see her in Paris you might tell her that I am a man of *prodigious talent*." Mme Gautreau would only sit at her country house Les Chênes Paramé in Brittany, where Sargent found her in every way a difficult subject. He made a number of sketches, and the full-length standing portrait, now in the Metropolitan Museum, proceeded with painful slowness. In this she is seen equally in profile, but from the other side. Owing to the innumerable overpaintings Sargent began a replica, now in the Tate Gallery, London (Richard Ormond, however, considers that the Tate Gallery picture could "easily be a first version"[2]). But he could not finish this in time for the Salon of 1884, where he intended the "Portrait of a Great Beauty" to be his sole exhibit. He set great store by its success. It provoked — for no reason obvious today — a resounding scandal, and consequently a furious scene between the painter and the sitter's mother.[3] It is not known whether Sargent's presentation of the sketch was made before this, or afterwards in appeasement, but the former seems more likely.

Painted presumably at Paramé in 1882, the sketch must have been among the very first studies. Its colour is explained by a letter from Sargent to Vernon Lee, Nice, 10 February 1883: "Do you object

John Singer Sargent — *Madame Gautreau Drinking a Toast*

to people who are 'fardées' to the extent of being a uniform lavender or blotting-paper colour all over? If so you would not care for my sitter; but she has the most beautiful lines, and if the lavender or chlorate of potash-lozenge colour be pretty in itself, I should be more than pleased.''

From the first Mme Gautreau had refused to commission the full-length portrait. A version was in Sargent's studio in Chelsea when Henry James took Mrs. Gardner to see it and to meet the painter. This was probably her first introduction to him, 28 October 1886; and Madame Gautreau's portrait, with its history, no doubt spurred Mrs. Gardner towards the commission of her own.

The panel was bought by Mrs. Gardner through her agent Robert at the sale of Dr. Pozzi in Paris, 23-24 June 1919 (Galerie Georges Petit, No. 23; the number is on the frame). *P3w41*

[1]Mount, C. M., *John Singer Sargent* (1955), pp. 73-93.

[2]Ormond in a note of 28 August 1973.

[3]Charteris, *op. cit.*, pp. 59-65.

OTHER AUTHORITIES

Downes, *op. cit.*, p. 260.

Ormond, *op. cit.*, p. 241.

ISABELLA STEWART GARDNER *Gothic Room*

Oil on canvas, 1.900 x 0.812. Inscribed at the top, on the left: *John S. Sargent*, on the right: *1888*.

Isabella Stewart (born in New York 14 April 1840; died at Fenway Court 17 July 1924) married in New York 10 April 1860 John Lowell Gardner (see his portrait by Mancini). By her will she established the Isabella Stewart Gardner Museum "for the education and enjoyment of the public forever." An account of her life and of the history of her museum is given by Morris Carter in *Isabella Stewart Gardner and Fenway Court* (Boston and London, 1925; 3rd edition, 1973). From the time when this portrait was painted there subsisted a close friendship between Mrs. Gardner and the artist. There is a collection of nearly two hundred letters from him in the Museum, most of them concerned with Mrs. Gardner's various acts of kindness towards him, or with mutual engagements.

Mrs. Gardner stands in a black dress against a piece of red and gold brocade of the sixteenth century. This is to be seen now in the Long Gallery, below the *Lamentation* by Giovanni della Robbia. From each of the three ropes of pearls at her neck and waist hangs one of her three large rubies.

John Singer Sargent — *Isabella Stewart Gardner*

Sargent arrived at Boston from Europe towards the end of September 1887, and was paid for the picture 6 February 1888. Its painting at her house on Beacon Street must have been something of an ordeal, for Mrs. Gardner was fond of recounting that there were eight failures to satisfy her taste, and that Sargent was advised by a friend that this was the method by which fashionable ladies contrived to terminate their contracts, without remaining legally responsible for the breach. He was at the point of surrender himself when the ninth attempt proved a portrait which Mrs. Gardner maintained to be the finest Sargent ever painted; though she could not make him commit himself to the same opinion. When the picture was exhibited the same year, Mr. Gardner so much disliked the comments overheard that he had the picture withdrawn, and the public never saw it again during Mrs. Gardner's lifetime.[1] *P30w1*

[1]Carter, *Isabella Stewart Gardner and Fenway Court* (1925), pp. 104-05.

OTHER AUTHORITIES

Charteris, *op. cit.*, pp. 97 and 260.

Downes, *op. cit.*, p. 150.

Ormond, *op. cit.*, pp. 243-44.

Exhibited 1888, Boston, St. Botolph Club, with anonymous title. A request from Sargent, dated Chelsea 14 January 1897, for permission to exhibit the portrait at the International Exhibition at Venice was declined.

MISS VIOLET SARGENT *Blue Room*

Oil on canvas, 0.50 x 0.40.

Violet Sargent (1870-1955), the painter's younger sister, married Francis Ormond in Paris in 1891. Until she married she frequently acted as the painter's model. She features in *The Breakfast Table*, of 1883-84, in the Fogg Art Museum. After their mother's death in 1906, she and her large family often spent part of the summer with Sargent in the Alps. She came to Boston with him in December 1889. She stayed in Boston and at Nahant with Mr. and Mrs. Charles Fairchild, whose daughter Sally was her contemporary and intimate friend.

The rapid, barely finished sketch was painted out of doors at Nahant in the summer of 1890.[1] It was bought by Mrs. Gardner about 1914 from Mrs. Henry Brown Fuller (Lucia Fairchild). *P3w35*

[1]Mrs. Richard W. Hale (the painter's cousin) in a letter to the Director, 6 November 1929.

OTHER AUTHORITIES

Charteris, *op. cit.*, p. 278.

Downes, *op. cit.*, p. 263.

John Singer Sargent — *Miss Violet Sargent*

McKibbin, *op. cit.*, p. 113; he gives a list of pictures by Sargent in which Violet appears.

ASTARTE *Blue Room*

Oil on canvas, 0.91 x 0.60. Inscribed at the foot on the right: *To Sir Frederic Leighton John S. Sargent.*

Astarte is a Semitic goddess, the embodiment always of the female principle, fertility and reproduction, and so of sensuality. The Ashtoreth of the Bible, she assumed varying local forms in the old world and became fused with the Greek and Latin goddesses, Aphrodite, Artemis, Diana, Juno and Venus.

This is a sketch for a part of the decoration in the Sargent Hall in the Boston Public Library. The finished composition, which has many variations, follows the curvature of the ceiling and has much of the ornament modelled in plaster and gilded. The terms for the decoration were agreed upon with the Trustees of the Library at Boston in May 1890, though the contract was not signed until 18 January 1893. The first subject which occurred to Sargent was *Spanish Literature*. By 24 December 1890, however, he had already arrived at Alexandria with his mother and Emily, and soon went on to Cairo, Luxor, Philae and Fayoum to study Egyptian iconography for *The Development of Religious Thought*. The *Astarte* and two other subjects, *Moloch* and

Nut, together with a lunette, were finished by the spring of 1894 and installed in the Library in 1895. The result was a second contract for an enlarged scheme of decoration in December 1895, and Sargent was at work altogether for the Library for twenty-six years.

Sargent was elected Associate of the Royal Academy in 1894. Leighton was President, and the canvas may well have been inscribed and given in gratitude for this event. Wilfred Meynell recorded Leighton's admiration for it.[1] At the sale of Lord Leighton, P.R.A., in London (14 July 1896, Christie's, No. 340) the study was bought by Dunthorne. From him it was bought for Mrs. Gardner by Richard Davis 4 August 1896. *P3e17*

[1]Meynell in *English Illustrated Magazine,* XIV (March 1896), p. 586. The reference was kindly supplied by Richard Ormond.

OTHER AUTHORITIES

Charteris, *op. cit.,* p. 285; he wrongly dates it 1899 (?).

Downes, *op. cit.,* pp. 166-67.

John Singer Sargent — *Astarte*

John Singer Sargent — *Charles Martin Loeffler*

Exhibited March 1899, Boston, Copley Hall, Sargent Exhibition.

Versions: (1) Boston Public Library, the finished decoration upon canvas affixed to the ceiling. See above. (2) Boston Public Library, a large study in oils on canvas, 83½ x 45 in., given from the collection of Mrs. Grace Nichols Strong in 1956.

CHARLES MARTIN LOEFFLER *Yellow Room*

Oil on canvas, 0.87 x 0.62. Inscribed at the top: *To Mrs. Gardner, con buone feste / from her friend John S. Sargent.*

Charles Loeffler (1861-1935) was born at Mulhouse in Alsace; he died at Medfield, Massachusetts. He had come to New York from Paris in 1881, and became a United States citizen in 1887. He came as an accomplished violinist, and from 1885 to 1903 he shared with Kneisel the first violinist desk in the Boston Symphony Orchestra. He resigned in order to devote himself entirely to composition. In 1910 he settled at Medfield, after marrying Elise Burnett Fay.

Sargent and Loeffler were very good friends by the time this portrait was painted, Easter 1903. The inscription refers to Mrs. Gardner's birthday, on

John Singer Sargent — *Yoho Falls*

April 14th. The portrait was painted at Fenway Court in three hours and three quarters on Good Friday, 10 April 1903, and given by Sargent to Mrs. Gardner on her birthday. She celebrated this with a concert given at Fenway Court, the programme consisting entirely of compositions by Loeffler.[1] The first was his *Poème Païen*, then arranged only for two pianos and three trumpets, and performed for the first time. Loeffler remained an intimate friend of Mrs. Gardner's until her death. P1w6

[1]Carter, Morris, *Isabella Stewart Gardner and Fenway Court* (1925), p. 205.

OTHER AUTHORITIES

Charteris, *op. cit.*, p. 271.

Downes, *op. cit.*, p. 205.

Mount, *op. cit.*, pp. 132-33; he describes a meeting of Sargent and Loeffler already in 1888 and of their playing together in Mrs. Gardner's house on Beacon Street.

McKibbin, *op. cit.*, p. 50.

Exhibited 1903, 10 June-31 August, Boston, Museum of Fine Arts.

YOHO FALLS *Blue Room*

Oil on canvas, 0.94 x 1.13. Inscribed at the top on the left: *John S. Sargent 1916*.

The falls, once called Twin Falls, are in the Yoho Valley, Canadian Rocky Mountains, British Columbia. Sargent wrote from there to Mrs. Gardner 20 August 1916: "I am camping under that waterfall that Mr. Denman Ross gave me a post-card of — it is magnificent when the sun shines which it did for the two first days. & I began a picture — that is ten days ago & since then it has been raining & snowing steadily — provisions and temper getting low — but I shall stick it out till the sun reappears. Tell Mr. Ross that he was quite right, but that now there is only one fall of the 'Twins,' thanks to some landslip above —." Ten days later he wrote to his cousin Mrs. Richard W. Hale:[1] "As I told you in my first or my last it was raining and snowing, my tent flooded, mushrooms sprouting in my boots, porcupines taking shelter in my clothes, canned food always fried in a black frying pan getting on my nerves, and a fine waterfall which was the attraction to the place pounding and thundering all night.

I stood it for three weeks and yesterday came away with a repulsive picture." And he again wrote to Mrs. Gardner, from Mount Stephen House, Field, B.C., 31 August: "I have done a picture of a fantastic waterfall, somewhat the same sort of nightmare as Mrs. Sears' picture, and I am off camping to another place near here where I expect to find other awful sights — whether to your liking or not you shall decide."

He was at Boston in November and wrote, inviting Mrs. Gardner to go and see his pictures exhibited by Messrs. Doll and Richards: "The price of either of the two large oil landscapes is £500. I am quite ready for you to be disappointed in them, and not to want either, so you are free as a bird. . . ." And from Boston 26 November 1916: "Very many thanks for your cheque just received ($2500 for the Twin Falls, or Yoho Falls sounds better), and thanks for having made it the round sum in spite of wars. I shall come & see it soon. . . ." P3e7

[1]Charteris, op. cit., p. 204 (he reproduced the letter, not identifying the picture), and p. 293.

OTHER AUTHORITIES

Downes, op. cit., p. 250.

Ormond, op. cit., p. 78.

John Singer Sargent — *A Spanish Madonna*

A SPANISH MADONNA *Long Gallery*

Oil on wood, 0.34 x 0.15. Inscribed along the foot: *To Mrs. / Gardner John S. Sargent.*

A slight and hurried sketch, the picture is recorded only in the Museum archives. From these it appears that it bore the present title by 1919, and this would seem to imply Sargent's approval of it. The Virgin appears without the Child more often in Spanish art than elsewhere, owing to the great popularity of the theme of the Immaculate Conception. The background to the figure suggests the wall of a church with a window gleaming above the canopy; but this and the cushion below, like the drapery of the figure, appear to be of textile material, and the head seems contemporary. Probably this is a wax figure dressed and displayed for some festival.

The painting is difficult to date, but it may well belong to the turn of the century. Sargent went frequently to Spain from 1879 onwards; but his visit in 1895 had the special purpose of studying religious art with a view to his decorations in the Boston Public Library. P27w2

INCENSING THE VEIL *Blue Room*

Water colour on paper, 0.321 x 0.210. Inscribed in ink at the foot on the right: *à Pozzi, souvenir amical/ John S. Sargent.*

Sargent went to Spain in autumn 1879, and crossed from Gibraltar to Tangier at the very end of the year or in January 1880. He spent little more than a month in Morocco, and most of his sketches were topographical. This is the principal exception. It is difficult to discover its exact status in relation to the canvas, *Fumée d'Ambre Gris*, which he exhibited at the Salon of 1880. This is now at Williamstown, Massachusetts. The composition is virtually identical. There is nothing sketchy about the watercolour, though there is, naturally, more detail in the large canvas. Sargent's sister Emily wrote to Vernon Lee, Colby College, Maine, 18 March 1880: "John returned to Paris about a month ago as the rains had begun, & he could not continue his picture of an Arab woman which he was painting in the Patio of a little house his friend and he had hired for a studio. He sent us a little watercolour sketch to give us some idea of the picture. . . ." This was evidently not Mrs. Gardner's watercolour, as the inscription on the latter shows, and was in fact done in oil.[1] It is perhaps therefore the most likely to have been the study for the exhibited picture. Sargent himself wrote to Vernon Lee 9 July 1880: "I shall send you a photograph of a little picture I perpetrated in Tangier. It [the

John Singer Sargent — *Incensing the Veil*

photograph] is very unsatisfactory because the only interest of the thing was the colour."[2] The "little picture" may possibly have been the finished canvas. This is four and a half feet high, but Sargent had a gift for understatement, especially concerning his own works. It must by now have been finished, and Sargent may have lost interest in the smaller essays.

Dr. Pozzi was the owner also of *Madame Gautreau Drinking a Toast* (above). After his murder by a madman, part of his collection was sold in Paris, 23-24 June 1919 at the Galerie Georges Petit. The watercolour (No. 24) was bought by Knoedler and Co., and sold to Farr of Philadelphia. From him Mrs. Gardner bought it by mail 17 November 1919.

P3w33

[1]Ormond, in a letter to the Director.

[2]Ormond, *op. cit.*, pp. 22, 27, 36, and p. 95, note 43. He implies that Sargent's letter refers to the large canvas.

OTHER AUTHORITY

Downes, *op. cit.*, p. 28.

Versions: (1) Williamstown, Mass.: Sterling and Francine Clark Art Institute, canvas, 1.37 x 0.68, inscribed: *John S. Sargent Tangier*; exhibited 1880, Paris, Salon, No. 3429; (2) J. L. Ormond, Switzerland (formerly Emily Sargent), canvas, 0.80 x 0.533, exhibited 1926, London, R.A., No. 258; (3) Williamstown, *loc. cit.*, pen and black ink on paper, 0.290 x 0.198, signed *John S. Sargent*. Done by Sargent for the Salon catalogue, 1880.

BUS HORSES IN JERUSALEM *Blue Room*

Water colour on paper, 0.305 x 0.458. Inscribed in ink at the foot on the right: *John S. Sargent Jerusalem/ 1905.*

The inscription was added in 1906 (an undated letter in the Museum from Sargent to Mrs. Gardner). Sargent wrote to Mrs. Gardner from Chelsea 7 January [1907]: "It is very kind of you to have written to me of the comfortableness of the horses in their new abode — I feel that to be worthy of this promotion they ought to have had blue ribands plaited into their tails and manes, like Herod's horses in Flaubert's beautiful Herodiade. You know your sketch was done in Jerusalem, but the stalls were not Herod's but Thomas Cook's who has succeeded him in Palestine."

P3w32

AUTHORITY

Downes, *op. cit.*, p. 280.

MRS. GARDNER AT FENWAY COURT *Yellow Room*

Water colour on paper, 0.45 x 0.30.

Painted in 1903 with unusual breadth, though the face is left blank. The setting is the recently completed courtyard.

P1s4

AUTHORITY

Downes, *op. cit.*, p. 280.

THE TERRACE AT LA GRANJA *Blue Room*

Water colour on paper, 0.30 x 0.45.

The palace of La Granja (the grange or farm), at San Ildefonso near Segovia in the Sierra de Guadarramas, was built 1721-23 for King Philip V, first Bourbon King of Spain.

Sargent was in Spain again in 1902, 1903 and in 1912. He sent this watercolour to Mrs. Asher Wertheimer. The Anderson Galleries sale catalogue states that it is inscribed on the back: *To Mrs. Wertheimer, with compliments of John S. Sargent.* This is no longer visible as the paper is now pasted onto card; but this has the name *Wertheimer*, and

Bus Horses in Jerusalem

Mrs. Gardner at Fenway Court

The Terrace at La Granja

S. Giuseppe di Castello, Venice

Ponte della Canonica, Venice

Sargent in a letter to Mrs. Gardner 14 November 1920 stated that he remembered giving it to some member of the family. With the two watercolours below, *S. Giuseppe di Castello* (formerly *Ponte San Trovaso*), and *Ponte della Canonica*, it was bought for Mrs. Gardner 6 February 1920 by the painter Louis Kronberg at an auction in New York (Anderson Galleries, No. 123, *The Palace Steps, Venice*. In the catalogue the number, title and measurements are erroneously placed under a reproduction of *Ponte della Canonica*, below).

Before the sale Mrs. Gardner sent Sargent reproductions of the three watercolours from the catalogue, and he replied from Boston 1 February 1920: "Further concealment is useless, I think all three of those watercolours are pretty good — The one with the Sphinxes was done at Aranjuez [he corrected this in a letter from London 14 November 1920]." After the sale he wrote, 8 February 1920: "I am shocked at your extravagance. Think of the hundreds of poor childless girls who could have been fed and clothed on the sums that you lavish on water colours that have 'no moral lesson in their chiaroscuro.' To what excesses will a mawbid [*sic*] craving not lead a convalescent? How did you elude the vigilance of your nurses? — and what will happen if you are disappointed when the things arrive? I shall be full of anxiety for a week." *P3s21*

S. GIUSEPPE DI CASTELLO, VENICE

Blue Room

Water colour on paper, 0.306 x 0.458. Inscribed in ink at the foot on the left: *To Helen Henschel and Wolfram Onslow Ford/ John S. Sargent.*

Sargent was in Venice in 1903 and 1904. The watercolour is likely to have been painted in one of these years as the dedication shows it to have been a present to the engaged English couple before their wedding in 1904. Helen was the daughter of Sir George Henschel, first conductor of the Boston Symphony Orchestra, Wolfram a painter, son of the sculptor Edward Onslow Ford. The picture was wrongly described before as *Ponte San Trovaso*.[1] For Mrs. Gardner's acquisition of it see under the last picture. *P3s22*

[1]McKibbin, David, in *Fenway Court* (1970), pp. 22-25. He reproduces a photograph of the scene taken by himself in 1966, showing virtually no change.

PONTE DELLA CANONICA, VENICE

Blue Room

Water colour on paper, 0.458 x 0.306. Inscribed in ink at the top on the left: *To Miss Wertheimer/ John S. Sargent.*

Like the last picture, this was painted probably in 1903 or 1904. The recipient was a daughter of the London art dealer Asher Wertheimer. He commissioned, 1898-1904, a great series of portraits of his large family, mostly now in the Tate Gallery, London.

Bought by Mrs. Gardner together with the last two watercolours, above. *P3w3*

AUTHORITY

McKibbin, *op. cit.*, pp. 20-22; the writer's photograph, taken in 1966, shows the scene litle changed.

RIO DI SAN SALVATORE, VENICE

Macknight Room

Water colour on paper, 0.251 x 0.355. Signed at the top on the right: *John S. Sargent.*

The scene was previously identified wrongly as *Rio delle Due Torri*.[1]

The picture formerly belonged to Mrs. Seymour Trower, to whom Sargent is likely to have given it. Her pictures were sold at Sotheby's in 1921.

Mrs. Gardner bought it from F. W. Bayley, the Copley Gallery, Boston, 24 October 1923. *P11e14*

[1]McKibbin, *op. cit.*, p. 25; he gives the correct identification, comparing the watercolour with his own photograph.

S. MARIA DELLA SALUTE, VENICE *Blue Room*

Water colour on paper, 0.349 x 0.535. Signed in ink at the foot on the right (under the mount): *John S. Sargent.*

Longhena's church is seen across the waters of the Giudecca Canal and through the trees of the Patriarchal Seminary. See also the picture by F. Hopkinson Smith in the Macknight Room.

Sargent rarely sold his watercolours, and this was no doubt given to Mr. or Mrs. Frederick Barnard, intimate friends since at least 1885, when Sargent began to paint their two little girls in the large canvas, *Carnation, Lily, Lily, Rose*, in the Tate Gallery. Mrs. Barnard still owned the watercolour in London in 1916.

It was bought that year by Mrs. Gardner from Doll and Richards, Boston. *P3w31*

AUTHORITIES

Downes, *op. cit.*, p. 281.

McKibbin, *op. cit.*, p. 20.

Exhibited 1916, London, Royal Society of Painters in Water-colours, No. 6.

Rio di San Salvatore, Venice

A Tent in the Rockies

S. Maria della Salute, Venice

Mrs. Gardner in White

S. Maria dei Gesuati, Venice

S. MARIA DEI GESUATI, VENICE

Macknight Room

Water colour on paper, 0.379 x 0.537. Inscribed in ink at the foot on the right: *To Mary Hunter/ John S. Sargent.*

Mrs. Charles Hunter, described by Ormond as a "quintessential" London hostess, was a close friend of the painter. She was the sister of Dame Ethel Smyth, the composer and feminist.

She sold the watercolour in 1920, and it was bought from Farr of Philadelphia the same year. P11s35

AUTHORITY

McKibbin, *op. cit.*, p. 25.

A TENT IN THE ROCKIES

Blue Room

Water colour on paper, 0.392-97 x 0.532. Signed in ink at the foot on the left: *John S. Sargent.*

After working in Boston on his murals for the Public Library in 1916, Sargent spent two summer months in the Canadian Rocky Mountains, where he painted in oils the *Yoho Falls* above. Returned to Boston by November, he wrote inviting Mrs. Gardner to see his paintings exhibited there by Messrs. Doll and Richards. He mentioned in his note the price of "the tent water-colour," but it is not included in his receipt of payment for the *Yoho Falls*. P3w17

AUTHORITY

Downes, *op. cit.*, p. 286, "Camp in the Rockies."

MRS. GARDNER IN WHITE

Macknight Room

Water colour on paper, 0.423 x 0.320. Inscribed in ink at the top on the right: *To my friend Mrs Gardner/ John S. Sargent.*

Painted at Fenway Court in September 1922, less than two years before Mrs. Gardner died. Sargent wrote to her from the Copley-Plaza Hotel 6 September: "It is very nice of you to be willing to let me try a water-colour — Will you propose an afternoon of next week?" A note of 25 September refers to "your water colour" as accomplished and in the hands of Bayley for framing. P11e13

AUTHORITY

Downes, *op. cit.*, p. 279. He wrongly dates it 1924.

For the drawing by Sargent, *Thomas Whittemore*, and others, see Hadley, *Drawings* (Isabella Stewart Gardner Museum, 1968), pp. 52-54.

Martin Schongauer

Born at Colmar, a free city of the Empire; died at Breisach on the Rhine 1491. Son of Caspar Schongauer, a goldsmith of Augsburg who settled at Colmar. His religious engravings circulated in his own day throughout Europe, and he is now regarded by many as the greatest of German engravers. Of his one certainly authentic painting the picture below is an early replica.

After Schongauer

THE VIRGIN AND CHILD

Dutch Room

Oil on oak, 0.443 x 0.305. Cleaning in 1948 removed overpainting from the face of the Virgin and from her hair, where the Child's right hand was not previously visible.

This is a free copy, on a tiny scale, of Schongauer's famous *Virgin in the Rose Bower*, in the choir of S. Martin's at Colmar. There is no record of the commission for Schongauer's altarpiece; but it is dated 1473 on the back of the panel in a more or less contemporary hand. This copy was made probably in the first half of the next century. It has many variations in colour and in details of design; but it has the great interest of probably preserving in its entirety the original composition. This was reduced somewhat all round, probably about 1720.[1]

Schongauer in his painting shows clearly a knowledge of the Netherlandish technique, and of the style of Rogier van der Weyden. The technique of this diligent and delicate copyist is purely German.

Mrs. Gardner's picture was acquired in Milan in 1826 by Joseph Schlotthauer, Professor of Fine Arts at the Academy of Munich. From him it was bought about 1853 by the religious historian Dr. J. N. Sepp of Munich,[2] who had a considerable collection of old German pictures. In 1899 he sold it to Colnaghi of London. Berenson recommended it very strongly to Mrs. Gardner, who acquired it through him as an original work of Schongauer. P21w17

[1] Kurt Martin in *Studien zur Kunst des Oberrheins* (*Festschrift für Werner Noack*, Constance and Freiburg, 1958?), pp. 82-91. The latest and most thorough account of the picture, with many additional references. He suggested a date about 1540.

[2] *Ibid.*

OTHER AUTHORITIES

Baum, *Martin Schongauer* (Vienna, 1948), p. 50: "16th century."

Dodgson, C., in *Noteworthy Paintings*, pp. 236-38: an "old replica."

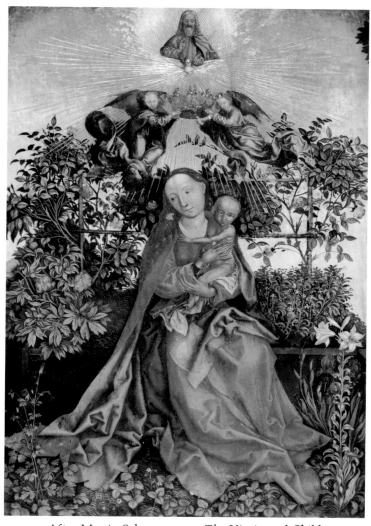

After Martin Schongauer — *The Virgin and Child*

Flechsig, *Martin Schongauer* (Strasbourg, 1946), pp. 341 ff.; he was the only writer of the last fifty years to attribute the picture to Schongauer "without doubt."

Friedländer, M. J., in *Noteworthy Paintings*, pp. 238-39: "probably a contemporary copy."

Kraus, *Kunst und Alterthum in Elsass-Lothringen* (Strasbourg, 1881); he attributed it to Schongauer, considering it later than and superior to the panel at Colmar.

Kuhn, *A Catalogue of German Paintings . . . in American Collections* (Cambridge, 1936), p. 48: "a copy."

Reber and Bayersdorf, *Klassischer Bilderschatz* (Munich, 1900), III, No. 332; they attributed it to Schongauer.

Scheibler, L., in *Repertorium für Kunstwissenschaft*, X (Berlin-Stuttgart 1887), p. 26: an imitation.

Schmidt, W., in *Repertorium*, XI (1888), p. 357: a copy, possibly Dutch.

Stange, *German Gothic Painting* (Munich-Berlin, 1955), V, p. 20: "a late copy."

Exhibited: 1886, Augsburg, Swabian Painters.

The original: Colmar in Alsace, S. Martin's church, altar to the left in the choir, panel, 2.50 high, cut at the foot to exclude the foreground and most of the edge of the robe, at the right along the prop of the hedge, at the left some inches beyond it and probably at the top, which is now arched, excluding the other members of the Trinity. The Madonna has an inscribed halo, the Child cruciform rays behind his head. His right hand appears round the Madonna's neck. The flowers are different: roses in every stage of blossom, and a variety of finches upon the hedge. The background is of plain gold and the Madonna's robe of pink, her cloak of deep scarlet.

The picture is often stated to have been originally the center of a triptych; but there is no evidence for this. It was stolen in 1971 but recovered in 1973.

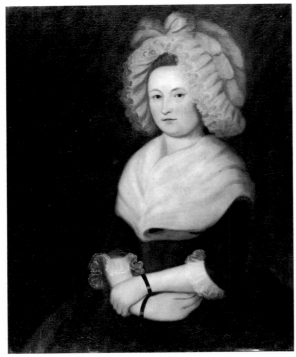

Scottish (?); 1770-1800 — *Mary Brough Stewart(?)*

Scottish (?); 1770-1800

MARY BROUGH STEWART (?) *Short Gallery*

Oil on canvas, 0.90 x 0.71.

The style is of the late eighteenth century, but the painting is perhaps a more recent copy.

Mary Brough married Thomas, second son of Andrew Stewart (died *ca.* 1765) of the Invernahyle branch of the famous Scottish clan. She was the heiress of Boghall, to which her husband added by purchase the adjoining estate of Steelend. Their fourth son James (1778-1813) emigrated to America and married Isabella Tod, of whom there is a portrait by Sully in the same room. The sitter was the great-grandmother of Isabella Stewart Gardner.

P17w33

Sarah C. Sears

SARAH CHOATE: born at Cambridge, Massachusetts, 1858; died at Goldsboro, Maine, 1935.

She married Joshua Montgomery Sears in 1877. She began to study painting some years later, probably in 1885 under Denis Bunker (*q.v.*) at the Cowles Art School in Boston; then at the School of the Museum of Fine Arts.

She painted mostly in water colour, never in oils. Her watercolours gained medals for her in several places: Charlestown 1892; Chicago 1893; Paris 1900; Buffalo 1901. By 1900 she was already interested in photography. Her portrait-photographs won wide recognition. She became associated with Steiglitz and the "Photo-Secessionists."

GLADIOLI *Macknight Room*

Pastel on dark buff paper, 0.50 x 0.43. Inscribed at the foot on the left: *Sarah C. Sears / 1915.*

Bought by Mrs. Gardner from the painter in 1915.

P11e9

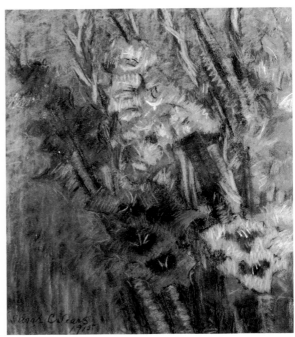

Sarah C. Sears — *Gladioli*

Jaime and Pedro Serra
See Francesc COMES

Sienese; *ca.* 1500

A HERO OF ANTIQUITY *Raphael Room*

Tempera and gold on wood, 0.860 x 0.532. Helmet, lorica and tunic skirt are all in gold, as well as the poleyns at knee and elbow. Sleeves and stockings are scarlet.

Pendant to the picture below. P16s12

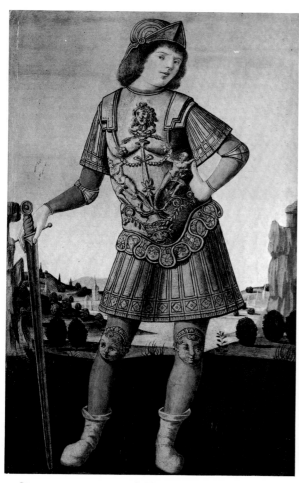

Sienese; *ca.* 1500 — *A Hero of Antiquity P16s12*

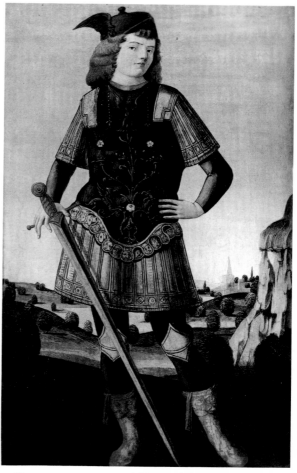

Sienese; *ca.* 1500 — *A Hero of Antiquity P16s13*

A HERO OF ANTIQUITY *Raphael Room*

Tempera and gold on wood, 0.861 x 0.531. The skirt of the tunic, the aillettes at the shoulder, and the poleyns are gilt; the lorica black, the sleeves and stockings blue-green, the buskins scarlet.

A third picture of similar style, now at Tours, seems to represent *Horatius Cocles.* There were, no doubt, several more panels in a series painted for the decoration of some palace hall. They imitate a suite which probably decorated the palace of Pandolfo Petrucci in Siena and are now scattered among six public galleries, including the National Gallery, Washington, which has two. One picture of this series, now in the Bargello in Florence, is rightly attributed by Berenson and others to the Sienese Neroccio di Landi (in collaboration, according to Berenson and others, with the "Master of the Story

of Griselda," named after three pictures now in London). Berenson,[1] who originally attributed the two Fenway Court pictures to Baldassare Peruzzi, included them (one only, but perhaps this was an error) in his posthumous lists, together with the *Horatius Cocles* at Tours, as from the studio of Neroccio. Offner[2] was perhaps nearer the mark with Francesco di Giorgio. A majority of the Petrucci series seems to have been designed by Signorelli, and Mrs. Gardner's two pictures were catalogued in the 1931 edition as "influenced by Signorelli." The influence, which is slighter here than in the more important series, may be indirect. The only certainty is that their author was consciously imitating the slightly larger and much more sophisticated pictures then in Siena.

The pair were acquired by Mrs. Gardner before March 1896. *P16s13*

[1]Berenson in *Gazette des Beaux-Arts*, XV (1896), p. 206; also *Central Italian and North Italian Schools* (1968), I, p. 291.

[2]Offner in a note in the Frick Art Reference Library (1925) attributed them to the school of Francesco di Giorgio.

OTHER AUTHORITY

Fredericksen and Zeri, *Census* (1972), p. 148; as by a follower of Neroccio.

Luca Signorelli

See SIENESE; *ca.* 1500

Simone Martini

Born in Siena 1283-85; died at Avignon 1344.

He was the pupil perhaps of Memmi di Filipuccio, whose daughter Giovanna he married in 1324 and whose son Lippo Memmi (*q.v.*) was assistant in his workshop. His career can be traced with some clarity from 1315, the date of his great *Maestà* in fresco in the Palazzo Pubblico at Siena. About 1317 he painted for Robert of Anjou the great altarpiece: *S. Louis Crowning Robert of Anjou King of Naples*, now in the Capodimonte Museum in Naples. He painted it at the court of the King, who in 1317 ordered him an annual salary of fifty ounces of gold. In 1319-20 Simone painted the large polyptych in S. Caterina at Pisa (parts are copies from the originals in the City Museum); and for S. Domenico at Orvieto a smaller altarpiece, from which come the five panels in the Opera del Duomo there, one of them signed and dated 1320. He no doubt visited both towns, but in 1321 he was again in Siena. Here he was employed intermittently by the commune as painter, architect or surveyor, while he kept a large workshop. 1328 is the date on his equestrian portrait in fresco of *Guidoriccio da Fogliano* in the Palazzo Pubblico, and 1333 that on *The Annunciation, with SS. Ansano and Julietta*, now in Florence, which he painted with Lippo for Siena cathedral. It is signed by them both. After 1335 there is a gap among his recorded activities, and his decoration of the chapel of S. Martin in the Lower Church at Assisi and the frescoes of *The Madonna and Saints* in the south transept may have been painted at this period, though they appear to be of earlier date. In February 1339 he was invited by Cardinal Iacopo Stefaneschi to the Papal court at Avignon, where from the end of that year he passed the rest of his life with his wife and brother. Of his work there in fresco only a battered mural in the cathedral porch survives. This has been detached from the underdrawing, which has thus become the most important extant example of Gothic draughtsmanship. There are small panels from Avignon at Liverpool (signed and dated 1342) and Antwerp, in Paris and Berlin. At Avignon we catch a single glimpse of his personality through his friendship with Petrarch, for whom he painted a portrait of his Laura and a frontispiece to his copy of Vergil, the latter now in the Ambrosiana Library, Milan. Petrarch boasts his acquaintance in a letter: "I have known two painters of talent, one Giotto, in high renown among the moderns, the other Simone of Siena."

These two painters were indeed the giants of the fourteenth century, but, as Petrarch perceived, their places in history are distinct. Simone was no such modern as Giotto. He was less interested in the drama of all mankind than in the refinement and sensitivity of an aristocracy. His scenes are without violence, his saints smooth and graceful, his heroes chivalrous and gay. Searching in the first place for an ideal beauty of form and movement, he translated his emotions into aesthetic terms, his line and colour expressing pathos or joy by rhythm rather than by the aptness with which they reproduce the gestures or the atmosphere of life. The figures in his frescoes have the grandeur imparted by ample frames and by firmly rounded contours; their actions are relevant and explicit, no longer half mystic, half symbolic like those of his precursors. But he never concentrated his powers, as did Giotto and many of the great realists, on obtaining sculptural force. He limited the roundness of the forms and drew in low relief, with a sensuous beauty of contour, indicating only subtle contrasts of faintly inclined planes, that he might make the utmost use of colour and of ornamentation. The colours are soft and varied, woven into rhythms tender and intricate.

With such a method he needed to make no revolution, taking the forms which Duccio had evolved from Byzantine models, formalising a technique already complex and refined. He thus arrived early at maturity, and brought to perfection in painting that Gothic style which in sculpture and architecture reached its fruition only in France, but which in the later fourteenth century permeated even Italy. His immediate influence was great. The Sienese painters followed in his footsteps for a century, and from Naples to Avignon his ideas were exploited by local imitators for a generation. In Florence they mingled with those of Giotto to colour and confuse the principles of the Renaissance.

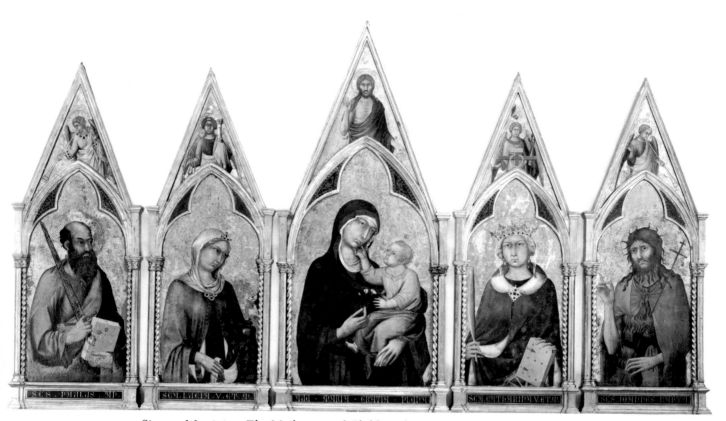

Simone Martini — *The Madonna and Child, with Four Saints* (SEE COLOUR PLATE)

THE MADONNA AND CHILD, WITH FOUR SAINTS
Early Italian Room

Pentaptych: *S. Paul, S. Lucy, The Madonna and Child, S. Catherine, S. John Baptist*; in the pinnacle over each male Saint an Angel trumpets; over the Virgin Martyrs two others display instruments of the Passion; above the Madonna the Redeemer shows his wounds.

The tempera has been transferred to modern panels, Gothic-cusped, like the originals, at the top; that in the centre, 0.990 x 0.607, the others (excluding the pinnacles, which have separate modern panels): *S. Paul*, 0.863 x 0.436; *S. Lucy*, 0.863 x 0.425; *S. Catherine*, 0.863 x 0.425; *S. John Baptist*, 0.860 x 0.428. The painting of the two male Saints is damaged. The original panel of the *S. Paul* was cracked down the centre and this has affected the right side of the face and the right hand; three inches of the painting from the foot are restored. Of the *S. John* the triangle beneath the left forearm and hand is repainted, with the tips of the fingers. The painting of the other three panels is not fundamentally damaged, but the restoration was clumsily done. The stamped patterns of the haloes are restored only with the brush. Of the frames, only the inner arches with their decorated spandrils are original.

The condition of the painting makes it difficult to estimate its quality exactly; but it has almost certainly been underestimated by several writers. This is colouring worthy of Simone, and these Virgin Martyrs have all his shapeliness, their pure features cast in a powerful oval, their bodies gently inclined to emphasise the relief. Lippo Memmi, as the ever present assistant, doubtless had some hand in the preparation and in the finishing of the panels, but a glance at his little *Madonna and Child* in the Gothic Room shows that the larger panels are the more delicate. Their rhythms are more subtly interwoven both in colour and in line. The contours are drawn in pure colour, in greens or reds, and they show, unlike those of the little panel, a complete mastery of the calligraphy of low relief.

These panels form the only large and complete altarpiece by Simone outside Italy. They are comparable with the great polyptych at Pisa, painted in 1319-20, and the arms and hands in the panels with *S. John* are almost identical in the two. These panels come from S. Francesco at Orvieto, where Simone was commissioned in 1320 to supply the altarpiece for S. Domenico, now in the Opera del Duomo there.

Mrs. Gardner's altarpiece was bought about 1860 by Cavaliere Mazzocchi[1] from S. Francesco at Or-vieto, where it was exhibited in the Opera del Duomo until 1899.[2] From his heirs it was bought by Berenson, who sold it in April to Mrs. Gardner. Her attention had been called to it by Richard Norton in 1898.
P15e4

[1] Crowe and Cavalcaselle, *A History of Painting in Italy* (ed. Langton Douglas, London, 1908), III, p. 40; they mention only "a church"; they also refer to the injured condition, mentioning in a note the "all-but obliterated St. Paul."

[2] Fumi, *Il Duomo di Orvieto* (Rome, 1891), p. 362.

OTHER AUTHORITIES

Berenson in a letter; also *Central Italian and North Italian Schools* (1968), I, p. 402.

Cecchi, *Trecentisti Senesi* (Rome, 1928), pp. 131-32.

Fredericksen and Zeri, *Census* (1972), p. 121; to Simone without qualification.

Gosche, *Simone Martini* (Leipsic, 1899), p. 25.

Gozzoli, with Rizzoli, *L'Opera Completa di Simone Martini* (1970), Pl. XVIIA, fig. 11, No. 89.

Van Marle, *Simone Martini et les peintres de son école* (Strasbourg, 1920), pp. 27-29; he suggested that the *S. John* is by Memmi. Also, however, *The Italian Schools of Painting* (1924), pp. 196-97; here he attributed *S. John* and *S. Paul* entirely to Simone, the other three panels to Lippo Memmi executing his designs.

Paccagnini in *Encyclopedia of World Art* (1964), IX, p. 503: "collaboration is clearly evident."

Perkins in *Rassegna d'Arte Senese*, I (1905), p. 75; he attributed the altarpiece to Memmi, working under the eye of Simone, or in cooperation with him.

Sirèn, O., in *The Burlington Magazine* (April 1909), p. 66.

Steinweg, in *Mitteilungen des Kunsthistorischen Instituts in Florenz* (July 1956), p. 166.

Venturi, L., *Pitture Italiane in America* (1931), Pl. LV.

Weigelt, C. H., *Sienese Painting of the Trecento* (New York, 1930?), pp. 22 and 77, note 43, Pl. 43: "the participation of the workshop is again clear, more so in the wing-panels than in the centre-piece."

C. Arnold Slade

Born at Acushnet, Massachusetts, 1882; died at Truro, Massachusetts, 1934.

At first the pupil of Frank V. Dumond in New York, he went to study at Julian's in Paris. There he lived intermittently for several years.

PONTE DELLA CANONICA, VENICE
Blue Room

Oil on canvas, 0.41 x 0.33. Inscribed at the foot on the right: *C. A. SLADE — / 12.*

Ponte della Canonica, Venice

A Gateway in Tunis

The Shore, Etaples

A Girl of Nabeul

Francis Hopkinson Smith
Venice: The Grand Canal with S. Maria della Salute

A more distant view of the bridge by Sargent is in the same room.

Bought from the painter 24 August 1915. *P3w27*

THE SHORE, ETAPLES *Blue Room*

Oil on grey pasteboard, 0.33 x 0.40. Signed at the foot on the right: *C. ARNOLD SLADE.*

Painted in 1913. Bought from the painter 24 August 1915. *P3w28*

A GATEWAY IN TUNIS *Macknight Room*

Oil on brown paper, 0.23 x 0.20.

Given to Mrs. Gardner by the painter in 1921.
 P11e16

A GIRL OF NABEUL *Macknight Room*

Oil on brown paper, 0.26 x 0.21. Signed twice in pencil at the top on the right: *C. A. SLADE* (the upper signature partly erased).

Painted in Tunisia in 1921, and bought by Mrs. Gardner from the painter 12 November. *P11e10*

John Smibert

See Joseph BLACKBURN

Francis Hopkinson Smith

Born in Baltimore, Maryland, 23 October 1838; died in New York City 7 April 1915.

In painting he was self-taught, and he was not able to give much time to it before the age of about fifty, when he was well established in his profession of construction engineer. With his partner Symington he had worked mostly for the United States Government on marine contracts, their most hazardous achievement being the Race Rock Lighthouse off Fisher's Island, New York, 1871-79. He was also a prolific writer. He painted few oils, but many watercolours.

VENICE: THE GRAND CANAL WITH
S. MARIA DELLA SALUTE *Macknight Room*

Gouache and pencil on grey carton, 0.32 x 0.59. Signed at the foot on the right: *F. Hopkinson Smith.*

Venice was perhaps the artist's favourite subject. According to the *Dictionary of American Biography,* "one summer in Venice, working ten hours a day, he painted a picture a day for fifty-three days."

 P11n35

Exhibited (?) 26 April 1880 — 3 June 1881, Boston, Museum of Fine Arts (Mrs. John L. Gardner, Jr., is recorded as lending, among others, a painting by F. H. Smith).

Joseph Lindon Smith

Born at Pawtucket, Rhode Island, 1863; died in Dublin, New Hampshire, 1950.

A student of painting at the School of the Boston Museum of Fine Arts, he was an instructor there 1887-91. From the beginning he was interested in antiquities and in the countries from which they

came; and he left the School to travel and paint, in Europe and in the East. Visiting the Nile valley in 1898, he did paintings of Egyptian carvings which attracted the famous archaeologist George A. Reisner by their *trompe-l'oeil* verisimilitude. Reisner saw their value as records, and from 1904 Smith accompanied him in the joint expeditions of the Boston Museum of Fine Arts and Harvard University which he led to Egypt. The museum owns thirty-nine pictures by Smith, of which twenty-four are of Egyptian subjects. From 1927 until his death he bore the title of Honorary Curator of Egyptian Art. He built a house on the lake at Dublin, New Hampshire. He was a lifelong friend of Mrs. Gardner, advising her on many of her purchases.

THE ADORATION OF THE KINGS *Long Gallery*

Oil on cardboard, almost semicircular, 0.23 x 0.44.

Smith painted few compositions of his own invention.

This was presumably bought from the artist by Mrs. Gardner in 1894. In January she bought five sketches by him, in September five pictures. *P27e25*

THE APARTMENTS OF THE CHIEF PRIEST, KYOTO *Yellow Room*

Oil on canvas, 0.57 x 0.72. Signed at the foot on the right: *JOSEPH LINDON SMITH*.

The inner view of the Daihōjō, part of the Chion'in, the main temple of the Jōdoshū (Pure Land Sect) at Higashiyama, Kyoto, Japan. The building, which no longer exists, dated from the first half of the seventeenth century, and the paintings are by well known artists of the period.[1]

Mr. and Mrs. Gardner visited Kyoto, the old capital of imperial Japan and still the religious centre, in 1883. They may well have stayed at the temple, which was then open to foreign visitors. Smith probably did the same in 1900, when he painted the picture. *P1w1*

[1]Horioka, Yasuko, in *Fenway Court*, Vol. 2, No. 7 (June 1969), pp. 57-58.

A THEATRE, MUKDEN *Blue Room*

Oil on canvas, 0.58 x 0.67. Signed at the foot on the right: *JOSEPH LINDON SMITH*.

Painted at Mukden (now Shengyang) in Manchuria, then the capital of the Manchu dynasty, about 1905. *P3w15*

THE BUST OF AKHENATON *Blue Room*

Oil on canvas, 0.74 x 0.44. Signed at the foot on the left: *JOSEPH.LINDON.SMITH*.

The coloured limestone bust of the idealistic revolutionary Pharaoh is in the Louvre, Paris. Smith wrote to Mrs. Gardner from Bedrasheim, Egypt, 8 April 1908: "I expect to leave Egypt in about a week or ten days and go straight to Paris, where I hope to paint a study of a splendid head, of a Pharaoh, which is in the Egyptian collection at the Louvre." *P3s15*

Exhibited 1908, Boston, Museum of Fine Arts (label on frame).

ADAM AND EVE, DOGE'S PALACE VENICE *Spanish Chapel*

Water colour and body colour on paper, 0.10 x 0.02.

In a cast bronze frame, this tiny sketch has suffered from water damage.

The early fifteenth century sculpture in Istrian stone forms the capital of the stout column supporting the façade of the palace at the corner facing the mouth of the Grand Canal.

Gift of the artist. *P6s5*

A HEAD BY DESIDERIO *Blue Room*

Water colour on paper, 0.475 x 0.348. Inscribed in pencilled Gothic letters at the foot: *FRoM THE ToMB oF/ CARLo MARSVPPINI/ IN S. CRoCE FLoRENCE/ BY DESIDERIo/ DA/ SETTIGNANo/ JOSEPH LINDON SMITH./ 1894*.

Presumably bought by Mrs. Gardner 19 September 1894, when she paid the artist for five pictures. *P3n4*

GASTON DE FOIX *Yellow Room*

Water colour on paper, 0.38 x 0.53. Inscribed along the top as if engraved: *GASTON DE FOIX* and, in smaller letters, to the right: *JOSEPH LINDON SMITH*.

A fragment of the tomb ordered by King François I in 1515 of Agostino Busti, "Il Bambaia," to commemorate the chivalrous Count who died in 1512. It was never completed and has been dispersed; but the greater part is now in the Castello Sforzesco at Milan.

The picture was painted at Ravenna about 1894.

It was presumably bought by Mrs. Gardner from the artist that year. *P1e9*

Sylvia Curtis Steinert

See Sylvia CURTIS

The Adoration of the Kings

The Apartments of the Chief Priest, Kyoto

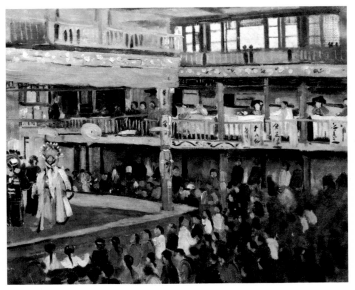

A Theatre, Mukden

A Head by Desiderio

The Bust of Akhenaton

Adam and Eve, Doge's Palace, Venice

Gaston de Foix

Thomas Sully — *Isabella Tod Stewart*

Thomas Sully

Born at Horncastle, Lincolnshire, England, 19 June 1783; died in Philadelphia 5 November 1872.

His grandfather had lived at Exeter, Devon. In 1792 his father Matthew settled with his wife at Charleston, South Carolina. After school and a period in an insurance office, Thomas was apprenticed to his brother-in-law Belzons, a French painter of miniatures. He soon joined his eldest brother Lawrence, who was painting miniatures at Richmond, Virginia, moved with him thence in 1801 to Norfolk, and returned in 1803 to Richmond. His brother dying, he supported his sister-in-law and her three children. He married her in Warren County, North Carolina, in 1805. She bore a new family of nine.

He had painted his first portrait in oils in 1802, and in 1805 he moved to New York City. There he took lessons by commissioning John Trumbull to paint his wife and attending the sittings. He visited Hartford, Boston and Philadelphia in 1807, and in 1808 settled in Philadelphia. In Boston he had called on Gilbert Stuart, shown him his work and received a degree of encouragement. In 1809 he went to England to study. There he lived with the American painter Charles Bird King, and painted his portrait, to show Benjamin West, then President of the Royal Academy. He became West's pupil; but he was influenced more strongly by Lawrence.

After some twelve months he returned to Philadelphia, to be accepted as her foremost painter. He was much employed by societies to portray the first men of the day: for West Point *General Jonathan Williams*, 1815, and *Ex-President Monroe*, 1831-32; for the American Society of Artists *General Jackson*, 1819; for the American Philosophical Society, Philadelphia, *Ex-President Jefferson*, sketched at Monticello 1821 and finished 1830. In 1837 he was sent to England by the St. George's Society of Philadelphia to paint the portrait of *Queen Victoria* now in Philadelphia. The original sketch, made at Buckingham Palace, is in New York.

There is a self-portrait of Sully painted in 1821 in New York and one of 1860 with the Historical Society of Pennsylvania in Philadelphia. He was small and methodical. Hart, who knew him in his old age and edited his *Register of Portraits*, described his frail appearance and those courteous manners which are always said to belong to an older school.

ISABELLA TOD STEWART *Short Gallery*

Oil on canvas, 0.750 x 0.620. Signed and dated on the reverse of the canvas, in red paint: *TS 1837* (the TS joined).

Isabella (1778-1848) was the daughter of David Tod (1746-1827), who had landed from England at Boston in 1761 and had settled at Suffield, Connecticut. She married James Stewart, son of Mary Brough Stewart, whose portrait by a Scottish painter hangs in the same room. To her he bequeathed in 1814, besides his considerable fortune, their large farm at Jamaica, Long Island. This she continued to manage with evident success, for she won silver cups from the New York Agricultural Society in 1821 and 1828.

The portrait is not to be found in the register in which Sully diligently entered his commissions; but the inscription is typical and the picture has all of Sully's grace and polish. It must have been painted early in 1837, for Sully was in London by May that year and was still there in 1838. The sitter was then some fifty-eight years old.

Of her three sons the youngest, David (1810-91), settled early in New York, where he made a fortune first by merchandise and then by mining. He founded the Stewart Iron Company, owning mines near Uniontown in Pennsylvania. He married in 1839 Adelia Smith (1814-86). Of their four children the eldest was Isabella Stewart Gardner. *P17w51*

Justus Suttermans

Born at Antwerp 1597; died in Florence 1681.

He was the son of Frans Suttermans, draper, originally of Bruges, and his wife Esther Scheepmans. In 1609 he is recorded in the list of the Guild of S. Luke at Antwerp as pupil of Willem de Vos. About 1616 he went to Paris, where he entered the studio of Frans Pourbus the Younger (*q.v.*). Pourbus was Court Painter to the Queen Regent, Marie de Médicis, and Suttermans must have graduated naturally to the Medici court in Florence. He arrived there in 1619 or 1620, and became Court Painter to Cosimo II, Grand Duke of Tuscany. Cosimo died early in 1622; but Suttermans remained as Court Painter in Florence for the rest of his long life.

His portraits of *Grand Duke Cosimo II* and of his wife *Maria Madalena of Austria* are in the Corsini Gallery, Florence, and almost the whole remainder of the ruling family are represented in portraits by him in the Pitti Palace there, or in the Villa Medici at Poggio a Cajano.

From Florence Suttermans was intermittently lent to Austria and to other Italian courts. Already in 1622 or 1623 he carried to Vienna his portrait of Eleonora Gonzaga, the fiancée of the Emperor Ferdinand II, of whom he painted the portrait in the Pitti Palace. He remained until October 1624, and then left at the Austrian court four brothers, two of them painters, one a musician. He went in 1627 to Rome to paint Pope Urban VIII; in 1640 to Parma, Piacenza and Milan, where he painted the Spanish Governor Legañes; in 1649 to Genoa, to paint Maria Anna, the wife of King Philip IV of Spain, and to Modena, to paint portraits of the d'Este family. He returned to Florence a year later; but in 1653 he was back at Modena to paint Isabella d'Este for King Louis XIV. He then proceeded for a year to Innsbruck, where Anna Maria de' Medici had become Archduchess of Tyrol. The King of France sent him back to Modena for the same purpose in 1653 and again in 1656.

He married at Florence three times, and all his wives bore him children.

The Florentine court was a dull one, flattering the waning power of Spain by the imitation of her black dress, her gloomy manners and her pietism. With Suttermans' master Pourbus at the French court and Rubens and Van Dyck painting for Spain and England, it knew that Flemish portraiture was the best in Europe; but the great position that it gave to Suttermans was a measure of its secondary quality. He rarely achieved any great degree of either elegance or vivacity. His earlier portraits have some of the shapeliness and firm craftsmanship of Pourbus, and it was probably after the visit to Florence in 1624 of Van Dyck, who etched Suttermans' portrait in a very courtly pose, that he painted most effectively. Suttermans' earnest temperament could gain little from contact with the empty Italian virtuosos like Furini and Albano whom the Grand Dukes called to decorate their court.

A YOUNG COMMANDER *Dutch Room*

Oil on canvas, 0.895 x 0.745. Cleaning in 1948 showed the painting to be well preserved.

Dressed in scarlet, with the blue sash of a commander across his steel breastplate, the subject stands before a dull green curtain, extending the plan of a fortress in his right hand. In the nineteenth century he was identified as the Duke of Monmouth, illegitimate son of King Charles II of England; and the portrait was bought as his by Mrs. Gardner. This claim was disallowed in the 1931 Catalogue.

Recently the commander has been tentatively

Justus Suttermans — *A Young Commander*

identified with Cosimo III de' Medici (1642-1723), who became Grand Duke of Tuscany in 1670, and the fort with that of Livorno;[1] but these identifications are by no means certain. The sitter's costume is unusually gay for the Florentine court, and is said to be of about 1650-55. Even in 1655 the future Cosimo III was only thirteen. Fifteen to seventeen seems a more likely age for this boy. At seventeen the young Cosimo, according to the Lucchese Ambassador, "exhibits the symptoms of a singular piety . . . dominated by melancholy beyond all that is usual." At nineteen on his wedding-day he had to be dragged to the ceremony from the foot of a crucifix in the SS. Annunziata.[2] He is, however, shown in armour in the authentic portrait of him as

a youngish man by Suttermans in Rome; and his appearance there is not incompatible with Mrs. Gardner's portrait.

Mrs. Gardner's interest in the picture was partly due to the earlier identification of the sitter with the Duke of Monmouth. In the summer of 1892 in Venice she had it reserved by the dealer Vincenzo Favenza, and on her return to Boston in November she paid for it. In the interval it had roused the envy of the Empress Frederick of Germany, who made several attempts, through R. W. Curtis in Boston and in 1894 through Count Seckendorf in Berlin, to persuade Mrs. Gardner to part with it. Mrs. Gardner argued that her Stewart ancestry gave her at least an equal claim.[3] *P21s2*

[1]Radice, A. M., in a letter (24 August 1972) to the Director.

[2]Acton, *The Last Medici* (London, 1958), p. 45.

[3]Carter, *Isabella Stewart Gardner and Fenway Court* (New York and London, 1925), pp. 132-34.

Exhibited 2-23 March 1896, Boston, Copley Hall, Loan Collection of Portraits, No. 281.

Gerard Ter Borch

See ter BORCH

Giovanni Battista Tiepolo

Born in Venice 1696; died 1770 in Madrid.

His name as a painter is recorded first in 1717, in the register of the *Fraglia*, a Venetian painters' guild. In 1719 he married in Venice, Cecilia, sister of the painter Francesco Guardi (*q.v.*). Of their nine sons Domenico (1727-1804) and Lorenzo (1736-76) were painters. These two began as young boys to work as his assistants, and they accompanied him probably on all his important missions, though Domenico was already painting independently in 1747. In 1756 Giambattista was made the first president of the Venetian Academy. He acquired considerable property on the mainland, including a handsome villa at Zianigo, near Mirano.

Tiepolo was apprenticed to Gregorio Lazzarini (1655-1730), who had already brought a lighter tone into the murkiness of seventeenth century Venetian painting. In this he was influenced also by Sebastiano Ricci (1659-1734); but the example which helped him most to acquire that robust power of modelling, the earthy foundation to which his soaring art was always moored, was the painting of Piazzetta (1683-1754). His influence is strong in the earliest picture by Tiepolo which is still *in situ*: the spandrel canvas with *The Sacrifice of Isaac* in the Ospedaletto, Venice, about 1715-16. Ten years later Tiepolo received his first recorded summons from the mainland: to fresco the ceiling of a chapel in Udine cathedral and to decorate the palace of the Patriarch. His preference for fresco, rare among Venetian painters, made it necessary for him to look for new wall spaces abroad; but his precocious brilliance was soon bringing more of such orders than he could fill. In 1731 he completed two large schemes in Milan, of which the cycle with *The Story of Scipio* in the Palazzo Casati-Dugnani has survived. He returned to paint the dome of the Colleoni chapel at Bergamo in 1732-33. He was in Milan again painting in 1737; and in 1740 frescoed the huge ceiling in the Palazzo Clerici there. At intervals he carried out schemes in several villas of the Veneto, of which the most extensive and enchanting is in the Villa Valmarana, near Vicenza, 1757.

About 1739 he painted the great altarpiece, *A Vision of the Trinity*, now in Munich, for the Archbishop Elector of Cologne; and ten years later he was summoned to Würzburg by the Prince Bishop to fresco the huge Dining Room (see the picture below) and the Grand Staircase in the Residenz, and to paint two altarpieces. He painted other great altarpieces for Germany, refused an invitation to the Court of Sweden by asking too high a price, and in 1761 was busy with a huge canvas for St. Petersburg. All this activity was in Venice, or north of a line from Venice to Milan. The final summons abroad came, however, from King Charles III of Spain. In June 1762 he arrived, with his two sons, in Madrid. Three great ceilings in the royal palace were finished by 1767. Tiepolo was ill, and over seventy years old; but he told the King that he preferred to stay in Spain. The King commissioned seven great canvases for S. Pasquale at Aranjuez, from which only *The Immaculate Conception*, now in the Prado, has survived intact.

These last years of voluntary exile are difficult to explain. In Italy he had been busy to the moment of departure, painting ceilings in 1761-62, first in the Palazzo Canossa at Verona, then in the Villa Pisani at Strà. In his native city he had been triumphant, certainly from 1743 when his great ceiling canvases in the Scuola del Carmine were unveiled and *The Madonna of Mount Carmel* in the centre was recognised for what it is: the greatest religious composition of the century. He had to leave behind in Venice well-tried collaborators like Girolamo Mengozzi-Colonna, who provided the often vertiginous architectural effects on which his more intricate schemes were founded. It was before Würzburg probably that they achieved the most dazzling example of their cooperation in the Palazzo Labia. Here the guests could dance the minuet or the gavotte in a ballroom of apparently sumptuous architecture which is all painted fantasy, lit clearly from above by the glimpses it allows into Olympus, air-conditioned by the Elements, opening freely at the sides onto the quay-side in Egypt or to other chambers still more brilliantly lit, where Anthony and Cleopatra act out the story of their superlative love. To 1753 and 1758 belong the two ceilings in Cà Rezzonico, now a museum, where family history becomes allegory, and allegory a vision in a sky which is also the ceiling, no less successfully integrated in the palace's already fantastic structure.

This integration of picture with building of which there was always a germ in Italian church decora-

Giovanni Battista Tiepolo — *The Wedding of Barbarossa* (SEE COLOUR PLATE)

tion, Tiepolo carried to the ultimate degree. He is the last great painter of the Italian Renaissance, and is its very summit in the power to launch fully modelled figures into space at any angle and in proportion to each other and to us. In this combination of decorative completeness with the apparent absence of any effort he represents, as no other painter, the charm of his century, elevated to Olympian heights. The visual poetry into which he translated Homer or Vergil, Ariosto or Tasso owes something frankly to the theatre, which was also a passion of the age. But Tiepolo's theatre is not all dalliance and comedy. Some little canvases of his last years are the very essence of compassion.

THE WEDDING OF BARBAROSSA
Veronese Room

Oil on canvas, 0.710 x 0.553. Cleaning in 1945 revealed paint in good condition.

The Holy Roman Emperor Frederick I, nicknamed Barbarossa (Red Beard), married Beatrice of Burgundy at Würzburg in 1156. Bishop Gebhard von Henneberg officiated.

A *modello* for a large painting in fresco at Würzburg, this canvas has a pendant in the Metropolitan Museum, New York: *Barbarossa's Investiture of Bishop Harold von Hochheim with the Duchy of Franconia*. The *modello* for the ceiling of the same room, *Apollo Bringing Beatrice to Barbarossa*, is at Stuttgart, and an earlier sketch for this is in the Mainfränkisches Museum at Würzburg. All these were painted by Giambattista Tiepolo himself probably in 1749-50 in Venice, where he received a programme for the three themes. This was drawn up by the court historian to the new Prince Bishop of Würzburg, Karl Philipp von Greiffenklau, and with it was sent a description of the hall to be decorated, and its measurements.[1] Tiepolo with his sons Domenico (then aged twenty-three) and Lorenzo (fourteen) arrived in Würzburg in December 1750, remaining until November 1753. Another design for *The Wedding of Barbarossa*, in London, is evidently from the hand of Domenico,[2] and must, since the officiating Bishop is now in the likeness of Karl Philipp von Greiffenklau, have been painted at Würzburg. It represents a further step towards the final composition; and the fresco painting itself, which is not signed, like the other two, seems also, largely at least, to be by Domenico's less sensitive hand.

These frescoes decorate the ceiling and the cove at the opposite rounded ends of the great Dining Room in the Residenz at Würzburg, named from the subjects the Kaisersaal. The frescoes in the coves differ in proportions from the upright canvases, being wider than they are tall. Concave in both directions, they are integrated with the highly ornamental room by the modelling in relief of the gilt and polychrome curtains which close the compositions towards the top. These are drawn aside, moreover, by *putti* modelled completely in the round. In *The Wedding of Barbarossa* the final composition is very different from the sketch. The architecture is greatly modified, in order to give the effect of greater height and space. No figure is quite the same. Above all, the Emperor has been moved, so that he may face the spectator from behind his bride, and the officiating bishop has become Prince Bishop Karl Philipp von Greiffenklau himself.

The result so pleased the Prince that a new contract was made with Tiepolo to paint frescoes over the Grand Staircase, leading up to the Kaisersaal. As a whole, these frescoes are Tiepolo's greatest undertaking, triumphing over the absurdities of the themes by boldness of invention, power of modelling in space and the complete union of all three visual arts.

The sketch was bought in April 1900 in Paris by Mrs. Gardner's agent Robert, on the advice of R. W. Curtis. *P25e4*

[1] von Freeden and Lamb, *Das Meisterwerk des Giovanni Battista Tiepolo* (Munich, 1956), pp. 41-47. The documents were exhibited in 1951 at Würzburg, *Tiepolo in Würzburg, 1750-53*, Nos. 2 and 3. The authors accept the fresco and both canvases as the work of Giambattista Tiepolo.

[2] Levey, *National Gallery Catalogues, The Seventeenth and Eighteenth Century Italian Schools* (London, 1971), pp. 234-38. He examines the relation of the pictures in Boston, New York and London in great detail, concluding that none is by Giambattista Tiepolo or prior to the frescoes at Würzburg. His argument centres, however, on the belief that the London picture is not painted by Giambattista but by Domenico Tiepolo. Here the present writer is in full agreement with him, contrary to the opinion of all other authorities; but he believes it more likely that, as suggested above, Giambattista should have relegated to Domenico the second *modello* and the fresco painting itself. This he had already suggested in the 1931 Catalogue. It seems unlikely that Domenico, if he had copied the fresco, would have introduced a number of compositional immaturities.

OTHER AUTHORITIES

Fredericksen and Zeri, *Census* (1972), p. 195; as Giambattista Tiepolo.

Molmenti, *Giovanni Battista Tiepolo* (Milan, 1909), p. 284; he attributed canvas and fresco to Giambattista Tiepolo.

Morassi, *G. B. Tiepolo* (1955), p. 26: "clearly a study for the fresco"; also *A Complete Catalogue of G. B.*

Tiepolo (1962), pp. 6-7; he attributes the fresco also to Giambattista Tiepolo.

Versions: (1) London, National Gallery, canvas, 0.724 x 0.527 (see above). It is much closer to the fresco in the architecture and the arrangement of the figures; but the Emperor has progressed only half way to his final position. The officiating Bishop is already a portrait of Karl Philipp; so the sketch, if it is one, was presumably done at Würzburg. (2) Würzburg, Residenz, the fresco (see above). (3) Brussels, 15 October 1928, O'Meara sale, No. 83, attributed to Domenico Tiepolo (see Levey, *loc. cit.*). A number of drawings must have been made later in closer connection with the fresco painting.

Paul Tilton

From the bills paid, Paul Tilton evidently sold Mrs. Gardner several pictures and pieces of furniture in 1892 and 1895. It would seem from these notes that he was an American artist in Venice, but his name does not appear in any of the standard reference books or in museums either in Boston or Venice. A painting of *The Lido* by the same hand signed and dated *P. H. Tilton / 1894* is in the Museum archives.

VENICE *Macknight Room*

Oil on panel, 0.32 x 0.42. Inscribed at the foot on the right: *Paul Tilon* [sic] *Venice / 1886.* The signature appears to be technically beyond suspicion.

P11n1

AUTHORITY

Bénézit, *Dictionnaire des Peintres* (Librairie Grund, 1955), VIII, pp. 313-14; he mistakenly attributes the painting to John Rollin Tilton (1833-88).

Paul Tilton — *Venice*

Tintoretto

JACOPO ROBUSTI: born in Venice 1518; died there 1594. His nickname TINTORETTO, diminutive of *tintore* (dyer) resulted from the profession of his father.

He married Faustina de' Vescovi, whose father Marco bought for him in 1574 a spacious house not far from Titian's. It was an interesting household. Two sons, Domenico and Marco, and Marietta, the eldest of five daughters, were painters, and no doubt assisted their father in the studio. Both Marietta and Tintoretto himself were accomplished musicians. In spite of some curtness and an impolitic wit his manners were open and popular. He managed to live in friendship with rival painters like Jacopo Bassano, Veronese and Schiavone, whom he was constantly underbidding in order to obtain the great spaces he felt impelled to fill.

Pictures were commissioned from him by their envoys at Venice for King Philip II of Spain and for Emperor Rudolph II. These were all painted in Venice. So perhaps were the paintings mentioned by Ridolfi in Genoa; at Brescia, where his *Transfiguration* is still in S. Afra; at Lucca, where there are still several pictures; in Bologna, where is *The Visitation*. In 1580 he embarked with his whole family on the Mantuan ducal barge, to finish and set up in the castello his eight *Scenes from the Military History of the House of Gonzaga*, now at Munich. But this is the only certain interlude in a life devoted mainly to the decoration of the public buildings of his city. To encourage the inception of large schemes he sometimes made a gift of a picture, and in place of the usual payments he preferred modest annuities in return for undertakings which he never failed to carry out. Thus in 1574 he obtained an annuity from the government; but, unlike Titian, who had regarded such a pension as a sinecure, he was continually at work in the Ducal Palace. Among the first of his paintings there are the pendants SS. *Andrew and Jerome* and SS. *Louis and George with the Princess*, now in the Accademia, painted about 1552; the last is the huge *Paradise*, painted 1588-90 upon one whole wall of the Hall of the Great Council. In return for the small annuity granted him by the Scuola di S. Rocco in 1577 he painted three pictures every year, until the decoration of the school, begun in 1564, was complete with its sixty-six great canvases. The church he had filled in the same way, beginning about 1559. He painted whole cycles for various churches. The two great scenes in the choir of S. Giorgio Maggiore are among the last.

Ridolfi gives an account of his methods. He studied with the surgeons in the anatomy schools.

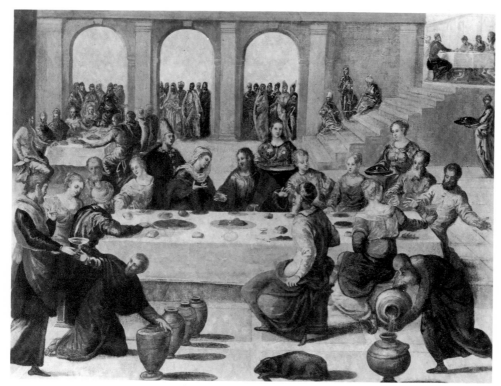

Tintoretto — *The Wedding Feast at Cana*

He obtained models from Florence of sculptures by Michelangelo, and filled his studio with casts from the antique. His own figures he often modelled first in wax or plaster, draped them and placed them in a little theatre. Here he could experiment in their arrangement, and with a light study the shadows that they cast.

This method of work illustrates the character of his expression. His colour was Venetian in its richness and translucency; but it was rarely allowed to tell in masses. Its function was to refine and reinforce the roundly modelled, rhythmic forms of a draughtsman, to give luminosity to the great spaces that he engineered on canvas, to the pools of darkness from which his figures would often break abruptly into a dazzling light. It is not astonishing to read in Ridolfi that an attempt to be the pupil of Titian (*q.v.*) only lasted ten days. Some of his earlier portraits are not immediately distinguishable from Titian's, but the temperament of two great painters of one city and one age could scarcely be more different. He had none of the dreamy sensuousness of Bellini or Giorgione or Palma. He was impatient with the moods of man or nature, contemptuous of luxury. In that huge gallery of his paintings, the Scuola di S. Rocco, it seems to be the spirit of the terrible god of the Old Testament which rules. For all their sensuous grace, his long lines of queenly heroines are as remote from us as those of Piero della Francesca. The race of supermen and superwomen that he conjured up are as splendid in mind and spirit as in their bodily stature.

Of the human figure in motion he achieved an unprecedented degree of control. Fusing the vision of two rival schools, he had made drawing and painting all one. With his Venetian inheritance of translucent oil colours and inborn comprehension of light and shade he created by the study of Florentine contours the most dynamic power of expression of the Renaissance.

THE WEDDING FEAST AT CANA *Long Gallery*

Oil on canvas, 0.725 x 0.943. The canvas has possibly been reduced all round. The paint has suffered by a general flaking and has been retouched in many places.

This is not a sketch for any known picture, or a copy. It is carefully finished; and the many shades

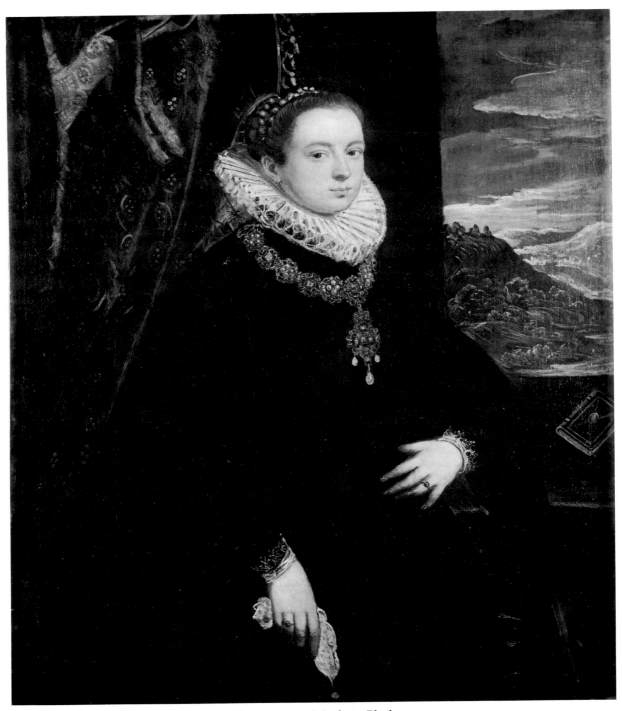

Tintoretto — *A Lady in Black*

of yellow and red, brown and green which colour it are studiously harmonised. It may well be an exercise which the artist set himself; for it is one of his earliest pictures, still showing the mark of the ruler and lacking subtlety in light and shade. If it is not acceptable to some authorities as the work of Tintoretto, this is perhaps because these crudities are combined with so many features of his mature imagination. Already the whole germ of it is here. The characteristic elongated figures gesticulate with restless power; the glowing colours are manipulated with a subtle freedom. From the beginning Tintoretto loved to organise in serried ranks these great multitudes of figures. The tall, mysterious chorus who close the background in a line are to reappear continually: in *The Miracle of the Loaves and Fishes* in New York, painted but little later, or in *The Gathering of the Manna* in S. Giorgio Maggiore in Venice, belonging to his last moments. He found a splendid motif for his formal composition in these banquet scenes, of which Venice offered magnificent studies in the life, and the action of pouring water into the wine jar was to be grandly developed in the same theme, painted in 1561, in S. Maria della Salute, that of passing up the cup in the last *Last Supper* in S. Giorgio Maggiore.

The picture was bought at a sale at Boston about 1888 by Charles Eliot Norton,[1] Professor of Fine Arts at Harvard College, who sold it to Mrs. Gardner 1 April 1905, together with the portrait head below. P28w16

[1]Miss Elizabeth Norton in a letter (24 December 1929).

OTHER AUTHORITIES

Berenson, *Venetian School* (1957), I, p. 170.

Fahy, in a letter to the Director of 16 April 1973, does not accept the attribution to Tintoretto.

Fredericksen and Zeri, *Census* (1972), p. 199: Tintoretto, uncertain attribution.

Freedberg, in comments in a letter of 22 May 1973, is equally sceptical.

De Vecchi, *L'opera completa del Tintoretto* (1970), p. 134, No. A28; he lists it among pictures not generally accepted as by Jacopo Tintoretto.

A LADY IN BLACK *Third Floor Hall*

Oil on canvas, 1.155 x 0.967. Cleaning in 1952 revealed paint in good condition.

The black dress, perhaps of mourning, fastened up to the chin, the severe ruff encircling the neck and the cross of square-cut gems and hanging pearls suspended from the heavy necklace make a costume more like those in contemporary portraits of Span-

ish ladies than that of a Venetian; the book of devotions adds to this character. The curtain is crimson, to support the red of mouth and cheeks, but the composition is otherwise almost without colour, the landscape sketched in grey and white. When Tintoretto, according to Ridolfi, was asked which are the most beautiful colours, he replied: "Black and white; one by deepening the shadows gives force to the figures, the other relief." Head and ruff, hands and handkerchief are brush-drawn with a speed and brusqueness, but also with a crisp power, which are characteristic of Tintoretto in his less interested moments. He did not readily paint portraits of women. The dashed-in landscape is also characteristic. The rest he evidently left to the hands of an assistant. Dress and the manner of painting suggest a late date in his career.

Formerly in the collection of Prince Chigi in Rome, the portrait was bought with the advice of the painter John S. Sargent from Knoedler, New York, 20 February 1903. P24e2

AUTHORITIES

Berenson in a letter to the compiler (4 February 1930); also *Venetian School* (1957), I, p. 170.

Fahy, in a letter of 16 April 1973, does not support the attribution to Tintoretto.

Fredericksen and Zeri, *Census* (1972), p. 199; to Tintoretto.

Freedberg, in comments in a letter of 22 May 1973, suggests the workshop.

Paola Rossi in *Arte Illustra* (June-September 1970), p. 96, attributes the portrait to Domenico Tintoretto, *ca.* 1598.

De Vecchi, *L'opera completa del Tintoretto* (1970), p. 121, No. 227.

Venturi, L., *Pitture Italiane in America* (1931), Pl. CCCCXII. He dated it *ca.* 1578.

Studio of Tintoretto

ZACHARIAS VENDRAMIN *Titian Room*

Oil on canvas, 1.142 x 0.975.

A version, formerly in the Walters Art Gallery, Baltimore, is inscribed: *ZACHARIAS/VENDRA-MENO/DIVI MARCI/PROCVRATOR*. It is not likely that the inscription was added to the portrait during the sitter's lifetime; but it no doubt represents a credible tradition that he is indeed Zaccaria Vendramin, Procurator of S. Mark's. The Vendramin was one of the oldest and wealthiest families of Venice, with several branches. The Procurators of S. Mark, whose gown and stole the sitter wears, were nominated from the nobility by the govern-

Studio of Tintoretto — *Zacharias Vendramin*

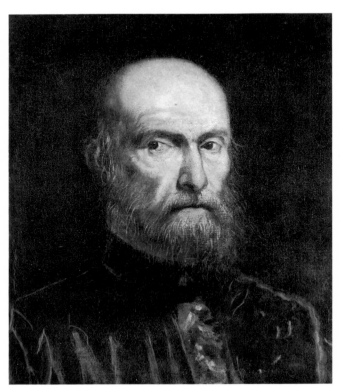

After Tintoretto — *A Procurator of S. Mark's*

ment in reward for services to the state. Responsible for public building, they exercised considerable power and privileges.

The existence of a version, with the same very loose and summary treatment, especially of the body, makes it no less likely that there was a portrait completely by Tintoretto's own hand. The colours are his, and in the Gardner picture the head itself could possibly have been painted by him.

Mrs. Gardner bought it as the work of Jacopo Tintoretto from Berenson in February 1896. *P26w10*

AUTHORITIES

Berenson in a letter (4 February 1930) attributed it to Jacopo Tintoretto; also *loc. cit.* (1957).

Fredericksen and Zeri, *Census* (1972), p. 199; follower of Tintoretto.

Version: Sold by the Walters Art Gallery to the Acquavella Galleries, New York, about 1955 (see above).

After Tintoretto

A PROCURATOR OF S. MARK'S *Long Gallery*

Oil on canvas, 0.472 x 0.390. The canvas has been cut on all sides, and this could be a fragment of a much larger picture. Cleaning in 1940 removed not only discoloured and opaque varnishes but considerable overpainting.

The head and shoulders are repeated from the three-quarter length in Berlin, one of Tintoretto's most vigorous portraits.

A label on the back has *GALLERIA MANFRIN* engraved and the signature *G* [?] *Manfrin* (the capitals in monogram). This collection was formed in Venice in the first half of the nineteenth century by Girolamo Manfrin and his son Pietro, and gradually dispersed by Pietro's heirs. From them it was bought in 1871 by Charles Eliot Norton.[1] From him it was bought by Mrs. Gardner 1 April 1905. *P27e24*

[1]Miss Elizabeth Norton in a letter to the compiler (24 December 1929). Another label on the back has *1871*.

OTHER AUTHORITY

Fredericksen and Zeri, *Census* (1972), p. 199; copy after Tintoretto.

Exhibited 2-23 March 1896, Boston, Copley Hall, Loan Collection of Portraits, No. 288, as by Tintoretto.

Version: Berlin, No. 299, *A Procurator of S. Mark's* (see above). He stands between green curtains in a robe of sharp crimson, his right hand holding his gown, his left extended downwards. A landscape is seen through the embrasure above his left shoulder.

Titian

TIZIANO VECELLIO: died in Venice 1576. About the date of his birth at Pieve di Cadore, in the mountains of Friuli, the evidence is contradictory. The once favoured 1477, given by his descendant Tizianello in a biography of 1622, has some corroboration. It makes him ninety-nine when he died; but it fits well with the belief of some recent writers that he had outstripped Giorgione before Giorgione died very young in 1510.

Ludovico Dolce in his *Dialogo della Pittura*, written in Titian's lifetime, relates that he went to Venice as a boy of nine; was apprenticed there to the obscure Sebastiano Zuccato; left Zuccato first for Gentile and then for Giovanni Bellini (*q.v.*); finally went into partnership with Giorgione, whom he assisted in painting frescoes on the Fondaco dei Tedeschi, the German Centre, on the Grand Canal. Giorgione was paid for these in 1508. According to Dolce, Titian himself painted the frescoes on the street façade, and he has accordingly been credited with the fragmentary and much worn *Judith* (?) from there, now in the Venice Accademia. This has led several modern writers to attribute to Titian's early years such pictures as the *Daniel and Susanna* at Glasgow or the *Concert Champêtre* in Paris, leaving to Giorgione little of significance painted after 1508. Stronger evidence, however, is needed to disprove the tradition, dating from Titian's lifetime, that Giorgione was a very great artist and the formative influence on Titian's early painting.

The exact record of his work begins late in 1511 at Padua, where he painted in fresco three *Miracles of S. Anthony* in the Scuola del Santo. His large canvas at Antwerp, *Jacopo Pesaro Presented to S. Peter by Pope Alexander VI*, belongs to about this moment. All these are powerful but scarcely subtle. It cannot have been very long afterwards that Titian provided the landscape setting to the *Reclining Venus* in Dresden which Giorgione had left unfinished, and painted his own most Giorgionesque picture, the *Noli me tangere* in London.

After the death of Giovanni Bellini in 1515 Titian stepped into his shoes as painter to the Republic. The strongest of individualists, he never gave himself willingly to the decoration of the city. He established his supremacy in Venice, however, with a succession of altarpieces on a new scale: the huge *Assumption of the Virgin* of 1516-18 in the church of the Frari; *The Madonna with the Pesaro Family*, finished in 1526, in the same church; *The Death of S. Peter Martyr* in SS. Giovanni e Paolo, finished in 1530, eventually destroyed by

fire. He was ambitious for wealth and position, and in the meantime had attracted great patrons by the depth and splendour of his portraiture and of his treatment of secular subjects. For Alfonso d'Este, Duke of Ferrara, he painted between 1516 and 1523 the three big mythologies, *The Worship of Venus* and *The Bacchanal* in Madrid and *Bacchus and Ariadne* in London, together with many other pictures, including the portraits of which there are versions in the Pitti Palace, Florence, and in New York. For Alfonso's nephew Federigo II Gonzaga, Marquis of Mantua, he painted many pictures, including the portrait now in Madrid and *The Entombment* in Paris, about 1525-30.

Ferrara and Mantua both discovered in his painting a bait for the Emperor Charles V. The full-length *Charles V with his Mastiff*, now in Madrid, was painted at Bologna in 1532-33, and Titian was thereafter created Count Palatine and Knight of the Golden Spur. A group of pictures now mostly in Florence, including the portrait of *Francesco Maria della Rovere*, painted in Venice 1536-37, that of his wife *Eleonora Gonzaga*, and the *Reclining Venus* painted for their son Guidobaldo II in 1538, testifies to the patronage of the Dukes of Urbino. It was with an escort supplied by Duke Guidobaldo that Titian went in October 1545 to Rome. Probably he had already painted several members of the Farnese family and perhaps Pope Paul III himself. It was in Rome certainly that he painted the large group with *Pope Paul III with his Nephews Alessandro and Ottaviano* and the *Danaë*, now, with other Farnese pictures, at Capodimonte, Naples.

Summoned twice by the Emperor to Augsburg, Titian painted there in 1548 the *Charles V on Horseback at the Battle of Mühlberg*, and in 1551 the full-length *Prince Philip in Armor*, both now in Madrid. Charles V continued his commissions, and after his abdication in 1555 many of Titian's pictures accompanied him to his monastery in Spain. It was for King Philip II that Titian began that great flow of decoration into the Spanish royal palaces which went on until the last years of his life, to be continued by Rubens (*q.v.*) and Velázquez (*q.v.*) for King Philip IV.

Venice in Titian's lifetime was the last peaceful scene of the Italian Renaissance. Her commerce was declining; but she enjoyed her limited inheritance with a zest which was the wonder of Europe. With due observance of religion, she lived unconsciously the paganism which was more an intellectual study in Florence and in Rome.

A giant who lived perhaps ninety-nine years and painted until almost the last in such a city, may well have given the fullness of life its most complete expression. His Madonnas and Venuses alike express the delight of the senses as boldly as the Song of Solomon. His portraits, which give the whole human compound of spirit and flesh, throb with no momentary sensation but with the history of the race. Intense appreciation of the passions of nature and of man is the root of Titian's expression.

Such an advance upon life implied a new openness of vision. The drier, more intellectual expression of other schools had found adequate means, for the most part, in line, a convention established by the usage of centuries for the expression of what is known by the mind to exist. Titian opened his eyes to a new measure of reality. Exposing the body with a new freedom, he was too conscious of the flesh and the blood to be curious of structural secrets which the Florentines had hastened to lay bare before they had explored the surface. From the first he sought its large masses instinctively, and learned to apprehend its volume and the qualities of its substance. Bellini in his altarpieces had already begun to develop this study of volumes; he had almost dispensed with line as he discovered the potentialities of oil painting. And in the new medium Giorgione had obtained a translucence and a delicacy of gradation with which he gave a haunting lyricism to all his subjects. Titian was less reticent than either. He expressed a robuster sensuousness in heavier masses of colour and of light and shade, and in bolder varieties of texture. The lyrical spirit of his prime found expression in feasts of pure colour, which reached their most intense glow in the *Bacchus and Ariadne*, a mosaic of contrasting hues and textures. The variety of manipulation gives the pigments a life of their own and makes canvas the most gorgeous of all the stuffs. The ceaseless adventure of his brush, as it continued to call forth a thousand suggestions of shape or texture by a mere touch of light or shadow, set free ideas and sympathies hitherto unexpressed. He gave modern painters a dangerous power to create illusions. Yet his own art was securely founded on that depth of sensuous consciousness and knowledge of mankind which were the birthright of Venice. He was rarely failed by the large sense of design which was the heritage of all Italy.

His huge altarpieces were models in their piled up volumes of form for the monumental compositions of Veronese and Tintoretto. His later compositions opened the way to the mature expression of the succeeding centuries. The variety of his expression and its sympathy with the tide of life are shown by the quick response of all Europe. Rubens copied his pictures in their full size wherever he

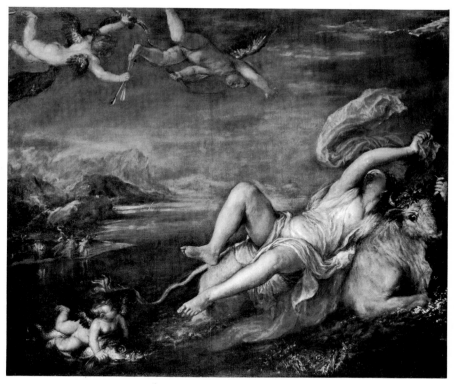

Titian — *The Rape of Europa* (SEE COLOUR PLATES)

encountered them. Van Dyck (*q.v.*) made sketches of them and became the owner of a score. Velázquez, who lived surrounded by them, reached the beauty of his last phase through their study. Titian, in short, invented modern painting, and one finds in his work the germ of almost every subsequent artist who came near to him in greatness.

THE RAPE OF EUROPA *Titian Room*

Oil on canvas, 1.78 x 2.05, excellently preserved. Inscribed at the foot on the left: *TITIANVS. P.*

The deceit is over; the white bull has plunged into the sea still crowned with the trustful flowers of Europa and her companions, who are now waving frantically from the shore. He is bearing her from her native Phoenicia to Crete, where he will reveal himself to be Zeus, the King of the gods, and where Europa will become Queen, the mother of Minos and Rhadamanthus. Among the Greek myths handed down through Ovid's *Metamorphoses* and *Fasti* this was one of the most popular with artists from the late fifteenth century. Titian also had the scene laid out for him in a Hellenistic romance, "Leucippe and Clitophon" by Achilles Tatius of Alexandria, which was a best-seller from

1550, when the whole text was published in Venice, translated by Francesco Angelo Coccio.[1] Under its influence perhaps, he has rendered Europa's situation with an uncompromising realism not found in the other *poesie*. The free movement has banished the old formalities of composition, disposing the main group in a corner of the canvas. Yet the balance of design is maintained by the sweeping curves which heroine and flying cupids describe against the background, and in the rhythm of the colour. This harks back to the scheme of many earlier pictures, with their dominant opposition of blue and red; but now sea and sky merge into one another, melting the mountains in their blue mist and tingeing even the shadows in Europa's shift. The setting sun flushes the white of her skin, reddening its shadows, and rests in a brilliant glow on the distant peaks. Titian's hand was deft as ever in his old age, but it no longer can have been as firm. It was perhaps most evocative in these wide seascapes, the *Europa* and the *Andromeda* in the Wallace Collection, where the loose scumbles of paint make the foreground flash and sparkle before vaguer, brighter distances. Titian was looking boldly as ever at nature, for the sea had never before been used to render so intense a

drama. In the *Europa* especially the menace of the atmosphere is perfectly attuned to the mixture of agony and ecstasy expressed in Europa's body and face. The *Andromeda*, which forms a pendant, the sweep of its design curving the other way, contrasts curiously in the classical elegance of Andromeda's pose. It has been suggested that even the pose of Europa is taken from the figure of Dirce in the famous Roman group the "Farnese Bull," now in Naples, which Titian certainly saw when it was newly excavated in Rome.[2] ·

Of all Titian's paintings, which exerted such an influence upon the whole Spanish school, upon Rubens, Van Dyck and Rembrandt, the *Europa* seems to have captured most thoroughly the imagination of other artists. Rubens carried back with him to Antwerp the full-size copy he had made in 1628-29 in Madrid, and Van Dyck, who probably owned the *Andromeda*, copied Rubens' copy. Velázquez paid his tribute by painting Titian's canvas into the background of *The Spinners*; and, when it had arrived in Paris, Watteau utilised the landscape for his own *Enlèvement d'Europe*, engraved by P. Aveline. Sir Joshua Reynolds was the owner of a little replica.

The Gardner picture is one of seven mythological scenes painted by Titian in Venice for King Philip II of Spain. Only *Danaë* and *Venus and Adonis*, the first two to be painted, are still in Madrid. *Diana and Callisto* and *Diana and Actaeon* are now (1974) on loan from the Duke of Sutherland in the National Gallery, Edinburgh; *Perseus and Andromeda* is in the Wallace Collection, London, *The Punishment of Actaeon* in the National Gallery there. Titian was summoned by Prince Philip, then twenty-one years old, to Milan in 1548; but the project probably dates from 1550, when he was called to Augsburg.[3] The first, *Danaë*, was of different shape and only a variant of one already painted. The progress of the others, which form a suite, is recorded in Titian's letters. *Venus and Adonis* is the first mentioned, in the spring of 1554. It was sent that autumn to England, where Philip had gone to wed Queen Mary. The remainder were sent at intervals via Genoa to Madrid. The *Europa* is first mentioned in a letter from Titian to the King from Venice 19 June 1559:

". . . After their dispatch [*Diana and Actaeon* and *Diana and Callisto*] I shall devote myself entirely to finishing the 'Christ on the Mount' [now at the Escorial] and the other two *poesie* which I have already begun — I mean the 'Europa on the shoulders of the Bull' and 'Actaeon torn by his Hounds.' In these pieces I shall put all the knowledge which God has given me, and which has always been and ever will be dedicated to the service of your Majesty."[4]

He had no receipt for the two pictures dispatched, and wrote anxiously from Venice 22 April 1560:

". . . If received at last with favour, I shall have more courage to proceed with 'The fable of Jupiter and Europa.' "[5]

Again, Venice, 2 April 1561:

". . . and in the meanwhile I shall get ready the 'Christ in the Garden' and the 'Poesy of Europa,' and pray for the happiness your royal crown deserves."[6]

And, 17 August 1561:

". . . Meanwhile, I shall proceed with the 'Christ in the Garden,' the 'Europa' and the other paintings which I have already designed to execute for your Majesty."[7]

On the précis of the last letter the King wrote:

"Tell Titian to hasten the completion of the pictures of which he speaks and to send them to the secretary, and write an order in my name that they may go by safe conveyance, and write further that they may be dispatched with similar care from Genoa."[8]

There is a letter in Italian of 22 October 1561 giving Titian these instructions, and in another, of 20 November 1561, Garcia Hernandez, the Secretary to the King at Venice, reports its delivery. Yet not until 26 April 1562 can Titian write to Philip from Venice:

"Most Serene and Catholic King:
With the help of Divine Providence I have at last finished the two pictures already begun for your Catholic Majesty. One is the 'Christ praying in the Garden,' the other the 'Poesy of Europa carried by the Bull,' both of which I send, and I may say that these put the seal on all that your Majesty was pleased to order and I bound to deliver on various occasions.
Devoted humble servant
TITIAN."[9]

There remained the matter of payment, for which Titian was still asking in a letter of 22 December 1574.[10] The *Europa portata dal toro* appears fifth in a list he encloses of pictures painted for the King.

It is not certain where the *poesie* were hung until a century later. It has been stated that in the meantime they were offered by King Philip to the Emperor Rudolph II.[11] Royal inventories of 1668, 1686, and 1700 show that they (except presumably for

the *Andromeda*) were then in the Alcáza, Madrid, hung in a room known as the *Bovedas de Ticiano*.[12] Descending through Philip III, they, or some of them, were given away by Philip IV to the Prince of Wales, later King Charles I. King Philip had been dangling the hand of his sister the Infanta Maria across the seas, without serious intention. When in the early spring of 1623 the Prince and Buckingham appeared unannounced in Madrid to see and carry off the bride, there was consternation, and the *Europa* was one of the courteous gifts intended as a substitute for the Infanta. The English were equally unwilling, and the Prince was recalled to England so precipitately that he had to leave his presents in Madrid. The *Europa* descended through Charles II of Spain to Philip V, the first Spanish Bourbon King. By him it was given early in the eighteenth century to the Duc de Gramont;[13]and from him it passed, with others of the same series, into the collection of the Duc d'Orléans, Regent of France (d. 1723), who was owner also of the little panel by Raphael here, the *Pietà*. They hung in the Palais-Royal in Paris until the Regent's great-grandson "Philippe Egalité" sold the huge collection entire to an English syndicate formed by the Duke of Bridgewater, the Earl of Carlisle and Earl Gower, later the Marquis of Stafford. Each kept a picture gallery for himself, and the remainder was dispersed in sales in London by their agent Bryan. The *Europa* was sold 7 May 1804 (Peter Coxe, Burrell and Foster, "Mr. Bryan's Celebrated Gallery of Original Pictures of the Very First Importance," No. 47) to Bettesworth (marked catalogue in the Museum). It was in the collections first of the Earl of Berwick and then, by 1824, of the fifth Earl of Darnley at Cobham Hall.[14] From the eighth Earl of Darnley Dr. von Bode had hoped[15] to obtain it for the Kaiser-Friedrich Museum, Berlin, when it was bought by Mrs. Gardner through Berenson in June 1896. *P26e1*

[1]David Stone, Jr., in *The Art Bulletin*, LIV, 1 (March 1972), pp. 47-49.

[2]Alastair Smart in *Apollo*, LXXXV, No. 64 (June 1967), pp. 420-31.

[3]Cecil Gould in *The Burlington Magazine*, CV (1963), pp. 112-17.

[4-10]Crowe and Cavalcaselle, *Titian: His Life and Times* (London, 1877), II; they translated the whole of the letters and in the appendix reproduced the Italian for the first time from the Archives of Simancas (S*ria* de Estado Leg⁰ 1336); [4]pp. 275-76 and (appendix) pp. 512-13; [5]pp. 305-06 and (appendix) pp. 518-19; [6]pp. 307-08 and (appendix) pp. 519-20; [7]pp. 310-11 and (appendix) pp. 520-21; [8]p. 311 and (appendix) p. 521, they reproduced the précis also; [9]pp. 319-20 and (appendix) p. 524; [10]pp. 404-05.

[11]Stryienski, *La Galerie du Régent* (Paris, 1913), pp. 13 and 45, stated that Philip II offered the *Europa* and the *Andromeda* to the Emperor Rudolph II.

[12]Cecil Gould, *loc. cit.*

[13]Dubois de Saint Gelais, *Description des Tableaux du Palais Royal etc.* (Paris, 1727), p. 473; he stated in the margin: "brought from the cabinet of the King of Spain by the Duc de Gramont" (trans.).

[14]Buchanan, *Memoirs of Painters* (London, 1824), I, p. 112.

[15]Bode confirmed this in a conversation with the compiler (August 1928).

OTHER AUTHORITIES

Berenson, *The Venetian Painters of the Renaissance* (3rd ed., New York and London, 1909), p. 141; *Venetian School* (1957), I, p. 184.

Crowe and Cavalcaselle, *op. cit.*, II, pp. 322-24; p. 283, note: "the 'Diana and Actaeon' and the 'Calisto,' together with the 'Europa' were given by Philip the Fifth (1704) to the Marquis of Grammont who took them to France."

Fischel, *Tizian* (1926), p. 198.

Fredericksen and Zeri, *Census* (1972), p. 201.

Freedberg, *Painting in Italy, 1500-1600* (1971), pp. 348-49; he gives the finest criticism of the series of *poesie*.

Fry in *Noteworthy Paintings*, pp. 170-72.

Keller, H., *Tizians Poesie für König Philipp II von Spanien* (Wiesbaden, 1969), pp. 162-68 and 175-77; he presents the picture as an allegory of Philip's rule over Europe.

Lafenestre in *Noteworthy Paintings*, pp. 167-69.

Pallucchini, *Tiziano* (1969), I, pp. 160-63, 166 and 312-13.

Panofsky, *Problems in Titian* (New York, 1969), pp. 163-66.

Pope, Arthur, *Titian's Rape of Europa* (Harvard University, 1960), 62 pp., a study of the composition and the mode of representation.

Rosand, D., in *New Literary History*, Vol. III (1971-72), pp. 527-46; he gives a balanced and learned account of recent discussions of the picture's origins in literature and art.

Shapiro, Maurice L., in *Gazette des Beaux-Arts*, LXXVII (February 1971), pp. 109-16; he discusses allegorical interpretations, suggesting that the picture illustrates the Stoic philosophy, the virtue of disengagement from the "four perturbations": joy, fear, desire, pain. He concludes that Titian was indebted to Horace.

Valcanover, F., *Tutta la Pittura di Tiziano* (1960), II, p. 44.

Vasari, *Le Vite* (ed. Milanesi, Florence, 1881), VII, p. 452; he described at length the effect of these paintings on contemporaries.

Venturi, L., *Pitture Italiane in America* (1931), Pl. CCCLXXXVII.

Francesco Torbido — *A Lady in a Turban*

Exhibited 1857, Manchester Art Treasures, No. 259 (label on back); 1876, London, R. A., Old Masters, No. 123 (label on frame); 1888, London, R. A., Old Masters, No. 134 (label on frame).

Engraved by V. Le Febre (1682) and J. L. Delignon.

Versions: (1) Madrid, Prado Museum, No. 1693, canvas, 1.81 x 2.00, copy painted by Rubens in Madrid in 1628 and bought from his estate after his death in 1640 by King Philip IV. (2) London, Wallace Collection, No. P5, canvas, 0.59 x 0.72, copy by a Spanish painter of the seventeenth century; from the sales of Sir Joshua Reynolds, P.R.A. (1795), Sir Francis Baring (1807), W. Young Ottley (1811), Dawson Turner (1852), and G. T. Braine (1857, bought for Lord Hertford). (3) London, Dulwich Gallery, No. 273, canvas, 0.460 x 0.560, a copy. (4) Rokeby, Yorkshire, Mrs. Donovan (1896), a copy (Herbert Cook in *Gazette des Beaux-Arts*, 1896, II, p. 340). (5) Boston, Isabella Stewart Gardner Museum, pen and water colour on paper, 0.34 x 0.40, a copy by Van Dyck of Rubens' copy (No. 1, above), exhibited on the table below Titian's original. (6) Chicago, Art Institute, panel, a free version by David Teniers, from the C. L. Hutchinson collection.

Francesco Torbido

Born in Venice about 1483; died at Verona 1561-62. His father was Marco India da Venezia. The nickname TORBIDO (turbid) belonged to him early, and he also acquired, presumably from his complexion, that of IL MORO (the Moor). His portrait of an old man at Naples is inscribed: *Franc⁸ Turbidus detto el Moro V.*

He came to Verona in his youth and was, according to Vasari, the pupil of Liberale (q.v.), who made him his heir. Certainly his daughters inherited from Liberale. *The Boy with a Rose* signed *Turbidus*, now at Munich, is dated 1516. Ten years later he was painting at Verona the frescoes in S. Maria in Organo. The altarpiece from there, said by Vasari to have been painted later for Giacomo Fontanella, is now in the Neues Palais at Potsdam (the lunette at Munich). The great altarpiece, *The Madonna with SS. Raphael and Apollonius, with the Trinity*

above, in S. Fermo Maggiore, Verona, is signed and dated 1523; the frescoes with *The Life of the Virgin* in Verona cathedral 1534; those in the choir of the church at Rosazzo in Friuli, now much repainted, 1535. Ten years later Torbido returned to Venice. In 1547 he painted for the Scuola della Trinità *The Creation of the Birds,* now in the depot of the Ducal Palace, part of a cycle from Genesis to be completed by Tintoretto; and in 1550 he was restoring some paintings for them. By 1557 he was at Verona again.

He began as an adherent of the Venetian painters, and, though his colour was always timid, he produced in *The Boy with a Rose,* modelled upon Giorgione, or in the portrait below, modelled upon Titian, an imitation which has some of the moving qualities of the originals. When he came to design frescoes upon a large scale he took as his example the stylised draughtsmanship of Giulio Romano or others from the studio of Raphael in Rome, who had stereotyped their principles of design and their idea of what was Classical in expression. The academicism of Torbido's frescoes invades his later canvases. Their hardness of colour and execution affects even the portraits of his later years in Naples and Milan.

A LADY IN A TURBAN *Titian Room*

Oil on canvas, 0.79 x 0.64. The surface of the paint is somewhat rubbed, especially in the shadow of the neck and jaw and in the blacks.

The attribution to Torbido is somewhat tentative. Made for the first time in the 1931 Catalogue, it is based upon comparison with *The Boy with a Rose* at Munich, signed by him and dated 1516, and with the *Paris (?)* at Padua, long attributed to him by various authorities. It resembles them in the pose, with the left shoulder looming uncomfortably large, the right proportionately small and the head slightly inclined; in the modelling of the features, with their expectant air, in the neutral colouring and in the actual condition of the paint. Evidently this picture is a little more mature, and follows more closely the model of some portrait painted about 1520 by Titian. It is conceived with something of Titian's breadth of character and composition; but there is not the same vitality, and the large outlines form a silhouette less bold. There are signs of hesitation. The gold chain which appears upon the left shoulder vanishes into vagueness; perhaps it was once painted over; and it can be seen how the first low outline of the shift proved too décolleté and was raised. The little freedoms of handling upon the frills are timid and uncertain; there is little more colour than a dull blue-grey and the pigments themselves are thin. These

are characteristics equally of Torbido's signed portrait at Naples, *An Old Man in Black.*

The *Lady in a Turban* was acquired by Antonio Scarpa, a well known surgeon who built a gallery for his collection at Motta in the Veneto. At the sale of the collection, 14 November 1895 in Milan (Galleria Giulio Sambon, No. 62, *Ritratto di donna vestita in nero con guanto in mano*), it was sold as the work of Titian. Mrs. Gardner bought it in March 1896 from Colnaghi, London, through Berenson. He attributed it to Polidoro Lanzani, recommending it particularly as a portrait of Isabella d'Este. *P26w7*

AUTHORITIES

Berenson, *Venetian School* (1957), I, p. 142: "Polidoro da Lanciano. Portrait of Isabella d'Este."

Fredericksen and Zeri, *Census* (1972), p. 246, as Venice, sixteenth century.

Constant Troyon

Born at Sèvres, near Paris, 1810; died in Paris 1865.

His father painted porcelain at the Sèvres factory, and his own colours were first applied to the same purpose. In 1833 he first exhibited at the Salon: two more or less topographical views. Ten years later, a

Constant Troyon — *A Cottage by a Ford*

painter of pure landscape, he may be accounted a member of the Barbizon School. A visit in 1847 to Holland, where he admired the work of Adriaen van de Velde and Paul Potter, confirmed his penchant for including cattle and sheep in his landscapes; and it was for this that he became famous, first in Holland and Belgium, then in France; and in the United States. He was very highly regarded. Théodore Duret wrote to Manet from Liverpool, 7 July 1871 (trans. Rewald): "I also saw in Boston some very beautiful Troyons. . . . A Courbet [*La Curée*, now in the Museum of Fine Arts] and some Troyons compensate for many errors in taste." Troyon is well represented, but little exhibited, in the Louvre.

A COTTAGE BY A FORD *Yellow Room*

Pastel on paper, 0.39 x 0.30. Signed with initials in the lower left corner: *C.T.*

Influenced by Millet, this is perhaps a comparatively late work.

The pastel was framed in New York. *P1e11*

Cosimo Tura

Born presumably in Ferrara, about 1430; died there 1495.

He is first recorded in 1451: at Ferrara, already working for Duke Borso d'Este, who from the following year paid him a regular salary for twenty years. The Este had governed Ferrara for two centuries, and in the fifteenth, under the successive rules of three brothers, Leonello, Borso and Ercole, it became one of the centres of humanism. About 1449-50 two of the greatest painters were at Ferrara, Rogier van der Weyden and Piero della Francesca (*q.v.*). Probably it is to Piero's strength of form that Tura owes the solid power which underlies his mannered outlines and decorative colour, and makes him, at his best, a monumental artist. It is, however, from the ferment at Padua that his style was brewed. Uccello, Castagno and Donatello had brought the Renaissance from Florence to Venetian territory. The young artists of the region gathered there to see the precocious fruit it bore in Mantegna's frescoes in the Eremitani church. Tura throughout his career peopled with overbred descendants of Mantegna's characters the landscapes of chiselled granite which he inherited from these frescoes. He discovered in them his own love of greens and purples.

From Padua the young artists carried their individual interpretations of the new ideas into the different regions of northeast Italy: Mantegna (*q.v.*) himself to Mantua, Crivelli (*q.v.*) to the Marches, Tura to Ferrara. In the capital of the little state Tura's mannerism was encouraged by the decorative function which he had, above all, to fulfil. Like Mantegna at the Mantuan court, he was well rewarded and rhymed by the poets. But he was constantly employed in devising every pomp and luxury for the heads of the state, their coverlets and cushions, their plate and their parade armour, their tournament trappings for man and beast, their marriage beds and funeral catafalques. Thus his paintings on panel or in fresco were comparatively few, and of what has survived not much records the patronage of the Este. There are records of a large number of commissioned portraits; but only the little *Portrait of a Boy*, an early work now in New York, could be one of these. Of all the decorative painting done for Borso or for Ercole there survives from Tura's hand only perhaps the *Allegorical Figure* in London. This may be from Belfiore, a palace on the edge of Ferrara. *In situ* are only the frescoes in the Schifanoia palace in Ferrara, incomplete and much deteriorated. Tura probably supervised the work of several painters who decorated the walls of the great hall there in 1469-71; but he can hardly be blamed for the lack of unification in the four tiers of small compartments found necessary to express the ideas invented probably by the court historian-astrologer. The five *Allegories* ascribed to Tura himself are the most demonic; for he entered readily into their rather sinister spirit. They are less gay and brilliant than those done by his junior Francesco Cossa, even if Cossa did owe much to his training. It is possible that the four small figures in Washington are from a portable altarpiece by Tura which was given to Duke Ercole, who succeeded in 1471.

Fortunately others commissioned pictures for the churches of Ferrara. For Antonio Cicognara, Tura painted in the early sixties *The Madonna, between S. Apollonia and S. Jerome* now in Ajaccio. It is now on canvas, and the three little panels connected with it by Ruhmer must therefore, if he is right, come from the frame: *The Virgin Annunciate* in the Colonna Gallery, Rome, *S. George* in Count Cini's collection, Venice, *S. Maurelius(?)* in the Poldi Pezzoli Museum, Milan. For the cathedral Tura painted in 1468-69 the great organ-shutters with *The Annunciation* and *S. George and the Dragon*. For the Roverella family he painted, probably not long before 1480, the great altarpiece for S. Giorgio, Ferrara, of which the central *Madonna with Angels* is now in London, the lunette with *The Pietà* in Paris, *SS. Paul and Maurelius with a Donor* in the Colonna Gallery, Rome, and a fragment with the head of *S. George* in San Diego, California. The

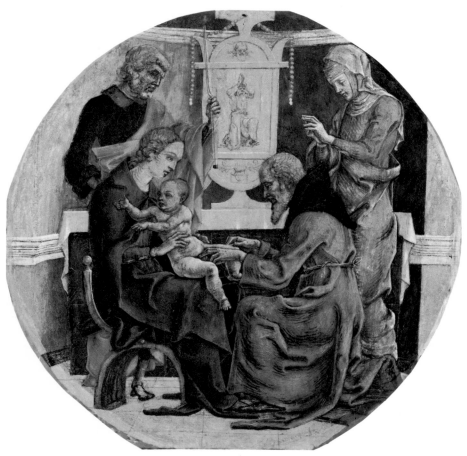

Cosimo Tura — *The Circumcision*

great *S. Anthony of Padua* now in Modena, is probably the picture that Tura painted for S. Niccolò, Ferrara, in 1484. This is one of the monumental figures of the early Renaissance. It shows the continuous development of his powers within the limits set by the artificiality of his conceptions; and prompts the wish that less of his life's work had been devoted to the pageantry of the court. He must have done much to make it gay. Perhaps he had more part than is recorded in mounting the performances of classical drama for which it was famous, and in enhancing the sophistication of Duke Ercole's two famous daughters, Beatrice and Isabella.

THE CIRCUMCISION *Early Italian Room*

Tempera and (?) oil on wood, the painted surface circular, 0.391 x 0.382. Cleaning in 1945 revealed that the paint is much worn. Also its increased transparency has made Tura's method more obvious

than he intended it to be. The green tunic of S. Joseph, who holds a taper to the scene, has gone very dark.

The circumcision is not described in the New Testament, and is only mentioned parenthetically by S. Luke (2:21) as the occasion for the naming of Jesus. A rite prescribed by the Mosaic law, it was essentially Jewish. In the fifteenth century, however, it became a popular subject for pictures, probably with the growth of the legend of Mary, being included among her sorrows. In Tura's great *Madonna* in London, from S. Giorgio, Ferrara, motifs from the New Testament and the Old are carefully combined in the elaborate design of the throne, its sides being faced with tablets inscribed in Hebrew with words from the Ten Commandments. These tablets are of the same unusual and striking design as the tablet on the altar in *The Circumcision*, though here the reminder of the Ten Commandments is represented by the carved figure of Moses kneeling to receive

them, and the hand of the Eternal Father in the lunette above.

The Circumcision makes one of a series with two panels of the same shape and dimensions: *The Adoration of the Kings* in the Fogg Art Museum, Cambridge, and *The Flight into Egypt* in the Metropolitan Museum, New York.

Gardner in 1911 suggested that the three panels were painted for the predella of the altarpiece in London;[1] but Girolamo Baruffaldi's *ms. Life of Cosimo Tura,* believed to have been written about 1706, before the dismemberment of the altarpiece of which the *Madonna* was the centre, states that this predella had scenes from the lives of SS. Bernard and Benedict.[2] Such reminders of the Mosaic law are unusual, and the temptation to link *The Circumcision* with the S. Giorgio altarpiece is a strong one; but the three panels would not go easily anywhere else on the frame. They differ somewhat in style from the *Madonna,* appearing to be earlier; but there are comparatively few cases in which the change of scale has not led to differences in the artist's way of painting.

The Circumcision was in the collection of Prince Santacroce in Rome;[3] then in that of the Contessa Passeri. From the Contessa it was bought by Mrs. Gardner through Richard Norton in January 1901.

P15s3

[1]Gardner, *The Painters of the School of Ferrara* (London and New York, 1911), p. 208, note.

[2]Davies, *National Gallery Catalogues, The Earlier Italian Schools* (2nd ed., 1961), pp. 513-17.

[3]Ruhmer, *Cosimo Tura* (1958), pp. 41, 83 and 177-78.

OTHER AUTHORITIES

Berenson in a letter (4 February 1930); also *Central Italian and North Italian Schools* (1968), I, p. 432.

Borenius in *Crowe and Cavalcaselle's History of Painting in North Italy* (London, 1912), II, p. 230, note.

Fredericksen and Zeri, *Census* (1972), p. 205.

Gruyer, *L'Art Ferrarais* (Paris, 1897), II, pp. 71 and 82.

Longhi, *Officina Ferrarese* (1934), pp. 36-38; like Gardner, he suggested that the three pictures came from the predella of the S. Giorgio altarpiece.

Salmi, *Cosmè Tura* (1957), p. 31; he supported Longhi's argument for the provenance.

Schubring, *Cassoni* (Leipsic, 1915), p. 151; he suggested that the three panels were painted for the cover of a baptismal font.

Venturi, A., in *L'Arte,* XI (1908), pp. 420-21; he dated the three pictures late in Tura's career.

Venturi, L., *Pitture Italiane in America* (1931), Pl. CCLXI; he suggested that the three panels were from a cassone.

J. M. W. Turner

JOSEPH MALLORD WILLIAM TURNER: born in London 1775; died there 1851.

He was the son of a barber, in whose shop near Covent Garden his watercolours were first exposed for sale. From 1789 until 1793 he studied in the Royal Academy Schools. He also learned from the topographical watercolorist Thomas Malton. He exhibited at the R.A. regularly from 1790; at first a single watercolour, in 1796 watercolours and one oil: *Fishermen at Sea off the Needles,* now in the Tate Gallery, London. At these exhibitions the oils gradually supplanted the watercolours; but he continued all his life to develop and refine the water colour technique. In this peculiarly English technique he never overreached himself, and can be proclaimed the supreme master.

Already in 1799 he was elected A.R.A.; in 1802 R.A. His early recognition was due to his facility in working in established styles. In 1801 the R.A. "picture of the year" had been the *Dutch Boats in a Gale,* painted for the Duke of Bridgewater as pendant to his seascape by Willem van de Velde (1633-1707). The two now belong to the Duke of Sutherland. Turner made a small, superior replica of his own seascape, now in the Public Library at Malden, Massachusetts. He outdid his Old Master models in spectacular power. Thus his *Dido Building Carthage* was painted in 1815 in open emulation of Claude (1600-82), and subsequently bequeathed to be hung beside Claude in the National Gallery. It contrasts unhappily there with the French painter's gentle nostalgia. It took longer to develop the original, unselfconscious faculties which made Turner, from some fifteen years later, the subject of contemporary criticism and, in retrospect, the most admired of English painters. While he was exhibiting ambitious histories in oil, fulfilling numerous contracts for engraved illustrations to books, himself publishing in instalments from 1806 to 1819 his engraved *Liber Studiorum,* he was also painting freely in oil and water colour studies from nature which are long ahead of their time in their observation of colour values.

A student of earth and sky and water and of their unity in the atmosphere, he travelled and noted continually. In 1802 he went abroad for the first time, travelling in Switzerland and returning via Paris and the Louvre. In 1817 he toured Belgium and the Rhineland. He was in Italy in 1819, and 1829, trudging over the Alps on foot. The English poets were singing the beauties of nature; the landlords were embellishing their inherited landscape. Turner had many wealthy supporters among them:

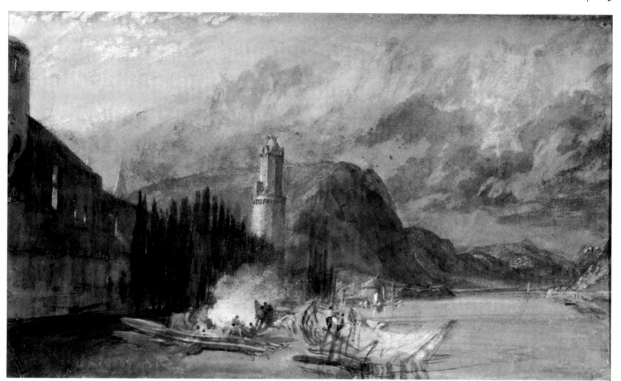

J. M. W. Turner — *The Roman Tower, Andernach*

in particular Mr. Fawkes (see below) of Farnley, Yorkshire, and Lord Egremont of Petworth, Sussex. It was at Petworth that he made some of his most revolutionary experiments in colour, which he extended to pictures of Venice. At the R.A. in 1833 these drew mostly abuse from the critics.

Turner is often compared with the Impressionists. Indeed he was before Monet in spending a life-time studying nature out of doors, in particular the colour of light. There is a vast difference, however, in their outlook, their history and their methods. Turner is the first great painter of the Romantic Movement, giving poetical titles to his pictures, from 1812 often publishing with these quotations from his own inarticulate poem *Fallacies of Hope*. Monet drew ever closer to nature in sensuous contact, painting to the last moment out of doors to catch her mood. Turner probably never painted even a watercolour in the open air. Rather, he made studies all day and worked with these, often at night, in his studio. Whether he was constructing histories or purely atmospheric scenes, he had to bend nature to his will. He takes us into a dreamy realm, beyond and above our own sensuous experience.

Never a society man, Turner, in spite of Ruskin's enthusiastic support in the first volume of his *Modern Painters*, published in 1843, became increasingly a recluse, living finally in Chelsea, where he died under an assumed name. Of the huge Turner Bequest, including some 20,000 pictures and drawings, the oils are mostly exhibited at the Tate Gallery, London, the watercolours mostly housed in the British Museum.

THE ROMAN TOWER, ANDERNACH

Yellow Room

Water colour on paper, 0.20 x 0.28. An inscription at the foot on the left is illegible (probably it stands for "J M W Turner R A"). In other respects the condition is good, the colour little faded.

The river is the Rhine. Andernach, some ten miles below Coblenz, was founded on its left bank as a Roman stronghold. Turner must have been there during the last ten days of August 1817. For the second time he made a brief tour on the Continent that year, leaving Margate 11 August for Antwerp, and returning probably from Rotterdam about five weeks later. After visiting Waterloo and making

sketches on the scene of the battle of two years before, he arrived at Cologne 18 August. He was back at Antwerp by 2 September, having gone up as far as Mainz on or along the river. He spent two days at Coblenz on the way up, and at least a night on the way down again. During this Rhineland tour he walked a great deal and must have made innumerable topographical drawings and colour notes. In mid-November he went to Farnley, Yorkshire, to stay with his friend and patron Walter Ramsden Fawkes, M.P. for a time, writer, abolitionist. In the interval since his return from abroad Turner had been on the move in the north of England and doing other work; but also during this period, and no doubt at Farnley, he produced more than forty watercolours, mostly on this small scale, based on the Rhineland material.[1] They were bought by Walter Fawkes as a group at Farnley.

There the series remained for three quarters of a century, together with a large number of other watercolours and oils. In 1889 Ayscough Fawkes lent forty-one Rhineland watercolours by Turner, including this, to the R.A. in London. Ten years later these were sold, together with others, at Christie's. *The Roman Tower, Andernach* was bought for Mrs. Gardner at this sale (27 June 1899, London, Christie's, No. 28). *P1e12*

[1]Finberg, *The Life of J. M. W. Turner, R. A.* (2nd ed., Oxford, 1961), pp. 249-50.

Exhibited 1899, London, R. A., No. 65.

Tuscan (?); 1350-1450

See Paolo di Giovanni FEI, studio of, and FLORENTINE; 1375-1425

John Henry Twachtman

Born in Cincinnati, Ohio, 1853; died at Gloucester, Massachusetts, 1902.

His parents were German-born; and, after studying at the University of Cincinnati School of Design, he went with Frank Duveneck, the son of family friends, to Munich. For the greater part of ten years, 1875-84, he remained in Europe: in Munich 1875-77, Venice 1877-78, 1881 and 1884, Florence 1880, Paris and Normandy 1883. In Munich he studied under Löfftz, in Paris under Lefebvre and Boulanger at Julian's. Returned to America, he spent most of his time at Greenwich, Connecticut, where he bought a house in 1889.

He painted as much as possible directly from nature, though at first with the thick paint and the chiaroscuro of the Munich School. By the time

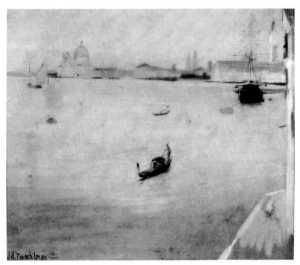

John Henry Twachtman — *The Lagoon, Venice*

he settled at Greenwich he had completely adopted Impressionism, muting its exuberance with low-toned harmonies derived perhaps from Whistler. He exhibited as one of the group, Ten American Painters, mostly drawn from Boston and New York.

THE LAGOON, VENICE *Macknight Room*

Pastel on paper, 0.34 x 0.40. Signed at the foot on the left: *J. H. Twachtman —*.

The artist was in Venice first in 1877, when he spent a whole year there, and last probably in 1884. *P11s34*

Uccello

PAOLO DONI: born in Florence about 1397; died there December 1475. Son of Doni di Paolo, a barber-surgeon from Pratovecchio, and his wife Antonia. He accepted his nickname UCCELLO (bird, or, in slang, cock) in his few signatures on paintings.

By 1407 he was apprenticed to the sculptor Lorenzo Ghiberti. He remained in this workshop, forcing ground of Florentine genius, perhaps until 1415, when he was admitted to the Physicians' Guild. The Venetian Senate had sent to Florence for mosaic workers, and in 1425 Uccello went to Venice in response. He remained in the Veneto until 1431. He seems to have returned to Florence in connection with mosaics in the cathedral; but his earliest work there now is a fresco of 1436: the great equestrian effigy in monochrome of the English *condottiere, Sir John Hawkwood*. This, in

the new style of the Renaissance, is the only fresco by Uccello which is preserved whole. The upper tier in a bay of a cloister of S. Maria Novella, Florence, with *Three Scenes of the Creation* and *The Fall* may have been painted before his departure for Venice; a ruined series of *Scenes from a Monastic Legend* in S. Miniato not long after his return. In the interval Masaccio had revolutionised painting, and Uccello was quick to follow. At S. Miniato he is already a considerable master of artificial perspective. He brought this mastery to perfection in the four famous scenes of a later fresco at S. Maria Novella: *The Flood* and *The Grounding of the Ark; Noah's Sacrifice* and *Noah's Drunkenness*. Perspective is no less scientific because it is unobtrusive in the six little scenes of *The Story of the Profanation of the Host* at Urbino, 1465-68. These formed the predella to the altarpiece there which was painted by Justus of Ghent after Uccello's design for the large panel had been rejected.

These little pictures on panel are well preserved, and so are two others probably of the same late period in Uccello's life: *S. George and the Dragon* in London and *The Hunt by Night* at Oxford. All three pictures are virtually signed with a crescent moon, and all three are endowed by its faint light with a fantastic quality characteristic of the painter. It seems to imbue already the three large scenes of *The Rout of San Romano* which were painted probably in the late fifties to decorate the Medici Palace in Florence and are now divided between Florence, Paris and London.

Since 1446, at latest, Uccello had lived in Florence. In a tax return of 1469 he complained of being old at seventy-three, of the youthfulness of his son Donato at sixteen and of the infirmity of his wife. One hopes that this prudent statement was the only basis of Vasari's story that he died in poverty.

His long life covers the most adventurous and varied period of Florentine art. He grew up with the architect Brunelleschi, the sculptor Donatello and the painter Masaccio (*q.v.*), all students of antiquity and masters of perspective. He was the friend of the mathematician Manetti, with whom, according to Vasari, he could dispute Euclid upon equal terms. In lauding the naturalism of his landscapes and animal studies and his passion for perspective, and damning the unnaturalness of his colour Vasari is perhaps missing the point: that Uccello was a designer, to whom everything was grist to the mill provided that it made a richer and more exciting blend. In his famous scenes of *The Flood* it is not the correctness of the perspective

which matters. It is his use of it. The perspective creates not only the design but the expression. With its dramatic immensity it shows up humanity in all its feckless pathos. This is very different from the grand humanist pathos of Masaccio. There is no "message" in Uccello's art; only a humorous scepticism, which seems to grow upon him, if it is fair to compare small late pictures with large early ones. It is no accident probably that no Madonna certainly by him has survived, nor any picture which is religious in anything but title. His predella at Urbino was accepted, for a certain licence was almost traditional in such pictures, but not his altarpiece. Emphasis was put upon the solemnity of the painter who was the final choice.

About his art itself Uccello had no scepticism. The Medici battle scenes are finished to the last detail with a refinement which can hardly have been appreciated where they were hung. Decorations for a palace had to be sensuous and gay, and Uccello's furious knights, armoured in white gold and mounted on horses of every colour, are deployed on a pink foreground against a hedge of rose — and orange — trees. The naturalistic criterion of Vasari has no validity in the face of such a complex of design elements, synthesised with a skill which leaves no inch of surface without a dynamism of its own or without a clear function in the whole design. There is energy in Uccello's every line.

A YOUNG LADY OF FASHION *Long Gallery*

Oil (?) on wood, 0.44 x 0.32. The scant remains of the original background, of azurite blue, have been overpainted in black. During cleaning in 1972 overpainting was removed from the dress, which had been modified by the addition of a cherry-coloured slip round the neckline of the blue gown. The original surface is much worn, except in the damask of the sleeve. A fundamental loss between the eye and eyebrow had to be made good.

The attribution to Uccello was first made in 1930 by Lionello Venturi[1] and was accepted in the first edition of this Catalogue in 1931. In 1933 Offner attributed the portrait to the "Master of the Castello Nativity,"[2] a still anonymous artist whose *oeuvre* had been reconstructed by Berenson round a *Nativity* at one time in the Villa Reale at Castello near Florence and now in the Accademia there. Berenson himself never included the portrait among this master's works, but attributed it consistently to the Florentine Domenico Veneziano.[3] Offner's attribution was repeated by Pope-Hennessy in 1950,[4] but stated more tentatively in 1966. He writes:

"The attributions to Uccello and Domenico Veneziano rest on a misestimate of the quality of the two panels."[5] The other panel in question is the *Profile Portrait of a Lady* in the Metropolitan Museum, New York, recently catalogued by Zeri as by the "Master of the Castello Nativity."[6] Published in 1971, Zeri's is probably the latest pronouncement on the subject, as well as the first to include positive arguments for the attribution: "This portrait [in the Metropolitan Museum] clearly shows the characteristics of the Master of the Castello Nativity, especially in the drawing of the face, the texture of the paint, and the peculiar pale shadow around the eye. . . . One in the Isabella Stewart Gardner Museum in Boston . . . is very close in style and composition to ours, and, like it, shows the luminous harmony of color and form that the artist adapted from the work of Domenico Veneziano, rather than the reflections of Paolo Uccello that some scholars claim to see in these two pictures." Since this was written both portraits have been cleaned of old surface coatings which had considerably distorted their colour and texture, and dimmed their distinctive luminosity. The cleaning has shown that they are by the same hand, but the similarities of costume and treatment now emphasise all the more the intense difference in characterisation. Any comparison with the work of the "Master of the Castello Nativity" in the drawing was always difficult to see. The *Nativity* itself is a conventional picture and the few paintings undoubtedly by the same hand (but some of them superior to it in quality perhaps owing to their better surface condition) have the same quiet harmony and timidity of expression. A good example is the *Madonna and Child with Two Angels* in the Fogg Art Museum. The two profile portraits on the contrary are daring and original in their witty presentation of character, in the strength of their colour and, above all in the tenseness of their outlines. The "misestimate of their quality" by those who attribute them to a mediocre artist may be partly explained by their former surface condition, and perhaps in the case of the Gardner picture by the hanging and the lighting. This is a picture of which the vibrant energy, of a type unique to Uccello, grows stronger in the light and makes itself felt across a wide space. Comparable with the predella painting in Urbino, it probably belongs to a late moment in his career.

The picture was sold in Paris by an Italian dealer to Böhler and Steinmeyer. From them it was bought by Mrs. Gardner in April 1914, presumably on Berenson's recommendation, as the work of Domenico Veneziano. P27w58

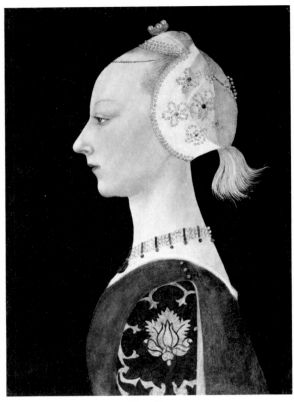

Uccello
A Young Lady of Fashion (SEE COLOUR PLATE)

[1]Venturi, L., in *L'Arte*, New Series, I (1930), pp. 52-87.

[2]Offner in *The Burlington Magazine*, LXIII (1933), p. 178, listed the picture among his attributions to the "Master of the Castello Nativity," adding in footnote 38: "I must say only that the colour . . . is identical with that of the body of the Castello Master's work."

[3]Berenson in a certificate letter to Steinmeyer (New York, 22 January 1914), in a letter to the compiler (Settignano, 4 February 1930) and, posthumously, *Florentine Pictures of the Renaissance* (1963), I, p. 61 and II, Pl. 702, attributed the picture to Domenico Veneziano.

[4,5]Pope-Hennessy, *Paolo Uccello* (1950), p. 150: "These female portraits . . . are by the Master of the Castello Nativity"; and *The Portrait in the Renaissance* (1966), pp. 40-41: "there are quite a number of portraits of women (in the Metropolitan Museum in New York, the Gardner Museum at Boston . . .), whose crudeness and conventionality would be inexplicable if we supposed that they resulted from the conjunction of live sitters and live artists"; p. 309, note 62: "The two portraits date from the third quarter of the fifteenth century and are by a single hand . . ."; and p. 340 as "Master of the Castello Nativity(?)."

[6]Zeri, *The Metropolitan Museum of Art, Italian Paintings, Florentine School* (1971), pp. 114-16.

OTHER AUTHORITIES

Fahy, in a letter to the Director of 16 April 1973, attributes it "definitely" to the "Master of the Castello Nativity."

Fredericksen and Zeri, *Census* (1972), p. 126; they attribute it to the "Master of the Castello Nativity."

Freedberg, in comments in a letter of 22 May 1973, agrees with Fahy.

Sindona, Enio, *Paolo Uccello* (Milan, 1957-59), p. 63, among *Opere Attribuite*, which probably signifies works not attributed to Uccello by the author.

Velázquez

DIEGO RODRÍGUEZ DE SILVA Y VELÁZQUEZ, born in Seville 1599; died in Madrid 1660.

Son of Juan Rodríguez de Silva and his wife Geronima Velázquez. About 1612 he went as pupil to Francisco de Herrera, and in 1613 to Juan de Pacheco, a history painter who became his first biographer. He married Pacheco's daughter Juana in 1618. Their daughter Francisca was to marry his pupil del Mazo. The accession of Philip IV drew all Seville to Madrid, for Olivares, the ruler of all, was a Sevillian. The first visit of Velázquez in 1622 was premature; but in 1623 Olivares summoned him to court. His place was there for the rest of his life. He became virtually Court Painter, with a pension, a house and a studio in the old palace. He was made an Usher of the Chamber, to give him formal rank and approach to the King. When Rubens was in Madrid on his diplomatic mission in 1628-29, Velázquez was detailed as his cicerone. Evidently Rubens prompted him to get leave to study in Italy. Crossing in August 1629, he travelled from Genoa to Venice, to study and copy Tintoretto (q.v.). Thence he went via Bologna and Cento, where Guercino had his studio, to Rome. There he was lodged in the Vatican and in the Villa Medici. At Naples he painted Philip's sister the Infanta Maria Anna, on her way to marry the King of Hungary. A sketch of the head is in Madrid.

He returned to Madrid in 1631 to organise the decoration of Philip's new palace, the Buen Retiro. He painted *The Surrender of Breda* and the royal equestrian portraits now in the Prado. Then the Torre de la Parada, a hunting lodge, had to be rebuilt and decorated. A gallery of pictures was ordered from Rubens. Velázquez about 1634-35 supplied the three shooting portraits *King Philip*, *Infante Fernando* and *Don Baltazar Carlos*, a few years later the *Menippus* and *Aesop*, now all in the Prado, and the *Philip IV Boar-hunting* in Lon-

don. The fall of Olivares caused a lapse in the festivities. In 1644 Velázquez accompanied his royal master towards the front against France, and painted at Fraga the three-quarter length *King Philip IV in Gala Red* now in the Frick Collection, New York. In 1649 plans for a Spanish Academy and extensions to the palace sent him again to Italy in search of pictures by Veronese and Tintoretto. In 1651, after buying pictures in Venice and painting *Pope Innocent X* in Rome, he obeyed the King's many summonses to return. Next year he was made Grand Quartermaster, and later a Knight of Santiago. Ordering not only the palace but the royal progresses, he arranged the details of the meeting of Philip IV and young Louis XIV in June 1660 on the frontier between Spain and France, where the Treaty of the Pyrenees was clinched by Louis' marriage with the Infanta Maria Theresa. He died of fever on his return to Madrid.

Velázquez was one of the most independent of artists, the only Spaniard prompted to paint, like Vermeer or Chardin, by the mere sight of familiar things. There are several youthful religious pictures — an *Adoration of the Kings* in Madrid is dated 1619 — but his most interesting early works are the kitchen pieces. These groups of pots and pans are unique in the sheer tangibility of their rough shapes and wholesome colours. *The Supper at Emmaus* in New York, his one expressive religious composition, shows the influence of Caravaggio (1573-1610), and in all these a cold light casts the heavy black shadows of the Italian *Tenebrosi*. But Velázquez already gives most of his calm consideration to the coloured masses, to their arrangement and the careful shaping of their outlines. He carried this honest manner to court, and the *Bacchus* now in the Prado, painted for the King before his first visit to Italy, is an expression not of classical elegance but of Spanish peasant life. Prose and poetry are curiously mixed, composition still unpolished; but the unleavened paint, the simple colours and hard light have the strength of the shadeless Spanish soil and its thirsty labourers. Italy washed the soil from his hands, but it could not teach them its gestures. Velázquez could not invent even a drapery, and the *Joseph's Coat*, now in the Escorial, and *The Forge of Vulcan* in Madrid, brought back by him from Rome, are only skilful realism. Spain was the declared enemy of ideas, and the royal family, whom it was his first duty to paint, were trained to maintain impassive masks. The ecstasy of El Greco, the great painter of the Counter-Reformation, had no message for him. He continued to develop and refine his own keen perceptions. These can hardly be called prosaic when

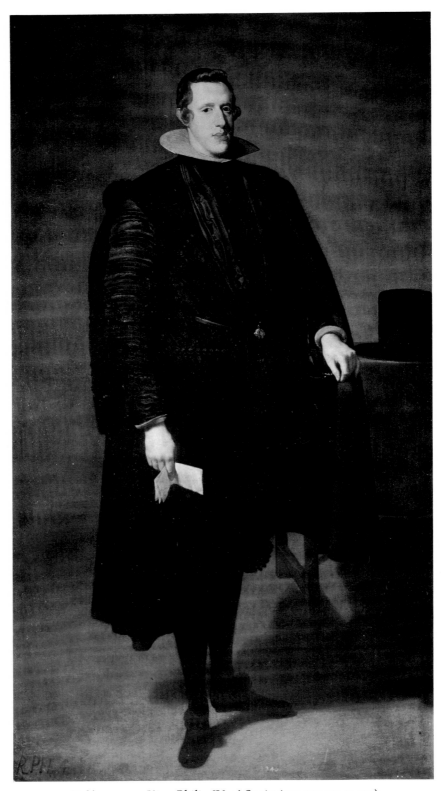

Velázquez — *King Philip IV of Spain* (SEE COLOUR PLATE)

he was able to endow either man or beast, and above all the dwarfs who were kept for court amusement, with the extraordinary detachment and dignity which must have been his own essentials. Under the influence of Titian, whose works filled the royal palace — *The Rape of Europa* in this collection was there and was copied by Velázquez in the background of *Las Hilanderas* — his brushwork learned by degrees a unique economy and refinement. As his colour deepened, so did the whole expression of his art. The entire tragedy of the Spanish kings lies in the *Head of Philip IV* in London and in the series of portraits of royal ladies and children in Vienna and Madrid.

In these last pictures the colours seem to have been breathed onto the canvas, the forms being moulded only by transitions of tone so slight as to be hardly perceptible, yet so subtle that they suggest the very material. Velázquez had developed a novel conception of visual relationships. The tradition of painting had grown up in the drawing school, its strongest means of expression forged by emphasis of the plastic element, of the dimension in nature which is probably less seen with the eye than perceived with the brain. In Venetian painting line ceased to be the great symbol of expression; but romantic emphasis of light and shade further exaggerated the solidity of form and extended it into deeper space. Velázquez laid all the emphasis upon colour values, noting them exactly and building up his compositions through their relationship. He left no drawings of significance, for he saw things as colour, and painted them so directly. His art is the result of applying Titian's free colouring to an exceptionally acute observation largely unaffected by the tradition of the Renaissance. Thus from the deadness of Madrid came the freshest of life. When the Renaissance had been at last exhausted, modern French painters discovered in the Spaniard a method of vision capable of infinite development. After *The Surrender of Breda* Velázquez had painted only two elaborate compositions, the great portrait group *Las Meniñas* and *Las Hilanderas,* and his vision was applied most consistently only in portraits which contained little more than a figure and a curtain. Manet, Monet and Cézanne were to carry it through the boulevards into the open fields.

KING PHILIP IV OF SPAIN *Titian Room*

Oil on canvas, 2.012 x 1.096. There are inventory inscriptions along the foot of the canvas: in the left corner: *R. PHE. 4* [Re Phelipe IV] in black, and to the right of centre *2340* in white. Cleaning in 1948-49 revealed a badly worn condition of the paint in the left side of the left eye and eye-socket and in the adjoining hair, and a considerable abrasion between the corner of the mouth and the tip of the nose on that side. There are damages also to the right hand and its index finger, and the black is somewhat worn throughout. Various small tears or breaks, the largest through the left forearm, do not affect the general appearance.

Philip Domenic (1605-65), eldest son of King Philip III and Margaret of Austria, succeeded his father in 1621 upon the most glittering throne in Europe. It was not, however, the most comfortable. While Protestant and practical Europe was developing fast, he inherited from his great-grandfather the Emperor Charles V a policy scarcely modified during the century elapsed. As His Catholic Majesty and as a Hapsburg, he was pledged to uphold the Faith and to pour out money in Germany and Italy in the Emperor's support. As King of Spain and Portugal, he had to maintain an awkward empire over the Low Countries, Naples and Sicily, and a large part of the New World. But the treasure from there was falling into the hands of English, French and Dutch pirates, and Spain herself had neither money nor political unity. During Philip's reign industry and commerce, smothered by a taxation innocent of political economy, came almost to a standstill. Catalonia revolted with impunity, and Portugal regained her independence. The United Provinces had to be recognized as the Dutch nation; the German Protestants won their right of worship, and France gained slices of Hapsburg territory.

Philip's personal inheritance was no happier. The burden of government he first laid upon the willing shoulders of the bully Olivares. After the minister's disgrace, his attempt at personal rule ended only in the concealed domination of de Haro. The heavier burden of his conscience he came to share with a nun, pouring out his soul to Sor Maria de Agreda, who gave him the only sound advice he received. The King of Spain must never so much as smile in public; yet Philip scoured the streets at night for dissipation and undignified situations. Had he been a constitutional monarch, his reputation might have been different. He had more than the traditional royal accomplishments: a true aim and a good seat in the saddle. In the golden age of Spanish literature he encouraged poets and dramatists, even himself wrote poetry and plays. Above all, he inherited from his grandfather Philip II not only a great collection of pictures, including Titian's *Europa* (above), but the love of painting. He made great additions to the collection, including Mantegna's *Sacra Conversazione* (above). He employed Rubens

(*q.v.*). His relations with Velázquez may well have been the most natural and the happiest of his life. He is said to have visited the studio daily, and Velázquez to have accompanied him whenever he left Madrid.

The King wears on a riband the badge of the Order of the Golden Fleece. His white collar is the golilla, the silk-covered pasteboard substitute for the extravagant ruff, abolished in 1623.

Cleaning made it clear that the remainder of the picture is not by the same accurate and powerful hand as the head. The picture has always been recognized as a replica of the virtually identical portrait in the Prado. The Madrid portrait has generally been dated about 1628, and it has hitherto been puzzling that, with its obvious superiority in the treatment of the head, it should merely repeat the pose of an earlier *King Philip IV* now in New York, known to have been painted in 1624. Radiography has recently revealed that the head in the Madrid picture was originally as it is seen in the New York version, and that Velázquez repainted it entirely after an interval.[1] The history of these two pictures is thus reversed. The Madrid portrait, which has never left the royal collection, must be the first that Velázquez painted of the King. Pacheco records that he painted the King's portrait 30 August 1623, meaning presumably that he had a sitting on that day for a portrait which would be developed over a period. The New York portrait is evidently a replica of this, painted by Velázquez in the following year. The Gardner portrait is the third version: a replica of the Madrid picture, made after Velázquez had repainted it. By now he may well have acquired assistants in his studio; and he himself evidently painted not much more than the head and hands. It is very likely that he owed to Rubens his great success in remodelling Philip's head in idealised form. Both here and in the Prado original it has lost its flabbiness of flesh and spirit, and acquired elegant and decisive lines. Rubens was at the court in Madrid in the autumn of 1628, and lost no time in painting several portraits of the King. What is probably his first study, a bust portrait now in the Ruzicka Foundation, Zürich, is particularly curvilinear in style.

The Gardner picture is said to have been painted for the Marquis of Leganés, a Guzman, cousin of Olivares, who was later made Commander-in-chief in Catalonia, but was badly defeated at Lerida in 1642 by the French. He had an extensive collection of Flemish and Italian pictures. From him it descended to the Counts of Altamira. From their palace in Madrid it was taken by the French during Joseph Bonaparte's occupation of the city. Among

property restored by a decree of King Louis XVIII of France, it was soon after in the sale of Count Altamira, 1 June 1827, in London (Maddox Street, Stanley's, No. 46). It entered the Bankes collection at Kingston Lacy in Dorset, from which (probably after the death of George Bankes, Esq., M.P.) it was bought by Colnaghi. From that firm it was bought in December 1896 through Berenson, who first wrote to Mrs. Gardner about it 9 November from Fiesole. P26e18

[1]López-Rey, *Velázquez, A Catalogue Raisonné* (1963), pp. 207-10; Pls. 236, 241 and 443-44.

OTHER AUTHORITIES

Curtis, *Velasquez and Murillo* (London and New York, 1883), p. 51, No. 116, then belonging to Walter R. Bankes, Esq.: "A repetition, probably, of No. 114 (the portrait formerly in the Huth collection)." But in *ms.* notes for a new edition he corrected this, describing it rightly as a replica of his No. 105, the Prado portrait (*Noteworthy Paintings*, Bibliography, p. 19).

Justi in a letter (27 January 1904) to the editors of *Noteworthy Paintings* (Bibliography, p. 20) wrote: "it is not impossible that the replica is by Velasquez' own hand." It was then still coated with repaint and varnish.

López-Rey, *op. cit.*: "Workshop portrait, after No. 241 [the Prado portrait]."

Stevenson, *Velasquez* (London, 1899), p. 134; he described it as belonging to Ralph Bankes; but it was then already Mrs. Gardner's.

Waagen, *Supplement* (1857), p. 382: "Collection of E. G. Bankes, Esq."

Versions: (1) Madrid, Prado, No. 1182, canvas, 2.01 x 1.02, the first version, mentioned above, in slightly better condition (the modelling of the cloak is complete). (2) Madrid, Prado, No. 1183, canvas, 0.57 x 0.44, bust only; the king is in armour with a crimson sash, but the head is the same and may be the study for the new head in the two full length portraits.

After Velázquez

POPE INNOCENT X — *Tapestry Room*

Oil on canvas, 0.835 x 0.620. The painting is well preserved.

Giovanni Battista Pamfili (1574-1655) succeeded Urban VIII as Pope 16 September 1644. His election represented the usual reaction. Urban had been stubborn and reserved, and the Barberini had acquired enormous riches. Innocent was changeable and talkative, and the Pamfili were now exalted in the person of his sister-in-law Donna Olimpia Maidalchini, who ruled Innocent at home. Outside his palace he governed firmly. Rome had become lawless, but he forbade oppression and enforced order, septuagenarian as he was at his accession. The Italian princes were forced to let Innocent

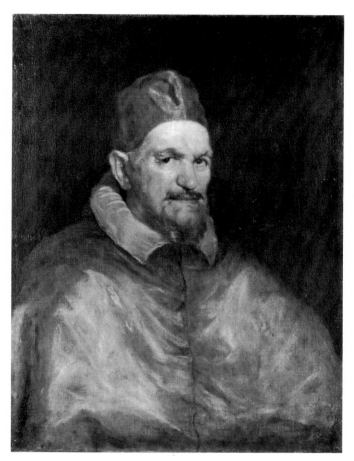

After Velázquez — *Pope Innocent X*

humble their former leader, the Farnese Duke of Parma, and take Castro for the Church. In doctrine he had no real interest. His sending for Velázquez to paint his portrait was a part of his attachment to the Spanish. He had been Nuncio to Naples and then Legate Apostolic to Spain. Now he appointed pro-Spanish Cardinals, helped to quell the revolt at Naples and refused to recognise the independence of Portugal.

In 1650 Velázquez painted in Rome the portrait of *Pope Innocent X* now in the Doria-Pamfili Gallery there. This shows the Pope to the knees seated in an armchair, holding a paper in his left hand. The paper has an original inscription by Velázquez which is not entirely legible but identifies the subject and includes the painter's signature. Though by no means the most sympathetic, the portrait is perhaps the most powerful that Velázquez ever painted. It created a furore in Rome.

There are some fifteen more or less old portraits which include at least the head from the three-quarter length in Rome. Of these, two bust portraits have a recognised claim to be by the hand of Velázquez himself, though it is unlikely that he made more than one sketch of the head before painting the large picture. The bust portrait which seems most likely to be the sketch is now in Washington.

The Gardner canvas is copied almost exactly from the other bust portrait, a picture of roughly the same dimensions, now in the Wellington Museum, Apsley House, London. Carl Justi (*Diego Velazquez and his Times* [1889], pp. 359-61) considered the Wellington head to be superior to the head in the completed portrait. August L. Mayer, *Velázquez* (1936), thought it was entirely by the hand of Velázquez, although he believed that the picture now in Washington was the original study for the Rome picture. José López-Rey, *Velázquez* (1963), believes that the Washington picture is a copy and that only the Wellington bust portrait is by Velázquez, though he attributes the cape to another hand. He

suggests that the Wellington picture is the copy of the Rome portrait that Velázquez is said by Palomino in 1724 to have brought back with him to Madrid and is identical with the bust portrait listed in the painter's rooms in the royal palace there at the time of his death. He points out, however, that a portrait of Innocent X was still in the palace in 1814, and that this goes ill with the general assumption that the Wellington bust portrait was among the pictures which Joseph Bonaparte had taken with him in 1813 on his flight from the capital, and had abandoned to Wellington on the field of Vittoria. Justi had already countered this last supposition by claiming that the Wellington portrait was identical with one which Le Brun had acquired in Rome and used for the oval outline engraving in his *Recueil*. This, however, was evidently the oval copy in oils now in a private collection in Paris (see *Varia Velazqueña*, 1960, II, Pl. 101). All that is certainly known of the history of the Wellington picture is that the Duke owned it by 1828; he lent it that year to the British Institution.

Perhaps Mrs. Gardner's copy was made in Rome while Velázquez was there. Certainly it was made before the end of the seventeenth century, to judge by the nature of the canvas and the aging of the paint. Mayer made the statement, without much evidence to support it, that it was painted by Juan de Pareja, the mulatto assistant whom Velázquez took to Rome, subject of the famous portrait by Velázquez, painted and exhibited in Rome and now in New York. The Gardner head was bought in Rome, October-November 1906, from Prince Brancaccio through Berenson. He had written to Mrs. Gardner about it first on 11 January 1905. *P19e26*

AUTHORITIES

López-Rey, J., *Velázquez, A Catalogue Raisonné* (1963), p. 274, No. 447: "obviously a copy" of the bust portrait at Apsley House; he doubts that it was painted in the seventeenth century.

Mayer, A. L., *Velázquez, A Catalogue Raisonné* (1936): "Executed by Pareja."

Version: London, Apsley House, Wellington Museum, canvas, 0.78 x 0.68 (see above).

Venetian; 1350-1400

THE MADONNA AND CHILD; THE CRUCIFIXION *Early Italian Room*

Altarpiece, gold and tempera on wood, 0.83 x 0.74. The engaged frame, carved and gilt, is much damaged by wood worm; and the round panel at the top is distorted by losses along the horizontal break in the wood. The rich gilding is otherwise well preserved. The paint is considerably rubbed and in the two scenes there are many coarsely repainted losses.

The eight arches below and the roundel which surmounts the paintings are all trilobate; but only those framing the two scenes are pointed at the apex. Above these in the circle is *Christ Pantocrator* (?) in half length. Below, in the six compartments of the arcade, are: *S. Peter; S. Anthony Abbot; An Apostle; A Father of the Church; S. Christopher; S. Paul.*

The condition of the painting distorts even the design and makes it difficult to judge the original quality of the execution. This must at least have been an object of great richness, for the gilding is unusually heavy and the Virgin's mantle is of gold, pounced with a free pattern. There has been little or no support for the attribution made by Evelyn Sandberg Vavalà in 1931 to Giovanni da Bologna,[1] the author of four signed pictures which have survived in unusually good condition. One of these, *S. Christopher*, in Padua is recorded as having been commissioned in 1377 for the Scuola dei Mercanti in Venice. The triptych with *The Madonna of Humility* in the Accademia there was painted for the Scuola di S. Giovanni Evangelista. Giovanni's signed works, all on a larger scale, are notable for their serenity, and there is no parallel in them for the passionate expression of this *Crucifixion*, with its grief-stricken figures, or of these Saints, with their fierce eyes. The picture is at least a fine example from the same time and place, while the Byzantine influence still predominated in Venice. *P15n1*

[1]Sandberg Vavalà in *Art in America*, XIX, No. 5 (August 1931), pp. 183-200.

OTHER AUTHORITY

Fredericksen and Zeri, *Census* (1972), p. 245, under Venice, fourteenth century.

Venetian; 1365-1415

THE MADONNA OF HUMILITY, WITH SAINTS *Early Italian Room*

Triptych, gold and tempera on wood, 0.65 x 0.46. In the centre *The Madonna of Humility*; in the tympanum above *Christ Rising from the Tomb*. In the left wing, *S. Catherine*, below; *A Male Saint*, above; *The Announcing Archangel* in the half-tympanum. On the right, *S. Lucy* (?); *A Bishop Saint*; *The Virgin Annunciate*.

Venetian; 1350-1400 — *The Madonna and Child; The Crucifixion*

The gold ground has flaked away in many areas. The painting has suffered in the same way, but less. The original carved and gilded Gothic frame, engaged with the pictures, is damaged but almost complete.

The "Madonna of Humility" is a theme especially dear to the painters of Venice and northern Italy, throughout the fourteenth into the early fifteenth century. The prototype of this small, probably provincial work, is perhaps *The Madonna of Humility* in a triptych in Venice signed by Giovanni da Bologna. In Giovanni's large picture also rays emanate from the group throughout the gold background, and the earth, rounded to represent the world, is carpeted with flowers. Seated on a cushion, the Madonna suckles the Child. These are all features usual in the treatment of this theme. In the Gardner picture the types have a certain resem-

blance to those in the early pictures of Jacobello del Fiore; and the frame is like the engaged frame in a signed example of his work.[1] Giovanni da Bologna settled in Venice about 1368, and worked mostly there for thirty years. Jacobello was perhaps Venetian born, and worked there and in the Marches from about 1394 until 1439. There is therefore quite a wide margin for dating the Gardner triptych, and for its place of origin. Roberto Longhi[2] attributed it to an anonymous Venetian of 1370-90; but of the three pictures which he thought with reason to be from the same hand two are, now at least, at Pavia (No. 114, *Coronation, with Saints*) and in the Estense Gallery (No. 255, a triptych) at Modena, in Emilia; the third, a polyptych, came from Torre di Palme, in the Marches. The triptych at Modena is very similar in every way to the triptych in this Museum.

Venetian; 1365-1415
The Madonna of Humility, with Saints

This triptych seems to have been acquired by Mrs. Gardner before 1905 as the work of the Sienese Andrea di Vanni.[3] *P15w37*

[1]Reproduced in Berenson, *Venetian School* (1957), I, Pl. 34.

[2]Longhi, *Viatico per Cinque Secoli di Pittura Veneziana* (Florence, 1946), p. 47, note 12.

[3]Perkins in *Rassegna d'Arte Senese*, I (1905), p. 75: "*Un trittico della Madonna con Santi si avvicina molto alla maniera di Andrea di Vanni, al quale è ascritto.*"

OTHER AUTHORITIES

Boskovits, Miklòs, (in a letter to the Director, 2 August 1972) dates it from the last third of the Trecento and believes it to have been executed by an artist between Jacobello di Bonomo and Guglielmo Veneziano, *i. e.* by Longhi's "Master of the Torre di Palme."

Fredericksen and Zeri, *Census* (1972), p. 245.

Gnoli (at Fenway Court, 16 December 1926) suggested an origin in the Marches and the influence of Alegretto Nuzi. He dated it about 1380.

Van Marle (at Fenway Court, 7 January 1930) suggested that the picture was painted at Bologna.

Pallucchini, *La Pittura veneziana del Trecento* (Venice and Rome, 1964), p. 212, supports Longhi's attribution to the "Master of the polyptych of Torre di Palme."

Venetian (?); 1400-50

THE MADONNA AND CHILD ENTHRONED
West Cloister

Fresco on lime plaster transferred to linen, 1.648 x 1.213. Several large lacunae, in which the outlines only have been filled in, remain visible in the reproduction. In addition much of the surface has been lost by flaking.

There is a background of blue sky, and before it a symbolic shrub hedge. On the left this bears fruit like miniature pomegranates, symbolical with their many seeds of the unity of the Church, on the right red cherries, traditionally suggesting the sweetness of Paradise. The German motif of the hedge was current throughout northern Italy in the late fourteenth century and the early fifteenth, through Verona and Venice. The peculiarly bright orange hair of Virgin and Child is a favourite motif of Veronese painters in the late Gothic period. Extravagant thrones were particularly favoured in the north, the extreme example being that of a *Madonna* before a rose hedge in S. Francesca della Vigna, Venice, by Antonio da Negroponte. This austere throne, fretted into patterns which seem as much Moorish as Gothic, is scarcely less unusual. The Virgin's mantle is of white damask with a figure in blue.

The composition seems complete within its own frame; but it evidently belongs to the same decorative scheme as the *S. Francis*, below. They were said to have come from a church in the Veneto when Mrs. Gardner bought them from Antonio Carrer in Venice 25 September 1897. *P12w20*

S. FRANCIS
West Cloister

Fresco on lime plaster transferred to linen, 1.480 x 0.825. The surface has suffered more than in the companion picture from flaking.

The Saint holds a small cross in his left hand, the Gospel in his right. The stigmata are clearly shown. The hanging behind him on a wall drab in colour has on its red ground a delicately traced foliated pattern unusual in painting. The closest analogy is to be found in a *Madonna* at Bergamo attributed to Jacopo Bellini, where the background of gold on black seems to be overpainted on an old pattern.

For the history, see *The Madonna and Child Enthroned*, above. *P12w24*

AUTHORITY

Fredericksen and Zeri, *Census* (1972), p. 246; under Venice, fifteenth century.

Venetian (?); 1400-50
The Madonna and Child Enthroned

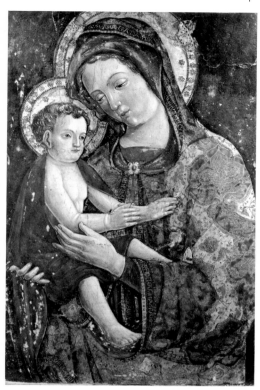

Venetian; 1425-75 — *The Madonna and Child*

Venetian (?); 1400-50 — *S. Francis*

Venetian; 1425-75

THE MADONNA AND CHILD *Gothic Room*

Gold and tempera on hardwood, 0.668 x 0.490.

The panel is almost certainly reduced from the top. The gesso ground and the paint have flaked from many places, especially in the haloes and in the Virgin's dress. Cleaning in 1936 revealed craftsmanship of a higher quality than could previously be deduced.

The Virgin's mantle is laid, like the haloes, with gold leaf, over which the pounced figure has been coloured with translucent lake red. The hem is fully inscribed with lettering which can be clearly read in places: *AVE MARIA ⁓ GRATIA ⁓ PLE*, over the head, *FIDELIA*, over the left wrist.

Technique and general style are those of Giambono (*q.v.*); but the picture comes from a workshop with a less exalted standard of craftsmanship.

It was bought from Consiglio Richetti in Venice, 2 September 1897, as the work of Jacobello del Fiore. *P30e2*

AUTHORITY

Fredericksen and Zeri, *Census* (1972), p. 224.

Venetian (?) 1525-75 (?) — *The Adoration of the Statue of Nebuchadnezzar*

Venetian (?); 1525-75 (?)

THE ADORATION OF THE STATUE OF
NEBUCHADNEZZAR
Raphael Room

Oil on pine wood, 1.150 x 1.340. Cleaning in 1942 showed that the painting is rubbed considerably, especially in the foreground and the lower left corner.

The subject may well be the story told in Chapter III of the Book of Daniel, where Shadrach, Meshach and Abed-nego, the wise Jews set by King Nebuchadnezzar over the affairs of Babylon, refuse to fall down and worship the image made of gold which he had caused to be set up in the plain of Dura in their province. "The princes, the governors, and the captains, the judges, the treasurers, the counsellors, the sheriffs, and all the rulers of the provinces" are gathered together and are told by the herald that they must do so at "the sound of the cornet, flute, harp, sackbut, psaltery, dulcimer, and all kinds of musick." The picture illustrates the text of Daniel, except for the presence of so many women.

The style of painting and the costume seem to belong to the second half of the sixteenth century; but they may represent a deliberate imitation by a later hand. The picture was apparently attributed at the time of its purchase to Pietro della Vecchia (1605-78), a Venetian well known in his own day for his imitations of Giorgione.

It was bought by Mrs. Gardner from Vincenzo Favenza at Venice in 1892. *P16w10*

AUTHORITY

Fredericksen and Zeri, *Census* (1972), p. 246; under Venice, sixteenth century.

Venetian or Austrian; 1550-1600

THE BIRTH OF CATERINA CORNARO (?)
Veronese Room

Oil on maple (?) wood, 0.418 x 0.522, including a strip added to the bottom. The painting has suffered somewhat through a fine cracking.

The bed has been brought into a wide hall, whose door opens on the world. Sideboards groan with

Venetian or Austrian; 1550-1600 — *The Birth of Caterina Cornaro (?)*

plate, the caldron is on the fire and sweetmeats are being served, while musicians drown the tiny cries and groups of women bring dishes and vessels for a feast. In the left foreground the father receives presents, which at Venetian christenings amounted sometimes to enormous sums. This illustration of life in a great house is curiously mixed with mythology and romance. At the foot of the bed stand the three Graces, above its canopy cupids shower gold, while outside the window hovers Venus in her car. In the right foreground gifts are brought by the queens of a score of nations from West and East.

All this foretells perhaps, as tradition has it, the destiny of Caterina Cornaro (1454-1510), daughter of Marco Cornaro and his wife Fiorenza, a grand-daughter of John Comnene, the Emperor of Trebizond. She was to be Queen of Jerusalem, Cyprus and Armenia, which sounds like a fairy realm. In Venice, however, women were pawns in the game of life, and men subjected even family interests to the state. The Cornaro family betrothed Caterina to James, the bastard usurper of the Kingdom of Cyprus. The Republic of Venice officially blessed the match, and in 1471 adopted her as its child,

in order to give her queenly rank and to leave no doubt about Venetian claims. Within a year of her arrival in the Kingdom her husband died, and the heir she subsequently bore was carried off by the nobles of Cyprus, who knew the nature of Venetian policy. When Venetian arms had quelled them, Venetian administrators arrived; and, when Caterina's son died in 1474 and further schemes in favour of the legitimate Lusignan heiress had to be scotched, all authority was taken from her hands. For fourteen years her reign continued under a distrustful observation which ordered the very details of her table. Her marriage would have been fatal to the Venetians, and offers from Alfonso of Naples forced their hand. In 1488 she had publicly to divest herself of her regalia, first in each Cypriot city and then in Venice. There, after a magnificent reception, she was granted in exchange the castle of Asolo in the foothills of the Alps. Even from Asolo she was driven in the end by the wars of the League of Cambrai. Her death and her magnificent funeral took place in Venice.

The style of the dresses shows that the panel must have been painted about a century after Cate-

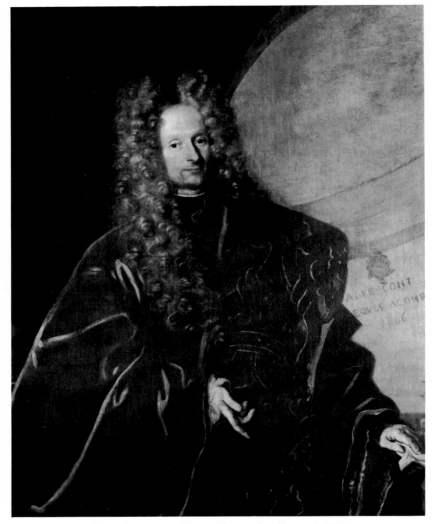

Venetian; 1766 (?) — *Alessandro Contarini (?)*

rina's birth, but her story was then a favourite legend. Titian and other sixteenth century artists painted her imaginary portrait.

The panel was bought by Mrs. Gardner 13 April 1895 from the Galleria Sangiorgi in Rome (their label is on the frame). On the back is a seal (probably nineteenth century) of the Austrian Empire: the imperial double-headed eagle, with an oval escutcheon defaced and an inscription destroyed. Another, that of the Papal States, must have licensed the panel's import or export from Rome. A third with a monogram is too rubbed to be decipherable.

P25w41

AUTHORITY

Fredericksen and Zeri, *Census* (1972), p. 246; Venice, sixteenth century.

Venetian; 1766 (?)

ALESSANDRO CONTARINI (?) *Veronese Room*

Oil on canvas, 1.300 x 1.018.

Cleaning in 1948-49 removed extensive overpainting which had become discolored and had thus come to make the damage to the original seem greater than it is. Some wearing was found in the forehead, chin and hands. In the background the sky is worn a little, and there are everywhere some small, scattered losses from flaking.

On the curved parapet to the right is a sculptured coat of arms: *or three bends azure.* Below this is inscribed, as if engraved in the stone: *ALEX ⌣ CONT/ EQVES AC. D M P / 1766.* The arms and

inscription are puzzling. The arms are those of the Contarini family, one of the largest and best known in Venice, with an old and noble root and multitudinous branches, of which some are still living. The letters *D.M.P.* stand for *Divi Marci Procurator*; and the sitter wears the robes and stole of a Procurator of S. Mark's. Given the coat of arms, it would seem that *ALEX ~ CONT* could stand only for Alessandro Contarini. Yet according to Lino Moretti[1] no Alessandro Contarini had been elected Procurator of S. Mark's since 1668. Moretti's statement that the name and date in the inscription have been tampered with (*storpiati*) is not borne out by the experience of the cleaning in 1948-49. The extensive retouchings which were then removed, especially from the background, would have been done presumably before the picture was acquired by Charles Eliot Norton, who already owned it by 1881. Solvents which removed these would have failed to remove only paint of a quite different consistency or of a very much earlier date. If the inscription has indeed been tampered with, or if it was added at a date later than the portrait, this must have happened in the eighteenth century. There are still some fifty years in which to place the event. The date 1766 is unlikely, for the style of painting belongs to the first half of the century, and more probably to the middle of that. Moretti attributes the picture, plausibly enough, to Pietro Uberti (born 1671), who seems to have left Venice about 1738. The picture is certainly not by Alessandro Longhi (1733-1813), to whom it has previously been attributed.[2]

A label on the frame shows that by 1881 the picture belonged to Charles Eliot Norton. Early in 1902, when her Venetian palace had newly risen on the Fenway but was not yet completed, he gave it to Mrs. Gardner, acknowledging her thanks in a letter dated Shady Hill, February 27. *P25n2*

[1]Moretti in *Bollettino dei Musei Civici Veneziani*, N. ¾, Annata XVI (1971), pp. 52-53.

[2]Moschini in *L'Arte*, 35 (1932), p. 146; he refuted the attribution to Alessandro Longhi.

AUTHORITY

Fredericksen and Zeri, *Census* (1972), p. 563: Alessandro Longhi, uncertain attribution.

Johannes Vermeer

Born at Delft 1632; died there 1675.

His father Reynier Janszoon Vos, or Vermeer, was a silk-weaver, and probably, at least for a time, a dealer in works of art. Johannes, for the whole of his short life, seems to have been a resident of Delft. In 1653 he married Catharina Bolnes there. They had ten children, of whom eight survived him. Towards the end of the same year he entered the Delft Guild of S. Luke; in 1662-63 and in 1670-71 he served on its committee. He had little financial success. At the beginning it took him several years to pay the full fee of the guild; three years before his death he was having money troubles, which he bequeathed to his widow. He too had tried dealing in art. His years were few, and his pictures only about the same in number. Not until the second half of the nineteenth century did he begin to acquire, through the de Goncourts and the collector and critic "W. Bürger" (E. J. T. Thoré), his great posthumous fame.

During the early years of his career two other talented painters lived in Delft. One of these, Rembrandt's most sensitive pupil Carel Fabritius, joined the guild in 1652; but he was killed two years later by the explosion of the powder magazine. The Rembrandt-Fabritius influence on Vermeer is obvious only in two pictures of a comparatively late date: *The Geographer* at Frankfurt and Baroness Edouard de Rothschild's *Astronomer*, a similar picture dated 1668. The other was Pieter de Hoogh, who married at Delft in 1654, joined the guild and lived in Delft at least until 1660. His last years there were those of his finest painting, and his example may well have encouraged Vermeer towards painting the everyday scenes of the Dutch house. Both believed that nobility was less in the theme than in the treatment of it. Both loved the subtle varieties of light and the consistency with which, coming from one source, light relates to one another all the forms which it reveals.

Meanwhile, however, Vermeer began with comparatively ambitious essays in the mythological, the sacred and the profane. In the tender, tentative *Diana and her Nymphs* in The Hague the essential influence is from some Venetian, even though it is virtually an adaptation of a picture by Jacob van Loo now in Berlin. The *Christ in the House of Mary and Martha* in Edinburgh, his largest picture, is gently shaped after the Italian Baroque; and the particular resemblance has been noted between his Christ in this picture and the Christ of several Italian painters. In *The Procuress* in Dresden of 1656, his earliest dated picture, the influence is from Caravaggio's followers in Utrecht: ter Bruggen (died 1629) or van Baburen (see below). Vermeer is already more at home with this characteristic Dutch subject, affording opportunities equally for an acute study of the lighting of forms and for the application of classical principles of formal design. He chooses cooler colours than de Hoogh's;

they absorb the light less and he was less interested in colour values. He eschews the suggestion of emotional warmth. Clarity of composition is his first principle. To make a unity perfect and clearly readable in all its parts out of facts reflecting the cool light of every day is a problem of a high order. It implies personal reserve; and his success in it sometimes places him, though at the very opposite pole, on a plane with Rembrandt (q.v.).

His field once chosen, he turned to a smaller scale and fewer figures. The spirit of the house is often expressed by a single girl, more often by a couple or a trio. The theme and his powers of expression grow consistently and continuously more subtle. *The Cook Pouring Milk* in Amsterdam becomes *A Lady Weighing Pearls* in Washington, or *A Girl Seated at the Virginals* in London. In *The Soldier and the Girl* in the Frick Collection, New York, the bold stare is answered by a grin; *The Love Letter* in Amsterdam is full of subtle unspoken irony. There is a parallel refinement in the observation of light and shade, the definition of tone, the distillation of blues, yellows and pearly greys which have scarcely been used since the fifteenth century.

Vermeer has purified the Baroque, satisfying all its demands for complex three-dimensional structure, while leading it back to the clean outlines and the bright colours of the early Renaissance, and to its wholesome love of the clear day. He was not the servant of any style, witness his *View of Delft* in The Hague, a panoramic slice of nature unique in its achievement of silent calm by the detached and exact weighing of every substance, whether it is sand or water, wood or brick. Yet he did not altogether abandon the Grand Manner. His *Allegory of the Faith* in New York must be one of his last works. It is as much a unity as any of his own household scenes. It is only too convincing for an anachronistic piece of iconology which he must have been commissioned to transcribe into paint. Quite otherwise is the earlier allegory, if it is one, in Vienna, *The Painter in his Studio*. Like van Eyck in his *Arnolfini Marriage* in London or Velázquez in his *Las Meniñas* in Madrid, Vermeer has created a world within a world, timeless and complete.

THE CONCERT *Dutch Room*

Oil on canvas, 0.725 x 0.647. Abraded throughout, with results particularly evident in the thinly painted darker tones. The blue dress is worn, the white fur at the hem almost lost. The lighter areas are in better condition. Cleaning in 1974 revealed subtle gradations of tone in the darker passages which had been obscured by discoloured varnishes.

The girl playing the clavichord wears a yellow bodice and a white skirt, both outlined with black; the man playing the viola da gamba, seated on a chair with a red back, has a brown coat; the singer is in blue. Behind her is *The Procuress* by Dirck van Baburen, now in the Boston Museum of Fine Arts. It is signed and dated 1622. There is an unsigned version in Amsterdam. Since the composition appears again in a picture painted by Vermeer some ten years later, *A Young Woman Seated at a Virginal*, now in London,[1] one of these two pictures may well have belonged to Vermeer. The picture behind the clavichord player may be one attributed to Fabritius, *An Inn by the River*, which belonged to Mr. Gustav Poll in Vienna in 1952.

Van Baburen had been to Italy, and he was certainly one of the painters through whom the principles of contemporary Italian art were transmitted to Vermeer. Yet Vermeer breaks away entirely from the academic school of the Romanists in his study of the dominion of light over form. The manner in which the day, coming through the unseen window on the left, reveals the whole form of this picture in one harmony is driven home by a comparison with ter Borch's composition in the same room. That *The Concert* itself appears at first sight less plastic than many of Vermeer's compositions is perhaps due to its condition. The table and musical instruments in the foreground show at once his preoccupation with clean shapes and their arrangement. This still life preponderates over the musicians in the background, yet its dominant planes are all directed towards the human group, to combine with it in a clearly ordered harmony of form and space. There is a composition of a similar kind in the British Royal Collection, in which the painting is rather better preserved. The two windows shown on the left side of the wall in that picture make it the more reminiscent of de Hoogh, and it may be the earlier of the two. Both pictures show Vermeer at his closest to the other artist, especially in their wide range of colours and in the amount of foreground space. Both may well have been painted, by analogy with de Hoogh's pictures, about 1658-60.

The canvas was brought from Holland probably by Baroness van Leyden, in whose sale it appeared in Paris (Paillet et Delaroche, 10 September 1804, No. 62, fully described). It reappeared in London 2 April 1860 (Christie's, No. 49, *A Musical Party*) among the property of a baronet, and was bought by Tooth (the mark *April 2/60* is in chalk on the back of the canvas). It was bought after December 1886 by Théophile Thoré Bürger,[2] a cabinet minister to the French Republic in 1848, who, exiled

Johannes Vermeer — *The Concert* (SEE COLOUR PLATE)

by Napoleon III, retired to Holland to become the first historian of Vermeer. At his sale in Paris (5 December 1892, Drouot, No. 31, *Le Concert*) the picture was bought by Mrs. Gardner herself, who ordered the bidding of her agent Robert with a handkerchief. *P21w27*

[1]Neil Maclaren, *National Gallery Catalogues, The Dutch School* (1960), pp. 438-39.

[2]W. Bürger in *Gazette des Beaux-Arts*, XXI (1866), p. 553, No. 23; he noted the·picture in Baroness van Leyden's sale as *"à vérifier et à retrouver."*

OTHER AUTHORITIES

Bode in *Noteworthy Paintings*, pp. 207-08.

Bredius in *Noteworthy Paintings*, pp. 206-07.

Conway in *Noteworthy Paintings*, pp. 205-06.

Goldscheider, *Vermeer* (2nd ed., 1967), p. 128, No. 14.

Gowing, *Vermeer* (1952), pp. 119-24.

De Groot, *Catalogue of Dutch Painters*, I (trans., London, 1907), Vermeer, No. 29.

Jacob and Bianconi, *The Complete Paintings of Vermeer* (1967), p. 91, No. 19.

Swillens, *Johannes Vermeer* (1950), pp. 52, 72 and 117.

Valentiner, W. R., in a letter to the compiler (Detroit, 1 October 1931); he dated it 1658-60.

De Vries, A. B., *Jan Vermeer van Delft* (2nd ed., 1948), p. 85.

Exhibited 5-28 March 1897, Boston, Copley Hall, Copley Society, One Hundred Masterpieces, No. 98.

Veronese

PAOLO CALIARI: born at Verona probably in 1528; died in Venice 1588.

Son of Gabriele di Piero di Gabriele and his wife Caterina. Pupil at Verona of Antonio Badile, whose daughter Elena he married there in 1566. By 1553 he was in Venice, where he resided for the rest of his life, visiting Rome at least once and acquiring for a summer resort a villa at Sant' Angelo near Treviso. His great decorations fill the public buildings of Venice. In the Ducal Palace a series of ceilings was painted at intervals between 1553 and 1581, and S. Sebastiano was decorated throughout between 1555 and 1570. There is much of his work also on the mainland: the decoration in fresco of the Villa Barbaro at Masér, probably 1560-62, *The Banquet of S. Gregory* at Monte Berico above Vicenza, 1572, or *The Martyrdom of S. Giustina* in S. Giustina at Padua, 1575.

By an Assistant of Veronese

THE CORONATION OF HEBE *Veronese Room*

Oil on square canvas, 3.87. Damaged here and there — in the two figures behind Hebe and in the group of five at the foot.

Beneath the eagle hovering with his thunderbolts Jupiter and Juno sit holding their reception. A little below them Venus displays herself, with Cupid urging restraint; and in the rank below Bacchus sports with Ceres, his Satyrs grinning from behind, and Minerva is at the elbow of Mars. Into the group below them steps Hercules, swinging his club, and on the other side Neptune grasps his trident. Before him Mercury, the messenger, supported by Diana, leads Hebe up the clouds, while a little cupid crowns her with flowers and a nymph above inattentively scatters pearls. Daughter of Jupiter and Juno, Hebe is the cupbearer of the gods. She personifies the bloom of youth.

The whole paraphernalia is Veronese's, as well as the bright cool colouring. The composition has everything of his but his science of construction and his power of expression. He was a complete master of the drastic foreshortening necessary for ceiling decoration, but this composition is drawn only at an angle suitable for hanging vertically, high upon a wall; not one of the figures is so projected as to appear suspended in space. Nevertheless, he may well have supplied an outline of the design and drawings for one or two figures: *e.g.* Mars.

The handling of the paint is enough to show that the painter is to be sought for among those who assisted Veronese in his decorations, the author perhaps of the subsidiary figures in the background of his *Thanksgiving for the Victory of Lepanto* in the Sala del Collegio of the Ducal Palace at Venice or of his *Coronation of the Virgin* in the Accademia there. This appears to be neither Paolo's brother Benedetto nor his son Carlo, assistants whose independent works bear a recognisable character. Another son Gabriele is less easily distinguished, and Parrasio Micheli, who was once Veronese's assistant, seems to have turned quickly from one manner to another.

The canvas was painted for a ceiling in the della Torre palace at Udine. It was sold as the work of Paolo Veronese by Count Sigismondo della Torre 21 April 1692 to Francesco Vezzi. Half of the capital was put up by Domenico Gambato, and a painter Francesco Cassi was to have a share in the profits. They brought the picture to Venice and lodged it in the house of Pietro Businello alla Croce. There the vendor's brother Count Girolamo

By an Assistant of Veronese — *The Coronation of Hebe*

della Torre obtained an injunction against its further removal or sale, while he sued Vezzi over its ownership. The suit had reached the Civil Council of Forty at Venice by December 1710. Meanwhile, however, Cassi had died and Gambato had sold his interests to Bernardo Nicolosi.[1] Later, the picture was in the Manfrin Gallery at Venice, a collection formed in the early nineteenth century by Girolamo Manfrin and his son Pietro. From this it was sold in 1896 (handwritten inscription on the pamphlet mentioned below; the name of the purchaser erased), and was bought by Mrs. Gardner through her agent Robert from Boudariat in Paris January 1899, as the work of Paolo Veronese. P25c26

[1]Museum archives, an old pamphlet of 12 pp. prints the relevant documents.

OTHER AUTHORITIES

Berenson in a letter (10 March 1930), to Veronese.

Fredericksen and Zeri, *Census* (1972), p. 38, as by a follower of Veronese.

Venturi, L., at Fenway Court, 31 January 1929, attributed it to Paolo Veronese.

Engraved by Galinberti, 1776. The engraving is inscribed: *Hebe patri Jovi in concilio deorum deducta.*

For the drawing by Veronese, *The Marriage of S. Catherine,* see Hadley, *Drawings* (Isabella Stewart Gardner Museum, 1968), pp. 25-26.

Style of Veronese

EIGHT SCENES FROM THE METAMORPHOSES OF OVID
Short Gallery

Oil on canvas, with rounded sides, each approximately 0.35 x 0.74. They are framed in two sets of four.

First set, over the doorway from the Raphael Room:

THE BIRTH OF ADONIS (lower left)

In Book X of the *Metamorphoses* Myrrha, under cover of the darkness, seduces her own father Cinyras, son of Apollo and King of Cyprus, and flees from his subsequent wrath to Saba in Arabia. Here, in answer to her prayer, she is changed into the myrrh tree; but only as her child is born. Lucina, goddess of childbirth, appears at the last moment, and the nymphs take charge of the infant Adonis.[1] P17w32-s-2

THE DEATH OF ADONIS (upper left)

Book X ends with the discovery by Venus, flying to Cyprus, of her beloved Adonis mortally wounded by the wild boar which he has been hunting.
P17w32-s-1

THE RAPE OF PROSERPINE (lower right)

In Book V Proserpine, daughter of Jove and Ceres, is seized by Pluto, and carried off in a chariot to his kingdom of the Underworld. In Sicily the nymph Cyane vainly tries to bar his way. P17w32-s-4

PYGMALION (?) (upper right)

In Book X Pygmalion in Cyprus carves a figure of a maid so fair that he falls in love with her, woos her with rich offerings and calls her his bride. In answer to his prayer, Venus turns her from ivory into flesh and blood. The boy who seems to hold up the hero's garment is perhaps a page, reminding us that Pygmalion is the Cypriot King.[2] P17w32-s-3

Second set, opposite:

PERSEUS AND ANDROMEDA (lower left)

In Book IV the guiltless Andromeda has to pay for the idle boasting of her mother Cassiope, wife of King Cepheus. The offended Neptune having sent a sea-monster to harass the Ethiopians, Jupiter Ammon decrees that Andromeda must be sacrificed. Perseus, returning from his duel with Medusa, slays the monster and frees Andromeda from her chains.
P17e34-s-2

THE JUDGMENT OF MIDAS (upper left)

Perhaps for simplification, the painter has illustrated the common version of the myth, which makes Midas, King of Phrygia, the judge in an unequal musical contest between Apollo and Pan. In Book XI of his *Metamorphoses* Ovid makes Tmolus, deity of the mountain of that name in Lydia, the judge, and the unwise Midas merely the sole opponent of the verdict in Apollo's favour. For this he gets a pair of ass's ears. P17e34-s-1

APOLLO SHOOTS THE SONS OF NIOBE (?) (lower right)

In Book VI Niobe, wife of Amphion, King of Thebes, boasts at the expense of Latona, particularly of her seven sons and seven daughters. Latona's only children, Apollo and Diana, avenge their mother by slaughtering all fourteen. The sons were shot down first. Strictly, seven of them should be depicted; but they were not all killed at once.
P17e34-s-4

The Death of Adonis

Pygmalion (?)

The Birth of Adonis

The Rape of Proserpine

The Judgement of Midas

The Death of Procris

Perseus and Andromeda

Apollo Shoots the Sons of Niobe (?)

Style of Veronese — *Eight Scenes from the Metamorphoses of Ovid*

THE DEATH OF PROCRIS (upper right)

In Book VII Procris, the wife of Cephalus, rouses the jealousy of Aurora, who persuades him to disguise himself and test his wife's fidelity. When he at last succeeds and then reveals himself, Procris flees to the hills and the protection of Diana. Disgusted with himself, he follows her, and they are reconciled. In token of this she gives him Diana's gift to her, a spear which cannot miss. With this, hunting at dusk and thinking he hears an animal in a thicket, he pierces her through the heart.

P17e34-s-3

The fifteen books of *Metamorphoses* (Greek for "Changes of Shape"), the last work written in Latin by the poet Ovid before he was banished from Rome in A.D. 8, had a great new vogue in the Renaissance for the vivid way in which they summarise a large part of the Greek and Roman mythology and for their easy flow of style. They thus provide the source from which a painter of the sixteenth century was most likely to draw the mythological subjects which were increasingly popular in decorative painting.

The pictures are executed coarsely but with considerable power, both in modelling and in design. They seem to be all by the same hand, though they resemble Veronese's style more clearly in some places than in others. They must be from a frieze or from a ceiling.

They were bought by Mrs. Gardner from Dino Barozzi in Venice 20 September 1899.

[1]Frances Preston, in a letter of 13 July 1973, identifies the subject.

[2]Miss Preston, *loc. cit.*, suggests that the boy is there to symbolise disguise, and that the subject may be the return of Cephalus to Procris, disguised in order to test her fidelity.

Jan Voerman

Born at Kampen, Over-Yssel, 1857; died at Hatten, in the same province, 1941.

He studied under August Allebé at the State Academy of Arts in Amsterdam; and, later, under Charles Verlat at the Academy in Antwerp. From 1889 he lived at Hatten, near the Yssel, painting mostly river landscapes with high, clouded skies.

NASTURTIUMS *Blue Room*

Gouache on paper, 0.34 x 0.55. Signed at the foot on the right: *J. Voerman.*

Bought through R. W. Curtis 16 September 1894 from Frans Buffa and Zonen of Amsterdam. *P3w40*

Rogier van der Weyden

Born at Tournai 1399-1400; died in Brussels 1464.

Apprentice to Robert Campin at Tournai 1427-32. By 1435 he was established in Brussels. There he painted murals in the Town Hall, one of which was dated 1439; but these have disappeared, and none of his many extant works has contemporary documentation, or a signature. *The Descent from the Cross* now in Madrid was painted before 1443. The altarpiece with *The Last Judgment* in the Hôtel-Dieu at Beaune was painted not very long afterwards. By 1450 he was in Italy, perhaps visiting Ferrara, perhaps painting in Florence his *Entombment* now in the Uffizi Gallery there. *The Madonna and Child with Four Saints*, now at Frankfurt, was painted for one of the Medici. In 1450 Rogier was certainly in Rome. His painting was famous also in France and Spain and Portugal. Outside Italy, he was the leading influence of his day.

Influenced by van der Weyden

THE MADONNA AND CHILD *Dutch Room*

Oil on oak, 0.76 x 0.62, including a strip about half an inch wide added all round. The original painting of the flesh has almost disappeared.

The Madonna and Child follow very closely the types of Rogier van der Weyden. Since they are repeated in at least two other mediocre pictures they perhaps reproduce those of some lost original of his. The head follows very closely that of the full-length *Madonna in a Niche* in Madrid, of which the origin is unknown, though there are several copies (*e.g.* in Philadelphia and Princeton). The original was bought for the Prado in 1931. The dark green of the Madonna's cloak and the deep brown-purple of her robe are colours equally characteristic of Rogier, as are the modelled touches of paint which render the damask on the sleeve

Jan Voerman — *Nasturtiums*

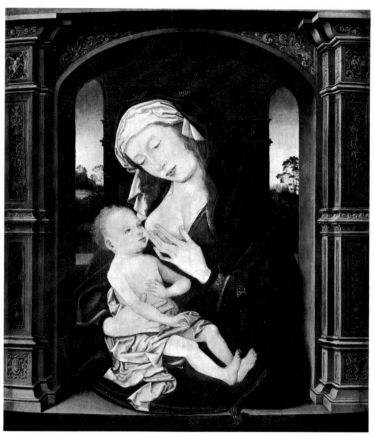

Influenced by Rogier van der Weyden — *The Madonna and Child*

and the embroidered inscription on the hem of the cloak. The painting, however, belongs to a later generation. The architecture, with its playful cupids and its forms freed from the Gothic, is more like that in the pictures of Mabuse.

The panel was bought in Paris in June 1895 through Mrs. Gardner's agent Robert as the work of Lucas van Leyden. *P21s19*

AUTHORITY

Friedländer, M. J., at Fenway Court, 3 December 1924), described it as a copy of a composition by Rogier van der Weyden.

Versions: (1) Milan, Cenolini sale (28 March 1901), No. 40, panel, 0.67 x 0.51, attributed to Hubert van Eyck (Hulin de Loo in a note in the Witt Library: "A copy after Rogier Van der Weyden, possibly by 'the Master of the Magdalen Legend'"); the background has two heavy pillars between which is seen a different landscape with towns. (2) Paris, a dealer (1924), panel, 0.610 x 0.415, with the figures only, against a plain ground. It was No. 2 in the sale (1923) of J. Normand in Paris (Hulin de Loo in *The Burlington Magazine*, XLV

[1924], p. 56, to Dirck Bouts); Friedländer, *Early Netherlandish Painting*, II (1967), No. 107h and Pl. 120. (3) New York, American Art Association, Canessa sale (25-26 January 1924), No. 160, a variant in which the background is red and only the figure of the Child is the same; from the collection of Count Galanti at Naples.

Whistler

JAMES ABBOTT McNEILL WHISTLER: born at Lowell, Massachusetts, 1834; died in London 1903.

His father left the United States in 1842 to build the railway from Moscow to St. Petersburg. After his death in 1849 the family returned. James, after failures at the Military Academy at West Point, 1851-54, and in the Coast and Geodetic Survey in Washington, left the United States finally in 1855, and entered the studio of Gleyre in Paris.

His artistic education was thus Parisian. He figures, with Manet and others, in Fantin-Latour's *Hommage à Delacroix* of 1864, now in the Louvre (Jeu de Paume). His first offering to the Salon, *At*

the Piano, was rejected in 1859; but in 1863 *The White Girl,* also rejected by the Salon of the Académie, was the most admired picture at that of the Refusés. That year he settled in London, where he had exhibited at the Royal Academy from 1860. His family lived there already, and he himself had frequently crossed. Always restless, he was off in 1866 to Valparaiso. He fled the bombardment; but he brought back a number of pictures. *Valparaiso Bay, a Nocturne in Blue and Gold* is now in the Freer Gallery in Washington.

His portrait of *Thomas Carlyle,* now at Glasgow, was painted about 1872. *The Artist's Mother,* now in the Louvre, was hung that year in the Academy. It was his last exhibit there. He was too clear-sighted an artist for Victorian London, and the exhibition of his own work in 1874, like that of Manet in Paris an appeal against academic judgment and a prototype of the modern individual exhibition, was ill received. For Ruskin's libel upon his *Nocturne in Black and Gold: The Falling Rocket,* now in Detroit, he was awarded the contemptuous damages of a farthing. The costs of this action were largely the cause of his bankruptcy in 1879 and of the sale of his scarcely built house in Chelsea. He went into retreat in Venice. His etchings and pastels were always a source of fame and a supplement to his inheritance; and his return to London marks the change in the quality of his reputation as a painter. He was elected in 1886 to the Presidency of the Society of British Artists. He resigned from the Society in 1888, and his other honours came from abroad: in 1888 Honorary Member of the Bavarian Royal Academy; in 1889 the Cross of the French Legion of Honour and a gold medal in Amsterdam; in 1898 President of the International Society of Sculptors, Painters and Gravers.

In 1886 he had married Beatrix Godwin, the widow of his architect. He returned with her to Paris in 1892. After her death in 1896 he moved his camp more frequently than ever. He was first threatened by death when travelling in Holland in July 1902 with the collector Charles Freer.

In a case in the Long Gallery at Fenway Court are five sheets of pen and ink sketches for the *Peacock Room,* now in the Freer Gallery, designed for F. R. Leyland (see Hadley, *Drawings,* pp. 37-41). There is also preserved one of Whistler's prodigious canes, a memorial of the dandyism with which he clad his small but powerful frame. He was free in his manners and fond of shocking, and the misunderstanding that his art encountered in London sharpened his eccentricities and pointed the sting of his tongue. A witty talker and controversialist, he collected his letters to the press under the title of *The Gentle Art of Making Enemies,* an art which brought him as much contemporary fame as his painting.

The antithesis of Sargent (*q.v.*) in character and appearance, he was equally opposed in his art. Acting as the advance guard of modern French ideas, he brought from Paris not so much the technical accomplishment of her studios as an understanding of the relation of art and life. He was the least prolific of artists; but he lived his art, decorating his houses and his person with the same delicate colour which covers his canvases, and in his pictures arranging a real vision in colours harmonized with thought and sensibility. Their titles are enough to explain his intentions; their structure is but slight, their expression suggestive. Design is rarely so emphatic or painting so solid as in his *Théodore Duret* in New York; but all his portraits have a distinguished, aristocratic character. He brought from Paris the Japanese affectation; but it is with glimpses of his own day — *At the Piano* or *The Morning Call* — that he gave new life to English painting.

HARMONY IN BLUE AND SILVER: TROUVILLE
Yellow Room

Oil on canvas, 0.50 x 0.76. In the lower left corner are four little dark blobs, the butterfly signature. This and the other pictures by Whistler are in the original frames from Chelsea.

There is a wide expanse of pale smooth sand, a strip of pale smooth sea, and in the topmost third of the picture their colours are mingled in the reflections of a milky sky. Nothing interrupts their dainty gradations but the white sails of two yachts punctuating the blue and a single figure in a frock coat standing upon the sand. This is the painter Courbet (*q.v.*), himself busy at this time upon large seascapes. Whistler joined him at Trouville in the late summer of 1865, when the picture must have been painted.[1]

It was bought by Mrs. Gardner in December 1892 in Paris. She had difficulty in persuading Whistler to part with it, taking with her to the studio his assistant William Rothenstein. When they had inspected the other pictures and had come to this, which Mrs. Gardner had admired on other occasions, she ordered Rothenstein, who had previously been coached in his part, to carry it down to the waiting carriage. Mrs. Gardner followed him and Whistler came last, protesting that he had not yet signed the picture.[2] This he was invited to do, and did the next day at Mrs. Gardner's hotel. His bill is the authority for the title. *P1e6*

Whistler — *Harmony in Blue and Silver: Trouville*

[1]Duret, *Whistler* (Paris, 1914), p. 27; he stated that Whistler was again with Courbet at Trouville in 1866.

[2]Carter, *Isabella Stewart Gardner and Fenway Court* (Boston and London, 1925), p. 135. Rothenstein in *The Atlantic Monthly*, CXLVII (1931), p. 28.

OTHER AUTHORITIES

Pennell, *The Life of James McNeill Whistler* (Philadelphia, 1908), I, p. 134.

Sutton, *James McNeill Whistler* (1966), p. 187.

Exhibited March 1898, Boston, Copley Hall and Allston Hall, No. 90, *Courbet on the Beach*.

NOCTURNE, BLUE AND SILVER: BATTERSEA REACH
Yellow Room

Oil on canvas, 0.39 x 0.63. At the foot to the right of the centre are faint blobs which are the butterfly signature.

The smoky blue of the London twilight, deepening against the dim form of the opposite shore, is broken only by a pattern of orange dots which mark an illuminated clock tower and a moored tug, and by the blur of a rowing boat in the foreground. Whistler was then living at Chelsea, which is separated from Battersea by the Thames. The Nocturnes are perhaps the most characteristic group of his paintings. Without probing into the full revelations of midday he found in the twilight just those delicate suggestions with which he liked to design.

Mrs. Gardner bought this picture from Whistler in Paris 25 June 1895. Again, his bill is the authority for the title. *P121*

AUTHORITIES

Holden, *Whistler Landscapes and Seascapes* (New York, 1969), p. 50.

Sutton, *op. cit.*, p. 192.

THE SWEET SHOP, CHELSEA
Veronese Room

Oil on wood, 0.12 x 0.21. The thin glazes are parting in fine cracks to reveal the pale grey priming.

This is a little tune composed in just the same way as the larger Symphonies, in horizontal lines and with a vague, delicate touch, but with more broken colour.

The panel was bought by Mrs. Gardner from Whistler 30 October 1886 in London. In his receipt

Whistler — *Nocturne, Blue and Silver: Battersea Reach*

Whistler — *The Sweet Shop, Chelsea*

it is called *The Note in orange and blue.* (Sweet-shop). *P25e6*

Version: Washington, Freer Gallery of Art, No. 04.315, *An Orange Note: Sweetshop,* oil on wood, 0.122 x 0.215, signed with the butterfly (reproduced in Stubbs, *Whistler, A Biographical Outline,* etc. (1950), Pl. 16.

MRS. GARDNER IN YELLOW AND GOLD
Veronese Room

Pastel on rough cardboard, 0.27 x 0.14, a little rubbed. To the right is the butterfly signature.

The portrait was drawn in October 1886, when Mrs. Gardner was in London and saw Whistler on several occasions.[1] The title in the receipt is *The little note in yellow and gold.* In the Long Gallery his brief letters to her are preserved in a small bundle.
P25e1

[1]Carter, *op. cit.*, p. 103.

THE VIOLET NOTE
Veronese Room

Pastel on rough cardboard, 0.26 x 0.18. To the right on the curtain behind the figure is the butterfly signature in red.

Bought by Mrs. Gardner from Whistler, with the last two pictures, in London, 30 October 1886. This is the title in his receipt.
P25e5

Exhibited Winter 1886, London, Society of British Artists (Whistler asked Mrs. Gardner for permission on a card enclosed with his receipt).

LAPIS LAZULI
Veronese Room

Pastel on rough cardboard, 0.13 x 0.26. To the right on the back of the couch is the butterfly signature in red.

A similar picture, *Pour le Pastel: Rose and Opal,* is in the Freer Gallery, Washington.

Bought by Mrs. Gardner from Whistler in Paris 25 June 1895. His receipt gives this title.
P25e2

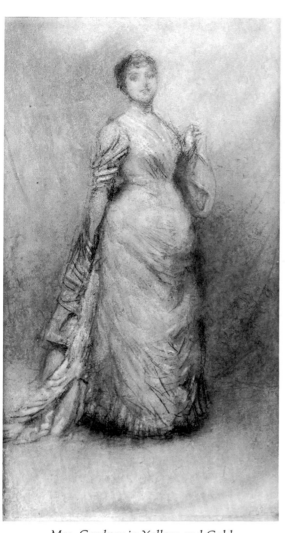

The Violet Note

Mrs. Gardner in Yellow and Gold

Lapis Lazuli

Sarah de St. Prix Wyman Whitman

SARAH DE ST. PRIX WYMAN: born in Baltimore, Maryland, 1842; died in Boston, Massachusetts, 1904. She married William Whitman.

MOONRISE ON A CANAL *Macknight Room*

Pastel on paper, 0.36 x 0.41. Inscribed at the foot on the right: *W* within a heart.

The pastel was bought by Mrs. Gardner from Doll and Richards, Boston, in 1878. *P11n36*

Exhibited (?) 30 April 1906 — 1 January 1907, Boston, Museum of Fine Arts (*Landscape*, lent by Mrs. Gardner. *A Hayrick* was lent by Mrs. Gardner at the same time, and previously 26 April 1880 — 3 June 1881, when she had also lent *Flowers* by Mrs. Whitman).

Sarah de St. Prix Wyman Whitman
Moonrise on a Canal

Charles Herbert Woodbury

Born at Lynn, Massachusetts, 1864; died in Boston 1940.

He graduated from the Massachusetts Institute of Technology in engineering, but after marrying Marcia Oakes, also an artist, they went to Paris, where he studied at Julian's. After several years abroad, he set up a studio in Boston and a popular summer school at Ogunquit, Maine.

PORPOISES *Macknight Room*

Water colour on white paper, 0.52 x 0.75.

Bought from the painter at Boston in November 1921. *P11e2*

Charles Herbert Woodbury — *Porpoises*

Exhibited 1917, Philadelphia, Water Colour Club, fifteenth annual exhibition.

Giuseppe Zais

Born at Canale d'Agordo, Belluno, 1709; died at Treviso 1784(?).

A picture in Venice (Accademia, No. 846) is signed: *Joseph Zaise*. It is possible that he was of Austrian descent.

It is thought that he may have been the pupil of Marco Ricci (1676-1729) in Venice. Francesco Zuccarelli came there from Florence after Ricci's death, and Zais soon changed his style under Zuccarelli's influence. He came to follow Zuccarelli closely, and his pictures are often attributed to the better known painter. Zuccarelli spent at least fifteen years in London. Zais seems to have remained in Venice continuously. He was elected to the Accademia there in 1774.

BY THE STREAM *Short Gallery*

Oil on canvas, 0.53 x 0.70.

Pendant to the picture below. *P17e40*

AT THE FOUNTAIN *Short Gallery*

Oil on canvas, 0.53 x 0.70.

The two pictures are in the style of Zuccarelli, but seem to be more genuinely rustic in conception and to be rather more coarsely painted. They seem to have escaped the authorities on either artist, and were catalogued in 1931 merely as Italian; 1700-1800. *P17e41*

By the Stream

At the Fountain

Ziem

FÉLIX-FRANÇOIS-GEORGES-PHILIBERT ZIEM: born at Beaune 1822; died in Paris 12 November 1911.

He was the son of a Croatian soldier who was captured at Montereau in 1814 and settled in France. He studied architecture in the school at Dijon and in 1840 won the architectural Grand Prix de Rome. From Rome he went to Venice and Constantinople, where, moved by their sparkling waters and gay shipping, he became a painter. He exhibited at the Salon in Paris from 1849.

For a time he attached himself to the school of Fontainebleau; but he returned to his allegiance to Venice and Constantinople, and painted the more melodramatic effects of the atmosphere of their harbours in colours influenced first by Turner and then by Monet.

LOWLAND PASTURES *Yellow Room*

Oil on wood, 0.26 x 0.43. Signed at the foot on the right: *Ziem*.

Painted in quiet colours with little abrupt touches, it belongs to a moment when Ziem was influenced by Rousseau and others of the Barbizon School.

It belonged to Mrs. Gardner already in 1880.

P1w7

Exhibited 26 April 1880 — 3 June 1881, Boston, Museum of Fine Arts.

Anders Leonard Zorn

Born at Mora in Dalecarlia, Sweden, 1860; died there 1920.

His mother Grudd Anna Persson was a peasant of Mora who worked in the summer in a brewery in Stockholm, where his father Leonard Zorn, a Bavarian, was brewmaster. He was brought up with his mother's family in the country. His facility in drawing and wood carving found him early bene-factors, who helped him first to the Grammar School at Enköping and then to the Academy of Fine Arts in Stockholm, where he learned to paint in water colour. With this he was soon earning a liv-ing. In 1881 he went to London and Paris; and, after travels in Spain, back again in 1882 to Lon-don. There he lived until 1885, when he returned to Stockholm, to marry Emma Lamm. He now turned to etching, for which he soon acquired inter-national fame. About 1888 he painted in Sweden and England his first large pictures in oil, and that year he settled for five years in Paris. His *Fisherman of St. Ives* won him a gold medal at the exhibition of 1889, and was bought by the Luxem-

Ziem — *Lowland Pastures*

bourg Museum. His portrait of himself was added the same year to the collection of self-portraits in the Uffizi Gallery at Florence. In 1893 he was Swedish Commissioner to the World's Columbian Exposition at Chicago. He returned to the United States for the winter of 1896-97, and thenceforward at frequent intervals to paint the portraits for which there was a great fashionable demand. He travelled constantly in Europe, and visited Algiers and Constantinople; but the last years of his life were spent in his great studio outside Stockholm or at an estate which he acquired near the place of his birth. Here he kept open house and devoted himself to the preservation and encouragement of the local peasant traditions in dress and dance and music. He liked to speak of himself as the peasant who had painted the portraits of all the Swedish royal family.

Many of his compositions are from scenes of the wholesome peasant life, while others depict his own robust sensuousness and the familiarity of his yacht with his native coasts. In idea his art differs little from that of Sargent. His subject was quickly chosen, the flash and movement of the scene commemorated in an instant with strong, rapid strokes.

THE MORNING TOILET *Veronese Room*

Oil on canvas, pasted on card, 0.60 x 0.36. Inscribed at the foot on the right: *Zorn/88.*

At the end of 1888 Zorn settled for five years in Paris. This picture was framed there. The title may be erroneous, but the picture is perhaps identical with one referred to by Zorn in a letter to Mrs. Gardner from Paris, probably of 1894: "You ask what I think of the Morning toilet. beautyfull! beautifull [*sic*]! best thing I ever did!"

The canvas belonged to Mrs. Gardner certainly by 1902. She left her house on Beacon Street that year, and it is given as her address on the back.

 P25e13

Etched in reverse by Zorn as *With her Child*, about 1890, signed: *Zorn* (Asplund, *Zorn's Engraved Work*, trans. Adams-Ray, 1920, No. 45).

THE OMNIBUS *Blue Room*

Oil on canvas, 1.26 x 0.88. Inscribed at the foot on the right: *Zorn — Paris 1892.*

The picture was Mrs. Gardner's introduction to the painter. She was struck by it when she and Mr. Gardner were visiting the Chicago Fair before its opening. She inquired immediately for Zorn, whose name was unknown to her, of Zorn himself, who was supervising the hanging as Swedish Com-

missioner to the exposition and one of the judges. The purchase began a lifelong friendship. A letter from Zorn dated Chicago, 15 July 1893, acknowledges her cheque, and another of 24 November excuses the delay in the picture's despatch. *P3e1*

Exhibited 1893, Chicago, World's Columbian Exposition. 1893-94, Boston, Museum of Fine Arts (labels on frame).
Etched in reverse by Zorn, inscribed: *18 Zorn 92* (Asplund, No. 72; Schubert-Soldern, No. 51; Delteil, No. 71).
Version: Stockholm, Thorsten Laurin, a sketch in oil.

MRS. GARDNER IN VENICE *Short Gallery*

Oil on canvas, 0.91 x 0.66. Inscribed at the foot on the left: *Zorn — / Venezia 1894.*

Mrs. Gardner, wearing a dress of plain yellow, steps through a long window onto the green carpet from the deep blue of the Grand Canal at night.

Mr. and Mrs. Gardner rented the Palazzo Barbaro at Venice from Mr. and Mrs. Daniel Curtis. Their friendship with Zorn had begun with the purchase of *The Omnibus* in 1893, and he had stayed with them in Boston early in 1894 to etch the portrait of Mrs. Gardner (Asplund, No. 84; Delteil, No. 83; Schubert-Soldern, No. 60), of which a print is in the case in this gallery. In October he brought his wife to the Palazzo Barbaro. The etching had not been a success, and countless pencil sketches of Mrs. Gardner which he now made were thrown away. Then this chance pose sent him to fetch his easel and his colours.

A small drawing of Mrs. Gardner's head was not thrown away, and is now in the Blue Room (Hadley, *Drawings*, p. 67). It was given to Mrs. Gardner by the artist. A bundle of affectionate letters from Zorn to Mrs. Gardner is in a case in the Long Gallery. *P17e10*

AUTHORITY

Asplund, *Anders Zorn* (London, 1921), p. 42.

MRS. GROVER CLEVELAND *Blue Room*

Oil on canvas, 0.68 x 0.51. Inscribed at the foot on the left: *Zorn to Mrs. JL Gardner/14 apr. 1899.*

Frances Folsom (b. 1864) married 2 June 1886 President Stephen Grover Cleveland (d. 1908), and 10 February 1913 Thomas Jex Preston, Jr.

This is a sketch for the larger portrait still in the possession of the sitter's family. Zorn painted also the portrait of *President Grover Cleveland* now belonging to Mr. Richard F. Cleveland. *P3w12*

Version: The finished portrait; exhibited 1924-25, Pittsburgh, Carnegie Institute, No. 25.

The Morning Toilet

The Omnibus

Mrs. Grover Cleveland

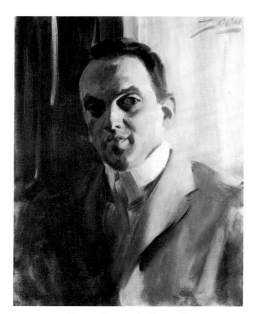

Abram Piatt Andrew, Jr.

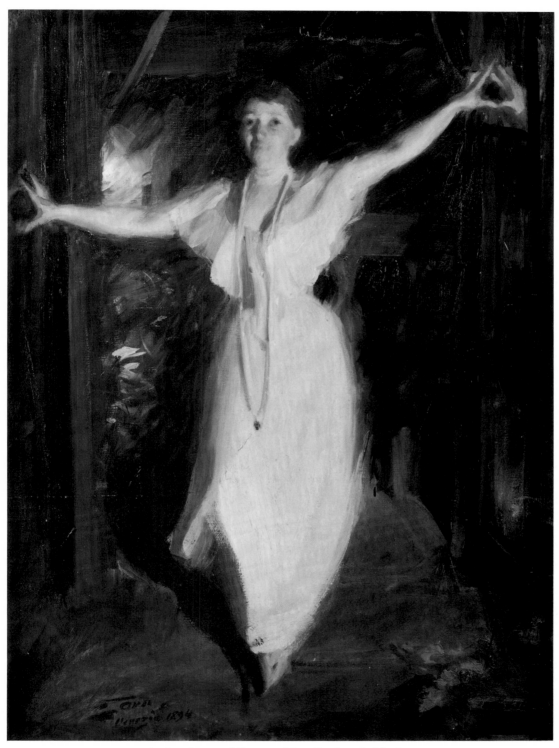

Anders Leonard Zorn — *Mrs. Gardner in Venice*

Etched by Zorn; two plates, each inscribed: *Zorn 1899* (Asplund, Nos. 145 and 146; Delteil, Nos. 143 and 144; Schubert-Soldern, No. 115, the second).

ABRAM PIATT ANDREW, JR. *Blue Room*

Oil on canvas, 0.60 x 0.44. Signed at the top on the right: *Zorn.*

The sitter (1873-1936) became Assistant Professor of Economics at Harvard in 1903, for five years; after which he worked on the National Monetary Commission, and became Assistant Secretary of the Treasury in 1910-12. He was at the same time Treasurer of the American Red Cross, and in World War I he directed the American Field Ambulance Service with the French army. He was a Republican Congressman 1921-37. He became a close friend of Mrs. Gardner's about 1908. She stayed at his house in Gloucester, Massachusetts, and was sometimes lent the house while he was away.

Zorn's sketch of him was commissioned by Mrs. Gardner. The artist wrote to her from Washington, D. C., 19 April 1911: "My dear Lady, The picture of Senator Aldrich is commenced yesterday — He is a delightfull modell [*sic*] but the president is a bad sitter — If I possibly can squeeze in time to make a sketch of Andrew I will do so — Yours very affectionately Zorn."

President Taft's portrait was completed, nevertheless, and presumably A. Piatt Andrew's was painted at the same time. P3s18

Francisco de Zurbarán

Born 1598 at Fuente de Cantos, half way between Badajos and Seville; died 1664 in Madrid.

The son of humble parents, he was apprenticed at fifteen for three years to a painter in Seville. His youthful ambition is recorded in a large picture now in a private collection at Bilbao, *The Immaculate Conception*, signed and dated 1616. In 1617 he moved a little nearer to Seville, to Llerena, then an important religious-administrative centre. There he was twice married, and lived until 1629. He must have developed a studio with assistants by January 1626, at latest, when he began to paint a long series of suites of large pictures for the numerous Sevillian monasteries. Of the twenty-one pictures for S. Pablo only five survive. Of these *S. Gregory*, *S. Ambrose* and *S. Jerome* now in the Seville Museum already show what Zurbarán did best. As a composer he developed slowly; but single figures like these are endowed with a powerful individuality by his native seriousness and sincerity of expression, his boldness in endowing form with grandeur

by simplification. Above all is the one great quality which he shared with Velázquez: a belief in the dignity of man. For the monastery of the Shod Mercedarians in Seville he painted *The Martyrdom of S. Serapion*, now at Hartford, signed and dated 1628; and that year the monastery commissioned twenty-two *Scenes from the Life of S. Pedro Nolasco.* Of the four now known, the two in Madrid are dated 1629, another, in Cincinnati, 1630.

Meanwhile in June 1629 Seville herself had invited him to become a citizen. He moved there the same year, with his second wife and three children by his first wife. Of these his son, Juan, became a painter, perhaps eventually his chief assistant. With one brief intermission, Zurbarán now lived in Seville until 1658.

Her virtual monopoly of trade with the New World made Seville the most prosperous town in Spain. Velázquez had been long gone to Madrid; and for fifteen years, in spite of some opposition from Alonso Cano and other artists, Zurbarán had no serious rival. The rich and powerful monasteries competed with one another for his pictures. He responded with a prodigious output. The great canvas with *The Apotheosis of S. Thomas Aquinas* in the Museum at Seville, painted for the high altar of S. Tomás there, is signed and dated 1631. This is not only the largest single picture which Zurbarán painted; it is almost the only large composition in which the tension is sustained throughout by the tactile realism which his own crisp handling of paint can impart to the surfaces of his powerfully sculptured forms.

From this time crisp and tangible pieces of still life often take a significant place in his compositions. At least the date 1633 accompanies Zurbarán's signature on the *Still Life with Oranges* in the collection of Mr. Norton Simon. To these same years in Seville seem to belong also the best of his many full-length figures of female Saints.

In 1634 he received commissions from Madrid for twelve large pictures in the new royal palace of the Buen Retiro. Of two great histories only *The Relief of Cadiz* has survived, in the Prado. If there is nothing new about its composition, all the aristocratic dignity of Spain is there. The ten panels with *The Labours of Hercules* are also now in the Prado: Baroque studies of the nude in different poses in the foreground of gloomy studio landscapes. Zurbarán returned to Seville with the title of Painter to King Philip IV.

From soon after this began the export of large numbers of canvases from his factory to the New World. Over eighty are known to have gone to Peru, including a set of twelve *Roman Emperors on*

Horseback. Of all these there have survived only fifteen religious pictures now in S. Francisco at Lima. Concerning export to Mexico there is no record; but pictures in Mexico City and in Guadalajara are probably the remnants of more than one series. In Guatemala City S. Domingo now has twelve *Apostles* brought from the old capital, Antigua.

This in no way reduced the output for the home market. In 1637-39 more than twenty paintings were supplied to the Charterhouse at Jerez. The majority of these are in the Museum at Cadiz, nearby; but one, *The Battle of Sotillo,* is now in New York, and perhaps the three best are at Grenoble. In the same years an even greater number of pictures were carried over the mountains northwards to the Geronomite monastery at Guadalupe, the richest in Spain. Most of these are still there, the eight *Geronomite Miracles* in their original places, in the sacristy.

Zurbarán's wife Beatriz died in 1639. Nearly five years later he married a third wife, Leonor de Tordera, a rich widow. They lived in style, and the export business seems to have flourished throughout the forties. A new star, however had arisen in Seville: Murillo, who was Zurbarán's junior by nearly twenty years. The demand for his work fell off abruptly, and the imitation of Murillo's soft and vaporous style brought no greater success. In 1658 Zurbarán moved to Madrid. *The Annunciation* in Philadelphia was painted there that year. He wrote in a letter that he worked much for the Court; but no picture certainly commissioned for the King has survived. Unless it is the touching *S. Luke before the Crucified* in the Prado. Here he is completely himself, and the S. Luke may be considered a portrait of the painter in these last years.

This picture leaves no doubt of the sincerity of Zurbarán's somewhat gloomy religion, which dictates the character of his work. He is at the opposite pole of expression from the other great painter of the Counter-Reformation in Spain, El Greco. In shimmering Venetian colour the Greek expressed a transcendent ecstasy by forms which barely touch the earth. The feet of Zurbarán's saints are firmly on the ground. Their eyes turned heavenward shine with the hope of redemption in a light which falls convincingly upon their tough surfaces through an opening in the clouds. Their prayers have to find their way upward in the blackness of the night sky, or through the embrasures of foursquare buildings. He was a somewhat archaic composer; but to the best spirits of a later day, after the soft theatricalities of the Rococo style and the simpering pedantries of the succeeding Neoclassicism, his very archaism came as a relief. When King Louis Philippe of France opened his Spanish gallery in the Louvre in 1838, the very harshness of Zurbarán's lighting, the hard tangibility of his objects, above all the sincerity which supplied the motive power were a revelation to the young Courbet (*q.v.*) and some of his contemporaries. After two centuries Zurbarán acceded to a higher place than Murillo in the history of painting.

A DOCTOR OF LAW *Dutch Room*

Oil on modern canvas, 1.955 x 1.045. The original support, doubtless of canvas, was removed long ago (? in Paris). The new canvas was lined in 1931 and relined in 1949. The many losses before or during the transfer of the paint are mostly confined to the background and the lower part of the dress.

The brown robe, scarlet hood and green tasseled cap are those of a doctor of law at the University of Salamanca.

In many of Zurbarán's compositions portraits take a predominant place, either idealized as saints or frankly as records of members of the religious orders which patronised him. Lay portraits by him are comparatively rare. In these the influence of Velázquez is more apparent than elsewhere. A comparison with his *King Philip IV* in the Museum shows the close connection, though the hand of Zurbarán's doctor is reminiscent of Velázquez at a rather later date. In both pictures the greater part of the costume is probably the work of an assistant.

Salamanca is much nearer to Madrid than to Seville, and this is an argument for dating this picture either 1634, when Zurbarán is known to have spent the greater part of the year in the capital or after 1658, when he went to live there. Though the influence is from the earlier style of Velázquez, the actual painting suggests the later manner of Zurbarán. Soria's dating of 1658-60 seems the most probable.[1]

He stated that before 1700 it belonged in Madrid to the Marquis of Leganés. In 1867 it was in the sale in Paris of the Marquis of Salamanca, attributed to Velázquez (June 3-6, No. 207). In 1908, still in Paris, it was in the sale of Ivan Stchoukine (19 June, Hotel Drouot, No. 70). It was bought by Mrs. Gardner from the Ehrich Galleries, New York, in February 1910. P21s28

[1]Martin S. Soria, *Francisco de Zurbarán* (1953), p. 186, No. 214.

OTHER AUTHORITIES

Gaya Nuño, *Zurbarán* (Barcelona, 1948), pp. 31 and 47; he dated it early in the decade 1650-60.

Guinard, *Zurbarán* (1960), p. 278, No. 577.

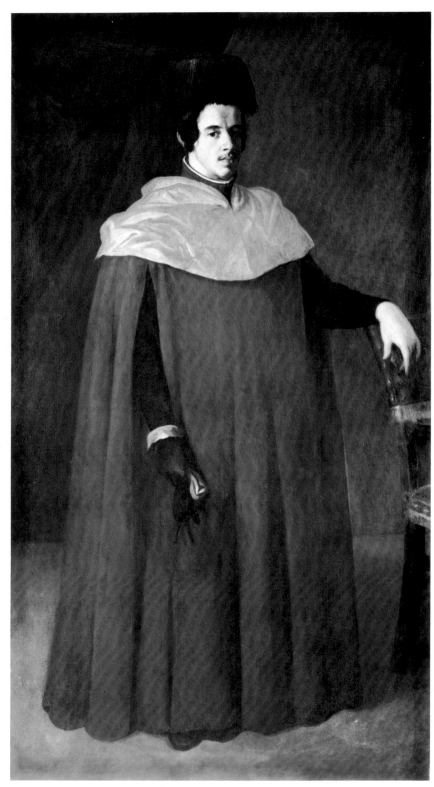

Francisco de Zurbarán — *A Doctor of Law* (SEE COLOUR PLATE)

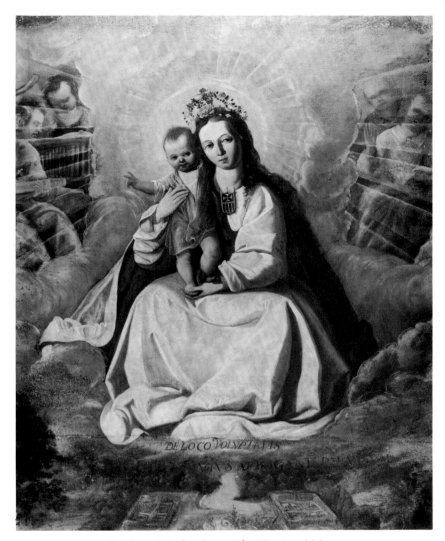

Studio of Zurbarán — *The Virgin of Mercy*

Kehrer, *Francisco de Zurbarán* (Munich, 1918), p. 140.
Van Loga, *Die Malerei in Spaniern* (Berlin, 1923), p. 284.
Mayer in *Arts and Decoration*, VI (1916), pp. 219-22.

Studio of Zurbarán

THE VIRGIN OF MERCY *Spanish Chapel*

Oil on canvas, 1.420 x 1.088. The canvas has been cut all round, and truncated details show that it is part of a larger picture. In 1940 the removal of old varnish and considerable overpainting revealed the inscription and everything below the Virgin's feet. These had all been covered with cloud.

Below the Virgin's feet is the inscription: *DE LOCO VOLVPTATIS/ VVIVS ÆD*

IRIGAND̄ PARAD.VM. An abbreviation of Genesis 2:10: *Et fluvius egrediabatur de loco voluptatis ad inrigandum paradisum, qui inde dividitur in quattuor capita* ["And a river went out of Eden to water the garden; and from thence it was parted, and became into four heads"]. Possibly therefore there were originally not two but four well planted gardens here, and the gold ornament surmounted by a cross may be only the apex of a crown. The foliage of a large tree in the lower left corner also suggests that originally the picture was considerably extended downward. That it was much wider is shown by the truncation of the angelic orchestra on the left. Of the lowest figure here, playing the lute, one sees only the knees and the left hand on

the strings; of the topmost figure there is only part and a hand holding a horn. Zurbarán's compositions were carefully symmetrical, and it is probable that two figures are missing from the other side. It is not necessary to suppose that the picture was originally more than approximately a square, with each side a little longer than the present height; but possibly this is only the miraculous vision of the Virgin cut from the top of a large altarpiece. This would explain why the quality of the execution is not very high: painters were apt to leave to their assistants parts which were well above eye level.

The badge worn by the Virgin at her throat is that of the Mercéd Calzada, the Order of the Shod Mercedarians, who were among Zurbarán's earliest patrons. The picture was painted probably 1630-35. From photographs, the group of Virgin and Child seems slightly inferior to the same group which appears on the same scale in a picture belonging (1953) to the Duchess of Montpensier, in Madrid. This comes from a church of the Barefoot Mercedarians, S. José in Seville, and the Virgin, wearing their badge, is appearing to two members of the Order, who pray to her from below on either side.

Mrs. Gardner bought her picture at Seville in April 1888 from Jacobo López Cepero. *P6n2*

AUTHORITIES

Gaya Nuño, *La Pintura Española fuera de España* (1958), p. 346; he seems to accept it as the work of Zurbarán. His statement that it is from the convent of the Mercéd of Seville is presumably based on the Virgin's badge.

Soria, M. S., *Zurbarán* (1953), p. 162; he mentioned it only parenthetically in connection with the picture painted for the Barefoot Mercedarians, his No. 122: "Two much inferior school copies with variations exist, one in the Gardner Museum. . . ."

Versions: (1) Madrid, Duchess of Montpensier (1953), canvas, 1.66 x 1.29 (reproduced in Soria, *op. cit.*, fig. 83). Instead of the angelic orchestra, two flying Cherubim hold garlands of flowers. The background is composed of Cherub heads, mistily seen. Two below are modelled to support the Virgin's feet. The two monks pray against a dark sky; one has a Cardinal's hat. If the Gardner picture is indeed copied from this (see above), the canvas may well have had the same dimensions. The Virgins must be on the same scale. (2) Madrid, Lázaro Foundation (see Soria, *op. cit.*, p. 162).

List of Painters in Chronological Order

Giotto di Bondone, 1267-1336/7

Simone Martini, 1283/5-1344

Giuliano da Rimini, *active* 1307-46

Lorenzetti, Ambrogio, *active* 1319-47

Daddi, Bernardo, *died* 1348

Memmi, Lippo, *died* 1357

Bulgarini, Bartolommeo, *active* 1337(?)-78

Gerini, Niccolò di Pietro, *active* 1368-1416

Fei, Paolo di Giovanni, *active* 1369-1411

Comes, Francesc, *active* 1380-95

Gentile da Fabriano, 1370(?)-1427

Bicci di Lorenzo, 1373-1452

Uccello, Paolo, 1397(?)-1475

Weyden, Rogier van der, 1399/1400-64

Angelico, Fra Giovanni, 1400(?)-55

Masaccio, 1401-28/9

Giovanni da Rovezzano, 1412(?)-59

Giambono, Michele, *active* 1420-62

Pesellino, Francesco, 1422-57

Giovanni di Paolo, *active* 1426-82/3

Schongauer, Martin, *died* 1491

Piero della Francesca, *died* 1492

Crivelli, Carlo, *active* 1457-95

Tura, Cosimo, 1430(?)-95

Bermejo, Bartolomé, *died after* 1495

Mantegna, Andrea, 1430/1-1506

Pollaiuolo, Piero del, 1443(?)-96

Botticini, Francesco, 1446-97

García, Pedro, de Benabarre, *fifteenth century*

Il Maestro Esiguo, *fifteenth century*

Botticelli, Alessandro, 1444/5-1510

Antoniazzo Romano, *active* 1452-1512

Bellini, Gentile, *died* 1507

Bellini, Giovanni, *died* 1516

Liberale da Verona, 1445(?)-1526(?)

Credi, Lorenzo di, 1448(?)-1537

Francia, Francesco, 1450(?)-1517/8

Pintoricchio, Bernardino, 1454(?)-1513

Cima, Giovanni Battista, 1460(?)-1517/8

Falconetti, Giovanni Maria, 1468(?)-1534

Cicognara, Antonio, *active* 1480-1500

Dürer, Albrecht, 1471-1528

Cranach, Lucas, 1472-1553

Luini, Bernadino, 1475(?)-1532

Titian, 1477(?)-1576

Mabuse, Jan Gossaert van, 1478(?)-1532

Raphael, 1483-1520

Catena, Vincenzo, *active* 1500-31

Bartolommeo Veneto, *active* 1502-46

Torbido, Francesco, 1483(?)-1561/2

Bonifazio Veronese, 1487-1553

Bandinelli, Baccio, 1488-1559

Bacchiacca, 1494/5-1557

Holbein, Hans, 1497/8-1543

Bordone, Paris, 1500-71

Bronzino, Angelo, 1503-72

Tintoretto, Jacopo, 1518-94

Mor, Anthonis, 1519(?)-76/7

Moroni, Giovanni Battista, 1520(?)-78

Veronese, Paolo, 1528(?)-88

Sánchez Coello, Alonso, 1531/2-88

Herri met de Bles, *active* 1535-75

Corneille de Lyon, *sixteenth century*

Pourbus, Frans II, 1569-1622

Rubens, Peter Paul, 1577-1640

Suttermans, Justus, 1597-1681

Zurbarán, Francisco de, 1598-1664

Dyck, Antoon Van, 1599-1641

Velázquez, Diego, 1599-1660

Rembrandt van Rijn, 1606-69

Borch, Gerard ter, 1617-81

Lauri, Filippo, 1623-94

Vermeer, Johannes, 1632-75

Tiepolo, Giovanni Battista, 1696-1770

Boucher, François, 1703-70

Zais, Giuseppe, 1709-84(?)

Guardi, Francesco, 1712-93

Blackburn, Joseph, *active* 1753-63

Turner, Joseph Mallord William, 1775-1851

Sully, Thomas, 1783-1872

Corot, Jean-Baptiste-Camille, 1796-1875
Delacroix, Ferdinand-Victor-Eugène, 1798-1863
Diaz, Narcisse-Virgile, 1807-76
Troyon, Constant, 1810-65
Jacque, Charles-Emile, 1813-94
Courbet, Gustave, 1819-77
Brabazon, Hercules Brabazon, 1821-1906
Bonheur, Rosa, 1822-99
Ziem, Félix-François, 1822-1911
Rossetti, Dante Gabriel, 1828-82
Manet, Edouard, 1832-83
Whistler, James Abbott McNeil, 1834-1903
Degas, Hilaire-Germain-Edgar, 1834-1917
La Farge, John, 1835-1910
Alexander, Francesca, 1837-1917
Smith, Francis Hopkinson, 1838-1915
Whitman, Sarah de St. Prix Wyman, 1842-1904
Brown, John Appleton, 1844-1902
Lanciani, Rodolfo Amadeo, 1847-1929
James, Francis Edward, 1849-1920
Besnard, Paul Albert, 1849-1934
Mainella, Raffaele, 1850-1942
Dewing, Thomas Wilmer, 1851-1938
Mancini, Antonio, 1852-1930
Twachtman, John Henry, 1853-1902
Ross, Denman Waldo, 1853-1935
Curtis, Ralph Wormeley, 1854-1922
Nordström, Karl Frederik, 1855-1923
Gaugengigl, Ignaz Marcel, 1855-1932
Fragiacomo, Pietro, 1856-1922

Sargent, John Singer, 1856-1925
Voerman, Jan, 1857-1941
Sears, Sarah Choate, 1858-1935
Helleu, Paul-César, 1859-1927
Hassam, Childe, 1859-1935
Zorn, Anders Leonard, 1860-1920
Macknight, Dodge, 1860-1950
Bunker, Denis Miller, 1861-90
Lockwood, Wilton, 1861-1914
Smith, Joseph Lindon, 1863-1950
Woodbury, Charles Herbert, 1864-1940
Potter, John Briggs, 1864-1945
Bakst, Leon Nikolaievitch, 1866-1924
Andersen, Andreas, 1869-1902
Cushing, Howard Gardiner, 1869-1916
Matisse, Henri, 1869-1954
Mower, Martin, 1870-1960
Hallowell, George Hawley, 1871-1926
Roberts, Elizabeth Wentworth, 1871-1927
Kronberg, Louis, 1872-1965
McComas, Francis John, 1875-1938
Anisfeld, Boris, 1879-1973
Pope, Arthur, 1880-1974
Ranken, William, 1881-1941
Slade, C. Arnold, 1882-1934
James, William, 1882-1961
Tilton, Paul, *active* 1886-95
Marshall, E. Newell, *twentieth century*
Curtis, Sylvia, *born* 1899

Dealers and Former Owners

Dealers and former owners with additional references are in the Index.

Index

Artists' names and Schools of painting for which there is a catalogue entry appear in capital letters. Italics are used for the titles of paintings except for portraits and biblical and classical subjects. Roman numerals refer to the colour plates.

DESIGNED BY LARRY WEBSTER

TYPE SET IN LINOTYPE PALATINO AND

PRINTED IN THE UNITED STATES BY THOMAS TODD COMPANY

BLACK AND WHITE PHOTOGRAPHS BY JOSEPH B. PRATT

COLOR PHOTOGRAPHS BY HERBERT P. VOSE

COLOR SEPARATED BY TECHNO-COLOUR

BOUND BY ROBERT BURLEN AND SON